W9-CJY-628

GIORGIO VASARI

ART AND HISTORY

Patricia Lee Rubin

Yale University Press · New Haven & London

For 3 Rothwell Street

Designed by Gillian Malpass
Set in Linotron Bembo by Best-set Typesetter Ltd., Hong Kong
Printed in Hong Kong through World Print Ltd

Library of Congress Cataloging-in-Publication Data

Rubin, Patricia Lee, 1951–
Giorgio Vasari: art and history / Patricia Lee Rubin.
Includes bibliographical references and index.
ISBN 0-300-04909-9
1. Vasari, Giorgio, 1511–1574.—Criticism and interpretation.
2. Vasari, Giorgio, 1511–1574. Vite de' più eccellenti architetti,
pittori et scultori italiani. I. Title.
N7483.V37R83 1994
709′.2—dc20 94-1254
 CIP

A catalogue record for this book is available from
The British Library

Frontispiece: Giorgio Vasari, *Self-Portrait as St. Lazarus,*
Arezzo, Badia of Santissime Fiora e Lucilla.

CONTENTS

PREFACE

SINCE THEIR PUBLICATION IN 1550 Vasari's *Lives* have been a source of information and pleasure. This immediacy after more than four hundred years is a measure of Vasari's success. He wished the artists of his day, himself included, to be famous. He made the association of artistry and innate talent, of renaissance and the visual arts so familiar that they now seem inevitable. The argument of this book is that both the inevitability and the immediacy should be questioned. However pleasurable and useful an experience, reading *The Lives* ought to be regarded as difficult. The difficulty is not, or not merely, that of understanding the language of sixteenth-century Italy or the ideas and ideals expressed in the biographies, but in recognizing the book as a period piece – as a product of the conventions and convictions of historical writing of Vasari's time. Difficulty was in itself an important concept in renaissance aesthetics, and the skillful resolution of complicated problems, the "difficulties of art," was an achievement often praised by Vasari. Because his *Lives* are the principal source for much of the study of renaissance art and because they are so remarkably vivid and apparently accessible, the extreme skill of their contrivance is seldom acknowledged. But to miss or dismiss their artifice is to deprive Vasari's work of much of its value. When his book is regarded as simply an amusing collection of tales about artists or as a dictionary of renaissance art, its essential meaning as a work of renaissance history is lost. Vasari can then be criticized for being frivolous, biased, or inaccurate and seen as a servile and self-serving court propagandist. It is my feeling that rather than accusing Vasari of failing to meet our expectations, we should try to respect his intentions. My hope is that my book will help to explain Vasari's methods and aims as a biographer and will suggest ways that the search for information can be tempered with sympathy for his ingenuity and invention.

★　★　★

I must thank my colleagues at the Courtauld Institute. The librarians and staff of the Photographic Survey and the Conway and Witt photographic collections were invariably co-operative and efficient. Michael Hirst and Lorne Campbell and my former colleague, Howard Burns, granted me the time to concentrate on Vasari. Much of that time was spent at the Warburg Institute. This book could not have existed without the resources of the Warburg, so graciously shared. Credit for the index goes to Crispin Robinson, and I am profoundly appreciative of all the efforts and intelligence that he put to the service of this

project. I owe a great deal to Alison Wright and Robert Maniura who helped me in checking sources, to Megan Holmes for untangling the archival references to Vasari's will, and to Katherine Anna Perlsweig for her extraordinary patience in assisting me in correcting the text. Thanks are due also to Margaret Walker, Letizia Panizza, and Allan Husband for their work on the translations. The interest, endurance, and editorial skills of John Nicoll and Gillian Malpass of Yale University Press made this book possible.

Considerable portions of the book were written at Villa I Tatti, the Harvard University Center for Renaissance Studies. I am grateful to the staff and to all of my companions and co-Fellows for making every visit there so wonderful and rewarding. My special thanks go to the Director, Walter Kaiser, and to Paul Barolsky, Bonnie Bennett, Anthony Cummings, Philip Gavitt, William Hood, Christine Huemer, Victoria Kahn, and F.W. Kent for their comments, support, and inspiration, and to Fiorella Superbi for performing miracles in obtaining photographs. I benefited greatly from the criticism and assistance given me by Charles Davis and Margaret Daly Davis. I must also express my gratitude to the Kunsthistorisches Institut in Florence, to Rosella Foggi at Cantini publishers, and to the authorities of the Florence and Arezzo Soprintendenze, notably Anna Maria Maetzke in Arezzo and Silvia Meloni in Florence.

I would like to acknowledge John Shearman, whose lecture on Vasari's Life of Raphael given at the Courtauld Institute in 1977 was the point of departure for my research and who has subsequently made many useful suggestions for this book. I want to record my admiration for the contributors to the catalogue of the exhibition held in 1981 at the Casa Vasari in Arezzo. It is a remarkable survey of Vasari's career and works, and I have returned to it often with pleasure and profit. I have enjoyed conversations with many fellow readers and admirers of Vasari, but would particularly like to thank James Ackerman, Michael Baxandall, David Cast, Philip Jacks, Fredrika Jacobs, Julian Kliemann, Konrad Oberhuber, and Robert Williams for sharing their enthusiasm and knowledge with me, and Caroline Elam for her kindness, wisdom, and critical acumen. Robert Black, Joanna Cannon, Berenice Davidson, David Franklin, Alessandra Galizzi, Fiona Healy, Tom Henry, Monique Kornell, Victor Meyer, William Wallace, and Nicholas Webb have given me invaluable advice in areas in which their expertise is far greater than mine, and I am indebted to them.

I am deeply obliged to my family and to my friends, who have been true friends indeed, unstintingly generous, helpful, hospitable, and encouraging, above all Barbara Santocchini, Hilarie Faberman, Honey Meconi, and Charles Robertson.

EDITORIAL NOTE

ALL QUOTATIONS IN THE MAIN TEXT are in English, with Italian given in the footnotes. The translations have retained the sentence structures of the original texts as closely as possible. This is in order to preserve the distance and difference that exists between sixteenth-century Italian and modern Italian and English. Where there are only slight variations between the two editions, I have quoted from the 1568 text of *The Lives*, which Vasari regarded as corrected and improved. In those cases where the differences are significant, the relevant edition is cited and noted. It is often the case that the Italian in the notes includes a fuller version of the texts than the fragments directly quoted in English. This is partly to try to minimize the mutilation of the sources. It is also owing to the fact that frequently the sources are paraphrased as well as quoted in the main text.

With respect to the texts given here as sources, where possible the versions Vasari is most likely to have known and consulted are indicated, but for the convenience of the modern reader, and those without access to rare-book and manuscript collections, only modern editions are quoted unless the wording of the earlier text is important in demonstrating Vasari's reliance on a given source or any significant variation from it.

So that the reader can conveniently consult the quotations from both editions, I have referred to the Bettarini/Barocchi parallel texts (BB) rather than the rare original editions or other modern versions of the single editions. All passages in Italian retain the punctuation and spelling of their sources, however idiosyncratic. I have followed Vasari in referring to *The Lives* in the plural.

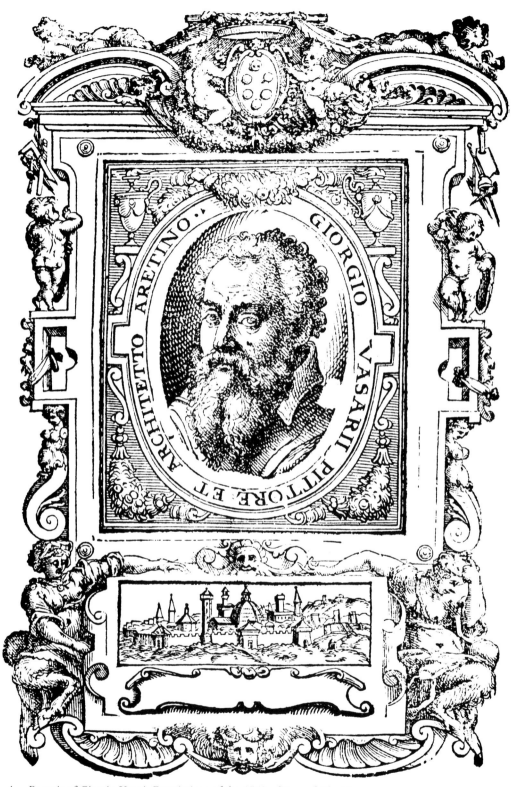

GIORGIO · VASARII · PITTORE · ET · ARCHITETTO · ARETINO ·

1. Portrait of Giorgio Vasari. Frontispiece of the 1568 edition of *The Lives*.

INTRODUCTION

GIORGIO VASARI INVENTED RENAISSANCE ART. In 1550 he published a collection of one hundred and forty-two biographies, his *Lives of the Most Excellent Italian Architects, Painters, and Sculptors from Cimabue to our Times*, and defined a period of artistic activity spanning nearly three hundred years in terms of rebirth (*rinascita*) and progress. He gave the history of the visual arts in Italy a determined course as they advanced towards the perfection of his own day through the contributions of individual artists. He turned a fragmentary tradition of discussion and appreciation into a coherent and forceful representation of achievement that has endured since his time. Scattered notices, dim memories, direct encounters, rumor, gossip, anecdote, and experience were structured and transformed by association with exemplary notions of behavior and shaped by a vision of stylistic development and historical continuity.

Vasari organized the Lives in his book into three parts, or ages, roughly corresponding to the fourteenth, fifteenth, and sixteenth centuries, each defined by their distinct character.[1] He dated the initial stages of the rebirth or recovery of the lost attainments of antiquity to around 1240, when Giovanni Cimabue was born to kindle "the first lights of painting" (pl. 2).[2] He regarded the arts to be in their infancy in this era, and traced the artists' faltering steps towards the perfection of later years. For Vasari the means of arriving at perfection lay in the mastery of the principles and models offered by ancient art: a correct understanding of the architectural orders and the imitation of the poses, proportions, and dramatic possibilities of ancient sculpture. To these were added the naturalistic rendering of light with harmoniously blended colors and chiaroscuro modelling in painting, and above all, in all the arts, in *disegno* – the command of idealized form that resulted from manual dexterity (drawing) and an intellectual perception of beauty (design). In the first era painters and sculptors are described as valiantly, if crudely, overthrowing the stiff, coarse, and clumsy figures of the style Vasari labeled as Greek, achieving more lifelike poses and expression in their figures. Architects are valued for building with more order, beginning to improve from what Vasari called the German manner, which had prevailed since the invasion of the Roman empire and the destruction of its monuments. In the second era, Vasari shows how

1 Set forth in the preface to Part 2, BB III, pp. 5–7.
2 Life of Cimabue, BB II, p. 35: "per dar e' primi lumi all'arte della pittura."

the prime goal of art – the imitation of nature – is nearly attained as a result of the successive technical discoveries made by the artists of that time through their diligence and study. These included the rediscovery of the measures, proportions, and ornaments of ancient architecture, and the mastery of anatomy and perspective. This era of technical advance is followed by Vasari's modern age, when, in various ways, various artists bring those techniques to their highest realization. They do so on the basis of their immediate past and the recovery and full comprehension of a distinguished repertory of classical models. With this comes the ability to surpass previous accomplishments, going beyond the rules with new and graceful inventions. The conquest of nature is complete. The palm of victory is granted to Michelangelo – the culminating figure of *The Lives*.

A full complement of dedicatory and prefatory material surrounds and explains Vasari's sequence of ages. The first preface, that to the whole book, sets out the aims of the history and then addresses the current debate on the relative merits of painting and sculpture. Vasari's airing of this question allowed him to elaborate upon the qualities of both and to unite them as equal, "sisters born of one father" – *disegno* or design.[3] This solution offered a conceptual basis for appreciating the arts. The general preface is followed by a technical introduction that instructs the reader in the material differences between the three arts of design (architecture, sculpture, and painting) and serves as a guide to the artists' "ways of working."[4] The preface to *The Lives* (*Proemio delle Vite*) then treats of the origins and nobility of the arts and their history from the Creation through the barbarian invasions that caused the ruin of Rome's glories, a history of perfection and ruin that sets the scene for restoration and revival.[5] The preface to Part 2 explains the premises of Vasari's history and its divisions. That to Part 3 gives a description of the qualities that brought about the improvement of the arts in the preceding era and that were perfected in the third – rule, order, measure, drawing, and style.[6] Within this overall framework each biography records the important works that together compose the sequence of excellence. The life of the artist is not divorced from the life cycle of the arts, but each artist is also granted the individuality of his temperament and talent. Artists are presented as unique creative personalities whose works and deeds are the subject of separate critical appraisal. Art history is not divided from art theory or art criticism, as Vasari exploited the gamut of praise and blame fundamental to the biographical tradition.

The components of Vasari's history had generic precedents and parallels in biography, technical treatises, and didactic literature, both classical and contemporary. The notion of a renaissance dated from the time of Petrarch, Vasari's first age. The novelty of *The Lives* was the fusion of the various genres on such a vast scale and their systematic association with the visual arts. Vasari's experience as an artist was the source of both his information and his passion. He felt a deep obligation to the past he observed and described and to the future he wished to affect. He discharged this debt with such conviction and authority that his association of periods and people and his alliance of history and style underlie much of the

3 General preface to *The Lives*, BB I, p. 26: "Dico adunque che la scultura e la pittura per il vero sono sorelle, nate di un padre, che è il disegno."

4 *Ibid.*, p. 29: "nella Introduzione rivedranno i modi dello operare."

5 Preface to *The Lives*, BB II, p. 13, Vasari describes

the course of the arts from Roman times as that of: "della loro perfezzione e rovina e restaurazione e, per dir meglio, rinascita."

6 Preface to Part 3, BB IV, p. 3: "regola, ordine, misura, disegno e maniera."

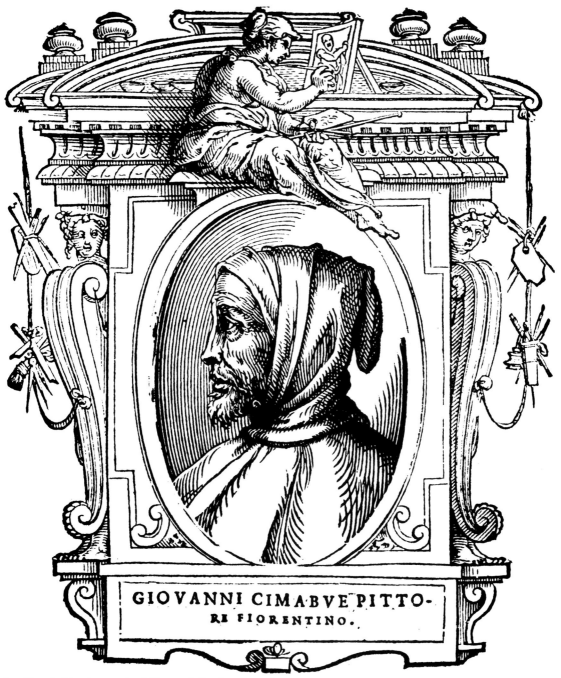

GIOVANNI CIMABVE PITTO-
RE FIORENTINO.

2. Giorgio Vasari, portrait of Giovanni Cimabue from the 1568 edition of *The Lives*.

study of Italian art and much of the subsequent historical investigation of the arts. Central Italy continues to be studied as the site and center of the renaissance of the arts, despite repeated attempts to dislodge it from its place at the summit of achievement. Later authors promoted different regions in response to Vasari, seeking to revise his history according to local interests, so Carlo Ridolfi championed Venice in his *Maraviglie dell'arte* (1648) and Carlo Cesare Malvasia Bologna in his *Felsina Pittrice* (1678).[7] Others like Giovanni Baglione supplied "what lacked in Vasari," by writing lives of the artists of their times.[8] But such writers took their terms of reference from Vasari's text, and however they might deny his accuracy by exposing his bias, they did not question the validity of his enterprise or its scope. In the same way, Vasari's selection of famous men, however resisted and criticized, provided the basis for future study. His canon, once fixed, was so decisive that to have escaped Vasari's attention often meant to have fallen from consideration for centuries. Those artists he failed to rescue from the "second death" of oblivion have remained there to be resurrected only with great difficulty.[9]

Due to Vasari's indefatigable efforts in seeking information and his relative proximity to the sources, his *Lives* soon became and have remained a standard reference. Richly informative and remarkably entertaining, they support a scholarly industry, occupying many volumes and many shelves. Vasari addressed his book to an audience of fellow artists and art-lovers, those who practiced and those who valued the arts. It is now largely the province of specialist art historians. *The Lives* are more often used and consulted than read, or else they are read with fond scepticism as a form of story book – as a series of picturesque, picaresque tales. Since the first appearance of critical editions of *The Lives* in the eighteenth century, Vasari's historical narrative has become increasingly divorced from its subject. *The Lives* have been treated as precisely the form of inventory or factual account Vasari rejected, or they have been viewed as amusing fictions. Information and stories about artists have been extracted and evaluated with little regard to their context. Excerpted, updated, annotated, corrected, and rearranged, the original two- and three-volume editions of 1550 and 1568 have both shrunken to quaint compendiums of anecdote and swollen to editions of fourteen volumes or more. In the late nineteenth century Gaetano Milanesi, whose edition of Vasari is itself a standard work, presented *The Lives* as valuable but flawed.[10] At the turn of

7 For this regional literature, see G. Perini, "Carlo Cesare Malvasia's Florentine Letters: Insight into Conflicting Trends in Seventeenth-Century Italian Art Historiography," *Art Bulletin* (1988), pp. 273–99, with further references. For Vasari's influence in Italy and northern Europe, see Schlosser, *La letteratura artistica*, pp. 354–8, 527–34, and the contributions by Barocchi, Bonsanti, Ercoli, Puppi, Thuillier, and Salvini in *Atti* 1974.

8 *Le vite de' Pittori scultori et architetti* (1642), letter to his readers, p. a3: "Ciò, che manca a Giorgio Vasari . . . hora è supplimento di questa mia fatica." For such Lives, see Schlosser, *La letteratura artistica*, pp. 459–76. For reactions, criticisms, and developments, see E. Goldberg, *After Vasari. History, Art, and Patronage in Late Medici Florence.*

9 General preface to *The Lives*, BB I, p. 10, Vasari explains his desire to: "difenderli [architetti, scultori e

pittori] il più che io posso da questa seconda morte e mantenergli più lungamente che sia possibile nelle memorie de' vivi."

10 Preface to *Le Vite* (1878), pp. v–vi. For Milanesi's historical outlook and the critical fortunes of Vasari's *Lives*, see Barocchi's introduction to the Sansoni reprint of Milanesi's 1906 edition (*Le Opere*, ed. Milanesi, pp. ix–xvii) and foreword to the parallel text edition of the 1550 and 1568 *Lives*, BB, *Commento*, I, pp. ix–xlv, and the note on Vasari editions in the Bibliography below. All modern readers of Vasari are profoundly indebted to Paola Barocchi. Her editions of juxtaposed 1550 and 1568 *Lives* have made it possible to observe and study the differences between the two editions and the development of Vasari's historical and critical thought. For a suggestive treatment of *The Lives* as imaginative literature, see Barolsky, *Why the Mona Lisa Smiles*, and for a discussion of the epistemological status of the text, see

this century a critical dissection of Vasari as a historian was begun by a Viennese scholar, Wolfgang Kallab, who undertook a thorough investigation of Vasari's sources. Regrettably he was never able to put together what he took apart. He died before his study was completed. His notes were published by Julius von Schlosser in 1908, and his views incorporated in von Schlosser's own magisterial book on art-historical writing.[11] Their work was important in re-establishing the value of Vasari's *Lives* by understanding them as a synthesis of different sources determining the nature and the quality of the information offered. Vasari's critical viewpoint has been elucidated by these and subsequent studies, but his accomplishment has continued to be diminished by measuring it against empirical notions of historical truth.

An evaluation of *The Lives* as a source depends upon an awareness of Vasari's intentions as a historian. He was explicit about his aims. In the preface to the second part of *The Lives* he says that he did not want to waste his efforts on "a note" or "an inventory." Following "the writers of histories" he saw the past as a "mirror of life."[12] And following those writers he defined the writing of history as an exercise of judgment based on the presentation of instructive examples. Vasari wished to give significant form to the history of the arts. The form he chose was biography. It is the aim of this book to study the motivations and consequences of that choice.

The selection of suitable models was essential to almost all types of writing in the renaissance. There was no specific model for artistic biography, and Vasari's *Lives* are a hybrid. The notion of writing a series of lives organized as a succession of masters and pupils was probably derived from the famous book of philosophers' lives by the third-century historian Diogenes Laertius. Association with this prototype equated artists with philosophers and their manual skill with an intellectual discipline. The structure of the individual Lives follows a sequence of topics that had its origins in classical biography, notably Plutarch, and that had been widely adapted by renaissance authors both in writing lives and in eulogistic orations. Vasari employed these models, generally applied to statesmen and saints, to prove the value of the visual arts and the merit of their practitioners. He created heroes. Biography was held to be related to panegyric, part of the literature of praise and example. Such exemplary history allowed Vasari to present the ideal artist and the ideal artistic ambience. His chosen form was suited to demonstrating character and accomplishment. Vasari did not write political or economic history. He focussed on works rather than events. The artists prove their character, their excellence or *virtù*, through their creation of objects that made them famous by being worthy of mention. Vasari's respectful record was in turn meant to inspire future generations. The rhetorical premises of historical writing assumed it to be as persuasive as it was instructive and amusing.

This study is not concerned with the critical fortunes of *The Lives* and certainly not with

Cast, "Reading Vasari again: history, philosophy," *Word and Image* (1993), pp. 29–38. For a consideration of Vasari's place within the history of art, see Belting, "Vasari and His Legacy," in *The End of the History of Art*, pp. 65–120.

11 *Die Kunstliteratur* (1924) and Kallab, *Vasaristudien*.
12 Preface to Part 2, BB III, pp. 3–4: "non fu mia intenzione fare una nota delli artefici et uno inventario . . . Ma vedendo che gli scrittori delle istorie . . . come quelli che conoscevano la istoria essere veramente lo specchio della vita umana . . . ho tenuto quanto io poteva, ad imitazione di così valenti uomini." This key passage is quoted at length and discussed below in Chapter IV, pp. 152–4.

correcting errors to purify Vasari's book as super-source, but to show how he found and articulated a powerful form of historical argumentation – one that effectively created art-historical writing by consolidating the position of the visual arts as a topic meriting serious literary discussion. It suggests a way of reading Vasari's *Lives* in the context of sixteenth-century writing by examining his procedure as a historian, the direct and indirect sources of his book, and its means and purpose of address. *The Lives* were based on Vasari's own life, summarized here in a biographical outline. Chapter I considers how we know Vasari – through surviving documents, letters, and *The Lives* – and how he chose to be known through history. Chapter II looks at how the circumstances of his early life influenced Vasari's definition of his profession, his selection of artists worthy of commemoration, and the nature of his examples in *The Lives*. Chapter III gives an account of what is known about the writing and publication of the first edition in the 1540s and its background in Vasari's curiosity and his travels. Chapter IV examines Vasari's historiographic models, his sources, and their combination. Vasari was an artist, he became an author. He attached his ambitions to the traditional prestige of letters and turned familiar forms to novel tasks. The moment was auspicious. The appearance of *The Lives* must be seen as part of a wider publishing phenomenon in Italy, where there was a rapidly growing enthusiasm for specialist works in Italian. This challenge to the dominance of Latin, and its necessarily learned writers, generated new types of text, and with them, new categories of interest, including the excellence of architects, painters, and sculptors.

Vasari presented the 1550 edition to his readers as a draft, with the hopes that it be improved and updated. He was to develop his own sketch, turning it into a fuller picture, producing a second edition in 1568. This is the version that is most commonly read. A refined reading of *The Lives* must be based on a knowledge of the interests represented in this edition and how they influenced what was corrected and what was added. Vasari's outlook as a writer and historian changed as his career advanced in the 1550s and 1560s. *The Lives* were revised according to notions of historical accuracy suggested to Vasari by his friend and adviser Vincenzo Borghini and also according to his experiences as artist or artistic impresario at the court of Duke Cosimo de' Medici. Chapter V summarizes the process that created the new edition as the changes in Vasari's life were incorporated into *The Lives*.

Vasari wanted his readers to come to understand the differences between styles and to learn how to assess the qualities and defects of works of art. Chapter VI examines his language and techniques of evaluation. In order to analyze his historical and critical method, three Lives have been selected for detailed consideration. These studies, one from each era, are intended to show how the progress of art from its rebirth in Cimabue's time to its perfection in Vasari's is expressed. The first (Chapter VII) looks at the formation and formulation of artistic ideals in the Life of Giotto and the sources of those ideals in previous writing on Giotto. The question of revival or *rinascita* as understood in the period and its association with the name of Giotto is investigated, as well as the way Vasari's praise for the accomplishments of fourteenth-century artists was tempered by his lack of enthusiasm for their works, which he saw as coarse and crude. The Life of Donatello is the second of the studies, showing how the attainments of artists are related to the nature of their times in *The Lives* through Vasari's application of an exalted ideal of behavior to artists of the second period and through his description of Donatello's works. This Life demonstrates how

history operates as a mirror – the good and bad behavior of artists in the past reflecting that of Vasari's contemporaries. The third study is of the Life of Raphael, where art and manners join to create an example of perfection. Vasari used Raphael's life to present an ideal of character and education, of talent and accomplishment, epitomizing the modern age.

In each of the studies Vasari's sources are scrutinized by looking at what he knew, how he knew it, and the Lives analyzed by indicating what he chose to do with that knowledge. The changes between the two editions are also outlined. In this way I hope to suggest a method for a contextual reading of *The Lives*. It would not be possible to discuss all the Lives without writing a book many times longer than Vasari's. Such a treatment would be bound to be more exhausting than exhaustive, and would certainly be unwieldy. A more selective procedure has been followed in order to provide an analytical model or tool for an enhanced appreciation of *The Lives*. This is an exploration, not an annotation. The issues discussed must be viewed as representative, not inclusive. Like Vasari's, this book is directed at a varied readership. It is meant both to instruct the novice about Vasari's basic topics and techniques and to inform the more expert about their origins and implications. Notes give references both to general background and to specialist matters. The first chapters require little knowledge of the actual biographies, while the case studies assume a familiarity with the Lives in question. They do not reiterate Vasari's narrative, nor are they conceived of as alternative, corrected, Lives. A book about *The Lives* obviously depends upon a reader engaging directly with Vasari's text. References are given to current literature on the artists in order to help orient readers to modern views on pertinent problems, but there is no attempt to supply complete bibliographies. My hope is that those who do not know Vasari find him more approachable and those who do, come to know him better. My premise is that Vasari's biographies do not need correction nor merit condemnation or condescension. Vasari explained his notion of history and stated his aims as a historian. His honesty should be respected and his intentions understood. Vasari's honor does not need defending. I am not an apologist. I am an enthusiast. Vasari did not pretend to be detached about his subject. Nor do I. I have written about Vasari because I enjoy reading *The Lives*. History is an interpretative exercise. The judgments and standards of one age are necessarily imposed upon another. Vasari was a very great and very creative interpreter. He discerned patterns and themes in the past that he felt could be usefully and honorably expressed. I have endeavored to understand those themes and their expression and to share that understanding in the chapters that follow.

BIOGRAPHICAL OUTLINE

1511 Vasari was baptized in Arezzo on 30 July, the first son of Antonio di Giorgio Vasari and Maddalena Tacci.

1512 *Michelangelo completed the* Sistine Ceiling *(unveiled in October, begun in the spring of 1508). Raphael was working on the fresco decorations of the papal apartments (from 1508 to 1517).*

1513 *20–1 February, death of Pope Julius II. Giovanni de' Medici was elected to the papacy and took the name Leo X.*

1513 *Machiavelli began writing* The Prince, *completed in 1514, first published in 1522.*

1516 *Titian was commissioned to paint an* Assumption *for the high altar of Santa Maria Gloriosa de' Frari in Venice (finished in 1518).*

1519 *2 May, death of Leonardo da Vinci.*

According to Vasari he was eight years old when the painter Luca Signorelli came to Arezzo to deliver an altarpiece to the Compagnia di San Girolamo (commissioned on 19 September 1519, actually delivered sometime before September 1522; now in the Galleria, Arezzo, predella in the National Gallery, London). He stayed with Vasari's family and advised Giorgio's father to let his son learn to draw.

Vasari was taught by Antonio da Saccone and Giovanni Lappoli (known as Pollastra) at school. He began his study of art with the French glass-painter Guillaume de Marcillat, then resident in Arezzo.

1520 *In April Raphael died, leaving the* Transfiguration *nearly complete (now in the Pinacoteca Vaticana, Rome).*

1521 *1 December, death of Pope Leo X, followed by the election of Adrian VI on 9 January 1522. Vasari described this pontificate as a sad time for artists, who were to rejoice in the succession of Clement VII (Giulio de' Medici) on 18 November 1523.*

1524 Vasari was taken to Florence in the entourage of Cardinal Silvio Passerini, who was sent there by Clement VII as governor and protector of the two Medici

3. Giorgio Vasari, *The Painter's Studio*. Florence, Casa Vasari, Sala delle Arti e degli Artisti.

heirs, Alessandro (b.1510, great-grandson of Lorenzo il Magnifico, natural son of Lorenzo, Duke of Urbino) and Ippolito (b.1511, grandson of Lorenzo il Magnifico and natural son of Giuliano, Duke of Nemours). Vasari says that he studied for two hours each day with the young Medici under their tutor Pierio Valeriano. He spent some time in the workshop of the painter Andrea del Sarto and also with the sculptor Baccio Bandinelli.

1527 *May, the sack of Rome by the army of Emperor Charles V.*

On 16 May popular government was restored to Florence. The Medici were expelled from the city. Vasari returned to Arezzo, summoned, he says, by his uncle Don Antonio after his father died of the plague on 24 August. He managed to make a living as an artist, receiving small commissions in Arezzo and neighboring villages. One work, a *Resurrection*, painted for Lorenzo Gamurrini, was based on a drawing by Rosso Fiorentino, who, impressed with the young Vasari, helped him by giving him drawings and advice.

1528 *Baldassare Castiglione's* Book of the Courtier *published.*

1529 In the spring, Vasari went to Florence where he apprenticed himself to a series of goldsmiths, convinced for the moment, it seems, that it would be a more lucrative trade. This course of study was interrupted in October by the siege of Florence by the imperial army supporting Clement VII and the Medici faction. Vasari, a Medici supporter who disliked wars for the disruption they caused to art, fled to Pisa. The city capitulated on 12 August 1530 and Medici domination was re-established.

1530 Vasari returned to Arezzo by way of Bologna, where he assisted with the decorations for the entry of Emperor Charles V.

1532 In January Vasari went to Rome in the household of Cardinal Ippolito de' Medici. He studied the famous works there with his friend Francesco Salviati and did canvases of mythological subjects. That autumn he went to Florence, entering the service of Duke Alessandro de' Medici. He remained attached to Alessandro's court until the duke's assassination in January 1537.

1534 *Death of Clement VII, election of Alessandro Farnese, Pope Paul III.*

1536 *Michelangelo began work on the* Last Judgment *in the Sistine Chapel, completed in 1541.*
or late 1535

1532–37 Works done for the Medici during this period include frescoes of stories from Caesar's *Commentaries* in a room in the Palazzo Medici (1534; now destroyed), the portrait of the duke (pl. 44), and decorations for the entry of Charles V (1536). He also continued to take commissions in Arezzo, and in 1534 worked in the Palazzo Vitelli, Città di Castello, where he began his association with Cristofano Gherardi who was to be his principal assistant until Gherardi's death in 1556.

| 1537–40 | *On the night of 6 January 1537 Duke Alessandro de' Medici was assassinated by his cousin Lorenzino. Cosimo de' Medici, the eighteen-year-old son of the soldier Giovanni delle Bande Nere (d.1526) and his redoubtable widow Maria Salviati, was made the duke of Florence.* |

Vasari left Florence after the death of Alessandro. In August 1537, through the influence of his former schoolmaster, Giovanni Pollastra, Vasari received a commission for a *Virgin and Child with Saints John the Baptist and Jerome* for the choir screen of the church at the monastery of Camaldoli. In this remote, but quite prestigious site he also painted a nocturnal *Nativity* (1538; pl. 45) and a *Deposition* (1539–40) with an elaborate surrounding of flanking panels (pl. 35) and frescoed grotesque ornament. During occasional trips to Florence he produced paintings for Ottaviano de' Medici. Vasari also went to Rome (February 1538) to continue his studies.

1539 In February Vasari undertook to decorate the refectory of the Olivetan monastery of San Michele in Bosco, Bologna, with three large panels including the *Feast of St. Gregory* and frescoes with Apocalypse scenes and views of Camaldolite convents.

1540 Vasari came back to Tuscany in the spring. That summer he took refuge from the heat at Camaldoli where, in August, he received a commission from the Florentine banker Bindo Altoviti for an altarpiece of the *Immaculate Conception* for the family chapel in the church of Santi Apostoli, Florence (pl. 46). Installed in September 1541, it was appraised by Pontormo, Giovanni Antonio Sogliani, and Ridolfo Ghirlandaio.

1541 Vasari continued to find employment in Florence, doing copies and original works for Ottaviano de' Medici and Francesco Rucellai. In July he painted a large canvas of the *Baptism of Christ* in chiaroscuro, part of the decorations for the baptism of Duke Cosimo de' Medici's son, Francesco. In September he bought a house in Arezzo for 700 florins.

In December he arrived in Venice by way of Modena, Parma, Ferrara, and Mantua. There he made the scenery for the comedy of *La Talanta*, written by his compatriot and correspondent, Pietro Aretino. In 1542, through the good offices of the architect Michele Sanmichele, he obtained the commission for a painted ceiling for the palace of Giovanni Cornaro.

1542 In Arezzo during the autumn, Vasari began the decoration of his house, beginning with a room devoted to Fame and the Arts (pls. 12, 58, 59, 60, 164, 165).

1542–4 His time was divided between Florence and Rome. In the former he was supported and encouraged by Ottaviano de' Medici and in the latter by Bindo Altoviti, whose influence helped to gain him the commission for a painting of *Justice* for Cardinal Alessandro Farnese (pl. 91). While in Rome Vasari cultivated his friendship with his idol, Michelangelo.

1544–5 Through the agency of his friend, the Olivetan don Miniato Pitti, Vasari received a commission for a number of works for the monastery of Monte Oliveto in Naples (pl. 5). Arriving there in the autumn of 1544 with a trusted band of assistants (Gherardi, Raffaello dal Colle, and Stefano Veltroni), he remained until September

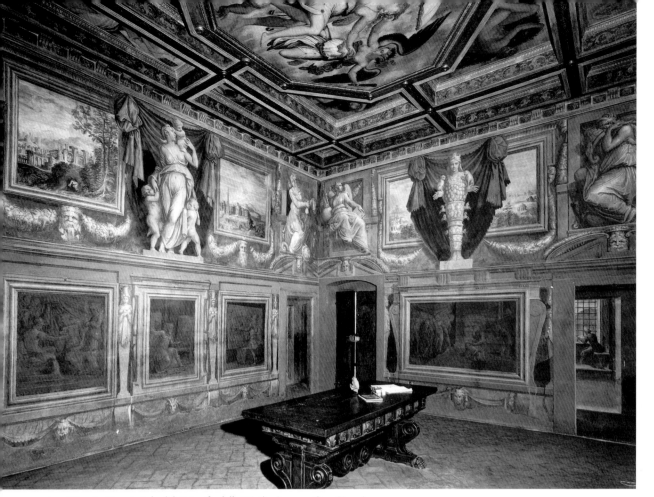

4. Giorgio Vasari, Sala del Trionfo della Virtù. Arezzo, Casa Vasari.

<table>
<tr><td></td><td>1545 on what he came to view as a mission to inspire artistic novelty and excellence in a city whose local traditions impressed him very little.</td></tr>
<tr><td>1545–6</td><td>While in Rome he continued to produce works for Naples: eighteen panels for the sacristy of San Giovanni a Carbonara and a pair of organ shutters for the cathedral. The latter were commissioned by the pope's grandson, Ranuccio Farnese, and were appraised by Titian in March 1546. At this time Vasari frequented the court of Cardinal Alessandro Farnese. After-dinner conversation there prompted the writing of The Lives. He decorated the great hall of the cardinal's residence, the Cancelleria, "in one hundred days" with scenes showing deeds from the pontificate of the cardinal's grandfather, Paul III (pls. 63, 64). He was supervised in both history painting and history writing by his friend Paolo Giovio. By October he was in Florence once again.</td></tr>
<tr><td>1547</td><td>Resident in Florence, Vasari continued writing The Lives. In August he signed an agreement to paint an Adoration of the Magi (pl. 47) for the Olivetan church in Rimini. Upon his arrival there in December, he undertook the decoration of the high-altar chapel and the apse. A fair copy of the draft version of The Lives was made by one of the monks.</td></tr>
</table>

5. Giorgio Vasari, *Patience*. Naples, Monastery of Monte Oliveto, refectory vault.

1548 Vasari worked in Rimini and Ravenna before going home to Arezzo where he spent the spring and summer decorating his house, finishing the ceiling and walls of the main room (pl. 4). In July he took the commission for a large painting for the refectory of the Badia of Santissime Fiora e Lucilla (Arezzo), showing the wedding feast of Esther and Ahasuerus (now in the Museo Statale di Arte Medievale e Moderna, Arezzo; pl. 110). He also produced some architectural designs for Cardinal Giovanni del Monte.

1549 In Florence in October Vasari received the commission from the Martelli family, executing the will of Sigismund Martelli, for an altarpiece for their chapel in San Lorenzo (finished in 1550; lost). The printing of *The Lives* was begun by the Torrentino press in the autumn. Vasari, newly wed to a well-born Aretine, Niccolosa Bacci, was in Arezzo.

Death of Pope Paul III on 10 November.

1550–3 The printing of *The Lives* was completed in Florence in March 1550 during Vasari's absence from that city. Although he dedicated his book to Duke Cosimo, expressing hopes of his support, Vasari apparently was more optimistic about advancing his career in Rome. As soon as he heard of the election of his former patron Giovanni Maria del Monte to the papacy as Julius III (7 February), Vasari got on his horse and hastened to Rome, where he was favored by papal patronage, if frustrated by papal whims. The projects he undertook for Julius III included the del Monte chapel in San Pietro in Montorio (done in collaboration with the sculptor Bartolomeo Ammannati), an altar for the Vatican (1551–61), and designs for the pope's pleasure house, the Villa Giulia. He also worked for Bindo Altoviti, decorating the loggia of his garden pavilion (*vigna*) and his house, painted an altarpiece of the *Beheading of St. John the Baptist* for the Florentine confraternity of San Giovanni Decollato, and a *Bacchus and Silenus* for his learned friend Annibale Caro.

1554 A year spent traveling between Arezzo, Florence, Cortona, and Rome. In Cortona he was responsible for frescoes with scenes from the life of Christ and Old Testament sacrifices in the church of the Compagnia del Gesù (finished December 1555) and for work on Santa Maria Nuova. He provided designs for the decoration of the facade of the palace of Duke Cosimo's chamberlain Sforza Almeni. These were executed by Cristofano Gherardi while Vasari worked in Rome and Arezzo. The program devoted to the ages of man was an elaborate and courtly compliment to the duke and evidently a successful bid for patronage. On 15 December Vasari came to Florence to enter the duke's service with an annual stipend of 300 ducats.

Pope Julius III died on 23 March, and he was succeeded briefly by the learned cardinal Marcello Cervini. Elected 10 April, Pope Marcellus II died of apoplexy on 1 May. On 23 May the zealous reformer Gian Pietro Carafa was elected to the papacy as Paul IV.

1555–8 On 15 December 1555 Vasari began his career in the ducal court, rebuilding, reorganizing, and redecorating the Palazzo Vecchio, transforming the former seat of the Republic's government into the official, and princely, residence of the duke. Decoration began in the set of five rooms that became known as the Quarter of the Elements with a program of mythological subjects devoted to the genealogy of the gods (pls. 6, 9). Vasari's friend, the scholarly gentleman Cosimo Bartoli, suggested

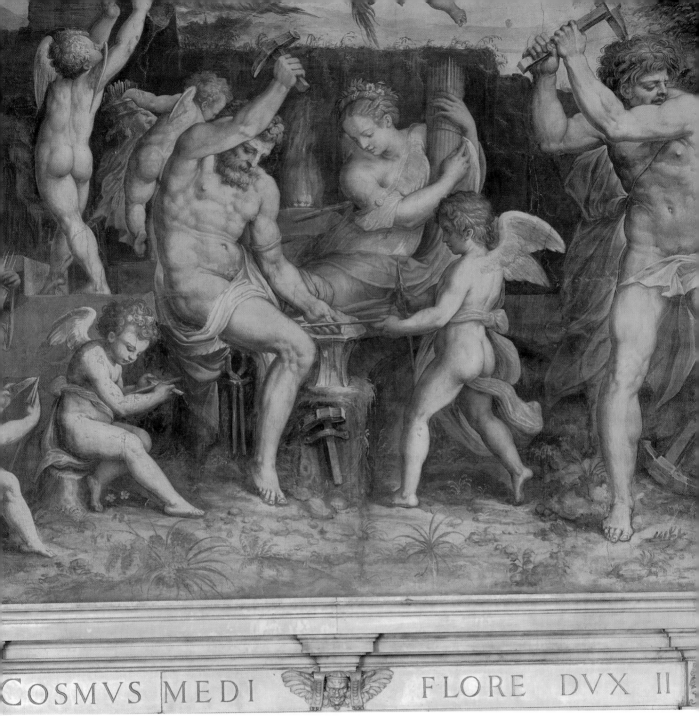

COSMVS MEDI · · FLORE DVX II

6. Giorgio Vasari and Assistants, *The Forge of Vulcan* (detail). Florence, Palazzo Vecchio, Quarter of the Elements, Sala degli Elementi.

the inventions for the subjects. Vasari was assisted in painting the ceiling panels and walls by Cristofano Gherardi and Marco da Faenza. While painting this suite of rooms on the upper floor, those below (the Quarter of Leo X) were being rebuilt.

1556–62 During these years the twelve rooms showing Medici family history from Cosimo il Vecchio to Cosimo I, known as the Quarter of Leo X, were decorated (pls. 76, 77). Vasari wrote that the Medici depicted there formed terrestial pendants to the celestial gods in the apartments above. Once again he was aided in the invention of the subjects by Cosimo Bartoli and in their design and execution by Gherardi (until his death on 4 April 1556), Marco da Faenza, and an important new collaborator, the Flemish painter Jan van der Straet, known as Giovanni Stradano.

1559 *25 December, Giovanni Angelo de' Medici (of Milan) was elected to the pontificate, taking the name of Pius IV. He was much friendlier to Cosimo than Paul IV, with the result that during this pontificate relations between Florence and Rome improved and Vasari resumed accepting papal commissions.*

1560 The building of the offices of the Magistrates (the Uffizi) was started in March. Vasari received an annual salary of 150 ducats for designing and supervising this project, which was completed in 1580, six years after his death. In April he went to Rome where Pius IV gave him the altarpiece of *Christ calling the apostles Peter and Andrew*, which he had begun for Julius III. Vasari took the panel to Arezzo, where he used it as the central element of a massive altarpiece and family tomb in the Pieve of Arezzo (completed in 1563, installed in April 1564). During this year, among other things, he painted altarpieces for the Botti chapel in the church of the Carmine (a *Crucifixion*), the duke's villa of Poggio a Caiano (a *Deposition*), and paintings for Cosimo Bartoli. He also noted in his record book that in August the engraving of the portraits of painters was begun for the book ("si comincjo a intagliar le teste de pictorrj, per fare il libro stanpato"; *ricordo* no. 266).

1559–62 Vasari and his team were working in the apartments of the duke and duchess. During these years they completed the Quarter of Duke Cosimo and between 1561 and 1562 that of the Duchess Eleonora.

1561 In June Duke Cosimo granted Vasari his house in Borgo Santa Croce, which he had previously rented. Vasari and his assistants Giovanni Stradano and Jacopo Zucchi began decorating it with scenes relating to the history of painting (pls. 3, 17). A letter from Cosimo Bartoli dated 17 March is the first explicit reference to research for the new edition of *The Lives*.

1561–5 Building of the grand staircase of the Palazzo Vecchio.

1562 Vasari provided a model for the palace of the Knights of the Order of St. Stephen in Pisa, newly founded with Cosimo as its grand master.

1563 13 January the duke approved the regulations of the Accademia del Disegno. In May work began on the cupola of the church of the Madonna dell'Umiltà in

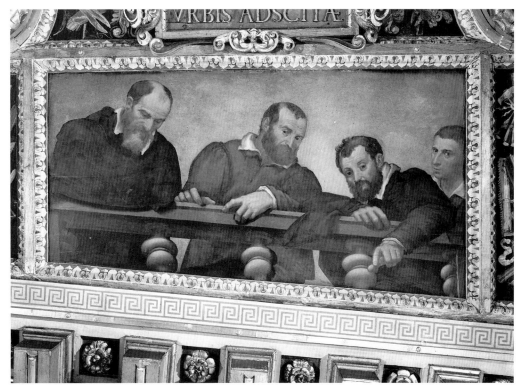

7. Battista Naldini, *Vasari's Assistants: the builder Bernardo di Mona Mattea, the carpenter Battista Botticelli, and the painters Stefano Veltroni and Marco da Faenza*, panel from the ceiling of the Salone dei Cinquecento. Florence, Palazzo Vecchio.

Pistoia. In this year Vasari also visited Assisi, as he states in the Life of Cimabue, making notes for the revision of *The Lives*.

1563–5 Design and completion of the ceiling of the main reception room of the Palazzo Vecchio, the Salone dei Cinquecento (pls. 7, 73, 75, 78, 79). The rebuilding and decoration of this room transformed the Savonarolan Council Hall into a regal state room, intended to be one of the most impressive such halls in Europe. Its scheme, devoted to important events in the history of Florence and the glorification of the duke, was devised in 1563 by Borghini and Vasari in close consultation with Cosimo I (pl. 80). The ceiling was completed by 21 December 1565, in time for the festivities arranged to celebrate the marriage of Francesco de' Medici to the archduchess Joanna of Austria.

1564 *Michelangelo died in Rome in February. His funeral in Florence was arranged by the Accademia del Disegno, the ceremonies were held on 14 July; his tomb in Santa Croce was one of its first official projects.*
 Duke Cosimo abdicated in favor of his son Francesco in May.

1565 In addition to preparing for the wedding festivities, Vasari supervised the construction of the corridor connecting the two ducal residences, the Palazzo Vecchio and

the Palazzo Pitti and began the remodelling of the church of Santa Maria Novella (finished in 1572). Santa Croce followed in 1566.

1566 *Death of Pius IV; his successor was the Dominican Michele Ghislieri, Pius V.*

Between March and June and before completing the new edition of *The Lives*, Vasari toured Italy. Starting in Arezzo (1 April; Frey II, dxxvi), he stopped in Perugia (4 April; Frey II, dxxvii) to deliver and install three large panels he had painted for the refectory of the Benedictine monastery of San Piero. He then proceeded to visit Cortona, Assisi, Foligno, Spoleto, Rome (14 April; Frey II, dxxviii), Narni, Terni, Spoleto again, Val di Varchiana, Tolentino, Macerata, Recanati, Loreto, Ancona (24 April; Frey II, dxxxii), Fano, Pesaro, Rimini, Ravenna, Bologna (30 April; Frey II, dxxxiii), Modena, Reggio Emilia, Parma, Piacenza, Pavia, Milan (9 May; Frey II, dxxxv), Monza (?), Lodi, Cremona, Brescia, Mantua, San Benedetto Po, Verona, Vicenza, Padua, Venice (15 May; Frey II, dxxxvi), Bologna and Ferrara (27 May; Frey II, dxxxvii).

1566–71 Between January and July 1566 Vasari made the drawings for the murals in the Salone dei Cinquecento. In his *Ragionamenti* Vasari described these six huge battle pieces as showing on one side three episodes from the war with Pisa, fought by the Republic of Florence for fourteen years, while opposite and in contrast was shown the war with Siena successfully conducted by Duke Cosimo in fourteen months (1553–5). Painting began in 1567. Working with Vasari were Giovanni Stradano, Marco da Faenza, Prospero Fontana, Giovanni Naldini, Jacopo Zucchi, Francesco Morandini, Stefano Veltroni, and Tommaso Battista del Verrocchio. The work was unveiled on 9 January 1572.

1567 In February Vasari went to Rome, taking Pope Pius V an *Adoration of the Magi* for the church of Santa Croce di Bosco Marengo. In March he provided designs for the celebrations of the baptism of Duke Francesco's daughter, Eleonora. During this year he also painted an altarpiece of the *Crucifixion according to St. Anselm* for the Bishop of Volterra, Alessandro Strozzi, for his altar in Santa Maria Novella.

1568 Publication of the second edition of *The Lives* by the Giunti press. A good son of Arezzo, Vasari made a banner showing St. Roch for the Company of St. Roch in Arezzo. A productive artist in Florence, in addition to the works in Palazzo Vecchio, Vasari painted an altar of the *Assumption of the Virgin* for the Badia, a *Pentecost* for the altar of Agnolo Biffoli (the duke's treasurer) in Santa Croce, and a *Resurrection* for Cosimo's personal physician, Andrea Pasquali, in Santa Maria Novella.

1569 In July he finished a *Last Judgment,* a *Martyrdom of St. Peter Martyr,* and flanking panels for a massive altarpiece commissioned by Pius V for the church of Santa Croce di Bosco Marengo. He painted an altar of the *Rosary* for Santa Maria Novella for its prior.

1570 Vasari went to Rome in the autumn with his assistants Alessandro Fei and Jacopo Zucchi to paint three chapels in the Vatican (dedicated to St. Michael, St. Peter Martyr, and St. Stephen). This year also marked the beginning of the decoration

of the *studiolo* of Duke Francesco with a scheme devised by Vasari and Borghini. In addition to the overall design, Vasari did a panel of *Perseus and Andromeda* (1570–2). The entire project was completed in 1576.

1571 Vasari returned to Rome to serve Pius V, supervising work in the pope's great hall, the Sala Regia. In June the pope made him a knight of the Golden Spur.

1572 *On 1 May Pope Pius V died. His successor, Gregory XIII, was elected on 13 May.*

Following the death of Pius V, Vasari went back to Florence. There he was given the task of designing a fresco of the *Last Judgment* to decorate the cupola of the duomo (finished after Vasari's death, with substantial modification, by Federico Zuccaro). He was recalled to Rome in November by Pope Gregory XIII in order to continue the Sala Regia.

1573 Vasari worked on designs for the duomo and also produced projects for frescoes in the Pauline Chapel in the Vatican and for building the Loggia in the Piazza Grande of Arezzo.

1574 On 27 June Vasari died. His body was carried to Arezzo for burial in the family tomb, which he had designed.

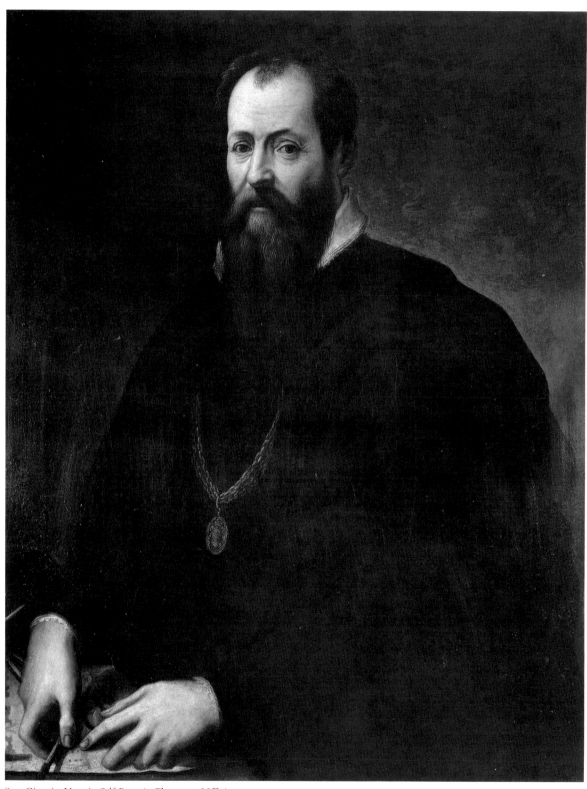

8. Giorgio Vasari, *Self-Portrait*. Florence, Uffizi.

I

IL MOLTO MAGNIFICO MESSER GIORGIO VASARI: THE INVENTION OF IDENTITY

VASARI LIVED BY HIS WITS, and hard work. From the outset of his career he saw devotion to the studies of his profession as the means to earning the honorable rewards of his art as well as the dowries for his three orphaned sisters.[1] His was a pragmatic idealism. He believed in what he did and what it could do for him. He counted himself among those "who had their spirit turned to becoming famous" and was prepared to exert every effort to become a celebrated son of his native Arezzo.[2] Moved by love for his work and indefatigable, Vasari more than fulfilled his ambition, succeeding as an architect, court artist, and writer as well as a painter. Indeed, through his activities he helped to establish a definitive connection between fame and the arts. When he died in 1574 his body was carried from Florence to Arezzo where he was buried at the foot of the high altar of the Pieve, which he had been allowed to convert into a family shrine.

Vasari took advantage of his times. By writing history he became part of it. *The Lives* may not be totally accurate or true to facts, but, written from Vasari's experience, they are completely genuine. They have a truth that transcends detail. Their flaws are part of the very humanity that makes them so present and compelling. Vasari did not arbitrarily impose patterns on the past, he found an order in events that explained or confirmed his ideas about the operations of society. *The Lives* are in this way conventional, but the conventions were the basis of Vasari's existence. They determined his own actions and expectations. His sensitivity to the realities of commonplace categories was fundamental to his success in his profession. It is also what makes his representation of his times so convincing. Vasari's effectiveness as an artist and as a historian resulted from his ability to comprehend and work with prevailing formulas. Time-honored maxims about virtue, study, talent, honor, and

1 Frey i, i, pp. 1–2 (Rome, April 1532, to Niccolò Vespucci, Florence), he expresses his "uolonta di uoler, s' io potrò, esser fra il numero di quelli che per le loro uirtuosissime opere hanno hauuto le pensioni, i piombi et gl' altri onorati premij da quest'arte . . . ne ho nessuno che habbi à guadagnar tre dote per tre mie sorelle se non lo studio, che farò per condurmi à qualche fine utile et honorato." In Frey i, ii, p. 7 (Rome, July 1532, to Ottaviano de' Medici, Florence), he refers to "gli studij della professione mia."

2 Frey i, xvi, p. 47 (Florence, 11–18[?] March 1536, to Pietro Aretino, Venice), about: "chi ha uolto l' animo à esser famoso." For this letter, see below, Chapter ii, pp. 62–3.

rewards provided both ends and means for him, creating goals that could be obstructed by events, but never entirely obscured.

An episode in the Life of Aristotile da Sangallo indicates the importance given to conventions of expression and behavior. Out of work in Florence, Aristotile went to Rome to seek employment with his cousin, the prominent architect Antonio da Sangallo. It seems that Aristotile could not rid himself of the habit of addressing his relative with the familiar pronoun *tu* instead of the more formal *voi*, even when they were in the presence of the pope or frequenting other lofty circles of lords and gentlemen. Vasari generalizes about this lapse, commenting that it was in the style of those Florentines who did not know how to adapt to modern life. Antonio's annoyance had his full sympathy and Vasari repeats Antonio's request that Aristotile learn to behave towards his cousin with better manners, especially in the company of important people.[3] Vasari, like Antonio, felt that both social identity and professional advancement depended upon being sensitive to the forms of modern life: to usages that were equated with breeding (*creanza*) and to their expression in a changing language of courtesy.

Vasari used his command of such rules to articulate a self-image based on a professional identity, that of the artist. That image was in turn projected onto the past and the future in the shape given to characters and events in the biographies. Vasari's self as articulated in his writings was consciously constructed in conformity with ideals of behavior associated with the learned and the courtly – the well-educated and the well-behaved. It was an ideological self. Vasari exploited the resources of writing to formulate and to propagate a favorable position for himself in particular and for artists and artistry in general. He offered his view or type against previous, less flattering, less prestigious, and less empowered stereotypes: the saturnine eccentric of literary tradition and the mechanic or artisan of the trade hierarchy.[4] He also took the task, and therefore the voice, from professional men of letters such as his friend Paolo Giovio, who had proposed to write a treatise on illustrious painters, but, "as it was sufficient for him to make a great sweep, he did not examine the matter in detail."[5] Vasari agreed that this would be a worthy project "if Giovio were assisted by someone who was of the profession in order to put things in their places and describe them as they really are."[6] That someone was to be Vasari and that truth his *Lives*.

His was also a normative self. Vasari applied a set of behavioral codes to his own actions and to his record of those of other artists. Even more daring with respect to history was the fact that he brought the exceptional into the realm of the normal, as all artists were subsumed under a scheme of conventional causes and effects. Even the most extraordinary and demonstrably difficult figures, such as Michelangelo, were explained with terms taken from established standards. They were thereby integrated into a coherent, if flexible, system

3 Life of Aristotile da Sangallo, BB v, pp. 400–1, concluding with Aristotile's demand: "che procedesse seco con altra maniera e miglior creanza, massimamente là dove fussero in presenza di gran personaggi."

4 For the image of the artist see R. and M. Wittkower, *Born under Saturn*, and Boskovits, *Pittura fiorentina alla vigilia del Rinascimento 1370–1400*, pp. 159–65. For artistic practice and guild structure see S. Rossi, *Dalle botteghe alle accademie*, chapter i.

5 Description of Vasari's works, BB vi, p. 389: "che bastandogli fare gran fascio, non la guardava così in sottile."

6 *Ibid.*: "se il Giovio sarà aiutato da chi che sia dell'arte a mettere le cose a' luoghi loro et a dirle come stanno veramente."

of values. The superlative (as exemplified by Leonardo, Raphael, Michelangelo) depended upon the comparative; the deviant (as Piero di Cosimo) was referred to the norm. When he represented Michelangelo as the epitome of virtues, Vasari appropriated his talent, making it the basis of a new, modern standard for the visual arts. This normalizing or normative process was essential to Vasari's record of himself and of others. It enabled him to find order in the inherently disordered material of existence by abstracting patterns based on key values of his society, above all a belief in perfection and perfectability. To strive for perfection was to realize the talents or gifts given by God and by nature. This notion of excellence, embedded in the title of Vasari's book, motivated efforts to achieve fame and validated individual glory. Its attendant values were utility and honor, both personal and public – an ethos of civility and humanity, whose formulas and formulations represent the diffusion of humanist thought to the wider realms of perception and practice. Vasari used events to confirm assumptions about himself and his circumstances. The artist was related to a universal design in a form of generalization or idealization that has a direct parallel in Vasari's painting. In both art and history nature was improved through an understanding and distillation of first principles.

While Vasari cannot be resuscitated or his times revisited, it is possible to examine the ways that he presents or represents himself and others and how he appears in documentary records.[7] The relative positions of man and myth can be examined to reveal some of the devices Vasari used to give meaning to his experience and to artists' lives.

Vasari's account of his own career takes the form of a confession, written in 1567 and placed at the end of the second edition of *The Lives*:

> Having up to this point discussed the works of others with the utmost diligence and sincerity that my intellect can conceive of and has been capable of, at the conclusion of my labors I would also like to collect and to make known to the world the works that Divine Goodness has given me the grace to carry out . . . and because they could by chance be written about by someone else, it is surely better that I should confess the truth and acknowledge my own imperfection, which I know best: sure of this, that if, as I have said, excellence and perfection are not perceived in them, there will at least be found an ardent desire to work well coupled with a great and untiring effort and the extraordinary love that I bear for our art. Whence it will come about that a large part will be forgiven me if, according to the rules, I openly confess my deficiency.[8]

7 For portraits of Vasari and self-portraits, see C. Davis in Arezzo 1981, pp. 310–11.

8 Description of Vasari's works, BB VI, p. 369: "Avendo io infin qui ragionato dell'opere altrui con quella maggior diligenza e sincerità che ha saputo e potuto l'ingegno mio, voglio anco nel fine di queste mie fatiche raccorre insieme e far note al mondo l'opere che la divina Bontà mi ha fatto grazia di condurre . . . E però che potrebbono per aventura essere scritte da qualcun altro, è pur meglio che io confessi il vero et accusi da me stesso la mia imperfezzione, la quale conosco davantaggio: sicuro di questo, che se, come ho detto, in loro non si vedrà eccellenza e perfezzione, vi si scorgerà per lo meno un ardente disiderio di bene operare et una grande et indefessa fatica e l'amore grandissimo che io porto alle nostre arte. Onde averrà, secondo le leggi, confessando io apertamente il mio difetto, che me ne sarà una gran parte perdonato." For this form, see Zimmerman, "Confession and autobiography in the early Renaissance," in *Renaissance Studies in Honor of Hans Baron*, ed. Molho and Tedeschi, pp. 121–40. Vasari's bid for forgiveness on the part of his reader is reminiscent of Petrarch's in the first sonnet of the *Canzoniere*: "spero trovar pietà, non che perdono" (ed. Contini, p. 3, 1:8). This is a rhetorical position that justifies the writer writing about himself. I would like to thank Letizia Panizza for pointing this out to me.

Vasari did not write his own Life (*vita*), unlike Benvenuto Cellini who believed that "All men of whatsoever quality they be, who have done anything of excellence, or which may properly resemble excellence, ought, if they are persons of truth and honesty, to describe their life with their own hand."[9] Vasari observed the distinction between Cellini's narrative and his own when he excused himself from giving more than a brief summary of Cellini's principal works, "seeing that he has written his Life . . . with far greater eloquence and order than I perhaps might know how to do here."[10]

Vasari wrote with a well-earned sense of achievement; but, by eschewing the genre of autobiography, he also refused, categorically, the status of hero. Although motivated by the same respect for his field of endeavor as Cellini, he did not narrate epic deeds for admiration. Where Cellini's Life is notoriously boastful in tone and actively engaged in its episodes, Vasari's is more matter of fact in its survey of events and concentrated on his production of paintings. Cellini began writing his autobiography while under house arrest for the crime of sodomy in 1558, and with it he sought to redeem his unfortunate present by recounting a heroic past.[11] Mixing adversity and triumph in an episodic account that often digresses from his art, Cellini reveals many talents and virtues beyond his consummate skill as a sculptor – intelligence, piety, courage, and resourcefulness. Observing his actions, overhearing conversations, sharing visions and dreams, his reader is made to wonder at a character of compound excellence. Vasari adopted a much more modest stance and through his chosen mode of self-description asked for the sympathy and complicity of the reader in a different way – "according to the rules" of the confessional. He wished to be identified with the sincerity of his efforts and the accumulation of his works: a moral man defined by a combination of traditional Christian and current secular models. He acknowledges, more than once, the grace of God that granted him opportunities to do good works; but he further asks for the grace of his fellow men in recognizing what he has done to realize the benefits of heaven through his unceasing labor and unbounded love for his profession.

Vasari's "confession," which reads like a simple, linear account, is actually as contrived as Cellini's autobiography. It represents the vindication or proof of a moral system. The events and episodes set within a framework of effort and appreciation testify to its inherent validity and to Vasari's worthiness. Necessity never outweighs honor and ties of friendship and duty are emphasized. Those who ask for and receive paintings are qualified in terms of ties of affection and obligation: "molto mio amorevolissimo e domestico," "molto mio affezionato," "miei amicissimi."[12] He shows himself earning favor and fame by constantly

9 Translation quoted from *The Autobiography of Benvenuto Cellini*, trans. Symonds, Book i, chapter 1, p. 5. The Italian text reads: "Tutti gli huomini d'ogni sorte, che hanno fatto qualche cosa che sia virtuosa, o sí veramente che le virtú somigli, doverieno, essendo veritieri e da bene, di lor propia mano deschrivere la loro vita" (*Vita*, ed. Bacci, p. 3).

10 Account of the academicians, BB VI, p. 246: "non ne dirò qui altro, attesoché egli stesso ha scritto la Vita e l'opere sue . . . con molto più eloquenza et ordine che io qui per aventura non saprei fare."

11 For a consideration of Cellini's invention and re-shaping of deeds following the archival record of those deeds, see P. Rossi, *The Artist and Society in Sixteenth Century Italy – Benvenuto Cellini*. For other analyses of Cellini's *Vita* see J. Goldberg, "Cellini's *Vita*," *Modern Language Notes* (1974), pp. 71–83; Gugliemetti, *La "vita" di Benvenuto Cellini*; and Cervigni, *The "Vita" of Benvenuto Cellini*.

12 Description of Vasari's works, BB VI, p. 405, of Luca Torrigiani, Antonio de' Nobili; p. 384, don Miniato Pitti, don Ippolito da Milano. Vasari wrote that he could never tire of expressing his obligation to Duke Cosimo: "io non sarò mai per le tante amorevolezze sazio di confessar l'obligo che io tengo con questo signore" (BB VI, p. 400).

seeking to improve in his art and unwaveringly fulfilling his duties. Through the descriptions he demonstrates how he continually sought the "difficult" in ingenious compositions, artful imitation of nature, and skillful expression of dramatic and learned subject matter. The successful completion of each commission is followed by the next, in confirmation of his code. "I did" or "made" – *feci* – the past definite of the verb *fare*, constantly repeated, creates a steady rhythm of production of works that he leaves to his patrons and readers to judge. Rather than praise his own efforts, he reports the reactions of others, allowing for a shortfall between what his intellect could conceive and his hand execute.[13] This not only puts a premium on the intellectual aspirations of his work, but depicts the painter as a modest man.

Other documents and disclaimers in the text indicate his selectivity throughout this self-portrayal. He did not want to tax his memory or the good will of his readers by recalling the many "minor works" he did.[14] He focussed on large-scale paintings, architectural projects, and relations with influential people, above all the Medici. Although he described the decorative cycle in his Arezzo house, he included only about eleven other paintings done in his native city. He severely edited his substantial involvement with local clients, confraternities, and churches there. His knowledge of these was displaced to the Lives of other Aretines, earlier painters such as Margaritone and Spinello Aretino, and contemporaries like Niccolò Soggi and Giovanni Lappoli. He represents himself as courtier artist not citizen painter.

This description is far from being Vasari's only account of his activities. There are other extensive autobiographical passages in the 1568 *Lives*, each with a distinct voice and purpose.[15] His memory of Luca Signorelli's advice that he be taught drawing (*disegno*) put Vasari in direct association with the artist whom he described as

> that person who, with the sound basis of drawing, particularly of nudes and with the grace of his invention and arrangement of narratives, opened the way for the majority of artists to ultimate artistic perfection so that those who subsequently followed could arrive at the summit.[16]

This distinguished painter, claimed by Vasari as a cousin, is described as being cordial, well mannered, and well dressed, a model both as friend and teacher.

13 So, for example, the *Marriage of Esther and Ahasuerus* for the refectory Badia of Santissime Fiora e Lucilla (now in the Museo Statale di Arte Medievale e Moderna, Arezzo), BB vi, pp. 392–3 (pl. 110): "mi sforzai di mostrare maestà e grandezza, comeché io non possa far giudizio se mi venne fatto o no . . . Insomma, se io avessi a credere quello che allora sentii dirne al popolo, e sento ancora da chiunche vede quest'opera, potrei credere d'aver fatto qualcosa: ma io so davantaggio come sta la bisogna e quello che arei fatto, se la mano avesse ubidito a quello che io m'era concetto nell'idea. Tuttavia vi misi (questo posso confessare liberamente) studio e diligenza." For similar presentations of himself and his paintings, see BB vi, p. 377 (the Camaldoli *Nativity*), pp. 381, 382 (the *Immaculate Conception* and *Pietà* for Bindo Altoviti), p. 391 (a *Stigmatization of St. Francis* for San Francesco, Rimini).

14 Description of Vasari's works, BB vi, p. 391: "feci per diversi amici molti disegni, quadri et altre opere minori, che sono tante . . . che a me sarebbe difficile il ricordarmi pur di qualche parte, et a' lettori forse non grato udir tante minuzie."

15 For a suggestive treatment of Vasari's use of the first person and autobiography in *The Lives*, see Le Mollé, "Il duplice linguaggio di Vasari nelle *Vite*," in *Letteratura italiana e arti figurative,* ed. Franceschetti, ii, pp. 561–9.

16 Life of Luca Signorelli, BB iii, p. 640 (1568): "quella persona che col fondamento del disegno e delli ignudi particolarmente, e con la grazia della invenzione e disposizione delle istorie, aperse alla maggior parte delli artefici la via all'ultima perfezzione dell'arte, alla quale poi poterono dar cima quelli che seguirono."

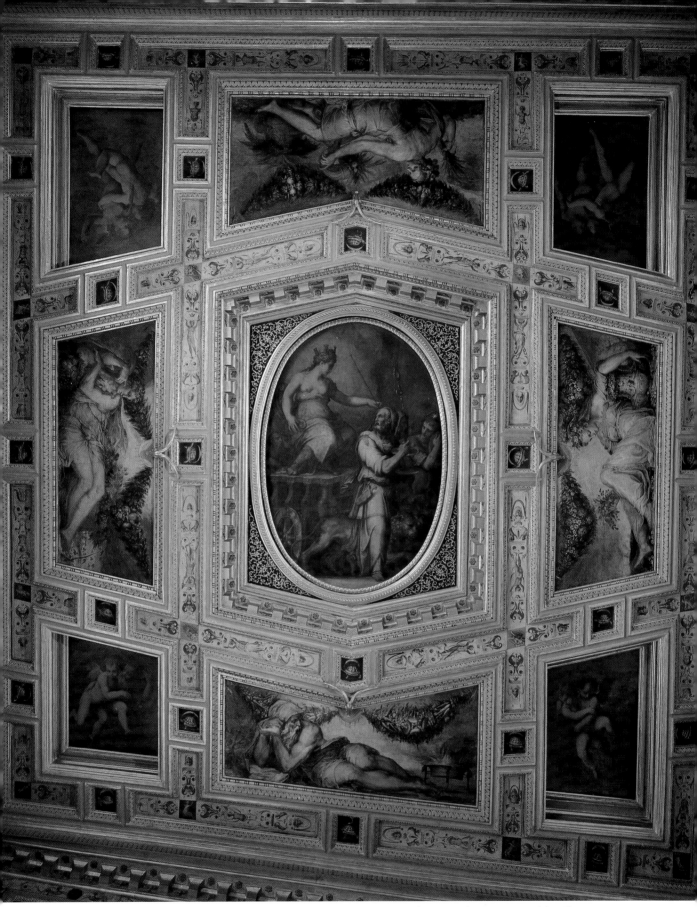

9. Giorgio Vasari and assistants, ceiling of the Sala degli Elementi. Florence, Palazzo Vecchio, Quarter of the Elements.

Vasari is particularly conspicuous in four Lives of the modern era: those of Cristofano Gherardi, Aristotile da Sangallo, Francesco Salviati, and Michelangelo. These appearances allow him to assume different guises. In the Life of his principal assistant, Gherardi, he defines his role as master. This Life is a vehicle for circumstantial accounts of how his paintings came to be and what they were. It is here – in a chronicle of an extremely effective practice – that the details of commission and composition of many major works are given as well as a description of the division of labor between master and assistant. Their association dated from near the beginning of Vasari's career as an independent master and continued to his establishment at Cosimo's court (Gherardi died in 1556). Their common course in life allowed for a full record of Vasari's activities through the decoration of the Sala degli Elementi in the private quarters of the Palazzo Vecchio (pls. 6, 9).

An ideal working relationship is illustrated. Vasari gives Gherardi due praise for his talents. According to Vasari Gherardi's accomplished contributions to joint projects brought both artists credit. In the decorations for the entry of Emperor Charles V to Florence, for example, "Cristofano acquitted himself in such a way that he amazed everyone, bringing honor to himself and to Vasari, who was greatly praised in the aforesaid works."[17] Nor did he ever begrudge Cristofano his special abilities. So he remarks about the now lost facade paintings on Sforza Almeni's palace, done following Vasari's drawings:

> But even if many things were retouched by Vasari, nonetheless the whole facade and the greater part of the figures and all of the frames, festoons and large ovals were by Cristofano who truly, as one sees, was so accomplished in the application of colors in fresco that one could say, and Vasari himself confesses it, that he [Cristofano] knew more about it than [Vasari].[18]

Vasari described the pleasure of having an assistant as tireless as himself who was "agreeable in chatting and joking while he worked."[19] What kept Gherardi back, Vasari is careful to note, was his lack of learning or knowledge in art. He had skill, judgment, and memory (*pratica, giudizio, memoria*), but apparently in his youth he had been deficient in application to study.[20] He was also, or Vasari describes him as being, slightly comical, careless in his dress, given to wearing mismatched shoes and his cloak inadvertently turned inside out. No slave to fashion, he asked Duke Cosimo to look at what he painted and not at how he dressed.[21] The fondly anecdotal evocation of Cristofano's unaffected character serves to explain and justify the relative positions of Vasari and his assistant – one studious and polished, the other able but uncultivated.

The situation is different with Aristotile da Sangallo and Francesco Salviati. Both were

17 Life of Gherardi, BB v, p. 287: "nelli quali si portò Cristofano di maniera che fece stupire ognuno, facendo onore a sé et al Vasari, che fu nelle dette opere molto lodato."

18 *Ibid.*, p. 296: "Ma se bene vi sono molte cose ritocche dal Vasari, tutta la facciata nondimeno e la maggior parte delle figure e tutti gl'ornamenti, festoni et ovati grandi, sono di mano di Cristofano, il quale nel vero, come si vede, valeva tanto nel maneggiar i colori in fresco, che si può dire, e lo confessa il Vasari, che ne sapesse più di lui." For this project, see C. and G. Thiem, *Toskanische Fassaden-Dekoration*, pp. 35–7, 131–3.

19 Life of Gherardi, BB v, p. 296: "grazioso nel conversare e burlare mentre che lavorava."

20 *Ibid.*, p. 296: "se si fusse Cristofano, quando era giovanetto, essercitato continovamente negli studii dell'arte . . . non arebbe avuto pari, veggendosi che la pratica, il giudizio e la memoria gli facevano in modo condurre le cose senza altro studio, che egli superava molti che in vero ne sapevano più di lui."

21 *Ibid.*, p. 303: "Ma guardi Vostra Eccellenza a quel che io dipingo e non a come io vesto."

great friends and masters in their own right. In these Lives, Vasari placed himself with peers, their talents complementing and competing with his, combining to create an ambient of great activity and worthy endeavor. Aristotile was a specialist in perspective who had studied with Bramante. Aristotile's Life is the setting for all the stage spectaculars that he, Vasari, and others collaborated in designing. It is also in this Life that Vasari put details about the atmosphere of intrigue, envy, and alliance at the courts he frequented, notably those of Duke Alessandro de' Medici and Cardinal Alessandro Farnese (Aristotile died in 1551).

Whereas Aristotile was an artist of definite limitations, Francesco Salviati (pl. 10) was among Vasari's most talented contemporaries. Vasari writes that he was

> rich, abundant and most fertile in the invention of all things and universal in all aspects of painting . . . He handled colors in oil, tempera, and fresco in such a way that it can be affirmed that he was one of the most worthy, fluent, bold, and expeditious artists of our age.[22]

Lodovico Domenichi dedicated his Italian translation of Leon Battista Alberti's treatise *On Painting* to Salviati as a mark of their great friendship and Salviati's skill. He praises not only Salviati's painting, but his learning, his eloquence, and his amiability. He contrasts his character with the bizarre and melancholic affectations of some artists wishing to seem exceptional.[23] While denigrating the author of this compliment, Domenichi's rival, Anton Francesco Doni published a letter to Salviati saying he rejoiced that for once decorum had been respected in the choice of dedicatee, such an outstanding painter being the right recipient of a book on painting.[24] Doni added that his current work for Duke Cosimo, paintings of the story of Camillus in Palazzo Vecchio, would show all that could be desired by a perfect painter and that each hour seemed a thousand years before Doni could return to Florence to see such a divine work completed.

Whereas Domenichi praised Salviati for being beloved by princes and private citizens alike, and Doni's competing compliments offer some confirmation of this, Vasari contrasted the perfection of his painting with the defects of his nature. According to Vasari, Salviati was "by nature melancholic, sober, sickly, and niggardly."[25] His was an "irresolute, suspicious, and solitary" character that harmed Salviati more than it did others and that damaged his

22 Life of Salviati, BB v, p. 533: "ricco, abondante e copiosissimo nell'invenzione di tutte le cose e universale in tutte le parti della pittura . . . Maneggiava i colori a olio, a tempera et a fresco in modo che si può affermare lui essere stato uno de' più valenti, spediti, fieri e solleciti artefici della nostra età." The critical context and implications of Vasari's presentation of Salviati as the perfect painter, heir to Raphael, are considered by Schlitt, "Francesco Salviati and the Rhetoric of Style," Ph.D. (Johns Hopkins, 1991).

23 *La pittura di Leonbattista Alberti* (1547), fols. 3r,v, to Francesco Salviati, "Pittore Eccellentissimo": "conoscerete quelle molte et rarissime doti a uoi dalla natura concesse, & dalla arte limate. Lequali sole non consistono intorno la pittura, ma ui fanno anco eloquente amabile & discreto: & ui danno giudicio & cognitione piu che mediocre delle buone lettere. Onde col mezzo loro sete caro ai Principi & carissimo ai priuati: & tanto piu non si ueggendo in uoi quella affettata & maninconica bizzaria, laquale molti pari uostri tanto fastidiosamente sogliono mendicare, per mostrarsi singolari: anzi in cambio di quella trouandosi ognhora in uoi gentilezza cortesia et nobiltà d'animo, oltra quella che le uirtu uostre meritamente acquistato u'hanno."

24 *Lettere* (1547), fols. 68v–69r (3 June 1547): "Perciochè ad altri che voi pittore eccellentissimo non conveniva meglio il libro che ragiona della pittura. Ancora che sapendo voi molto meglio dipignere, che colui non ne seppe ragionare." He repeated this in his *La Libraria del Doni Fiorentino* (1550), p. 47. The frontispiece of Doni's *Prose antiche* (1547) has an ornamental frame that closely resembles Salviati's illusionistic style and its design could be attributed to him.

25 Life of Salviati, BB v, p. 528: "di natura malinconico, sobrio, malsano e stitico."

10. Francesco Salviati, self-portrait from the *Triumph of Camillus*. Florence, Palazzo Vecchio, Sala dell'Udienza.

career numerous times.[26] Vasari's insistence on their enduring friendship betrays the strain of what must have been a complicated and occasionally embittered relationship, starting from early in their careers, when Vasari usurped an anticipated place at Ippolito de' Medici's court in Rome in 1532, and continuing to Salviati's last years in Rome, when Vasari had the favor of the reigning pope.[27] Vasari may well have wanted to guard his career against Salviati's successes and been jealous of the acclaim he achieved, but there is some corroboration for his account in Annibale Caro's letters. Caro, while secretary to Pier Luigi Farnese, was called upon to use his good offices on Salviati's behalf to prevent him from being thrown into prison for having angered the duke with his sudden departure and to excuse his behavior to the duke and regain his favor at court.[28] And for all his talents Salviati was unable to survive the politics of Cosimo's court when he worked there in the mid-1540s.

26 *Ibid.*, p. 533: "quella sua sì fatta natura irresoluta, sospettosa e soletaria non fece danno se non a lui."

27 The similarities and divergences in their careers are described by Cheney, "The Parallel Lives of Vasari and Salviati," in *Studi* 1981, pp. 301–8.

28 See, for this episode, *Lettere familiari*, ed. Greco, I, pp. 294–6 (Caro in Rome, 29 February 1544, to Salviati, Florence). He also assiduously promoted and praised his talents; for their relationship and Salviati's reputation in general, see Rubin, "The Private Chapel of Cardinal Alessandro Farnese," *Journal of the Warburg and Courtauld Institutes* (1987), pp. 87, 112.

Vasari interweaves his story with Salviati's from the beginning of the Life, evoking their boyhood friendship in Florence, where they shared teachers, drawings, and adventures. Salviati is portrayed as unflagging in his study of art and enjoying the company of the learned and the great, like Vasari. Unlike Vasari, he is shown as intolerant and inconsistent in his behavior. Through the juxtaposition of their temperaments – Vasari's sanguine, Salviati's melancholic – and their careers – Vasari's successes, Salviati's reverses – there results a close comparison of good and bad behavior and their consequences, putting Vasari's virtues into context and in a favorable light. This is not unlike a Hogarthian series of vignettes detailing the careers of the good and bad apprentices with a similarly predetermined outcome. Vasari's is the voice of wisdom as he gives advice and of charity as he seeks to help Salviati in his difficulties. This parallel construction gave Vasari the chance to cast himself as example and hero as well as to expound on the problems and defects of character that need to be overcome in order for talent to be granted its due rewards. Structured in this way, Salviati's Life represents a challenge to the stereotype of the anti-social and somewhat mad and melancholic artist. Almost paradoxically he is made to live out the contrast presented in Domenichi's dedication.

The other case of conspicuous presence in the 1568 edition is in the heavily revised Life of Michelangelo.[29] Writing from a secure position as the principal artist of Cosimo de' Medici's court, and after Michelangelo's death, Vasari freely inserted himself into this biography from the earliest possible moment (his own arrival in Florence in the 1520s) and reappears at every opportunity, associating the progress of his career with that of the most celebrated artist of the day. He also wrote Michelangelo firmly into his program for the arts, the concluding touch being the insertion of a full account of the Accademia del Disegno's funeral ceremony and attendant program of decorations, so that the artist who never became Cosimo's courtier in his life, indeed who resisted it, was immortalized as such with elaborate pomp and circumstance after his death. This exemplary transformation is evident even in the engraved portrait of the 1568 edition (pl. 11) where Michelangelo, the greatest of artists, is given the grandest dress. He, uniquely, is shown in a brocade, fur-lined coat.

In addition to these developed episodes, Vasari makes many other cameo appearances in the 1568 *Lives*. He frequently mentions his position as intermediary: his sponsorship of promising artists (as the sculptor Bartolomeo Ammannati); his reassurance to those wanting encouragement (as Tribolo, sick and depressed at the death of Clement VII); and his assistance to colleagues in need. So it was a lucky moment for the sadly reduced Giovanni da Udine when Vasari, seated in a coach with the papal banker Bindo Altoviti, spotted him in the crowd on pilgrimage to Rome during the Jubilee of 1550, "on foot and dressed in poor clothes as a pilgrim and in the company of low, common people."[30] Vasari says that he intervened with the pope and later with Duke Cosimo, obtaining help and favor from both.

His interventions demonstrate his position of influence among artists and his close connections to those in power. They are also described as deeds of love and friendship, examples of behavior that was both in itself morally correct and that, as such, benefited art

29 See Barocchi, "Michelangelo tra le due redazioni delle *Vite* vasariane (1550–1568)," in *Studi vasariani*, pp. 35–52.

30 Life of Giovanni da Udine, BB v, p. 455: "a pigliare il santissimo Giubileo a piedi e vestito da pellegrino poveramente et in compagnia di gente bassa."

11. Portrait of Michelangelo from the 1568 edition of *The Lives*.

and artists. The desire to advance through such behavior in concrete social terms is stated explicitly in a long passage in the Life of Aristotile da Sangallo, recalling an uncouth, unkempt, and unshaven band, or gang of artists, "who pretending to live as philosophers instead lived like pigs and beasts."[31] Its leaders were the painter Jacone, a fellow student of Andrea del Sarto, the goldsmith Piloto, and the woodcarver Battista del Tasso. This group of friends rejoiced in a heedless life style that deeply offended Vasari. Their hands were unwashed, their houses unswept, their sheets unchanged. They drank from the bottle and used cartoons for tablecloths. For Vasari, who probably suffered their pranks and jibes, it was a sad time for the art of design in Florence when the principal occupations of artists were hanging about and drinking and their study was finding ways to insult the works of those who chose to live like civilized and honorable men, presumably Vasari and his friends. He makes the point that, "since the exterior is a sign of what is inside and is a sign of our internal nature, I choose to believe . . . that they were consequently as filthy and ugly in spirit as they looked from the outside."[32] He clearly remembered the day when, returning from a visit to

31 Life of Aristotile da Sangallo, BB v, p. 404: "[una] compagnia d'amici, o più tosto masnada, che sotto nome di vivere alla filosofica, viveano come porci e come bestie."

32 *Ibid.*: "perché il di fuori suole essere indizio di quello di dentro e dimostrare quali sieno gl'animi nostri, crederò . . . che così fussero costoro lordi e brutti nell'animo come di fuori apparivano."

his reverend friend, the Olivetan don Miniato Pitti, Jacone tried to tease him. He was able to silence his would-be tormentor, answering:

> I was once poor like all of you and now I have three thousand *scudi* or more; you thought me foolish, but the monks and priests consider me to be a worthy man; I once served you and now I have this servant to wait upon me and take care of this horse; I once wore those rags that are worn by painters who are poor, and now I am clothed in velvet; I once went on foot and now I ride a horse: so, my dear Jacone, everything is going quite well; God be with you.[33]

Vasari recalls this as a decisive last laugh; the more so since he reported that Jacone died in miserable poverty and his friend Piloto fared little better, murdered by a youth he had insulted.

By contrast, Vasari's absence can be as conspicuous as his presence. This is the case for much of his biography of Baccio Bandinelli, for example, in spite of the fact that Bandinelli was his teacher in the mid-1520s, and probably because of the fact that he became a rival in the 1550s. The lack of personal involvement here results in the impression of detachment, giving the narrative a more objective-sounding historical voice that Vasari used to tell of Bandinelli's times and deeds and to evaluate them seemingly without personal prejudice.

It is not until after Bandinelli's death that he intervenes and, when he does so, he remains as much as possible in the third person, "Giorgio Vasari," not *io*. This occurs when, seven years after Bandinelli's death, he is called upon to complete the work begun by Bandinelli on the Udienza of the Palazzo Vecchio. In one of the concluding passages of the biography Vasari appears valiantly attempting to remedy the defects of that project, even though, he says, many thought that it would have been advisable to dismantle it: "But it was decided that it would be better to follow the work as it was, so as not to seem malicious and presumptuous towards Baccio and lest we demonstrate that we did not have sufficient spirit to correct the mistakes and shortcomings discovered and done by others."[34] Here Vasari scrupulously, if conspicuously, avoids the malice that caused Bandinelli problems, jeopardizing the fame due to his works:

> he would have received far greater recognition during his life, and been more respected, if he had received from nature the grace of being more pleasant and courteous: because his being just the opposite and being very rude in his speech lost him people's favor and obscured his own virtues and insured that his works were viewed askance and with ill-will and therefore could never please.[35]

33 *Ibid.*, pp. 405–6: "io era già povero come tutti voi et ora mi truovo tre mila scudi o meglio; ero tenuto da voi goffo, et i frati e' preti mi tengono valentuomo; io già serviva voi altri, et ora questo famiglio che è qui serve me e governa questo cavallo; vestiva di que' panni che vestono i dipintori che son poveri, et ora son vestito di velluto; andava già a piedi, et ora vo a cavallo: sì che, Iacon mio, ella va bene affatto; rimanti con Dio."

34 Life of Bandinelli, BB v, p. 275: "Ma è stato giudicato ch'e' sia meglio il seguitare così quel lavoro, per non parere maligno contro a Baccio e prosuntuoso, et aremo dimostro che e' non ci bastasse l'animo di correggere gli errori e mancamenti trovati e fatti da altri."

35 *Ibid.*, p. 276: "molto più ancora sarebbe egli stato vivendo conosciuto quello che era, et amato, se dalla natura avesse avuto grazia d'essere più piacevole e più cortese: perché l'essere il contrario e molto villano di parole, gli toglieva la grazia delle persone e oscurava le sue virtù, e faceva che dalla gente erano con malanimo et occhio bieco guardate l'opere sue, e perciò non potevano mai piacere."

Bandinelli made himself insufferable by his treatment of others, and just as Vasari had to remedy the defects of his architecture, he tried through his graciousness to remedy those of his reputation, thus paying a compliment both to himself and to his subject.

Explicit autobiography or self-chronicle is a feature of the second edition of *The Lives*. Vasari's direct interventions rarely feature in the first edition. This is the case even with episodes in which Vasari participated. Some, such as Pope Paul III's breakfast deliberations over the design for the cornice of his family palace, omitted from the 1550 *Lives*, are included in the 1568 edition.[36] This difference is owing to the closed historiographic conception of the first edition as well as to its author's age, status, and position in his profession in the 1540s when it was written. Even so, his presence in the first edition is pervasive if oblique, as events are reported or structured in ways that follow the patterns and events of Vasari's life. And he gave himself an important position in that edition by his ordering of the Lives directly preceding Michelangelo's.

The final group of Lives – Antonio da Sangallo, Giulio Romano, Sebastiano del Piombo, and Perino del Vaga – are a crescendo to the climax of Michelangelo. They are made to represent the triumph of the classicizing Central Italian style that was the basis of Vasari's own manner. The architect Antonio da Sangallo is presented as a modern Vitruvius. Giulio Romano, Raphael's heir, is compared with both Vitruvius and Apelles. With the penultimate pair, Sebastiano and Perino, Vasari creates a contrast of Venetian indolence (Sebastiano) and Tuscan industry (Perino). Sebastiano died in June 1547 and Perino in October, when *The Lives* were being completed. The insertion of their biographies at the end of the book is partly owing to this, but Vasari used these late additions to reinforce his scheme of praise and blame and his demonstration both of stylistic progression and varieties of contemporary excellence. Above all, he identified himself thoroughly with the Florentine student of Raphael, Perino, whose Life precedes Michelangelo's. Although Michelangelo was the premier artist, Perino was the most productive painter in Rome while Vasari was there in the 1530s and 1540s. A favorite of Pope Paul III, he controlled almost all of the major decorative projects in the city just when Vasari wished to enter into the market as an independent master. Perino's industry was a model for Vasari, and in his biography Perino's experience is resonant with Vasari's desires. A painter of modest beginnings, Perino is shown to rise to the top of the profession through his diligence.

His description of the young Perino in Rome is only thinly disguised autobiographical projection. He writes of Perino's "stealing time from time," studying day and night, having carefully divided his week into work and study, earning his living while seeking to attain the greater glory of art as witnessed in the ancient buildings and sculptures he saw there. Perino, like Vasari,

> seeing the ancient works of sculpture and the most wonderful structures of the buildings, for the most part in ruins, was very admiring of the worth of such distinguished and illustrious men who had designed those works. And so inspired thereby by an even greater desire for artistry, he always yearned to come close to their achievements, so that his works would bring him fame and other benefits, just as with the artists whose beautiful works had so amazed him.[37]

36 Life of Antonio da Sangallo, BB v, pp. 50–2. 37 Life of Perino del Vaga, BB v, pp. 110–11:

Both the motivation and the inspiration take a form similar to that Pietro Bembo outlined at the beginning of Book iii of his dialogue on vernacular style.[38] He describes artists coming to Rome to study the ancient remains, and aiming to achieve the excellence of those examples in their own works, all the more when they wanted to be praised for their efforts because they recognized that the ancient ones more nearly approached the perfection of art than anything done subsequently. He gave Michelangelo and Raphael as examples of those who had succeeded. At stake for both Vasari and Bembo is fame, which is commemorated through writing, and the forms that grant fame – a beautiful style, which fuses contemporary language with classical principles. Just as Bembo's example of artists' study was based on actual practice, so too was the expression of Vasari's desires influenced by the terms and tastes articulated by writers such as Bembo. A similar exchange informs the vocabulary of desire and perfection applied to such study, which had as its goal a pleasing and expressive style. It was ultimately derived from classical treatises on oratory such as that written in the first century ad by the rhetorician and teacher Quintilian whose advice was "to strive with all our hearts and devote all our efforts to the pursuit of virtue and eloquence; and perchance it may be granted to us to attain to the perfection that we seek."[39] Vasari's only criticism of Perino is that he degraded himself by taking on jobs of little account, rather than concentrating on the noble tasks available to him, and worked himself to death by such injudicious devotion to gain. This conclusion was almost inevitable according to Vasari's moral system, for Perino had violated the balance of utility, honor, and necessity, ignobly allowing necessity to dominate.

Vasari's autobiography is written into *The Lives* in both editions. The boundaries of Vasari's experience delimited those of *The Lives*. Where he traveled, whom he knew, whom he honored, and for whom he worked determined his text. In the introduction to the Lives of the group of Lombard artists added to the 1568 edition he stated as a matter of principle that he could not write about their works "if I had not seen them first."[40] He also gives his geographical range: Rome, Tuscany, part of the Marches, Umbria, Emilia Romagna, Lombardy, Venice and its territories. That his was a wide experience, encompassing service for several popes, various dukes, numerous lords, gentlemen, well-placed clerics, and the occasional nun, made his picture of artistic life a rich, if selective, one. The mechanisms and morality of love, devotion to art and fellow artists, fruitful collaboration and competition are installed in each biography. Although Vasari explicitly recounted the events of his life only in the second edition, when he had demonstrated the effectiveness of his philosophy of life having lived it to a distinguished maturity and assured success, they are an implicit feature of the book in both editions.

<p style="text-align:center">★ ★ ★</p>

"vedendo le opere antiche nelle sculture e le mirabilissime machine degli edifizi, gran parte rimase nelle rovine, stava in sé ammiratissimo del valore di tanti chiari et illustri che avevano fatte quelle opere. E così accendendosi tuttavia più in maggior desiderio dell'arte, ardeva continuamente di pervenire in qualche grado vicino a quelli, sì che con le opere desse nome a sé et utile, come l'avevano dato coloro di chi egli si stupiva vedendo le bellissime opere loro ... Fece adunque proponimento di dividere il tempo ... rubando al tempo il tempo, per divenire famoso e fuggir dalle mani d'altrui più che gli fusse possibile."

38 *Prose della volgar lingua*, ed. Marti, pp. 97–8.

39 *I.O.*, xii.i.31, vol. iv, pp. 372, 373.

40 Lives of the Lombard artists, BB v, p. 409: "se io non l'avessi prima vedute."

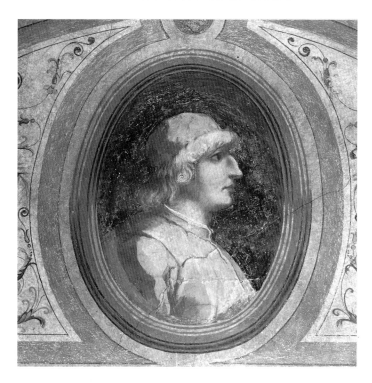

12. Giorgio Vasari, *Lazzaro Vasari*. Arezzo, Casa Vasari, Camera della Fama e delle Arti.

The Vasari of *The Lives*, the biographical and historical Vasari, is consistent with the one found in other types of record. Vasari's life is richly documented. The legacy from pen and brush is substantial. He composed a formal explanation of the subjects of the decorations of the Palazzo Vecchio, which he addressed to Duke Cosimo's heir, Francesco (the *Ragionamenti*). He says that he wrote a dialogue based on his conversations with Michelangelo, held on horseback as they did a pilgrimage to the seven churches in Rome during the Holy Year of 1550. In the 1568 Life of Michelangelo he claimed that he intended to publish it along with other material on art at a more favorable time.[41] He wrote letters and sonnets, signed contracts, and kept records. He owned two houses, one in Arezzo, purchased in 1541, and one in Borgo Santa Croce, Florence, granted to him by Duke Cosimo in 1561 (he had lived there as a tenant since 1557). Soon after acquiring his Arezzo house he began transforming it, covering its walls and ceilings with allegorical decorations.[42] One room was devoted to Fame and the Arts and included portraits of those artists he held to be the leading artists, his predecessors, sponsors, and heroes: the Aretines Bartolomeo della Gatta, Spinello Aretino, his great-grandfather Lazzaro (pl. 12), his Florentine teacher, Andrea del Sarto, and Michelangelo. The principal reception room has

41 Life of Michelangelo, BB VI, p. 83: "facendo le sette chiese a cavallo, che era l'anno santo . . . nel farle ebbono fra l'una e l'altra chiesa molti utili e begli ragionamenti dell'arte et industriosi, che 'l Vasari ne distese un dialogo, che a migliore occasione si manderà fuori con altre cose attenente all'arte."

42 Paolucci and Maetzke, *La casa del Vasari in Arezzo*, for color illustrations, a full description, and further references. See also Corti, "Un artista e la sua casa: Giorgio Vasari," in *Arezzo al tempo dei Medici*, pp. 17–31.

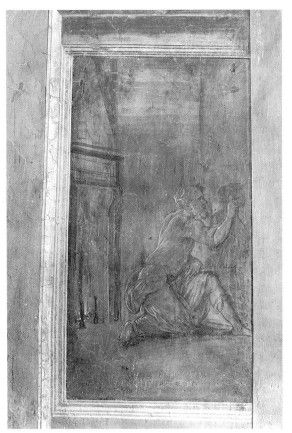

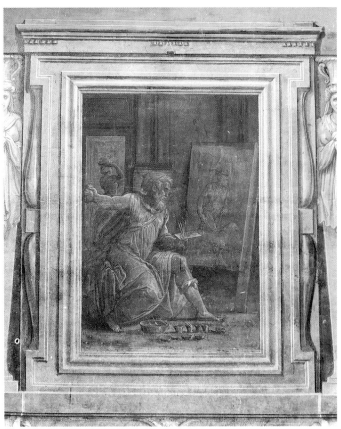

13. Giorgio Vasari, *The Invention of Painting* [Pliny, *N.H.*, xxxv.15]. Arezzo, Casa Vasari, Sala del Trionfo della Virtù.

14. Giorgio Vasari, *Protogenes Throws a Sponge at His Painting of Ialysus* [Pliny, *N.H.*, xxxv.103]. Arezzo, Casa Vasari, Sala del Trionfo della Virtù.

a ceiling showing Virtue with Envy at her feet and holding Fortune by her forelock (pl. 55), surrounded by the signs of the zodiac and symbols of the seasons. The walls show virtues and scenes of the discovery of painting taken from lives of the ancient painters and depicted as though in bronze (pls. 4, 13, 14, 86). With these and a series of landscape views (pl. 15), Vasari demonstrated the full range of the painter's skills in his ability to imitate the varied effects of nature and vie with sculpture through illusionism. His chosen virtues were Labor, Plenty, Justice, Honor, Happiness or Concord, Wisdom, Charity, Liberality (pl. 16), Immortality, and Prudence: a fairly comprehensive statement of the guiding values that allowed him to engage so successfully with Fortune. In Florence he decorated his reception room with allegories of the arts and a frieze with portraits of the artists and scenes of the origins of the arts based on the descriptions in the first-century AD *Natural History* by Pliny the Elder (pls. 3, 17). He consulted with his learned friend Vincenzo Borghini about an allegorical cycle to celebrate famous Aretine artists. This ceaseless decorating is a fair indication of his passion for his profession as well as the equivalence he gave to learned text and learned images in conveying major themes and "subtle points."[43]

43 The phrase "sottili considerationi" occurs in Borghini's note to Vasari about the scheme, in del Vita, *Lo Zibaldone*, p. 18, pp. 16–20, for the entire text. For this house, its inventory, and its history, see A. Cecchi

15. Giorgio Vasari, *Nocturnal Landscape with a Burning Building*. Arezzo, Casa Vasari, Sala del Trionfo della Virtù.

16. Giorgio Vasari, *Liberality*. Arezzo, Casa Vasari, Sala del Trionfo della Virtù.

Vasari specified in his will that whichever nephew displayed some ability either in letters or in design should have first place in this Florentine house; that is, an apartment of his choosing. That property was to be inherited by his brother's sons.[44] His papers, kept in a box in his study, seem to have come into the special keeping of his nephew Giorgio, an aspiring courtier and architectural theorist, who dutifully administered the literary estate, advancing his own career while honoring his uncle. He made a list of all the "Great Princes and Lords" who had written to his uncle at various times and on various subjects.[45] He organized the

et al. in Arezzo 1981, pp. 37–47, pls. 79–116; A. Cecchi, "Nuove ricerche sulla casa del Vasari a Firenze," in *Studi* 1981, pp. 272–83; and Fossi, "Documenti inediti Vasariani," *Antichità viva* (1974), no. 3, pp. 63–4.

44 For the will, dated 25 May 1568, see Gaye, *Carteggio inedito d'artisti*, II, pp. 502–17, p. 513, for the stipulation about his house. The will was published on 28 June 1574 and is ASF, Notarile moderno, acts of Raffaello di Santi Eschini, *protocollo* no. 635 (1572–5), fols. 133v–145r. This includes a copy of the 1568 will (fols. 135r–143r), a codicil of 15 November 1570 (fols. 143v–145r), and an inventory of Vasari's goods (fols. 146v–148r). I would like to thank Megan Holmes for checking these documents.

45 Now in the Biblioteca Riccardiana, Florence, MS 2354, fols. 91–2: *Nota di diversi Gran' Principi, et Signori, che hanno scritto in diversi tempi a messer Giorgio Vasari, sopra diverse Cose, le Lettere de' quali si trovano la maggior' parte appresso il Cav.re Vasari suo Nipote,* published by C. Davis in Arezzo 1981, p. 207. For Vasari's nephew, see Olivato, "Profilo di Giorgio Vasari il Giovane," *Rivista dell'Istituto nazionale di archeologia e storia dell'arte* (1970), pp. 181–229; "Giorgio Vasari il Giovane," *L'arte* (1971), pp. 5–28; "Giorgio Vasari e Giorgio Vasari il Giovane," in *Atti* 1974, pp. 321–31.

17 (following pages). Giorgio Vasari, *The Painter's Studio* (detail). Florence, Casa Vasari, Sala delle Arti e degli Artisti.

correspondence in his possession according to senders: letters from cardinals and princes, from prelates and monks, for example. He also made fair copies of a selection of letters, regarding inventions for things Vasari had painted or had intended to paint.[46] He edited and published Vasari's *Ragionamenti* on the inventions of the decorations in the Palazzo Vecchio, dedicating the book to Grandduke Ferdinand and prefacing it with Latin verses by Pietro Filippo Arselli, who not unexpectedly compared Giorgio's uncle to Zeuxis and Apelles.[47] He assembled notes on different subjects in a book that he titled the *Libro delle invenzioni*, now called the *Zibaldone*.[48] The younger Giorgio's editing of his uncle's reputation was obviously intended to highlight the inventive and erudite character of his work and the resulting esteem awarded the artist.

Some of the papers collected in Vasari's study remained in the house in Borgo Santa Croce. After the direct line of the family died out in 1687, one of the administrators of the Florentine estate, senator Bonsignori Spinelli, who had the neighboring palace, incorporated some, if not all, of the surviving papers into his family archive. A portion of them was recognized in 1908, and that group of papers from the Rasponi-Spinelli archive was deposited with the city of Arezzo in 1921 by Count Luciano Rasponi-Spinelli on the condition that they be kept in the Casa Vasari. They constitute the present Archivio Vasariano whose holdings include the *Zibaldone*, eight codices of collected letters, the fair copy of Vasari's record book (the *ricordanze*), as well as other family papers.[49] Three volumes of documents, overlooked in 1908, were acquired with the rest of the Spinelli archive by Beinecke Rare Book and Manuscript Library at Yale University in 1988. These include a copy of Vasari's will, an inventory with a note of paintings owned by Vasari, business papers, family records, and accounts.[50] The note of correspondents in Giorgio the Younger's list, the occasional aside in *The Lives*, and fragments of record and account books at Yale indicate that this is still just a portion of Vasari's own treasured papers.[51] While the bulk of Vasari's known correspondence is that from the Florentine study, letters to and from Vasari and concerning him are also to be found in numerous archives and manuscript collections, above all the Florentine Archivio di Stato.[52] The records of the Medici court in the Archivio di Stato in Florence also document payments to Vasari and his assistants.

46 The originals are lost, the collection of forty-eight letters is in Riccardiana MS 2354: *Varie lettere di messer Giorgio Vasari Aretino Pittore, et Architettore, scritte in diversi tempi, à diversi Amici sua, Sopra inventioni di varie cose da lui dipinte, ò da dipingersi, raccolte dal Cav.re Giorgio Vasari Suo Nipote da certi suoi scritti* (fol. 1r). For the letters in the Vasari archive and their categories, see del Vita, *Inventario e regesto*.

47 Giunti Press (Florence, 1588). The manuscript of the *Ragionamenti* in Giorgio the Younger's hand is now in the Biblioteca della Galleria degli Uffizi, Florence, MS no. 11.

48 Now in the Archivio Vasariano, cod. no. 31, published by del Vita, *Lo Zibaldone*.

49 Del Vita, *Inventario e regesto*.

50 Babcock and Ducharme, "A Preliminary Inventory of the Vasari Papers," *Art Bulletin* (1989), pp. 300–4.

51 So in the Life of Salviati he writes of a copious correspondence with Salviati, of which Vasari kept copies and originals of the letters sent and their replies,

now all lost, BB v, pp. 532, 533. He also mentions a correspondence with Giulio Romano, BB v, p. 78, and in a letter dated 7 June 1545 don Miniato Pitti sent Vasari greetings·from the sculptor Tribolo, who was ashamed that he had not written and who acknowledged that that he owed Vasari many letters (Frey ı, lxxi, p. 152).

52 The letters in the Archivio Vasariano, Riccardiana MS 2354 and others, mainly in the Archivio di Stato in Florence (hereafter ASF), were published by K. Frey (Frey I, II). There is a supplement by his son, H.W. Frey, *Neue Briefe von Giorgio Vasari*, published as volume ııı of *Der Literarische Nachlass Giorgio Vasaris* (77 letters, all but one from the Ginori Conti Archive, Florence, with additional documentation). Frey ıı includes other manuscript material from the Archivio Vasariano: the *ricordanze*, Marc'Antonio Vasari's account of his uncle's life from 1568–74, Vincenzo Borghini's iconographic invention for Francesco I's *studiolo* in Palazzo Vecchio, payments for the Sala Regia (1572–3), and inventories of

This mass of material is indicative of Vasari's place in a culture where the written word was an important form of social as well as business exchange. Vasari's allegiance to the pen should be set in the context of a society in which collection and recollection were habitually linked. Establishing a family archive that included personal as well as financial records was both good business and part of forming and consolidating a family identity. There was a vested interest in the past. Knowledge, not nostalgia, was the motivating force. From knowledge came the ability to act prudently, to exercise judgment in the face of the vagaries of fortune, and to benefit materially from such judicious behavior.[53] Vasari's ease with the past seems to reflect this general predisposition to make notes and to remember. Record and memory were united in the manner of accounting for day-to-day transactions with entries beginning with the words *ricordo come* or *ricordo che* ("I recall that"). Paperwork was part of Tuscan culture, and with it the systematic ordering of information. Vasari's was a native genius.

What is Vasari's documentary profile? He appears in notarial records, Giorgio or Giorgio di Antonio Vasari, Aretine painter, buying and selling property, contracting or being contracted for paintings.[54] He attended to the business of art with a careful regard for its

Vasari's houses in Florence, Arezzo, and Frassineto. Six letters that Frey could not locate, first published by Milanesi, *Sei lettere inedite*: Frey xlii (to Francesco Leoni in Venice, 1540), xliii (to Leoni), xlv (to Leoni), lii (to Pancrazio da Empoli in Venice, 1543), lvi (to Leoni in Venice, 1544), lvii (to Leoni, 1544), are to be found in ASF, Acquisti e Doni 67.1; Frey cli and clii from Vasari in Rome in 1551 to Lorenzo Ridolfi in Florence (published by Milanesi in *Le Opere*, VIII, pp. 297–8), which Frey could not find, are ASF, Acquisti e Doni 167, ins. 1, nos. 2, 3. Frey cdlxxxviii (Vasari to Giovanni Caccini in Pisa, 1565) is Biblioteca Riccardiana, Carte Frullani 1908. There is yet to be anything approaching a systematic account of indirect documentation, above all the letters concerning Vasari and his projects in Cosimo I's correspondence and that of his secretaries in the ASF such as Carte strozziane, series I, XXXIV, fol. 190, Cosimo in Livorno to Francesco di ser Jacopo in Livorno, 8 November 1557 (report on various operations: "De Lavori che fa Giorgio Pittore et che fa fare, non habbiamo che dirvi altro, senon che tutto sta bene"), and fol. 191, the duke in Pietrasanta to Francesco di ser Jacopo, 7 December 1557. Philip Gavitt kindly informed me of references to Vasari in the Archive of the Ospedale degli Innocenti, to be discussed in his book on the Ospedale (*Cities of Women. Gender, Inheritance, and Abandonment in Sixteenth-Century Italy*): a letter from Vincenzo Borghini to Duke Cosimo about Vasari's health and work in the Sala di Clemente (Innocenti, Suppliche e sovrani rescritti, series VI, vol. I, fol. 287r, 21 February 1560 [1561 s. c.]) and a copy of a codicil to Vasari's will referring to provision for an illegitimate child, brought up at the Ospedale degli Innocenti (Innocenti, Filza d'archivio, series LXII, vol. VII, fol. 49r, 28 June 1574). These documents are discussed below, pp. 53–4. Another unpublished letter by Vasari is in the Biblioteca Laurenziana, Acquisti e Doni 296, int. 11140,

no. 1 (Vasari in Florence to Averardo Serristori in Rome, 7 August 1568). A related letter to Duke Cosimo from Serristori's sister, Costanza Spinelli, is at Yale, Beinecke Library, Spinelli archive Box 47, folder 1027. A number of previously unpublished or little-known letters are in Arezzo 1981. Palli d'Addario published fourteen letters from and concerning Vasari in the Archivio Guidi housed in the ASF, Carte Guidi (*Studi* 1981, pp. 363–89). Lunardi published the rediscovered documents for the restructuring of the interior of Santa Maria Novella, "La Ristrutturazione vasariana di S. Maria Novella," *Memorie Domenicane* (1988), pp. 403–19. Full documentation for the commission for the high altar of the Florentine Badia found by Ugo Procacci has recently been published, "Sull'allogagione e sull'esecuzione della tavola del Vasari," *Antichità viva* (1991), no. 6, pp. 5–11.

53 Bec, *Les Marchands écrivains*, pp. 49–54. See also Anselmi, Pezzarossi, and Avellini, *La "memoria" des mercatores,* and Klapisch-Zuber, *La Maison et le nom*, pp. 28–35.

54 See, for example, the documents assembled by degli Azzi, "Documenti Vasariani," *Il Vasari* (1931), pp. 216–31. David Franklin has discovered documents relating to a banner for an Aretine confraternity (ASF, Compagnie Religiose Soppresse, Arezzo, Gliv, Compagnia di San Giovanni de' Peducci, vol. 2394, no. 7, *entrate e uscite*, 1538–56, fol. 75r, 20 October 1550), one for a confraternity in Montepulciano (ASF, Compagnie Religiose Soppresse, Montepulciano, Sdxlix, Compagnia di Santo Stefano, vol. 3494, *Libro dei partiti*, 1533–60, no. 1, unpaginated, April 1556), and a record of the contract for a *Coronation of the Virgin* for San Francesco, Città di Castello (ASF, Archivio Rondinelli Vittelli, filza prima, ins. 4, unpaginated, 1563). I want to thank David Franklin for telling me about these documents, which are important in confirming the range of

forms. Like many artists in Tuscany, including his first master Guillaume de Marcillat, he held records of his accounts and contracts. In the Spinelli archive at Yale there are fragments of daily account books kept by Vasari and other members of his household over various years with detailed notation of income and expenses.[55] The register that Vasari called his book of *ricordanze* is a retrospective one, a fair copy of his dealings relating to his profession and property culled from his other payment books. Beginning with entries from 1527, the year of his father's death, it ends in 1572. It opens with an invocation, seeking the protection of God, the Virgin, Sts. Peter and Paul, the Baptist, and St. Donatus (the latter respectively the patron saints of Florence and Arezzo), and St. George ("advocate and particular protector of our house").[56] In a prefatory paragraph Vasari explains that this is a book

> In which record will be made of all the paintings in fresco, in tempera, in oil, on wood or wall or on canvas, that may be executed by me over time in every place and every town, here in Arezzo as well as all over Italy and abroad, who commissions them and their prices, here recorded by me, and all that which might happen daily: That all this might be to the honor of God and the benefit and exaltation of me and of all of my house and the health of our bodies and our souls for all time.[57]

This type of survey was common and the book follows a traditional form (pl. 18).[58] *Ricordanze* were regularly assembled by tradesmen and merchants in Arezzo from at least

Vasari's activities beyond the works he commemorated in his autobiography and formal book of *ricordanze*.

55 Beinecke Library, Spinelli archive, Box 52, folders 1112–22: folder 1112, sheet with four sides of *ricordanze* from 1553 to 1565; folder 1113, pages from an account book (1539), 20 pp.; folder 1114, payments for flax thread (1551), 2 pp.; folder 1115, pages from an account book (1560–2), 38 pp.; folder 1116, account book (1560–3), 32 pp.; folder 1117, account book (*Conti e Ricevute*, 1562), 8 pp.; folder 1119, assorted pages from account books (1558–66), 22 pp.; folder 1120, accounts (1568), 16 pp.; folder 1121, household accounts (food, wine, and various; 1572). There is also a copy of an inventory of Vasari's house in Arezzo (1567), and a later note of paintings there (Box 47, folder 1022), a copy of his will (Box 47, folder 1035), and documents about his wife's dowry (Box 48, folder 1044). Box 52, folder 1115 has payments for work on the Uffizi from 1560 to 1562, discussed by Jacks, "Giorgio Vasari's *Ricordanze*: Evidence from an Unknown Draft," *Renaissance Quarterly* (1992), pp. 756–8. Box 48, folder 1057 has various important and tantalizing bits of documentation, including the commission for the frescoes in the cupola of the duomo of Florence (1572, to be published by P. Jacks) and one sheet concerning the 1568 edition of *The Lives* (to be published by R. Babcock).

56 Frey II, p. 847: "Al nome sia del sommo, magnio et imortale Iddio et della Sua Intemerata Vergine Maria et de princjpi degli appostolj Santo Pietro et Santo Pauolo et del precussore di X°. [*Cristo*] Santo Giouannj Batista, auocato della inclita citta di Fiorenza, et del presule et martire San Donato, groriosissimo auocato,

guida et capo di questa nostra antica cita d' Arezzo, et del Beato et groliosissimo [*sic*] martire et caualjer di X°. [*Cristo*] San Giorgio, auocato et singular' defensore della casa nostra."

57 *Ibid.*: "Questo libro, chiamato delle ricordanze, [è] scritto da me Giorgio d Antonjo di Giorgio Vasarj, cittadino Aretino. Nel quare [*sic*] si fara memorja di tutte le opere di picttura a fresco, a tenpera, a oljo, in legnio o in muro o in tele, che per me fussino lauorate di tenpo in tenpo in ogni luogo et paese, cosi qui in Arezzo come per tutta Italja et fuora di essa, da chj elle sarano allogate, et i prezzi loro, da me in questo fattone memorja, et tutto quello che giornalmente accadera: Che tutto sia a honore della diujna maesta et a utjle et esaltatione di me et di tutta la casa mja et salute de corpi nostrj et delle anjme per infinita secula seculorum." The actual date of the *ricordanze* and the process of assembling and updating them remain to be studied in detail. For a discussion of the problems regarding this manuscript, see C. Davis in Arezzo 1981, pp. 201–2, and Jacks, "Giorgio Vasari's *Ricordanze*: Evidence from an Unknown Draft," *Renaissance Quarterly* (1992), pp. 739–84.

58 Klapisch-Zuber, "Du pinceau à l'écritoire," in *Artistes, artisans et production artistique au moyen age*, ed. Barral I Aitet, I, pp. 567–76, and Phillips, *The Memoir of Marco Parenti*, pp. 33–8. For the form and layout, see Petrucci, *Il libro di Ricordanze dei Corsini (1362–1457)*, p. lxv. For a discussion of the genre and problems of definition, see Pezzarossa, "La memorialistica fiorentina tra medioevo e rinascimento," *Lettere Italiane* (1979), pp. 96–138.

the early fourteenth century.[59] These books chart the adult life of the head of the family, as he kept his own, and therefore his family's, affairs in order. Such record books served as a type of memorandum for posterity of success achieved, tracing the course of a life through its principal transactions in a chosen field. They could also serve as legal documents so that the value of such a book for future generations could be quite real in case of litigation, dispute, or need for precedent. Vasari's *libro* was not a daybook; it is rather an inventory of earnings which, taken in its entirety, is an accounting of his career.

The handwriting is neat throughout. This is not the case in his less formal accounts. The ink color is consistent for a number of sheets, but it changes, usually at the beginning of a new sheet (such at the beginning of the second ligature, fol. 19r, between the entries for 3 and 30 June 1549, or the top of fol. 19v, 3 June 1550). There are instances when a mistake in transcription is corrected, as 4 March 1532, first written 1552, and there are additions, such as a note in the margin of fol. 20v referring to a commission from 6 May 1553 that was delivered in 1559.[60] The entries generally follow chronologically through the year. In one case, however, a short entry regarding work on the ceiling of Vasari's Arezzo house, begun on 30 July 1548, precedes a longer one referring to the commission for a painting for the Badia of Santissime Fiora e Lucilla received on 15 July where Vasari summarized a written agreement.[61] The short entry fitted onto the bottom of a page (17v), the long one started the next sheet (18r) – so that space rather than time determined the order. The retrospective nature of this book is demonstrated also by the pervasive use of the past tense. It is furthermore the case that entries indicate both the receiving of a commission and its completion.[62] Starting in 1555 (fol. 21v) there is a separate sheet for each year, whereas before then the years ran on.[63] That year marked a decisive point in his career, as he entered the service of Duke Cosimo in Florence with an annual stipend. The voice also changes, from the personal – such as "I agreed to do" ("io conuennj con"), Ottaviano de' Medici "had from me" ("ebbe da me"), Cardinal Farnese "commissioned me" ("mj alloga a fare")

59 The archive of the Confraternita dei Laici, Arezzo, has a number of these books called variously, *ricordanze, ricordi, memoriale, giornale*, dating from the fourteenth century onwards. For a list, see Antonella, *L'Archivio della Fraternita dei Laici.*

60 Frey II, p. 870, no. 209 (6 May 1553): "Questo quadro si dette a Andrea della Fonte, come segniato innanzi'; the delivery is noted in 1559 (Frey II, p. 874, no. 261). The entries are not numbered throughout the manuscript. There are numbers in the left margin, but this sequence ends at the bottom of fol. 20v, "82," 10 June 1553 (Frey, no. 213). For convenience, references are given here to Frey's numbers.

61 Frey II, p. 867, nos. 181, 182.

62 For example, the record of a commission accepted on 12 June 1539 for the Camaldoli *Deposition*, which Vasari began to paint only on 16 June 1540: "laquale per auerla fatta comincjare a Stefano, mjo cugino, a bozzare con un cartone di mja mano, non ne o fatto ricordo, se non quando io ritornaj da Bolognia a lauorui sopra, che fu questo di 16 di Giugnio 1540" (Frey II, p. 857, no. 105); the altarpiece commissioned by Bindo Altoviti on 10 August 1540, noted with its appraisal and payment on 4 September 1541 (Frey II, p. 857, no. 107); the commission from Pope Julius III in May 1551 for a painting of *Christ calling Saints Peter and Andrew*, not finished until 1561 when Pius IV gave it to Vasari who used it for his family altar in the Pieve of Arezzo (Frey II, p. 870, no. 200: "Questa tavola ste in opera fino al anno 1561").

63 Jacks, "Giorgio Vasari's *Ricordanze*: Evidence from an Unknown Draft," *Renaissance Quarterly* (1992), pp. 750–2, notes that the handwriting changes at this point and suggests that the last nine sheets date from later, probably the last eighteen months before Vasari died.

64 Frey II, p. 848, no. 5 (22 November 1527, "io conuennj con"), p. 857, no. 101 (15 April 1540, "ebbe da me"), p. 860, no. 130 (6 January 1543, "mj alloga a fare"), p. 872, no. 223 (1555, "nel medesimo anno si fecie"), no. 225 (15 December 1555, "si diede princjpio," "si comincjo"), no. 232 (1556, "al fine dell anno si finj"). This is also noted by Jacks, "Giorgio Vasari's *Ricordanze*: Evidence from an Unknown Draft," *Renaissance Quarterly* (1992), pp. 749–50.

– to the impersonal, "one did," "one began," "one finished."[64] Both Vasari's position and his perception of his person seem to change in that year in addition to the form of his recordkeeping.

Even though there are three hundred and sixty-eight entries, the book is selective, omitting details of payments to assistants, references to some small paintings, and tasks that are documented elsewhere.[65] There is a list of works on four sides of a folded sheet in the Beinecke Library with entries dating from 28 December 1553 to 25 December 1565 that offers evidence of the process of assembly and editing represented by the final form of the *ricordanze* (pls. 18, 19). Far messier than the *ricordanze*, with dates crossed out and changed, the form of the entries is closer to account books: giving the day, month, and year, with a running tabulation, rather than starting with the verb *ricordo*. There is a crossed-out note "to leave a space for new things" next to the entry for 17 May 1561, suggesting that Vasari was going to make additions. Where the two records coincide, works and destinations agree, but dates often do not, varying by months, even years. The discrepancies may sometimes be due to differences in receiving and delivering commissions, and sometimes to faulty memory or sloppy transcription. With one exception the Beinecke sheet records the month and day of commissions, where the *ricordanze* may refer just to the year. During these years there are about thirty more works cited in the *ricordanze* with more information about dimensions and subjects. The *ricordanze* have all but five entries from the Beinecke sheet, and these, with the exception of a room frescoed in Sforza Almeni's palace, are for minor works. The Beinecke sheet seems to be a draft for a record book and, given the dates, might also be loosely related to Vasari's ordering of his past for the description of his works in the second edition of *The Lives*.[66] The *ricordanze* are more formal, go beyond 1568, and incorporate information from other sources. Written in different stages, the *ricordanze* show Vasari using his business book to leave an image of himself as an industrious, prosperous, and cosmopolitan artist.

A total earning of 51,620 *scudi*, 4 *lire*, 3 *soldi* is recorded over forty-five years (the sum was calculated by his nephew). The changing fortunes and prospects of Vasari's working life are registered here, from the modest beginnings in 1527–8, when he painted signs for local shops for 14 *lire* and did various works in Arezzo and surrounding villages for a total income of 27 *scudi* and 1 *lira* in 1528, to payments of 1,130 *scudi* for decorating chapels for Pope Pius V in the Vatican in 1571 and an annual total of 4,865 *scudi*.[67] Some indication of the relative

65 See, for example, Salmi, "Due lettere inedite di Giorgio Vasari," *Rivista d'arte* (1912), pp. 121–4, for letters from 6 January 1556 and 26 February 1558 to the Compagnia della Santissima Trinità in Arezzo, about his intervention with Duke Cosimo on behalf of the confraternity, which wished to build a hospital in former granaries at that time occupied by Franciscan nuns (ASF, Compagnia della Santissima Trinità d'Arezzo, vol. XXII, fols. 576, 511). Vasari also supplied plans for the hospital (fols. 588, 590: *Pianta dello Spedale della compagnia della trinità fatta per me giorgio vasari*). I would like to thank David Franklin for this reference.

66 For a careful analysis of the relationship between the two versions of the *ricordanze* and their purposes, see Jacks, "Giorgio Vasari's *Ricordanze*: Evidence from an Unknown Draft," *Renaissance Quarterly* (1992), pp. 761–8. A close comparison of the autobiography with both

the Beinecke sheet and the *ricordanze* reveals many differences. The order and wording in the autobiography differ from the Beinecke draft. Similarly the wording is different again from the fuller *ricordanze* entries. Vasari's account of his life in *The Lives* seems to follow, selectively, some form of list until 1555, when he begins his description of his works in Cosimo's service. From that year works are grouped much more associatively and freely with respect to chronology, relying more on memory; at one point, for example, Vasari corrects himself, noting that he had forgotten to say that the year before he had installed three large panels in the refectory of San Piero, Perugia ("Mi era anche scordato di dire che l'anno innanzi [1566]"; BB VI, p. 404).

67 Frey II, p. 848, no. 8 (10 April 1528), and p. 882, no. 360 (2 December 1571), pp. 848, 882, for the annual totals.

value of these figures in the sixteenth century may be given by considering that an unskilled laborer in the building trade earned about 10 *soldi* a day, a mason or skilled worker about twice that in Florence. Giovanni Pollastra, Vasari's grammar teacher paid by the city of Arezzo, received 100 florins a year and a place to live.[68] Guillaume de Marcillat, the leading artist in Arezzo during Vasari's early years as a painter, undertook to paint the first bay of the vaults of the Arezzo cathedral for a price not to exceed 200 ducats, including the cost of pigments and gold. Pigments for this project, bought in Florence in February 1521 cost 55 *scudi*, 8 *lire*, 6 *soldi*. Cobalt-blue glass (*smalto azzuro*) came at 10 *soldi* per ounce, the earth colors, yellow, red, and black, at 4 *soldi* a pound.[69] Although he was well paid for major tasks and was able to buy a house in Arezzo for 300 florins, Marcillat also took on minor jobs such as painting two wall-hangings (*spalliere*) "by the yard" ("a 22 soldi il bracio") and retouching an image of the Virgin.[70] The relative scarcity of significant opportunities for artists in small towns is a recurrent theme in *The Lives*. As Vasari explained in the opening to the Life of the sculptor Niccolò Aretino, Niccolò was forced to leave his native town to learn

> elsewhere what he could not do at home, since usually (except in the case of the large cities, of which there are not many, however) each particular place is ill-equipped for their needs, especially in the sciences and those distinguished and worthy arts that confer both benefit and fame on whomever wishes to endure the hard work.[71]

Small-town aspirants were forced to leave in order to "make themselves immortal" and to escape the proverbial sad lot of "birds hatched in bad valleys."[72] And Vasari, like Niccolò Aretino, soon sought the more beneficial, competitive, and eventually for him lucrative, marketplaces of Florence and Rome.

His income in 1571 as painter to the pope and artist to the grandduke of Florence can be compared to the sum of 4,000 *scudi* that was the first investment made by the Riccardi family when they entered the wool trade in 1568 by setting up a business venture with a total capital of 6,000 *scudi*.[73] The figures in the *ricordanze* represent income (*entrate*) without expenses (*uscite* or *debiti*), such as those for materials, assistants, and transport. Moreover, they do not include money or goods from other sources, such as his property outside

68 A *lira* was divided into 20 *soldi*. The value of the *scudo* fluctuated. Vasari's usual exchange rate was 7 *lire* to a *scudo*, as in *ricordo* no. 168. The ducat and florin were also worth about 7 *lire*. For these relative salaries and values, see Goldthwaite, *The Building of Renaissance Florence*, chapter 6, and Black, "Humanism and Education in Renaissance Arezzo," *I Tatti Studies* (1987), p. 229. The grammar master's assistant, the coadjutor, was paid 25 florins a year, p. 231. For a discussion of salaries and cost of living in mid-sixteenth-century Florence, with further references, see Rolova, "Alcuni osservazioni sul problema del livello di vita dei lavoratori di Firenze," in *Studi in memoria di Federigo Melis*, IV, pp. 129–46.

69 One pound (*libbra*) was twelve *once*, a weight of 339.5 grams.

70 For these prices and commissions, extracted from Marcillat's account books, see Mancini, *Guglielmo Marcillat Francese*, pp. 37, 82, 83, 85.

71 Life of Niccolò Aretino, BB III, p. 31 (1550): "e'

si vede pur bene spesso che molti ancora se ne vanno altrove a cagione di imparare e di apprendere fuori quello che a casa non si può fare, essendo comunemente (eccetto le città grandi, che non sono però molte) ogni luogo particulare mal fornito de' suoi bisogni, e massimamente de le scienzie e di quelle arti chiare et egregie che dànno utile e fama insieme a chi vuol durarvi fatica."

72 *Ibid.*, pp. 31–2: "Non è sempre vero il proverbio . . . 'tristo a quello uccello che nasce in cattiva valle,' perché se bene la maggior parte degli uomini si stanno ordinariamente più che volentieri nel paese dove e' son nati, e' si vede pur bene spesso che molti ancora se ne vanno altrove a cagione di imparare e di apprendere fuori quello che a casa non sono può fare . . . cavati degli infelici paesi loro e condotti ancora in que' luoghi dove e' possino comodamente farsi immortali."

73 Malanima, *I Riccardi di Firenze*, p. 59.

1562

18. Giorgio Vasari, sheet from the *Ricordanze*. Arezzo, Casa Vasari, codice 30, fol. 25.

19. Giorgio Vasari, draft sheet of *ricordanze*. New Haven, Conn., Yale University, Beinecke Rare Book and Manuscript Library.

Arezzo, a farm at Frassineto, acquired in 1548 and subsequently enlarged.[74] While these sums do not give a tally of his net worth at any time, they do, however, give a clear view of steady and progressive material success.

When Vasari went to work in Cosimo I's household in 1555 his annual salary of 300 *scudi* was higher than that previously recorded for other artists at the court. In 1553 Bronzino had a stipend of 150 *scudi*, Bacchiacca, 96 *scudi*, and Cellini, 200 *scudi*.[75] In 1555 the sculptor Ammannati received 100 *scudi*. Vasari's stipend was probably meant to provide for his assistants as well as for himself and reflects the scale of the task he was about to undertake. The artists' salaries were, in any event, well above the 20–24 *scudi* paid to footmen (*staffieri*) and cleaners (*spazzatori*). They compared with those of chamberlains (as the 100 *scudi* to the *cameriere* Francesco Gambacorta), the majordomo (150 to Tommaso de' Medici), and secretaries (150 to Lorenzo Pagni).[76] Once established in his career, Vasari's earnings were probably similar to those of a manager in a banking house. That he came to own a house in Florence and one in Arezzo and two country properties near Arezzo (Frassineto and Montici) is an indication of both his financial security and his traditional nature. Property was a favored form of investment in Tuscany. The inventories of his household effects – linens, furniture, clothing – show that he lived very comfortably. And in his will he tried to ensure the continued respectability of his entire extended family in material terms. He made provisions for the education of his nephews and the dowries of his nieces. Having earned a place for the house of Vasari, he was concerned with the details of its perpetuity as well as its "health and comfort."[77]

All of the transactions in the *ricordanze* are written in the same unadorned language, regardless of the source – parish priest or pope. Descriptions become lengthier as the works become more complicated, and the specifications at times more detailed as the expense grew; but the form of transaction hardly varies. The entries begin *Ricordo, come*, followed by the date of Vasari's record. He then identifies the client, describes the work, the medium (oil, fresco, tempera) and support (panel, canvas, wall), the subject, special conditions, the terms of payment, and gives a note of completion. This is an abbreviated form of the work contract, *allocatione* or *allogagione*. Vasari occasionally uses the verb *allogare*. In some cases he refers to a notarial document, as the contract drawn up by the notary Camillo di Senso Carderini for a panel of the Virgin and Child with saints for the confraternity of St. Roch.[78] Other times he alludes to contracts made without a notary (a *scritta*) or less formal

74 Documents relating to this transaction are in the Archivio Vasariano, MS 4 (38), fols. 35–37v. It was purchased from Francesco Vespucci on 20 December 1548.

75 ASF, Depositaria Generale, Parte Antica, Salariati 393 (1553), fol. 115.

76 ASF, Depositaria Generale, Parte Antica, Salariati 394 (1555).

77 Gaye, *Carteggio inedito d'artisti*, II, p. 503: "salute et comodo et perpetuità." The inventories are printed in Arezzo 1981, pp. 30–3, 42–4. This testamentary concern to control the future of his family and its behavior fits with a pattern in mid-sixteenth-century wills discussed by Cohn, *Death and Property in Siena, 1205–1800. Strategies for the Afterlife*, p. 42.

78 Frey II, p. 853, no. 78 (1535), on the basis of a drawing: "in sul quale ser Camillo di Senso Carderinj ne rogo un contratto publjco." Similarly the "public instrument" ("publjco jstrumento") for the *Deposition* for the Company of Corpus Christi mentioned in Frey II, p. 853, no. 76 (3 January 1535). This document is ASF Notarile Antecosimiano F476, 1535–7, fols. 30r,v. I would like to thank David Franklin for providing me with a copy of this document and the reference to the deliberations of the confraternity about this commission (fols. 24r,v).

agreements of terms.[79] Some of his records show that he negotiated for the possibility to display his talent, accepting a small payment for a big opportunity, like the painting of the *Marriage of Esther and Ahasuerus* for the refectory of the Aretine abbey of Santissime Fiora e Lucilla, Arezzo (pl. 110).[80] For smaller works or more casual arrangements, as with his friend Paolo Giovio, he simply states that he did or made ("feci") something or that the client "had" ("ebbe") a work from him.[81]

His efficiency and the volume of his work is apparent at a glance. In 1567, for example, at the height of his career, he was capable of finishing three large-scale altarpieces, decorations for the celebrations of the baptism of Duke Cosimo's daughter, and the cartoon and painting of the first of the large scenes in the main hall of the Palazzo Vecchio. He was employed by Pope Pius V as well as the duke and other notable gentlemen. Vasari's versatility is evident from the first and developed over time as his practice expanded from producing images of local saints and paintings from the standard devotional repertory to more ambitious and elaborate themes, both sacred and secular. The scale becomes grander over the years; but the range and reliability are consistent. Vasari regularly met the specified terms. And from the earliest years he was working in fresco, oil, and tempera. His adaptability might have been born of necessity, stemming from a time when he could not afford the luxury of specialization, but it became the basis of the reputation that brought him as much honor as gain. No wonder that the *ricordanze* show him gradually building up a clientele through his contacts in Arezzo and with the Medici and important Florentine families (with businesses and business contacts in Rome, Naples, and France), monastic orders, and loyal friends in Rome and Florence. He did not let them down.

The numerous purposes and places of paintings are also recorded here: from small paintings for monks' cells to massive murals covering the walls of refectories and palaces. He painted to pay his brother's grammar teacher (a portrait), for export, for his own piety and local pride, as well as his wife's.[82] Here too is evidence of a shared culture of images. There is an assumed repertory in his listing and labeling of required subjects, situations, and sites.

As an ordered account of what was done, for whom, and in what technique, this habit

79 As Frey II, pp. 868–9, no. 196 (14 October 1549): "Ricordo, come . . . Pandolfo di Piero Martellj, cittadino Fiorentjno, mj alloga in Fiorenza una tavola da farsi in tela . . . come apare in una scritta, fatta di mano di messer Cosimo Bartolj per tuttadua le parti, soscritta di mano di Pandolfo et mja"; and p. 869, no. 198: "Ricordo, come a di 6 di Settenbre 1550 Filippo di Auerardo Salujatj . . . mj alloga a fare una tauola . . . Laquale tauola promessi finire per tutto di 10 d[']Ottobre prossimo senza farne altra scrittura."

80 Frey II, p. 867, no. 182 (15 July 1548): "Et per detta opera mj contentaj, ancora che fussi gran lauoro et dificile, per esserui diuersita di figure, farlo per prezzo di scudi cento uenti doro inn oro da pagarmelj, secondo uedrano il lauoro"; or Frey II, p. 869, no. 196 (1549) for the Martelli altarpiece in San Lorenzo, to be done as he decided ("secondo il ljbero voler mjo").

81 Frey II, p. 867, no. 178 (12 March 1548), a canvas with the portraits of six Tuscan poets: "a monsignor Joujo . . . fecj in una tela"; and Frey II, p. 864, no. 162 (10 February 1546): "Ricordo, come . . . monsignor Joujo, vescouo di Nocera, ebbe in Roma vna testa . . . duno inperatore . . . in tela."

82 Frey II, p. 856, no. 100 (11 April 1540): "messer Niccolo Serguidi, canonico Volterano, ebbe da me inn una tela il suo ritratto dalle ginochja in su; el quale dedi in premio di parte di fatiche, che egli faceua intorno a Pietro, mjo fratello, che glinsegniava gramatica," its value was six *scudi*; for export, see Frey II, p. 874, no. 258 (1559), five paintings for Luca Mannelli, one mythological, four Old Testament scenes, "per mandare inn Francja," 25 *scudi* each; p. 880, no. 337 (1568), donation of a banner to the confraternity of St. Roch of Arezzo, "perche ero de fratellj anticamente," and p. 878, no. 299 (1564), altar for the nuns of Santa Maria Novella, Arezzo, "per satisfatione dj monna Cosina, mia consorte."

of documentation and accountability is a key to Vasari's recording of an artist's behavior and to his own historical identity. The course of his career is registered step by step in a progress from modest subsistence in and around Arezzo to affluence and prestige working in the major centers for important patrons. Vasari's diary of works is a commercial document: it is about the business of art. It shows commitment to work, and that well rewarded: his "assiduous labor" earning the "position and status" he had hoped for in his youth.[83] In *The Lives* Vasari emphasizes productivity over creative procedures, although these have a place, particularly in the second edition. This was because finished works were the testimony to an artist's powers of invention and execution. They were the subject of his study as he toured and took notes; but the reflexive equation of commission and execution is more intentional than accidental. It is the normative structure for evaluating an artist. Deviations caused by unfortunate events or defective characters required justification and usually became warnings or counter-examples. Parmigianino was reduced to the state of a savage by alchemy, Piero di Cosimo was abandoned by his students because of his reclusive habits, and Sodoma was abandoned by society for his bestial ways. Such behavioral explanations for lack of work or commissions not completed are characteristic in *The Lives*. Whereas Benvenuto Cellini wrote disparagingly of Duke Cosimo de' Medici for acting more like a merchant than a duke and preferred princely largesse to fixed terms and written agreements, Vasari drew his salary with no objection and performed his duties with full sympathy for the Medicean blend of mercantile order and courtly pretension.

In addition to Vasari's business record, well over one thousand letters survive. According to the list made by his nephew, his correspondents included six popes, thirty-six cardinals and an assortment of dukes, princes, high-ranking clerics, literary celebrities, artists, merchants, bankers, and other gentlemen of note. This is more than a record of an efficient postal service. It reflects a respect for writing as a means of negotiation and contact, worthy of being saved. It also shows how writing was used to build and maintain a network of connections and a variety of relationships. Vasari wrote and was addressed as dear friend, humble servant, supplicant, and recipient of requests. Over time he advanced in address from "virtuous youth Giorgio Vasari, painter in Arezzo" to "the very magnificent and most excellent messer Giorgio Vasari, painter."[84] The painter is granted titles of respect and grows to become a gentleman among gentlemen. From the first these letters demonstrate a fluency of expression, a willingness to put pen to paper to write about his work, to express and to realize his ambitions. His early letters document his ties of friendship and his gratitude to the Medici, particularly Ottaviano, a distant cousin of the governing branch, who was entrusted with the care of the heirs, the cousins Alessandro and Ippolito. Ottaviano provided the

83 Description of Vasari's works, BB VI, p. 371: "Onde diceva fra me stesso alcuna volta: 'Perché non è in mio potere con assidua fatica e studio procacciarmi delle grandezze e gradi che s'hanno acquistato tanti altri? Furono pure anch'essi di carne e d'ossa come son io' . . . mi disposi a non volere perdonare a niuna fatica, disagio, vigilia e stento per conseguire questo fine."

84 These instances are from Count Cristoforo di Montaguto, Frey I, xxviii, p. 84 (9 March 1537), addressed "Al uertudioso giouane Giorgio Vasaj, pitore in Arezo," and from Bishop Guiglielmo Sangalletti, Frey II,

dcxxxi, p. 392 (31 July 1568), "Al molto mag.co et Ecc.o m̄. Giorgio Vasari pittore."

85 Frey I, xxxvi, p. 94 (Spring 1538), Ottaviano is addressed as "Magnanimo Patrone"; Frey I, xlvii, pp. 111, 116 (February 1542), he is greeted as "Magnifico Patrone," and in closing Vasari writes to "Vostra Signoria": "Et me li offero pronto per seruirla." Vasari's gratitude is reflected in the numerous mentions of Ottaviano in *The Lives*, particularly the 1568 edition, where Ottaviano is always a friend to artists and often

young artist with hospitality, advice, and commissions. Vasari addressed him with respect as "your honor," calling him his patron, offering his services.[85]

Friendship was phrased as brotherhood, "beloved as a brother" (*carissimo quanto fratello*) was the formula; the comparison was that of a family tie. This form of endearment expresses a bond that was conceived of in terms of duty and obligation, loyalty granted with the expectation of protection as due a son or brother. Vasari's commitment to the extended family he created by faithful filial and fraternal behavior is thoroughly chronicled in his letters. His correspondence with his "dearest," like Paolo Giovio, Cosimo Bartoli, and Vincenzo Borghini, once established, spanned decades. The letters also show how his politeness and tact guided him in finding to whom to write and how in order to effect introductions to court, as by way of the duke's chamberlain, Sforza Almeni, to Cosimo or the humanist and court secretary Annibale Caro to Cardinal Alessandro Farnese. They were the means of conducting business with court officials such as Cosimo's various chamberlains and secretaries like Lelio Torelli, Antonio Serguidi, Jacopo Guidi, Bartolomeo Concino, Antonio de' Nobili, Giovanni Caccini. Where there was no sympathy, as with Pierfrancesco Ricci, Duke Cosimo's former tutor who became majordomo, he found or used few words, arriving at other means to attract and to hold Cosimo's attention. His ability to write clearly, even of complicated matters, obviously suited the Medici duke, whose vast archive is a monument to a bureaucratic genius. But Vasari could also be florid if favor required it. He seems to have understood that the best way to address Cardinal Alessandro Farnese was in a courtly manner, for that is the tone he took.[86] He could also take a literary tone, as with Pietro Aretino in a series of letters from the 1530s. These fellow countrymen showed their refined sensibilities in elaborately formulated descriptions of festival decorations and paintings in a cordial if contrived exchange of words and images between members of the professions of pen and brush, certainly intended for wider circulation even as they were being written. He kept in contact with fellow artists, for business and for pleasure. He received commissions by letter.[87] And he could gossip, as with the chatty Florentine cleric, Bernadetto Minerbetti, who succeeded his uncle as bishop of Arezzo in 1537, and the Olivetan monk, don Miniato Pitti, both of whom were early supporters who helped him to find commissions within their ever-widening spheres of influence.

This copious yet still fragmentary correspondence is ample evidence of the benefits of Vasari's good schooling. In Ambrogio Lorenzetti's Life he made the point that Ambrogio was esteemed in his native town not only for his merits as a painter, but because of his pursuit of humanistic studies ("lettere umane") in his youth:

Which were such an ornament to his life along with painting, that, constantly frequenting literary men and scholars, he was accepted and always welcomed by them as talented and

the agent of important commissions. For this figure, see Bracciante, *Ottaviano de' Medici e gli artisti*.

86 Frey I, l, pp. 121–2 (Vasari in Rome, 20 January 1543, to Cardinal Alessandro, Castro). The opening paragraph is so stylized as to suggest that it might have been drafted or outlined by someone like Annibale Caro, which is one way that Vasari probably learned such conventions.

87 Frey II, p. 860, no. 133 (4 April 1543): "Brancatio da Enpolj mj diede conmessione per lettere di Venetia"; similarly Frey II, p. 865, no. 169 (3 April 1547): "messer Tonmaso Cambj dj Napolj mi scrisse, che io douessi fare una tavola alle monache del Bigallo per satisfatione di suor Gostanza, sua sorella."

was employed by the Republic in public offices many times and with a respectable rank and with great respect. His manners were most praiseworthy and, like a great philosopher, he was always disposed to be content with anything the world gave him, good and bad, and throughout his life he bore things with infinite patience.[88]

This is a typical transfer of ideas from Vasari's life to one of those he was writing about, and it takes a typical form. Its terms, comparing the prudent artist to a philosopher and describing him as a good man and good friend were based on ideals of behavior formulated in antiquity and revived and reformulated by the *lettere umane* Vasari says Ambrogio studied so profitably. By Vasari's time the observation and description of behavior largely occurred in a framework constructed from commonplaces culled from authors such as Cicero, Seneca, Plutarch, and Aristotle. Castiglione sent for his copy of Cicero's *De oratore* when he began to write *The Courtier*. To be modern, as Vasari represented himself and his times, meant to demonstrate an assimilation of such models. The texts were not confined to a limited Latinate public. They were available through translations and transformations, as digests of wise sayings and exemplary deeds, instructive dialogues, and improving letters.[89] The texts were also context, as they informed the assumptions that dominated the forms of courteous and civilized exchange. Artificial, they have the force of all prevailing conventions simultaneously to disguise and to create everyday realities. Vasari's acceptance of them is manifest in his letters and in *The Lives*. The mastery of acceptable manners and modes of behavior was his introduction to the company of the cultured (*persone letterate*) and the ruling elite upon whom he depended. They gave him a recognized, shared, mode of address while offering a systematic structure of goals, desires, and rules with which to establish an identity: one that had the authority and moral weight of its source. Vasari's artist and Castiglione's courtier were closely related in this respect. It was by exploiting his command of those governing norms that Vasari achieved such remarkable mobility in his society. The desire to obey a norm was in itself part of the construct of a moderate, disciplined, and virtuous individual. The letters and *The Lives* demonstrate the degree to which Vasari's self was self-conscious.

★　　★　　★

88 Life of Ambrogio Lorenzetti, BB II, pp. 181–2 (1550): "Fu grandemente stimato Ambruogio nella sua patria non tanto per esser persona nella pittura valente, quanto per avere dato opera agli studi delle lettere umane nella sua giovanezza. Le quali gli furono tanto ornamento nella vita, in compagnia della pittura, che praticando sempre con lit[t]erati e studiosi, fu da quegli con titolo d'ingegnoso ricevuto e del continuo ben visto, e fu messo in opera dalla Republica ne' governi publici molte volte e con buon grado e con buona venerazione. Furono i costumi suoi molto lodevoli e, come di gran filosofo, aveva sempre l'animo disposto a contentarsi d'ogni cosa che il mondo gli dava, e'l bene e'l male finché visse sopportò con grandissima pazienzia." This passage was expanded in the second edition as though confirmed by Vasari's experience. The association of artists with learned men is a recurrent theme in Part 1, remarked upon, for example, in the cases of Simone Martini (BB II, p. 191) and Giovanni dal Ponte (BB II, p. 241), suggesting that this type of friendship and the kinship between letters and visual arts were part of the explanation for the advance of the arts away from the dark ages in that period.

89 Such as Cicero's moral treatises in *Opere di Marco Tullio Cicerone*, trans. Vendramino (1528) and trans. Brucioli (1539 and 1544), Liburnio, *Le molte et diuerse virtu delli saui antiche* (1537) and *Elegantissime sentenze et aurei detti di diuersi antiqui saui* (1543), or *Il Segreto de Segreti, le Moralita, & la Phisionomia d'Aristotile*, trans. Manente (1538). On the most popular level there was the moralizing compendium, the *Fior di Virtù*. For letters there were modelbooks such as Miniatore's *Formulario ottimo & elegante* (1531) and books of models like Doni's anthology, *Prose antiche di Dante, Petrarcha, et Boccaccio, et di molti altri nobili et virtuosi ingegni* (1547).

Is the Vasari thus propagated by Vasari the "true" man, the "real" Giorgio? If one were to ask Cellini, the answer would be absolutely not. His "Giorgetto Vassellario" was a disgusting, lying, creature with dry scab who scratched himself with filthy uncut fingernails. Cellini describes him chattering away at Duke Cosimo, unsuccessfully trying to convince him of the qualities of a model by Ammannati for the fountain of Neptune, a commission Cellini was hoping, also unsuccessfully, to obtain.[90] For Cellini, Vasari was elected by God to make every sort of error.[91] Baccio Bandinelli, another court rival, wrote of Vasari as a pretentious incompetent and sneak, not fit to lick Bandinelli's shoes or call himself Bandinelli's student. He says that Vasari detested, feared, and slandered him.[92] The complexities of Vasari's account of Salviati suggest that there were tensions between his idealized projections of himself and the actual events he describes. Yet on the whole, the correspondence between the documentary record and Vasari's manipulation of his image through literary forms is remarkably close, unlike Cellini's, whose police file and Life diverge significantly.[93] One seeming contradiction, given Vasari's general disapproval of amorous indulgence, was his generous testamentary provision for the upbringing of Antonio Francesco, son of "Isabella *mora*, formerly a servant in my house," at the Foundlings Hospital with a deposit of 500 *scudi*.[94] Although the will specifically mentions both legitimate and natural children as though they were legal eventualities and not living charges, the sum suggests that Vasari was the child's father.[95] Whether he is to be viewed as extremely beneficent master or reluctant and embarrassed father, his behavior in the case was totally respectable. By depositing both the child and an endowment with one of Florence's leading charitable institutions – its orphanage, whose prior was his friend Vincenzo Borghini – he acquitted himself as a dutiful member of society, if not as a fond parent. It is true, however,

90 *The Autobiography of Benvenuto Cellini*, trans. Symonds, Book i, chapters 86, 87, pp. 158–60, Book ii, chapter 101, pp. 389–90. Vasari was in fact instrumental in obtaining the commission for Ammannati, thwarting both Cellini and Baccio Bandinelli, to whom it had originally been given.

91 *Rime*, 127: "par che sol questi Iddio abbia eletto/ per far nel mondo d'ogni sorte errore." Vasari, "L'impio botol suo crudel Giorgetto," is being paired with Borghini (*Opere,* ed. Ferrero, p. 968).

92 Colasanti, "Il memoriale di Baccio Bandinelli," *Repertorium für Kunstwissenschaft* (1905), pp. 428–9: "non essendo abile nel disegno a sciormi le scarpe nè essere mio discepolo, voleva fare del saccente e del saputo, onde più volte gli mostrai la sua buassagine . . . mi odiava a morte, mi biasimava e detraeva, ma alla sfuggiasca, perchè aveva paura di me."

93 P. Rossi, "The writer and the man," in *Crime and Disorder in Renaissance Italy*, ed. Dean and Lowe, pp. 157–83.

94 In his will dated 25 May 1568: "Et in caso che morissi innanzi che da me fussi posto in sullo ospedale degli Innocenti di Fiorenza scudi cinque cento, di lire 7 per iscudo, sia obligato la mia eredità a mettervegli subito, i quali voglio che i frutti di detti 500 servino per elementare Anton Francesco, nato di Isabella mora serva già di casa mia . . . e infino che arà 18 anni, stia a

obedientia del priore" (Gaye, *Carteggio inedito d'artisti,* II, p. 507). A transcription of this clause is in the archive of the Innocenti, Filza d'archivio, series LXII, vol. VII, fol. 49r. The Innocenti document, dated 21 February 1586 [1587 s. c.] refers to a 1562 will made at the Innocenti: "il primo suo testamento." This will, dated 20 December 1562, is registered in the ASF, Notarile antecosimiano 6499, acts of Raffaello di Santi Eschini (1560–5), fols. 124r–125r. The Innocenti document further transcribes the section of the 15 November 1570 codicil published on 28 June 1574 that details the provisions for housing and income for Antonio after the age of eighteen, when he would leave the Innocenti. This is ASF, Notarile moderno, acts of Raffaello di Santi Eschini, *protocollo* no. 635 (1572–5), fols. 144v–145r. Another copy of the June 1574 act is at Beinecke Library, Spinelli archive, Box 47, folder 1035. The clause relating to Antonio Francesco is item 6, between dispositions made for Vasari's sister Rosa and his niece Maddalena (fols. 12r,v).

95 Gaye, *Carteggio inedito d'artisti,* II, pp. 504–5. I would like to thank Philip Gavitt for discussing these documents and their implications with me. See further Gavitt, *Charity and Children in Renaissance Florence. The Ospedale degli Innocenti 1410–1536,* and *Cities of Women. Gender, Inheritance, and Abandonment in Sixteenth-Century Italy* (forthcoming).

that unlike Cellini he did not boast of his bastard. Perhaps more importantly, whereas Duke Cosimo could simply note on the back of a letter that the board of works of Santa Maria Novella should just "use Giorgio Vasari," he apparently had to be dunned for Cellini's unpaid rent as well as endure delays and complications in his commissions, in part withdrawing his support.[96] Vasari's devotion to his work not only took aggrandizing literary forms. In February 1561 Vincenzo Borghini wrote to Duke Cosimo to express preoccupation about his friend's health. Vasari had fallen seriously ill following a relentless work pace while trying to finish the vault of the room of Clement VII in the Palazzo Vecchio. Borghini was worried that he would be too anxious to continue and not take proper rest despite the advice of doctors and Borghini's concern. He asked the duke to intervene and restrain his over-zealous servant, which Cosimo did.[97] The duke also wrote from Livorno to Vasari telling him that he should not come to report on the palace works until he was totally recovered.[98] Limping and still feverish Vasari presented a memorandum to the duke later in March, recorded in a letter from Livorno to Borghini in Florence, where he says that the approval of the projects cured him completely and he was returning home happy and satisfied.[99]

In his day Vasari was far from alone in being an artist with pretensions to learning and desirous of access to court culture. Rosso Fiorentino, who impressed Vasari greatly in his youth, had equipped himself with a copy of *The Courtier*, a Latin primer by Niccolò Perotti, as well as Pliny the Elder's *Natural History* and Vitruvius' book *On Architecture*.[100] Vasari remembered Rosso for his "very gracious and grave manner of speaking," and his command of philosophical terms.[101] The first lines of Vitruvius's book declare that "the

96 The note to the *operai* of Santa Maria Novella reads: "Piglin Giorgio Vasari." This was written on their request for an architect to undertake the removal of the choir screen and the restructuring of the church interior (5 October 1565). See Lunardi, "La Ristrutturazione vasariana di S. Maria Novella," *Memorie Domenicane* (1988), p. 408. On 14 November 1551 Bernardo Acciaiuoli wrote from Rome to Cosimo's majordomo Pierfrancesco Ricci about Cellini's rent, guaranteed by the duke, still unpaid despite waiting for months for some action on the matter: "da poi che il detto Benvenuto vi entro dentro non si è mai hauto pigione ne recognitione alcuna" (Mediceo 1170A, fasc. II, ins. 7, fol. 18). For Cellini's natural daughter Costanza, see *The Autobiography of Benvenuto Cellini*, trans. Symonds, Book ii, chapter 37, p. 295, for the suspension of the subsidy to pay his workmen's wages for assistance with the Perseus, Book ii, chapter 66, p. 337.

97 Borghini's letter is in the archive of the Ospedale degli Innocenti, Suppliche e sovrani rescritti, series VI, vol. I, fol. 287r, 21 February 1560 [1561 s. c.]: "Io non vo' mancare di dire a V. E. I. che a M[esser] Giorgio d'Arezzo accadde più dì fa un male accidente che lo fu per affogare, ello ha lasciato di sorte debole et intronato della testa, che gli potrà far villania non si curando; et hier mattina accozzai qui lui e certi medici, perche perdendolo V. E. I. perderebbe un buon sollecito e amorevole servidore. La cagione più propinqua par che

sia stato che sforzandosi per finire la volta della sala di Clemente, lavorò parecchi e parecchi giorni stando disteso e lavorando all' in su, tal che fra questo disagio et che il tempo era molto crudo, gli fece una ostruzione alla testa, che gli cadda come una specie di gocciola, e benche hora e paia guarito, et vadia fuori, io veggo e ritraggo da' medici, che se e non si ha cura, potrebbe riuscire mala cosa. Egli è tanto volenteroso di fare e di servire V. E. I. che non si riguarda et se fa così la servirà poco tempo." Cosimo's response to Borghini is on the letter ("Fate che si curi in ogni modo"). The illness, "specie di gocciola," translates as dropsy.

98 Frey I, cccxxxvii, p. 610 (1 March 1561).

99 Frey I, cccxxxviii, pp. 610–11 (22 March 1561).

100 Documented in an inventory of goods left with the Compagnia di SS. Annunziata in Arezzo when Rosso departed suddenly in 1529, fleeing invading troops, published by degli Azzi, "Documenti su artisti aretini e non aretini," *Il Vasari* (1931), pp. 64–6. A translation is in Carroll, *Rosso Fiorentino*, pp. 28–9. *The Courtier* was published only in 1528, as noted by Hirst in his discussion of the inventory, "Rosso: a Document and a Drawing," *Burlington Magazine* (1964), p. 122. For artists' level of culture, see further the comments by Shearman, *Only Connect*, pp. 246–7.

101 Life of Rosso, BB IV, pp. 473–4: "il modo del parlar suo era molto grazioso e grave . . . et aveva ottimi termini di filosofia."

architect should be equipped with the knowledge of many branches of study and varied kinds of learning."[102] Ghiberti paraphrased this in his *Commentaries*. Paolo Giovio adapted it to Leonardo in his brief Life, which he opened with praise for Leonardo who "added great splendor to painting by maintaining that it could not be correctly pursued by anyone who had not mastered those sciences and liberal arts that are the necessary handmaidens to painting."[103] And in the commentary to his Italian translation, Cesare Cesariano advised painters to read Pliny and Philostratus and many other authors like Vitruvius, as well as going to Rome to study the monuments there.[104] Vasari's teacher, Marcillat, bought a copy of Vitruvius in 1526.[105] Since Pliny and Vitruvius were the only surviving treatises on art from antiquity it is not surprising that artists sought to own them. Daniele da Volterra had copies of both, as well as Dante.[106] But some artists of Vasari's acquaintance had far more extensive book collections, if not libraries. Bandinelli boasted that he had read, in Latin, Livy, Tacitus, Sallust, Horace, Virgil, Herodotus, and some Homer, and, in the vernacular, Dante and Petrarch.[107] Bronzino was a member of the Accademia Fiorentina and wrote Petrarchan sonnets, and Salviati, as noted earlier, was regarded for his learning.

These were not superficial accomplishments. Bringing letters to the arts was part of a process of definition through the exchange and realignment of essential terms of practice and perception. From the art of rhetoric came the model of invention, of finding topics to be elaborated in a manner consonant with the subject, a model that Vasari obeyed in his paintings. Vasari may also be said to have invented his identity; that is, he found the topic of artist and then applied suitable concepts and modes of behavior in order to develop the theme, arguing his case through his actions. That he was a convincing advocate is documented by his undoubted success in his profession and by the equally manifest success and influence of *The Lives*. The literary origins of the means for the expression and contrivance of character did not remove them from the realm of social life or activity. Eloquence was conceived of as being pragmatic and effective, an essential form of cultural exchange, not its embellishment. The relationship of rhetoric to social action and social ideals was one established in antiquity and propagated by the influential humanist teachers and their disciples, the professionally literate and their employers (pl. 20).[108] By Vasari's time this was regarded as axiomatic and repeated without qualification.

Following the classical authorities, qualities of character and behavior were wedded to a course of study. And when Vasari spoke of an artist's training, his own or others, he did so using the terms of the humanist program: the artist must have talent (*ingegno*) for his profession, and that aptitude had to be cultivated and channeled through diligence and study. He would thereby acquire the skills and the techniques, or the basic vocabulary, necessary to express that talent. An essential part of the method of instruction was the

102 *The Ten Books on Architecture*, trans. Morgan, Book i, chapter 1, p. 5.

103 Translated from Barocchi ed., *Scritti d'arte*, i, p. 7: "magnam picturae addit claritatem, negans eam ab iis recte posse tractari qui disciplinas nobilesque artes veluti necessarie picturae famulantes non attigissent."

104 Vitruvius, *De Architectura* (1521), ed. Bruschi, Carugo, and Fiore, Book iii, fol. 48v.

105 Mancini, *Guglielmo Marcillat Francese*, p. 70.

106 Gasparini, "La casa di Michelangelo Buonarroti,"

Il Buonarroti (1866), p. 179, from an inventory of 5 April 1566. Daniele actually owned two copies of Vitruvius.

107 Colasanti, "Il memoriale di Baccio Bandinelli," *Repertorium für Kunstwissenschaft* (1905), p. 428.

108 See Grafton and Jardine, *From Humanism to the Humanities*. See also O'Malley, *Praise and Blame in Renaissance Rome*. Within Vasari's ambience, see, for example, Kliemann, "Il pensiero di Paolo Giovio nelle pitture eseguite sulle sue invenzioni," in *Atti del convegno Paolo Giovio*, p. 207.

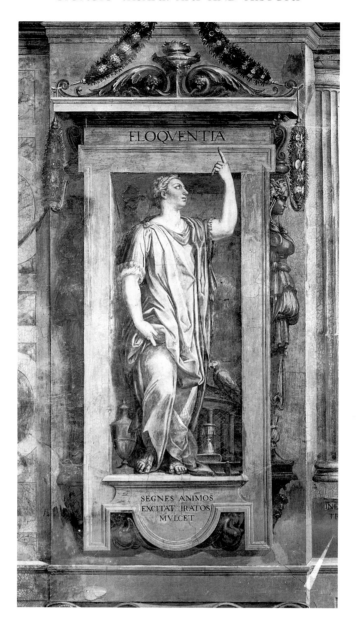

ELOQVENTIA

SEGNES ANIMOS
EXCITAT IRATOS
MVLCET

20. Giorgio Vasari, *Eloquence*.
Rome, Cancelleria, Sala dei
Cento Giorni.

selection of the best models, both modern and ancient. The model was to be taken as both
source and inspiration, to be imitated, but not slavishly followed. The artist's mastery of its
principles, its inherent excellence or perfection was a means to demonstrate his own innate
gifts or genius. The most fruitful relationship to a model was always given as competitive or
progressive. It was in this way that tradition was the basis of modernity. When Vasari
defined his age as modern, his reference point was a knowledge of the past, immediate and
classical. This was both a generally cultural and specifically artistic relationship (pls. 21, 22).

 These were notions that made form and canons of form highly significant. Once again
this was both a social and an artistic phenomenon. The recognition of qualities of character

21. Giorgio Vasari, *Cupid*. Arezzo, Casa Vasari, Sala del Trionfo della Virtù.

22. *Belvedere Torso*. Rome, Musei Vaticani.

had a parallel in the recognition of qualities of style, a heightened sensibility to demeanor and to authorship that had developed through the study and imitation of classical texts and that had passed to the vernacular. One feature of Vasari's time was the translation of such exercises and sensibilities to modern usage and to the Italian language. His mentors Paolo Giovio and Claudio Tolomei were notable protagonists in this. Realizing one's talent was also the realization of one's identity within a determined framework (that of profession or social group, for example). Vasari's organization of his *Lives* according to style and his association of artists with their individual manners depended upon this association of personality with accomplishment and a prevalent desire to find definitions of individual talent. The stimulus and reward for the exercise of one's personal, particular *virtù* was fame. Like the celebrated good citizens and great orators of the past, Vasari and the artists he esteemed worked to acquire honor, not for gain. In the opening to the Life of Agnolo Gaddi, he described how both (*onore e utile*) resulted from excellence in a noble profession, to the prosperity and glory of the Gaddi family.[109] He reflected about the problems of being forced to work simply to survive in the opening to the Life of the sculptor Rustici:

109 Life of Agnolo Gaddi, BB II, p. 243: "Di quanto onore e utile sia l'essere eccellente in un'arte nobile, manifestamente si vide nella virtù e nel governo di Taddeo Gaddi, il quale, essendosi procacciato con la industria e fatiche sue oltre al nome bonissime faccultà, lasciò in modo accomodate le cose della famiglia sua . . . che agevolmente potettono Agnolo e Giovanni suoi figliuoli dar poi principio a grandissime ricchezze et all'esaltazione di casa Gaddi, oggi in Fiorenza nobilissima e in tutta la cristianità molto reputata."

And to tell the truth, those artists rarely succeed in being excellent whose final and principal aim is gain and profit and not glory and honor, even if they have admirable talent; because to work to survive as do many weighed down by poverty and by family cares, working not as their fantasy takes them and when their minds and will are turned to it, but driven by need from sunrise to sundown, is a thing, not for men who have as their goal glory and honor, but for day laborers, as one says, and for manual workers: since good works are not made without first having considered them at length.[110]

For Vasari true profit consisted in the recognition of merit, not base earning, and the motivation was desire for glory, not material necessity. He had to earn his way, but he wanted that way to be perceived as the result of virtuous endeavor not enforced necessity.

Vasari formulated his identity in terms of professional rather than social rank. Although he desired and accepted honors, unlike his contemporaries Baccio Bandinelli, Benvenuto Cellini, or Michelangelo, he did not trace or manufacture a genealogy that led to noble ancestry. He wrote instead with pride and some exaggeration of his great-grandfather Lazzaro, a saddler whom he promoted to "a famous painter of his day."[111] He viewed rank, station, advancement as honorable, but they were to result from nobility of talent not nobility of birth. Vasari was well aware of both, in their local variants and gradations. He observed social rank in writing to patrons, in recording commissions, and in writing about artists. In *The Lives* he notes those born of affluent or noble families, he gives princes and prelates their titles, and he is careful about the rank of his supporters and clients. And he believed that it was important for the well-placed to observe the duties of their station. He prized and praised the hierarchic court structures that offered the possibility for the display of talent and its reward. He had a vested interest in the social order that he served and that served him so well.

What emerges from the written record is a respect for form: forms of contract in the accounts, forms of address in the correspondence. The phenomenon of the canonical turned personal is manifest also in his paintings, as Vasari adapted motifs studied from admired ancient and modern works. This was not a distanced formalism, however. Vasari was engaged with his public, his viewers and sponsors, his readers, his friends and associates. He wanted to create an ingratiating manner and a graceful style, sources of mutual pleasure. A vocabulary of desire permeates his legacy. And this ardent love, frequently invoked, generated the remarkable energy of his activities as student, master, collaborator, servant, admirer, and friend – roles also defined and played out by the artists in *The Lives*. As roles

110 Life of Rustici, BB v, p. 475: "E per dirne il vero, quegl'artifici che hanno per ultimo e principale fine il guadagno e l'utile, e non la gloria e l'onore, rade volte, ancorché sieno di bello e buono ingegno, riescono eccellentissimi; senzaché il lavorare per vivere, come fanno infiniti aggravati di povertà e di famiglia, et il fare non a capricci e quando a ciò sono vòlti gli animi e la volontà, ma per bisogno dalla mattina alla sera, è cosa non da uomini che abbiano per fine la gloria e l'onore, ma da opere, come si dice, e da manovali: perciò che l'opere buone non vengon fatte senza essere prima state lungamente considerate."

111 Life of Lazzaro Vasari, BB iii, p. 293: "Grande è veramente il piacere di coloro che truovano qualcuno de' suoi maggiori e della propria famiglia esser stato in una qualche professione o d'arme o di lettere o di pittura . . . singolare e famoso . . . quanto sia il piacere . . . lo pruovo in me stesso, avendo trovato fra i miei passati Lazaro Vasari essere stato pittore famoso ne' tempi suoi, non solamente nella sua patria, ma in tutta Toscana ancora."

they are inventions, but the inventions were functional. Like his pictorial inventions, they express essential themes and values of his time. Vasari had a point of view that must be called conventional, and his means of expressing it was based on received forms; but he knew places as well as commonplaces. He lived in the courts, frequented the palaces, piazzas, churches, and cloisters he described. This is the reality that makes *The Lives* live. Artists could have cold feet as well as high-minded goals. He took his portraits from life, flesh and blood, a pulse that beats strongly in his biographies.

23. Giorgio Vasari, *Mary Magdalene*, detail from *The Deposition*. Arezzo, Santissima Annunziata.

II

GIORGIO VASARI OF AREZZO

"The city of Arezzo is forty miles from Florence, a distance that can be traveled in one day . . . it is well situated and has good air, and it begets men of good intellect."

G. Dati, *Istoria di Firenze* (1409)

GIORGIO VASARI, THE FIRST SON OF Antonio di Giorgio and Maddalena Tacci, was baptized in Arezzo on 30 July 1511.[1] Named after his grandfather, he came from a line of craftsmen. His great-grandfather Lazzaro was a *sellaio*, a saddler, who had moved to Arezzo from Cortona in the mid-fifteenth century. According to Vasari, the family maintained its connections with Cortona, for he claimed both the Cortonese cardinal Silvio Passerini and the painter Luca Signorelli as relations.[2] The family name of Vasari was derived from the trade of *vasaio*, potter, a craft exercised by Vasari's grandfather and his uncles. Vases were part of Arezzo's ancient heritage. They were singled out by the fourteenth-century Florentine chronicler Giovanni Villani in his description of the city: "red vases with various tracings, done in ancient times by most skillful masters . . . it does not seem possible that they are of human hands, and it is still possible to find them."[3] Vasari says that his grandfather took an active interest in such vases, discovering both original examples and the way to reproduce them. Apparently the ancestral fakes were still proudly displayed by the family. He also says that on a visit to Arezzo (which is documented in April 1483) Lorenzo de' Medici was presented with four authentic antique vases by grandfather Giorgio, marking the beginning of his

1 Archive of the Fraternita dei Laici, Arezzo, Inv. 764, *Baptizati in Pieve* (1511), fol. 95r.

2 For Passerini, see the Life of Francesco Salviati, BB v, p. 511. For Signorelli, his Life, BB III, p. 633, where Lazzaro is called his uncle, and Vasari's Life, BB VI, p. 369, as "mio parente." Neither connection (with Passerini or with Signorelli) has been established through documentation. Lazzaro Vasari was not Signorelli's uncle. Signorelli's mother was Bartolommea di Domenico di Schiffo; see Mancini, *Vita di Luca Signorelli*, pp. 4–5. For Vasari's family history, see del Vita, "L'origine e l'albero genealogico della famiglia Vasari," *Il Vasari*

(1930), pp. 51–75. Lazzaro was in Arezzo in 1453, and set up his shop there in 1454. For this and new documents relating to Lazzaro (c.1399–1468), see Dabell, "Domenico Veneziano in Arezzo and the problem of Vasari's painter ancestor," *Burlington Magazine* (1985), pp. 29–32, where Dabell also shows how Vasari both shortened his ancestor's life and constructed his career out of works by more noteworthy artists.

3 Villani, *Cronica*, I, chapter 47, p. 72: "anticamente fatti per sottilissimi maestri vasi rossi con diversi intagli . . . parevano impossibili a essere opere umana, e ancora se ne truovano."

service to the house of Medici.[4] Neither this early Medici connection nor the extent of the potter's artistic ability can be proven, but his business acumen is recorded in his hand in an account book in the family archive. He was able to acquire some property in the country-side, a favored form of investment, and in 1500 expanded his business from a shop in his house to the rental of one on the Piazza del Comune.[5] Those of Vasari's uncles and great uncles who were not potters became priests, his unmarried aunts, nuns. The family shared the house above their shop, rented from the Confraternita dei Laici. Vasari's father was a dealer in small goods, a *treccolo*, and Vasari characterized him as a "poor citizen and artisan."[6] Coming from this background of pious tradesmen, it is little wonder that Vasari was so comfortable in the company of clerics and so assiduous in the business of art. He had a distinct and quite conventional sense of loyalty to the honor of his lineage and pride in its accomplishments in various trades.[7] Although his horizons, social and geographic, were to expand considerably, he never forsook his Aretine identity. As soon as he could he bought a house there and holdings in the neighboring countryside. He belonged to its confraternities and held public offices. Once established in Florence in the 1550s he had to balance civic duties with court obligations, and through Duke Cosimo's interventions he was granted privileges of exemption and substitution. But as a self-declared "good son" of the city he frequently acted on behalf of Arezzo as an unofficial ambassador to Cosimo, and he was regarded as one of its most eminent citizens.[8]

When he was in his mid-twenties, he wrote to his friend and fellow Aretine, the influential man of letters, Pietro Aretino:

> Don't doubt that, provided heaven grants me the energy, I will struggle to such a degree . . . just as Arezzo (where up to now there have only been mediocre painters), has flourished in arms and letters, could, through me, make its breakthrough as I pursue the studies I have begun.[9]

Arezzo was a town of about five thousand inhabitants. About one-tenth the size of Florence, since 1384 it had been a somewhat restive subject of that city. Relatively poor, it lacked power, but not prestige. There was a tradition of distinguished emigrants, mostly learned and professional men – humanists, lawyers, and doctors – who left Arezzo to become famous elsewhere.[10] Pietro Aretino, one such pilgrim spirit, traced the city's reputation as the "mother of intellects" (including Vasari) back to the classical historian Livy.[11] He wrote

4 Life of Lazzaro Vasari, BB III, p. 297.

5 Pasqui, *La famiglia dei Vasari*, p. 22.

6 Frey I, xi, p. 30 (Florence, December 1534, to Antonio di Pietro Turini, Arezzo): "pouero cittadino et artigiano."

7 *Ibid.*: "l'utile et onore di casa mia," and the Life of Lazzaro Vasari.

8 Palli d'Addario, "Documenti vasariani nell'Archivio Guidi," in *Studi* 1981, pp. 363–6. In the autumn of 1566 Vasari answered to a request of the Aretine city council: "come buon figliolo di cotesta città et come amorevole della [sua] patria" (p. 364).

9 Frey I, xvi, p. 47 (Florence, 11–18[?] March 1536, to Aretino, Venice): "Non dubitate, che io mi

affaticherò tanto, prestandomi il cielo le forze . . . che Arezzo, doue non trouo, che ui fussin mai pittori se non mediocri, potrebbe, cosi come ha fiorito nell'armi et nelle lettere, rompere il ghiaccio in me, seguitando i cominciati studij."

10 For Arezzo's economy in the fourteenth and fifteenth centuries and its intellectual traditions, see Black, *Benedetto Accolti*, pp. 1–21, and "Politica e cultura nell'Arezzo Rinascimentale," in *Arezzo al tempo dei Medici*, pp. 17–31; Pardo, *Arezzo*, pp. 71–99; and Wieruszowski, "Arezzo as a Center of Learning and Letters in the Thirteenth Century," *Traditio* (1953), pp. 321–91.

11 *Lettere sull'arte di Pietro Aretino*, ed. Pertile and

to Vasari on this subject: "Do you know why I do not regret that I come from Arezzo? So as not to malign, along with the antiquity of that city, those celebrated spirits from whose reputation such a noble land was called the mother of intellects."[12] Vasari's regard for diligence, talent, and learning as well as his ability to combine them so effectively to further his career can easily be linked to his origins in a city proud of its intellectual reputation and willing to invest in that reputation by providing public education of a high standard.[13] And his mission to become the first notable native painter could be created only by the vacuum. In Arezzo the great and glamorous works were by imported talents such as Piero della Francesca, Luca Signorelli, and, during Vasari's youth, the French glass painter Guillaume de Marcillat. The value placed on these works by outsiders may well have impressed him with the honor that he could achieve through his art.

When Vasari wrote to Aretino about his ambitions he was referring to a tradition cherished in their city, giving it the personal intonation of his interests as an artist. Repeating arguments that had been made over centuries, the general council of the city declared in 1524 "how useful and necessary letters are in your city is demonstrated by the true experience of ancient times, for only men of letters have given Arezzo true nobility."[14] When Vasari went to school it is unlikely, given his origins, that he was there with a view to entering one of the learned professions; but his later writing shows that he was inculcated with the ideology of education – the notion that study and diligence were the basis for an active, useful life and the means to acquire fame.

Vasari certainly fulfilled the promise of that schooling and repeated its maxims throughout his career. Indeed, the model for his account of his early years is that of the recognition and cultivation of talent as prescribed by pedagogical treatises. This is the subtext to the statement that his father took "every sort of loving care" that he might be "set on the path of excellence and in particular of drawing," noting his son's particular aptitude.[15] A father was supposed to study his child's inclinations and see that he was given proper instruction to develop them. He says that when he was eight years old Luca Signorelli came to stay with his family while supervising the installation of the altarpiece he had painted for the Compagnia di San Girolamo in Arezzo. This work was commissioned in September 1519 but not delivered before September 1522, when Vasari was eleven. In any event, Vasari was already in school, and apparently more interested in scribbling than in the syllabus. He tells how Signorelli advised Giorgio's father to have him study drawing, "in any case, because even if he pursues his study of letters, drawing can not help but be anything but useful, honorable, and pleasurable, as it is for all gentlemen."[16] Vasari's childhood vignette com-

Camesasca, ii, dxciv, p. 362, to Francesco Coccio (September 1550), celebrating the election of Pope Julius III, whom he claims as an Aretine and who had: "Lione [Leoni] che sa sculpirlo, Giorgio che può ritrarlo, e io poco meno che bastante a discriverlo . . . Avvenga che Arezzo (madre de gli ingegni, dice Livio), quasi come a noi, èvvi patria."

12 Frey i, cxviii, p. 232 (Venice, April 1549, to Vasari, Florence): "Sapete voi, perch'io non mi dolgo d'esser' di Arezzo? Per non ingiurare insieme con l'antichità di cotal' patria quegli spiriti celebri, per il che da la fama vien' chiamata sì nobil' terra degli ingegni madre."

13 Black, "Humanism and Education in Renaissance Arezzo," I Tatti Studies (1987), pp. 171–237.

14 Ibid., p. 206, pp. 214–15.

15 Description of Vasari's works, BB vi, p. 369: "da Antonio mio padre con ogni sorte d'amorevolezza incaminato nella via delle virtù, et in particolare del disegno, al quale mi vedeva molto inclinato." For theories of education, see Chapter ix, pp. 379–81.

16 Life of Signorelli, BB iii, p. 639 (1568): "avendo inteso dal maestro che m'insegnava le prime lettere che io non attendeva ad altro in iscuola che a far figure, mi ricorda, dico, che voltosi ad Antonio mio padre gli disse:

bines a topos about artistic talent, the small boy whose only interest was drawing, with a statement of his social aspirations. The painter Signorelli echoes the courtier Castiglione, who included knowing how to draw and knowing about painting among a gentleman's attainments, citing the example of the ancients. Castiglione was repeating a prescription of humanist educational theory, which by Vasari's day was probably a commonplace.[17]

About his early study as a painter Vasari says that he drew after all that was worthwhile in the churches of Arezzo, a repertoire recalled in the Lives of Aretine artists, his predecessors, and in that of Piero della Francesca.[18] His first teacher was the glass painter from Burgundy, Guillaume de Marcillat, who in about 1508 had gone to Rome where he was employed by Pope Julius II in the Vatican and in Santa Maria del Popolo and who provided glass for most of the important chapels and churches decorated in Central Italy in the early sixteenth century. Marcillat worked on various projects for Cardinal Silvio Passerini in Cortona between 1515 and 1517, painting frescoes as well as glass. His account book shows that he had financial transactions with Signorelli while he was there.[19] Vasari gave Marcillat a place of honor in *The Lives*. His biography is just after Raphael's.

Marcillat's association with Arezzo began in 1516 and lasted until his death in 1529. On 31 October 1516 he received a commission for a window dedicated to Sts. Sylvester and Lucy for the cathedral. Although he continued to divide his time between Cortona and Rome until 1520, he steadily produced windows for the Arezzo cathedral in an ambitious and prestigious program of decoration that must have been a matter of great local pride.[20] On 31 December 1520 he undertook to paint the vaults of three bays of the central nave of the cathedral, and from that summer lived in Arezzo. He worked on the vault decoration between 1521 and 1525.[21] It was his major project during the time of Vasari's apprenticeship, from about 1522 to 1524. The art world of Arezzo was extremely limited, and Marcillat soon became its dominant figure. He was the most distinguished artist and the most informed about the latest events in Rome. This familiarity with Rome is manifest in

'Antonio, poi che Giorgino non traligna, fa' ch'egli impari a disegnare in ogni modo, perché quando anco attendesse alle lettere, non gli può essere il disegno, sì come è a tutti i galantuomini, se non d'utile, d'onore e di giovamento.' "

17 Castiglione, *Cortegiano*, ed. Cian, Book i, chapter 49, p. 122: "un'altra cosa . . . penso che dal nostro Cortegiano per alcun modo non debba esser lassata adietro; e questo è il saper disegnare, ed aver cognizion dell'arte propria del dipingere." Aristotle said that drawing was sometimes added to the four "customary branches of education," *Politics*, Book viii, chapter 3, 1337b24–5 (*The Complete Works of Aristotle*, ed. Barnes, II, p. 2122). Castiglione's discussion in part follows Aristotle, but his remarks about drawing are closer to those found in Vergerio's treatise *De ingenuis moribus et liberalibus studiis adulescentiae*, Book ii, chapter 12. Although dating from 1402 or 1403, Vergerio's book was widely diffused in the sixteenth century; see Robey, "Humanism and Education in the Early Quattrocento: the *De ingenuis moribus* of P. P. Vergerio," *Bibliothèque d'Humanisme et Renaissance* (1980), p. 27, and Grendler, *Schooling in Renaissance Italy*, p. 118.

18 Description of Vasari's works, BB VI, p. 379.

19 The account book is in the Biblioteca Comunale, Arezzo, MS 352. There are entries for Signorelli on fols. 23v (20 October 1517), 24r (30 April 1517), and 26r (18 September 1517). He later acted on Signorelli's behalf in Rome (10 June 1520), BCA MS 352, fols. 60v, 61r and in October 1522 he repaired the blue in a panel by Signorelli in Arezzo. See Mancini, *Guglielmo Marcillat Francese*, for his career and for excerpts from the Arezzo account book, which is one of two that Marcillat left to the monastery of Camaldoli. Entries begin in 1515 and continue to his death. The other is ASF Camaldoli 571 (Corporazioni Religiose Soppresse). I want to thank Tom Henry for helping me with information about Marcillat's chronology.

20 The Aretines' motivations in employing Marcillat have been studied by Henry, "Guillaume de Marcillat at the Cathedral, Arezzo," M.A. thesis (Courtauld Institute, 1989). The windows are described and illustrated in Tafi, *Guglielmo de Marcillat e le sue vetrate istoriate di Arezzo*.

21 The documents are summarized in the Life of Marcillat, *Le vite* (Club del Libro), IV, p. 125, n. 1.

his windows and in the vaults of the cathedral where, as Vasari describes, he imitated Michelangelo's Sistine ceiling in the scale of the figures (pls. 25, 26).[22] Whatever else the young Giorgio learned from Marcillat, his first lessons must have included respect for current innovations, notably the forms and compositions of Michelangelo and Raphael, as well as a sense of Rome as the artistic *caput mundi*. Marcillat's compositions are compendia of up-to-date devices and quotations, bringing the splendors of papal Rome to Arezzo. His window of the *Raising of Lazarus*, for example, juxtaposes a Lazarus taken from Sebastiano del Piombo's painting done for Cardinal Giulio de' Medici after drawings by Michelangelo with a kneeling sister whose gesture of wonder is copied from the woman at the left foreground of Raphael's *Mass at Bolsena* (pls. 26, 27, 28). In Marcillat's Life Vasari praised this window for its "incredible presentation in so small a space of so many figures, descriptive of the fear and amazement of the people and the stench of the body, the two sisters weeping and rejoicing," and the way that the "colors melt beautifully into each other," yet with "every detail most vivid in its kind."[23] Marcillat taught Vasari lessons in invention and variety in the Roman manner. He also impressed him with his mastery of colors in his glass painting. In his early paintings Vasari seems to imitate Marcillat's use of deep, bright areas of color, vivid patterns, and dense surfaces.

As to reading and writing, Vasari was particularly fortunate in at least one of his teachers. The principal grammar teacher in Arezzo from May 1515 to April 1521 was an accomplished humanist, Giovanni Lappoli, called il Pollastra or Pollastrino.[24] Pollastra was pro-Florentine and a Medici supporter, a stance that resulted in exile from Arezzo between 1502 and 1512. During his career he dedicated a number of writings to successive Medici worthies. Skilled as a Latin writer, he was also concerned with the vernacular and produced Italian translations of the sixth and twelfth books of the *Aeneid*. He wrote in praise of his city and its great men, inserting a patriotic passage into a verse life of St. Catherine of Siena composed in 1505 during his exile in that town.[25] Although Vasari was just ten when Pollastra left his post as teacher, he became both a protégé and friend of the former schoolmaster, whom he regarded as an excellent poet and a "most learned man."[26] In the summer of 1537 he addressed a letter to him from the monastery of Camaldoli where he had been recommended by Pollastra. Its theme is melancholy, and it celebrates the pleasures of contemplative quiet. He expressed his gratitude to Pollastra for an extremely important introduction – Vasari did not rest in retreat, the Camaldolites became his patrons.[27]

22 Life of Marcillat, BB IV, pp. 225–6: "et alla similitudine delle cose della cappella di Michelagnolo fece le figure per la altezza grandissime."

23 *Ibid.*, BB IV, p. 224: "dove è impossibile mettere in sì poco spazio tante figure, nelle quali si conosce lo spavento e lo stupire di quel popolo et il fetore del corpo di Lazaro, il quale fa piangere et insieme rallegrare le due sorelle della sua resurressione; et in questa opera sono squagliamenti infiniti di colore sopra colore nel vetro, e vivissima certo pare ogni minima cosa nel suo genere."

24 Black, "Humanism and Education in Renaissance Arezzo," *I Tatti Studies* (1987), pp. 229 and 219–23. For Pollastra and Vasari's early education, see also Scoti-Bertinelli, *Giorgio Vasari Scrittore*, pp. 5–8, Kallab, *Vasaristudien*, pp. 11–18, and Kliemann, in Arezzo 1981, pp. 103–4. See further Black and Clubb, *Romance and*

Aretine Humanism in Sienese Comedy. The other teacher mentioned by Vasari, Antonio da Saccone, has eluded all scholars so far and is not mentioned in the lists published by Black in his Appendix I giving the principal grammar teachers and coadjutors.

25 Black, "Humanism and Education in Renaissance Arezzo," *I Tatti Studies* (1987), p. 221. The life, *In laude et gratia della diva et seraphica Catharina senese* is Biblioteca Comunale, Arezzo, shelf mark XVIII, 359, fols. 88v ff., for Arezzo, fols. 89v–90v.

26 Life of Salviati, BB V, p. 512 ("eccellente poeta aretino"), and Life of Lappoli, BB V, p. 182 ("uomo litteratissimo").

27 Frey I, xxxiii, pp. 89–91 (Vasari in Camaldoli, 1537, to Pollastra, Arezzo).

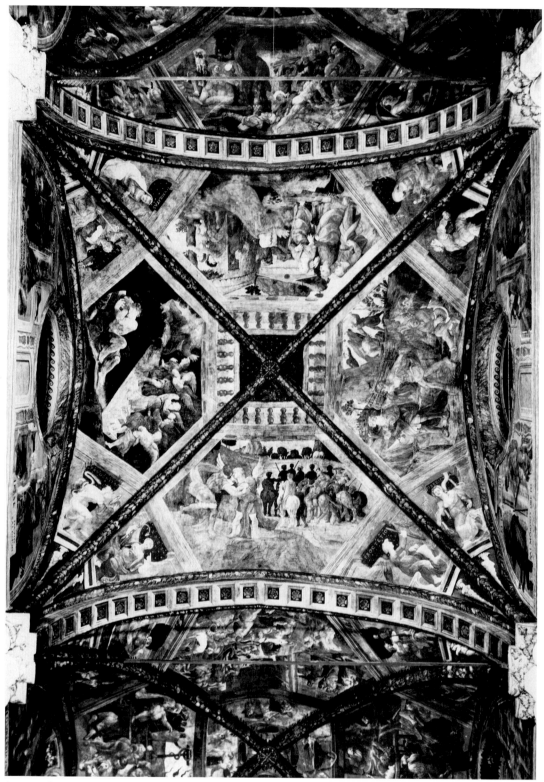

24. Guillaume de Marcillat, bay of vault. Arezzo, cathedral.

25. Guillaume de Marcillat, *The Brazen Serpent*, detail of the vault. Arezzo, cathedral.

Vasari wrote that before leaving Arezzo his elementary schooling with messer Antonio da Saccone and messer Giovanni Pollastra had reached the point where he knew a great part of Virgil's *Aeneid* by heart.[28] While vague about the dates (he claims he was "not more than nine years old"; thirteen is more likely), and eager to picture his precocity, his terms are very specific, and this remark allows a reconstruction of his early education. *Le prime lettere* mean the first stages of grammar, or Latin, education. The typical curriculum in Vasari's time was based on an elementary phase of reading and writing and a secondary stage of studying Latin, the language (*lactinare*) and literature (*auctores*).[29] Students were taught to read by learning the alphabet from the *tavola* or *carta* (usually a sheet of parchment or paper on a wood support) and then by sounding out syllables and then words in Latin primers, the *salterio* (a collection

28 Life of Salviati. BB v, pp. 511–12: "per la diligenza di messer Antonio da Saccone e di messer Giovanni Polastra eccellente poeta aretino, essere nelle prime lettere di maniera introdotto, che sapeva a mente una gran parte dell'Eneide di Vergilio."

29 For a well-documented and concise discussion of the stages of schooling and the syllabus, see Black, "The Curriculum of Italian Elementary and Grammar Schools, 1350–1500," in *The Shapes of Knowledge from the Renaissance to the Enlightenment*, ed. Kelley and Popkin, pp. 137–63. See also Grendler, *Schooling in Renaissance Italy*.

27 (facing page left).
Sebastiano del Piombo,
Lazarus, detail from *The
Raising of Lazarus*.
London, National
Gallery.

28 (facing page right).
Raphael, *Mass at Bolsena*
(detail). Rome, Vatican
Palace, Stanza d'Eliodoro.

26. Guillaume de
Marcillat, *The Raising of
Lazarus*, window.
Arezzo, cathedral.

of prayers and religious texts), and the grammar manual, the *Donato* or *Donatello*.[30] They were instructed in this by a reading teacher, whose position and own education were distinct from those of grammar teachers, like Pollastra. Basic grammar was taught through drills in the rules of the parts of speech and their inflection, and through reading and memorizing elementary texts, starting with a moralizing compilation known as Cato's *Distichs*.[31] This level was described as teaching the *principii*, principles or beginnings of Latin. When Vasari wrote that Pontormo had been taught simply "to read and write and the first principles of Latin grammar," he is recording the standard progression.[32] That he went on to memorize Virgil indicates that Vasari had proceeded to a more advanced stage in the *auctores*. In his treatise *De ordine docendi et discendi* (1459) the humanist pedagogue, Battista

30 For a definition of these books, see Black, "Curriculum," in *Shapes of Knowledge*, pp. 139–44, and Grendler, *Schooling in Renaissance Italy*, pp. 142–61, 174–88, and Lucchi, "La Santacroce, il Salterio e il Babuino," *Quaderni storici* (1978), pp. 593–30.

31 Black, "Curriculum," in *Shapes of Knowledge*, pp. 144–5, and Grendler, *Schooling in Renaissance Italy*, pp. 197–9, and Roos, *Sentenza e proverbio nell'antichità e i "Distici di Catone,"* p. 230, n. 57.

32 Life of Pontormo, BB v, p. 307: "leggere e scrivere et i primi principii della grammatica latina."

Guarini, had advised that the student should learn the poetry of Virgil by heart. The initial study of poetry was through reading and memorization of this sort.[33] This discipline is likely to have developed an aptitude for knowing things by heart that helps to explain Vasari's ability to recall the works and deeds of artists when he decided to learn about them. Students of age twelve or so also began mastering prose style and absorbing moral precepts by writing letters on prescribed themes. One of the most common being the letter of obligation, and Vasari's first surviving formal letter, addressed to Niccolò Vespucci, develops exactly that topic.[34] By the time he was thirteen, Vasari had acquired a preliminary acquaintance with the set texts, which he learned to parse and to recognize. He did not embark on a humanist course of study. His was not a preparation for university. Vasari differentiated between himself as an artist and literary men and scholars (*letterati* and *studiosi*). He was not a Latinist and had no serious or extensive practice at Latin composition, but he was trained to write Latin in a rudimentary fashion and had the preparation to read it.[35] With respect to his subsequent venture into the realms of history and writing, this schooling would allow him to appreciate and manipulate the structures of periodic prose that were held to be the basis of elegant style in the vernacular as well as in Latin. It also meant that, when necessary, he could refer to texts that were not available in Italian.

The benefits of his schooling were almost immediate. Although in later years when he came to write about himself he was contradictory about the dates, Vasari was consistent in the importance he gave to his encounter with the papal legate and his supposed relative, the bishop of Cortona, Cardinal Silvio Passerini, when the cardinal visited Arezzo. Passerini had been appointed governor of Florence and guardian of the Medici heirs by Pope Clement VII. Well-drilled by his teachers, the young Giorgio impressed the cardinal by his recitation from the *Aeneid*. As a result Passerini ordered Vasari's father to bring him to Florence where he seems to have taken an interest in furthering the boy's career, allowing him to be a form of court companion to the young Medici and finding him a place, Vasari claims, with Michelangelo.[36] Three principal strands are interwoven in Vasari's recollection of this period of his life: one, an account of his early study of art; another, his tuition in letters; and the third, equally important, his early association with the Medici. There are two other key themes: the recognition of talent and the importance of proper instruction, which necessitated his transfer from a small town to an artistic center. There is a significant component of myth-making here, but the essential truth of Vasari's historical account of himself consists in the underlying example of virtue discovered and rewarded. And if not factual in every detail, the circumstances are in the main plausible.

There were many links between Passerini and Vasari, including claimed kinship, which might have led to an introduction. The cardinal from Cortona had dealings with both Marcillat and Signorelli; either might have brought Vasari to his attention. Equally Pollastra's publicized Medicean sympathies might have helped his eager pupil to gain an introduction to Clement VII's legate. Passerini was not a hero in Florentine sixteenth-

33 Grendler, *Schooling in Renaissance Italy*, p. 241.

34 Frey I, i, pp. 1–2 (Vasari in Rome, 1532, to Vespucci, Florence). Cicero's letters, the *Epistolae ad Familiares*, were used at this stage of instruction; see Grendler, *Schooling in Renaissance Italy*, pp. 223–33.

35 I would like to thank Robert Black for discussing this matter with me.

36 Life of Salviati, BB v, pp. 511–12.

century history. Vasari's friend Cosimo Bartoli later made him an example of the ill-effects of avarice and characterized him as a person of little spirit and less judgment.[37] In his history of Florence Benedetto Varchi wrote that he was stingy and cowardly.[38] It is an indication of the factual basis of Vasari's story that he gave him such an key role in his life in spite of the view of him propagated by contemporary historians. Then again, Passerini was disliked partly because he was not a native Florentine, although citizenship was a privilege that had been granted to him by special law just before his arrival in Florence in May 1524. Clement sent him there at that time to preside over its government as his representative, giving him a position of authority much resented by the Florentines, resentment reflected in later accounts of events in Florence leading to the Medici expulsion. Blaming Passerini's ineptitude also allowed subsequent historians to explain the rebellion in terms that did not get them into trouble with their patron Duke Cosimo de' Medici. Passerini's status as an outsider might have been a factor in his sympathetic attention to Vasari, however. He may have sponsored the young Aretine in Florence in order to widen the circle of his Medici charges.

Vasari gives three dates for his arrival in Florence under the protection of Passerini: 1523, 1524, 1525.[39] The first seems improbable, as there was plague in Florence in 1523 and most reasonable citizens were escaping it by leaving for the countryside (including Vasari's eventual teacher, Andrea del Sarto). Moreover, both Ippolito and Alessandro were still in Rome, their arrival in Florence but a rumor. Passerini's responsibilities for Clement did not yet encompass the government of that city. Indeed, Cardinal Giulio de' Medici became pope only on 19 November 1523. It is possible that the "3" was a misprint for a "5." The earlier date should be disregarded. Passerini arrived in Florence on 11 May 1524 and the new regime began to take shape that summer, when the fourteen-year-old Ippolito was sent to Florence, granted the title of *Magnifico*, and, in spite of his age, made eligible for all state offices.[40] Alessandro arrived in June 1525.[41] In his description of Bronzino's works, Vasari states that he had known the artist since 1524, when Bronzino was working at the Certosa of Galluzzo with Pontormo and where he would go to draw.[42] In the Life of Andrea del Sarto Vasari describes how he saw that artist painting a copy of Raphael's portrait of Leo X and two cardinals, which was sent to the duke of Mantua, Federigo Gonzaga. Correspondence about this dates from 10 November 1524 when Clement VII agreed to send the original to Federigo. In December he ordered that a copy should be made to keep in the family palace in Florence in memory of Pope Leo.[43] Vasari tells how Ottaviano de'

37 *Discorsi historici universali, Discorso* XVII: "Quanto la Avarizia sia nociva et quali effetti naschino da lei," p. 127, for Passerini: "persona di poco animo et di manco iudizio."

38 *Storia fiorentina,* ed. Arbib, I, Book iii, p. 141; see also Book ii, p. 69, for comments on Passerini.

39 Respectively in the Life of Salviati, BB V, p. 511, in his account of his works, BB VI, p. 369, and in Michelangelo's Life, BB VI, p. 53.

40 Stephens, *The Fall of the Florentine Republic,* pp. 169–70. Ippolito entered Florence 30 August 1524.

41 *Ibid.* The dates are from Cambi's *Istorie,* III, pp. 264–5, 273, in *Delizie degli Eruditi Toscani,* ed. San Luigi, vol. XXII.

42 BB VI, p. 238: "abbiam tenuta insieme stretta amicizia anni quaranta tre, cioè dal 1524 insino a questo anno, perciò che cominciai in detto tempo a conoscerlo et amarlo, allora che lavorava alla Certosa col Puntormo, l'opere del quale andava io giovinetto a disegnare in quel luogo." Pontormo is documented working on the cloister Passion cycle between 4 February 1523 and 10 April 1524. He continued working for the monks there and payments to him continue until 1527.

43 Shearman, *Andrea del Sarto,* II, p. 266, cat. no. 75, for the correspondence. Life of del Sarto, BB IV, pp. 378–80, for Vasari's description of the episode. The original is in the Uffizi, Florence, the copy is in the Museo Nazionale di Capodimonte, Naples.

Medici, who supervised this, did not want to deprive Florence of such a great painting and secretly sent the copy instead, although on 6 August 1525 he promised to send the original to Mantua in two days. No one noticed the deception until Vasari pointed it out to Giulio Romano in 1541. This episode dating from late 1524 and so circumstantially described by Vasari makes him an associate of del Sarto and an intimate of Ottaviano by the winter of 1525.

He stayed in Niccolò Vespucci's house at the south end of the Ponte Vecchio above the church of San Sepolcro.[44] A knight of Rhodes, Vespucci held the benefice of San Sepolcro in Florence and of San Jacopo in Arezzo, which was also under the patronage of the Knights of Malta. Later dealings between Vasari and the Vespucci indicate that they had property just outside of Arezzo.[45] It is possibly the Aretine connection that suggested this as a suitable household. The Vespucci were known to Passerini as well; Niccolò's brother Piero is mentioned in his correspondence.[46] The Vespucci were a distinguished, if somewhat impoverished family, with a rich tradition of patronage, of service to the Florentine state, and of strong Medici loyalties. Niccolò was included among the papal household portrayed by Giulio Romano in the *Baptism of Constantine* painted in 1523–4 in the great reception hall of the Vatican, the Sala di Costantino.[47] According to Vasari, this branch of the family had due consideration for art and artists. Niccolò's father, Simone, while *podestà* of Monte San Savino discovered the young sculptor Andrea and brought him to Florence, placing him in the workshop of Antonio del Pollaiuolo. Vasari later owned one of two terracotta busts of Roman emperors by Andrea Sansovino that had adorned a mantlepiece in the Vespucci household.[48] In his youth Niccolò had apparently spent time at the d'Este court in Ferrara, where he became friends with the poet Lodovico Ariosto, who visited him in 1513.[49] A friend of painters as well as poets, when Lodovico Capponi wanted to decorate his chapel in Santa Felicita he conferred with Vespucci who advised him to commission the work from Jacopo Pontormo.[50]

Vasari did not forsake his studies. On the cardinal's orders he spent two hours a day at lessons with the Medici heirs, the cousins Ippolito and Alessandro.[51] A manuscript relating

44 Life of Salviati, BB v, p. 512.

45 Information about Niccolò is to be found in the Biblioteca Nazionale, Florence, Passerini 158 bis: *Notizie storiche intorno alla famiglia Vespucci*, fol. 1v, and Passerini 176, *Memorie storico-genealogiche della fam. Vespucci*. The Arezzo benefice is mentioned in the will of Simone Johanni Simonis dei Vespucci, Niccolò's father (8 March 1504 [1505 s. c.]), which names: "fratri nicholaio eius filio ordinis hyerosolomitani" and cites the "beneficii sancti jacobi di Arezzo." A copy of the will is in the Archivio Vasariano, MS 4 (38), fol. 3r. The church of San Jacopo was destroyed in 1967. Its connection with the Maltese order is recorded in Arezzo Biblioteca Comunale MS 512, *Memorie delle chiese e monasteri e confraternite della Diocesi d'Arezzo fatte copiare da un manoscritto del fu marchese Antonio Albergotti*, no. 14, p. 201. Archivio Vasariano MS 4 (38), fol. 4v, fols. 35–37v, records Vasari's purchase of the property at Frassineto from Niccolò's son, Francesco (20 December 1548). A Vespucci document in the Archivio Vasariano MS 4 (38) dates their ownership of this property to at least

1529. There are other Vespucci papers from the Vasari archive now in the Spinelli archive at the Beinecke Library, Yale University, Box 47, folder 1019.

46 ASF, Acquisti e Doni 139, Ins. 1, no. 26, a letter dated 4 October 1521 to his brother in Cortona, from Arezzo.

47 Life of Giulio Romano, BB v, pp. 60–1: "e fra molti familiari del Papa, che vi ritrasse similmente di naturale, vi ritrasse . . . messer Niccolò Vespucci, cavaliere di Rodi."

48 Life of Andrea Sansovino, BB iv, p. 272, where he mentions also that they owned a cartoon by Andrea of the *Flagellation of Christ*.

49 *La Spositione di M. Simon Fornari da Rheggio sopra L'Orlando Furioso di M. Ludovico Ariosto* (1549), i, pp. 26–8.

50 Life of Pontormo, BB v, pp. 322–3.

51 Life of Salviati, BB v, p. 512: "non lasciando gli studii delle lettere, d'ordine del cardinale si tratteneva ogni giorno due ore con Ipolito et Alessandro de' Medici sotto il Pierio, lor maestro e valentuomo."

to one part of Ippolito's instruction indicates that they had begun the more advanced stages of the curriculum.[52] The dynastic family hopes were focussed on those orphaned bastards, who were Vasari's contemporaries. They were being prepared to follow in the Medici tradition of intellectual distinction, and to act as princes. Their tutor was Pierio Valeriano, an antiquarian and humanist who had made his career in Rome, winning the support of Leo X, who had been a pupil of his uncle, and serving Clement VII as a secretary during his cardinalate.[53] While acting as tutor to Alessandro and Ippolito, Valeriano also studied the Medici collections, pursuing an interest in hieroglyphics. His book on the subject, *Hieroglyphica, sive de Sacris Aegyptiorum literis commentarii*, was published in 1556, dedicated to Cosimo I. During the autumn of 1524 he prepared an anthology of his Latin poems. In the dedicatory letter he warned his student Ippolito never to deviate from the imitation of classical models.[54]

Vasari entered Medici service at a point when the family imagery was being developed and propagated, as in the frescoes at the villa of Poggio a Caiano and in the family tombs and library being built at San Lorenzo following Michelangelo's designs. Training in Medici mythology was one element of his formation. Contact with this circle was also Vasari's elementary introduction to the conventions of court service. It is most likely that a substantial part of his schooling there consisted of learning the established meanings of love and loyalty in service and how they might be rewarded by princely support. Here too was to be found a preliminary introduction to the types of antiquarian enthusiasm that became the reference points for many of the images he designed and painted. Unlike Ippolito and Alessandro, he was not being prepared to rule, but he was being prepared to be with rulers. His later letters, addressed to Ippolito, Alessandro, and Ottaviano de' Medici with reverence, humility, and trust in their patronage, demonstrate his understanding and acceptance of the terms.

Whatever the details, Vasari's was not a usual workshop apprenticeship. His training as an artist was combined with a form of affiliation to the leading family of the city, one that brought him friends and favors and set the course for his career. It was through the offices of messer Marco da Lodi, a gentleman in the service of Passerini, that he met his best friend and comrade in art, Francesco Salviati, and probably through Passerini or Ottaviano de' Medici that he was introduced to his teacher Andrea del Sarto; and he says that Ippolito de' Medici placed him with Baccio Bandinelli, who was also a Medici servant. In the opening of the Life of another peripatetic artist, Gherardo Starnina, he made the point that

> Truly those who venture far from their native town to stay in another place often create a good-spirited temperament in themselves, because, seeing various honorable customs while abroad, one learns to be affable, pleasing, and patient more readily than might have been the case staying at home. And it is also true that if you wish to educate men in the ways of the world you could search for no better tempering fire nor challenge than this

52 See Scoti-Bertinelli, *Giorgio Vasari Scrittore*, pp. 8–9: *Ad magnificum et illustrem adolescentem Ippolytum Medicem Pierii Valerii introductio ad artem metricam,* then in the Biblioteca Vittorio Emmanuele, Rome.

53 The standard reference for Valeriano is Ticozzi, *Storia dei letterati*, I, pp. 85–150; more recently and for further bibliography, see Schüssler in Arezzo 1981, pp. 181–3.

54 Ticozzi, *Storia dei letterati*, I, p. 122.

because those who are rough by nature become more refined and the refined become even more gracious.[55]

This was one of his early lessons, apparently learned quite well. His ingratiating ways as a boy in the inner circle of the Medici earned their support and that of their supporters to further both his education and his career.

Florence: City of Refined Air and Sharp Intellects

The air of Florence, like that of Arezzo, had a reputation. It too was famous for fostering special talents. Though he was to praise Tuscan genius, it is clear that Vasari accepted the view of Florence specifically as a place where talent could flourish. In the Life of Gaddo Gaddi he argued that Florentine painters of the first age were "aided by the refinement of the air of Florence, which regularly produces spirits both talented and acute."[56] The opening of Michelangelo's Life is based on the premise that

> the benign ruler of heaven . . . saw that in the practice of these most singular disciplines and arts, namely painting, sculpture, and architecture, the Tuscan intellects have always been exalted and raised high above all others because they are far more devoted to the labors and studies of every skill than any other people of Italy, [and so] chose to give him to Florence as the most worthy of all cities to be his native city so that in her, deservedly, all the virtues might achieve their absolute perfection by means of one of her citizens.[57]

Numerous passages in *The Lives* describe the limitations of a small-town background and the need for any ambitious artist of such origins to leave home with the hope of returning as a celebrated son.[58] For artists, Vasari had no doubt that the first place to go was Florence.

The arts were given a conspicuous place there. They are featured on the bell-tower, whose design was attributed to Giotto. A cycle of reliefs begun in the 1330s includes the Creation, the Fall, and the redemption of man through labor – the exercise of liberal and mechanical arts. Painting, architecture, and sculpture have their places in this scheme. Pride in native genius was a civic tradition, and it was very much part of the artistic culture when Vasari arrived in the 1520s. An incident dating from 1522 and recounted at length in the

55 Life of Starnina, BB ii, p. 291: "Veramente chi camina lontano dalla sua patria nell'altrui praticando fa bene spesso nell'animo un temperamento di buono spirito, perché nel veder fuori diversi onorati costumi . . . impara a esser trattabile, amorevole e paziente con più agevolezza assai che fatto non arebbe nella patria dimorando. E invero chi disidera affinare gl'uomini nel vivere del mondo, altro fuoco né miglior cimento di questo non cerchi, perché quegli che sono rozzi di natura ringentiliscono e i gentili maggiormente graziosi divengono."

56 Life of Gaddo Gaddi, BB ii, p. 81: "aiutati dalla sottigliezza dell'aria di Firenze, la quale produce ordinariamente spiriti ingegnosi e sottili."

57 Life of Michelangelo, BB vi, pp. 3–4: "il be-

nignissimo Rettore del cielo . . . vide che nelle azzioni di tali esercizii et in queste arti singularissime, cioè nella pittura, nella scultura e nell'architettura, gli ingegni toscani sempre sono stati fra gli altri sommamente elevati e grandi, per essere eglino molto osservanti alle fatiche et agli studii di tutte le facultà sopra qualsivoglia gente di Italia, volse dargli Fiorenza, dignissima fra l'altre città, per patria, per colmare alfine la perfezzione in lei meritamente di tutte le virtù per mezzo d'un suo cittadino."

58 For example, the Lives of Andrea Pisano, Antonio Viniziano, Ambrogio and Pietro Lorenzetti, Jacopo della Quercia, and Vasari's compatriot and contemporary Giovanni Lappoli.

Life of Perino del Vaga recalls a lively debate over issues of style based on a developed sense of Florentine artistic heritage and its sites of pilgrimage, notably the Brancacci chapel in Santa Maria del Carmine painted by Masaccio a hundred years earlier. Although first trained in Florence, Perino's real artistic formation took place in Raphael's workshop in Rome. His return from that city prompted the interest of a large group of artisans, painters, sculptors, architects, goldsmiths, and stone- and woodcarvers who wanted to hear what he had to say and to "see what the difference might be between the artists of Rome and those of Florence in practice."[59] They held a perambulatory discussion looking at old and new works in churches, finally arriving at the chapel by Masaccio which elicited numerous and various comments in praise of that artist. Perino's response to this enthusiasm was to challenge the assembly, saying that he totally refused to accept that Masaccio's style could not be equaled. On the contrary he said, "not out of scorn, but as the truth," that he knew many who were "both more resolved and more graceful and whose works in painting were no less lifelike and were moreover much more beautiful."[60]

This bold attitude resulted in a commission to prove himself by painting an apostle in a free space there, a St. Andrew to face a St. Peter by Masaccio. There was apparently great curiosity, if some doubt, about "this Roman style."[61] Perino never completed his saint. He was given the opportunity to make his point on an even grander scale through a commission to paint a narrative scene, the *Martyrdom of the Ten Thousand*, for a confraternity of artisans, the Compagnia de' Martiri in Camaldoli. The spot was remote, but the space large, the subject ambitious, and, if successful, the rumor of his talent would be replaced by the reality of his work and the esteem of the Florentines would be his reward.[62] This project reached the stage of a cartoon that was judged to be "in beauty and excellence of design second only to that done by Michelangelo for the Council Hall" of the Palazzo Vecchio, the *Battle of Cascina* (pl. 29).[63] Vasari describes the cartoon, evoking Perino's success in conveying the violence of the subject, the passion and anguish in the attitudes of the figures, pointing out in detail the variety of expression and positions as well as the *all'antica* armor of the soldiers. For him Perino's ornamental abundance, concern for artifice, and mastery of the antique represented the culmination of art. The cartoon remained in Florence, a showpiece in the house of the goldsmith Piloto. It is lost, but a drawing now in Vienna, possibly the one mentioned by Vasari made as a modello for the cartoon, "a small drawing, regarded as divine," shows how Perino opposed twisting and elegantly disposed figures to Masaccio's statuesque dignitaries (pls. 30, 31).[64] The composition with its dense and decorative

59 Life of Perino del Vaga, BB v, p. 125: "per veder che differenza fusse fra gli artefici di Roma e quegli di Fiorenza nella pratica." For the date of this episode see Davidson, "Early Drawings by Perino del Vaga," *Master Drawings* (1963), no. 4, p. 19.

60 Life of Perino del Vaga, BB v, p. 126: "che questa maniera non ci sia chi la paragoni, negherò io sempre; anzi dirò . . . non per dispregio, ma per il vero, che molti conosco e più risoluti e più graziati, le cose de' quali non sono manco vive in pittura di queste, anzi molto più belle."

61 *Ibid.*, p. 127: "questa maniera di Roma."

62 *Ibid.*, pp. 128–9: "ancora che il luogo fusse discosto et il prezzo piccolo, fu di tanto potere l'inven-

zione della storia e la facciata che era assai grande, che egli si dispose a farla . . . attesoché questa opera lo metterebbe in quella considerazione che meritava la sua virtù . . . in Fiorenza, dove non era conosciuto se non per fama." Vasari was later to use exactly this strategy working for the monks at Camaldoli, see below p. 105.

63 Life of Perino del Vaga, BB v, p. 130: "pari bellezza e bontà in disegno dopo quello di Michelagnolo Buonarroti fatto in Fiorenza per la sala del Consiglio."

64 *Ibid.*: "fattone un disegno piccolo, che fu tenuta cosa divina." There is a modello drawing by Perino of the *Martyrdom* in the Albertina, Vienna, Inv. Nr. 2933 (pen and ink, white heightening, 363 × 340 mm) that may correspond to the drawing known by Vasari. For

29. (?) Aristotile da Sangallo after Michelangelo, *Battle of Cascina*. Holkham Hall, Earl of Leicester.

patterning of the surface owes much to Raphael's *Battle of Ostia* in the Stanza dell'Incendio (pl. 32) and to Raphael's sources in classical relief carving. That Vasari was impressed is indicated by the fact that one of the copies of the drawing can be attributed to him.[65] Indeed, such a copy drawing might have been the basis of his detailed description (pl. 33).

Vasari's record of Perino's eventful visit reveals his own stylistic bias. He does not tell the story to show Perino's inadequacy in failing to complete his commissions, but as proof of his success in presenting the designs. He wanted to narrate a triumph. He also summoned up an atmosphere of discussion, challenge, and artistic self-awareness. The gathering that provoked this episode was apparently not a special occasion; the artists had come together "according to long-standing custom."[66] Vasari also writes of regular meetings in the shop of the woodworker and architect Baccio d'Agnolo during the winter. He says that artists from Florence and elsewhere, including Raphael, Andrea Sansovino, Antonio and Giuliano da Sangallo, Francesco Granacci, and very occasionally Michelangelo, would ponder difficult and important questions. There the "most excellent minds" were able constantly to resolve these "most beautiful perplexities."[67] Leonardo da Vinci may have been the most philosophical and scientific of Florentine artists, but he was not the only one to speculate about art. The topics raised in his notebooks about painting find a more general resonance.

the provenance and location of the cartoon, see BB V, p. 132, and for Vasari's description, see BB V, pp. 129–30.

65 Davidson, "Early Drawings by Perino del Vaga," *Master Drawings* (1963), p. 25, n. 6, suggests that the copy in the Fogg Art Museum, Cambridge, Mass., may be by Vasari.

66 Life of Perino del Vaga, BB V, p. 125: "secondo il costume antico si erano ragunati insieme."

67 Life of Baccio d'Agnolo, BB IV, p. 610 (1550): "dove difficultà grandissime si proponevano e bellissimi dubbî si vedevano del continuo risolvere dagli eccellentissimi intelletti loro, ch'erano e sottili e ingegnosissimi."

Arguments about the relative merits of painting and sculpture, painting and poetry, as well as experiments with perspective, address themes present in contemporary practice and found elsewhere in Florentine discussions about art.

Perino's encounter with his Florentine colleagues also belongs to what could be called a cartoon culture, that is, one where artistic display was no longer a subsidiary function: the design for a project could take priority over the project itself. The comparison with Michelangelo's *Battle of Cascina* cartoon is revealing. Never completed as a fresco, this fragment of a design became the school of a generation, exactly those artists dominating the scene at Vasari's arrival in Florence. In his youth Vasari's teacher Andrea del Sarto spent every spare moment and all the holidays with other young artists doing drawings in the Sala del Papa at Santa Maria Novella where the Council Hall cartoons by Michelangelo and Leonardo were displayed at that time.[68] The impact of Michelangelo's cartoon and its importance are described in Michelangelo's Life. It caused

> artists [to be] seized with astonishment and admiration, seeing the extreme artistry demonstrated to them by Michelangelo in that cartoon . . . As we have seen, it happened that for many years all those who studied and drew the cartoon in Florence, whether foreigners or natives, became eminent in that art; Aristotile da Sangallo, his friend Ridolfo Ghirlandaio, Raphael Sanzio of Urbino, Francesco Granacci, Baccio Bandinelli, and the Spaniard Alonso Berreguete studied there, as later did Andrea del Sarto, Franciabigio, Jacopo Sansovino, Rosso, Maturino, Lorenzetto, Tribolo, at that time a boy, Jacopo Pontormo, and Perino del Vaga, and all of them were excellent Florentine masters.[69]

This diligent and admiring company of young artists, as Andrea del Sarto and Franciabigio, Aristotile da Sangallo and Ridolfo Ghirlandaio, who met and mixed and formed alliances, were the "new artists," as Vasari called them, in Perugino's Life. They would criticize a work if it were ordinary or formulaic, however popular the formulas had been. Perugino, for example, was relentlessly assailed by sonnets and public insults, which, according to Vasari, drove the aged and bewildered artist from Florence.[70] The younger generation abandoned their first masters – Perugino, Lorenzo di Credi, and Piero di Cosimo – to learn directly from this new mastery of art.

These surrogate students of Michelangelo were Vasari's teachers and first friends when he arrived in Florence in the mid-1520s. At this time Michelangelo was designing the Medici family burial chapel in the New Sacristy and the Laurentian library for the Medici at San Lorenzo – further "schools" for the painters, architects, and sculptors of Florence; indeed, in 1563 Vasari was to try to make the New Sacristy the meeting place and first project of

68 Life of Andrea del Sarto, BB IV, p. 344.

69 Life of Michelangelo, BB VI, pp. 24–5: "Per il che gli artefici stupiti et ammirati restorono, vedendo l'estremità dell'arte in tal carta per Michelagnolo mostrata loro . . . tutti coloro che su quel cartone studiarono e tal cosa disegnarono, come poi si seguitò molti anni in Fiorenza per forestieri e per terrazzani, diventarono persone in tale arte ecc[ellenti], come vedemo; poi che in tale cartone studiò Aristotile da S. Gallo, amico suo, Ridolfo Ghirlandaio, Raffael Sanzio da Urbino, Francesco Granaccio, Baccio Bandinelli et Alonso Berugetta spagnuolo; seguitò Andrea del Sarto, il Francia Bigio, Iacopo Sansovino, il Rosso, Maturino, Lorenzetto, e'l Tribolo, allora fanciullo, Iacopo da Puntormo e Pierin del Vaga, i quali tutti ottimi maestri fiorentini furono." Similarly, in the Life of Aristotile da Sangallo, BB V, p. 393, Vasari notes that the cartoon: "fu un tempo la scuola di chi volle attendere alla pittura."

70 Life of Perugino, BB III, p. 610.

30. Perino del Vaga, *Martrydom of the Ten Thousand*, pen and ink, with white heightening, 363 × 340 mm. Vienna, Graphische Sammlung Albertina.

31 (below). Masaccio, *The Tribute Money*. Florence, Santa Maria del Carmine, Brancacci chapel.

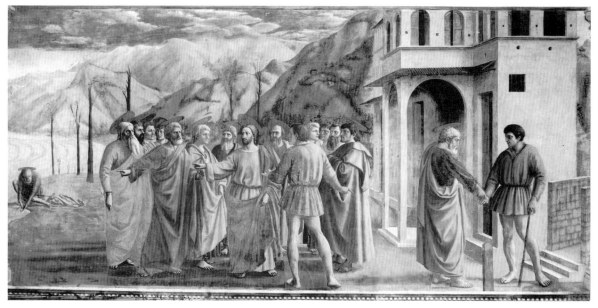

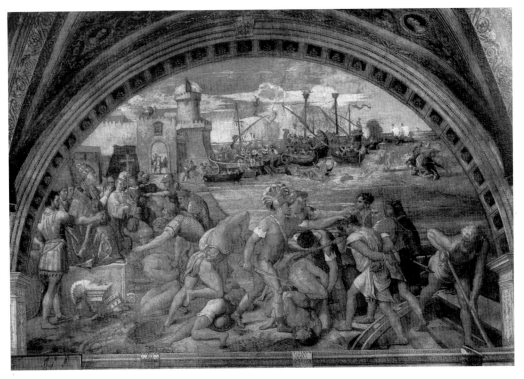

32 (above). Raphael, *Battle of Ostia*. Rome, Vatican Palace, Stanza dell'Incendio.

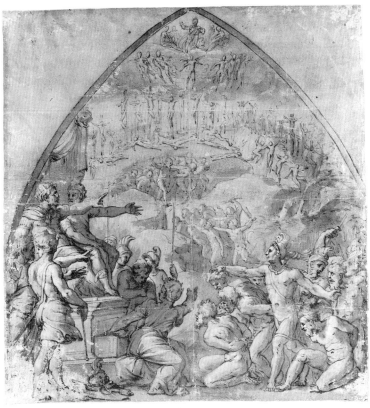

33. Giorgio Vasari after Perino del Vaga, *Martrydom of the Ten Thousand*. Cambridge, Mass., Fogg Art Museum.

the Accademia del Disegno. Andrea del Sarto was the pre-eminent painter. Del Sarto's style was grounded in the Florentine figurative and narrative tradition, but it was constantly evolving with detailed study from life and from consideration of the models proposed by Michelangelo, the antique, and the fashionable imported prints by the German artist Albrecht Dürer. Younger painters, like Rosso Fiorentino and Jacopo Pontormo, had made their mark by striving constantly to be original and inventive in their work, in their use of color and types of composition, sometimes to the perplexity of their patrons and fellow artists.[71] And a band of ambitious apprentices, goldsmiths, and painters – Vasari's contemporaries, like Francesco Salviati – used to meet on holidays to go to draw the most highly praised works around the city.[72]

In describing his training, Vasari put himself at the center of all of this activity. He states twice that Cardinal Passerini placed him with Michelangelo: in Francesco Salviati's Life and in Michelangelo's.[73] Both statements occur in the second edition of *The Lives* and so were written after Michelangelo's death, when one theme of the revised biography had become Vasari's intimacy with the great hero of the arts of design. Such an apprenticeship seems improbable except as wish fulfillment. Michelangelo did not have a regular artist's studio, although he had numerous associates and assistants on the San Lorenzo project.[74] His was more a *cantiere* than a *bottega*, a workplace not a workshop.

Vasari's apprenticeship to Michelangelo is much more likely to have been to his public or semi-public works, such as the *David* in the Piazza Signoria, the unfinished *St. Matthew* in the Opera del Duomo, the *Hercules* in the courtyard of Palazzo Strozzi, and possibly some of those in private collections. He certainly knew the Virgin and Child tondo, begun for Bartolomeo Pitti, whose fortunes he traced as it passed as a gift from his friend don Miniato Pitti to another early patron of Vasari's, Luigi Guicciardini.[75] In his Life of Michelangelo Vasari further mentions the sculpted tondo owned by the Taddei family and the painted tondo belonging to heirs of Agnolo Doni, as well as the wooden crucifix in Santo Spirito. He also must have looked at those drawings made by the artists who had copied from the *Battle of Cascina* cartoon. From these he could have learned the lessons that he later credited to Raphael's study of Michelangelo: the beauty of nudes, composition based on complicated foreshortened positions, and the need for a detailed study of anatomy.[76] He learned to appreciate the difficulties proposed by Michelangelo's figures and the figural basis of

71 See the Life of Rosso Fiorentino, where this is registered in the description of the altarpiece he painted for the Dei family in Santo Spirito (now in the Galleria Palatina, Palazzo Pitti, Florence), BB IV, p. 476: "la quale per la bravura nelle figure e per l'astrattezza delle attitudini non più usata per gli altri, fu tenuta cosa stravagante; e se bene non gli fu allora molto lodata, hanno poi a poco a poco conosciuto i popoli la bontà di quella e gli hanno dato lode mirabili." Vasari characterized Rosso as being critical of other masters, so unwilling to be apprenticed to them ("con pochi maestri volle stare all'arte, avendo egli una certa sua opinione contraria alle maniere di quegli"; BB IV, p. 474). Pontormo was a source of perplexity to Vasari for his unsettling changes of style, described in detail with respect to the frescoes at the Certosa at Galluzzo, the

Capponi chapel at Santa Felìcita and the high altar chapel at San Lorenzo (Life of Pontormo, BB V, pp. 320–2, 323, 332–3).

72 Life of Salviati, BB V, p. 511.

73 *Ibid.*, p. 512, and Life of Michelangelo, BB VI, p. 53.

74 Wallace, "Michelangelo at Work," *I Tatti Studies* (1989), pp. 235–77.

75 Life of Michelangelo, BB VI , p. 22. For this provenance and its implications in Michelangelo's network of friends and family relations, see Wallace, "Michelangelo In and Out of Florence Between 1500 and 1508," in *Leonardo, Michelangelo, and Raphael*, ed. Hager, pp. 68–70.

76 Life of Raphael, BB IV, pp. 205–6 (1568).

composition. In 1536 he wrote to Pietro Aretino describing a cartoon he was sending to him. It was for the frescoes of scenes from Caesar's *Commentaries* that he was painting in the Palazzo Medici, and he sent it as a token of his ambition. A focal point was a skirmish of battling nudes, done firstly to demonstrate his "study of art and then to follow the story."[77] Although observing this priority of virtuoso command of the human form, like Raphael he also learned that "painting did not consist solely in doing naked men, but that it had a wide field," one that Raphael explored and Vasari closely followed in his subsequent study of Raphael's works in Rome.[78]

Vasari says that Michelangelo entrusted him to Andrea del Sarto when he had to go to Rome to consult with the pope about the San Lorenzo commission, a logical explanation for something that probably occurred in a slightly different fashion.[79] Michelangelo did go to Rome, but that brief trip was in December 1523, pre-dating Vasari's arrival in Florence. On the other hand, Vasari's sponsors, Silvio Passerini and Ottaviano de' Medici, both had dealings with Andrea del Sarto. He produced designs for an embroidered vestment given by the cardinal to the cathedral of Cortona and did the fresco of the *Tribute to Caesar* in the main hall of the villa at Poggio a Caiano (pl. 113), a project supervised by Ottaviano who owned at least three paintings by del Sarto: one of St. John the Baptist and two of the Virgin and Child.[80] His sympathies seem to have been Medicean and these connections might provide an explanation for Vasari's placement with this artist, who was an influential teacher and collaborator as well as company man and congenial dinner partner, a member of the Company of the Cauldron, one of Florence's dining clubs.[81]

Del Sarto's friends and professional associates included the painter Franciabigio, the ornament specialist Andrea Feltrini, and the sculptors Jacopo Sansovino, Tribolo, and Rustici. Vasari wrote that del Sarto had an infinite number of students. The list included Jacopo Pontormo, Francesco Salviati, as well as the infamous Jacone. Vasari said that not every one had the same training with del Sarto, however, for some simply could not abide his wife's imperious ways and left after a short time rather than be tormented by her.[82] Vasari's antipathy may well have taught him to mistrust marriage, and he applied the model of marital misery to many husband artists.

There were, nonetheless, many positive lessons for him in this studio. One of them was friendship and its practical value in sustaining relations with patrons and associations with fellow artists. Another was productivity. Del Sarto was a prolific painter, doing devotional works on all scales, narrative cycles, history paintings, and portraits. Vasari admired his soft

77 Frey I, xvi, p. 47 (Vasari in Florence, March 1536, to Aretino, Venice): "Che come uedrete, ho fatta la una zuffa di igniudi, che combattono, per mostrare prima lo studio dell'arte et per osseruar poi la storia."

78 Life of Raphael, BB IV, p. 206: "la pittura non consiste solamente in fare uomini nudi, ma che ell'ha campo largo."

79 Life of Salviati, BB V, p. 512.

80 For the paintings owned by Ottaviano, see the Life of del Sarto, BB IV, p. 374. For the Passerini commissions see Shearman, *Andrea del Sarto*, II, pp. 249–50, cat. no. 60, for the vestment. He was later (c.1528) commissioned to paint a large-scale altarpiece of the

Assumption of the Virgin for the high altar of the church of Sant'Antonio Abbate in Cortona for Passerini's mother, Margherita; see Shearman, pp. 268–9, cat. no. 78 (now in the Galleria Palatina, Palazzo Pitti, Florence). Vasari used this composition as the basis for the *Assumption* he painted for the church of Sant'Agostino in Monte San Savino, commissioned in 1537 and signed and dated 1539.

81 The *compagnia del paiuolo* is described in the Life of Rustici, BB V, pp. 481–2, in an excursus on such clubs and their customs (BB V, pp. 481–7).

82 Life of del Sarto, BB IV, p. 395.

34. Andrea del Sarto, *Sts. John the Baptist and Bernardo degli Uberti*, panel from the Vallombrosa altarpiece. Florence, Uffizi.

35. Giorgio Vasari, *Sts. Donatus and Hilarion*. Monastery of Camaldoli, Church of Sts. Donatus and Hilarion.

and graceful style of drawing and vivid command of color in fresco and oil.[83] Del Sarto was also a gifted decorator, acutely sensitive to the demands of subject and site. He investigated not only nature, but the nature of pictorial experience itself. His paintings transform their space. The logic of their perspective is often based on the viewer's placement or participation, which is urged through appeals of gesture and glance. This involved considerable preparatory drawing and part of del Sarto's attraction as a teacher might have been his own devotion to study. He was an assiduous draftsman; so famous were his drawings and workshop equipment that they were stolen from his heir, Domenico Conti.[84] The substantial surviving corpus of drawings shows how intensely he considered each element of a composition: poses, drapery, heads, hands, and hair. Some of his many students must have served as models, for life studies played an important role in his working process; everyday dress and unidealized bodies are a recognizable feature of his studies. Even when repeating a composition or returning to his stock of motifs, he would make further drawings. Vasari remembered that he would sketch from nature to capture a pose, which he then polished as he worked, the life drawings being a memory aid not meant to be copied literally.[85] Along with drawing, Vasari could have also learnt design, in the sense of finding underlying patterns in individual forms and in overall compositions, a geometrical structuring evident in both del Sarto's paintings and Vasari's early works. Vasari must have filled his notebooks with del Sarto's ideas, not hesitating to pay the compliment of imitation, particularly in his early commissions (pls. 34, 35).

Vasari's apprenticeship to Florentine design did not end with del Sarto. He also spent time studying with the sculptor Baccio Bandinelli.[86] Bandinelli returned from Rome to Florence in 1525, and he resumed an earlier interest in painting, a forced versatility that was probably meant as another round in his self-perpetuating rivalry with Michelangelo. His success was limited, but the attempt may explain the acceptance of a young painter into his practice. His profession was sculpture, but his two great and generally acknowledged talents were manipulating the Medici to obtain commissions and being an accomplished draftsman.

According to Vasari, even in his youth Bandinelli handled stylus, pen, and both red and black chalk with dexterity and had surpassed his contemporaries at the cartoon in his ability to understand Michelangelo's nudes in the graphic terms of contour, shade, and finish.[87] He later promoted the idea of an academy, a precursor to the Accademia del Disegno that Vasari was instrumental in founding. In the mid-1520s Bandinelli published proof of his capacity as a draftsman and designer in a large print showing the martyrdom of St. Lawrence (pl. 36), which Vasari greatly admired, although he also narrates at some length how Pope Clement VII gave credit to the engraver Marcantonio for correcting many errors with "great judgment."[88] Vasari's respect for Bandinelli's design vocabulary is apparent in his adaptation

83 *Ibid.*, p. 394: "Avendo egli dunque dalla natura una dolce e graziosa maniera nel disegno et un colorito facile e vivace molto, così nel lavorare in fresco come a olio."

84 *Ibid.*, p. 396.

85 *Ibid.*, BB IV, pp. 394–5: "quando egli disegnava le cose di naturale per metterle in opera, faceva certi schizzi così abbozzati, bastandogli vedere quello che faceva il naturale: quando poi gli metteva in opera, gli conduceva a perfezzione; onde i disegni gli servivano più per

memoria di quello che aveva visto che per copiare a punto da quelli le sue pitture."

86 Shearman, *Andrea del Sarto*, I, p. 9, n. 4, quotes a document substantiating the association, ASF, Monte delle Graticole, No. 980, fol. 728, a dividend paid to Bandinelli: "Et adì di genaio 1526 [1527 s. c.] . . . a Barto deto portò gorgo d'anto sta con lui."

87 Life of Bandinelli, BB V, pp. 240, 241.

88 Vasari describes the print in the Life of Bandinelli,

36. Marcantonio Raimondi after Baccio Bandinelli, *Martrydom of St. Lawrence*, engraving. London, British Museum, Department of Prints and Drawings.

of Bandinelli's robust and schematized forms, as in his 1532 *Entombment* (pl. 37). Bandinelli's account of himself in his *Memoriale* shows that the image of the well-trained and well-schooled artist was important to him.[89] Whatever Vasari's antipathy for the person, he had great sympathy for his ideals, finding him praiseworthy for his ardor in pursuing the honor and excellence of his profession.

Some of Bandinelli's interests became Vasari's. Leonardo da Vinci had praised Donatello's reliefs to Bandinelli, advising him to imitate them.[90] And Bandinelli not only had workers on his father's country property pose nude to draw them as well as the farm animals, but also went to the nearby town of Prato where he would spend the entire day drawing in the Pieve chapel painted by Fra Filippo Lippi, learning to imitate that master's drapery style.[91] Vasari

BB v, p. 247. In the Life of Marcantonio he tells how Bandinelli went to Pope Clement VII and accused Marcantonio of making mistakes, and how Marcantonio vindicated himself by showing both the drawing and the engraving to the pope, who recognized Marcantonio's judgment in correcting Bandinelli's errors, BB v, p. 14: "[Marcantonio] gli mostrò l'originale . . . e poi la carta stampata; onde il Papa conobbe che Marcantonio con

molto giudizio avea non solo non fatto errori, ma correttone molti fatti dal Bandinello e di non piccola importanza, e che più avea saputo et operato egli coll'intaglio che Baccio col disegno."

89 Colasanti, "Il memoriale di Baccio Bandinelli," *Repertorium für Kunstwissenschaft* (1905), p. 422.

90 Life of Bandinelli, BB v, p. 240.

91 *Ibid.*

37. Giorgio Vasari, *Entombment*. Arezzo, Casa Vasari.

so admired Donatello's works that he was tempted to place him in the third era, but obeyed chronology leaving him in the second.[92] Fra Filippo Lippi became a special case for Vasari, represented as an artist whose virtue in art overrode his vices in venery. The Prato cycle received an extensive description, with special mention being given to the manner of dress as being unusual for Fra Filippo's time and serving to inspire painters to rid themselves of "that simplicity that could be called old rather than antique" (pl. 38).[93]

Vasari's canon of heroes was formed by his early contacts. The conceptual core of *The Lives* came from his Florentine study and from his circle of friends there. Directly and indirectly, from Michelangelo, del Sarto, Bandinelli, and others, Vasari learned the principles of Florentine practice, its traditions, and current modes. He absorbed or was absorbed by the myth of Florence: Giotto's legacy became his as well as theirs. Florentine history was based on notions of modernity. In the arts this was defined as a break with the ignorant, barbarous "German" or "Greek" styles and a return to the classical model. In painting, this translation from Greek to Latin had been given the name of Giotto.[94] In architecture, Brunelleschi was praised for restoring the *all'antica* manner of building and with this causing the demise of the German, the "modi Tedeschi."[95] This outlook became the basis for Vasari's history of the arts. The authors of the modern manner were those who worked in the Tuscan fashion and Giotto was credited for the origin of that style in painting.

Vasari put his first era under the dominance of Giotto's style and organized it so that those artists who were not Florentine and not students of Giotto or Giotto's immediate followers either came to Florence to study or, like Pietro Lorenzetti, derived their success from the imitation of Giotto. This unified, undifferentiated explanation of fourteenth-century style is one that did much to determine the subsequent perception of a period actually rich in distinct personalities. The Central Italian bias persists in the second era, even though Vasari did not define a predominant style. He held that the revival of architecture arose from the understanding of classical buildings first manifested by Brunelleschi in that period. North Italian artists are made to find Florentine masters. An explanation of this pre-eminence is given towards the end of Part 2 in the Life of Perugino, who, like Vasari, was ambitious and came from a small town. When he asked his teacher's advice, he always got the same answer: "that it was in Florence more than anywhere else that men became perfect in all the arts and especially in painting."[96] He gave three reasons for this, based on motivation:

the first is finding fault, which is done often by many because that air makes men's intellects so free by nature that none is able to content himself with mediocre works, but always considers them more with respect to the honor of the good and the beautiful than out of respect for their maker; the other is that if a man wishes to live there he must be industrious, which means nothing other than continually to use his intellect and judgment and to be quick and ready in his business, and finally he must know how to

92 Preface to Part 2, BB III, p. 18. For Vasari's resolution of this predicament, see below, Chapter VIII.

93 Life of Fra Filippo Lippi, BB III, pp. 335–6: "sonvi alcune figure con abbigliamenti in quel tempo poco usati, dove cominciò a destare gli animi delle genti a uscire di quella semplicità che più tosto vecchia che antica si può nominare."

94 In chapter 1 of his *Libro dell'arte* Cennino Cennini wrote that "Giotto changed the profession of painting from Greek back into Latin, and brought it up to date" (The *Craftsman's Handbook*, trans. Thompson, p. 2). For this tradition, see below, Chapter VII, pp. 287–9.

95 Manetti, *Vita*, ed. De Robertis and Tanturli, p. 77.

96 Life of Perugino, BB III, p. 597: "cioè che in Firenze più che altrove venivano gli uomini perfetti in tutte l'arti e specialmente nella pittura."

38. Fra Filippo Lippi, *Dance of Salome* (detail). Prato, cathedral.

make money, because Florence does not have a territory large or rich enough to be able to support cheaply those who stay there, as in places where there is sufficient wealth; the third, which is probably no less important than the others, is a lust for glory and honor that the very air generates mightily in those of any excellence, which in all those who have any spirit will not let them remain as equals, much less as inferior to those whom they see are men like themselves, even though they may recognize them as masters. Indeed, it forces them very often to wish so greatly for their own advancement that, if they are not kindly or wise by nature, they become spiteful, ungrateful, and unmindful of favors. It is certainly the case that once a man has learned there as much as suffices him, he must leave that place and find a market abroad for the excellence of his works and the reputation received from that city if he wishes to do anything but live from day to day like an animal and desires to become rich . . . because Florence treats her artists as time treats its own works, which when perfected, it destroys and consumes little by little.[97]

97 *Ibid.*, pp. 597–8: "l'una dal biasimare che fanno molti e molto, per far quell'aria gli ingegni liberi di natura e non contentarsi universalmente dell'opere pur mediocri, ma sempre più ad onore del buono e del bello che a rispetto del facitore considerarle; l'altra che, a volervi vivere, bisogna essere industrioso, il che non vuole dire altro che adoperare continuamente l'ingegno et il giudizio et essere accorto e presto nelle sue cose, e finalmente saper guadagnare, non avendo Firenze paese largo et abbondante di maniera che e' possa dar le spese

For Dante, indeed, the Florentines were an "ungrateful, malicious lot . . . miserly, jealous, and proud."[98] Vasari experienced the stimulation and the malice of Florence as well as the need to sell his skills elsewhere. Even when well established it was not an easy place. Duke Cosimo himself advised Vasari about difficulties in building the Uffizi: "Just remember that the Florentines are always fighting among themselves and that we have never managed to bring together two who would agree; since you are Aretine and not Florentine, don't enter into their quarrels."[99] In spite of this Vasari never abandoned the place he often had to leave, and he was rewarded for this loyalty, which he wrote into *The Lives*.

The status of the Florentine mode and model, so greatly emphasized in the first and second eras, persists in the third. But for Vasari the modern manner was not entirely Florentine. It involved a significant component of study of ancient art and a knowledge of works done in Rome by modern masters. This formula dominates his evaluation of the era, and it was derived directly from his own experience.

Rome: The True Teacher

On Friday 26 April 1527 there was an anti-Medici riot in the Piazza Signoria. In a story that matches his own youthful vigilance and heroism to its subject, he says that, with Salviati, he rescued the pieces of Michelangelo's *David*. The statue's arm was broken when the rebellious citizens threw stones from the parapets of the Palazzo della Signoria to repel the Medici forces at the door. According to Vasari, the pieces lay in the piazza for three days until the fearless boys braved the guard and carried them off to the house of Francesco's father.[100] On 17 May the cardinal and his Medici charges were forced to leave Florence, and

per poco a chi si sta, come dove si truova del buono assai; la terza, che non può forse manco dell'altre, è una cupidità di gloria et onore che quella aria genera grandissima in quelli d'ogni perfezzione, la qual in tutte le persone che hanno spirito non consente che gli uomini voglino stare al pari, nonché restare indietro, a chi e' veggono essere uomini come sono essi, benché gli riconoschino per maestri, anzi gli sforza bene spesso a desiderar tanto la propria grandezza che, se non sono benigni di natura o savî, riescono maldicenti, ingrati e sconoscenti de' benefizii. È ben vero che quando l'uomo vi ha imparato tanto che basti, volendo far altro che viver come gl'animali giorno per giorno e desiderando farsi ricco, bisogna partirsi di quivi e vender fuora la bontà delle opere sue e la riputazione di essa città . . . perché Firenze fa de li artefici suoi quel che il tempo de le sue cose, che fatte se le disfà e se le consuma a poco a poco." See also Gombrich, "The Leaven of Criticism in Renaissance Art," in *The Heritage of Apelles*, pp. 111–31.

98 *Divine Comedy*, *Inferno*, canto 15, verses 61, 68: "quello ingrato popolo maligno . . . gente avara, invidiosa e superba."

99 Frey I, cccli, p. 640 (Cosimo in Livorno, 10 November 1561, to Vasari, Florence): "Et ricordateui, che gli Fiorentini combattono sempre insieme; et che sendo uoi Aretino et non Fiorentino, non entriate nelle brighe loro, et che Noi non potemmo mai accozzare duoi Fiorentini insieme che fussino d'accordo."

100 Life of Salviati, BB v, pp. 512–13. For the place of this episode in the autobiographical construction of *The Lives*, see Barolsky, *Michelangelo's Nose*, p. 79. Vasari says that Duke Cosimo eventually took the pieces and had the statue repaired. Two little-known documents substantiate the breakage during fighting around the Palazzo Vecchio and its repair under Cosimo. The first is a letter from Fabrizio Pellegrino to Duke Alessandro dated 28 April 1527, describing the damage: "Insino il povero gigante di piazza ha patito per lo Stato de' Medici, chè gli è stato rotto un brazzo da quelli ch'erano entrati nel palazzo" (published by Ferrai, *Lorenzino de' Medici*, p. 44, n. 10; see also Roth, *The Last Florentine Republic*, pp. 29, 35 n. 75). The second is a letter by Cosimo's majordomo, Pierfrancesco Ricci of 7 November 1543, chronicling popular curiosity about the scaffolding built to repair the statue: "El populo passa un pocho di tempo nel veder fabricare un ponte intorno al gigante David. Fassi per rannestargli il suo povero braccio: ma molti pensano che gli s'abbia a lavare il viso" (published by Gotti, *Vita di Michelangelo Buonarroti*, I, p. 31). I would like to thank Michael Hirst for supplying these intriguing references, which deserve wider recognition and further consideration.

the republic was restored. Vasari did not follow them into exile. He returned to Arezzo where his father's death from plague in August made him the head of his family, a responsibility that forced him to earn a living as best possible as a painter in Arezzo and neighboring towns. Bereft of great masters he learned what he could from local painting, considering, for example, how one earlier painter had handled his colors and the rendering of shadow in a fresco he was commissioned to repaint in the duomo in 1529.[101] He was encouraged and greatly influenced by Rosso Fiorentino, who helped him by supplying a drawing for a painting of the *Resurrection*. He studied Rosso's *Christ in Glory with Saints* in Città di Castello (pl. 39) and *Deposition* in Sansepolcro (pl. 40). Clearly impressed by their elegance and expressiveness, he found figural motifs that he repeated throughout his career.[102] In his early paintings, such as the *Entombment* (pl. 37) and the *Deposition* now in Santissima Annunziata, Arezzo (pl. 41), he imitated also Rosso's rich faceting of color in the drapery and his compositions compiled of figures fixed in complicated juxtaposed and interlocking poses. He copied Rosso's geometrically schematized faces and fold vocabulary, both inspired by classical models. Through Rosso, as with Perino, Vasari could study the idealized and self-consciously stylized Roman manner. He found in them the poses, drapery, movement, expression, and style that were the basic components of appreciation, as indicated by his letter to Aretino on the cartoon he submitted to the judgment of his friends in Venice.[103]

He tried not to be discouraged by circumstances; he returned to Florence where he continued to learn painting and worked for a while as a goldsmith. And he did not lose sight of his Medici protectors. He was in Bologna in February 1530 for the coronation of Charles V, the formal reconciliation of the pope with the emperor after the years of war that had resulted in the sack of Rome and the Medici expulsion from Florence. Present there were Ippolito, now a cardinal, and Alessandro, designated to become the duke of Florence with imperial backing. Clement VII's division of sacred and secular realms of power for his nephews, however tactical, was problematic, as Ippolito had been brought up under the impression that he was destined to be the Florentine head of state. The change from *Magnifico* to *cardinale* did not suit him.[104]

101 Frey II, p. 849, no. 19 (5 January 1529): "messer Guasparri Gozzari, canonjco Aretjno, mj alloga in vescouado di Arezzo duo figure in fresco di San Jacopo et Filippo innella capella loro." In the Life of Giottino, BB II, p. 236 (1568), he gives the original fresco of the Annunciate Virgin with the two saints to Giovanni Toscani, saying that it was nearly ruined by damp when he repainted the two saints shortly after another Aretine painter, Angelo di Lorenzo, had redone the Virgin: "La qual opera . . . era poco meno che guasta affatto dall'umidità quando rifece la Nunziata maestro Agnolo di Lorenzo d'Arezzo, e poco poi Giorgio Vasari, ancora giovanetto, i Santi Iacopo e Filippo con suo grand'utile, avendo molto imparato—allora che non aveva commodo d'altri maestri—in considerare il modo di fare di Giovanni e l'ombre e i colori di quell'opera, così guasta com'era." Vasari grouped Toscani among Giottino's students. This is not the case, as Toscani's career dates from the fifteenth century: Giovanni di Francesco Toscani is recorded as matriculating in the painter's guild in 1424 (*Le*

vite [Club del Libro], I, p. 487, n. 2). In Salviati's Life Vasari states that in late 1527 he returned to Florence and with Salviati and Nannoccio di San Giorgio joined the shop of Raffaello del Brescia (BB V, p. 513). If this is the case, Vasari's stay there must have been brief, for his other records show that he was working in and around Arezzo in 1527 and 1528.

102 For Vasari's study of these paintings and their influence, see Franklin, *Rosso in Italy: The Italian Career of Rosso Fiorentino*. For the *Deposition*, see also C. Davis in Arezzo 1981, p. 59.

103 Frey I, xvi (Vasari in Florence, March 1536, to Aretino, Venice), pp. 46, 48: "Et da quello che mando conoscerete gli andari delle figure, de panni, del moto et dell'affetto, la maniera et qualità de gl'altri . . . degnateui mandarmi à dire il parer loro [Jacopo Sansovino and Titian] e cosi il giuditio uostro."

104 Moretti, "Il cardinale Ippolito," *Archivio storico italiano* (1940), pp. 137–78.

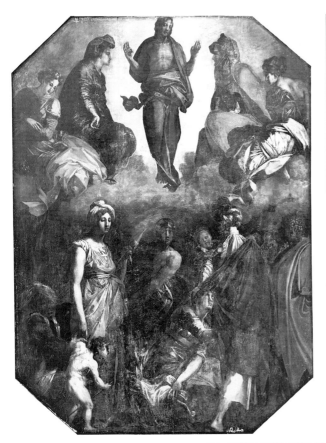

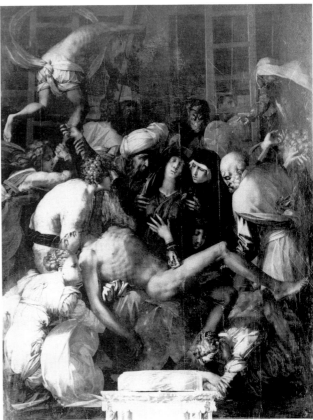

39 (above left). Rosso Fiorentino, *Christ in Glory with Saints*. Città di Castello, cathedral.

40 (above right). Rosso Fiorentino, *Deposition*. Sansepolcro, San Lorenzo.

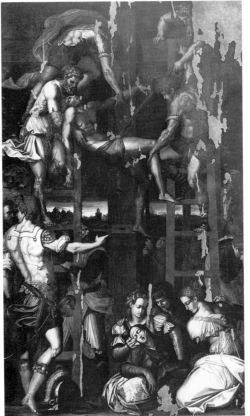

41. Giorgio Vasari, *Deposition*. Arezzo, Santissima Annunziata.

42. Raphael, *Coronation of Charlemagne*, detail showing Ippolito de' Medici as a boy. Rome, Vatican Palace, Stanza dell'Incendio.

Vasari says that Raphael depicted Ippolito as a boy in the *Coronation of Charlemagne* in the Stanza dell'Incendio in the Vatican (pl. 42). This scene of pomp and splendor was apparently an appropriate setting for Ippolito, who soon made his name as one given to luxury and unbounded liberality. A revealing episode is recounted in a book of anecdotes collected by a sixteenth-century author, Lodovico Domenichi. Pope Clement tried to limit his nephew's prodigality, reviewing the list of his household. When the cardinal was presented with a drastically edited court roll, he said, "Our Lordship speaks the truth, I do not need all of these servants that he has crossed out, but they need me, and in as much as you care for my good favor, do not let any of them go."[105] Vasari described his household as teeming with men of excellence, among them many painters and sculptors.[106] He supported the sculptor Alfonso Lombardi and the gemcarver Giovanni di Castel Bolognese. He collected paintings by Parmigianino and sent Sebastiano del Piombo on a special mission to portray his lady love, Giulia Gonzaga. When he heard that Michelangelo liked a Turkish horse he owned, he gave it to him, sending a groom and ten mules laden with fodder as well. "Padre de

105 Domenichi, *Facetie, motti, et burle*, pp. 196–7: "Nostro Signore dice il uero; che io non ho bisogno di questi tanti seruitori, che egli ha cancellati; ma perche essi hanno bisogno di me, per quanto tu hai cara la gratia mia, non ne licentiar niuno."

106 Life of Alfonso Lombardi, BB IIV, p. 411: "aveva appresso di sé, oltre agl'altri infiniti virtuosi, molti scultori e pittori."

virtuosi," he inspired a mock treatise in praise of piacentine cheese and was the dedicatee of one on priests' beards.[107]

Ippolito reintroduced Vasari to court life. Passing through Arezzo in the spring of 1531, he found his needy young friend fatherless and doing his best to survive: "wanting him to profit in his art and desirous of his company, he ordered the town's deputy governor Tommaso de' Nerli to send him to Rome."[108] He entered the cardinal's service in the first days of January 1532, becoming a form of official painter-protégé of the court, given time and resources to study. The entry in his *ricordanze* for 4 January notes the arrangements made for him by the "most reverend and illustrious cardinal." He was given rooms in which to work, a monthly stipend sufficient for himself and his assistant, Battista del Borgo, pigments, and "all that he required." It was agreed that he would spend three days a week studying by drawing and three working on things for Ippolito.[109] Vasari did not fail to realize the opportunity or to be grateful. He was to recall the incredible effort he made and its importance to him as his "real and most important teacher of this art."[110] He studied with unremitting zeal, day and night, dividing the task of drawing with his friend Francesco Salviati. So that both might have drawings of everything, they would draw different things by day and copy each others' drawings by night, often barely finding time even to eat.[111] This campaign is recalled in many Lives where similar industry in the pursuit of knowledge is praised. It was the basis of his treatment of Raphael and his students, above all Polidoro da Caravaggio and Giulio Romano, whose Lives have elaborate, eulogistic passages describing the exemplary style on which Vasari based his own in those long days and nights of study.

For Vasari the polish of Rome perfected the training of Florence. He said of his own teacher,

> Nor can there be any doubt that, if Andrea [del Sarto] had remained in Rome when he went there to see the works by Raphael and Michelangelo and also the statues and the

107 [Landi], *Formaggiata di sere Stentato al serenissimo re della virtude* (1542), where Ippolito is invoked as the "padre de virtuosi" (fol. 2v), and Valeriano, *Pro sacerdotum barbis*. Life of Michelangelo, BB vi, p. 109, for the gift of the horse.

108 Life of Salviati, BB v p. 514: "che era rimaso senza padre e si andava trattenendo il meglio che poteva; per che disiderando ch'e' facesse qualche frutto nell'arte e di volerlo appresso di sé, ordinò a Tommaso de' Nerli, che quivi era commessario, che glielo mandasse a Roma."

109 Frey ii, p. 851, no. 49: "Ricordo, come questo di 4 di Gennaio 1532 [come] io mj aconcjo a seruire il reuerendissimo et illustrissimo cardinale Hipoljto de Medicj. Et dalluj mi si ordina oltra la spesa per me et per uno garzone di y 21 il mese et oltre darmj stanze per lauorare et colorj et ogni cosa necessarja . . . Et conuenjmmo, che io dovessi tre di della settjmana disegniare per mio studio et altrj tre lauorare cose per luj"; the "garzone" is identified as Battista dal Borgo in a letter to Paolo Giovio, Frey i, iii (September or October 1532), p. 11.

110 Description of Vasari's works, BB vi, pp. 371: "E potrei dire con verità questa commodità e lo studio di questo tempo essere stato il mio vero e principal maestro in questa arte."

111 *Ibid.*, pp. 371–2: "Et acciò che avesse ciascuno di noi i disegni d'ogni cosa, non disegnava il giorno l'uno quello che l'altro, ma cose diverse; di notte poi ritraevano le carte l'uno dell'altro, per avanzar tempo e fare più studio: per non dir nulla che le più volte non mangiavamo la mattina, se non così ritti, e poche cose." See also the Life of Salviati, BB v, p. 515. Vasari completed his studies in the winter of 1538 when he made over three hundred drawings with his assistant Battista dal Borgo, courtesy of Ottaviano de' Medici who gave him a letter of credit for 500 *scudi* and told him to use the money so as to be able to attend to his studies and to repay him at his convenience in kind or with works: "Sèrviti di questi per potere attendere a' tuoi studii; quando poi n'arai il commodo, potrai rendermegli o in opere o in contanti, a tuo piacimento" (Description of Vasari's works, BB vi, p. 377).

ruins in that city, he would have greatly enriched the style of his narrative compositions and eventually would have given greater refinement and greater force to his figures: something that is never completely achieved except by those who have been in Rome for a while in order to spend time with those works and to consider them in great detail.[112]

Florence supplied the basic principles; Rome the advanced lessons. The sculptor Pierino da Vinci, for example, went as a youth to see the celebrated works in Rome and found that he was not yet prepared to understand them in spite of his desire to profit from the experience. He "judiciously" returned to Florence, "considering that the things in Rome were still too profound for him and that they can be seen and imitated, not thus at the beginning, but only after greater knowledge of art."[113]

Vasari at twenty-one evidently thought that he was ready for Rome. His education in the refinements of style was essentially Roman. This is registered both in his works with their conspicuous classicism and in his description of the styles of other artists. He says that when Benvenuto Garofalo arrived in Rome the grace and lifelike qualities of Raphael's paintings and the profundity of Michelangelo's power of design, his *disegno*, made him both wonder and despair. He cursed the styles of Lombardy and Mantua that he had learned with such effort and decided from being a master to become a pupil.[114]

Vasari became a student of Raphael's school – Raphael's former assistants Giovanfrancesco Penni, Giulio Romano, Polidoro da Caravaggio, and Perino del Vaga, who had dominated the scene and determined the look of the city before the sack of 1527.[115] They had established a model of efficient bravura, whereby unhesitating design and speed of execution became essential features of their practice, which came to be contrasted with the laborious study of Florentine masters typified by Andrea del Sarto. Vasari affirms that one thing that daunted del Sarto in Rome was that the young painters there were so spirited as draftsmen and able to work with confidence and without hesitation.[116] This difference in practice must have been one element in the debate with Perino in 1522, which resurfaced in the late 1540s when Salviati's work in the Sala dell'Udienza in the Palazzo Vecchio was criticized. His facility and speed there laid him open to accusations that he was working by rote without sufficient preparatory study for the project.[117]

112 Life of del Sarto, BB IV, p. 394 (1568): "Né è dubbio che se Andrea si fusse fermo a Roma, quando egli vi andò per vedere l'opere di Raffaello e di Michelagnolo, e parimente le statue e le rovine di quella città, che egli averebbe molto arric[c]hita la maniera ne' componimenti delle storie et averebbe dato un giorno più finezza e maggior forza alle sue figure: il che non è venuto fatto interamente se non a chi è stato qualche tempo in Roma a praticarle e considerarle minutamente."

113 Life of Pierino da Vinci, BB V, p. 231: "considerato giudiziosamente che le cose di Roma erano ancora per lui troppo profonde, e volevano esser vedute et imitate non così ne' principii, ma dopo maggior notizia dell'arte."

114 Lives of the Lombard artists, BB V, pp. 410–11: "giunto . . . in Roma, restò quasi disperato nonché stupito nel vedere la grazia e la vivezza che avevano le

pitture di Raffaello e la profondità del disegno di Michelagnolo; onde malediva le maniere di Lombardia e quelle che avea con tanto studio e stento imparato in Mantoa . . . si risolvé a volere disimparare e, dopo la perdita di tanti anni, di maestro divenire discepolo."

115 Vasari uses the term "school" for this group as in the Life of Giovanni da Udine, BB V, p. 447: "da esso Castiglioni . . . accommodato nella scuola de' giovani di Raffaello."

116 Life of del Sarto, BB IV, p. 394: "il vedere molti giovani discepoli di Raffaello e d'altri essere fieri nel disegno e lavarare sicuri e senza stento . . . non gli diede il cuore di passare; e così facendosi paura da sé, si risolvé per lo meglio tornarsene a Firenze."

117 Life of Salviati, BB V, p. 523. For an analysis of this incident and its critical context, see Schlitt, "Francesco Salviati and the Rhetoric of Style," Ph.D. (Johns Hopkins, 1991).

Raphael's school had flourished in what had come to be known as a Golden Age, the time of Leo X and the first years of the pontificate of Clement VII. The splendors of that period remained to be re-established following the pope's return to a city traumatized after its virtual ruin by imperial soldiers in 1527. Cardinal Ippolito, with his lavish ways, was a protagonist in this restoration. He occupied the palace purchased by the Medici in 1505, which had been the residence of Lorenzo the Magnificent's son Cardinal Giovanni (later Pope Leo X) and housed a collection of classical sculpture. A late sixteenth-century drawing by Maerten van Heemskerck depicts a view of the sculpture garden where Vasari must have spent some of his study time. A massive torso, visible in the foreground of the drawing, became one of his recurrent motifs. The importance he gave to Lorenzo de' Medici's "school," "academy," or sculpture garden probably derived from his own experience of Ippolito's.[118]

One of Vasari's functions was to cater for this taste for antiquities. He wrote to his former Florentine host Niccolò Vespucci:

> The wish I have to serve [the cardinal] uplifts me; so much the more since I have not yet been here for two months and have been wonderfully supplied with rooms, beds, a servant. He has already given me a new set of clothes. In addition to which I carry out an important task, every time that I go about Rome making drawings of either antiquities or paintings I bring them to him as the final fruits at his table whether it be evening or morning.[119]

Another of Ippolito's dependents, Claudio Tolomei, founded an academy under his protection, the Accademia della Virtù. Devoted to congenial meetings at Tolomei's house, the academy's discussion ranged from the most nosey of noses to the rules of poetic composition. Towards the late 1530s its principal task became the systematic study of Vitruvius.[120] The Vitruvian comparison was already such a commonplace in this circle, however, that one courtier, Paolo Giovio, could write to the cardinal that Vitruvius would have laughed at Giovio's new house in Como.[121] Vasari's knowledge of and respect for the "Vitruvian opinion and rule" as mentioned in the Life of the architects Giuliano and Antonio da Sangallo the Elder probably had its origins in this court whose members comprised also the leading lights of the Roman literary and learned antiquarian set.[122] In addition to Giovio and Tolomei they included the poet Francesco Maria Molza, the wit and

118 A drawing by Heemskerck in Berlin was identified as a view of Ippolito's sculpture garden by M. Davis, "Der Codex Coburgensis," *Kunstchronik* (December 1988), pp. 661–2, pl. 8c. For the palace generally, see del Gaizo, *Palazzo Madama*, pp. 19–30. For Lorenzo's garden, see below, p. 202.

119 Frey I, i, p. 2 (Vasari in Rome, April 1532, to Vespucci, Florence): "Tant'alto mi porta la uolonta, che io ho, di seruirlo; tanto piu, che non sono dua mesi, che son qui et accomodato benissimo di stanze, letti, seruitore. Et di gia mi ha uestito tutto di nuouo; oltre che gli fò un' seruitio segnalato, ogni uolta ch'io uò fuora à disegnare per Roma ò anticaglie ò pitture ò portargnene per l'ultime frutte della tauola sia ò sera ò mattina."

120 See Sbaragli, *Claudio Tolomei*, pp. 49–79. For the Vitruvius project and its context, see Tolomei's letter to Count Agostino de' Landi (14 November 1542) in Barocchi ed., *Scritti d'arte*, III, pp. 3037–46, and also the letter to Francesco Sansovino, pp. 3047–8, and Pagliara, "Vitruvio da testo a canone," in *Memoria dell'antico nell'arte italiana*, ed. Settis, III, pp. 67–74.

121 Giovio, *Lettere*, ed. Ferrero, I, no. 44, p. 136, from Como (13 December 1533).

122 Life of Giuliano and Antonio da Sangallo, BB IV, pp. 151–2, about their use of the doric order: "con miglior" misure e proporzione che alla vitruviana opinione e regola prima non s'era usato di fare." For the members of the court, see Tiraboschi, *Storia della Letteratura Italiana*, VII, part 1, p. 20.

satirist Francesco Berni, Ippolito's former teacher Pierio Valeriano, and many others. In his mid-sixteenth-century history of Florence Benedetto Varchi wrote that the generous and talented cardinal treated them as companions rather than servants.[123] Among them Vasari found friends and protectors, especially in Giovio and Tolomei, "who because they are virtuous and noble, favor me, love me, and teach me as a son."[124] Tolomei was a poet, lawyer, and antiquarian from Siena who was successively in the service of Leo X, Ippolito de' Medici, and later Cardinal Alessandro Farnese. Giovio was a humanist trained as a physician and philosopher whom Leo X had appointed as teacher of moral philosophy at the Sapienza in Rome.[125] This circle remained useful as well as familiar. After Ippolito's death the equally precocious, but much more prudent, Cardinal Alessandro Farnese adopted many of its most eminent members into his family.

In Rome Vasari not only polished up his stylistic tone, but also found a context for its description and exercise. Both Valeriano and Tolomei had entered the current debate on the Italian language, defending the excellence and the eloquence of Tuscan in dialogues on the vernacular.[126] Tolomei is a protagonist in Valeriano's dialogue, where he defines language as the spoken picture of mental images.[127] In his own dialogue he praises the vernacular for its perfection in its beauty, grace, and sweetness. His vocabulary of refinement and richness is the same that Vasari later applied to actual images to create mental pictures. Tolomei had also been involved in selecting the text of Machiavelli's *Discorsi* to be used for publication.[128] Paraphrasing Machiavelli's *Prince*, he preached the lessons of history to Cardinal Ippolito in a letter that suggested a model of imitation similar to the one Vasari proposed to himself as an artist and to his readers as a historian:

> Nor should one doubt that, in choosing to imitate some rare and excellent man and in aiming at the same kind of happiness and greatness it must follow that one strives to achieve the same virtues as those possessed by the person placed before one's self as a guide. And one also struggles to walk along the same path and to climb the same steps that can lead to those heights he had first suggested. For example, one reads that in ancient times Theseus imitated the deeds of Hercules, Alexander those of Achilles, Scipio those of Cyrus, Caesar those of Alexander. As a consequence both one and the other achieved glory and eternal fame through the virtuous deeds that they accomplished enthused by the glory of others. It is not enough only to know deeds that great men have done, but one must discuss and understand their roots and principles because results always follow upon causes.[129]

123 Varchi, *Storia Fiorentina*, ed. Arbib, ii, Book xii, p. 560.

124 Frey i, i, p. 2 (Vasari in Rome, 1532, to Niccolò Vespucci, Florence): "i quali per esser nobili et uirtuosi, mi fauoriscano, mi amano et ammaestrano da figliuolo."

125 Zimmerman, "Paolo Giovio and the evolution of Renaissance art criticism," in *Cultural Aspects of the Italian Renaissance*, ed. Clough, and the essays in the *Atti del Convegno Paolo Giovio*.

126 Valeriano, "Dialogo . . . sopra le lingue volgari" (1516), in *La infelicità dei letterati*, and Tolomei, *Il Cesano*, written before 1529, published in an unauthorised edition in 1555 (Giolito, Venice).

127 Valeriano, "Dialogo . . . sopra le lingue volgari," in *La infelicità dei letterati*, p. 345: "La lingua è pittura vocale delle immagini che sono nell'intelletto nostro."

128 See Mazzoni, "Sul testo dei 'Discorsi,'" *Rendiconti della R. Accademia Nazionale dei Lincei. Classe di Scienze Morali, Storiche e Filologiche* (1933), fasc.1–4, pp. 41–82, for the edition printed by A. Blado in 1531.

129 Letter to Cardinal Ippolito about reading Caesar's *Commentaries* (12 December 1529, from Bologna), *De le lettere*, Book i, fol. 13r: "Ne si dubbita che pigliandosi l'imitazion di qualche huomo raro ed escellente, e ponendosi per segno la felicità e grandezza di quello, forza é che s'ingegni ciascuno de le medesime uirtu

Tolomei's message about the inspiration of glorious deeds and their reward in the glory of eternal fame was appropriately urged in the periodic refrains of Ciceronian eloquence. And Vasari never seems to have doubted this rhetoric of virtue, and sought to follow the paths of the great men of his profession and trace them in his history of their deeds.

Vasari's other mentor, Paolo Giovio, had written about the celebrated lights of perfect art, Leonardo, Michelangelo, and Raphael, who had eclipsed the earlier fame of Perugino. He did this in the context of a discussion of eloquence in a dialogue written in 1527, in which he used the analogy of artistic and literary practice, drawn from the classical authors, in order to consider questions of talent and imitation.[130] His examples included Donatello, Sebastiano del Piombo, Dosso Dossi, and Titian. He also composed brief eulogistic lives of Leonardo, Michelangelo, and Raphael in the 1520s. His writings indicated how fame, history, and rhetoric could be related directly to the description or evocation of artists and their works. Giovio was, moreover, skilled in service, and Vasari's developed notions of the position of *servitore* and of *servitù* echo those expressed by Giovio in his letters.[131] Nor did Giovio fail to use his medical skills on the young artist, who had nearly blinded himself, so keen was he to please Ippolito and to master the ancient and modern works of Rome. Vasari owed his sight to the versatile physician.[132]

This clerical, cosmopolitan court also suggested a model for an ideal career. It was in Rome that an artist, like Raphael, could come to live more like a prince than a painter. It was a city where talents collected and were culled from all over, rather than bred in local *botteghe*. And even if the rumors of a cardinalate for Raphael were not true, they existed to tantalize the ambitious.[133] There were substantial pensions and honors available at the papal court: the office of the *Piombo*, master of the papal seals, for example, which was given to the architect Bramante by Pope Julius II. Less meritorious, according to Vasari, was the current holder of the prestigious and profitable sinecure, the Venetian painter Sebastiano, who used the income to live well and form a convivial set of dining companions, enjoying the best wines, finest foods, and the company of poets. Vasari believed that this prize should have stimulated him to more worthy activities. Vasari's revenge for the betrayal of his trust that virtue should be rewarded and that rewards prompt virtue was to write a form of inverted eulogy in Sebastiano's Life, which becomes a demonstration of "How greatly our

riempiersi, de lequali era pieno colui ch'egli s'ha posto inanzi per guida: e si sforzi per quella strada caminare, e per que gradi salire, che sono atti a condurlo a quella altezza, ch'egli prima s'ha proposto ne la mente. Come si legge che Teseo anticamente imitaua i fatti d'Hercole, Alessandro quelli d'Achille, Scipione quelli di Ciro, Cesare quelli di Alessandro; onde e questi, e quelli per l'opere uirtuose ch'infiammati da l'altrui gloria faceuano, ne son diuenuti con eterna fama gloriosi. Ne basta solo il saper le cose fatte da glihuomini grandi, ma bisogna discorrere, ed intendere le radici e i fondamenti di quelle; conciosia che gli effetti vengono sempre da le cagioni." This view of great men and history is close to that given by Vasari in the preface to Part 2, BB III, pp. 3–4. Tolomei added Theseus and Hercules to a series taken from chapter 14 of *The Prince*, where Machiavelli advises the prince to read history "so that he can do

what eminent men have done before him: taken as their model some historical figure who has been praised and honoured; and always kept his deeds and actions before them" (trans. Bull, p. 90). I want to thank Nicholas Webb for pointing this out to me.

130 See Zimmerman, "Paolo Giovio and the evolution of Renaissance art criticism," in *Cultural Aspects of the Italian Renaissance*, ed. Clough, pp. 410–15, for an analysis of this dialogue (*De viris illustribus*); p. 411, for the passage about Perugino.

131 See Giovio, *Lettere*, ed. Ferrero, I, no. 25, p. 110, to the duke of Ferrara, Alfonso d'Este (28 June 1524), and no. 38, p. 131, to the duke of Milan, Francesco Sforza (6 January 1531).

132 Frey I, ii, p. 7 (Vasari in Rome, 7 June 1532, to Ottaviano de' Medici, Florence).

133 Life of Raphael, BB IV, pp. 208–9.

reason can be deceived and the blindness of human prudence."[134] When Vasari came of the age and state to contemplate marriage, he did it with great caution and seems to have been weighing the merits of a good match against the possibility of advancement at the papal court. This is evident from the dowry negotiations. Among many other things he wanted his prospective bride to realize "Exactly how important it is at court in Rome, to be without a wife, because of the benefices and offices that become vacant."[135] In the event, Vasari's honors and rank were not to come from employment in that city; but the congenial social ambient there inspired his hopes and provided a model of advancement through talent that he never abandoned.

It is indicative of the tone of Ippolito's court that the paintings Vasari did for the cardinal were all of classical subjects, and those not the most obviously edifying. Their literary quality is notable. Invented subjects, they could be expanded through descriptions commenting upon their meaning. They were meant for pleasure and delectation, such as a nude Venus at her toilet attended by the three Graces and a bacchanalia with a battle of satyrs, which the cardinal enjoyed even when just sketched, precisely because it was light-hearted, "humorous and ridiculous."[136] Clement VII by contrast commissioned a painting of the philosopher Hippocrates, so that the cardinal might recognize in Hippocrates

> how to be patient and so that the intellect of such an elevated and quick spirit will mature with time, with the result that with judgment and vigilance, once he is totally purged of his bad habits, he might be led to the true way of the life that at the moment he does not esteem.[137]

Pleased as Vasari might have been to follow the example of his learned predecessors among the ancient painters, finding intricate figures to symbolize wisdom and prudence, Ippolito was not amenable to the lessons he could decipher from such imagery. He did not want to hear his uncle's message or take his advice. He was eager to give up his cardinalate and continued to scheme so that he might rule Florence. Benedetto Varchi evaluated his character, adding, after praising his learning and liberality, "It is true that he was of a frivolous and inconstant nature, and did many things under the influence of others and more out of boastfulness and ambition (not to say pretentiousness) than by his own judgment or for any other serious and commendable reason."[138] Certainly his behavior in Bologna had

134 Life of Sebastiano, BB v, p. 85 (1550): "Tanto si inganna il discorso nostro e la cieca prudenzia umana."

135 Frey i, cxix, p. 235 (Vasari in Florence, before 10 September 1549[?], to Vincenzo Borghini, Le Campora[?]): "Di quanta inportanza sia lo stare in corte di Roma senza auer moglie per i benefitij et ufitii, che uacano." Vasari's hesitation here seems similar to Raphael's as described in Raphael's Life; a similar spirit of calculation informs Raphael's letter to his Urbino uncle about the relative values of prospective brides; see Golzio, *Raffaello nei documenti*, p. 32 (1 July 1514).

136 The *Toilet of Venus* is described in Vasari's letter to Niccolò Vespucci, Frey i, i, p. 2 (June 1532). The *Bacchanalia* is described in a letter to Ottaviano de Medici, Frey i, ii, p. 7 (Rome, beginning of June 1532, to Ottaviano, Florence): "la quale per esser giocosa et ridicula, ha dato sommo piacere al cardinale il uedere

alcune cose che ci sono, ancor che abozzate; et gli piaccino assai." The paintings are lost, but known in later versions, see Ewald in Arezzo 1981, pp. 74–5.

137 Frey i, ii, pp. 7–8: "per esempio del cardinale nostro, conoscendo in lui il modo dello aspettare, che col tempo si maturi l'intelletto di si alto et ueloce animo, accio col giuditio et con la uigilantia, purgatissima da gli sperimenti, si conduca alla uera uia di quella uita che ora non è stimata da lui." For a discussion of the sources of the imagery in Pliny, see Frey's note, pp. 9–10.

138 *Storia Fiorentina*, ed. Arbib, ii, Book xii, pp. 560–1: "Vera cosa è, ch'egli era di natura leggiere e incostante, e faceva molte cose più per una cotale vanagloria e per ambizione (per non dire saccenteria) e mosso da altri, che per proprio giudizio, o da altra cagione grave e commendabile."

hardly been priestly: he went about in disguise at night provoking duels with the imperial soldiers to try their valor and his. He leapt at the chance for real battle against the Turks, leaving Rome in the summer of 1532 to join the imperial forces there in a campaign against Suleiman the Magnificent. His character is well demonstrated by Titian's portrait of him painted at this time (pl. 43). Vasari describes this as Hungarian dress, which was a suitable costume for his destination in Hungary. The outfit also seems similar to that described by the Venetian ambassador in his account of the cardinal's departure on his journey, dressed "as a soldier with a red cap, white plumes, a short cloak, and a sword and dagger, and not wearing a cross."[139]

When Ippolito went to fight the Turks he left Vasari under the protection of Clement VII. According to a letter to Paolo Giovio, he tried to stay in Rome to pursue his studies but fell into a depression and then a fever, so that he had to be carried back to Arezzo and to his mother's loving care. But his mother's love was only second best to that of the cardinal. He goes on to say:

> That if [your Lordship] had remained in Rome, I would have never wished to leave, even if I had died, encouraging myself that beneath the shadow of the cardinal, even if I had not perfected our art, it would have seemed to me that I had died gloriously and that under his protection I had achieved, even dead, that fame which I would in time have acquired through labor had I remained alive.[140]

Even ill, he was not idle. In this letter from his sickbed he included a drawing for Ippolito of the tree of Fortune, a secular subject, he notes, but a fanciful one that he thought might make the cardinal laugh. He says also that the invention was suggested by a gentleman; this may have been his former teacher Pollastra.[141] This letter gives a good indication of the tone of Ippolito's court and Vasari's activities there, among those whom he greeted as "my friends in your academy."[142]

In December he went to Florence where he was well received by the duke, given a stipend, sustenance for himself and a servant, rooms in Santissima Annunziata, and put in the care of Ottaviano de' Medici. There he returned to his accustomed studies. Through the offices of the duke he was even able to spend time in the New Sacristy making careful studies of Michelangelo's statues, which were still on the floor.[143] His letters indicate that he believed this Florentine sojourn to be temporary and had his hopes vested in the fun-loving Ippolito and his circle in Rome. He wrote to the cardinal that he was glad to hear that he was soon to return to Bologna and hoped that he would speedily make his way to Rome,

139 Sanuto, *Diarii*, ed. Berchet, Barozzi, and Allegri, LVI, p. 770, describing the departure from Mantua on 27 July. The plumes in the Titian portrait are dark, and Ippolito holds a baton not a dagger, but the general effect is that in Sanuto's account: "da soldato con berretto rosso, piume bianche et casacca tagliata, et spada et pugnale et non porta croce." For Vasari's description, see the Life of Titian, BB VI, p. 162.

140 Frey I, iii, p. 11 (Arezzo, September/October 1532, to Giovio, Venice[?]): "Che se quella [la Signoria Vostra] fussi stata in Roma, io mai mi sarei uoluto partire, quando ben fussi morto, confortandomi, che

sotto l'ombra del cardinale, ancor che io non fussi uenuto à perfectione ne fine della nostra arte, mi sarebbe parso morir glorioso et hauere conseguito sotto di lui, cosi morto, quella fama che harei acquistato col tempo, faticando, s'io fussi stato uiuo."

141 *Ibid.*, p. 12: "Il capriccio della inuentione è d' un gentilhomo, amico mio."

142 *Ibid.*, p. 13: "Salutate per mia parte gl' amicj miei della uostra accademia."

143 Description of Vasari's works, BB VI, p. 372; Life of Gherardi, BB V, p. 286, about his accommodation in the Servite convent.

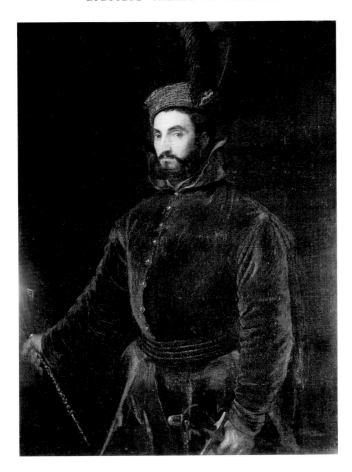

43. Titian, *Cardinal Ippolito de' Medici*. Florence, Palazzo Pitti, Galleria Palatina.

where returning to your side (even though I lack for nothing here), I hope my virtue will grow as I am striving to acquire it through the passing years and with your greatness to go as far as I can towards excellence. And so as not to deviate from the usual routine . . . so that drawing and painting might go at equal pace, I have made a cartoon for a large painting for your most Reverend Honor to be kept in your bedroom.[144]

The painting, an Entombment (pl. 37), eventually found its way to Alessandro's bedroom. The change of destination is revealing: it effectively marks a change of patron: one that was politic, if not actually political.

When Vasari opted to stay in Florence under Alessandro's protection, he was choosing a recognized ruler and the Medicean party. Those who supported the legitimized rule of Alessandro in the name of the Medici included Luigi Guicciardini, Francesco and Palla Rucellai, and Antonio de' Nobili, all of whom became Vasari's patrons. The disobedient,

144 Frey I, iv, p. 15 (Florence, 23 November–5/6 December 1532, to Ippolito, Mantua[?]): "doue ritornando appresso di lei (ancor che qui non mi manchj niente), spero far crescer la uirtu, che cerco acquistare insieme co gl' anni et con la grandezza uostra à quella perfettione che più alto potro ire nell' eccellentia. Et per non deuiare dall'usato ordine . . . accio il disegno col colorito cammini à paro, ho fatto un' cartone per fare un' quadro grande da tenere in camera per la Signoria Vostra Reuerendissima."

disaffected, and profligate Ippolito allied himself with those Florentines who had fought the Medici and who were exiled after the siege of 1529–30 (the *fuorusciti*). He continued to argue his case to the emperor, ever eager to give up the privileges of his ecclesiastical state for the powers of a secular one. This did not earn him the love of his cousin, whom he sought to depose and possibly assassinate.[145] On a visit to the beautiful Giulia Gonzaga at her castle near Itri, Ippolito fell ill and died on 10 August 1535. Rumor suggested he was poisoned on Alessandro's orders.

Vasari's allegiance to Alessandro was very likely encouraged by Ottaviano de' Medici, the duke's distant cousin and treasurer (*depositario*). Ottaviano, Vasari's true friend as well as patron, had an abiding commitment to the image of the Medici, pictorial as well as political. He owned a commemorative portrait of Cosimo il Vecchio by Pontormo, and in 1534 he added to the family gallery, commissioning from Vasari on behalf of Alessandro a portrait of Lorenzo the Magnificent as well as portraits of Alessandro and his sister Catherine. Alessandro and those around him were responsible for re-establishing secure power in Florence, a city devastated by recent events. The population had been cut in half, many buildings ruined, and the countryside laid waste by the war, siege, plague, and famine of 1529–30. While reputedly offending the honor or attending to the pleasures of various well-born ladies of the city, Alessandro also took care to reconstruct, indeed reinforce, its defenses and built a fortress, the Fortezza da Basso, to hold the imperial garrison. The garrison not only represented his military strength but was one of the most convincing arguments for his right to rule.[146] The days of Florentine republican liberty were manifestly over. Vasari's first experience as an architect was a direct result of this fortification and political reorganization: "having noticed that the duke was totally occupied with fortifications and building, I began to work on architectural projects in order to be able to serve him better, and I spent a lot of time on them."[147] Vasari's involvement with Alessandro's affirmation of princely rule is in keeping with his sympathies, which were programmatically elitist, and his desire to be a devoted servant in a flourishing court.

His portrait of his patron can be read as emblematic of both the prince and his painter (pl. 44). Vasari wrote of the armor: "it shines, as should the mirror of the prince so that his peoples and their actions can be reflected in him."[148] This mirror reflects also Vasari's aspirations as a painter. He remembered how trying to achieve the luster on the armor nearly drove him mad. He was rescued from insanity by a lesson in illusionism from Pontormo, who told him that if he took away the real armor he would see that his

145 In a written confession dated June 1535, Bishop Giovanni Battista Cibo confirmed that Ippolito had asked him to kill Alessandro some months before in Rome; see Stephens, "Giovanbattista Cibo's Confession," in *Essays Presented to Myron P. Gilmore*, ed. Bertelli and Ramakus, I, pp. 255–69.

146 For a detailed account of this, see Gianneschi and Sodini, "Urbanistica e politica durante il principato di Alessandro de' Medici," *Storia della città* (1979), pp. 5–34. For a summary with bibliography, see Hale, *Florence and the Medici*. See also Ferrai, *Lorenzino de' Medici*, with numerous documents, and Cummings, *The Politicized Muse*. Vasari ("Giorgio dipintore") is included on the list

of Alessandro's household in July 1535, *Nota delle bocche di casa di sua Ex.ta*, ASF, Carte strozziane, I 13,3 fol. 12v.

147 Description of Vasari's works, BB VI, p. 374: "veggendo io che il Duca era tutto dato alle fortificazioni et al fabricare, cominciai, per meglio poterlo servire, a dare opera alle cose d'architettura, e vi spesi molto tempo."

148 Frey I, x, p. 28 (Florence, 18 August–9 December[?] 1534, to Ottaviano, Florence): "lustranti sono quel medesimo, che lo specchio del principe dourebbe essere tale, che i suoi popoli potessino specchiarsi in lui nelle attioni della uita."

44. Giorgio Vasari, *Alessandro de' Medici*. Florence, Uffizi, Depositi, inv. 1563.

imitations were not as bad as he thought.[149] Vasari held the painting of such reflections to be one of a painter's most difficult challenges, as he was to point out in the Life of Raphael and in his letter to Benedetto Varchi about the arts of design.[150] Similarly, the obvious allusion to Michelangelo's statue of Giuliano de' Medici in the New Sacristy (pl. 50) – dynastic reference and artistic compliment – also served to direct attention to the painter's problem of re-creating a three-dimensional object in two. Vasari here employed distinguished terms to express the comparison of painting and sculpture, or rather to enter the debate on their relative difficulties and merits. The concurrent production of a colored wax image of the duke by the sculptor Montorsoli as an ex-voto for Santissima Annunziata made this comparison a real one for Vasari.[151] And in making an emblematic portrait that required or could sustain verbal elaboration as well as visual appreciation, he was consciously adding a dimension to portraiture. More than a likeness, this emblem of rule with its *storia* or program was also an example in a historical sense. By adding meaning, he amplified the painter's task, adding to his own glory as well as to Alessandro's.[152]

With this portrait Vasari stated his position as ardent Medicean and ducal servant. He was rewarded. Alessandro put him in charge of the decorations for the entry of Charles V into Florence in 1536. Undeniably a major undertaking for a young man, it was one that he discharged punctually and satisfactorily despite the jealousy and eventual defection of the first team of assistants. For this Vasari not only received due credit, but a salary bonus, which he used towards the dowry of one of his sisters.[153]

Alessandro's vigilance for the state was not matched by that for his person it seems. Vasari claimed to have foiled one plot against his life by another Medici cousin, Lorenzo di Pierfrancesco, who tried to engineer the construction of faulty stage scenery during the festivities for the marriage of the duke and his imperial bride Margaret of Austria. Vasari apparently noticed that it would fall on the spectators, including the duke, inevitably crushing everyone to death.[154] It was a time of plot and counterplot. Vasari was not present to defend his duke the night of 6 January 1537 when Lorenzino was successful in assassinating Alessandro in the name of Florentine liberty.

The sudden and violent deaths of his first protectors temporarily shook Vasari's faith in court service and its rewards. He later recalled,

> Now, while I was procuring honor, name, and wealth under Duke Alessandro's protection, the poor lord was cruelly murdered and all that Fortune promised me through his favors was taken from me. On account of having lost in the course of a few years,

149 Description of Vasari's works, BB VI, p. 373.

150 Life of Raphael, BB IV, pp. 188–9, and Frey I, lxxxix, p. 190 (Florence, 12 February 1547, to Varchi, Florence).

151 Campbell, "Il Ritratto del Duca Alessandro de' Medici di Giorgio Vasari," in *Studi* 1981, pp. 339–59.

152 For Alessandro, Vasari, and history, consider his letter to Aretino in which he describes the duke's admiration for Caesar's deeds and the possibility that, in time, Vasari will fill the palace with paintings of those deeds, Frey I, xvi, p. 46 (Vasari in Florence, March 1536, to Aretino, Venice): "Il nostro illustrissimo duca porta tanta affettione à fatti di Iulio Cesare, che se egli seguita in

uita, et io uiuendo lo serua, non ci uà molti anni, che questo palazzo sarà pieno di tutte le storie de fatti, che egli fece mai."

153 See Vasari's letter to Raffaello dal Borgo, Frey I, xvii, pp. 49–50 (Florence, after 29 March 1536, to Raffaello, Borgo San Sepolcro), asking for emergency assistance, and assistants, and to Pietro Aretino in Venice, Frey I, xviii, pp. 52–61 (April) describing the decorations and his triumph. See also the Life of Tribolo, BB v, pp. 206–7, and the description of Vasari's works, BB VI, pp. 374–5.

154 Life of Aristotile da Sangallo, BB v, p. 397.

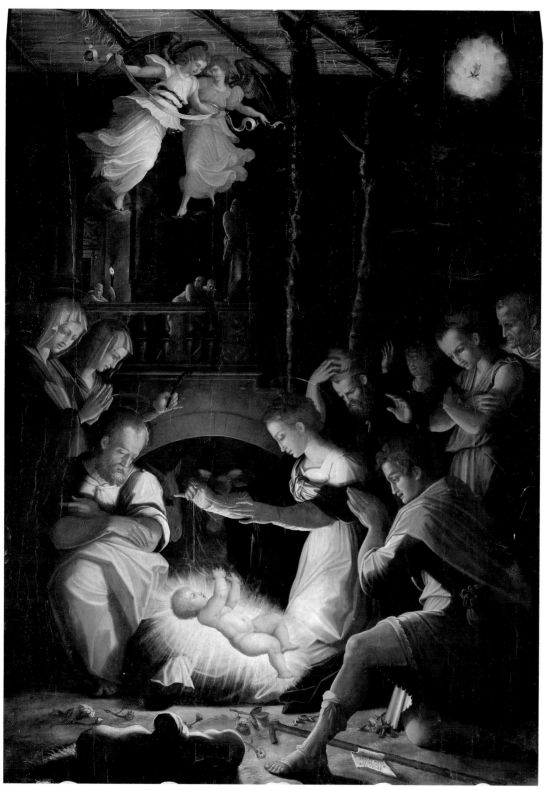

45. Giorgio Vasari, *Nativity*. Monastery of Camaldoli, Church of Sts. Donatus and Hilarion.

46. Giorgio Vasari, *Immaculate Conception*. Florence, Santi Apostoli.

Clement, Ippolito, and Alessandro, I resolved, on messer Ottaviano's advice that I no longer wished to follow the fortune of courts, but that of art alone, even if it would have been easy to have found a position with the lord Cosimo de' Medici, the new duke.[155]

His passion for his profession did not cool despite these disappointments. His apparent retreat to work in the remote monastery at Camaldoli was actually very strategic. This hermitage was frequented by few people, but they were very influential. Vasari had a showcase and no competitors. The monks wanted to decorate their church with a high altar and side altars on a choir screen (pl. 45). Vasari acted with shrewd charity in this commission. He insisted on beginning with a trial piece, a subsidiary altar of the *Virgin and Child with Sts. John the Baptist and Jerome* (1537). He did it without demanding a previously agreed price, a tactic that generated good will and subsequent orders from the Camaldolites. Vasari did not need a general public. He wanted an appreciative patron. And he got what he wanted, catching the attention of the aristocratic Florentine Bindo Altoviti, who went to Camaldoli to supervise the transport of timber for the building of St. Peter's. Bindo gave him a commission for an altarpiece for his family chapel in Florence (pl. 46) and supported him at Cardinal Alessandro Farnese's court in Rome when in the early 1540s Vasari sought to make his way there.

The Farnese court provided the circumstance prompting the writing of *The Lives*, but their contents depended upon the uncommon love that Vasari felt for his fellow artists.[156] He wanted his colleagues to benefit as much as he had from the works and deeds of those he imitated.[157] Far from dispassionate, *The Lives* are a very personal projection of stylistic and social ideals. Central Italian artists are predominant, and artists from other regions are appraised using standards based on the style prevalent in Rome in the 1530s and 1540s when Vasari came to artistic maturity. There the reputations of Michelangelo and Raphael reigned supreme. Those artists had achieved the incorporation of classical models into a modern idiom in a way that had a parallel in the elegant Ciceronian styles of the Roman court humanists: a coincidence of figural and textual vocabulary that Vasari exploited when he turned art into history.

155 Description of Vasari's works, BB vi, pp. 375–6: "Ora, mentre andava procacciandomi sotto la protezione del duca Alessandro onore, nome e facultà, fu il povero signore crudelmente ucciso et a me levato ogni speranza di quello che io mi andava, mediante il suo favore, promettendo dalla fortuna. Per che, mancati in pochi anni Clemente, Ipolito et Alessandro, mi risolvei, consigliato da messer Ottaviano, a non volere più seguitare la fortuna delle corti, ma l'arte sola, se bene facile sarebbe stato accomodarmi col signor Cosimo de' Medici, nuovo Duca." He wrote letters on this theme of retreat, one from Arezzo to Niccolò Serguidi in Florence, Frey i xxxi, pp. 85–7 (6 July[?] 1537), and one from Camaldoli to Pollastra in Arezzo, Frey i, xxxiii, pp. 89–91 (after 1 August 1537).

156 Conclusion, BB vi, p. 409 (1550): "la affezzione, anzi pur lo amor singulare che io ho sempre portato e porto agli operatori di quelle [fatiche] mi avesse già molte volte spronato e stretto a difendere gli onorati nomi di questi da le ingiurie della morte e del tempo."

157 *Ibid.*, p. 413: "Il che, Artefici miei, tanto vi faccia di giovamento quanto a me l'hanno fatto l'opere e' gesti di coloro che io vado imitando nella nostra professione."

III

MEMORY'S ITINERARY:
RESEARCH AND PUBLICATION

THE STORY OF *The Lives* is not a simple one. In March 1550 Vasari wrote to Duke Cosimo de' Medici presenting him with his *Lives of the Artists*, the result not of "two months', but of ten years' labors."[1] In his epilogue to his readers Vasari said that he had scoured Italy for ten years, searching for "the manners, the burial places, and the works" of the artists whose lives he described.[2] The scale of the enterprise, he claimed, was unexpected:

> At the outset I never thought, however, to write such a large volume or to embark on such a wide sea, where in the end I was led against my will by too ardent a desire to satisfy those who long to know about the first origins of our arts, as well as by many fervent persuasions of friends who, because of the love that they bore me, perhaps expected more of me than was within my powers, and by certain patrons' hints, which to me are more than commands.[3]

Vasari's metaphorical voyage from a limited beginning to a large-scale work followed a route charted by the rhetorical convention of affected modesty, meant to elicit sympathetic attention for the argument. The terms of his disclaimer set his efforts within the system of service; they bound the book to its readers with ties of reciprocal desire that Vasari hoped to have satisfied in acquiring and imparting knowledge about artists.

Vasari gives other dates. In the Lives of the Lombard artists, written for the second edition, he says that "until this year of 1566" he had not traveled throughout Italy since 1542, pilgrim research which was a prerequisite to writing in both cases.[4] In his account of his own works, however, he dates the project to dinner conversations at the court of Cardinal Alessandro Farnese in 1546, when he was asked to assist Paolo Giovio with a

1 Frey I, cxxxi, p. 270 (Rome, 8 March 1550, to Cosimo, Pisa): "ui porgho non le fatiche et lo stento di duo mesi, ma quelle di dieci annj."

2 Conclusion of *The Lives*, BB VI, p. 409 (1550): "nel cercare minutamente dieci anni tutta la Italia per i costumi, sepolcri et opere di quegli artefici de' quali ho descritto le Vite."

3 *Ibid.*: "non pensava io però da principio distender mai volume sì largo, od allontanarmi nella ampiezza di quel gran pelago: dove la troppo bramosa voglia di

satifare a chi brama i primi principii delle nostre arti, e le calde persuasioni di molti amici, che, per lo amore che'e' mi portano, molto più si promettevano forse di me, che non possono le forze mie, et i cenni di alcuni padroni, che mi sono più che comandamenti, finalmente, contra mio grado, m'hanno condotto."

4 Lives of the Lombard artists, BB V, p. 409: "dall'anno 1542 insino a questo presente 1566 io non aveva, come già feci, scorsa quasi tutta l'Italia."

treatise about famous artists from Cimabue to modern times. This prompted him to search through and organize all the "notes and writings" that he had made since his youth, "both as a sort of hobby and as a mark of affection for the memory" of his fellow artists in order to put whatever seemed relevant into an ordered account.[5] Vasari insists that he intended to have one of them revise, embellish, and publish it in his own name; just as he offered the final version to posterity as a sketch to be filled in by "whichever happy talent" might be inclined to celebrate the artists with greater style.[6]

His correspondence offers further information about the writing and publication of *The Lives*. The book is first mentioned in a letter dated 27 November 1546 from Paolo Giovio in Rome to Vasari in Florence. Giovio tells him to attend to his book, offering to act as an editor.[7] Giovio continued to receive news and to give advice. In April 1547 he encouraged Vasari to be diligent "in compiling the beautiful book about the famous painters, which will certainly make you immortal." He promised that it would escape the ravages of time, unlike Vasari's recently completed paintings in Naples or his new wife: "for a bride's beauty might fade within a year," as Giovio guaranteed he would realize "before you finish the first part of the book."[8]

The book was already acquiring a reputation. On 10 March Anton Francesco Doni included it in a list of books he intended to print soon, giving a full title: *Le uite de gli artefici, architetti, scultori, & pittori, cominciando da Cimabue fino a tempi nostri, scritte per Giorgio Vasari pittore Aretino, con una introduttione nell'arti del medesimo non meno necessaria che nuoua.*[9] Doni was a talented but temperamental former Servite turned migrant man of letters; he had established a press in Florence in March 1546 with Duke Cosimo's encouragement. Secretary of the Florentine academy, he published twenty books between 1546 and 1547, many by its own members.[10] Vasari's place on Doni's list suggests that his project had support from the Florentine literary world. Indeed, one of its leading lights, Benedetto Varchi, mentioned it in a lecture given to the academy on 13 March.[11]

In May Giovio urged Vasari to "write . . . write," with the incentive of earning greater happiness, glory, and wealth than if he had painted the Sistine chapel, which, he noted, was already suffering damage. Two thirds or more of the book was completed: "the body and the head."[12] The missing parts were soon supplied. By July Giovio was able to congratulate

5 Description of Vasari's works, BB VI, p. 389: "E così messomi giù a ricercare miei ricordi e scritti, fatti intorno a ciò infin da giovanetto per un certo mio passatempo, e per una affezione che io aveva a la memoria de' nostri artefici, ogni notizia de' quali mi era carissima, misi insieme tutto che intorno a ciò mi parve a proposito."

6 Conclusion to *The Lives*, BB VI, pp. 410–11 (1550): "ma solo per lasciare questa nota, memoria o bozza che io voglia dirla, a qualunque felice ingegno che . . . vorrà con maggior suono e più alto stile celebrare e fare immortali questi artefici gloriosi."

7 Frey I, lxxxvii, p. 175.

8 *Ibid.*, xciii, pp. 196–7 (Rome, 2 April 1547, to Vasari, Florence): "La uostra lettera ettuta da filosofo; come spero, che sarete in compilare il bel libro dellj famosi pictorj, qual ui fara al certo immortale: Perche in fatto, le cose che hauete fatto a Monte Holiueto in

Napolj . . . alla fine fine saranno chachabaldole, colsumate dal sanitro e dalle tarle; ma quello che scriuerete, non lo consumera il ladro tempo, qual suole consumare li uisi delle sposate in termine duno anno: E uoj lo conoscerete per proua, hauantj che finisca la prima parte del libro."

9 To Francesco Revesla, Ricottini Marsili-Libelli, *Anton Francesco Doni*, p. 339. From *Lettere del Doni. Libro Secondo* (1547), fols. 61r,v.

10 Ricottini Marsili-Libelli, *Anton Francesco Doni*, pp. 342–56.

11 Published in *Due lezzioni di M. Benedetto Varchi* (1549), see Barocchi ed., *Scritti d'arte*, I, pp. 526–7. For the relation of the academy to *The Lives*, see below, pp. 167–8, 179–85, 290–2.

12 Frey I, xcv, p. 198 (Rome, 7 May 1547, to Vasari, Florence): "Io penso, che quelle frittate di Chiusura non harete gittato lotio indarno senza fare le ghanbe alla

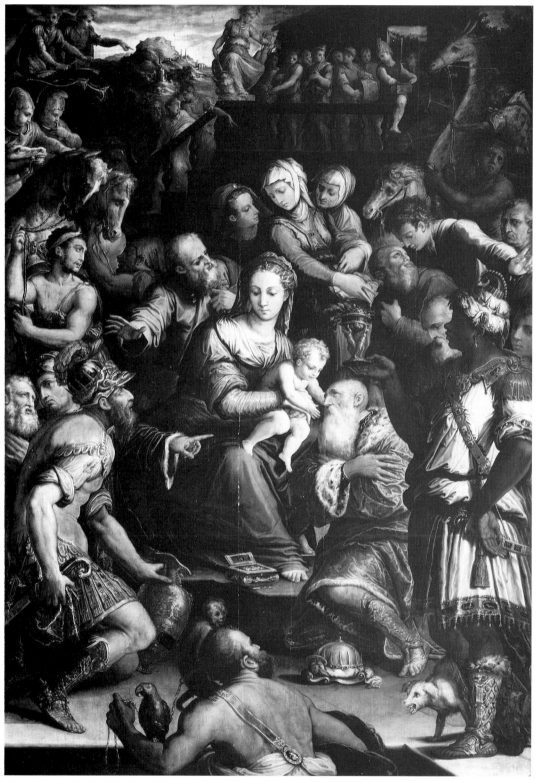

47. Giorgio Vasari, *Adoration of the Magi*. Rimini, San Fortunato.

Vasari on finishing the book. He was looking forward to giving it his formal blessing, sprinkling it with rose water. This could not be done, Giovio said, unless they got together to compare opinions and justify their arguments. He also mentions plans for printing it – either in Rome or with Duke Cosimo's recently established printers in Florence, the Torrentino press.[13]

Vasari never got the chance to take the manuscript to Giovio for such a discussion. On 9 August he had agreed to paint an *Adoration of the Magi* for the Olivetan monks at Rimini (pl. 47), a commission to be finished in Rimini itself, where he also undertook to paint the high-altar chapel of their church, Santa Maria di Scolca. He was lured there by the abbot, Gian Matteo Faetani da Rimini, "a person of culture and talent," who promised to have Vasari's manuscript copied by one of his monks, "an excellent scribe, and to correct it himself."[14]

The book was apparently in draft form in the summer of 1547, not yet ready to be sent for Giovio's criticism or blessing. The learned doctor was still waiting in September: "And as regards your book, I beg you, please put the finishing touches to it and then do whatever is necessary so that I may see it"; in a postscript he recommends that Vasari show his work to Benedetto Varchi.[15] By October Vasari was in Rimini where Doni's associate Lodovico Domenichi wrote to him from Florence with advice about the avarice of publishers and with some hope of assisting with the publication of the book.[16] But even as don Gian Matteo's steady-handed scribe was at work, Vasari must have been making additions. Perino del Vaga died on 20 October and thereby qualified for such immortality as Vasari's pen could confer. His compensation for death was a very long Life.

Giovio waited through November, his anticipation growing.[17] He finally received the book in December and "devoured" it immediately; he noted the few things that struck him and enjoined Vasari to get it printed, assuring him that he would be immortal.[18] Similar enthusiasm and suggestions for minor corrections to what was obviously an impressively finished work came from Annibale Caro, Vasari's other distinguished reader from Cardinal Alessandro's household. He had been sent a part of the text with a table of contents, and

uostra bell opera, pensando, che gia gli abbiate fatto il capo et il corpo. E certo, sarete assaj piu allegro, piu glorioso e piu richo dauer fatto questa bell opera, che se auessi dipinto la capella di Michelagniolo, quale si va consumando con il sanitro et con le fessure. Scriuete, fratel mio, scriuete."

13 *Ibid.*, xcvi, p. 199 (Rome, 8 July 1547, to Vasari, Florence): "mj congratulo, che hauiate condotto el libro al fine . . . Ma a dirui el uero, e neciessario, che io lj dia 1. sbruffata de acqua rosa . . . Et questo non si puo fare, se non ci abbocchiamo insieme per confrontare el iuditio mio con el uostro, comunicando le ragione del perche." For the Torrentino press, see Hoogewerff, "L'editore del Vasari," in *Studi* 1950, pp. 93–104.

14 Description of Vasari's works, BB vi, p. 390: "mi venne alle mani don Gian Matteo Faetani da Rimini, monaco di Monte Oliveto, persona di lettere e d'ingegno, perché io gli facessi alcun'opere nella chiesa e monasterio di Santa Maria di Scolca d'Arimini, là dove egli era abate. Costui dunque avendomi promesso di

farlami trascrivere a un suo monaco, ecc[ellente] scrittore, e di correggerla egli stesso."

15 Frey i, xcvii, p. 200 (Rome, 2 September 1547, to Vasari, Florence): "Et quanto pertiene al libro vostro, vi prego, voglate limarlo et poi di far di sorte, che io lo veda." For a correct reading of the postscript, see Giovio, *Lettere*, ed. Ferrero, ii, no. 279, p. 108: "e fate veder l'opera al Varchi, che la purghi," rather than Frey's "che la inverghi."

16 Frey i, xcix, pp. 202–3 (Florence, 15 October 1547, to Vasari, Rimini).

17 *Ibid.*, ci, p. 206 (Rome, 5 November 1547, to Vasari, Rimini), and ciii, p. 208 (Rome, 19 November 1547, to Vasari, Rimini).

18 *Ibid.*, civ, p. 209 (Rome, 10 December 1547 to Vasari, Rimini): "Io deuorai il uostro libro subito subito, che l'hebbi . . . Io notai quel poco che mi parue et ui conforto a stampare il libro a buon conto . . . State sopra di me, che sarete immortale."

wished to see the rest.[19] Paolo Giovio wrote at the end of January 1548 with more praise, a title (*Le vite de gli excellenti artefici*), and the friendly advice to dedicate the book to Cosimo de' Medici, enclosing a model dedication.[20] He also advised his friend to hire a proofreader.

It seems that even at this point Vasari had not fixed on a publisher. In February don Miniato Pitti wrote to him arguing in favor of the Torrentino press in Florence: "If you have not yet published your history of painting and wish to have it printed, that Fleming who has set up press here has some beautiful founts, quite another thing from Venice and Doni: so think about it."[21] Doni, as he points out, had broken dramatically with Domenichi, whom he denounced as a heretic, before himself fleeing Florence. There was also some delay over the question of the illustrations ("figure"), probably artists' portraits. Giovio advised Vasari, at that time in Ravenna, to go ahead and print without them so as not to lose time and money, continuing to promise that Vasari would achieve honor in life and after death regardless.[22] He was still working on *The Lives* over a year later, hoping for verses from Pietro Aretino, who wrote from Venice in September 1549 to excuse himself from providing them, saying that he was working day and night to prepare his fifth book of letters for publication.[23] Vasari was also expecting epitaphs from Giovanni Battista Adriani.[24] He later wrote that it was Duke Cosimo's wish to have the book, "which was nearly completed," printed, with the result that Vasari gave it to the ducal printer.[25] At that time Vasari had not received any major commissions from Cosimo and this might explain his hesitation in placing the work with the Torrentino press without some positive sign from the duke. Printing had just begun when Pope Paul III died on 10 November 1549. The technical introduction was not yet printed and Vasari feared that he would have to leave Florence without seeing the book through the press, as was in fact the case. During this period Vasari went to Rome hoping for commissions from his former patron, Cardinal Giovanni Maria del Monte, who in his turn was hoping to become pope.[26] Del Monte was elected to the papacy on 8 February 1550, and Vasari included the new Pope Julius III in the dedication of *The Lives*, which was among the last things to be printed.

Any doubts Vasari may have had about Duke Cosimo's favor were offset by the apparently enthusiastic and certainly kind co-operation of his friends in Florence: Cosimo Bartoli, Vincenzo Borghini, Pierfrancesco Giambullari, and Carlo Lenzoni, who supervised the publication of *The Lives* in Vasari's absence.[27] The course of printing can be followed by

19 *Ibid.*, cv, pp. 209–10 (Rome, 15 December 1547 to Vasari, Rimini).

20 *Ibid.*, cvii, p. 215 (Rome, 29 January 1548, to Vasari, Rimini).

21 *Ibid.*, cix, pp. 217–18 (as 22 February 1548, but "el secondo Mercedi di quaresima" was 21 February; addressed to Vasari, Arezzo): "Se uoi non hauete publicato anchora la uostra istoria della pittura et la uogliate stampare, quel Fiammingo che ha ritto la stampa qua ha di bellissime lettere, altra cosa che Venetia et Doni: Siche pensateci."

22 Frey I, cx, pp. 218–19 (Rome, 31 March 1548). See C. Davis and Kliemann in Arezzo 1981, pp. 238–40, for a discussion of these missing figures and convincing arguments that they were portraits.

23 Frey I, cxx, p. 241 (September 1549, to Vasari, Florence).

24 One item in a memorandum about the book from Vasari in Arezzo to Vincenzo Borghini who was taking charge of things in Florence, Frey I, cxxv, p. 257 (before 22 February 1550).

25 Description of Vasari's works, BB VI, p. 396: "disiderando il signor duca Cosimo che il libro delle Vite, già condotto quasi al fine . . . si desse fuori et alle stampe, lo diedi a Lorenzo Torrentino, impressor ducale."

26 *Ibid.*, and Frey I, pp. 225–7, for this sequence of events.

27 For this group, see Frey I, pp. 248–53. For what their work involved, see Bettarini in BB I, pp. xi, xvii–xx, A. Rossi's textual introduction to *Le vite* (1550), ed. Bellosi and A. Rossi, and Trovato, "Notes on standard language, grammar books and printing in Italy, 1470–1550," *Schifanoia* (1986), pp. 84–95.

their letters to him in Arezzo and Rome with progress reports and questions. The first such letter is dated 7 January 1550. From Pierfrancesco Giambullari, it states that work was proceeding well, three printed folio sheets ("forme") a day. The printers had reached signature "PP" of the third alphabet, nearly through the Life of Ghirlandaio (Torrentino, pp. 481–4) and hoped to maintain the pace. The second part was in hand, but Vasari still had to send the dedicatory letter and the beginning of the preface.[28] It is likely that one gathering had been allowed for this introductory material to be inserted later without causing problems, giving Vasari time to deliberate over matters of debt and dedication. The printers wanted to bring out the first two parts in one volume and the third part separately, which Vasari had not foreseen, and Giambullari asked for his consent. He also asked for his opinion about a print made by a German at the press after a drawing by Vasari; the alternative was to send it instead to Venice. In the event the woodcuts for *The Lives* were done in Venice.

Borghini wrote just over a week later saying that he was arranging the index, but had not had time to visit the Torrentino shop recently, although he understood that things were going well.[29] When he did visit on 22 January he collected what had been printed – eighty gatherings. He was not totally satisfied with the way the book was organized, but said that he would confer with Bartoli and Giambullari. The frontispiece was lacking, as was the epilogue. Borghini was inclined to do without the concluding address because the work had grown larger than anticipated, but he allowed that Vasari might want to say a few words by way of apology, and even outlined the topics he might want to cover.[30] Vasari duly enclosed a draft epilogue in a memorandum to Borghini, including the request that he revise, cut, add to, and improve it and then pass it along to Giambullari.[31] He also asked for one page in the chapter on sculpture to be reprinted owing to an error that made nonsense of the text, indicating that he had been given some form of proof copy.[32] He had seen the title page of the third part and insisted that his name go on the title page to the whole work as "Giorgio Vasari, picttore Aretino," admonishing his editors not to do it like "the third part, which does not say that I am a painter, because I am not ashamed of it."[33]

Borghini had clearly taken over as Vasari's principal editor. He prepared the indices and wrote of them as a labor of love in his next letter (22 February).[34] His letters and the efforts on Vasari's behalf that they disclose are the first evidence of the enduring friendship between the scholarly cleric and the artist author. The letter of 22 February particularly shows how Vasari came to rely so much on Borghini. Borghini reassured him about the dedication, which was still causing doubts: "even if it is dedicated as you say, there is no need to change the original plan. Even though the work may be divided in its dedication, it need not be not divided in its content or order, but remains exactly the same."[35] Having read and answered

28 Frey i, cxxii, p. 247.

29 *Ibid.*, cxxiii, p. 254 (Le Campora, 16 January 1550, to Vasari, Arezzo).

30 *Ibid.*, cxxiv, pp. 255–6 (Le Campora, 24 January 1550, to Vasari, Arezzo).

31 *Ibid.*, cxxv, p. 257 (Arezzo or Florence, before 22 February 1550, to Borghini, Le Campora).

32 The page in question is p. 57, of which there are variants, so that a new page was set although those already printed were retained. See A. Rossi in *Le vite* (1550), ed. Bellosi and A. Rossi, pp. xxxiv–xxxvii.

33 Frey i, cxxv, p. 257: "et non fate come nella terza parte, che fa, che io non sia picttore: che non mene vergognio."

34 *Ibid.*, cxxvi, p. 263 (Le Campora, 22 February 1550, to Vasari, Rome).

35 *Ibid.*: "Ma io penso, che anchor che si dedichi, come dite, non bisogna mutarla punto del primo disegno: Che anchor che lopera si diuida nella dedicatione, non si diuide nella materia, ne l'ordine, ne tutto el corpo della cosa, ma rimane el medesimo apunto."

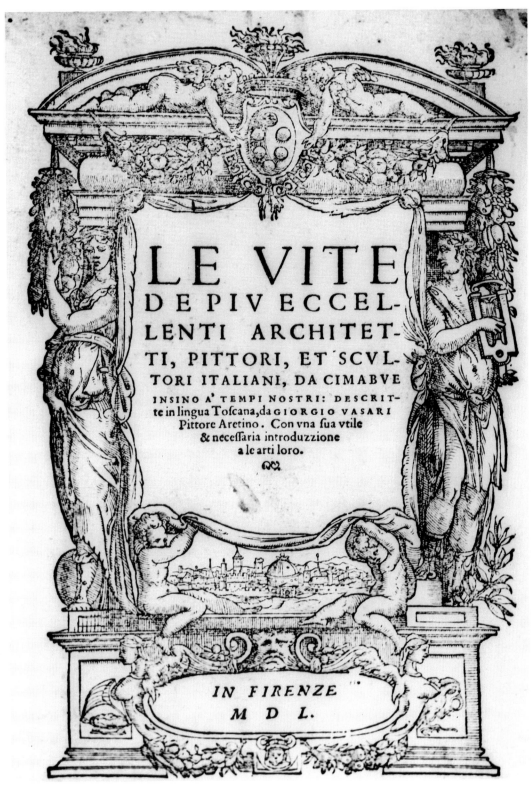

LE VITE
DE PIV ECCEL-
LENTI ARCHITET-
TI, PITTORI, ET SCVL-
TORI ITALIANI, DA CIMABVE
INSINO A' TEMPI NOSTRI: DESCRIT-
te in lingua Toscana, da GIORGIO VASARI
Pittore Aretino. Con vna vtile
& neceſſaria introduzzione
a le arti loro.

IN FIRENZE
M D L.

48. Title page of the 1550 edition of *The Lives*.

49. *Fame and the Arts*,
endpiece to the 1550 edition of
The Lives.

Vasari's letter enclosing the epilogue, Borghini said that he would go to Florence at once
(he was at his country retreat, Le Campora) and get the opinion of Vasari's other friends.

Those friends seem to have been waiting with some perplexity for Vasari's next com-
munication, as he had instructed the press to stop printing. The printers had hoped to finish
within the week, having reached the middle of Michelangelo's Life. Cosimo Bartoli wrote
the following day (23 February) to ask about Vasari's intentions. Two woodcuts had arrived
from Venice, and Bartoli commented that Vasari had been well served.[36] These were
presumably the title page and the woodcut of Fame and the Arts used as the endpiece
(pls. 48, 49).[37] A letter from Vasari, dated 22 February, reached Giambullari on the morning
of 1 March and resolved all the distress and dilemmas. Printing was to proceed, dedicatory

36 *Ibid.*, cxxvii, p. 265 (Florence, 23 February 1550,
to Vasari, Rome).

37 See Kliemann, "Su alcuni concetti umanistici del
pensiero e del mondo figurativo vasariani," in *Studi*
1981, pp. 73–82, for the engraving of the Arts, probably
planned as a frontispiece but moved to the end of the
book because it did not leave room for the title, as
Giambullari pointed out: "che respetto a la sua grandezza

non ui lasciaua accomodare titolo" (Frey I, cxxxii,
p. 273 [Florence, 15 March 1550, to Vasari, Rome]).
Kliemann, pp. 74–5, argues that the arts are given
gestures and poses reminiscent of the Fates. They are
also reminiscent of figures by Michelangelo, notably
Sculpture, whose position resembles that of the Libyan
sibyl in the Sistine chapel.

letter and epilogue in place, prefatory or concluding verses honoring Vasari to be omitted by the unanimous decision of Vasari's editors who were "desirous that people go for the wine and not the tavern sign."[38] Only the proofreading remained to be done. Answering a letter from Vasari on 8 March, Bartoli said that, in order to serve his friend, he would begin that evening and work without stopping or sleeping until it was finished.[39]

Tiresome details of correction, indexing, and title pages continued to cause delays, but by 15 March, Giambullari predicted that the book would be ready in eight days.[40] Borghini wrote on 17 March that it had been printed, and he had delivered the index, which he felt had been finished with diligence (he was in a position to know).[41] He was working on the table of errors, but with discretion, not wanting to point out too many defects as that would be more likely to diminish than to enhance the book's good name. On 29 March Giambullari wrote with somewhat peevish grace that the book was at last finished, "and with that tiny addition that you wanted, which lost us several days"; binding remained, but copies would be sent as soon as possible and Giambullari added that he would be extremely pleased should it bring Vasari honor and "bear good fruit."[42]

That Vasari saw to harvesting the rewards of his efforts with dispatch is indicated by a list on the back of a letter from Bartoli dated 5 April 1550.[43] It names the noteworthy people to whom he wished to send copies of *The Lives*. The recipients were to be Annibale Caro, the pope's brother Balduino del Monte, Cardinal Giovanni Salviati, Cardinal Alessandro Farnese, Cardinal Ridolfo Pio da Carpi, the cardinal of Burgos Francesco Mendoza Bodavilla, Cardinal Georges d'Armagnac, Michelangelo, Bindo Altoviti, Alfonso Cambi, Duke Guidobaldo of Urbino, and Charles V's ambassador Don Diego Hurtado de Mendoza. He sent a copy to Cosimo with an accompanying letter of supplication reiterating his service of twenty-two years and devotion to the house of Medici and expressing his hope for even the smallest favor or sign of pleasure from the duke.[44] By such acts and with this book he was demonstrating his belief in the power of publication as declared in the Life of Alberti:

> With respect to increasing fame and reputation it can be seen to be true that among all things writings have both the greatest force and the longest life, considering that books readily travel everywhere and win trust as long as they are truthful and without lies; by these means any country can know of a person's worth, talent, and admirable virtues more effectively than by means of manual works, which can only rarely move from where they have been placed.[45]

38 Frey i, cxxviii, p. 267 (Florence, 1 March 1550, to Vasari, Rome): "noi non ce ne uogliamo per questa uolta, desiderando, che gli uominj corrino a'l vino et non a la frasca."

39 *Ibid.*, cxxx, p. 269 (Florence, 8 March 1550, to Vasari, Rome).

40 *Ibid.*, cxxxii, pp. 272–3 (Florence, to Vasari, Rome).

41 *Ibid.*, cxxxiii, p. 274 (Le Campora, to Vasari, Rome).

42 *Ibid.*, cxxxvi, p. 280 (Florence, 29 March 1550, to Vasari, Rome), he excused himself for not having written a few days earlier: "Non perche ella non sia finita del

tutto et con quella breuissima aggiunta che ui ê piaciuta, laquale ci ha tolto parecchi giorni; ma perche io ueggo tanto adietro le legature de' libri . . . sarammi bene sommamente grato lo intendere, che uoi ne siete onorato, et che e' partorisca qualche buon frutto."

43 *Ibid.*, pp. 282–3. For this list, see C. Davis in Arezzo 1981, p. 222, and for a description of the completed book and the known copies, see the introduction to *Le vite* (1550), ed. Bellosi and A. Rossi.

44 Frey i, cxxxi, pp. 270–1 (Rome, 8 March 1550, to Cosimo, Pisa).

45 Life of Alberti, BB iii, p. 284 (1550): "E vedesi per il vero, quanto a lo accrescere la fama et il nome,

This text helps to explain the intended frontispiece to his book, the image of Fame and the Arts (pl. 49), put instead at its conclusion. His writing could "travel everywhere" as an agent of artistic excellence.

Research: "since my youth"

The writing and publication of *The Lives* was certainly not the work of two months, but what of the ten years referred to by Vasari in his statement to Cosimo? In part this is a familiar device meant to indicate the difficulty of a chosen subject. The great effort and expense that Vasari said he devoted to his work have a direct parallel in the time, discomfort, and dangers that Machiavelli claimed were involved in the production of *The Prince*, for example. And following classical precedents Leonardo Bruni made the particular difficulty of history a topic of the prologue to his *History of Florence*. But the starting date of 1542 mentioned in the Lives of Lombard artists and Vasari's reference to his habit of collecting notes since his youth are both specific and plausible. What then inspired him to make these notes? How did his affection turn archival? And how did the process of gathering information over time affect the shape of his history?

In his book of *ricordanze* he noted on 6 May 1529 that he spent two months in the house of Vittorio Ghiberti where he went to study the art of painting at a cost of two *scudi* a month.[46] There were other lessons to be learned in the Ghiberti household. While there the eighteen-year-old Vasari began his career as a collector of professional souvenirs. He bought drawings attributed to Vittorio's great-grandfather Lorenzo Ghiberti, Lorenzo's stepfather Bartoluccio, Giotto, and others. In the 1568 edition of Ghiberti's Life he says that he had always venerated these drawings for their beauty and for the recollection of such great men. He adds, with some regret, that, "had he known then what he knew now," being close friends with Vittorio he could easily have acquired many other very beautiful things.[47] This is quite likely. Vittorio seems to have been parting with his patrimony. He had given Matteo Bartoli his father's commonplace-book (*zibaldone*), which Vasari's friend Cosimo Bartoli inherited when his father died in 1525. At some point the Bartoli family also came to own a manuscript of Lorenzo Ghiberti's book about the arts, his *Commentaries*.[48] The archive Vittorio was dispersing was a distinguished example of its kind and seems to have spurred

che fra tutte le cose gli scritti sono e di maggior forza e di maggior vita, attesoché i libri agevolmente vanno per tutto e per tutto si acquistan fede, purché e' siano veritieri e senza menzogne; per il che qualunque paese può conoscere il valore dello ingegno e le belle virtù di altrui molto più che per le opere manuali, che rare volte posson mutarsi da quel luogo ove elle son poste." The statement is retained in the second edition with modification and amplification about the relationship between theory and practice.

46 Frey II, p. 849, no. 24: "Ricordo, come a di 6 di Maggio 1529 io andaj a stare inn casa di Vettorjo Ghibertj, cittadino Fiorentjno, per atendere a studiar larte del dipignere per prezzo di [scudi] dua il mese: che tantj fummo dacordo insiemj. Stetti in casa sua mesi dua."

47 Life of Ghiberti, BB III, p. 104: "E se quando io aveva stretta amicizia e pratica con Vettorio io avessi quello conosciuto che ora conosco, mi sarebbe agevolmente venuto fatto d'avere avuto molte altre cose che furono di Lorenzo, veramente bellissime."

48 Mancini, "Cosimo Bartoli (1503–1572)," *Archivio storico italiano* (1918), pp. 88–9. Bonaccorso Ghiberti's *Zibaldone* is in the Biblioteca Nazionale, Florence, Magl.XVIII.2. It has a note on the first page: "Questo libro fu donato da Vectorio Ghiberti a Matteo di Cosimo Bartoli il quale morto, tochò a me suo figlio nelle divise di noi fratelli e figliuoli di Matteo decto." The manuscript of the *Commentaries* is Biblioteca Nazionale, Florence, II, I, 133, inscribed "Di m. Cosimo di Matteo Bartoli no. 65."

Vasari to start his own collection. The drawings he purchased beginning at that time are probable visual sources for some descriptive passages in *The Lives*. The Ghirlandaio shop also kept papers he eventually consulted.[49] Vasari, who could trace his ancestors in art back only to saddle painters and ceramic-makers, may well have been impressed by those workshops descended from the great and grand masters of their arts whose records made a glorious past both immediate and available to him. He acknowledged writings by Ghiberti and Ghirlandaio as among his sources, but the careful process of dissecting, checking, and adapting them undoubtedly dates from the mid-1540s when the project of *The Lives* was formally underway. In the late 1520s the importance of such *scritti* (Vasari's word for Ghiberti's *Commentaries*) was in providing a model for memory. Ghiberti, following the chapters on painters and sculptors in Pliny the Elder's *Natural History* listed a succession of masters, describing representative and remarkable works. This form was used by subsequent Florentines making notes about artists. It fits into a tradition of writing about famous men and their deeds. The biographical rather than topographical model seems to have guided Vasari in his note-taking.[50] Although his visual memory may have summoned up works in their places, and he is often very precise about sites, he did not recall or record everything in each place he visited. Instead he remembers works by those masters he had taken the trouble to see and to study.

The unsettled years of the Medici exile, of changing Florentine governments, of siege and plague between 1529 and 1532 left Vasari little time for calm reflection on artistic matters. But when he joined Cardinal Ippolito de' Medici's household in Rome in January 1532 and returned to his study of art he also began to develop his skills as a writer, producing elaborate formal letters addressed to his benefactors and literary acquaintances. These mainly survive in a manuscript in the Biblioteca Riccardiana in Florence, which is a collection of copies made by Giorgio Vasari the Younger, possibly with the intention of publishing a selection of his uncle's letters to famous men. His intervention must be recognized in reading them as his selection and editing imposed a *post facto* stylistic and thematic coherence on the group.[51] Still, the fact that the original drafts were part of Vasari's literary legacy is an indication of their importance to him in formulating and publicizing his professional identity. He did so in terms of study, obligation, and honor. With this correspondence he placed his ambitions within the framework of favors and friendship offered by court patronage, hoping to secure his place even as he defined it by representing his patrons to themselves as beneficent, loving, and generous. In these essays, he traced the progress of his studies and, as proof of his diligence, in each letter he offered his reader a description of a work in progress or recently delivered. The form of description, an exposition of the subject through the placement and action of the principal figures, followed the most famous account of an ancient painting – Lucian's of Apelles' painting of calumny.[52] As he wrote Vasari was manifestly creating his own history, and doing so by wedding the description of

49 Mentioned in the letter to the artists, BB vi, p. 411, and in the 1568 edition of the Life of Michelangelo, BB vi, p. 6.

50 For these contexts, see Fletcher, "Marcantonio Michiel," *Burlington Magazine* (1981), p. 603.

51 Riccardiana MS 2354, see the discussions by Scoti-Bertinelli, *Giorgio Vasari Scrittore*, pp. 137–41, and

by C. Davis in Arezzo 1981, pp. 206–7. An additional three letters addressed to Pietro Aretino (Frey xiv, xxi, xlvi) are known from a publication of *Lettere scritte al Signor Pietro Aretino* (1552; colophon 1551), i, pp. 260–8.

52 See Massing, *La Calomnie d'Apelle*, for translations of Lucian into Italian and for the influence of the passage on calumny.

his paintings to episodes in his life. He was also practicing and perfecting the "true form of writing well" associated with such letters.[53]

Manuals of letter writing provided readily available models of proper address for all purposes and according to rank and station.[54] Courteous exchange demanded ornate speech, but Vasari's formal letters are more than copybook exercises in the conventions of greeting and supplication. They are ambition made literary. Combining, in various ways, pictorial invention with anecdote, autobiography, and moral reflection, they aspire to a status beyond necessity. With them the painter sought a place in the discourse of civility established between those who shared the "profession of studies" and their patrons.[55] Classical letter collections, particularly Cicero's book of *Epistolae ad familiares*, but also those by Seneca and Pliny the Younger, were distinguished and oft-referred-to models, inspiring and legitimizing the culture of correspondence among learned men, first in Latin, but increasingly in the sixteenth century in the vernacular. Private in address, but public in purpose, such rhetorically contrived letters were among the most fashionable literary genres of the sixteenth century and were a favored means of using writing to promote and manipulate reputation. In a letter published in 1547 Claudio Tolomei wrote to Pietro Aretino that Aretino's beautiful letters had not only manifested his love and goodness, but had bettered any mirror in bringing his image to life in Tolomei's mind.[56]

Vasari, too, was successful in creating flattering reflections of himself in this mirror of mutual admiration. In June 1536 Pietro Aretino saluted his compatriot Vasari as a "historian, poet, philosopher, and painter" when thanking him for his description of the decorations made for Charles V's entry into Florence.[57] This letter was included in Aretino's book of letters, published in 1538. Aretino was the first to print his own collection in the vernacular, and his success created a precedent soon to be followed by many others, including Claudio Tolomei, and repeatedly by Aretino himself. Vasari's inclusion among Aretino's correspondents may have inspired him to continue to write such set pieces, possibly with a view to publication. He wrote two of his longest letters to Aretino describing the festive entries into Florence of the emperor Charles V and later that of his illegitimate daughter, Margaret of Austria; the latter was printed with two others in a volume of letters to Aretino in 1552.[58]

53 For example, Manuzio, *Lettere volgari di diversi nobilissimi huomini, et eccellentissimi ingegni* (1544), published as examples of "la vera forma del ben scrivere" (p. ii).

54 Miniatore, *Formulario ottimo & elegante, il quale insegna il modo del scrivere lettere messive & responsive, con tutte le mansioni sue a li gradi de le persone convenevoli* (1531). For these formularies, see Longo, "L'arte di 'componer letter' nel Cinquecento," in *Le "Carte messaggiere,"* ed. Quondam, pp. 177–201, and Clough, "The cult of Antiquity: letters and letter collections," in *Cultural Aspects of the Italian Renaissance*, ed. Clough, pp. 49–61.

55 The phrase "profession di studii" occurs in a letter from Aretino to Claudio Tolomei, *Lettere sull'arte di Pietro Aretino*, ed. Pertile and Camesasca, I, cxvii, p. 188 (23 May 1541).

56 Tolomei, *De le lettere*, Book ii, p. 36v (8 April 1541): "che pensate c'habbiano fatto le uostre amoreuoli, e belle, e purgate lettere? ne le quali ho cosi riconosciuto l'amore, e la bontá uostra, che nissuno specchio cosi ben rappresenta l'imagine altrui, come queste dinanzi a la mente mia u'hanno uiuamente rappresentato."

57 Frey I, xxii, p. 70 (Venice, 7 June 1536, to Vasari, Florence): "sete historico, poeta, philosopho e pittore." For Vasari's letter of 3 June 1536, see Frey I, xxi, pp. 65–9. For a reconstruction of Vasari's correspondence with Aretino, see *Lettere sull'arte di Pietro Aretino*, ed. Pertile and Camesasca, III, pp. 503–11.

58 Frey I, xviii, pp. 52–61 (Florence, 28[?] April 1536, to Aretino, Venice), and Frey I, xxi, pp. 65–9 (Florence, 3 June 1536, to Aretino, Venice), and *Lettere scritte al Signor Pietro Aretino*, I, pp. 260–8, for the latter, which was probably edited by Aretino for publication in this collection.

His correspondence with Aretino not only called upon Vasari's skills of visual to verbal transcription, but also provided him with new models for such writing. In a clever, and typical, piece of rhetorical display Aretino more appropriated than answered Vasari's letter about Charles V's entry, turning Vasari's observation to his own experience: "I see for myself" ("Io per me veggo"), he said, and repeated the verb "I see" throughout to conjure up the sequence of sights along the processional route. The contrivance of indirect, yet immediate vision, was a device Aretino often used to enhance the power of his descriptions. By emphasizing the paradox of things "seen with words" he called attention to its resolution through his eloquence.[59] The devices employed are those of demonstrative oratory, where vivid images served to make arguments convincing and memorable. Aretino uses appropriately compelling embellishments of style: accumulation, repetition, comparison, interrogation, and exclamation. He exhorts his readers to participate in a particular experience and to respond as he had, usually with amazement (stupore). With this rhetoric of appreciation, Aretino mediated between the eyes and the intellect in a way intended to point out and parallel the artifice of imitating life.[60]

Vasari adopted these techniques in The Lives. Aretino's letters were among the writings that he collected and consulted for descriptive strategies as well as for Aretino's elegantly formulated opinions on artists and their practices. Vasari closely followed a paragraph of praise that Aretino included in a letter to Giulio Romano in the preamble to Giulio's Life.[61] He also transferred a hyperbole that Aretino wrote to him on the "head of one of the advocates of the glorious Medici house" to his description of the statue of Giuliano de' Medici in the New Sacristy of San Lorenzo (Aretino's letter was a response to drawings of the Medici tombs sent to him by Vasari). Aretino exclaims of the head:

> What a luxuriant beard, what locks of hair, what a forehead, what arched eyebrows, what eye sockets, what a shape for the ears, what a profile for the nose, and the cut of the mouth! It is impossible to say how it expresses the feelings that make it breathe with life; it is impossible to imagine the manner in which the finished work appears to look and listen in silence.[62]

59 In a letter to the sculptor Niccolò Tribolo, Aretino describes how the architect Sebastiano Serlio "m'ha fatto vedere con le parole" the beauties of a Pietà by Tribolo (Lettere sull'arte di Pietro Aretino, ed. Pertile and Camesasca, I, xliv, p. 73 [29 October 1537]).

60 The conjunction of the eyes and intellect occurs in the same letter to Tribolo where Aretino goes on to describe Titian's Martyrdom of St. Peter and how, when they looked at it, "fermati gli occhi del viso e le luci de l'intelletto in cotal opera, comprendeste tutti i vivi terrori de la morte e tutti i veri dolori de la vita ne la fronte e ne le carni del caduto in terra" (ibid.). For Aretino's methods, see Land, "Titian's Martyrdom of St. Peter and the 'Limitations' of Ekphrastic Art Criticism," Art History (1990), pp. 207–17.

61 Lettere sull'arte di Pietro Aretino, ed. Pertile and Camesasca, I, cxlii, p. 215 (June, 1542; published in the second book of letters, Il secondo libro de le lettre [1542], pp. 507–8). This is discussed in Lettere sull'arte, III, pp. 512–13, and by McTavish in Arezzo 1981, pp. 108–10.

In the 1550 edition Vasari credited Aretino (as "a great friend" of Duke Federico Gonzaga) with introducing Giulio to the duke of Mantua in Rome; in the 1568 edition this is changed to Baldassare Castiglione (the duke's ambassador; BB V, p. 65). Vasari also referred to Aretino's play La Talanta for Raphael's Life, see below Chapter IX, pp. 375–6. For a general consideration of Aretino's influence on Vasari, see Venturi, "Pietro Aretino e Giorgio Vasari," in Mélanges Bertaux, pp. 323–38.

62 Lettere sull'arte di Pietro Aretino, ed. Pertile and Camesasca, I, x, p. 25 (Venice, 15 July 1535, to Vasari, Florence), also Frey I, xiii, p. 35: "Che berli di barba, che ciocche di capegli, che maniera di fronte, che archi di ciglia, che incassatura d'occhi, che contorno d'orecchie, che profilo di naso e che sfenditura di bocca! Non si può dire, in che modo ella accordi i sentimenti che la fanno viva; non si può imaginar con che atto ella mostri di guardare, di tacere e d'ascoltare." The head ("testa d'uno de gli auocati de la gloriosa casa de i Medici") was identified by Gottschewski as a model of

50. Michelangelo, *Giuliano de' Medici*. Florence, San Lorenzo, New Sacristy.

Vasari takes up the enumeration of parts to express the whole. The statue of Duke Giuliano was so proud a figure "with the head, the throat, the setting of the eyes, the profile of the nose, the opening of the mouth, and the hair all so divine, to say nothing of the hands, arms, knees, and feet and in short everything that he carved therein that the eye can never be weary or have its fill of gazing at them" (pl. 50).[63] In continuing his description of the sculptures in the sacristy, Vasari questions what he can say: "And what can I say of Night, a statue that is not only rare, but unique?"[64] The play of inexpressible and unimaginable

the head of St. Damian in the New Sacristy ("Der Modellkopf von der Hand Michelangelos im Besitze des Pietro Aretino," *Monatshefte für Kunstwissenschaft*, [1909], p. 399).

63 Life of Michelangelo, BB VI, p. 57: "il duca Giuliano, sì fiero, con una testa e gola, con incassatura di

occhi, profilo di naso, sfenditura di bocca, e capegli sì divini, mani, braccia, ginoc[c]hia e piedi; et insomma tutto quello che quivi fece è da fare che gli occhi né stancare né saziare vi si possono già mai."

64 Life of Michelangelo, BB VI, p. 58: "E che potrò io dire della Notte, statua non rara ma unica?"

suggested by Aretino's passage became a keynote to Vasari's Life of Michelangelo, for him, as for Aretino, a god. Aretino's sophisticated and sensuous descriptions, which made the lifelike vivid, were an important influence on Vasari's descriptive repertoire throughout *The Lives*.

The creation of a literary identity was obviously not Vasari's primary concern as it was Aretino's, but his letters demonstrate that from early on writing was integral to his perception of his career and that he saw how painting might be translated to prose to ingratiate his efforts. With them he established a place, however minor, in the realm of letters. He also established explicit links in his own life between the great abstracts of honor, fortune, obligation, and diligence and the specifics of artistic invention that he later incorporated in the lives of other artists.

His study of those lives was far from abstract. Vasari's regard for his profession was an active one, based on constant association with other artists and the realities of his practice. His affection was conditioned by this as were the circumstances of his curiosity: what he cared to see, where he was, for how long, and with what contacts. It is well to remember that he collected information "as a hobby," only later shaping it to history.[65] This retrospective purpose imposed a deceptive unity and authority on material gathered unsystematically over a number of years. There are a variety of voices in the text; some are the sources Vasari subordinated to his scheme: "they say," "it is said." These register local traditions, answers to questions Vasari asked as he found out about current opinions, looked at esteemed masters, sought out friends, enjoyed good stories, and cast a critical eye at the competition.

The Life of Perino del Vaga demonstrates the extent and nature of Vasari's accumulation of sources. It must have been written soon after Perino died in October 1547 when Vasari was in Rimini polishing up his manuscript, which was sent to Paolo Giovio in December. This detailed Life was, therefore, necessarily generated from existing drawings, notes, and memories. Vasari's haste is indicated by blanks left to be filled in: the date of the flood that damaged the *Deposition* in Santa Maria sopra Minerva ("che venne a Roma l'anno MD . . .") and the name of the official who commissioned an altarpiece for the Pisa cathedral ("messer . . .").[66] Yet it was complete enough when first written to need very few additions or corrections for the second edition and to have served as the basis for all subsequent biographies of Perino.[67] It was the fourth longest biography in the 1550 *Lives*; only Raphael's, del Sarto's, and Michelangelo's Lives were longer. Vasari enthusiastically celebrated Perino's style and readily exploited the pun of his adopted surname Vaga and the adjective *vaga* (charming) to invoke what he felt were the principal qualities of that style: grace (*grazia*) and loveliness (*leggiadria*). He had followed Perino's career since his own arrival in Florence in 1524 where he encountered the excitement stirred by Perino's recent visit (1523), whose souvenirs, like the drawing for the *Martyrdom of the Ten Thousand*, he

65 Description of Vasari's works, BB VI, p. 389, when asked by Cardinal Alessandro to help Giovio with his proposed history of the arts, Vasari consulted his "ricordi e scritti, fatti intorno a ciò infin da giovanetto per un certo mio passatempo."

66 Life of Perino del Vaga, BB V, pp. 121, 143. In 1568 the first was completed to read "doppo il Sacco" (the flood was on 8 October 1531) and the "operaio" of

Pisa cathedral is identified as Antonio di Urbano. The good and bad thieves, two fragments of the *Deposition*, are now at Hampton Court, see Shearman, *The Early Italian Pictures in the Collection of Her Majesty the Queen*, nos. 192, 193, with a discussion of the flood damage.

67 See Parma Armani, "Per una lettura critica della vita di Perino del Vaga," in *Atti 1974*, pp. 605–21.

sought out and copied (pls. 30, 33). His second contact was directly with Perino's works in Rome, those done in the Vatican among Raphael's assistants and subsequently as an independent master until the sack of Rome in 1527. These, too, are carefully chronicled; most likely from copy drawings that Vasari made in his self-appointed apprenticeship to Raphael and his school. Details about the workings of that shop were available to him from his friendship with Giovanni da Udine, his visit with Giulio Romano in 1541, and from Perino himself. That some of Perino's works done during his second stay in Rome in the 1540s are given more summary attention, listed but not always fully described, is probably owing to the fact that Vasari did not study them with such care. He knew about them as a co-professional and a competitor, he knew where they were and for whom they were done, and included that information. It is also owing to the fact that some were painted by Perino's assistants after his designs. Vasari saw these through his own recent experience. He tells how, in his later years, Perino preferred designing works to executing them, with consequent loss of quality due to too great a reliance on assistants; here he drew a moral not only from Raphael, Perino, and Giulio but from his own frantic campaign of decorating the great hall of the Cancelleria in the late spring of 1546 (pls. 20, 63, 64). Under pressure to complete it in one hundred days,

> a great number of painters were employed to paint it, who departed so far from the outlines and true form [of the cartoons] that I made a resolution, to which I have adhered, that from that time onward no one should lay a hand on any works of mine. Whoever, therefore, wishes to ensure long life for his name and his works, should undertake fewer of them and do them all by his own hand, if he desires to obtain that full measure of honor that a man of exalted genius seeks to acquire.[68]

Vasari's identification of himself with Perino is further indicated by the fact that in the first edition of the Life he finds a chance to bring in his principal assistant, Gherardi, by naming him as a gifted painter who came to see Perino in Rome, but decided that he did not want to work with him.[69]

The two other places in Perino's career that are given significant attention are Genoa and Pisa. Perino was in Genoa between 1528 and 1537/8. Vasari gives a brief, but deliberate description of Perino's decoration of the Palazzo Doria there. He did so according to the general arrangement of the palace and the paintings rather than their order of exectuion, so as not to be confusing about the best of all of Perino's works, he said.[70] His progress through the palace follows the ceremonial route that was part of its plan;[71] but in this case Vasari's itinerary was not Perino's. There is little evidence that he ever visited Genoa.[72] And though

68 Life of Perino del Vaga, BB v, p. 155: "vi si messe tanti pittori a colorirla, che diviarono talmente da' contorni e bontà di quelli, che feci proposito, e così ho osservato, che d'allora in qua nessuno ha messo mano in sull'opere mie. Laonde chi vuol conservare i nomi e l'opere, ne faccia meno e tutte di man sua, se e' vuol conseguire quell'intero onore che cerca acquistare un bellissimo ingegno."

69 *Ibid.*, p. 157.

70 *Ibid.*, p. 137: "il quale più brevemente che io potrò m'ingegnerò di descrivere, con le stanze e le

pitture et ordine di quello, lasciando stare dove cominciò Perino prima a lavorar[e], acciò non confonda il dire quest'opera, che di tutte le sue è la migliore."

71 Gorse, "Triumphal Entries into Genoa During the Sixteenth Century," in *Art and Pageantry in the Renaissance and Baroque*, ed. Wisch and Munshower, pp. 197–9.

72 For a discussion of this, see Sborgi, "La cultura artistica in Liguria attraverso le *Vite*," in *Atti* 1974, pp. 623–36, and for the possibility that Paolo Giovio might have been a source, Parma Armani, *L'anello mancante*, pp. 85–6.

orderly, his tour of Palazzo Doria is generalized. Of the many inscriptions, he quotes but one. Of the various paintings, he gives few specific subjects. As it happened, one of Perino's chief assistants on the project – Prospero Fontana – was one of Vasari's in Rimini. The Genoese section of the Life is likely based on what he heard from Fontana and perhaps some drawings related to the project in Fontana's possession.[73] Some of the details about Pisa (Perino's purchase of a house, his distracting amours, and his distraught wife) may also derive from Fontana. For those relating to Perino's designs for an altarpiece and wall decorations for the duomo that were left incomplete, however, biography and auto-biography are explicitly mixed. Perino's aborted commission was part of a program to renovate the duomo, for which Vasari supplied two altarpieces, as he notes.[74] Vasari probably learned about previous dealings between Perino and the duomo authorities in the course of executing his own commissions.

Vasari's associations with Perino were varied. Direct and indirect, they spanned more than twenty years. They formed different levels and layers of memory suddenly called upon to commemorate Perino in 1547. At that time Vasari could refer to drawings, and probably prints, he had collected. He is expansive on the qualities of Jacopo Caraglio's engravings of the loves of the gods done after Perino's drawings and their similarity to Perino's drawing style.[75] Vasari could further enhance his memories with Prospero Fontana's. The one piece of deliberate research for Perino's Life was finding out about his burial: he quotes the epitaph on his tomb in the Pantheon.

Recollection was part of Vasari's training. By June 1538 when he felt he had completed his education on the monuments of Rome, he had hundreds of drawings after ancient sculpture and architecture and modern artists. He wrote that he derived pleasure and profit from them for many years afterwards, consulting them to refresh his memory.[76] His portfolio included also copies from a "book of antiquities, drawn and measured by Bramantino, in which there were Lombard things and the plans of many noteworthy buildings."[77] The book belonged to the goldsmith and gemcarver Valerio Belli, whose dies for medals, magnificent paxes, and a splendid cross for Paul III are remembered in a Life of a few

73 See Davidson, *Mostra di disegni di Perino del Vaga* (Uffizi, 1966), no. 20, pp. 28–9, Uffizi 907 S, for a drawing attributed to Fontana, copied from studies by Perino for figures in the atrium spandrels of Palazzo Doria. For the career of Fontana (1512–97), see Fortunati Pietrantonio ed., *Pittura Bolognese del '500*, pp. 339–414 (pp. 339–40 for Genova).

74 Life of Perino del Vaga, BB v, p. 146. Perino is documented as "dipintore in Pisa" in July 1534, and at this time he purchased a house there. For Perino in Pisa, see Parma Armani, *L'anello mancante*, pp. 153–4. For the duomo project, see Ratti and Cataldi, "La pittura in Duomo dal Cinque al Seicento," in *Livorno e Pisa*, pp. 407–44, and for an analysis of Vasari's compressed, but reasonably accurate history of the various commissions for the duomo, see Popham, "Sogliani and Perino del Vaga at Pisa," *Burlington Magazine* (1945), pp. 85–90. For Vasari's work, see Frey ii, pp. 859–60, no. 134 (9 October 1532), for a *Virgin and Child with saints*, delivered on 15 July 1543, and Frey ii, p. 865, no. 171 (7

May 1547), for a *Pietà with saints*, probably commissioned in 1543. For this project, see also C. Davis in Arezzo 1981, pp. 58–9. Six *putti* by Perino remain. Vasari's altarpieces were destroyed in a fire in 1594. The *Pietà* is known from a print by Enea Vico. The series of commissions also features in the 1550 edition in the Life of Giovanni Antonio Sogliani, who took over Perino's altarpiece commission, and the complicated affair is further detailed in the 1568 edition of that Life, BB iv, pp. 442–4.

75 Life of Perino del Vaga, BB v, p. 136.

76 Description of Vasari's works, BB vi, p. 377: "de' quali ebbi poi piacere et utile molti anni in rivedergli e rinfrescare la memoria delle cose di Roma."

77 Lives of Lombard artists, BB v, p. 432 (1568): "Onde mi ricordo aver già veduto in mano di Valerio Vicentino un molto bel libro d'antichità, disegnato e misurato di mano di Bramantino, nel quale erano le cose di Lombardia e le piante di molti edifizii notabili, le quali io disegnai da quel libro, essendo giovinetto."

sentences in the 1550 edition, half of which is given over to remarks about his avid collecting of ancient sculptures, plaster casts of works both ancient and things, and drawings by excellent masters.[78] Vasari did not describe Bramantino's drawings in the first edition, but he looked at those few paintings by Bramantino that were called to his attention in Milan and mentioned them in a paragraph inserted in the Life of Piero della Francesca.[79] These various inclusions and omissions reveal some causes and consequences of memory's selections. His original study of Belli's book of antiquities is entirely consistent with Vasari's formation and the antiquarian interests of Ippolito's court that so inspired him. These in turn led to Belli's inclusion in The Lives. Gemcarvers, as Vasari points out, were among the most successful imitators of ancient art. Their precious works were highly valued by Vasari's patrons. In the 1550 edition the Lives of these artists are basically a few sentences tributary to the taste of Ippolito de' Medici and his cousin Cardinal Giovanni Salviati who owned crystals engraved by Giovanni da Castel Bolognese and the Farnese, Pope Paul III and Cardinal Alessandro, who had objects by Belli. Notable as well is the existence of an artist's collection and the importance that Vasari gave it as an aspect of Belli's fame. Vasari's consultation of Belli's collection put Bramantino's name into his catalogue of curiosity, so that he made an effort to find out about an artist whose name survived in Rome and was attached to an object of his own study.[80] He recorded the results of that research, but not, in the first instance, any notice of the drawings so carefully copied and extensively described in the second edition. It is possible that he did not have them among his notes when writing in Florence and Rimini in 1547. It is also possible that he did not view them as relevant to the painted works he chose to mention in his brief record of a painter who was "excellent in his day."[81]

78 Life of Valerio Belli, BB IV, pp. 626–7.

79 Life of Piero della Francesca, BB III, pp. 259–60. In the second edition he returned to Bramantino in the Lives of the Lombard artists and wrote of him as the one who had brought good drawing to Milan and added an expanded description of his works (BB V, pp. 431–3). In the Life of Baccio da Montelupo, Vasari wrote of the tomb of Gaston de Foix in Santa Marta in Milan begun by Agosto Milanese (Bambaia): "oggi rimasta imperfetta; nella quale si veggono ancora molte figure grandi e finite, e me[z]ze fatte et abbozzate, con assai storie di me[z]zo rilievo in pezzi e non murate, con copia grandissima di fogliami e di trofei" (BB IV, pp. 293–4). This and a phrase about Bramantino's Dead Christ that he had seen on the portal of San Sepolcro ("Et ho veduto in Milano"; BB III, p. 260, now in the Pinacoteca Ambrosiana, Milan) are the only direct indications that Vasari went to Milan before the trip documented in 1566. Kallab, Vasaristudien, p. 254, reasonably suggests that Vasari went there in 1541/2 on his way to or from Venice. The few traces left in the 1550 Lives show his attention focussed on Leonardo da Vinci's Last Supper at Santa Maria delle Grazie (BB IV, pp. 25–7) and Bramantino. At Santa Maria delle Grazie he also notice a Resurrection by Bernardino da Triviglio (Zenale) in the cloister (Life of Bramante, BB IV, p. 75, destroyed in World War II). Otherwise he learned about Marco d'Oggiono's Death of the Virgin and Marriage at Cana at Santa Maria della Pace (Life of Leonardo, BB IV, p. 38, as follower of Leonardo) and Gaudenzio Ferrari's Last Supper at Santa Maria della Passione (Life of Pellegrino da Modena, as a contemporary of Pellegrino's, BB IV, p. 338). He seems to have stopped at San Francesco where he noted the Bambaia tomb for the Birago family (BB IV, p. 294) and the chapel painted by Zenale with the deaths of Saints Peter and Paul (Life of Bramante, BB IV, p. 75, destroyed in 1688; the church was destroyed in 1807), glanced at the duomo and saw "some very beautiful things in marble" by Niccolò Lamberti there (Life of Lamberti, BB III, p. 35: "nel Duomo fece di marmi alcune cose bellissime"), and perhaps gone to the Certosa at Pavia (preface to The Lives, BB II, p. 27; Life of Perugino, BB III, p. 605, Life of Correggio, BB IV, p. 56, for Andrea del Gobbo [Solario]). He took no interest in Bramante's architecture in Milan.

80 Vasari's other source of interest in Bramantino was Paolo Giovio, whose museum included portrait heads copied from frescoes attributed to Bramantino in the room in the Vatican palace known as the Stanza d'Eliodoro. According to Vasari, they were destroyed when Raphael painted the Liberation of St. Peter and the Mass at Bolsena, but Raphael had copies made, which later went to Giulio Romano who gave them to Paolo Giovio (Life of Piero della Francesca, BB III, p. 259 [1568]).

81 Life of Piero della Francesca, BB III, p. 259: "pittore ecc[ellente] de' tempi suoi."

The habit of study served Vasari well, and he did not relinquish it even after he was a recognized master. Thus when he received the commission in February 1539 to paint the refectory of the church of San Michele in Bosco in Bologna, he took time to tour the city to see its "most famous paintings" before beginning his own work there.[82] In the course of his stay until May 1540 he visited more than twenty churches and religious foundations, not always liking what he saw. He was contemptuous of the pervasiveness of Amico Aspertini whose daubs were visible at every turn.[83] Five Lives (Galasso Ferrarese, Ercole Ferrarese, Francesco Francia, Alfonso Lombardi, Girolamo da Treviso, Properzia de' Rossi) and the grouped account of the Romagnoli (Bartolomeo da Bagnacavallo, Amico Aspertini, Girolamo da Cotignola, Innocenzo da Imola) were later written in great part from this stay. Bolognese sources account for much of Parmigianino's Life and Bolognese works are mentioned in the Lives of Jacopo della Quercia, Filippino Lippi, Perugino, Raphael, and Giuliano Bugiardini. Vasari pursued the familiar – Central Italian masters and artists, like Alfonso Lombardi, another protégé of Cardinal Ippolito and Duke Alessandro de' Medici.[84] He also looked at dominant masters, especially those whose works of the 1520s and 1530s preceded his own at San Michele in Bosco (Bagnacavallo, Girolamo da Cotignola, Biagio Pupini, and Lombardi). Friends there, such as Prospero Fontana, a student of Innocenzo da Imola, could have acted as guides to things that were "much praised" or "held beautiful." Local pride influenced his itinerary at least to the extent of directing his attention to works by Francesco Francia. The city's pre-eminent artist of the late fifteenth and early sixteenth century, Francia had been celebrated by Bolognese humanists, and his fame, compared to that of Polygnotus, Phidias, and Apelles, had been attached to the city's honor.[85] Francia's is the most detailed Life of a Bolognese artist. Vasari mentions around thirty paintings in Bologna and elsewhere, which indicates a form of quest, as well as discussing Francia as a goldsmith. One of Vasari's acquaintances in Bologna, Girolamo Fagiuoli (Faccioli), was also a goldsmith and may have suggested an interest in this part of Francia's activity. Having set out to see some of Francia's altarpieces, Vasari's task was made easier by the fact that many were signed. His identification of the oeuvre is relatively accurate, if not complete; but even when he wrote the biography he did not intend to produce a catalogue, and in 1539–40 his tribute to Francia's memory was a function of professional courtesy not historian's zeal.

Vasari was impressed by Francia's productivity and his reputation and used these as linking mechanisms in Francia's biography whereby his numerous paintings spread his fame, resulting in more commissions until "cities competed to have his works."[86] Vasari was less

82 Description of Vasari's works, BB VI, p. 378: "ma prima volli vedere tutte le più famose opere di pittura che fussero in quella città, di Bolognesi e d'altri."

83 Lives of the Emilian painters, BB IV, p. 497 (1550): "per ogni chiesa, strada, spedale, cantone e casa, ogni cosa è di suo o di terretta o di colori imbrattato."

84 Life of Alfonso Lombardi, BB IV, pp. 411–12; Vasari purchased a head by Lombardi on behalf of Ottaviano de' Medici.

85 For Francia's reputation see Baxandall and Gombrich, "Beroaldus on Francia," Journal of the Warburg and Courtauld Institutes (1962), pp. 113–15, Foratti, "Note su Francesco Francia," L'archiginnasio (1914), pp.

160–73, Romano, Storia dell'arte italiana, VI.1, pp. 51–2, and Malvasia, Felsina Pittrice (1678), I, pp. 48–50, for a section of tributes to Francia. Vasari had contact with Bolognese literary circles through his "great friend" there, the eminent jurist and historian Andrea Alciati, who supplied a Latin inscription for the refectory at San Michele (Description of Vasari's works, BB VI, p. 379). Alciati may have been the source of the Latin verse Vasari quoted in Raphael's Life about the St. Cecilia (BB IV, p. 186–7).

86 Life of Francia, BB III, p. 587: "facevano le città a gara per aver dell'opere sue." For some corrections to Vasari's Life relating to paintings by Francia sent to

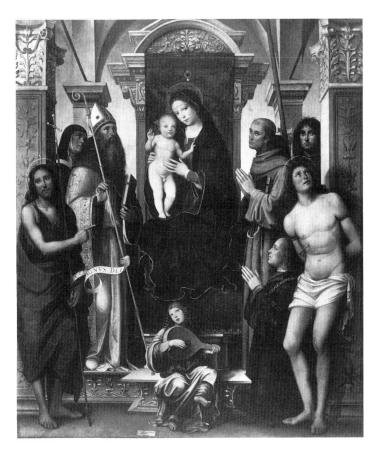

51. Francesco Francia, *Virgin and Child with Sts. John the Baptist, Monica, Augustine, Francis, Proculus, Sebastian, and a Portrait of the Donor, Bartolomeo Felicini*. Bologna, Pinacoteca Comunale.

impressed by the works themselves. In Michelangelo's Life his hero calls Francia a dolt ("goffo") for seeming to value materials more than artistic skill.[87] What the Bolognese praised, Vasari found at best "worked in oil with the utmost diligence" or regarded as "very well done" (pl. 51).[88] He turned Francia's career into an example of misguided conceit. The moral of the Life, expressed in its opening sentence, is that in any profession it is always very harmful to be presumptuous and not pay heed to the fact that others' works can far surpass one's own.[89] In Vasari's construction of the case Francia's self-esteem becomes his fatal error. Stimulated by Bolognese praise for Francia heard in Rome, Raphael and Francia struck up a friendship by letters and eventually Raphael entrusted the unpacking of his *St. Cecilia* altarpiece for San Giovanni in Monte in Bologna to Francia, modestly requesting that

Modena and Reggio Emilia, see Roio, "Intorno alla vasariana 'gara delle città' per Francesco Francia," *Antichità viva* (1991), no. 3, pp. 5–16.

87 Life of Michelangelo, BB VI, p. 32; in the 1550 edition Francia is paired with Cossa as "due solennissimi goffi nell'arte." In the 1568 edition Francia alone is the target, but Vasari adds further anti-Bolognese anecdotes to Michelangelo's repertory.

88 Life of Francia, BB III, p. 584, *Virgin and Saints* painted for Bartolomeo Felicini in Santa Maria della Misericordia (now in the Pinacoteca Comunale, Bologna): "lavorata a olio con grandissima diligenza"; the *Annunciation* for the church of the Annunziata (now in the Pinacoteca Comunale, Bologna): "tenuta cosa molto ben lavorata."

89 *Ibid.*, p. 581 (1550): "Di gran danno fu sempre in ogni scienza il presumere di sé e non pensare che l'altrui fatiche possino avanzar di gran lunga le sue."

"should he see any error, he would, as a friend, correct it."[90] Francia, instead, "seeing his own error and the foolish presumption of his mad belief, sickened with grief and within a short time, died."[91] Francia may have died suddenly, but he did so at least a year after Raphael's panel was installed in its chapel at San Giovanni in Monte.[92] Vasari's affecting story is a product of his own historical logic, it served the larger narrative of *The Lives* as a whole rather than the details of one Life. Francia, whose works look more like Perugino's than Raphael's, was given a place in the scheme just before Perugino, concluding the era before the glories of the modern age and necessarily eclipsed by them. That, at any event, is how Vasari saw them in 1539–40 and commemorated them in 1550.

Vasari's various citations and descriptions of paintings such as Francia's can broadly be classed according to two kinds of recollection: generic and specific. Certain types of images, and Francia's belong in this category, were inherently memorable, for they were themselves meant to appeal to memory. The compositional formulas of traditional altarpiece design with hieratically arranged figures, symmetrically placed saints, and standard attributes were the simple, shared language of devotion. Vasari, like any contemporary viewer, was fluent in these signs and their combinations. They were part of his own production as a painter and were also convenient stencils for memory, such as a basic enthroned Virgin with two figures on each side of Francia's Felicini altarpiece (pl. 51).[93] To mark differences in the genre, Vasari recalled enhancements or deviations from pattern, which were therefore remarkable: donor portraits, like that of Bartolomeo Felicini, or the musical angels in the altarpiece Francia painted for Giovanni Bentivoglio.[94] Another way of differentiating was through his judgment, as in the case of Girolamo da Treviso, who "painted a panel in oil of a Madonna and some saints in San Domenico in Bologna, which is the best of his things."[95] Occasionally Vasari mistakes a subject by remembering it through an analogous pattern, as in Francia's murals in the oratory of St. Cecilia where he identifies the marriage of St. Cecilia as the marriage of the Virgin, forgetting the context of the paintings in the cycle, remembering instead the pattern of marriage and its most famous application.

Specific memory applies to those things given longer descriptions. In the case of Francia, Vasari's most engaged description is a dramatic reconstruction of a destroyed work – Judith in the act of killing her drunken, somnolent enemy and debaucher, the giant Holofernes. The vivid passage is a clue that such word pictures depend on some form of visual note, a drawing made or collected as a record of a striking subject or accomplishment. Perhaps not coincidentally there are at least four versions of a finished drawing by Francia showing

90 *Ibid.*, p. 590: "conoscendoci alcuno errore, come amico lo correggesse."

91 *Ibid.*, pp. 590–1: "conoscendo qui lo error suo e la stolta presunzione della folle credenza sua, si accorò di dolore e fra brevissimo tempo se ne morì."

92 Francia died in January 1517. The chapel at San Giovanni was completed in 1516. Raphael's painting is generally dated to 1514–16, see *L'Estasi di Santa Cecilia*, pp. 29–30. For a concise, documented biography of Francia, see Giudici's entry in *Bologna e l'umanesimo 1490–1510*, ed. Faietti and Oberhuber, pp. 358–60.

93 Life of Francia, BB III, p. 584 (1550): "una Nostra Donna a sedere sopra una sedia con due figure per ogni lato."

94 *Ibid.*: "Giovanni Bentivogli . . . gli fece fare in una tavola una Nostra Donna in aria e due figure per lato con due Angioli da basso che suonano" (in San Giacomo Maggiore). The "figures" are Sts. Augustine, Proculus, John the Evangelist, and Sebastian. Vasari might have deduced its patronage from the painting's inscription: IOHANNI BENTIVOLO II FRANCIA AURIFEX PINXIT.

95 Life of Girolamo da Treviso, BB IV, p. 450: "Fece in San Domenico di Bologna una tavola a olio di una Madonna et alcuni Santi, la quale è la migliore delle cose sue," as opposed to the *Virgin and Child with Saints* in San Salvatore, which Vasari found to be weak: "che fu veramente la più debole che di suo si vegga in Bologna" (BB IV, p. 450).

Judith and her maidservant with the head of Holofernes. Two are on vellum: one is in the Pierpont Morgan Library and the other is in the Louvre.[96] The known drawings do not correspond to Vasari's description, as they depict a moment after Holofernes is killed, but one might have served for dramatic embellishment and indicates how Francia's name could be closely identified with the subject. One of the longest descriptions of a work in Bologna is that of Ercole de' Roberti's *Crucifixion* in the Garganelli chapel in San Pietro.[97] Later writers quoted Michelangelo's praise for this fresco; a tradition that suggests and confirms its renown. Vasari saw many "noteworthy things" ("cose notabili") in its contrasting figures of pathos and impiety and his circumstantial account suggests that he took notes. His concentration may also have been encouraged by the fact that he had just finished the cartoon of a Deposition for the high altar of Camaldoli, and pondered some of the same motifs, particularly the fainting Virgin and attendant Maries.

Listening as well as looking, his images of artists depended on verbal memory. He collected stories about them: the crazed, loquacious Amico Aspertini or the foppish Alfonso Lombardi. The latter, in love with himself and seeking to make love to a noble lady, summoned Petrarch to his cause and asked her "If this is not love, then what is it that I feel?"; "Probably some sort of louse" was her reply, soon famous throughout Bologna.[98]

Verbal slips account for some of Vasari's more notable confusions. Lorenzo Costa became Cossa, and in the first edition of *The Lives* his career was conflated with that of another Ferrarese, Francesco del Cossa, in spite of the fact that signed Costa works are cited. Similarly, Vasari created one Ercole Ferrarese from two: Ercole Grandi (1462–1531), who worked with Costa in Bologna, and Ercole de' Roberti (*c*.1456–96), who was probably a student of Francesco del Cossa. Although inaccurate about identifying them, he had a predeliction for the Ferrarese in Bologna and also went to Ferrara where he visited Garofalo.[99] The nature of his curiosity on this trip to the north of Italy is recollected in the 1568 Life of Girolamo da Carpi in which he wrote of a *Venus and Cupid* by Girolamo in the ducal palace of Ferrara, subsequently sent to King Francis I in Paris: "I saw it in Ferrara in 1540, and can truly state that it was most beautiful."[100] At this point he was a witness to beauty, a painter not a historian.

As a painter Vasari was not happy among the local artists, he says, because they thought that he might want to stay and deprive them of commissions, so that they tried to make his

96 Life of Francia, BB iii, p. 585. For the drawings, see Bean and Stampfle, *Drawings from New York Collections*, i: *The Italian Renaissance*, no. 12, p. 25. See also *Bologna e l'umanesimo 1490–1510*, ed. Faietti and Oberhuber, no. 66, pp. 260–1.

97 Life of Ercole Ferrarese, BB iii, pp. 420–1. Now destroyed, for a reconstruction see Manca, "Ercole de' Roberti's Garganelli Chapel," *Zeitschrift für Kunstgeschichte* (1986), pp. 147–64, and Manca, *The Art of Ercole de' Roberti*, pp. 116–26, cat. nos. 12, 13. Copies were made of parts of the paintings in the fifteenth and sixteenth centuries, see Manca 1986, p. 148, and in his catalogue, pp. 119–21. In the 1550 edition, the identification of the site, San Pietro, is correct, in 1568 it is changed to San Petronio.

98 Life of Alfonso Lombardi, BB iv, p. 410: "'S'amor non è, che dunque è quel ch'io sento?' Il che udendo la gentildonna, che accortissima era, per mostrargli l'error suo, rispose: 'E' sarà qualche pidocchio'. La quale risposta essendo udita da molti, fu cagion che s'empiesse di questo motto tutta Bologna e ch'egli ne rimanesse sempre scornato." Lombardi's lovelorn question is the first line of Petrarch's sonnet 132. Barolsky, *Mona Lisa*, p. 36, discusses this with respect to Vasari's petrarchism, suggesting that it is Vasari's literary invention for the character of Lombardi. It could equally have been part of Lombardi's own courtly self-invention, deflated by both his scornful would-be mistress and Vasari. For Aspertini, see the Lives of the Emilian painters, BB iv, pp. 498–9.

99 Lives of the Lombard artists, BB v, p. 414.

100 *Ibid.*, BB v, pp. 417–18: "et io, che la vidi in Ferrara l'anno 1540, posso con verità affermare ch'ella fusse bellissima."

life uncomfortable, naming particularly Girolamo da Treviso and Biagio Pupini. However, according to Vasari, "they gave more trouble to themselves than they did to me. I laughed at their passions and their behavior."[101] His annoyance emerged directly in *The Lives* in his lukewarm assessment of Girolamo da Treviso and Biagio Pupini and indirectly in the experiences of the young Ercole from Ferrara (Ercole de' Roberti). Described by Vasari as modest, extremely talented, and also industrious, he went to Bologna where he studied day and night. Reclusive in his work habits, he was, according to Vasari, "greatly hated in Bologna by that city's painters, who, out of jealousy, have always hated outsiders brought in to work there, and occasionally behave also the same way in their rivalries among themselves."[102]

Vasari made jealousy the theme of the opening to his grouped Lives of Bartolomeo da Bagnacavallo, Amico Bolognese (Aspertini), Girolamo da Cotignola, and Innocenzo da Imola, who became examples of artists whose mutual envy, "which fed on arrogance rather than glory, caused them to stray from the right path that leads to eternity those who strive valiantly for fame rather than rivalry."[103] None of them fares very well in the eternity Vasari chose to grant them. He describes them as distinctly second rate, doing what seemed good to them: "but in truth they did not attend to particular artistic skills as one ought."[104] Such inattention was tolerated because their patrons were ignorant of anything better. Further proof of this lack of taste occurs in the case of Giuliano Bugiardini, for Vasari a generally laughable artist, but a Florentine whose *Virgin and Child with Saints* for a chapel in the choir of San Francesco in Bologna was praised in the city because of the dearth of good masters there.[105] And those who came to Bologna were not well received. He accused the Spedale della Morte's officers of failing to recognize the "opportunity sent to them by the good Lord" when Bugiardini's gifted student Francesco Salviati produced a design for an altarpiece for the hospital while he was staying with Vasari in the spring of 1539.[106]

101 Description of Vasari's works, BB VI, p. 379: "non cessavano d'inquietarmi: ma più noiavano loro stessi che me, il quale di certe lor passioni e modi mi rideva."

102 Life of Ercole Ferrarese, BB III, p. 422: "fu molto odiato in Bologna dai pittori di quella città, i quali per invidia hanno sempre portato odio ai forestieri che vi sono stati condotti a lavorare; et il medesimo fanno anco alcuna volta fra loro stessi nelle concorrenze." For Ercole's character and studiousness, see BB III, p. 420 (1550).

103 BB IV, pp. 493–4 (1550 text): "quella invidia che l'un l'altro si portarono, nutrita più per superbia che per gloria, li deviava da la via buona, la quale a la eternità conduce coloro che, valorosi, più per il nome che per le gare combattono."

104 *Ibid.*, p. 495: "ma nel vero non attesero all'ingegnose particolarità dell'arte come si debbe." For the consequences of Vasari's distasteful experience for the subsequent treatment of Bolognese painters, see Dempsey, "Malvasia and the Problem of the Early Raphael and Bologna," in *Raphael Before Rome*, ed. Beck, pp. 66–7.

105 Life of Bugiardini, BB v, p. 280.

106 Life of Salviati, BB v, p. 518: "ma con tutto che il Salviati ne facesse un bellissimo disegno, quegl'uomini come poco intendenti, non seppono conoscere l'occasione che loro aveva mandata messer Domenedio di potere avere un'opera di mano d'un valent'uomo in Bologna." This was possibly related to the commission for which Girolamo da Treviso provided a design and was also disappointed (Life of Girolamo da Treviso, BB IV, p. 451): "Avvenne che per Bologna si diede nome di fare una tavola per lo Spedale de la Morte; onde a concorrenza furono fatti varii disegni." Jealousy is part of this story, and Girolamo's sense of injury was given by Vasari as the reason for his departure for England (dated to *c.*1538). To make his point Vasari overstates his case with respect to Salviati and the Bolognese. Salviati painted an altarpiece of the *Virgin and Child with Six Saints* for the Camaldolite monastery of Santa Cristina. See Mortari, *Francesco Salviati*, p. 108, cat. no. 4, and p. 211, cat. no. 257, for a preparatory study in Linz, Graphische Sammlung des Stadtmuseum (Inv. Nr. S 70). See also Voss, "Kompositionen des Francesco Salviatis in der italienischen Graphik des XVI Jahrhunderts," *Die graphischen Künste* (1912), p. 34, for the prints produced after Salviati drawings left in Bologna, mentioned by Vasari (BB v, p. 518).

What Vasari found to admire were Raphael's *St. Cecilia* (pl. 143) and paintings by Parmigianino – imported works that confirmed rather than broadened his taste. Vasari notes that it was said of Parmigianino in Rome that "Raphael's spirit had passed into [his] body," a compliment to Parmigianino's rare gifts, his gracious manners, and devotion to the study of Raphael.[107] Vasari had probably come to admire this Raphael reincarnate early on. As a boy he had seen Parmigianino's youthful self-portrait in a mirror, at that time in Pietro Aretino's house and apparently a tourist attraction in Arezzo.[108] Cardinal Ippolito owned several small panels by Parmigianino, described by Vasari as "truly marvelous."[109] In addition, Parmigianino had been in Bologna for the coronation of Charles V and had painted a spectacularly large portrait of the emperor crowned by Fame.[110] All these works are referred to in Parmigianino's Life, which was based largely on his career in Rome and Bologna. In fact, while Vasari was in Bologna he bought a painting by the artist on behalf of Ottaviano de' Medici, and also one for himself, an unfinished painting of the Virgin.[111] Parmigianino, by his very name not Bolognese, was a particularly attractive artist for Vasari, who sought out his paintings and other traces of his career while in that city. He lists works held by private owners, including friends of Parmigianino. He mentions both drawings and prints, otherwise rarely cited in the 1550 edition. His diligent pursuit of Parmigianino at this time was part of his own continuous study for self-improvement – the search for models and motifs for emulation.[112] But it also provided him with information that subsequently proved useful.

The year 1542 was the one Vasari later associated with travel research for *The Lives*: probably a reference to his second trip to North Italy. Between August 1540 and late 1541 he was in Florence, where he painted the altarpiece of the *Immaculate Conception* for the Altoviti chapel in Santi Apostoli (pl. 46). In December 1541, at Pietro Aretino's request, he went to Venice to produce the setting for Aretino's Carnival play, *La Talanta*. "Forced," he said, by Aretino's great desire to see him, he also went "willingly in order to see the works of Titian and of other painters"; on the way he saw, in the space of a few days, "Correggio's works in Modena and in Parma, Giulio Romano's in Mantua, and Verona's antiquities."[113]

107 Life of Parmigianino, BB IV, p. 536: "lo spirito del qual Raffaello si diceva poi esser passato nel corpo di Francesco."

108 *Ibid.*: "il ritratto dello specchio mi ricordo io, essendo giovinetto, aver veduto in Arezzo nelle case di esso messer Pietro Aretino, dove era veduto dai forestieri che per quella città passavano come cosa rara."

109 *Ibid.*: "molti quadretti che fece in Roma, la maggior parte de' quali vennero poi in mano del cardinale Ipolito de' Medici . . . veramente maravigliosi."

110 *Ibid.*, p. 542. A painting corresponding to Vasari's description was formerly in the Cook collection, Richmond. Its status as copy or unfinished original has been debated, see *The Age of Correggio and the Carracci*, pp. 172–3, no. 62.

111 For Ottaviano's painting, see Frey II, p. 857, no. 102: "Appresso a di 20 di Maggio 1540 spesi per luj [Ottaviano] a Bolognia in un quadro di mano di Francesco Mazzola Parmjgiano [scudi] quindicj, il qual quadro mandaj incassato et bene aconcjo per mano di Stefano Veltronj." For the one owned by Vasari, see the

Life of Parmigianino, BB IV, p. 541: "Abbozzò anco un quadro d'una Madonna, il quale fu poi venduto in Bologna a Giorgio Vasari aretino, che l'ha in Arezzo nelle sue case nuove e da lui fabricate, con molte altre nobili pitture, sculture e marmi antichi."

112 See McTavish, "Vasari and Parmigianino," in *Studi* 1981, pp. 135–44.

113 BB VI, pp. 381–2: "Perciò che chiamato a Vinezia da messer Pietro Aretino . . . fui forzato, perché molto disiderava vedermi, andar là; il che feci anco volentieri per vedere l'opere di Tiziano e d'altri pittori in quel viaggio. La qual cosa mi venne fatta, però che in pochi giorni vidi in Modena et in Parma l'opere del Correggio, quelle di Giulio Romano in Mantoa, e l'antichità di Verona." Vasari's interest in the latter might have been piqued by the fact that one of his assistants at San Michele in Bosco, the Veronese painter Giovanni Caroto, provided drawings for Sarayna's *De amplitudine ciuitatis Veronae* (1540) as Vasari mentioned in his brief notice about Caroto in the Life of Fra Giocondo (BB IV, pp. 573–4).

As he traveled he was still probably observing out of ambition and enthusiasm rather than with any determined project of writing. As in Bologna he listened to local gossip and legend: hearing of Parmigianino's interest in alchemy and Correggio's family cares. He was attentive to the perception of artists and their reputation, collecting anecdotes, judgments, praise, and poems (such as verses about Giovanni Bellini by Bembo and Ariosto). He enquired about what was most praised or most worthy of note; that is how his recollections were later registered in *The Lives*. Painting dominated Vasari's interest. As a result there are almost no buildings or sculptures and therefore almost no architects or sculptors described in the relevant parts of *The Lives*. He seems to have been indifferent to works by fourteenth-century artists in that region, and consequently they have virtually no place in the 1550 edition. Antonio Veneziano is the only one granted a full biography; but he is included as an example of an immigrant artist, a Venetian who made his career in Florence to his eventual credit in his birthplace. Vasari was most likely evaluating what he came across with a very pragmatic eye to his own work, sizing up the competition and locating useful sources and contacts. He recalled north Italian artists in terms of competition and imitation, as in the collective account of Carpaccio and other Venetian painters that he grouped together as dependent on Giovanni Bellini's style in Part 2, or in Pordenone's rivalry with Titian.

The brief, but intense visit with Giulio Romano was the portion of his journey that was most productive of memories for *The Lives*. He stopped there on his way to Venice. Warmly received by Giulio, for four days Giulio "never left his side, showing him all his works, and especially all the plans of the ancient buildings of Rome, Naples, Pozzuolo, Campania, and all the other best antiquities . . . drawn partly by him and partly by others. Afterwards, opening a huge cupboard, he showed him [Vasari] plans of all the buildings done after his designs and order."[114] Giulio's collection of measured drawings probably dated to his time in Raphael's shop, and were related to Raphael's plan to produce a map of ancient Rome, a plan revived by Tolomei and the Vitruvian academy. Giulio's cupboards produced other souvenirs of Raphael. Giulio, with Giovanni Francesco Penni, was heir to Raphael's workshop effects, as Vasari noted in Raphael's Life. While in Mantua he saw a self-portrait sent to Raphael by Albrecht Dürer as part of their friendly exchange.[115] There were probably also those writings by Raphael Vasari credited in *The Lives*, perhaps including his will and the letter to Leo X about the plan of Rome.

Vasari toured the recently completed Palazzo del Te – giving its layout in Giulio's Life, where he wrote as though going from one room to the next ("One then arrives in a room that is on the corner of the palace," "Next one passes . . .").[116] As he went through the rooms in his memory he confused the order, so it seems that he was not working from a map or groundplan. He generalized about the "various histories" and interpreted the subjects

114 Life of Giulio Romano, BB v, p. 79: "per quattro giorni non lo staccò mai, mostrandogli tutte l'opere sue e particolarmente tutte le piante degli edifizii antichi di Roma, di Napoli, di Pozzuolo, di Campagna, e di tutte l'altre migliori antichità di che si ha memoria, disegnate parte da lui e parte da altri. Dipoi, aperto un grandissimo armario, gli mostrò le piante di tutti gl'edifizii che erano stati fatti con suoi disegni et ordine."

115 Life of Raphael, BB iv, p. 190: "Era questa testa fra le cose di Giulio Romano, ereditario di Raffaello, in Mantova."

116 Life of Giulio Romano, BB v, p. 68 (1550): "Arrivasi poi in una stanza, ch'è sul canto del palazzo" (Psyche); "Si passa poi in una camera." See Hartt, *Giulio Romano*, I, p. 124, n. 23, for Vasari's mistakes in the order and identification of rooms.

through their principal figures, such as "a Bacchanal with a Silenus" in the room depicting the story of Psyche.[117] Throughout his record is of his admiring wonder at the inventions and possible inspirations, not a detailed explanation of the subjects or the scheme. Although he later returned to Mantua and his 1568 description of the palace is more precise, he did not change the order or even the basic sequence of impressions. The most detailed passage in the earlier edition is about a ceiling he interpreted as showing Icarus plummeting from the sky. In the Palazzo del Te, the fall is instead Phaeton's. In this case he combined his memory of the ceiling with looking at a *modello* drawing of the *Fall of Dedalus and Icarus* that he owned and whose motifs he studied for his ceiling of *Virtue, Fortune, and Envy* in the Sala del Camino in his house in Arezzo, painted in 1548. There Virtue's outstretched arms and splayed legs with the left one bent are taken from the dramatic pose of Giulio's Dedalus (pls. 52, 55).[118] As with Parmigianino, Vasari was interested in Giulio's drawings. He wrote that "drawing for him was like writing for a skillful writer who never stops," his pen could readily express any caprice (pls. 53, 54); in sum, "he was so replete with every sort of talent that painting seemed the least of his virtues."[119]

Vasari respected Giulio's judgment; he used it as the authority on Correggio, quoting a remark about two paintings he identified as a Leda and a Venus, commissioned by Federico Gonzaga for the emperor Charles V: "he never had seen any painting that achieved that standard" in its handling of paint.[120] Vasari viewed the paintings through Giulio's somewhat confused memory of them. He made what he had not seen visible with the qualities and details Giulio praised and further with Correggio's use of color, the aspect of Correggio's style that he had come to appreciate himself in the paintings he had seen (pls. 56, 57):

> the softness, the coloring, and the well-wrought shadows of the flesh were such that they appeared not as colors but as flesh. In one there was a marvelous landscape, nor was there ever a Lombard who did such things better than he; and besides this, hair so lovely in color, and its strands individuated and executed with such exquisite finish that it is not possible to see anything better.[121]

117 Life of Giulio Romano, BB v, p. 68 (1550): "una Baccanaria per un Sileno."

118 *Ibid.*, p. 69: "E nel nostro Libro de' disegni di diversi pittori è il proprio disegno di questa bellissima storia di mano di esso Giulio." The drawing is now in the Louvre, Inv. 3499. It was identified by Monbeig Goguel, "Giulio Romano et Giorgio Vasari. Le dessin de la *Chute d'Icare* retrouvé," *Revue du Louvre* (1979), pp. 273–6, who argues that it only entered Vasari's possession when he began collecting drawings for his anthological book of drawings sometime around 1555. This ignores the fact that Vasari's activity as a collector predated the project of finding drawings for the *libro de' disegni*. She also says that the text of the second edition modifies the terms of the first description by adapting them to the drawing. In the second edition Vasari added some detail about the astrological signs, and the word order is slightly altered, but otherwise the content is the same in both editions, and in both editions the description relates to the subject of the drawing rather than to any in the Palazzo del Te. It is likely that Vasari returned

to the drawing, along with new notes and drawings when he wrote the expanded account of the Palazzo for the second edition.

119 Life of Giulio Romano, BB v, pp. 77–8 (1550): "il disegnare in lui era come lo scrivere in un continuo pratico scrittore. Né pensò mai a fantasia che, aperto la bocca, non avesse inteso, e lo animo altrui con la penna sùbito non esprimesse. Era d'ogni ordine di buone qualità carico talmente, che la pittura pareva la minor virtù ch'egli avesse."

120 Life of Correggio, BB iv, p. 52: "le quali opere vedendo Giulio Romano, disse non aver mai veduto colorito nessuno ch'aggiugnesse a quel segno." The *Leda* is now in the Galleria Borghese, Rome. The other painting is probably the *Danae* now in the Staatliche Museen, Gemäldegalerie, Berlin. These were two of four loves of Jupiter given to Charles V by the duke of Mantua, probably in 1532. See Bevilacqua and Quintavalle, *L'opera completa del Correggio*, p. 109, nos. 77, 78.

121 Life of Correggio, BB iv, p. 52: "sì di mor-

52. Giulio Romano, *The Fall of Dedalus and Icarus*, pen and ink with brown wash over black chalk with white heightening, 405 × 573 mm. Paris, Louvre, Cabinet des dessins.

53. Giulio Romano, *Psyche Asleep Among the Grain*, study for the Sala di Psiche, Palazzo del Te, pen and ink, 239 × 285 mm. Vienna, Graphische Sammlung Albertina.

54. Giulio Romano, compositional sketch for *The Dance* in the Loggia della Grotta, pen and ink, 253 × 400 mm. Vienna, Graphische Sammlung Albertina.

55 (facing page). Giorgio Vasari, *Virtue, Fortune, and Envy*. Arezzo, Casa Vasari, Sala del Trionfo della Virtù.

The little that he knew about Mantegna in Mantua may well have been observed under Giulio's guidance, for he was as much struck by contemporary praise as by the works he only dimly recollected: the small panel in the chapel of the Castello had stories with small

bidezza, colorito e d'ombre di carne lavorate, che non parevano colori ma carni. Era in una un paese mirabile: né mai lombardo fu che meglio facesse queste cose di lui; et oltra di ciò capegli sì leggiadri di colore e con finita pulitezza sfilati e condotti, che meglio di quegli non si può vedere." Illustrated here is the *Virgin and*

Child with Sts. Mary Magdalene and Jerome, which Vasari saw in the church of Sant'Antonio in Parma (now in the Galleria Nazionale, Parma). He wrote, BB IV, p. 52: "è colorita di maniera sì maravigliosa e stupenda che i pittori ammirano quella per colorito mirabile e che non si possa quasi dipignere meglio" (pls. 56, 57).

56. Correreggio, *Virgin and Child with Sts. Mary Magdalene and Jerome* (detail). Parma, Galleria Nazionale.

57. Correggio, *Virgin and Child with Sts. Mary Magdalene and Jerome*. Parma, Galleria Nazionale.

figures; a room there had a vault with well-considered foreshortened figures, but still a harsh style.[122] He remembered the triumphs in the palazzo of San Sebastiano, like Giulio Romano's frescoes in the Palazzo del Te, for their profusion of elements, rather than any details of composition or subject. For Vasari Mantegna's achievements in illusionistic decoration, in emulation of the antique, and in attaining honors at court were overshadowed by Giulio's. He devoted five pages to Mantegna's Life, twelve to Giulio's.

Once settled in Venice, in addition to producing the set for Aretino's play and its attendant festivities and a ceiling for the Cornaro palace, Vasari did not fail to visit the ducal palace and various churches and confraternities (*scuole*). He never intended to chronicle the glories of the Venetian tradition, however, and was not thorough or precise in considering

122 Life of Mantegna, BB III, pp. 549–50. The panel ("tavoletta") is usually related to three panels in the Uffizi showing the *Adoration of the Magi, Ascension*, and *Circumcision* now assembled as a triptych. See Martindale and Garavaglia, *The Complete Paintings of Mantegna*, pp. 96–8, nos. 34 A–E. The room is the *camera picta* known as the Camera degli Sposi.

it, merely noting, for example, the numerous painting done by Lorenzo Lotto or the custom of making portraits from life, introduced by Giovanni Bellini.[123] He more often recalled simply that an altarpiece existed rather than remembering any parts of its subject or composition. His accounts of the large-scale narrative paintings in the *scuole* or the Council Hall are vague. The subjects from Venetian history in the Council Hall and the highly localized mode of narrative in the *scuole* made them less tractable to memory by analogy than altarpieces or standard hagiography. Nevertheless, he was paying enough attention to artistic achievement, to its places of display, to constructing relations between painters that when he began to write four years later in 1546 he was able to give some sort of account of around twenty painters and of where to find dozens of their works. He made a reasonably ordered list of Giovanni Bellini's major altarpieces and knew of the Bellini burial place in Santissimi Giovanni e Paolo. He took a considerable interest in Pordenone's works, themselves of considerable interest in Venice at the time. Pordenone had died just two years previously. His works were still novelties and his image still fresh.[124]

Despite, or perhaps because of, his friendship with Titian, Vasari learned little about Titian's early associate, Giorgione. Whereas in the notes he was making about works of art in his native city, Marcantonio Michiel listed fourteen paintings by Giorgione, Vasari specifically names six, two actually by other artists.[125] The difference has to do with the fact that Michiel had access to more private palaces than did Vasari, whose research in Venice as elsewhere was largely a matter of looking at major recent works in easily accessible places, mostly churches and palace facades. He vaguely knew of "many paintings of the Virgin and other portraits" painted by Giorgione when he was young, but in this case and generally he was more concerned with large-scale works of the sort he liked to produce than with less profitable portraits and small paintings, which were the substance of Giorgione's output.[126] He was misled about the attribution of Sebastiano del Piombo's altarpiece in San Giovanni Crisostomo, which he gave to Giorgione and later ruefully corrected.[127] But he was

123 Life of Lorenzo Lotto, BB IV, p. 552 (1550): "lavorò in Vinegia infinite pitture." Portraits are commented upon in the Life of the Bellini, BB III, pp. 438–9.

124 Life of Pordenone, BB IV, p. 435, Vasari writes of his wit, sociability, love of music, and his learning: "aveva prontezza nel dire, era amico e compagno di molti, e si dilettava della la musica, e, perché aveva dato opera alle lettere latine, aveva prontezza e grazia nel dire." See Furlan, *Il Pordenone*, pp. 33–4, for Pordenone's rivalry with Titian in 1537–8 and his reputation, which was celebrated by Aretino in his play the *Cortigiana* (1534): "Ecco il Pordonone, le cui opre fan dubitare se la natura dà il rilievo a l'arte, o l'arte alla natura" (Act III, scene vii, *Tutte le commedie*, p. 173). Pordenone died on 14 January 1539.

125 For Michiel's treatment of Giorgione, see Fletcher, "Marcantonio Michiel," *Burlington Magazine* (1981), pp. 605–6.

126 Life of Giorgione, BB IV, p. 43: "Lavorò in Venezia nel suo principio molti quadri di Nostre Donne et altri ritratti di naturale, che sono e vivissimi e belli."

127 *Ibid.*, p. 45 (1550): "Gli fu allogata la tavola di San Giovan Grisostimo di Venezia, che è molto lodata, per avere egli in certe parti imitato forte il vivo della natura e dolcemente allo scuro fatto perdere l'ombre delle figure"; Life of Sebastiano, BB V, p. 86 (1568): "Fece anco in que' tempi in San Giovanni Grisostomo di Venezia una tavola con alcune figure, che tengono tanto della maniera di Giorgione, ch'elle sono state alcuna volta, da chi non ha molta cognizione delle cose dell'arte, tenute per di mano di esso Giorgione." For a similarly disowned mistake, which also gives an insight into Vasari's methods of research and attribution, see the Life of Benozzo Gozzoli about the frescoes (by Melozzo da Forlì) in Santi Apostoli, Rome, BB III, p. 376 (1550): "Non mancano però alcuni che attribuischino questa cappella a Melozzo da Furlì; il che a noi non pare verisimile, sì perché da Melozzo non abbiamo visto già mai cosa alcuna, e sì ancora perche e' vi si riconosce tutta la maniera di Benozzo: pure, ne lasciamo il giudicio libero a chi la intende meglio di noi." This is changed in the 1568 version: "E perché quando Benozzo lavorò in Roma vi era un altro dipintore chiamato Melozzo, il quale fu da Furlì, molti che non sanno più che tanto, avendo trovato scritto Melozzo, e riscontrato i tempi, hanno creduto che quel Melozzo voglia dir Benozzo; ma sono in errore" (BB III, p. 379).

interested in the origins of the modern style in Venice, the change from the predominance of the Bellini to the triumph of Titian. Giorgione was well enough known to have figured in Castiglione's discussion of style in *The Courtier* with Leonardo, Mantegna, Raphael, and Michelangelo as among the "most excellent masters."[128] Vasari pursued that reputation as best he could.

His presentation of Giorgione is based on his decision to place him at the beginning of Part 3 as one of the first three artists of the modern era: a Tuscan (Leonardo da Vinci), followed by two artists from North Italy, Giorgione and Correggio. What unified the three painters for him was their manner of painting – soft (*morbido*) as opposed to the hard or harsh (*duro*) style of the second period. Although misguided about the specifics, his placement of Giorgione emphasizing his ability to infuse life into painted figures and give a sense of living flesh through soft and subtle shading is true enough and may derive from contemporary Venetian recognition of Giorgione's influence.[129] The pre-eminence Vasari granted Giorgione may explain his other misattribution, the remarkable rendering of a sea storm in the Scuola Grande di San Marco.[130] Standing at the opening of the third era, Giorgione's achievements were meant to be indicative of the excellence to be achieved in the period. To hold this position it was appropriate that Giorgione be a hero and inventor in the Plinian sense, that he do things that were nearly unprecedented, on a monumental scale, and subject to dramatic, evocative description. Nothing suited this purpose better than a good battle or shipwreck, full of sound and fury. To render the storm, the darkness and the lightning was to compete with Apelles who, according to Pliny, "even painted things that cannot be represented in pictures – thunder, lightning and thunderbolts."[131] Vasari also genuinely admired the painting, and his own description of it, which, in the second edition he expanded and relocated correctly in the Life of Palma. Vasari's Giorgione in the first edition was the product of historical necessity. Vasari needed a particular kind of protagonist and that historical imperative was the filter for his recollection of what he had seen in Venice.

Venice did not suit Vasari, however. Unlike Antonello da Messina or Giorgione, as he chose to describe them, he was not a person "dedicated to pleasure and completely sensual."[132] He was neither a lover nor a lute-player. Despite his friendships with Venetian artists, his acquaintance with various Venetian gentlemen, and the fact that he apparently did not lack commissions, he returned to Tuscany at the end of the summer of 1542.[133] In the Life of Gherardi he claimed that his friend, the Veronese architect Michele Sanmichele,

128 *Cortegiano*, ed. Cian, Book i, chapter 37, pp. 92–3, Castiglione gives a list of outstanding painters, noting that they are each perfect in their own style: "Eccovi che nella pittura sono eccellentissimi Leonardo Vincio, il Mantegna, Raffaello, Michelangelo, Georgio da Castelfranco: nientedimeno, tutti son tra sé nel far dissimili; di modo che ad alcun di loro non par che manchi cosa alcuna in quella maniera, perché si conosce ciascun nel suo stil essere perfettissimo."

129 Life of Giorgione, BB IV, pp. 42–3: "egli nel colorito a olio et a fresco fece alcune vivezze et altre cose morbide et unite et sfumate talmente negli scuri, ch'e' fu cagione che molti di quegli che erano allora

eccellenti confessassino lui esser nato per metter lo spirito ne le figure e per contraffar la freschezza de la carne viva più che nessuno che dipignesse, non solo in Venezia, ma per tutto."

130 *Ibid.*, p. 45 (1550). For the history and consequences of this attribution, see Rylands, *Palma il Vecchio*, pp. 256–7.

131 Pliny, *Natural History*, vol. IX, XXXV.xxxvi. 96, pp. 332, 333.

132 Life of Antonello, BB III, p. 306: "persona molto dedita a' piaceri e tutta venerea."

133 Description of Vasari's works, BB VI, p. 382.

begged him to remain and that he might have done so had not Gherardi dissuaded him by saying that:

> it was not a good idea to stay in Venice where drawing was not held in consideration, nor did the painters of that place use it; moreover, the painters were the reason that little effort was put into the labors of the arts and it was better to return to Rome, the true school of the noble arts where excellence received much greater recognition than in Venice.[134]

Particularly Vasari's sort of excellence it seems. Convinced he could not advance his career in Venice, he preferred to benefit from the criticism of the Florentines or the study of Roman works. Perhaps making a virtue of necessity, both of these reasons for traveling south are attributed to other artists in *The Lives*. Donatello, for example, is said to have willingly left behind Paduan praise for Florentine censure, which "gave him reason for study and consequently for greater glory."[135] Vasari's disapproval of Venice as finally expressed in *The Lives* must have had traditional resonance for his Tuscan readers. It was already a commonplace for Boccaccio who referred to it in the second story of the fourth day of *The Decameron*, that of the man from Imola, Berto della Massa. Berto was a well-known evil-doer and liar who, when he realized that his tricks would no longer work in Imola moved to Venice, receptacle of all forms of wickedness.

Vasari spent part of the autumn in Arezzo decorating one of the rooms in his house, that dedicated to Fame and the Arts. In the centre of the vault Fame sounds her horn (pl. 58). In the spandrels Painting, Sculpture, Architecture, and Poetry are each shown absorbed in their art (pls. 59, 60, 164, 165). Vasari left eight roundels that he later filled with portraits of artists. This visit is worth noting because Vasari's iconography in his interior decoration expresses essential values of his historical outlook: that the arts bring fame, that poetry and the visual arts are connected, and that individuals ought to be celebrated. It also emphasizes Vasari's origins in Arezzo: Aretine artists – Spinello Aretino, Lazzaro Vasari (pl. 12), and Bartolomeo della Gatta – were reserved places in the portrait roundels in this room, just as they found places in *The Lives*.

In late 1542 Vasari left Arezzo for Rome. His hopes for advancement were focussed on the Farnese court where he used his contacts to try to secure Cardinal Alessandro Farnese's favor. Introduced by Bindo Altoviti and Paolo Giovio in January 1543, he received a commission from the cardinal for a painting of *Justice* (pl. 91).[136] However, he did not find

134 Life of Gherardi, BB v, pp. 292–3: "ma Cristofano ne lo dissuase sempre, dicendo che non era bene fermarsi in Vinezia, dove non si tenea conto del disegno, né i pittori in quel luogo l'usavano, senzaché i pittori sono cagione che non vi s'attende alle fatiche dell'arti, e che era meglio tornare a Roma, che è la vera scuola dell'arti nobili e vi è molto più riconosciuta la virtù che a Vinezia." For Aretino's displeasure at this departure, see the letters from don Ippolito and don Miniato Pitti, Frey I, lxxix, p. 163 (don Ippolito in Milan, 17 December 1545, to Vasari, Rome), and Frey I, lxxxii, p. 167 (don Miniato Pitti in Agnano, 7 April 1546, to Vasari, Rome).

135 Life of Donatello, BB III, pp. 215–16: "il quale biasmo gli dava cagione di studio, e consequentemente di gloria maggiore."

136 BB vi, pp. 382–3, for this introduction and the painting (now in the Museo Nazionale di Capodimonte, Naples). The commission is noted in the *ricordanze*, Frey II, p. 860, no. 130 (6 January 1543). There is also a letter dated 20 January from Vasari in Rome to the cardinal in Castro with a drawing and description of the invention (Frey I, l, pp. 121–2). Frey I, li, p. 125 (24 January) is Cardinal Alessandro's reply from Corneto: "mi è piaciuta così la nouità dell' istoria come la bellezza delle figure, sicome al ritorno mio, che sarà presto, ne parleremo più à lungo con dar principio à qualche bella impresa." For this, see Robertson, *Alessandro Farnese, Patron of the Arts*, pp. 55–7.

58. Giorgio Vasari, *Fame*. Arezzo, Casa Vasari, Camera della Fama e delle Arti.

an immediate place in the cardinal's entourage and was forced to continue his travels between Rome and Florence (where Ottaviano de' Medici gave him both a home and constant support) and also to Naples to paint the high altar and to decorate the refectory of the monastery of Monte Oliveto (1544–5). He was not eager to accept this commission, which he received in November 1544, feeling that the site was ugly and problematic and that he might not be able to do himself credit there. He was urged to the task by his tireless Olivetan supporters, the Florentine don Miniato Pitti and the Milanese don Ippolito.[137] Don Miniato had found Vasari work in the Order's churches and with its monks since his earliest career and, with don Ippolito, took pride in its progress. Between 1529 and 1548 Vasari and

137 Description of Vasari's works, BB VI, p. 384.
Frey II, pp. 861–2, nos. 145, 146 (7 and 20 November 1544).

his shop did paintings (panels and frescoes) for the Olivetans at Agnano (outside of Pisa), Sant'Anna a Camprena (near Siena), Arezzo, Bologna, Naples, and Rimini. In 1545 don Ippolito wrote that he had set aside 200 *scudi* for an altarpiece for Milan.[138] Their support for Vasari was convivial and congenial. Their many mutual friends included Ottaviano de' Medici, Paolo Giovio, and artists such as Salviati, Pontormo, Bronzino, Tribolo, Francesco da Sangallo, Raffaele da Montelupo, and Giulio Clovio. The Olivetans seem to have been pursuing a policy of furnishing and refurbishing their monasteries with up-to-date works. Visual awareness of current ideas is indicated in one of don Miniato's letters to the artist in which he mentions the Abbot General's desire to decorate the guest quarters (*foresteria*) in Naples, saying that the abbot would like him to paint the vault like the room of the giants in the Palazzo del Te at Mantua.[139]

Vasari's association with the Olivetans, like his Medici connections, is one strand of information subtly woven into the fabric of *The Lives*. Their patronage is recorded in works that Vasari knew about in their churches and monasteries at Monte Oliveto Maggiore, Arezzo, Naples, Palermo, Verona, and Venice. Because their foundations were part of Vasari's itinerary, they had a place in his history. His account of Naples, for example, is based largely on works that were in the church of Sant'Anna dei Lombardi attached to the monastery where he was working.[140] He was greatly struck by the altar by the sculptor Girolamo Santacroce in the del Pezzo chapel and also admired his statues at Santa Maria a Cappella Vecchia, another Olivetan church.[141] Santacroce's Life is a clear case of a career bounded by the perimeters of Vasari's patronage, the other work mentioned in any detail is the chapel of the Marchese del Vico at San Giovanni a Carbonara, the Augustinian monastery where Vasari painted an altarpiece and a fresco.[142] But nowhere does he give an account of either Augustinian or Olivetan patronage as such, any more than he gives a

138 Frey I, lxxix, p. 163 (Milan, 17 December 1545, to Vasari, Rome). There was also the idea that he might paint the ceiling of the chapter house at Monte Oliveto Maggiore, Frey I, lxx, p. 151 (don Miniato Pitti in Siena, 8 May 1545, to Vasari, Naples).

139 *Ibid.*, p. 150: "uorrebbe, gli dipignessi quel cielo tutto ad aria di smalto chiaro, come sta quello della stanza de Giganti all Ti di Mantoua."

140 At Sant'Anna he described works by Guido Mazzoni "Modanino") and Benedetto da Maiano (Life of Giuliano da Maiano, BB III, p. 255), Pintoricchio (BB III, p. 575), Giovanni da Nola (BB IV, p. 417), Girolamo da Cotignola (BB IV, p. 500), and Fra Giovanni da Verona, who was Olivetan. Vasari gives a brief notice of Fra Giovanni's intarsia works in a paragraph in the Life of Raphael (BB IV, p. 174). Another important source for Naples was Vasari's patron, the Florentine merchant Tommaso Cambi who had assisted Giovanni Francesco Penni, who came to Naples with a copy of Raphael's *Transfiguration*, fell ill, and died there (BB IV, p. 334). Cambi also provided lodgings for the Bolognese Girolamo da Cotignola (BB IV, p. 500).

141 Life of Girolamo Santacroce, BB IV, pp. 417–18.

142 *Ibid.*, pp. 416–17. The other work noted was an unfinished statue of the emperor Charles V (p. 418). Following Vasari's construction jealous fortune cut short

Santacroce's life, so that at thirty-five years old he left but few works. Santacroce (*c.*1502–37) died young, but he also left many more sculptures than the four that constitute his Life. See Morisani, "Geronimo Santacroce," *Archivio storico per le province napolitane* (1944–6), pp. 70–84, for his career, and Weise, *Studî sulla scultura napolitana*, pl. XXXII, fig. 97, for the del Pezzo altar, dated 1524 by an inscription, pl. LIII, fig. 161 for the Vico altar. The architecture that Vasari praised in the Caracciolo di Vico chapel can be dated to 1516 by a dedicatory inscription, therefore too early to be reasonably attributed to Santacroce. Vasari's attribution of the statue of St. John the Baptist on the altarpiece is generally held to be correct. For illustrations of the chapel and the questions of attribution and dating, with a summary of the literature, see Migliaccio, "I rapporti fra Italia meridionale e penisola iberica nel primo Cinquecento," *Storia dell'arte* (1988), pp. 225–31. For Vasari's commissions, see Frey II, p. 862, no. 150 (30 May 1545), for the altarpiece showing the Crucifixion and a stucco frame, and no. 155 (28 August), for a fresco in the convent (lost). He further received a commission for eighteen panels for the sacristy, which he executed in Rome (p. 863, no. 158, 18 September; now at San Giovanni a Carbonara, the Museo di Capodimonte, Naples and the Musée Calvet, Avignon).

59 (following page). Giorgio Vasari, *Painting*. Arezzo, Casa Vasari, Camera della Fama e delle Arti.

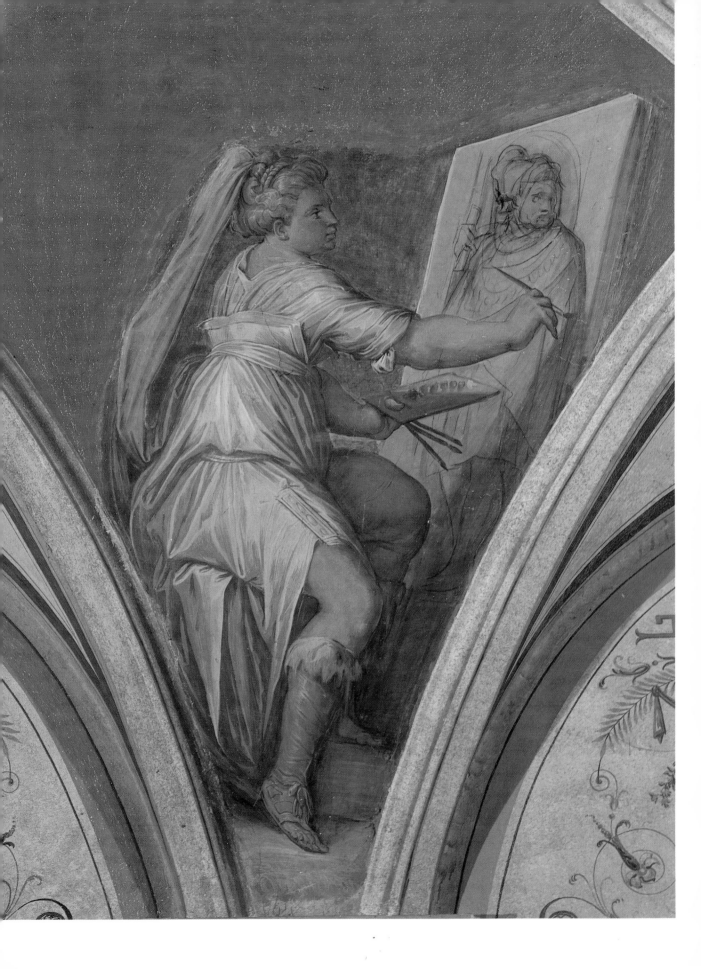

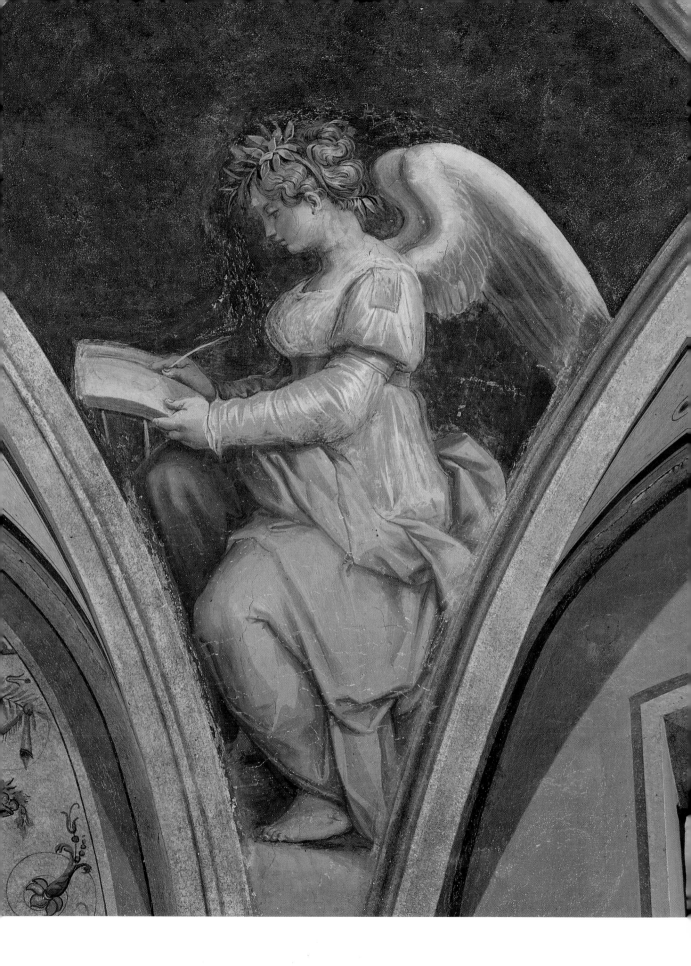

synthetic view of civic, court, confraternity, or family patronage. He was very attentive to the sponsorship and placement of the things he saw and later wrote about, specifying for whom, in a church of what Order, occasionally at what cost, but he noted them as subordinate to the artist. This was the priority of his history, and it was one of great consequence for establishing the artist as a subject and as a primary force in the creation of works. With this form of editing Vasari both extracted the artist from a dependent position and exalted his production by putting it in his name. So in the case of the Olivetans, the patronal rights of the high-altar chapel of San Bernardo, their church in Arezzo, belonged to the Marsuppini family, who paid for the decoration and the furnishing of the chapel with frescoes by Bicci di Lorenzo and an altarpiece by Fra Filippo Lippi. Vasari associated Carlo Marsuppini with these commissions, but subdivided the chapel complex into its artistic components, celebrating them in the name of Lorenzo di Bicci (whose career he confused with his son Bicci's) and Fra Filippo Lippi. By means of this treatment of patronage he created an effective and crucial new definition of the activity.

He later remarked that after Giotto nothing of importance had been produced in painting in Naples until his arrival; the honorable exceptions to the generally abysmal standards were imported works by Perugino and Raphael.[143] Vasari conceived of his task as bringing the modern style to the benighted city. His efforts to appraise the situation are represented by a few works cited by Polidoro da Caravaggio and by the one painting that constitutes the Life of Marco Calavrese (Cardisco), the high altar of Sant'Agostino where he said "one sees a harmonious style that approaches the good qualities of the modern style, as well as great beauty and skill in coloring" (pl. 61).[144] Well might he say this, for its figural vocabulary spoke directly to his taste: a figure in the foreground is adapted from Raphael's *Transfiguration* (pl. 62), the figure next to St. Augustine from the sinuously gesturing philosopher in the left foreground of *School of Athens* (pl. 146), and St. Augustine from the figure to the right of the altar in the *Disputa*.

Although he was kept busy with Neapolitan commissions, Vasari felt a year was long enough to stay, particularly as his assistants had gone into hiding having wounded policemen in a fray caused by a misunderstanding between the viceroy and the monks of Oliveto, and a dispute between the Dominicans and the Olivetans that resulted in a visit to the monastery by the constabulary with orders to seize the abbot and some of his monks.[145] His contempt

143 Description of Vasari's works, BB VI, p. 385. The imported paintings by Perugino and Raphael were the *Assumption* on the high altar of the duomo by Perugino (BB III, p. 605; removed from the high altar, but still in the duomo) and Raphael's *Madonna del Pesce* in San Domenico (BB IV, pp. 184–5; now in the Prado, Madrid). The other imported works that he knew of were Fra Filippo Lippi's altarpiece in the Castello (BB III, p. 330); Pintoricchio's *Assumption* at Monte Oliveto (BB III, p. 575), and Donatello's Brancacci tomb at S. Angelo a Nilo (BB III, p. 213).

144 Life of Marco Calavrese, BB IV, p. 526: "nella quale opera si vede una maniera molto continuata e che tira al buono delle cose della maniera moderna, et un bellissimo e pratico colorito in essa si comprende." Now in the Museo Nazionale di Capodimonte, Naples, no. 973, see Abbate, "A proposito del 'Trionfo di

Sant'Agostino' di Marco Cardisco," *Paragone* (1970), pp. 40–3, pl. 139, who suggests a date of *c*.1540, towards the end of Cardisco's career (d.1542). Vasari is inaccurate in his treatment of Cardisco as a complete provincial seduced on the road to Rome by the siren call of Naples. Cardisco is documented painting the vault of Giovanni Battista Turchi's chapel in Trinità dei Monti in Rome in *c*.1532, see Giusti and Leone de Castris, *Pittura del Cinquecento a Napoli*, pp. 226, 236. In 1568 Vasari attributes frescoes there to another Calabrese artist, an associate of Marco whose name he did not know (BB IV, p. 527).

145 Description of Vasari's works, BB VI, p. 386. The situation is alluded to by don Ippolito (Frey I, lxxiii, p. 155 [Milan, 16 July 1545, to Vasari, Naples], and lxxvii, p. 160 [Milan, 20 August 1545, to Vasari, Naples]).

60 (previous page). Giorgio Vasari, *Poetry*. Arezzo, Casa Vasari, Camera della Fama e delle Arti.

61. Marco Cardisco, *Triumph of St. Augustine*. Naples, Museo Nazionale di Capodimonte.

62. Raphael, *Transfiguration* (detail). Rome, Pinacoteca Vaticana.

for the city emerges in an observation about Polidoro da Caravaggio's decision to take his leave of a place where "men thought more of a horse that could jump than of a master whose hands could give painted figures the appearance of life."[146] He left behind those gentlemen of limited taste and finished his Neapolitan tasks in Rome. He arrived there in September (1545), but not until the following March was he able to begin work on painting a large-scale cycle of history paintings to decorate Cardinal Alessandro Farnese's great hall. A memorandum about the program dated 1545 reveals that Vasari and his supporters, particularly Paolo Giovio, had previously been endeavoring to gain the cardinal's interest. Vasari says that he made "many drawings of various inventions" that were not used.[147] But once decided, the cardinal wanted the work done quickly and conveniently during his

146 Life of Polidoro da Caravaggio, BB IV, p. 467: "deliberò partire da coloro che più conto tenevano d'un cavallo che saltasse che di chi facesse con le mani figure dipinte parer vive."

147 Description of Vasari's works, BB VI, p. 387: "monsignor Giovio, disiderando che ciò si facesse per le mie mani, mi fece fare molti disegni di varie invenzioni, che poi non furono messi in opera." The memorandum

absence as papal legate to the imperial army in Germany, hence Vasari's frantic and prodigious hundred days of painting that gave the room its name: the Sala dei Cento Giorni (pls. 20, 63, 64).[148]

It was in Cardinal Alessandro's court that the project of writing biographies of artists finally gave form to Vasari's assorted notes and dedicated but diffuse enthusiasm. He described how he would often go to

> see the said illustrious Cardinal Farnese dine, where Molza, Annibale Caro, messer Gandolfo [Porrino], messer Claudio Tolomei, messer Romolo Amaseo, monsignor Giovio, were always present to entertain him with the most elegant and noble conversation, as were many other scholars and gentlemen who always filled the court of that lord.[149]

Their conversations resulted in *The Lives*.

Vasari's story of these dinner gatherings is a demonstrable fiction: in 1546 those particular gentlemen were not all in Rome. Molza was dead in fact (since 1544).[150] It is an invention meant to give a distinct and distinguished literary pedigree to Vasari's book. The dinner-table symposium was itself a convention going back to Plato. More recently and more directly relevant to Vasari, Filarete says that he decided to write his treatise on architecture at just such a convivial gathering, and Giovio also used this kind of setting to explain the origins of a treatise.[151] Nevertheless, Vasari's account is based on actual experience: Cardinal Alessandro enjoyed good table talk, and the gentlemen of the Farnese court took an interest in artistic topics. When, for example, Vasari responded to Benedetto Varchi's letter asking for his opinion on the comparison between painting and sculpture, he began by describing a similar debate "in Rome, where two of our Farnese courtiers took opposite sides on the

is in the *Zibaldone*, ed. del Vita, pp. 22–5, Archivio Vasariano MS 4, fol. 7. It has a note on the back: "Cose della Cancelleria 1545." See for this project, and generally for Vasari and Cardinal Alessandro's patronage, Robertson, *Alessandro Farnese, Patron of the Arts*, pp. 57–68.

148 The commission specified that the work was to be done in a hundred days, Frey II, pp. 864–5, no. 164 (29 March 1546). The paintings were finished by October, when Vasari left Rome. The cardinal was in Germany between July and October. He arrived in Rome on 10 December. Giovio reported the cardinal's cool reaction to the frescoes in a letter of 18 December, Frey I, lxxxviii, pp. 176–7 (to Vasari, Florence): he was satisfied, he would have liked the portraits to have been better, but the work seemed more beautiful than he expected, given the rush. For the chronology and iconography of the project, see Frey I, pp. 177–84. For Vasari's collaboration with Giovio, see Kliemann, "Il pensiero di Paolo Giovio nelle pitture eseguite sulle sue invenzioni," and Robertson, "Paolo Giovio and the 'Invenzioni' for the Sala dei Cento Giorni," in *Atti del convegno Paolo Giovio*, pp. 197–223, 225–38.

149 Description of Vasari's works, BB VI, p. 389: "a veder cenare il detto illustrissimo cardinal Farnese, dove

erano sempre a trattenerlo con bellissimi et onorati ragionamenti il Molza, Anibal Caro, messer Gandolfo, messer Claudio Tolomei, messer Romolo Amaseo, monsignor Giovio, et altri molti letterati e galantuomini, de' quali è sempre piena la corte di quel signore."

150 For this story, see Kallab, *Vasaristudien*, pp. 143–8, and C. Davis in Arezzo 1981, pp. 213–15, who also provides a gloss of the cast list. Boase, *Giorgio Vasari. The Man and the Book*, p. 44, prefers to date the episode to 1543.

151 *De Romanis piscibus* (1524). For Giovio and such dinners, see Zimmerman and Levin, "Humanist Conviviality in Renaissance Rome," in *Rome in the Renaissance*, ed. Ramsey, pp. 265–78, and Zimmerman, "Renaissance Symposia," in *Essays Presented to Myron P. Gilmore*, ed. Bertelli and Ramakus, I, pp. 363–74. Claudio Tolomei wrote a letter on the subject of the *simposio* or *convito*, its classical origins and contemporary pleasures (*De le lettere*, Book II, p. 32r, to Giovambattista Grimaldi [26 July 1543]). For Filarete, see the *Trattato di architettura*, ed. Finoli and Grassi, I, p. 8: "Istando io una fiata in uno luogo dove uno signore con più altri mangiava, e intra molti e varii ragionamenti entrorono in sullo edificare." Filarete, like Vasari, intervened because the discussion pertained to his profession (p. 9).

63. Giorgio Vasari, *The Nations Paying Homage to Pope Paul III*. Rome, Palazzo della Cancelleria, Sala dei Cento Giorni.

same dispute," and Vasari appealed to Michelangelo's authority.[152] And in a letter from
Paolo Giovio to Cosimo's majordomo, Pierfrancesco Ricci, thanking the duke for sending
his portrait, Giovio tells of the discussion generated at the court by the arrival of the
painting: "The marvelous portrait of his Excellence enormously pleased the gentlemen of
this court and was judged by the painters to be exceptionally fine . . . Blessed be the hand
of Bronzino, who seems to me to surpass his teacher Pontormo."[153] Giovio goes on to ask
about the Doni press in Florence where he wanted to publish his Life of Leo X, a matter
about which he had repeatedly written to Ricci, directly and through intermediaries.[154] The

152 Frey I, lxxxix, p. 185 (12 February 1547, to
Varchi, Florence): "Ritrouandomi in Roma, doue si
fece scommessa fra dua nostri cortigiani di Farnese della
medesima disputa, in me tal cosa rimessono . . . andai à
trouare il diuino Michelagniolo, il quale per esser in
tutte due queste arte peritissimo, mene dicessi lanimo
suo."

153 ASF, Mediceo 1170A, Insert 2, busta 6, fol. 14r
(July, 1546). See Simon, "'Blessed be the hand of
Bronzino,'" *Burlington Magazine* (1987), pp. 387–8.

154 As reported in letters from Marco Bracci in
Rome to Pierfrancesco Ricci, ASF Mediceo 1172, Insert
2, busta 50 (22 May 1546) and busta 19 (28 May 1546).

64. Giorgio Vasari, *Pope Paul III Distributes Honors*. Rome, Palazzo della Cancelleria, Sala dei Cento Giorni.

mixture of artistic gossip, gentlemanly opinion, and interest in publishing, biography, and portraiture in Giovio's letter is indicative of the "elegant and noble" matters discussed in the cardinal's circle, particularly by Vasari's mentor Giovio. So that when Vasari describes his dinner-time visits to that court, he is describing something true even if it did not happen exactly as he chose to write about it.

One evening, according to Vasari, the conversation turned to

Giovio's museum and the portraits of illustrious men that he had arranged there in order and with wonderful inscriptions; and passing from one matter to another, as one does in conversation, monsignore Giovio said that he had always had, and continued to have, a great desire to add to his museum and to his book of *Elogii* a treatise that would be about those who were illustrious in the art of design from the time of Cimabue up to our own. Expanding on this subject, he certainly demonstrated great knowledge and judgment in artistic matters; but it is equally true that, since it sufficed for him to make a grand sweep, he did not look in detail, and in speaking about those artists he often either confused their names or surnames, birthplaces, [and] works or did not speak about things precisely, but approximately.[155]

Vasari tells how, when asked, he advised Cardinal Alessandro that Giovio should have the assistance of someone who could "put things in their proper places and describe them as they actually were," and how he was urged by his friends to take on the task.[156] It was at this point that he sorted out his notes, bringing some form of outline or draft to Giovio, who turned the whole enterprise over to him, deferring to the artist's greater experience and knowledge. Giovio confessed that the most he could hope to achieve would be a "little treatise" like Pliny's.[157]

Giovio's affected modesty and his alleged dismissal of Pliny are an indication of Vasari's remarkable ambitions. Pliny was virtually the only direct classical model for the historical description of artists. The chapters in the *Natural History* had a distinguished record as a prototype. It was assumed that Vasari's book would be comparable to Pliny's. In the published version of Varchi's lecture on the relative merits of the arts of sculpture and painting, he describes Vasari as having written about painting "in imitation of many other ancient painters, or rather of Pliny."[158] This seems to have been Giovio's idea as well: Vasari was clearly familiar with Pliny's "trattatetto," and he would turn its critical terms and topoi, comparisons and anecdotes to considerable effect.[159] Vasari wanted to give his affection for his predecessors a far grander form of memory. He wanted to write history.

155 Description of Vasari's works, BB vi, p. 389: "si venne a ragionare, una sera fra l'altre, del Museo del Giovio e de' ritratti degl'uomini illustri che in quello ha posti con ordine et inscrizioni bellissime; e passando d'una cosa in altra, come si fa ragionando, disse monsignor Giovio avere avuto sempre gran voglia, et averla ancora, d'aggiugnere al Museo et al suo libro degli Elogii un trattato, nel quale si ragionasse degl'uomini illustri nell'arte del disegno, stati da Cimabue insino a' tempi nostri. Dintorno a che allargandosi, mostrò certo aver gran cognizione e giudizio nelle cose delle nostre arti; ma è ben vero che bastandogli fare gran fascio, non la guardava così in sottile, e spesso, favellando di detti artefici, o scambiava i nomi, i cognomi, le patrie, l'opere, o non dicea le cose come stavano apunto, ma così alla grossa."

156 *Ibid.*: "a mettere le cose a' luoghi loro et a dirle come stanno veramente."

157 *Ibid.*: "Giorgio mio, voglio che prendiate vio questa fatica di distendere il tutto in quel modo che ottimamente veggio saprete fare . . . quando pure io facessi, farei il più più un trattatetto simile a quello di Plinio."

158 See Barocchi ed., *Scritti d'arte*, i, p. 527: "a imitazione di molti altri pittori antichi o più tosto di Plinio."

159 See Becatti, "Plinio e Vasari," in *Studi di storia dell'arte in onore di Valerio Mariani*, pp. 173–82, and Tanturli, "Le biografie d'artisti prima del Vasari," in *Atti 1974*, pp. 275–98.

IV

"IN ANOTHER'S PROFESSION": VASARI AND THE "WRITERS OF HISTORIES"

HAVING READ A PORTION OF the final draft of *The Lives*, Annibale Caro wrote Vasari in December 1547 to congratulate him that "in another's profession you have done such beautiful and useful work."[1] Caro was a professional man of letters, one of the most accomplished and admired of his day. His praise is a measure of Vasari's success. It is also a definition of his task: to give literary form to facts about artists, a task that was not properly that of a painter, but of a historian. Vasari himself repeatedly made the distinction between the professions of the pen and the brush. In the dedicatory letter to Duke Cosimo de' Medici he says that his intention was not to win praise as a writer, but, as an artist, to praise those who had given life to the arts and who should not suffer a second death.[2] The very structure of the sentence with its use of the rhetorical figure of repetition ("lode," "lodar") and its play on the vocabulary of life, death, oblivion, and memory belies Vasari's modest stance and indicates his skill as a writer. The statement also defines the nature of his history, placing it within the oratory of praise, the division of rhetoric proper to Lives.

A self-effacing stance was a prescribed rhetorical form, part of the introduction "ab nostra persona" intended to make the hearer receptive to the speaker's cause.[3] Vasari's disclaimers were not, however, empty phrases; they were selected forms of address. With his professions of inadequacy Vasari states a fact in a way that poses and resolves a paradox: he is an author who is not a writer. With such statements he shows himself to be qualified to undertake the work, because he is familiar with the rules, if not practiced in their application. He also

1 Frey I, cv, p. 210 (Rome, 15 December 1547, to Vasari, Rimini): "Del resto mi rallegro con voi, che ne la professione altrui habbiate fatta si bella et si utile fatica." For further comment on this letter, see below, Chapter VI, p. 253.

2 BB I, p. 3: "[la] pura mia intenzione, la quale è stata non di procacciarmi lode come scrittore, ma, come artefice, di lodar l'industria e avvivar la memoria di quegli che, avendo dato vita et ornamento a queste professioni, non meritano che i nomi e l'opere loro siano in tutto, così come erano, in preda della morte e

della oblivione." He excused himself in a similar fashion in the letter to his readers that concluded the 1550 edition of the *Lives*, BB VI, p. 410: "Non perché io ne aspetti o me ne prometta nome di istorico o di scrittore, ché a questo non pensai mai, essendo la mia professione il dipignere et non lo scrivere."

3 *Ad H.*, I.iv.7–v.8, pp. 13–15. For the topos of "affected modesty," see Hardison, *The Enduring Monument*, p. 30, and Curtius, *European Literature and the Latin Middle Ages*, pp. 83–5.

indicates that he is creating a totally new, idiosyncratic sort of text based on his own, painter's way of speaking, yet that it will be intelligible and meaningful to his readers.

The idiosyncracy was not simply stylistic. There were no direct models for artistic biography on the scale of *The Lives*.[4] Ghiberti's *Commentaries*, written around 1447 to 1455, provided the closest modern precedent, and Vasari relied on them and on Ghiberti's own source of inspiration, Pliny's chapters on sculptors and painters in Books xxxiv and xxxv of *The Natural History*. As the most extensive and most familiar account of ancient art, Pliny's short notes were an implicit reference. They proved that the written word had a capacity for survival and could guarantee artists and their works a measure of immortality. They also represented almost all that was known of ancient art and the critical standards and terms applied to its appreciation. They created a corpus of famous names listed in an order based on a series of inventions. Vasari's construction of his own artistic past as a such a series is basically Plinian. Pliny's repertory of critical terms and concepts applied to ancient painting and sculpture – *ingenium, studium, diligentia, inventio, facilitas* – had already become part of the understanding of modern artists and artistry.[5] More important to Vasari's history was Pliny's recitation of "firsts," which suggested criteria for inventiveness. So, for example, for Pliny, Aristides was the first to depict feelings; for Vasari it was Giotto who initiated the expression of emotions. Similarly, the grace and lifelikeness of Giotto's heads had a parallel in Parrhasius. Vasari's ecstatic summation of Michelangelo's sovereignty in all the arts concludes by saying that "if we chanced to have some [paintings] by the most famous Greeks and Romans, so that we might compare them face to face, [Michelangelo's] would prove to be as much higher in value and more noble as his sculptures are superior to those of the ancients."[6] In seeing through Pliny by selecting motifs famous from his *Natural History*, Vasari implicitly made that comparison for his readers. The Plinian model framed Vasari's own possibilities as a painter; Paolo Giovio, for example, wrote to Cardinal Alessandro Farnese: "I therefore urged master Giorgio of Arezzo to wish to make a worthy example of his art by painting a panel that had something of the greatness of the ancient painters celebrated by Pliny."[7]

By virtue of being a record of the glorious past of classical antiquity, Pliny provided a stock of prestigious types, recurrent since fourteenth-century re-readings of *The Natural History* as representative of rules or precedents. They occur as such in Filippo Villani's passage on painters in his late fourteenth-century book *On the origins of Florence and her famous citizens* and in Varchi's 1547 lectures to the Florentine academy.[8] Vasari frequently adapted Pliny's anecdotes, which he viewed as a form of authority about artists' behavior

4 Tanturli, "Le biografie d'artisti prima del Vasari," in *Atti* 1974, pp. 275–98.

5 See Becatti, "Plinio e Vasari," in *Studi di storia dell'arte in onore di Valerio Mariani*, pp. 173–82.

6 Preface to Part 3, BB iv, p. 12: "Il che medesimamente si può credere delle sue pitture; le quali, se per avventura ci fussero di quelle famosissime greche o romane da poterle a fronte a fronte paragonare, tanto resterebbono in maggior pregio e più onorate, quanto più appariscono le sue sculture superiori a tutte le antiche."

7 Giovio, *Lettere*, ed. Ferrero, i, p. 303, no. 158 (21

January 1543), about the painting of *Justice*: "Ho poi essortato mastro Giorgio d'Arezzo ad volere fare un degno paragone dell'arte sua, con pingere una tavola qual abia de quel grande degli antichi pittori celebrati da Plinio." Borghini later wanted Vasari to devise a night scene for a painting of Judith, referring to a passage in Pliny about reflections and comparing this in turn to Vasari's own previous nocturnal *Nativity* at Camaldoli (Frey ii, cdlix, p. 101 [Borghini in Poppiano, 14 August 1564, to Vasari, Florence]).

8 For Villani, see below, Chapter vii, pp. 295–6. For Varchi, see, for example, Barocchi ed., *Scritti d'arte*, i,

and its consequences. Parmigianino was so intent on his work that he did not leave off even when his house was invaded by German soldiers during the sack of Rome, like Protogenes who did not suspend painting even as battles were being waged around him.[9] An acknowledged source for Vasari's history, Pliny's chapters did not provide Vasari with the more grandiose historiographic framework he set forth in the dedication and prefaces.

Vasari combined several different types of writing, and probably as many manners of speaking, in his *Lives*. An analysis of *The Lives* depends upon discerning his various sources and models. These can be divided roughly into conceptual and structural (those of the practices of history and biography, classical and modern), critical (strategies and vocabularies of appreciation), and factual. In addition, as a Tuscan, Vasari's language was inescapably conditioned by the three "fountains of eloquence": Dante, Boccaccio, and Petrarch.[10] Here the notions of history and biography Vasari relied on to give coherence and meaning to his scattered and diverse notices will first be considered, looking at the sources of his ways of thinking and writing about the past. Next the factors influencing his approach to writing more specifically about the qualities of the visual arts will be suggested, and then the material that was thus shaped will be summarized as well as the circumstances of writing the 1550 *Lives*. Both editions depend on the sources and models discussed here. They are fundamental to the book as first published, subsequently revised, and currently read.

Vasari's own library was probably very small. The inventory of his house in Arezzo mentions only one "gold-bound Petrarch with commentary" kept in a cupboard with a crucifix.[11] There are no books listed in his house in Florence, but if his collection was like that of other mid-sixteenth-century readers of similar means, he owned very few books, and those probably the Bible or some version of scripture, *The Divine Comedy*, Ariosto's *Orlando Furioso*, and *The Decameron* – the most read books of the first half of the sixteenth century.[12]

p. 265, from the last of the 1547 lectures. For Vasari's notion of prototype, see the preface to Part 2: "But in the painting and sculpture of former times, something quite similar must have happened, for if their names were changed, their cases would be exactly alike" (BB III, p. 7: "Ma nella pittura e scultura in altri tempi debbe essere accaduto questo tanto simile che, se e' si scambiassino insieme i nomi, sarebbono appunto i medesimi casi'). Vasari used one of the editions of Cristoforo Landino's translation of *The Natural History*, which first appeared in 1476 and was subsequently published several times (references are given to Brucioli's 1543 version here). Vasari's reliance on Landino's translation is indicated by the fact that he calls Alexander's mistress Campaspe, as does Landino. The Latin versions call her Pancaspe, Pancaste, or Pacate. For this, see *Dolce's "Aretino,"* ed. Roskill, p. 245.

9 Life of Parmigianino, BB IV, p. 538 and *N.H.*, xxxv.xxxvi.105, pp. 338–41. For other instances of the adaptation of Pliny anecdotes, see the case studies below, Chapters VII–IX.

10 For the title "three fountains" and one instance of their exemplary status, see, Liburnio, *Le tre fontane di Messer Niccolo Liburnio in tre libbri divise, sopra la grammatica, et eloquenza di Dante, Petrarcha, et Boccaccio*

(1536). For Vasari's reliance on them, see, for example, the Life of Brunelleschi, about the cupola, BB III, p. 138: "mostrando che il valore negli artefici toscani, ancora che perduto fusse, non perciò era morto," which compares with Petrarch, *Rime sparse*, cxxviii.95–6: "ché l'antiquo valore/ne l'italici cor non è ancor morto" (*Le rime sparse*, ed. Chiòrboli, p. 112); in the Life of Ghirlandaio, BB III, p. 486, Vasari describes the impression made by the sight of the baby dying at his mother's breast in the *Massacre of the Innocents* in the Tornabuoni chapel, Santa Maria Novella: "da tornar viva la pietà dove ella fusse ben morta," a turn of phrase echoing Dante, *Inferno*, xx.28: "Qui vive la pietà quand'è ben morta." For Boccaccio, see Riccò, "Tipologia novellistica degli artisti vasariani," in *Studi* 1981, pp. 95–115.

11 Arezzo 1981, p. 30 (21 August 1574): "Uno armario con un crocefisso di noce regolato con l'inginocchiatoio et un Petrarcha messo doro col comento."

12 This list is extracted from Bec, *Les Livres des Florentins*, pp. 53–63. See also L. Perini, "Libri e lettori nella Toscana del Cinquecento," in *Medici* 1980, I, pp. 109–31.

Like Rosso and other artists, he might have owned Vitruvius and Pliny. But his resources were not restricted to his *scrittoio*. His advisers on the project of *The Lives*, principally Paolo Giovio for the first edition and Vincenzo Borghini for the second, both owned and had access to important collections of books. Vasari, like Ghiberti a hundred years earlier and like many other renaissance writers, joined a pool of resources, borrowing and being lent books and manuscripts, or seeking and being given relevant excerpts.[13] In the letter to his readers Vasari thanked his friends, who did all they could supplying references and advice, and helping him to resolve his doubts on various points.[14] Of those writings he acknowledges (Ghiberti's, Ghirlandaio's, and Raphael's) he said, "although I trusted them, I have always nevertheless desired to compare what they say with an examination of the works themselves."[15] Vasari's history of the visual arts was fundamentally visual. His research went far beyond the boundaries of any available books, and for this reason it determined the territory of future writing.

The Mirror of History

History was a literary art for Vasari and his contemporaries. It demanded eloquence. What was said gained importance by how it was said. A substantial corpus of classical texts had survived, but only few rules about history. Such direct guidance as renaissance historians could find in their desire to emulate classical writers had to be gleaned from occasional remarks. Among the most influential (and most often repeated) were Cicero's comments on history in *De Oratore*, where he defined history as allied to philosophy and rhetoric: "And as History, which bears witness to the passing of the ages, sheds light upon reality, gives life to recollection and guidance to human existence, and brings tidings of ancient days, whose voice, but the orator's, can entrust her to immortality?"[16] Like oratory, it was an instrument for persuasion, meant to inspire men to act virtuously and to perform glorious deeds.[17] History was distinguished from chronicle, according to Cicero, because "in the narrative of achievement" the writer not only gives a statement of "what was done or said, but also of the manner of doing or saying it" and an "estimate of consequences," which calls for "an exposition of all contributory causes."[18] To do this required the moral authority of

13 For Ghiberti, see Gombrich, "The Renaissance Conception of Artistic Progress," in *Norm and Form*, pp. 5–6. For Vasari and Borghini, see Borghini's letters to Vasari about texts for the 1568 edition, Frey II, cdxxx, p. 26 (24 February 1564), cdlvi, p. 93 (5 August 1564), cdlvii, p. 95 (7 August 1564). For Borghini's library, see Testaverde Matteini, "La biblioteca erudita di Don Vincenzo Borghini," in *Medici* 1980, II, pp. 611–43.

14 BB VI, p. 411: "di notizie e d'avisi e riscontri di varie cose, delle quali, comeché vedute l'avessi, io stava assai perplesso e dubbioso."

15 *Ibid.*: "ai quali, se bene ho prestato fede, ho nondimeno sempre voluto riscontrare il lor dire con la veduta dell'opere."

16 *De Ora.*, II.ix.36, vol. I, pp. 224, 225. Cicero's prescriptions were widely known and available in Italian as well as in Latin, for example, Memmo, *L'oratore*

(1545), fols. 65r–v, closely follows much of the discussion of history in the *De Oratore*.

17 For concise summaries of humanist notions of history and their connection with rhetoric, see Black, "Benedetto Accolti and the beginnings of humanist historiography," *English Historical Review* (1981), pp. 36–58, F. Gilbert, *Machiavelli and Guicciardini*, pp. 203–35, and Ullman, "Leonardo Bruni and Humanistic Historiography," *Medievalia et Humanistica* (1946), pp. 45–61. For more expanded discussions of renaissance historiography, see Fueter, *Geschichte der neueren Historiographie*, and Seigel, *Rhetoric and Philosophy in Renaissance Humanism*. See also the introduction and essays in Mayer and Woolf, *Rhetorics of Life-writing in the Later Renaissance*.

18 *De Ora.*, II.xv.63, vol. I, pp. 244, 245.

eloquence. It was necessary for the historian to reconcile fact with the appearance of truth in order to create an effective example. This was not falsifying; "history's first law," known to all, was that "an author must not dare to tell anything but the truth."[19] And it was also necessary to have an understanding of causes and consequences based on the commonplaces of rhetoric. Such structures were not viewed as inhibiting. They offered a way to order and to give value to the past.[20] The principles of rhetoric underlying history demanded decorum of representation in style of speech and probability of subject, and also established an active relationship between author and audience.

Vasari's definition of history owed much to Cicero's formulations. For Vasari, following Cicero, history was "the true guide and teacher of our actions."[21] Like Cicero, he distinguished "bare records of dates, personalities, places, and events" without any rhetorical ornament from true history.[22] In the preface to the second part of *The Lives* he stated that it was not his intention to produce a mere list, an inventory of artists, their origins, and their works, which he "could have done with a simple chart, without my judgment entering into any part."[23] Chronicle was a genre amply represented in the vernacular writing of Florence in particular, and tables or dateline charts of events were also a familiar form, as in the often renewed world chronicle or *Chronicon*, which gave a list of events and dates from the beginning of the world to the present.[24] Vasari allied himself instead with those "writers of histories . . . who by common consent have the reputation of having written with the best judgment." Such writers

> were not happy simply to narrate a succession of events, but with all the diligence and with the greatest curiosity they could muster have set about investigating the methods, the means, and the courses of action that were used by illustrious men in managing their undertakings . . . as men who recognized history to be truly the mirror of human life, they applied their ingenuity not to recount drily the things that happened to a prince or to a republic, but to make known the judgments, counsels, decisions, and strategies of men: the cause, then, for fortunate or unfortunate actions. This is truly the soul of history, which teaches men how to live and makes them prudent and which – along with the pleasure taken in seeing past things as though present – is its true purpose . . . I have attempted, as far as I could, to imitate the manner of such worthy men; I have made every attempt not only to say what they have done, but also in the course of my discussion to distinguish the better from the good and the best from the better . . . seeking with the greatest diligence in my power to make known to those who do not know this for

19 *De Ora.*, II.xv.62, vol. I, pp. 242–5.

20 See for this, Struever, *The Language of History in the Renaissance*. For Vasari specifically, see Goldstein, "Rhetoric and Art History in the Italian Renaissance and Baroque," *Art Bulletin* (1991), pp. 641–52.

21 General preface to *The Lives*, BB I, p. 29: "vera guida e maestra delle nostre azzioni"; *De Ora.*, II.ix.36, vol. I, p. 224: "Historia, vero testis temporum . . . magistra vitae."

22 *De Ora.*, II.xii.53, vol. I, pp. 236, 237.

23 Preface to Part 2, BB III, p. 3: "non fu mia intenzione fare una nota delli artefici et uno inventario . . . dell'opere loro . . . ché questo io l'arei potuto fare con una semplice tavola, senza interporre in parte alcuna il giudizio mio."

24 [I. Sichardus], *En Damus Chronicon Diuinum plane opus eruditissimorum autorum, repetitum ab ipso mundi initio, ad annum usque salutatis 1512* (1529). For this highly successful outline, see Cochrane, *Historians and Historiography in the Italian Renaissance*, pp. 23–4. For the chronicle tradition, see Phillips, "Machiavelli, Guicciardini, and the Tradition of Vernacular Historiography in Florence," *American Historical Review* (1979), pp. 86–105.

themselves, the causes and origins of the various styles and of the improvement and deterioration in the arts that has occurred in different times and in different individuals.[25]

Vasari's reader, addressed directly as his "most humane" reader in the 1550 edition, was bound to recognize the Ciceronian echoes and also to be able to supply the names of those "writers of histories" Vasari declared as his models for imitation.[26] They were taken from the canon of classical historians whose works supplied the conventions of greatness and its description: writers such as Plutarch, Livy, and Diodorus Siculus. The metaphor of the mirror occurred in Plutarch's *Lives*: "I began the writing of my 'Lives' for the sake of others, but I find that I am continuing the work and delighting in it now for my own sake also, using history as a mirror and endeavoring in a manner to fashion and adorn my life in conformity with the virtues therein depicted."[27] The visibility and exemplarity of the past received its paradigmatic formulation in Livy's preface to his history of Rome: "What chiefly makes the study of history wholesome and profitable is this, that you behold the lessons of every kind of experience set forth as on a conspicuous monument; from these you may choose for yourself . . . what to imitate, from these mark for avoidance what is shameful in the conception and shameful in the result."[28] The utility of history in immortalizing those "who by their virtue have achieved fame," so inspiring noble deeds and providing examples for imitation and correction, is the subject of the opening chapters of Diodorus's *Library of History*.[29] These texts had provided the models for humanist historians and defined the oft-repeated principles of modern concern for the past. By the mid-sixteenth century reference to them was almost reflexive and certainly widely diffused in the vernacular as well as in Latin.[30] A mixture of maxims similar to Vasari's occurs, for example, in the preface to Jacopo Bracciolini's translation of his father's history of Florence and the

25 Preface to Part 2, BB III, pp. 3–4: "vedendo che gli scrittori delle istorie, quegli che per comune consenso hanno nome di avere scritto con miglior giudizio, non solo non si sono contentati di narrare semplicemente i casi seguiti, ma con ogni diligenza e con maggior curiosità che hanno potuto sono iti investigando i modi et i mez[z]i e le vie che hanno usati i valenti uomini nel maneggiare l'imprese . . . come quelli che conoscevano la istoria essere veramente lo specchio della vita umana, non per narrare asciuttamente i casi occorsi a un principe o d'una republica, ma per avvertire i giudizii, i consigli, i partiti et i maneggi degli uomini, cagione poi delle felici et infelici azzioni–il che è proprio l'anima dell'istoria, e quello che invero insegna vivere e fa gli uomini prudenti, e che appresso al piacere che si trae del vedere le cose passate come presenti, è il vero fine di quella . . . ho tenuto quanto io poteva, ad imitazione di così valenti uomini, il medesimo modo; e mi sono ingegnato non solo di dire quel che hanno fatto, ma di scegliere ancora discorrendo il meglio dal buono e l'ottimo dal migliore . . . quanto più diligentemente ho saputo, di far conoscere a quegli che questo per se stessi non sanno fare, le cause e le radici delle maniere e del miglioramento e peggioramento delle arti accaduto in diversi tempi et in diverse persone."

26 *Ibid.*, p. 3 (1550): "umanissimo lettor mio."

27 *Plutarch's Lives*, trans. Perrin, VI, pp. 260, 261 (Life of Timoleon).

28 *Livy*, trans. Foster, I.10, pp. 6–7.

29 *Diodorus of Sicily*, trans. Oldfather, I, pp. 4–13, quotation from pp. 10, 11.

30 A representative statement about the value of history and the availability of ancient authors in both Latin and Italian occurs in the prologue to *I dilettevoli dialogi, le vere narrationi, le facete epistole di Luciano philosopho, di Greco in volgare tradotto per M. Nicolo da Lonigo* (Venice, 1535/6), fol. 1: "Certamente conuenevole cosa è carissimo lettore, che hauendo la benigna natura fra nuoi mortali qualche buona & lodeuole uertu particularmente concessa & data, che quella simigliantemente con li amici & nostri beneuoli participare si debba, il che a tempi nostri, da piu huomini letterati & degni esser stato fatto ueduto habbiamo, percioche leggendo tal fiata i famosi & celeberrimi scrittori, tu ritrouerai Plutarco, Herodiano, Polibio, Diodoro Sicolo, & altri molti, di greco in latino con ottimo stile esser stati tradocti, similmente a comune utilita d'huomini indotti, molti & vari historici, come Livio, Salustio, Quinto Curtio, Appiano Allessandrino, i Comentari di Cesare, in lingua uolgare dilgentissimamente conuersi."

preface to the 1526 translation of Diodorus.[31] With this densely allusive statement of purpose Vasari sited his endeavor in a matrix of influences and authorities that both explained and legitimized his text. This was at once predictable – as he obeyed the etiquette of the discipline, reciting the formulas of justification – and ingenious – as he passed from the familiar and usual applications of history to princes and republics to the methods, manners, and styles of artists. Through a skillful elision of terms he extended the realm of historical investigation to the visual arts. The success of Vasari's rhetoric, his persuasiveness, owed much to this subtle matching of a new matter (*res*) to a prestigious style of treatment (*verba*). By translating the events and consequences of political histories to modes and manners, he made artists into protagonists worthy of imitation, and united the study of character and particular talent (*ingegno*) to style.

The preface to the second part is Vasari's most developed delineation of his role as a historian, but it is preceded by other explanations of his aims and more explicit definitions of his readership. In the letter of dedication to Cosimo de' Medici he introduced the progressive, commemorative, and exemplary nature of his project, and the variety of tasks encompassed.[32] He declared his purpose according to the familiar duality of usefulness and pleasure, dividing it between his fellow artists (who are to benefit from the examples in their practice) and art-lovers (who are to enjoy this account of worthy deeds). The third reader is the duke himself, representative of the class of major patrons to whom the flattering mirror of history was also turned. The social stratification of Vasari's variously directed address was based on the reality of his professional status, which he could not necessarily change, but which he could certainly enhance through history. The formulaic pairing of usefulness and pleasure recurs in the subsequent preface (*Proemio di tutta l'opera*) as the motivation for turning his personal commitment to the past to this more public form. Here he opposes the desire for glory that inspires and supports remarkable works to the voracity of time that ruins those works.[33] History, or memory, is perceived as a mediator, both preserving names and works of past artists and prompting present artists to seek to merit similar fame.

Vasari did not take writing for granted. It was meant to bring about changes in attitude and behavior. He saw it as a powerful instrument, a defence against death. It was also extremely pragmatic in its relation to prudence, invoked by Vasari in the preface to Part 2. Prudence was understood as the practical knowledge of things to be sought for and to be avoided, the right reason required for making choices about actions. In its classical formulation prudence had three parts: the memory of the past, the knowledge of the present, and

31 P. Bracciolini, *Historia Fiorentina* (1476), in Bruni and Bracciolini, *Storie Fiorentine*, ed. Garin, fol. a.i (r): "Certamente come e facti sono dapreporre alle parole: equello siuede congliocchi piu muoue, che quello sintende da altri: cosi lecose uegiamo fare daglhuomini prestanti molto piu cinfiammano, e destanci aexercitare opere degnie disomma loda: che quelle legiamo o udiamo . . . per industria eingegnio deglhuomini excellenti estata trouata lahistoria: alla quale commectendo lecose occorrono indiuersi luoghi possiam come inuno specchio raguardare eprocessi deuiuenti seguiti inmolti secoli." *Diodoro Siculo delle antique historie fabulose*

nuouamente fatto vulgare & con diligentia stampato (1526), p. 3: "E (senza dubio) ogni huomo obligato, & non poco alli scrittori de historie, perche monstrandoci con le fatiche loro, lo andare delle cose passate, ad exemplo di quelle comprehendere possiam, quel che sia da fuggire, ò da pigliare, et alle spese altrui, cioe di chi ne ha con sudore & periculo fatta experientia . . . In cui specchiandoci senza periculo nostro vegniamo in cognitione di tutte cose."

32 BB I, pp. 1–3.

33 General preface to *The Lives*, BB I, pp. 9–10.

provision for the future. By putting the experiences of the past at the disposition of the present for the benefit of the future, history was a form of memory justly allied with prudence. True history was not, therefore, simply descriptive or factual, it was effective or useful, and it was meant to be read for that utility. In the preface to his *Discourses* on Livy, Machiavelli, for example, said that he had written them so that his readers might receive "that usefulness that one ought to seek in the knowledge of history."[34] The notion of historical morality was propagated in compendia of wise sayings and deeds, such as the digest from Plutarch, *I motti et le sententie notabili de prencipi, Barbari, Greci, et Romani da Plutarcho raccolti* (1543).

The process of reading was more than scanning words, the process of writing more than an accumulation of facts. To read was to *riconoscere* – to recognize the skills of individual artists through which they achieved technical perfection, to recognize the connection between different talents and times and styles as they developed, to recognize the kinds of behavior on the part of artists and patrons that resulted in beautiful and honorable works, and, in the context of biography, to recognize the heroic nature of the visual arts and their practioners that made them worth celebrating.

Illustrious men (and women) were a topic of renaissance literature. Usually presented as a series of brief notices, this type of collection went back to St. Jerome's fourth-century *De viris illustribus* (ecclesiastical writers from the apostles to his time). It had an influential advocate in Petrarch.[35] For Vasari the most important such collection was Filippo Villani's *On the Origins of Florence* (*De origine civitatis Florentiae et eiusdem famosis civibus*) written around 1381, which has a passage on painters who had revived an art that was almost dead. The first was Cimabue, followed by Giotto and his students, whose painting imitated nature.[36] Vasari adopted Villani's themes of revival and imitation of nature and took up the specific terms of his praise for Giotto, but to write a life implied something more than a short characterization of Villani's sort. Paolo Giovio wrote that "history has a role, which is the writing of the lives of the excellent men whom fortune made powerful either in the governing of states or in military matters . . . or [who] by virtue of letters and learning were famous, like those celebrated by Laertius, Plutarch, and Pliny in his book of illustrious grammarians."[37] In general terms, Vasari's biographies follow exactly those models proposed by Giovio, particularly Plutarch and Diogenes Laertius. The observations about biography in Plutarch's *Lives* provided Vasari with insights into biographical method, the use of anecdote, and the

34 Machiavelli, "Discorsi," in *Opere*, ed. Bonfantini, p. 91: "a ciò che coloro che leggeranno queste mia declarazioni, possino più facilmente trarne quella utilità per la quale si debbe cercare la cognizione delle istorie." Similarly Donato Acciaiuoli's preface to his translation of Bruni's *Historia Fiorentina*: "Et none dubbio che lanotitia della historia e utilissima & maximamente achi regge & gouerna. Pero che riguardando lecose passate possono meglio giudicare lepresenti & le future" (Bruni and Bracciolini, *Storie Fiorentine*, ed. Garin, fol. a2 r). See for this Landfester, *Historia Magistra Vitae*.

35 See Kohl, "Petrarch's Prefaces to the *De Viris Illustribus*," *History and Theory* (1974), pp. 132–44. In the preface Petrarch paraphrases Livy about "the profitable goal for the historian: to point up to the readers those things that are to be followed and those to be avoided, with plenty of distinguished examples provided on either side" (p. 141). For the form, see Cochrane, *Historians and Historiography in the Italian Renaissance*, p. 393.

36 Villani, *Le vite*, ed. Mazzuchelli, p. 47.

37 *Lettere*, ed. Ferrero, I, p. 174, no. 60 (1534–5), to Girolamo Scannapeco: "Ora l'Istoria ha una parte, la quale è lo scrivere le vite de gli eccellenti uomini, i quali la fortuna abbia fatti, o in Stati, o in arme, potenti . . . overo che per virtù di lettere e di scienze siano stati famosi, come i celebrati da Laerzio, da Plutarco, e da Plinio nel libro de' grammatici illustri."

study of both good and bad examples so that his readers might learn what "ought especially to be known by men who would live aright."[38] Vasari, like Plutarch, included some with undesirable characters. Plutarch reasoned: "I think, we shall also be more eager to observe and imitate the better lives if we are not left without narratives of the blameworthy and the bad."[39] Plutarch also showed the way that birth, education, character, and accomplishments could become interdependent topics of a biography. And Plutarch occasionally included prefaces to his Lives that generalized on topics relating to individual Lives or to history generally, a form that Vasari adopted. But Plutarch's *Lives* were of little use as a direct prototype because they were chiefly about political figures. Their concentration was on events and affairs of state. Vasari wanted to focus on works and development of style. Diogenes Laertius's *Lives of the Philosophers* of the third century AD offered a more directly applicable scheme for this. It was organized according to school and succession of master and pupils. The Lives take different forms, ranging from an orderly succession of topics (origins, exposition of character, works, death, students) to a few lines just naming writings. Rather than assume a strict and decisive voice, Laertius weighs evidence and cites other authors. He includes conversations, anecdotes, poems, epitaphs, letters – a motley assemblage that allowed for a variety of testimony and characters and the exposition of different philosophical views. Vasari is not so openly eclectic, but accepted many of the devices and above all the substitution of works for deeds as a demonstration of excellence or *virtù*.

The coincidence of topics in Plutarch, Diogenes Laertius, and later Vasari is due to the relation of biography to the oratory of praise – a position that is fundamental to Vasari's critical system. Demonstrative oratory, *genus demonstrativum* – the art of praise and blame – was meant to set forth deeds and examples for admiration and imitation.[40] Virtue and vice, the noble and the base, were the contrasting subjects of epideictic. The rules for epideictic oratory and for the other types, judicial and deliberative, are set forth most simply and schematically in the *Rhetorica ad Herennium*. An Italian version of this rhetorical manual attributed to Cicero was published in 1538.[41] Basically the epideictic oration consisted of an introduction, an exposition of the topics of praise, a statement of facts or *narratio*, and a conclusion. Vasari more specifically held to the conventions of the funeral eulogy, that branch of epideictic most suited to his purposes of commemorating past masters and making examples of their Lives, and probably the one most familar to him, as funeral orations were part of renaissance civic ritual.[42] The order and topics of such an oration were an introduc-

38 This advice is given in the introduction to the Life of Demetrius, *Plutarch's Lives*, trans. Perrin, ix, pp. 4, 5. For Plutarch's approach to biography, see Gossage, "Plutarch," in *Latin Biography*, ed. Dorey, pp. 45–77.

39 *Plutarch's Lives*, trans. Perrin, ix, pp. 4, 5.

40 The classic treatment of this genre is Burgess, "Epideictic Literature," *University of Chicago Studies in Classical Philology* (1902), pp. 89–261. See also the important studies by O'Malley, *Praise and Blame in Renaissance Rome*, and McManamon, "The Ideal Renaissance Pope," *Archivum Historiae Pontificiae* (1976), pp. 9–76.

41 *Rhetorica di Marco Tullio Cicerone, tradotta di latino in lingua toscana per Antonio Brucioli* (1538, 1542), Book iii,

fols. 38ff. (1542 ed.), for the following prescriptions for epideictic orations. By an unknown author of the first century BC, since the time of St. Jerome the *Rhetorica ad Herennium* was held to be by Cicero. Although this was doubted and disproved in the fifteenth century, it continued to be attributed to Cicero throughout the sixteenth century. For this, and for the use of this book in teaching rhetoric, see Grendler, *Schooling in Renaissance Italy*, pp. 212–14.

42 For this form and its implications, see McManamon, *Funeral Oratory and the Cultural Ideals of Italian Humanism*.

tion or *exordium*, followed by sections on ancestry, birth, youth, pursuits in life (profession, deeds), comparison, and conclusion.[43] This was Vasari's outline for a Life.

According to the *Rhetorica ad Herennium*, the introduction could be based on the author, containing a statement of purpose and usually a prefatory claim of inadequacy; it could also be drawn from topics relating to the person under discussion. Having placed his modest disclaimer at the beginning of the entire series of biographies, Vasari did not repeat it, preferring a thematic introduction to each artist. About half of these prologues were eliminated from the second edition, but their moral remains embedded within Vasari's presentation of the subsequent developments in an artist's career. The style of these introductions is "ornate" and "grand," appropriate for praise.[44] This enhanced the stature of the subject and was meant to dispose the listener to sympathetic attention, or even, according to Quintilian, to transport them with admiration and move them to acclaim the subject.[45] Vasari's opening paragraphs are properly characterized by "ornate words" and "impressive thoughts."[46] They are based on grandiose abstractions – virtue, honor, the excellence of art, grandeur itself. Heaven is often invoked, divine grace made the agent of greatness. The vocabulary is notable for the selection of words that are specific, striking expressions describing the artists' characters and careers. These words were combined with obvious artifice in constructions relying on recognizable rhetorical ornaments and figures of diction, such as antithesis, repetition, and interrogation.

Such artifice was part of amplification. Held to be essential to the ornate style, amplification was so named because it served to increase the importance of a subject or diminish it, if it so deserved. It involved an abundant marshalling of moralizing statements (*sententiae*). Vasari's eloquence in the introductions is based on his command of such statements, maxims showing "concisely what happens or ought to happen in life."[47] In all the introductions Vasari presents "indisputable principles drawn from practical life," and his audience was expected to give "tacit approval."[48] *Sententiae*, associated with amplification, were related both to rhetorical grace and moral philosophy. This type of moralizing was a practice embedded in any writer's training. Thematic essays were schoolboy exercises, prescribed and codified by textbooks and collected for memorizing and consultation in source books.[49] Vasari's education was undoubtedly topical in that sense. But the maxims and morals of the openings, though familiar, were far from meaningless. Vasari's topics – excellence acquired through study, the stimulus of fame, competition as a spur to achievement, friendship and rivalry, for example – were formulas related to his practice and experience. In *The Lives* and, as has been argued here, in his life, Vasari's view of the world operated through the conventions of commonplace. Formulas about nature, fortune, and *virtù* provided rules about cause and effect, demonstrated in turn through the examples of history. It is clear that

43 McManamon, "The Ideal Renaissance Pope," *Archivum Historiae Pontificiae* (1976), pp. 21–2. For panegyric and artistic biography, see Parshall, "Camerarius on Dürer–Humanist Biography as Art Criticism," *Joachim Camerarius*, pp. 11–29. Camerarius followed the form much more literally than Vasari did, so that his biography reads very differently.

44 See Memmo, *L'oratore*, fol. 64r, who names Cicero and Aristotle as authorities.

45 *I.O.*, VIII.iii.5, vol. III, pp. 214, 215.

46 *Ad H.*, IV.viii.11, pp. 254, 255.

47 *Ad H.*, IV.xvii.24, pp. 288, 289.

48 *Ad H.*, IV.xvii.25, pp. 290–3.

49 For these compilations of ethical maxims, collections of set speeches, and source books of invention, see Lechner, *Renaissance Concepts of the Commonplaces*, pp. 42, 44, 153–6, and Grendler, *Schooling in Renaissance Italy*, pp. 203–4.

the process is circular. The validity of a maxim was demonstrated by the career of the artist from which it was derived and to whom it was applied. Essential here, making the circle virtuous, rather than vicious, was selection. Vasari's topics were topical, formed from prevailing social and moral codes and practices. Normative and authoritative, they were also flexible. Vasari wrote using the assumptions of his time and place, shaping them to his purpose. The rules of nature and of art were matched with care to the circumstances of each case.

Following the exordium the eulogistic form then demanded a consideration of the "topics on which praise is founded."[50] The *Rhetorica ad Herennium* states, following the tradition established by Aristotle's *Rhetorica*, that the subjects of praise were external circumstances, physical attributes, and qualities of character. External circumstances were those of fortune and of descent and ancestry that could provide advantages and disadvantages. They also included education to show "that [the subject] was well and honourably trained in worthy studies throughout his boyhood."[51] A description of physical advantages – impressiveness and beauty – should follow, and then a description of the qualities of character, of virtues and defects. These are the invariable components of a renaissance Life, Vasari's biographies included.

Having set forth the things to be praised or censured the next thing was to recount the deeds and events (*res gestae*) in sequence. The acts were to be evaluated according to the established moral criteria. In Vasari's case this could also mean aesthetic judgments. Following this came the conclusion. For Vasari, as for others, this was the place for a recapitulation of the subject's particular virtues. Brief amplifications were to be inserted throughout the eulogy by means of commonplaces, that is, edifying embellishments intended to please and instruct in order to make the praise more effective.

The *Rhetorica ad Herennium* describes this as "the order we must keep when portraying a life" ("vita") and it was the order Vasari held to in portraying a life.[52] For Vasari this order defined the difference between a Life (a *vita*) and other forms of commemoration: an inventory, a narrative of works, or a description.[53]

In ordering each Life Vasari was more concerned with presenting examples of accomplishment and with the development of careers than with the order of works as executed. He often grouped works in a Life according to stylistic rather than chronological criteria, just as he had the entire series of Lives. While he pays attention to and points out the

50 *Ad H.*, iii.vi.10, pp. 172, 173.

51 *Ad H.*, iii.vii.13, pp. 180, 181.

52 *Ad H.*, iii.vii.13, pp. 178, 179: "Ordinem hunc adhibere in demonstranda vita debemus."

53 As discussed above, in the preface to Part 2, BB iii, p. 3, Vasari opposes describing Lives to making an inventory: "Quando io presi primieramente a descrivere queste Vite, non fu mia intenzione fare una nota delli artefici et uno inventario." He introduced his collective account of Lombard artists saying that as he could not write a detailed Life of each artist, it seemed sufficient to recount their works (BB v, p. 409): "si farà brievemente un raccolto di tutti i migliori . . . pittori, scultori et architetti . . . non potendo fare la Vita di ciascuno in particolare, e parendomi a bastanza raccontare l'opere loro." He gives the heading "Descrizione dell'opere" to some of his accounts of living artists, like Primaticcio (BB vi, p. 143), Titian (BB vi, p. 155), and Jacopo Sansovino (BB vi. p. 177), and of his own career (BB vi, p. 369). This distinction is based primarily on living and dead subjects, as is demonstrated by the case of Jacopo Sansovino. In the 1568 edition there is a description of his works. After he died in 1570 a full *Vita* was published. Although based on the version in *The Lives*, it was announced as "enlarged, revised, and corrected" ("ampliata, riformata, et corretta"). For this restructuring and its possible motivations and sources with respect to Jacopo's son, Francesco, see C. Davis in Arezzo 1981, pp. 293–5.

formation and development of artists' styles, describing an artist's early works, noting how they imitate, equal, and surpass those of his master, he stresses typical or pivotal works. Vasari often describes all the works in one place before moving on to the next: a probable reflection of his own information-gathering itineraries.

Usually a few minor works are listed, the preliminary efforts culminating in the first masterpiece – the work first demonstrating the artist's talents and establishing his reputation. His name and fame established, the account of a painter's oeuvre could be ordered in a crescendo of ever more distinguished patronage, as in Piero della Francesca's Life. Born in the small town of Borgo San Sepolcro, Piero's growing fame passed from ducal ear to ducal ear, Vasari has him going from the court of Guidobaldo da Montefeltro at Urbino[54] to that of Borso d'Este at Ferrara, and thence to the papal court at Rome; only his mother's death brings him back home.

The order can also follow Vasari's hierarchy of the arts, thus Antonio Pollaiuolo's works as a goldsmith are described before his paintings. Having seen his works destroyed by fire during war time, Antonio changed arts, seeking the more enduring fame granted by painting.[55] Similar professional snobbery is used to advance Benedetto da Maiano's career. Benedetto started work, Vasari says, in the family business, as a woodworker, but an embarrassing incident involving an inlaid bed coming unglued as it was unwrapped with fanfare for the king of Hungary forced a more elevated career on him. He renounced his first profession, moved by the shame he had suffered, timidity conquered, he took sculpture as his profession.[56] Artists also earn their way from provincial towns to the privileged centers of artistic excellence, notably Florence and Rome.

In any place or any order, Vasari's lists are not intended as complete catalogues. They include those works worthy of mention, demonstrating the quality rather than the quantity of an artist's output. Vasari does not merely recite the artist's deeds (or "miracles" as in the case of Michelangelo), he gives variety to the narrative and personality to the biographies by means of the amplifications and digressions expected in encomium. These digressions sometimes take the form of anecdotes, expressive of the artist's character. In rhetoric wit was the spice of argument, to be used sparingly and correctly to advance a cause. Vasari employed it to vary the tone of the text and often to demonstrate character flaws that might thwart success. He mocked Paolo Uccello, describing the timid painter as being fed so full of cheese by the monks of San Miniato that he fled from work there, afraid that he might be used for making glue and worried that if it were to go on much longer "I would probably be Paolo no more, but cheese."[57] This mockery fits into Vasari's critical construction of the artist. He is represented as given to futile speculation rather than the profitable exploitation of his talent, so that his poverty matched his fame.[58] It is in these episodes that the vivid characterizations of both Dante and Boccaccio were Vasari's great teachers. The short story and practical joke (novella and beffa) were indigenous forms, Boccaccio's Decameron

54 A slip of dukes, Piero's contemporary during the early years would have been Federigo; Piero's theoretical writings were actually in Guidobaldo's library, Vasari elided two dukes.

55 Life of Antonio and Piero Pollaiuolo, BB iii, p. 502.

56 Life of Benedetto da Maiano, BB iii, p. 525.

57 Life of Paolo Uccello, BB iii, p. 65: "non sarei più forse Paulo, ma Cacio."

58 Ibid., p. 61.

providing an illustrious example combining both.[59] Many of the quips, role reversals, and revealing antics in *The Lives* fit closely into the forms and figures of the Tuscan *novella*. Verisimilitude is the link between storytelling and historical narrative. Vasari's portrayal of figures from the past was based largely on instructive probabilities, which abounded, not actual facts, which were limited. Right and wrong were matters of morality. Utility was the measure of Vasari's truth.

Speeches were another conventional embellishment of biography. These orations, placed at crucial moments, effectively gave a summary of the subject's virtues in the subject's voice. While there is a certain amount of reported conversation in *The Lives*, Vasari rarely wrote speeches for his heroes, as the artists seldom had to deliberate upon a course of action for the public welfare, lead an army, or sway a jury. One notable exception is the passionate set of insults hurled at the "two-bit merchant" Giovambattista della Palla by the valiant Margherita in Pontormo's Life. Wife of Pierfrancesco Borgherini and worthy daughter of the prudent citizen Roberto Acciauioli, she defended the decorations of her marriage bed against one who would despoil his city of its treasures and sell them to foreign countries and enemies of Florence.[60] One of the other such set pieces was Brunelleschi's address to the jury of the competition for the bronze doors of the Florentine Baptistery, persuading them that Ghiberti ought to be awarded the commission. A speech meant to demonstrate Brunelleschi's noble spirit and Ghiberti's artistic skill, it was an obvious fiction and was omitted in the 1568 edition.

Artists generally speak through their works in *The Lives*. Descriptive passages were also a traditional element of historical writing, descriptions of battles and of scenery being the most common.[61] Vasari combined description of character with dramatic or dramatized word pictures to bring the artistic personality into focus.

Following the narrative of deeds comes a concluding description of character, death, burial, epitaphs, students. The emphasis on death is integral to the concept of a Life as commemorative, in demonstrating the honor earned through actions and surviving beyond the artist's lifetime. Vasari often included elaborate accounts of death, mourning, and funerals. He was partly inspired in this by the relation of funeral orations to his biographical form and partly by the fact that the full rituals of mourning and burial were essential to posterity and honor.[62] By the forms of inscription and commemorative verse he associated with artists, he effected an implicit rise in status for his subjects, as what must have generally been rather modest markers were inflated to polished epitaphs and artfully contrived verses.

59 Fontes, "Le thème de la *beffa* dans le *Décameron*," in *Formes et significations de la 'beffa' dans la littérature italienne de la Renaissance*, ed. Rochon *et al.*, I, pp. 11–44. One of the most famous of Florentine *beffe*, that of Grasso *legnaiuolo* was credited to Brunelleschi and told at the opening of the fifteenth-century biography of Brunelleschi attributed to Antonio Manetti. For anecdote as a critical device and its place in writing history, see G. Perini, "Biographical anecdote and historical truth: an example from Malvasia's 'Life of Guido Reni,'" *Studi secenteschi* (1990), pp. 149–60.

60 Life of Pontormo, BB V, pp. 317–18, for the speech from Margherita to the "mercatantuzzo di quattro danari," della Palla.

61 For this technique in *The Lives*, see Alpers, "'Ekphrasis' and aesthetic attitudes in Vasari's 'Lives,'" *Journal of the Warburg and Courtauld Institutes* (1960), pp. 190–215. For Vasari's descriptive techniques, see below, Chapter VI.

62 Fetel, Witt, and Goffen eds., *Life and Death in Fifteenth Century Florence*, and Strocchia, "Burials in Renaissance Florence," Ph.D. (University of California, Berkeley, 1981), and *Death and Ritual in Renaissance Florence*.

The sequence of topics followed by Vasari were the *sine qua non* of renaissance biography. In his account of Dante which prefaces the commentary to *The Divine Comedy*, Boccaccio, for example, said that he would write about the nobility of Dante's birth, his life, his studies, his behavior, his works.[63] Machiavelli's sequence in his Life of Castruccio Castrocani was origins, upbringing, education, deeds, illness, death bed speech, burial, description of his person and his character, and sayings.[64] That the chosen structure was part of the validity and pleasure of the form is indicated by the letter from Zanobi Buondelmonti to Machiavelli about this Life. Buondelmonti reports the positive reactions of Machiavelli's friends and notes that his model of history gave pleasure.[65] The topics of encomia that determined biography had a distinguished and recognized heritage, which is structurally incorporated into Vasari's message about the prestige of his profession. His articulation of the structure represents his own variation on the theme, one suited to his material, to the didactic function of the entire group of *The Lives*, and to the number of Lives.

Biography seems to have been widely read. A rich tradition was available to Vasari when he thought about publishing Lives. There was a considerable body of manuscript Lives and notices of great men, some, like Filippo Villani's, known to Vasari. Indeed, the one category of biography represented more in manuscript than in print seems to be collected Lives of contemporary figures.[66] This highlights Vasari's originality and acumen in proposing the subject for a printed book. His success indicates its period validity – artists could be "great men," their deeds of consequence. A survey of printed Lives confirms both the interest in reading about the famous as well as the unique nature of Vasari's project in diffusing artistic fame. Biographies by classical authors were published in Latin and Italian in the fifteenth and sixteenth centuries. The most frequently reprinted single Lives seem to have been Xenophon's idealizing account of the Persian king Cyrus (the *Cyropaedeia*) and the historical romance, *The Life of Aesop*.[67] The most frequently published collections were those by Plutarch (in various forms) and Suetonius.[68] The predominant categories of published

63 Boccaccio, *Opere*, ed. Ricci, p. 568, similarly p. 642.

64 Machiavelli, *La vita di Castruccio Castracani*, ed. Brakee and Trovato.

65 *Lettere*, ed. Gaeta, no. 177, pp. 394–5 (6 September 1520). The model was essentially Plutarch. One of those present at that reading, Jacopo Nardi was later to write to Benedetto Varchi about his own historiographic preferences, "Certo mi piace più lo imitare Cornelio Tacito che Livio" (1547), see Pirotti, *Benedetto Varchi*, p. 173. For an exchange between Francesco Guicciardini and the humanist Giovanni Corsi in the winter of 1538–9 about Guicciardini's *History of Italy*, see Black, "The new laws of history," *Renaissance Studies* (1987), pp. 153–4.

66 For some of these see Miglio, "Biografia e raccolte biografiche nel Quattrocento italiano," *Atti della Accademia delle Scienze dell'Istituto di Bologna, Rendiconti* (1974–5), pp. 166–99.

67 The following, admittedly rough, but hopefully revealing, statistics are derived from a count of biographies printed before 1550 in the British Museum *Short-Title Catalogue of Books Printed in Italy and of Italian Books*

Printed in Other Countries from 1465 to 1600. The editions of Xenophon (Life of Cyrus) listed in the fifteenth century are: 1 in Latin, 3 in Italian. The editions of *The Life of Aesop* are: fifteenth century, 2 in Italian, 7 in Latin; sixteenth century, 6 in Italian. The other single Lives by classical authors were Quintus Curtius, *De rebus gestibus Alexandri Magni*: fifteenth century, 1 in Latin, 1 in Italian; Philostratus (Life of Apollonius of Tyre): sixteenth century, 1 in Latin, 2 in Italian.

68 The different versions of Plutarch's works listed are: *Epitome* (Latin), 1 in the fifteenth century, 1 in the sixteenth century; *Apophthegmata* (Latin), 2 in the fifteenth century, 1 in the sixteenth century; *The Lives*, 4 editions of the full book in Latin and 1 edition of the first part in Italian in the fifteenth century, 3 editions in Latin and 1 in Italian in the sixteenth century; *De claris mulieribus*, 1 in the sixteenth century; *Motti e sentenze* (*Apophthegmata*), 1 in the sixteenth century. Suetonius, *Lives of the Caesars*: in the fifteenth century, 16 in Latin; in the sixteenth century, 5 in Latin, 1 in Italian. Diogenes Laertius' *Lives of the philosophers*: in the fifteenth century, 7 in Latin; in the sixteenth century, 1 in Italian. Pliny (*De viris illustribus*): in the fifteenth

modern groups of Lives in the fifteenth and sixteenth centuries were those of saints, popes, and rulers or military leaders.[69] The modern subjects for individual Lives were saints, rulers, and poets.[70]

Saints' Lives were the most common form of biography. These narratives, which also formed part of the liturgy, must have shaped Vasari's historical awareness to a considerable extent. Pictured on the walls of churches, recited on feast days, and sold as popular books, these Lives were the omnipresent embodiment of superhuman virtue and its rewards. They created a corpus of approved actions, meant to be imitated by the faithful.[71] Both the continuity and presence of the past as an active agent of virtue are fundamental to religious lives as written, illustrated, and preached. The recurrence of an event was its authority. Truth is not invested in the details of the episode, but in the example it teaches. This form of consciousness of the paradigmatic past, with its authoritative and compelling messages, its exemplary acts, and its characterization through deeds was an essential influence on Vasari – and saintly gestures, both good christian behavior and near miraculous deeds are part of his recreation and explanation of artists. Though suggestive of episodes and motifs and an indelible aspect of Vasari's consciousness, saints' Lives were not a source for the structure of his biographies. This was derived from the stricter sequence of topics of classical form. From these topics renaissance biographers, Vasari included, portrayed distinct individuals operating within a shared system of social virtues. Innate gifts, fortune, and moral codes are both motivation and explanation. The generic character of the "civilized man" populates the form, and Vasari purposefully adhered to this. He did not copy any one Life, but observed the general principles of life writing. Poets' Lives were the most relevant precedent, particularly those of Dante and Petrarch. These established a connection between cultural renewal and individual accomplishment, celebrated glory through works, and proposed issues of style in terms that were important to the more general consideration of the arts.[72]

It cannot be a coincidence that Paolo Giovio was the most prolific published biographer of the day. His celebrations of great men took various forms and occupied much of his career. In the 1520s he had written on Leonardo, Michelangelo, and Raphael. At the time Vasari was embarking on *The Lives*, he was preparing a biography of Leo X for publication.

century, 9 in Latin; in the sixteenth century, 1 in Italian. Cornelius Nepos (Lives of the Emperors): in the fifteenth century, 3 in Latin; in the sixteenth century, 1 in Latin.

69 Collected Lives of saints (predominant here are Jacopo da Voragine's *Golden Legend* and St. Jerome's *Lives of the Desert Fathers*): fifteenth century, 2 in Latin, 9 in Italian; sixteenth century, 2 in Latin, 6 in Italian. Collected Lives of members of religious orders: sixteenth century, 2 in Latin. Collected Lives of popes (predominant here, B. Sacchi de Platina, *Vitae pontificum*): in the fifteenth century, 6 in Latin; in the sixteenth century, 4 in Latin and 2 in Italian. Modern rulers: sixteenth century, 2 in Latin. Ancient subjects by modern authors (emperors): sixteenth century, 3 in Latin, 2 in Italian. *Chronica delle vite de pontifici et imperatori romani*: 2 in the sixteenth century. Petrarch, *Illustrious Men*: fifteenth century, 1 in Italian; sixteenth century, 1 in Italian.

70 Saints: fifteenth century, 8 in Latin, 22 in Italian; in the sixteenth century, 5 in Latin, 20 in Italian. A pope: sixteenth century, 1 in Italian and 1 in Latin. A modern ruler: fifteenth century, 4 in Latin, 2 in Italian; in the sixteenth century, 4 in Latin and 11 in Italian (additionally Machiavelli's *Life of Castruccio Castracani* published with his other works in various editions). Individual poet's Lives were often part of the commentary to their works, such as Boccaccio and Landino's Lives of Dante. See Solerti, *Le Vite di Dante, del Petrarca e del Boccaccio*.

71 For the traditions and forms of saints' Lives, see Delehaye, *The Legends of the Saints*, Heffernan, *Sacred Biography*, and Wilson, *Saints and their Cults*. See Barolsky, *Michelangelo's Nose*, pp. 55–8 for cases of pious artists and saintly virtues in *The Lives*.

72 For this see Sousloff, "*Lives* of poets and painters in the Renaissance," *Word and Image* (1990), pp. 154–62.

It appeared in Latin in 1548 and in an Italian translation by Lodovico Domenichi in 1549.[73] Moreover, Giovio's hobby was collecting portraits of famous men, and he had a plan to publish the portraits with short, biographical summaries – the book of *Elogii* mentioned by Vasari. The first set was published in 1546.[74] The work was never completed as he envisioned it, but his advice to Vasari in his letter of March 1548 to go ahead with publication of *The Lives* without waiting for illustrations, suggests that portraits were to be a feature of Vasari's own series of great men.[75] Similarly, the moralizing passages that preface each life in the 1550 edition probably were encouraged by Giovio's interest in eulogistic captions for his portraits. Giovio was most likely Vasari's immediate guide to the historiographic tradition, its texts and principles in the mid-1540s, that crucial point when he converted his notes to Lives. As a professional historian he could have helped Vasari through the requisite commonplaces and to the most useful models, acting as both translator and mediator for Vasari doing his historical homework. Cicero's *Brutus* and Quintilian's *Institutio Oratoria*, both referred to by Vasari, were not available in Italian. He is likely to have been provided with excerpted passages. Giovio favored a Ciceronian, exemplary view of history that is basic to Vasari's representation of artists. In his letter about his Life of the humanist Pietro Gravina, he wrote about his desire to praise his subject truthfully: not to lie or exaggerate or adulate, but to keep to the middle way in order to produce a distinguished portrait and to maintain the reputation and dignity of his history. Giovio knew Gravina's faults (he was occasionally vindictive and overly fond of young boys), but he excluded them from his biography to concentrate on his virtues:

> You well know that history must be truthful, and one should not trifle with it at all except in a certain and limited latitude given to the writer by ancient privilege to exaggerate or minimize the vices in which persons err; and conversely to heighten or underplay their virtues by the use of ornate or plain styles according to their merits and the counter-weights to them.[76]

Giovio had great faith in the relation of eloquence to immortality, and in the promptings of fame to glorious deeds.[77] The subjects and length of Giovio's biographies make them

73 *Pauli Iovii Novocomensis Episcopi Nucerini de vita Leonis Decimi Pont. Max. Libri IIII.* See Cochrane, "Paolo Giovio e la storiografia del rinascimento," in *Atti del convegno Paolo Giovio*, pp. 19–30, for a brief account of Giovio as one of the first and few professional historians of the period. See also Zimmerman, "Paolo Giovio and the Rhetoric of Life-Writing," in *Rhetorics of Life-writing in the Later Renaissance*, ed. Mayer and Woolf.

74 *Elogia veris clarorum virorum imaginibus apposita.* Giovio's intention of continuing to publish the portraits and epitaphs is indicated by a letter to Anton Francesco Doni dated 14 September 1548 acknowledging the receipt of one from Doni with the exemplar of the book of medals and expressing the hope that they could engrave the pictures in his Museum, "at least those famous in war," for which he had begun to write his brief eulogies, see Bottari and Ticozzi, *Raccolta di lettere sulla pittura, scultura ed architettura*, v, pp. 148–9. The *Elogia virorum bellica virtute illustrium* appeared three years later.

The history of this enterprise as well as its precedents is discussed in great detail by Rave, "Paolo Giovio und die Bildnisvitenbücher des Humanismus," *Jahrbuch der Berliner Museen* (1959), pp. 119–54. The collection is reconstructed and its motivations skillfully analyzed in Klinger, "The Portrait Collection of Paolo Giovio," Ph.D. (Princeton University, 1991).

75 Frey I, cx, pp. 218–19 (Rome, 31 March 1548, to Vasari, Ravenna).

76 *Lettere*, ed. Ferrero, I, p. 177, no. 60 (1534–5), to Girolamo Scannapeco: "Sapete bene che l'istoria dee esser sincera, né punto bisogna in essa scherzare se non in una certa e poca latitudine donata allo scrittore per antico privilegio di potere aggravare e alleggerire le persone de' vizii, ne' quali peccano; come per lo contrario con florida e digiuna eloquenza alzare e abbassare le virtù secondo i contrapesi e meriti loro."

77 Expressed, for example, in the dedication of his Life of Leo X. For the relation of Giovio's ideas to

entirely different from Vasari's, which, with appropriate decorum, have their own proportions and emphases and with great enterprise wed conventions of biography with those of history.

In his *Lives of Dante and Petrarch* (1435) Leonardo Bruni wrote that

> Francesco Petrarch was the first who had been graced with such intellect that he recognized and returned to light the elegance of ancient style that had been lost and extinguished. Even though he did not achieve perfection, still he alone saw and opened the way to perfection by rediscovering the works of Cicero, taking pleasure in them and understanding them, and adapting himself, as far as he could, to that most elegant and perfect eloquence.[78]

For Vasari the parallel example was Giotto, who "opened the door of truth" and who resuscitated and rediscovered the lost forms, leading the way to perfection.[79] Giotto's name was as established as Petrarch's by the time Vasari came to write *The Lives*, as was the conviction of a renewal of the glories of antiquity in modern times, separated from a dark and ruinous immediate past.[80] By the sixteenth century almost no discussion of the state of an art was proposed without these terms and a series of comparative cases. The polar oppositions of rough (*rozzo*) to refined (*ornato, grazioso, bello*) had long been fixed to this history of rediscovery. Manetti's *Life of Brunelleschi*, Alamanno Rinuccini's dedication of his translation of Philostratus' *Life of Apollonius of Tyre*, Paolo Cortesi's dialogue on learned men, and Niccolò Liburnio's preface to his book on eloquence (*Le tre fontane*) are typical. The visual arts were cited as examples, for instance by Filippo Villani, Leon Battista Alberti in his book *On Painting*, Matteo Palmieri in his treatise *On Civil Life*, and Rinuccini in his dedication. This tradition offered Vasari richly associative metaphors, a cultural chronology, and a sense of current accomplishment, but it did not offer a precedent for a panorama of his profession either as wide ranging or as specific as that of *The Lives*. Nor did it propose a systematic subdivision of artistic development into ages like the one he adopted. This arrangement depended on concepts borrowed from principles of development that had traditionally been applied to states: the cycle of fortune and the biological theory of origins and growth, both of which proposed subdivisions into separate and definable periods. The ages of man were particularly appropriate for a construction of the past based on a notion of rebirth (*rinascita*).[81] Vasari made a telling modification to these often adapted schemes: he

Vasari's activities, see Davitt Asmus, *Corpus Quasi Vas*, pp. 41–113, Kliemann, "Su alcuni concetti umanistici del pensiero e del mondo figurativo vasariani," in *Studi 1981*, pp. 73–82, and "Il pensiero di Paolo Giovio nelle pitture eseguite sulle sue invenzioni," in *Atti del convegno Paolo Giovio*, pp. 197–223.

78 Baron ed., *Leonardo Bruni Aretino, Humanistisch-Philosophische Schriften*, pp. 65–6: "Francesco Petrarca fu il primo, il quale ebbe tanta grazia d'ingegno che riconobbe e rivocò in luce l'antica leggiadria dello stile perduto e spento. E posto che in lui perfetto non fusse, pur da sè vide ed aperse la via a questa perfezione, ritrovando l'opere di Tullio e quelle gustando e intendendo, adattandosi, quanto potè e seppe, a quella elegantissima e perfettissima facondia."

79 Life of Cimabue, BB II, p. 44: "Giotto . . . fu quegli che andando più alto col pensiero aperse la porta della verità."

80 For precedents and further references, see McLaughlin, "Humanist concepts of renaissance and middle ages in the tre- and quattrocento," *Renaissance Studies* (1988), pp. 131–42, and Smith, *Architecture in the Culture of Early Humanism*, pp. 64–7. For a list of the occurrence of the metaphors of revival from the fourteenth to the sixteenth centuries, see Black, "The Donation of Constantine: A New Source for the Concept of the Renaissance?" in *Language and Images in Renaissance Italy*, ed. A. Brown.

81 Vasari applies the biological and cyclical notions to his historical organization of the arts in the preface to

did not allow maturity to progress to senility or Fortune's wheel to turn against his time. Dante was surely his inspiration for this optimistic view. The process of discovery and enlightenment that informs *The Lives*, and the division into three parts have obvious parallels with Dante's journey from Hell to Heaven in *The Divine Comedy*. And just as at every stage of his spiritual pilgrimage to enlightenment Dante met representatives of virtues and vices – embodiments of actions and consequences – so too Vasari led his reader through a series of historical exemplars. The symbolism of the path was available to him in previous biography and biblical lore, but he alone found the signposts and subdivisions for his history. He took credit for this and explained it because "long experience teaches careful painters to recognize . . . the various styles of the artisans."[82]

The mid-1540s were a propitious time to become an apprentice to history. Many major classical works appeared or reappeared in translation: sayings from Plutarch (1543), Tacitus (1544), Plutarch's *Lives* (1545), a new Italian edition of Diogenes Laertius (1545), Sallust (1545), Thucydides (1545), Dionysius of Halicarnassus (1545), Florus (1546), Livy (1547). A vender in Aretino's play *La Cortigiana* hawks "beautiful histories" in the streets of Rome.[83] It was an equally propitious time to make that history one of the arts. A burgeoning literature had focussed attention on matters of style. Vasari, both fortunate and shrewd, seized the moment.

The Kinship of the Arts

In the preface to Part 2 Vasari reflects upon his belief that it is

> a property and a particular character of these arts – that from a humble beginning they very gradually improve, and finally reach the summit of perfection. I am led to believe this by having observed almost the same occurrence in other fields of learning, and the fact that there exists a certain kinship between all the liberal arts provides no small argument that it is true.[84]

This coincidence, this progress, and the examples from ancient art that Vasari proceeds to cite were also noted by Cicero in his treatise on oratory, *Brutus*. Cicero's point, "true of all the other arts," is that "nothing is brought to perfection on its first invention," and this was the basis of Vasari's history.[85] In the *Brutus* Cicero undertook the task "of distinguishing the

Part 2, BB III, pp. 5, 7, 14–15. For these notions generally, see Trompf, *The Idea of Historical Recurrence in Western Thought*. See Panofsky, "The First Page of Giorgio Vasari's 'Libro,'" in *Meaning in the Visual Arts*, pp. 216–18, for Vasari's use of the ages of man and for the suggestion that he derived this model of periodicization from the four ages of Roman history as set forth by L. Annaeus Florus in his second-century AD *Epitome rerum Romanorum*, which appeared in Italian translation in 1546 just as Vasari was writing *The Lives*.

82 Letter to the artists, BB VI, p. 411: "essendo che insegna la lunga practica i solleciti dipintori a conoscere . . . le varie maniere degl'artefici."

83 Act I, scene iv, *Tutte le commedie*, pp. 123–4: "A le belle istorie, istorie, istorie."

84 Preface to Part 2, BB III, p. 7: "giudico ch'e' sia una proprietà et una particolare natura di queste arti, le quali da uno umile principio vadino appoco appoco migliorando, e finalmente pervenghino al colmo della perfezione; e questo me lo fa credere il vedere essere intervenuto quasi questo medesimo in altre facultà: che, per essere fra tutte le arti liberali un certo che di parentado, è non piccolo argomento che e' sia vero."

85 *Brutus, Orator*, trans. Hendrickson and Hubbell, *Brutus*, xviii.71, pp. 66, 67. See Gombrich, "Vasari's 'Lives' and Cicero's 'Brutus,'" *Journal of the Warburg and Courtauld Institutes* (1960), pp. 309–11. Cicero opened his speech on behalf of the poet Archia commenting that "the subtle bond of a mutual relationship links together all the arts which have any bearing upon the common life of mankind" (*Pro Archia Poeta*, trans. Watts, i.2, pp. 8, 9).

characteristics of orators within their respective periods," as Vasari did for artists.[86] In the *Orator* Cicero states that he "held that in all things there is a certain 'best,' even if it is not apparent, and that this can be recognized by one who is expert in that subject."[87] And in his treatise on the teaching of rhetoric, Quintilian cited examples from painting and sculpture to demonstrate varieties of style among different kinds of works, by different authors at different times and related admiration both to "conditions of time or place" as well as "taste and ideals of individuals."[88] He also wrote, using the painter Polygnotus as a parallel case, that "there were certain kinds of oratory that, owing to the circumstances of the age, suffered from lack of polish, although in other respects they displayed remarkable genius."[89] Such reasoning underlies Vasari's presentation of the artists of the first era, considering the quality of the times. This kind of discernment, and its need for expert judgment, was fundamental to Vasari's historical construction of the arts and artists – in their development and their varieties of talent. These rhetorical texts provided a model for linking a critical consideration of style with history. They further provided a basic vocabulary of stylistic differentiation and related beautiful forms to expressive purposes. The discussion of the ideal standards for an art, the attainment of perfection, and the technical mastery of skills by individual practitioners through the study of principles and the selection of models are key topics of these writings, adopted by Vasari for his book on the visual arts of his day.

The parallels between the arts made by Cicero and Quintilian were frequently repeated by renaissance authors. They were a commonplace in discussions of style. Giovio relied upon them in his writings about painters (in his dialogue *De viris illustribus* and his short lives of Leonardo, Michelangelo, and Raphael), Bembo in his letter on imitation, and Castiglione in *The Courtier*, for example.[90] These extremely influential passages had created a place for painters and sculptors to become paradigms, to be cited in conversation, and for modern artists to be compared with, or substituted for, ancient ones. Vasari exploited this place, and expanded it considerably. By adapting Cicero and Quintilian's well-known remarks he both employed an extremely serviceable framework for organizing his history and accepted the resonance and authority of the reference. It is also the case that the critical perceptions of the ancient authors had exerted some influence on the practices of the periods that Vasari was observing precisely because they were important in the articulation of taste and of judgment from the late fourteenth century to Vasari's day.

By Vasari's time the question of style had become fashionable, if not urgent. One of the most heated debates of the first half of the sixteenth century was the question of the Italian language: what it was, what were its qualities, and what were its origins. Many of Vasari's acquaintances had contributed to the debate, and most were strong champions of Tuscan, if not Florentine, as the true and most eloquent form of the vernacular. So, for example, Claudio Tolomei, Pierio Valeriano, and later the group who saw the first edition of *The Lives* through the press, Pierfrancesco Giambullari, Cosimo Bartoli, and Carlo Lenzoni,

86 *Brutus, Orator*, trans. Hendrickson and Hubbell, *Brutus*, xix.74, pp. 70, 71.

87 *Ibid.*, *Orator*, xi.36, pp. 330–3.

88 *I.O.*, Book xii.x.1–10, vol. iv, pp. 448–51, quoted from xii.x.2, pp. 450, 451.

89 *I.O.*, Book xii.x.10, vol. iv, pp. 454, 455.

90 For Giovio, see Zimmerman, "Paolo Giovio and the evolution of Renaissance art criticism," in *Cultural Aspects of the Italian Renaissance*, ed. Clough, pp. 406–24. For Bembo, see *Le epistole "De Imitatione" di Giovanfrancesco Pico della Mirandola e di Pietro Bembo*, ed. Santangelo, p. 41. For Castiglione, see *Cortegiano*, ed. Cian, Book i, chapter 37, pp. 92–3.

were engaged in the dispute. Referring to Dante, Petrarch, and Boccaccio they argued against those who were advancing other dialects or an invented, composite courtly language for literature and learning.[91] The issues rehearsed in these dialogues and debates – about imitation, decline and renewal, decorum, antique models, and the predominance of Tuscan excellence of style – related both to the theory and practice of the visual arts as understood by Vasari. Indeed, they created the conditions and vocabulary of that understanding. Another developing literature was that of poetics, where painting often featured as a comparative art, following the tradition of Horace's dictum *ut pictura poesis*.[92]

Artists were both participants in and subjects of these modish discussions. Castiglione made the visual arts a topic of conversation in *The Courtier*. Alessandro Piccolomini had a section on the arts in his often reprinted book on education, *De la institutione di tutta la vita de l'huomo nato nobile* (first edition, 1542). Vasari remembered how many artists and other clever men would repair to the house of the Mantuan ambassador to Venice, to debate and discuss various matters.[93] Aretino attached himself to Michelangelo's reputation and Titian's bravura in his letters, and characters in his plays (*Il Marescalco, La Talanta*) chat about painters and paintings. Alberti's books on architecture appeared in translation in 1546 and again in 1550 in a version by Cosimo Bartoli with a frontispiece designed by Vasari.[94] Lodovico Domenichi's translation of Alberti's book *On Painting* came out in 1547 (dedicated to Salviati). Anton Francesco Doni described Vasari's paintings in the Cancelleria in great detail in a letter addressed to Cosimo de' Medici's secretary, Lelio Torelli, published in his 1547 book of letters. Doni further wrote a dialogue, *Il Disegno*, published in 1549, developing the dispute about painting and sculpture. Paolo Pino's *Dialogo della Pittura* appeared in 1548 and Michel Angelo Biondo's *Della nobilissima Pittura* in 1549. At about this time Michelangelo contemplated writing on the arts of design, an intention given voice in Donato Giannotti's *Dialogi* on Dante (1546), where he is present as a Dante expert. His ideas are somehow registered in Francisco de Hollanda's dialogues *De la pintura antigua* (1548). These various textual exchanges, part of the expanding repertory of publishing, emerge from a context of actual exchange between practicing artists and literary practitioners.

Bronzino, Tribolo, Michelangelo, Francesco Sansovino, Benvenuto Cellini, Baccio Bandinelli, and Francesco Salviati were members of the Florentine academy, until excluded, along with others, in a reform of March 1547 requiring all members to produce lectures or some form of literary contribution (some, like Bronzino and Tribolo, were later

91 See for this Hall, *The Italian Questione della Lingua*, De Gaetano, *Giambattista Gelli*, chapters III–V, and Nencioni, "Il volgare nell'avvio del principato mediceo," in *Medici* 1980, II, pp. 683–705.

92 See Weinberg ed., *Trattati di poetica e retorica del Cinquecento*.

93 Life of Genga, BB V, p. 354: "molti della professione . . . si riducevano spesso con altri begl' ingegni a disputare e far discorsi sopra diverse cose in casa il detto conte, che fu veramente uomo rarissimo."

94 Vasari's drawing for this frontispiece is Uffizi, Gabinetto dei Disegni e Stampe, 394 Orn. For its iconography, see Kliemann, in Arezzo 1981, pp. 148–50. Bartoli's translation is mentioned by Vasari, BB III, p. 285. For Bartoli as translator and editor of Alberti, see

Bryce, *Cosimo Bartoli*, pp. 185–208. Bartoli's ideas on architecture probably influenced Vasari's views, particularly as expressed in the 1550 edition of *The Lives*. Bartoli shared Vasari's veneration for Michelangelo's architecture and for the way that he was able to vary from the antique, an appreciation of license fundamental to Vasari's description of the New Sacristy, one of the few extended passages of architectural criticism in the first edition. For Bartoli's "michelangelism," see C. Davis, "Cosimo Bartoli and the Portal of Sant'Apollonia by Michelangelo," *Mitteilungen des Kunsthistorischen Institutes in Florenz* (1975), pp. 263–76. Charles Davis has also noted that Vasari's interest in stones, treated at length in the first chapter of the technical introduction, was also one found in Alberti and shared by Bartoli.

readmitted).[95] Even so, the visual arts remained on the agenda of the academy and the academicians. Giovanni Battista Gelli wrote on painting and poetry and began a series of Lives of Florentine artists. Varchi also lectured on painting and poetry, and sonnets by Michelangelo. He solicited the opinions of artists on the relative merits of painting and sculpture. Their responses formed the basis of an address delivered to the academy in March 1547. Vasari was one of the correspondents, and though biased towards painting, he declared *disegno* to be the mother of all the arts.

Vasari fully understood the power of joining theory with practice and art with letters:

> when by chance they coincide, there is nothing more agreeable for our life, both because art by means of learning becomes more perfect and richer and because the advice and the writings of learned artists have in themselves much more efficacy and greater credit than the words or works of those who do nothing more than mere practice, whether they do it well or ill.[96]

Alberti was a particular hero of Vasari's friend Cosimo Bartoli. But Vasari arrived at his own (artist's) opinion of Alberti. Aware of the force that Alberti's writings subsequently had "on the pens and tongues of the learned," Vasari makes the point that they granted him fame beyond his merit; Alberti lacked practical skill (*pratica*), yet he had, through his writings, "surpassed all those who had surpassed him in actual works."[97] Vasari believed that theory and practice must be combined. *The Lives* were a contribution to that equation of art and science and participated in contemporary discussions about the definition of the arts.

Sources: Dusty Records and the Archives of Experience

Vasari's project, which can be conceptually sited in this developing discourse of the arts, was in reality as peripatetic as its author. Inspired by years of traveling, it was outlined in Rome, written in Florence, and completed in Rimini. It was influenced at each stage. There is both "history" within the text, in its models and structures, and a history of the text, in their combination and application to Vasari's information about artists' lives. As discussed above, the principal sources for Vasari's historiographic framework and narrative techniques were the classical texts (by Diogenes Laertius, Plutarch, Diodorus Siculus, Livy, Cicero, Quintilian, Pliny), the modern classics (by Dante, Boccaccio, Petrarch), and modern historians (such as Bruni, Machiavelli, Giovio). Outlined below are the sources of the material that formed *The Lives* and the circumstances of its composition.

95 Accademia degli Umidi, Annali I, Florence, Biblioteca Marucelliana, MS B III 52, fols. 1–59. Heikamp, "Rapporti fra accademici ed artisti nella Firenze del '500," *Il Vasari* (1957), pp. 139–63. In spite of his eventually quite considerable literary production, which included poetry as well as prose, Vasari was never a member. This was probably due to the fact that he arrived in Florence soon after the reform.

96 Life of Alberti, BB III, pp. 283–4: "quando elle si abbattono per avventura a esser insieme, non è cosa che più si convenga alla vita nostra, sì perché l'arte col mezzo della scienza diventa molto più perfetta e più ricca, sì perché i consigli e gli scritti de' dotti artefici hanno in sé maggior efficacia e maggior credito che le parole o l'opere di coloro che non fanno altro che un semplice esercizio, o bene o male che se lo facciano."

97 *Ibid.*, p. 284: "per avere atteso alla lingua latina e dato opera all'architettura, alla prospettiva et alla pittura, lasciò i suoi libri scritti di maniera che, per non essere stato fra gl'artefici moderni chi le abbia saputa distendere con la scrittura, ancorché infiniti ne siano stati più eccellenti di lui nella pratica, e' si crede comunemente (tanta forza hanno gli scritti suoi nelle penne e nelle lingue de' dotti) che egli abbia avanzato tutti coloro che hanno avanzato lui con l'operare."

Vasari's primary sources were visual: the works that he sought and was shown, attributed by tradition and by inscription. While he invented many funerary epitaphs, he also visited artists' burial places.[98] With respect to written sources, Vasari explicitly credits writings only by Lorenzo Ghiberti, Domenico Ghirlandaio, and Raphael.[99] The first can be identified as Ghiberti's *Commentaries*. Those by Ghirlandaio are lost; they included some notes on fourteenth-century painters and the record of Michelangelo's apprenticeship.[100] Raphael's legacy probably consisted of various letters and his will. The opening to the Life of Properzia de' Rossi cites a battery of ancient writers (Aristophanes, Athenaeus, Dio Cassius, Eusebius, Eustasthius, Homer, Pausanius, Varro), but this is a pro-forma appeal to authority in what is basically a treatise on famous women. Pliny is cited as regards the origins of design.[101] Vasari regularly refers to Vitruvius's rules regarding the proportional systems of architecture, and Vitruvius was a source for his discussion of architecture in the technical introduction.[102] He also consulted Alberti's *Books on Architecture* and relied substantially and without acknowledgment on Sebastiano Serlio's 1537 book on the architectural orders (*Regole generali di architetura sopra le cinque maniere de gli edifici*).[103] There are a number of unacknowledged written sources, such as Polydore Vergil on the origins of sculpture and painting, used for the preface to *The Lives*.[104] For the first era he consulted Giovanni Villani's fourteenth-century chronicle, primarily about the building of the cathedral and bell-tower in Florence, and he borrowed ideas from Boccaccio's *Decameron* and Filippo Villani's *Origins of Florence*, as well as taking names and places from Francesco Albertini's 1510 guide to Florence (*Memoriale di Molte Statue et Picture sono nella inclyta Cipta di Florentia*). This guide was of even greater use for Part 2, for which Vasari also pirated the remarks on artists in Cristoforo Landino's 1481 Dante commentary and the entire text of Antonio Manetti's *Life of Brunelleschi*. He knew of Alberti's treatises on painting and architecture, and books by Piero della Francesca in Borgo San Sepolcro and in the library of the dukes of Urbino. For the later period he referred to Pietro Aretino's letters and his play *La Talanta*.

Vasari made two statements about his sources. The first is in the preface to the whole

98 Kallab, *Vasaristudien*, pp. 231–2, 234–5, 241–5.

99 Letter to the artists, BB VI, p. 411.

100 Michelangelo's indentures are mentioned in the 1550 edition and quoted in 1568 (BB VI, pp. 6–7). See Cadogan, "Michelangelo in the workshop of Domenico Ghirlandaio," *Burlington Magazine* (1993), pp. 30–1, for comment on this lost document and a payment to Ghirlandaio for the altarpiece for the Ospedale degli Innocenti collected by Michelangelo in June 1487, proof of his presence in the Ghirlandaio shop. Vasari further cites the Ghirlandaio papers as evidence that Giottino was the son of Giotto's pupil Stefano and not Giotto (BB II, p. 137). Vasari knew of these through Domenico Ghirlandaio's heir, Ridolfo, a contemporary and friend of Vasari.

101 Preface to *The Lives*, BB II, p. 6. Also in the preface to Part 2, about his ambition to do more than merely quote from Pliny (BB III, p. 5), preface to Part 3, about excavations (BB IV, p. 7).

102 For examples of citations of Vitruvius in the 1550 edition, see BB III, p. 289, for Alberti's understand-

ing of Vitruvius, the Life of Antonio da Sangallo, where Vasari says his works followed Vitruvian principles (BB V, p. 28), the Life of Giulio Romano, where he states that Vitruvius (and Apelles) would be conquered by Giulio's style (BB V, p. 55). Vasari notes Cesare Cesariano's Vitruvius commentary in the Life of Bramante (BB IV, p. 75). For Vasari's use of Vitruvius in the technical introduction see the table in Satkowski, "Studies on Vasari's Architecture," Ph.D. (Harvard, 1977), pp. 150–1.

103 *Ibid.*, pp. 154–6, for the description of the orders in the technical introduction, where Vasari invokes Vitruvius but paraphrases Serlio. Serlio's reference to Bramante (fol. 19r) as the inventor of true architecture in the time of Julius II coincides with Vasari's remarks at the opening of Bramante's Life.

104 *Polydoro Virgilio di Urbino, de la origine e de gl'inventori de le leggi, costumi, scientie, arti, ed di tutto quello che a l'humano uso conviensi*, trans. Lauro (1543), Book ii, chapter 23 (*Dell'origine de pitture, & statue*), fols. 67v–68r. His version differs from Pliny's, and Vasari's wording (BB II, pp. 6–7) follows Polydore's text.

work, where he says that he had used great diligence finding out "the birthplaces, origins, and deeds of artists and with great effort obtained them from the accounts of many old men and from various records and notes left by heirs as a prey to dust and food for woodworms."[105] The second is in the conclusion where he thanks his friends for their help and mentions the writings by Lorenzo Ghiberti, Domenico Ghirlandaio, and Raphael, "although I trusted them, I have always nevertheless desired to compare their words with an examination of the works themselves."[106] These statements can be glossed to a certain extent. The "many old men" were taken from roster of acquaintances, friends, and associates. Some, like Andrea della Robbia, dead (1528) long before *The Lives* were a project, had spoken with Vasari, still but a boy, and told the young Giorgio how honored he was to have been among Donatello's pallbearers.[107] From the same era he knew Lorenzo Ghiberti's great-grandson, Vittorio, with whom he stayed in 1529, and Andrea del Sarto (who died in 1531). Through artists like Filippino Lippi's son Roberto, or Baccio d'Agnolo's son Giuliano, he was in contact with several generations of artistic memory. This was also the case with Ridolfo Ghirlandaio and the Sangallo family: Antonio the Younger, Francesco (son of Giuliano), and Aristotile da Sangallo. Workshop genealogies were another legacy of memory Vasari exploited. Andrea di Cosimo, whom Vasari knew through del Sarto's shop, was so named because he was a student of Piero di Cosimo. One Gian Jacopo was a student and heir of Lorenzo di Credi, who was in turn Verrocchio's heir.

Vasari not only talked with these old men, but knew many others, who became subjects of Lives: Valerio Vicentino, Perino del Vaga, Giulio Romano, Rosso Fiorentino, Marcillat, Baldassare Peruzzi, and Michelangelo, for instance. Those like the Sienese Domenico Beccafumi and the Ferarrese Benvenuto Garofalo who died in 1551 and 1559 respectively, had biographies only in the second edition but were informants for the first. Colleagues and acquaintances, who offered hospitality, were also ultimately sources of information: in 1547 or 1548 he probably stayed in Faenza with the gemcarver Giovanni di Castel Bolognese, another former employee of Cardinal Ippolito and the Farnese and correspondent of Annibale Caro; while in Faenza he saw works attributed to Ottaviano da Faenza, Donatello, and Titian.[108] There were his friends, collaborators, and competitors – contemporaries and near contemporaries – some, but not all, mentioned in the 1550 *Lives*, who formed the arena of his interests and activities, and whose opinions, works, and manners were the living subtext to the first edition and the subject of the second edition. These included painters like Titian, Pontormo, Sogliani, Salviati, Gherardi, and Giovanni da Udine, sculptors like Bandinelli, Cellini, Tribolo, Montorsoli, Rustici, and Jacopo Sansovino, and the Veronese

105 General preface to *The Lives*, BB I, p. 10: "avendo speso moltissimo tempo in cercar quelle [opere], usato diligenzia grandissima in ritrovare la patria, l'origine e le azzioni degli artefici, e con fatica grande ritrattole dalle relazioni di molti uomini vecchi e da' diversi ricordi e scritti lasciati dagli eredi in preda della polvere e cibo de' tarli."

106 Letter to the artists, BB VI, p. 411: "mi sono stati . . . di non piccolo aiuto gli scritti di Lorenzo Ghiberti, di Domenico Grillandai e di Raffaello da Urbino; ai quali, se bene ho prestato fede, ho nondimeno sempre voluto riscontrare il lor dire con la veduta dell'opere."

107 Life of Luca della Robbia, BB III, pp. 56–7.

108 Vasari mentions Giovanni's house and family in Faenza, where he saw two paintings done for Giovanni's father-in-law: a portrait by Giorgione (Life of Giorgione, BB IV, pp. 43–4, Life of Valerio Vicentino, BB IV, p. 622) and painting of a "naked shepherd and a country girl offering him pipes to play" by Titian (Life of Titian, BB VI, p. 159), similar to, if not actually the *Three Ages of Man* in the National Gallery of Scotland, Edinburgh. For the works he attributed to Ottaviano da Faenza (whom he called a pupil of Giotto), see BB II, p. 119, and for those given to Donatello, BB III, p. 216, and Chapter VIII, p. 323.

architect Michele Sanmichele. This list is not complete, but it is representative of the types of informant and the nature of information, which ranged from dim recollection to direct interview.[109] "I heard" from Andrea di Cosimo and Andrea del Sarto Vasari says of the iconography of a festival decoration by Piero di Cosimo.[110] He recalls Titian's amazement at Peruzzi's illusionistic paintings at Agostino Chigi's loggia.[111] These fugitive testimonies are the core of *The Lives* and a significant factor in the lively voice of the book. The concluding part of the second section and the entire third section of *The Lives* were based on Vasari's contacts and interests. His debt to his teachers is graciously discharged. Guillaume de Marcillat is given the compliment of proximity to Raphael. Andrea del Sarto has one of the longest Lives in Part 3. It is also one of the most precise in terms of commissions and chronology, which suggests that Vasari might have had access to a record book, presumably at one time in the possession of Domenico Conti, who inherited Sarto's drawings and other things pertaining to his art.[112] The blind and aged, but still breathing, Benedetto da Rovezzano, who had worked for Bindo Altoviti in Santi Apostoli as had Vasari, was given a Life. He was the only living artist so honored, with the exception of Michelangelo.

The other direct informants were the patrons and owners from whom Vasari learned about commissions, collections, ownership, and provenance. Of the "records and writings" left with artists' heirs the most easily discernible to us, and the most comprehensively historical, were Ghiberti's *Commentaries*, which Vasari probably saw first during his brief apprenticeship to Vittorio Ghiberti and later studied carefully to adapt to *The Lives*, most likely consulting the manuscript copy owned by Cosimo Bartoli.[113] The *Commentaries* were Ghiberti's own bid to a form of social credibility through learning. Basing himself on Vitruvius, Ghiberti expounded on the ideal of the artist as one who combined practical skills with theoretical knowledge.[114] He also called drawing the foundation of painting and sculpture, a view shared by Vasari.[115] Scanning his past with a fond and pragmatic eye, he established a model of critical viewing and suggested how terms of appraisal could be related to the historical development of the arts.

Although Vasari criticized Ghiberti for being too brief (except about his own works), he used the *Commentaries* exhaustively. Ghiberti's first book complied with the convention of contemporary treatises to open with a treatment of the origins of the field of endeavor under discussion, and to present the reader with a parallel between ancient and modern times. Vasari did this as well in the preface to *The Lives*. Ghiberti's second book was about art from Giotto's birth to Ghiberti's own day, which he called the "new art."[116] It was definitive for Vasari, in articulating and exemplifying the break between ancient accomplishments and a new era, and for its explanation that the break resulted from the destruction of ancient

109 For example, see Venchi, "La veridicità di G. Vasari nella biografia del B. Angelico," in *Beato Angelico. Miscellanea di Studi*, pp. 91–124, for Vasari's Dominican sources.

110 Life of Piero di Cosimo, BB IV, pp. 64–5: "Sentì dire io a Andrea di Cosimo . . . et Andrea del Sarto."

111 Life of Baldassare Peruzzi, BB IV, p. 318.

112 Life of Andrea del Sarto, BB IV, p. 396.

113 See Krautheimer, *Lorenzo Ghiberti*, I, p. 306, for the copies and also for a description of the *Commentaries* and their place in Ghiberti's career. See further von Schlosser's analysis of Ghiberti's sources in the second volume of his edition of the *Commentaries*.

114 Ghiberti, *Commentari*, ed. Schlosser, pp. 4–5.

115 *Ibid.*, p. 5.

116 *Ibid.*, p. 35: "l'arte nuoua."

statues and pictures through the persecution of idolatry when Christianity came to power. Vasari expanded on this considerably in the preface to *The Lives*, where he maintained the accusation against the fervent zeal of the new religion, destructive of marvelous works and worthy reputations.[117] In a typical process of elaboration, Ghiberti's few lines on the subject are made much more circumstantial. They are attached to monuments that Vasari had seen. Vasari similarly adapted Ghiberti's view that art had practically perished and been feebly revived in the coarse and crude works of the Byzantine Greeks, until the moment of Giotto's birth when the art of painting began its rise.[118]

Ghiberti's second book traces his artistic ancestry and ends with his autobiography. It is in a sense all autobiographical and because of this is an important precursor to Vasari, not only for what he records, which became the core of Vasari's first part, but for the immediacy of perception. Far more than just recite names, Ghiberti records what was for him a living legacy, and a selective one. He says, for example, of the Florentines that "there were in our city many other painters who might be listed among the outstanding, but to me it does not seem that I should place them among these."[119] He was strongly impressed with Sienese painters, above all Ambrogio Lorenzetti: "a most perfect master, a man of great talent. A most noble designer, very skilled in the theory of this art."[120] Vasari made Ambrogio's learning a central topic of his Life. Ghiberti's heartfelt admiration for Ambrogio also resulted in one of the first extended descriptions of a modern work of art, the story of *St. Francis before the Sultan* in San Francesco, Siena. Ghiberti's dramatic evocation of the scene as a "wonderful thing," making a written picture of a painted one by recounting "what is there," its incidents and detail one by one, was one model for Vasari's narrative descriptions.[121]

Vasari accepted Ghiberti's list, but also modified it according to his own judgment and other sources. He added Pietro Lorenzetti, for example, through works he knew from his travels. He dubbed him Laurati from a misreading of an inscription on an altarpiece he saw in San Francesco, Pistoia.[122] In the case of Duccio, in the 1568 edition, he quoted Ghiberti as saying that Duccio had painted a double-sided altarpiece with a *Coronation of the Virgin* for the high altar of the duomo of Siena. He says that "I have tried to find out where this panel

117 *Ibid.*, and BB II, pp. 18–20. For the tradition of this explanation, see Buddensieg, "Gregory the Great, the Destroyer of Pagan Idols," *Journal of the Warburg and Courtauld Institutes* (1965), pp. 44–65.

118 *Commentari*, ed. Schlosser, p. 35: "Cominciorono i Greci debilissimamente l'arte della pictura et con molta roçeza produssero in essa; tanto quanto gl'antichi furon periti, tanto erano in questa età grossi et roçi," until, when Giotto was born, "Cominciò l'arte della pictura sormontore in Etruria . . . lasciò la roçeza de' Greci."

119 *Ibid.*, p. 40: "Fu nella nostra città molti altri pictori che per egregii sarebbero posti, a me non pare porgli fra costoro." Ghiberti starts with painters, beginning with Giotto, then his pupils Stefano, Taddeo Gaddi, Maso, Bonamico (Buffalmacco), Pietro Cavallini in Rome, Andrea Orcagna and his brothers, and the Sienese Ambrogio Lorenzetti, Simone Martini, Lippo Memmi, Barna da Siena, Duccio. He then mentions the Tuscan sculptors, Giovanni Pisano, Orcagna, Andrea

Pisano, and concludes with the northern goldsmith Gusmin and himself. Vasari omitted master Gusmin, and reorganized the list of artists to suit his order of styles.

120 *Ibid.*, p. 112: "Costui fu perfectissimo maestro, huomo di grande ingegno. Fu nobilissimo disegnatore, fu molto perito nella teorica di detta arte."

121 *Ibid.*, pp. 40–1: "Iui è dipinto come due gl'anno battuti . . . Eui il Soldano a.ssedere al modo moresco . . . Eui dipinto come essi ne inpiccano uno a uno albero . . . Euui come essi frati sono dicapitati . . . Eui lo executore . . . Vedesi piegare gli ablieri . . . Vedesi el giustitiere cadergli . . . Per una storia picta mi pare una marauiglosa cosa." Now destroyed, see Borsook, *Ambrogio Lorenzetti*, pp. 27–9.

122 *Virgin and Child with angels now in the Uffizi*, Florence; the inscription reads: PETRUS.LAVRENTI.DE SENIS.ME.PINXIT.ANNO DOMINI.M.CCC.XL. See E. Cecchi, *Pietro Lorenzetti*, pl. cx.

is to be found today, but for all the effort I have expended I have never been able to trace it."[123] Ghiberti praised the work as magnificent, excellently and wisely made, and Duccio as outstanding, describing him as holding to the Greek manner. Vasari instead says that it was painted nearly in the Greek manner, but mixed with the modern. This modification about Duccio's style was his way of translating Ghiberti's wisdom. Duccio could not be excellent and wise if his style were completely Greek, so Vasari surmised that it had something of the modern: not too much, however, for he recognized that the style of Sienese masters was not that of Giotto; indeed, it suited his purposes to see it that way, for that maintained a Florentine superiority. And knowing Duccio to be important, famous, he sought out something to confirm and justify that reputation. For him this was the inlaid pavement of the Siena cathedral. He credited Duccio with the invention of this sort of inlay, perfected by modern artists, notably his friend and probable informant Domenico Beccafumi. The opening to Duccio's Life includes the observation that "doubtless those who are the inventors of a noteworthy thing have an important place in the pens of those writing history."[124] Here he is following Pliny, trying to give an important artist an important invention. This form of deduction creates a history, false according to present information and notion of fact – the pavement was begun after Duccio's death – but true according to the requirements of Vasari's collection of biographies, and according to the sources available to him, which were very few for Siena. In this case he constructed a subject from the limited materials available to him. He created an emblematic figure comparable to the many allegories he attached to his painted histories. In so doing he reserved a place in history for the high altar of Siena cathedral and for its author, and his brief sketch has been filled in by subsequent historians.

In the early Lives, Vasari plundered Ghiberti, but did not totally depend on him. He added and subtracted works, made his own observations, and supplemented both with information derived from Vitruvius, Alberti, Albertini's guidebook, and, above all, from a series of notes on artists and their works. Undoubtedly Florentine, the notes are a product of the Florentine taste for enumeration and for historical compilation. The earliest surviving version of a group of related manuscripts of these notes, which Vasari called "stratti," is that known as the *Libro di Antonio Billi* after Antonio Billi (1481–1530), a merchant from a prominent Florentine family, who was possibly its author, certainly its owner. In his book he had notes taken from Villani, Landino, and Manetti's *Life of Brunelleschi*.[125] In addition

123 Life of Duccio, BB II, p. 260: "In questa tavola, secondo che scrive Lorenzo di Bartolo Ghiberti, era una incoronazione di Nostra Donna, lavorata quasi alla maniera greca, ma mescolata assai con la moderna . . . dipinta dalla parte di dietro come dinanzi . . . Ho cercato sapere dove oggi questa tavola si truovi, ma non ho mai, per molta diligenza che io ci abbia usato, potuto rinvenirla." In the first edition he wrote: "nel Duomo fece una tavola, che a suo tempo si mise allo altar maggiore e poi ne fu levata per mettervi il tabernacolo del Corpo di Cristo ch'al presente si vede." The *Maestà* was removed in July 1506 and replaced by a bronze tabernacle by Vecchietta from the hospital of Santa Maria della Scala. For its history, see Stubblebine,

Duccio di Buoninsegna and His School, I, pp. 33–7. Ironically, perhaps, the *Coronation of the Virgin*, which was the pinnacle of the front of the altarpiece, is still missing.

124 Life of Duccio, BB II, p. 259: "Senza dubbio coloro che sono inventori d'alcuna cosa notabile hanno grandissima parte nelle penne di chi scrive l'istorie."

125 The *Libro di Antonio Billi* is in the Biblioteca Nazionale, Florence, Strozziano, Cl. XXV, n. 636. For this manuscript, see Fabriczy, "Il Libro di Antonio Billi," *Archivio storico italiano* (1891), pp. 299–334, and *Il Libro di Antonio Billi*, ed. C. Frey. Fabriczy notes that there is an error in transcribing the name Dello, creating an artist called Eliseo del Fino, which suggests that the manuscript was copied from another (n. 109, pp. 347–

to copying from these texts, the author had sought out and listed works, principally of Florentine artists, from Cimabue to Pollaiuolo, with appended sections on Leonardo and Michelangelo. The gathering of notices in Billi's book was continued by other authors, who also made additions.[126] The version known to Vasari is lost, but that closest to the one used for *The Lives* is one now in the Biblioteca Nazionale in Florence, known from its provenance as the Anonimo Magliabechiano, dated *c.*1537−42.[127] The author of this manuscript also knew of Ghiberti's *Commentaries*, which he added to his version of Billi's notes. Perhaps inspired by Ghiberti's pretensions, he included a section on ancient art, largely taken from Pliny. In the Anonimo Magliabechiano manuscript greater attention is given to the succession of master and pupil and to an overall chronological arrangement than in Billi's book. The order of works in individual entries, however, continues to be a chain: "He made . . . and . . . and . . . another" ("Fece," "et," "anchora"). It does not have the biographical ambitions of Vasari's book. A later variant, belonging to a canon of San Lorenzo, Antonio Petrei, adds notes from Vasari's *Lives*, indicating that the manuscript continued to circulate and to be copied by interested amateurs.[128]

Most of the Lives in the first period result from a process of combining and balancing evidence from Ghiberti's book, the Ghirlandaio papers, and the manuscript notes, a process explicitly mentioned in the Life of Stefano, answering the question of whether Giottino was Giotto's or Stefano's son in favor of the latter.[129] The principal written sources for Vasari's second era were Albertini's guidebook, the manuscript notes, and presumably the Ghirlandaio shop's *ricordi*. In addition there were Ghiberti's autobiography and a biography of Brunelleschi written around 1480 and attributed to Antonio Manetti. The latter was extremely useful to Vasari for its description of the history of architectural styles, from "the origins of those buildings which are called *alla antica*" to the degraded "German" manner of building and Brunelleschi's recovery of the antique, as well as its wealth of detail about Brunelleschi's career.[130] The biography is polemical. Manetti defends Brunelleschi against any criticism of his works. He explains all defects as interference with original projects by ignorant, incompetent, and scheming antagonists of his architect hero. He is biting about both Ghiberti and Donatello, a bitter view that Vasari suppressed. The sources for the third period are the most immediate, and so to us, the most elusive − they came from Vasari's early experiences, his study drawings, and his own commissions. The body of "most praised works" that Vasari enshrined was also the curriculum of aspiring artists whose future

8). Vasari calls such notes "stratti" in the Life of Stefano, BB ii, p. 137. For Vasari, these manuscript notes, and the different versions, see Kallab, *Vasaristudien*, pp. 171–207.

126 See for these, Schlosser, *La letteratura artistica*, pp. 189–93, 198–9, 295–6.

127 Magliabechiano, Cl. xvii, n. 17, published by C. Frey, *Il Codice Magliabechiano*. Frey's edition of this manuscript will be referred to subsequently as representative of the group of notes that were an important source for Vasari.

128 See Fabriczy, "Il Libro di Antonio Billi," *Archivio storico italiano* (1891), pp. 302–5, for Petrei and his set of notes, now Biblioteca Nazionale, Florence, cod. Magliabechiano, Cl. xiii, n. 89.

129 Life of Stefano, BB ii, p. 137: "Stimasi che Maso detto Giottino . . . fusse figliuolo di questo Stefano; e se bene molti per l'allusione del nome lo tengono figliuolo di Giotto, io, per alcuni stratti ch'ò veduti e per certi ricordi di buona fede scritti da Lorenzo G[h]iberti e da Domenico del Grillandaio, tengo per fermo ch'e' fusse più presto figliuolo di Stefano che di Giotto."

130 Manetti, *Vita*, ed. De Robertis and Tanturli, p. 70, for the account of the "origini di questi muramenti che si dicono alla antica," and pp. 70–7, for the subsequent history of architecture, p. 77 for "modi Tedeschi."

65. Michelangelo, Copy after Giotto's *Ascension of St. John the Evangelist* in the Peruzzi chapel, pen and ink, 315 × 205 mm. Paris, Louvre, Cabinet des Dessins, inv. 706.

66. Michelangelo, Copy after Masaccio's *Tribute Money* in the Brancacci chapel, red chalk, pen and ink, 315 × 197 mm. Munich, Staatliche Graphische Sammlung, no. 2191.

depended upon the appreciative and competitive mastery of the past.[131] The path of greatness Vasari charted from Giotto to Masaccio to Michelangelo was one followed by Michelangelo himself (pls. 65, 66).

Vasari's view of the arts was based on a cumulative tradition both of acquired skills and of appreciation of these skills, on professional preoccupations and on patrons' demands. A vast and disparate body of material, Vasari gave it coherence by using the structures of history to connect episodes to larger patterns and make the anecdotal exemplary. The Life of Andrea del Castagno offers a good instance of Vasari as a historian, both impartial judge and highly engaged artist. The manuscript notes said that Andrea had died the confessed murderer of Domenico Veneziano.[132] This allegation of murder actually resulted from a confusion about a painter named Andrea who killed another painter called Domenico del Matteo.[133] In fact, Castagno died in 1457, four years before his supposed victim. Vasari based

131 In the Life of Salviati, BB v, p. 511, Vasari wrote about young artists who went around Florence on their holidays "a disegnare . . . l'opere più lodate."

132 Anon. Maglia, p. 98.

133 Milanesi, "Esame del racconto del Vasari circa la morte di Domenico Veneziano," *Giornale Storico degli*

67. Andrea del Castagno,
The Trinity and St. Jerome with
Sts. Paula and Eustochium(?).
Florence, Santissima
Annunziata, Corboli chapel.

his story and its moral on the available information, however, and presented Andrea as an example of: "How greatly the vice of envy is to be deplored in a person of excellence."[134] Andrea remained excellent because of his talents, above all in drawing. His behavior toward his erstwhile friend and victim, Domenico Veneziano, served to illustrate the difference between "most infamous" jealousy and "emulation and competition," which were neces-

Archivi Toscani (1862), pp. 3–5, and von Einem, "Castagno ein Mörder?," in *Festschrift für H. Lützeler zum 60. Geburtstage*, pp. 433–42.

134 Life of Castagno, BB III, p. 351: "Quanto sia biasimevole in una persona eccellente il vizio della invidia."

sary and useful.[135] Competition resulted in efforts to acquire glory and honor, jealousy in shame and hateful deeds. Vasari did not dismiss Castagno; instead, he allowed Castagno's actions to demonstrate truths. Andrea's work is described as having awe-inspiring qualities, as in the heads of the figures in the frescoes he painted in the cloister of San Miniato al Monte.[136] Castagno's force or *terribilità* and his attainments in drawing and perspective are described as prefiguring and leading the way to the third era and Michelangelo. But Castagno's glory is not unalloyed. He is depicted as being hypocritical and violent, not only against the unfortunate Domenico, but in defacing the works of other artists.[137] His paintings were "somewhat crude and rough."[138] While he was accomplished in drawing and invention, what the bold Andrea lacked was "refinement in his coloring."[139] This the affable, lute-playing Venetian, Domenico could supply. He knew the method of oil painting, which was not yet in use in Tuscany and which he taught Andrea, the accomplished draughtsman and perfidious friend.[140] Andrea del Castagno's murder of Domenico Veneziano, once he had been taught oil technique, is a sort of perverse triumph of drawing over color, Florentine over Venetian tradition. And Castagno is actually represented as the hero of this double Life. He survives and thrives. Vasari was impressed by his works. His descriptions of them allowed that they deserved great praise, as in the *St. Jerome with the Trinity* in Santissima Annunziata (pl. 67), where he had done the foreshortening "in a much better and more modern style than others before him."[141] It was the posture of impartiality that allowed Vasari to interweave the themes of great art and deplorable behavior and to use both to show what should be imitated and what rejected, what brought glory and what shame. And he was also able to tell a compelling story.

Writing The Lives

Exactly how Vasari turned his assorted notes into a historical account remains a mystery. Vasari had little time for writing during the famous hundred days when he was designing, painting, and supervising the decoration of Cardinal Alessandro's reception hall. While the biographies of the artists in Rome whose works Vasari had studied as part of his artistic formation, notably Michelangelo, Raphael, and Polidoro da Caravaggio, are among the most serious and detailed of *The Lives*, the fourteenth- and fifteenth-century Lives are among the most perfunctory. This indicates that he did little to supplement his knowledge of Rome beyond a few visits to familiar sites. The traces of such visits are discernible in his precision about location, such as the chapels painted by Jacopo dell'Indaco in Sant'Agostino on the right side of the facade door as one entered the church, or the addresses he gives for

135 *Ibid.*: "quanto la emulazione e la concor[r]enza che virtuosamente operando cerca vincere e soverchiare i da più di sé per acquistarsi gloria et onore è cosa lodevole e da essere tenuta in pregio come necessaria ed utile al mondo, tanto per l'opposito, e molto più, merita biasimo e vituperio la sceleratissima invidia."

136 *Ibid.*, p. 354: "terribile nelle teste de' maschi e delle femmine." The frescoes are destroyed, but a *sinopia* was discovered in the place mentioned by Vasari, see Horster, *Andrea del Castagno*, p. 190.

137 Life of Castagno, BB III, p. 357.

138 *Ibid.*, p. 353: "alquanto crudette et aspre."

139 *Ibid.*, p. 356: "se la natura avesse dato gentilezza nel colorire come ella gli diede invenzione e disegno, egli sarebbe veramente stato tenuto maraviglioso."

140 *Ibid.*, pp. 358–9.

141 *Ibid.*, p. 355: "avendo condotto gli scòrti con molto miglior e più moderna maniera che gl'altri inanzi a lui fatto non avevano."

the palace facades decorated by Polidoro da Caravaggio and Maturino da Firenze.[142] Roman Lives such as those of Pietro Cavallini, Paolo Romano, and Iacopo dell'Indaco and the Roman sections of Lives such as Cosimo Rosselli's are clearly the result of a few afternoons spent looking at churches and tombs, copying inscriptions, and, probably, a few congenial evenings telling stories over dinner. Vasari's friends in Rome, especially Paolo Giovio, did not lack a sense of humor. Equally important was the form of historical idealization that is the substance of the Cancelleria frescoes, where identifiable protagonists play out exemplary roles based on real events. Pope Paul III is peacemaker, benefactor, and builder of St. Peter's (pls. 63, 64). He receives and grants honors, and his actions are framed by representative virtues. This is the same kind of inventive portrayal that informs *The Lives*, and it was a historical scheme that resulted from a collaboration between Vasari and Giovio and the court culture of Cardinal Alessandro Farnese.

Vasari left Rome when the wall-paintings were completed. When Giovio wrote to him in Florence on 27 November 1546 offering to act as editor, he mentioned the book as though it were a fully formed but unrealized project.[143] Vasari had probably decided on the division of the ages, and the outline the biographies were to follow, from eulogistic openings to concluding epitaphs, while in Rome. He says that Cardinal Alessandro asked him to produce a summary or outline ("sunto") to help Giovio with his proposed series of artists' lives. The trial piece or résumé that he produced convinced Giovio that the painter should take on the project.[144] There is literally only a scrap of evidence remaining to indicate how Vasari began to organize his material. It is a fragment of a dateline with artists' names entered by the year of their supposed death with a reference to pages in a manuscript or a numbered set of notes (pl. 68).[145] There seem to have been three columns, one for each century. The bottom edge of the list now has the dates 1458 and probably 1547, but it has been cut. The first column is almost entirely missing. Making this type of cross-referenced digest follows a method not unlike that proposed by Annibale Caro to the extremely precocious Silvio Antoniano. The fourteen-year-old Ferrarese (later to become secretary to Carlo Borromeo and then a cardinal) asked how to order his study of medals. Caro suggested that he make note of all the medals that came into his hands or that he heard about, with as complete a description and identification of both sides as possible, separating the types (consuls from emperors, Latin from Greek) and putting them into chronological order, "the best one can as a first draft."[146] Each sheet was to be divided into two columns with the description in one column; the other would refer to an alphabetical list of all the names kept in another book. The resulting compilation was meant to result in a systematic way of collating and comparing information. Similar advice from such experienced scholars might have been given to Vasari as he set about the task of making his ordered account from

142 Life of Jacopo dell Indaco, BB III, p. 629, and Lives of Polidoro da Caravaggio and Maturino da Firenze, BB IV, pp. 458–9.

143 Frey I, lxxxvii, p. 175.

144 Description of Vasari's works, BB VI, pp. 389–90.

145 This drawing is now in a private collection. It was sold at Christie's, 8 April 1986, *Catalogue of Old Master Drawings*, no. 24. Exhibited by Bellinger, *Drawing in Florence 1500–1600*, cat. no. 6. Kliemann has pub-

lished a preliminary study of the drawing, its attribution, use, and history, with extremely useful tables and transcriptions, "Giorgio Vasari: Kunstgeschichtliche Perspektiven," in *Wolfenbütteler Forschungen. Kunst und Kunsththeorie 1400–1900*, pp. 65–74.

146 Caro, *Lettere*, II, p. 110, no. 374 (Caro in Rome, 25 October 1551, to Silvio Antoniano, Ferrara): "il meglio che si potesse per la prima bozza."

his various records. The page references reach "376," "Marco Vicentino." They do not correspond to either the Torrentino (1550) or the Giunti (1568) edition of *The Lives*. In some cases the dates do not match those Vasari eventually gave in the biographies, and some artists who have Lives are not included. This sheet seems, therefore, to be a preliminary preparatory sequence of the chronological type that Vasari decided against when he organized *The Lives* by style rather than by strict order of time – when he chose art history over chronicle. This research exercise was apparently later dispensable, for the other side of the paper was used for a compositional study for an altarpiece painted by Prospero Fontana in Santa Maria del Baraccano, Bologna (pls. 69, 70). The altarpiece is signed and dated 1551, a year after the publication of the first edition of *The Lives*, which explains why this register was no longer of interest to Vasari and could become scrap for re-use. The sheet has been cut to follow the arched form of the altarpiece study. In the paragraph Vasari devoted to Prospero Fontana in the 1568 *Lives*, this painting is the only one he identifies with any precision.[147] Prospero was working for Julius III in Rome in 1550–1, at the same time as Vasari, who seems to have provided him with this design, and possibly a more finished *modello*, a type of assistance Vasari gave to Fontana in other cases.

When he left the Farnese circle in the autumn of 1546, Vasari did not forsake advice. Not only did he continue to correspond with his friends there, but having been inspired by one learned group, he mobilized another to his cause. He must have worked in consultation with his Florentine friends, because he asked for and received Latin and Italian verses from them to use as epitaphs. Caro contributed some from Rome; in Florence the academicians Giovanbattista Strozzi, Fabio Segni, and Giovanbattista Adriani added others. The 1550 edition of *The Lives* is actually, apart from everything else, an anthology of minor mid-sixteenth-century commemorative verse, some by Vasari, much of it by his obliging friends. In order to receive appropriate epitaphs Vasari must have given some indication of his subjects. The verses encapsulate the thematic messages of the Lives in question, often repeating key wordplays from the biographies. Aretino refused Vasari's request for verses, but Vasari obviously discussed the book with other more willing and more modest friends.[148] The epitaphs were originally published without attribution, sometimes as honorific verses, sometimes as tomb inscriptions.

The 1540s had been a busy decade for the educated men of Florence. It was the time of the founding and flourishing of the academy, which had among its projects a program of translation to be decided upon so that "all branches of learning may appear in our language," and which instituted a program of public lectures in order to promote an understanding of

147 Life of Primaticcio, BB VI, p. 147: "In Bologna ha fatto il medesimo molte opere a olio et a fresco, e particolarmente nella Madonna del Baracane, in una tavola a olio, una Santa Caterina che alla presenza del tiranno disputa con filosofi e dottori, che è tenuta molto bell'opera." The identification of the drawing was first made by Berenice Davidson and subsequently by Julian Kliemann and Charles Davis. I want to thank these scholars for discussing this drawing with me.

148 Aretino wrote to Vasari from Venice that he was too busy preparing his fifth volume of letters: "Voi . . . ricercate . . . nel conto del libro, che fate istampar' di pittura, dal mio ingegno versi. Per esser' io tutto dato . . . al fornir' del quinto [volume delle lettere] . . . deuete perdonarmi" (Frey I, cxx [September 1549], p. 241). The other authors are known from epitaphs attributed in the 1568 *Lives* and Vasari's memorandum to Vincenzo Borghini, Frey I, cxxv (11/12[?] February 1550), p. 257. See C. Davis in Arezzo 1981, pp. 219–20, and Bettarini, "Vasari scrittore: come la Torrentiniana diventò Giuntina," in *Atti* 1974, pp. 494–6.

68 (right). Giorgio Vasari, date list for *The Lives*, pen and ink, 201 × 108 mm. Private collection.

69 (facing page left). Giorgio Vasari, study for the *Dispute of St. Catherine*, pen and ink with light brown wash, 201 × 108 mm. Private collection.

70 (facing page right). Prospero Fontana, *The Dispute of St. Catherine*. Bologna, Santa Maria del Barracano.

the learned disciplines ("le scientie").[149] Academicians like Cosimo Bartoli wished to create a vernacular culture as rich and distinguished as that of the classical past. Bartoli urged that the Romans be imitated, "in the attempt to translate the sciences into this language of yours,

149 Accademia degli Umidi, *Annali*, Biblioteca Marucelliana, Florence, MS B iii 52, fol. 1v: "le scientie tutte si potessino veder in nostra lingua." The story of the founding of the academy is told in various places with various interpretations, see Samuels, "Benedetto Varchi, the *Accademia degli Infiammati*, and the Origins of the Italian Academic Movement," *Renaissance Quarterly* (1976), pp. 599–634, and Bareggi, "L'accademia fiorentina," *Quaderni storici* (1973), pp. 572–4. For a politicized reading, see Plaisance, "Une première affirmation de la politique culturelle de Côme Ier," in *Les écrivains et le pouvoir en Italie*, pp. 361–438.

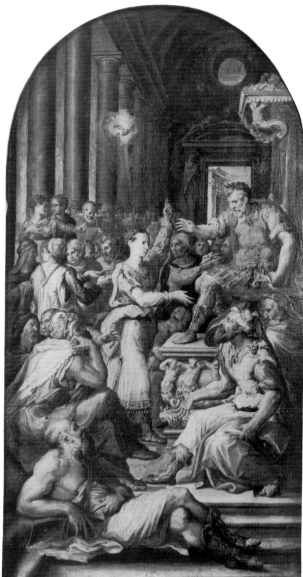

as the Romans had once translated them from Greek into theirs."[150] Specialist vocabularies were essential to this, hence Bartoli's interest in publishing translations of technical works like Alberti's *Ten Books on Architecture* and ultimately Vasari's introduction to the arts in *The Lives*.

The founding of the academy started a literary boom in Florence, as many of the

150 Bryce, *Cosimo Bartoli*, p. 165: "in far pruova di condurre in questa vostra lingua le scienzie, si come gia dalla Greca le condussono nella loro i Romani."

academicians began to work on books, translations and lectures, commentaries on Dante, reflections on Petrarch and Platonism. Almost everybody that Vasari knew was writing something and was involved in the study of philosophy, history, poetry, and literature, focussing on Florentine culture and language.[151] As the Latin dominance of written culture was challenged, new categories of readers and writers developed.[152] Vasari's professional aspirations found a place in an emerging class of authors, writers who were not professional men of letters.

Vasari's discussions with his friends in Florence are echoed in the number of their concerns and interests taken up in *The Lives*. Vasari makes an issue of language, as had the Florentine academicians, who were eager champions of the Florentine dialect. The general preface to the work is devoted in large part to answering Varchi's 1547 lecture, the "dispute, born and nurtured among many without resolution of the primacy and nobility . . . of sculpture and painting."[153] There is even a nod to the curious argument that Noah's grandson Aram came from Mesopotamia to Tuscany, making it the first populated region in Europe after the flood and therefore giving priority to Tuscans in the language and civilization of Italy. Vasari wrote in the preface to *The Lives*:

> But while the nobility of this art [of design] was held in esteem, its origins are still not known for certain . . . and it is possible, not without reason, to think that it was perhaps most ancient among the Tuscans, as our own Leon Battista Alberti asserts.[154]

Much more compelling was Vasari's need to establish a position for the visual arts in response to the learned arguments of those like Varchi who sought to rank them as practical or mechanical as opposed to speculative or philosophical.[155] Varchi had delivered two lectures on painting and sculpture to the Academy on 6 and 13 March 1547, which were published in 1549. One was based on the analysis of a sonnet by Michelangelo. The comparison became one between poetry and painting, and between the formulation of an idea and the production of an object. For Varchi the process of making something was "to take it from its potential existence and reduce it to its actual existence"; and it was just that, a reduction to material Aristotelian manufacture and not a form of Platonic creation.[156] Vasari answered one of the two lectures directly in the preface to *The Lives* when he wrote on the dispute about the arts, resolving it in favor of design, a unifying concept based on the translation of idea to image. As regards the other lecture, he adapted Varchi's terms to his own purposes; after all, he regarded Varchi as an "outstanding poet, orator, and

151 See L. Perini, *Editoria e società*, especially pp. 280–90, and Rilli, *Notizie letterarie ed istoriche intorno agli uomini illustri dell'accademia fiorentina*.

152 Dionisotti, *Geografia e storia della letteratura italiana*. For a contemporary consideration of the question of the role of printing and the polemic about study and status, noble learning and persons of low birth, see Doni, *I Marmi*, ed. Chiòboli, "Ragionamento della Stampa," pp. 171–213. See also Eisenstein, *The Printing Press as an Agent of Change*, Graff, *The Legacies of Literacy*, and Grendler, *Critics of the Italian World*.

153 General preface, BB I, pp. 11–27: "una disputa, nata e nutrita tra molti senza proposito, del principato e nobiltà . . . della scultura e della pittura" (p. 11).

154 Preface to *The Lives*, BB II, p. 9: "Ma con tutto che la nobiltà di quest'arte fusse così in pregio, e' non si sa però ancora per certo chi le desse il primo principio . . . E puossi non senza ragione pensare ch'ella sia forse più antica appresso a' Toscani, come testifica il nostro Lion Batista Alberti." See D'Alessandro, "Vincenzo Borghini e gli 'Aramei,'" in *Medici* 1980, I, pp. 133–56, for this dubious and debated notion championed by Gelli, Giambullari, Bartoli, and Lenzoni.

155 For Varchi's position on this question, see Quiviger, "Benedetto Varchi and the Visual Arts," *Journal of the Warburg and Courtauld Institutes* (1987), pp. 219–24.

156 This statement from Varchi's *Lezzioni* is quoted by Quiviger, *ibid.*, p. 222.

philosopher."[157] In his description of Michelangelo, Varchi spoke of Nature's desire to manifest the extremes of her possibilities in a complete man, one who not only surpassed all modern and ancient artists in the professions of architecture, sculpture, and painting, but who was also outstanding as a poet.[158] When Vasari gave a summary description of Michelangelo, he, too, found the "complete man," compounded of excellence:

> a spirit sent from heaven, universally accomplished in every art and every profession . . . [God, the most benevolent rector] wished also to grant him true moral philosophy, embellish him with poetry, so that the world could prefer him and admire him as His most singular mirror in life, in his works, and in the sanctity of his behavior and in all his human actions – so that he could be called by us more heavenly than earthly.[159]

Vasari took up Varchi's point about Michelangelo as a poet. For the philosopher it was this activity, not sculpture or painting, that partook of the essence of his creative spirit. But Vasari represented Michelangelo as something much greater, a form of holy figure to be admired for his sanctity, not just his philosophy or poetry. The description *divino* had already been granted to Michelangelo by Varchi and others. Ariosto, for example, had written in *Orlando Furioso* (1532) of: "More than mortal Michael, divine Angel."[160] What was a hyperbolic figure or poetic pun for the philosopher and the poet became a statement of fact for Vasari. In Michelangelo's Life he combined hagiography with panegyric. So God is revealed as intervening in the course of human affairs and sending Michelangelo as an example to all. The proof of this, following the model of saints' lives, was a series of miracles testifying to this state of grace: the dead material comes to life (the case of *David*); on the Sistine ceiling Adam is made anew as though by the Creator and not by the brush of a man; miracles of art are performed (the *Pietà*).[161] The painting of the *Last Judgment* could be seen as the true Judgment, the true Damnation and Resurrection,

> for our art is that example and that great painting sent down to men on earth by God, so that they might see how Destiny works when intellects descend from supreme height to earth and have infused in them divine grace and knowledge.[162]

157 Life of Tribolo, BB v, p. 216: "messer Benedetto Varchi, stato ne' tempi nostri poeta, oratore e filosofo eccellentissimo."

158 From the conclusion of the first lecture, on Michelangelo's sonnet: "Da questo sonnetto penso io, che chiunque ha giudizio, potrà conoscere quanto questo Angelo, anzi Arcangelo, oltra le sue tre prime e nobilissime professioni architettura, scultura e pittura, nelle quali egli senza alcun contrasto non solo avanza tutti i moderni, ma trapassa gli antichi, sia eccellente, anzi singolare nella poesia . . . la quale non è nè men bella, nè men faticosa, ma ben più necessaria e più profittevole dell'altre quattro . . . quello che apparisce manifesto a ciascuno, che la natura volle fare, per mostrare l'estremo di sua possa, un uomo compiuto, e, come dicono i Latini, fornito da tutte le parti" (*Opere*, II, p. 626).

159 Life of Michelangelo, BB vi, pp. 3–4: "uno spirito che universalmente in ciascheduna arte et in ogni professione fusse abile . . . [il benignissimo Rettore] Volle oltra ciò accompagnarlo della vera filosofia morale, con l'ornamento della dolce poesia, acciò che il mondo lo eleggesse et amirasse per suo singularissimo specchio nella vita, nell'opere, nella santità dei costumi et in tutte l'azzioni umane, e perché da noi più tosto celeste che terrena cosa si nominasse."

160 *Orlando Furioso*, canto xxxiii.2: "Michel, più che mortale, Angel divino."

161 Life of Michelangelo, BB vi, pp. 20, 41, 16–17.

162 *Ibid.*, p. 74: "E questo nell'arte nostra è quello essempio e quella gran pittura mandata da Dio agli uomini in terra, acciò che veggano come il Fato fa quando gli intelletti dal supremo grado in terra descendono et hanno in essi infusa la grazia e la divinità del sapere." Vasari's insistence on the divine inspiration of this painting was also a response to accusations that its display of nudes was indecorous. For the controversy about the *Last Judgment*, see Barocchi, "Schizzo di una

The vocabulary of sanctity is pervasive in the Life and is applied to the visual arts as a definitive answer to any attempted demotion of the profession. What Michelangelo created was not derived from a mere "practical intelligence" as Varchi would have it. It was born of a knowledge both philosophical and spiritual so that "it suffices to say this, that where he has put his divine hand, there he has resuscitated all things and given them eternal life."[163]

In his exaltation of Michelangelo, Vasari exploited a position that had been granted to that artist by the academicians, who were eager to assert Tuscan, or more specifically Florentine, genius. Tuscan pre-eminence in poetry through Petrarch and Dante was shown to be matched by that in other arts with Michelangelo as the outstanding example in what became a commonplace form of comparison. This was the argument made, for example, by Giovanni Battista Gelli in a lecture given in May 1549 based on a sonnet by Petrarch in praise of Simone Martini's portrait of Laura.[164] Gelli turned the history of Florentine art from Giotto to Michelangelo to his purpose in terms that are very close to Vasari's. According to Gelli,

> finally, about three hundred years ago in our most illustrious city of Florence, by means of the sharpness of intelligence that nature grants to Florentine blood, both [poetry and painting] were rediscovered and, as though from a long death, resuscitated. And from this beginning, today they have been advanced to such an extent by the many divine spirits who have worked in these arts, that they are in each of them not only near the ancients, but have reached the same level, and perhaps have actually surpassed them.[165]

Painting evolved as artists

> taking the path shown to them by Giotto, each taking a further step forward, brought it to such a state that it seemed perfectly rediscovered, until Michelangelo, also one of our Florentine citizens, carried it finally to such a degree of perfection that there does not seem to be anything else left for anybody to desire.[166]

The striking similarity of conception to Vasari's is explained by mutual acquaintance and shared interest. Gelli also worked on a series of artists' lives, which he abandoned, perhaps daunted by the much more ambitious scale of Vasari's project and satisfied by publishing his

storia della critica cinquecentesca sulla Sistina," *Atti dell'Accademia Toscana di Scienze e Lettere. La Colombaria* (1956), pp. 221–35.

163 Life of Michelangelo, BB VI, p. 113 (1550): "Basta sol dire questo, che dove egli ha posto la sua divina mano, quivi ha risuscitato ogni cosa e datole eternissima vita."

164 Gelli, *Lezioni petrarchesche*, ed. Negroni, pp. 230–1, no. 6. The Florentine academy's attitude to the visual arts and the use of artists in this play for prestige are treated in detail by Quiviger, "Aspects of the Criticism and Exegesis of Italian Art, circa 1540–1600," Ph.D. (Warburg Institute, 1989).

165 Gelli, *Lezioni petrarchesche*, ed. Negroni, pp. 230–1: "Tanto che finalmente, circa trecento anni sono, furon dentro alla nostra famossisima città di Fiorenza, mediante la acutezza dall'ingegno concesso dalla natura

al sangue Fiorentino l'una e l'altra ritrovate, e quasi che da una lunga morte suscitate. E da tal principio sono oggi da molti divinissimi spiriti, che si sono esercitati in quelle, a tal termine condotte, che e' si ritruovono e nell'una e nell'altra di quegli, i quali non solamente si sono appressati agli antichi, ma sono iti loro al pari, e forse anco passati inanzi."

166 *Ibid.*, pp. 232–3: "camminando per quella via la quale era stata dimostrata loro da Giotto, e ponendo sempre l'uno il piede alquanto innanzi l'altro, la ridussero in tal grado, che a tutto il mondo pareva ch'ella si fosse perfettamente ritruovata, fin che Michel Agnol Buonnarroti, ancora egli cittadin nostro Fiorentino, l'ha condotta finalmente a tal termine di perfezione, che non pare che sia restato più nulla ad alcuna da desiderare in quella."

general points in a printed version of his lectures, which was issued by the Torrentino press in 1549.[167]

This community of interest must have both supported and challenged Vasari, offering ideas and a developed vocabulary of discovery, of poetic creation, of progressive improvements. The academicians' involvement with knowledge and its philosophical justifications in Aristotle and Plato also supplied elevated terms that Vasari readily adopted. With these terms he answered the very points about intellectual and professional status being raised by his academic friends. Vasari's editors were all members of the academy. The final form of *The Lives* was undoubtedly influenced by their concerns. Vasari's remark about orthography in his conclusion, confessing his innocence of the proper usage of "Z" and "T" and his reliance on an unspecified judicious and reliable person (possibly Borghini), was a prudent response to issues of orthography.[168]

While drafting *The Lives* in Florence between November 1546 and the summer of 1547 he undoubtedly continued to check and recheck "dubious points" and to return to look at works, following his declared method.[169] Florence dominates *The Lives*: most artists' careers are based on descriptions of works there. Vasari continued to make additions to the book until the final moments of printing, however, and this, too, affected its contents. The draft he took to Rimini and the fair copy he brought back to Florence were constantly updated and changed. On his return to Tuscany Vasari passed through Ravenna and Faenza, and what he came across there was duly accommodated: Giotto, for example, was given a number of followers from the region. And even the book that was printed was not complete. Vasari concluded by promising an addition.[170]

Vasari was very grateful for all the help he had received, the faithful and true assistance of his good friends, their advice and opinions.[171] Their enthusiasm had inspired him to produce a work that was more ambitious than originally expected. He had successfully involved the learned world with his art. He accepted their counsel and responded to their interests, but the work remained the result of his own efforts and judgment.

Vasari's success with history was perhaps owing to his insight into its visual possibilities. Livy defined history as a monument whose purpose was to set the past before the present. Vasari was accustomed to composing narratives that did just that, and he used history to create and re-create images, to describe paintings and sculptures and buildings, and to portray their makers. According to classical theory, memory itself functioned through pictures by putting the topics to be recalled in vivid tableaux or by arranging them in places. Vasari's commemoration of the artists operated by means of striking visual effects and ingenious wordplays that called to mind the characters of the artists and their works. Vasari's mental images corresponded to real images, and his places to real places.

Vasari's fusion of types of history writing was creative and original. The combined

167 See Mancini, "Vite d'artisti di Giovanni Battista Gelli," *Archivio storico italiano* (1896), pp. 32–62; Kallab, *Vasaristudien*, pp. 182–7; Schlosser, *La letteratura artistica*, pp. 193–5; M.D. Davis in Arezzo 1981, pp. 190–1; and Quiviger, "Aspects of Criticism and Exegesis of Italian Art, circa 1540–1600," Ph.D. (Warburg Institute, 1989), pp. 63–4, for the date of Gelli's text, its sources, and relation to Vasari.

168 Conclusion, BB VI, p. 412 (1550).

169 *Ibid.*, p. 411 (1550): "E mi sono ingegnato . . . con ogni diligenzia possibile, verificare le cose dubbiose con più riscontri."

170 *Ibid.*, p. 413 (1550).

171 *Ibid.*, pp. 409–10 (1550).

apparatus of his book is unprecedented. Perhaps because Vasari was not a writer he was freer to make unconventional use of conventions. The novelty was such that the readers of his manuscript could not ascribe it to any one genre. It was called variously a commentary on artists ("commentario"), a history of painting ("istoria della pittura"), and "lives and works of the most famous painters."[172]

Vasari's understanding of pictorial design enabled him to approach historical composition with subtlety and brilliance. He understood artifice and the use of sources. Vasari claimed that he was leaving behind a "note, memorandum, or sketch" that could be expanded by others.[173] This humility was calculated. It was based on the proud fact that he was a painter. It was based also on a famous disclaimer. Cicero had reported that Caesar's aim in writing his *Commentaries* "was to furnish others with material for writing history," but that his presentation was so clear and correct that men of sound judgment were deterred from trying to embellish his work.[174] Whatever Vasari intended concerning his own work, no one did make the attempt. In his time it was left to Vasari to surpass himself.

172 Respectively by Annibale Caro, Frey I, cv, p. 209 (Rome, 15 December 1547, to Vasari, Rimini), don Miniato Pitti, Frey I, cix, p. 217 (Florence, 22 February 1548, to Vasari, Arezzo), and Paolo Pino in his *Dialogo della Pittura* (1548), ed. R. and A. Pallucchini, p. 149: "hà unito, & raccolto in un suo libro con dir candido tutte le uite, & opere de più chiari pittori."

173 Conclusion, BB VI, pp. 410–11 (1550): "nota, memoria o bozza."

174 *Brutus, Orator,* trans. Hendrickson and Hubbell, *Brutus,* lxxv.262, pp. 226, 227. Leonardo Bruni repeated this in his *Rerum suo tempore gestorum commentarius.*

V

THE SECOND EDITION:
CHANGING HISTORY

IN THE DEDICATORY LETTER ADDRESSED TO Duke Cosimo de' Medici, Vasari presented the 1568 edition of *The Lives* as "almost completely done anew."[1] The differences are declared on the title page, which announces the book as revised and enlarged, with artists' portraits and with the Lives of artists still living and of those who had died between 1550 and 1567 (pl. 71). The new book was three times longer than its predecessor.[2] The third era had increased to the extent that it demanded a separate volume, comprising new Lives, brief notices of current artists (including Vasari) and their important works in Florence, other parts of Italy, and Europe, and an account of the artists of antiquity (pl. 72). Vasari added the profession of architect to his own self-description. Still, the later edition, though greatly altered through correction and addition, remains a "quasi" new book. Vasari did not alter his descriptions of his purpose or methods, his developmental scheme, or his fundamental concepts of commemoration of works and deeds. In reading *The Lives* it is essential to understand the way that the two editions are fused. If the different voices in the text are recognized, their messages become clearer. It also becomes possible to make a more refined evaluation of the information offered. In rewriting *The Lives* Vasari did not discard the first text or reject the exemplary notion of history, but he approached historical writing with a different critical standard, transforming a closed historical system – a cycle of lives presenting a life cycle of the arts – into an open-ended compendium of artistic achievement. By making additions and corrections and by including the works of living artists he hoped to inspire his fellow artists and future generations,

that each might continue to work excellently and always advance from good to better, so that whoever comes to write the remainder of this history will be able to do so with more greatness and majesty, having the opportunity to include those rarer and more perfect works that one by one the world will see emerge from your hands in the

1 BB I, p. 6: "quasi tutto fatto di nuovo." He repeated this assertion in the letter to his fellow artists, BB I, p. 175: "non tanto ho potuto correggere quanto accrescere ancora tante cose che molte Vite si possono dire essere quasi rifatte di nuovo."

2 For the range and nature of the changes, see also

Kallab, *Vasaristudien*, 1908, pp. 293–402, Barocchi, "Michelangelo tra le due redazioni delle 'Vite' vasariane," "L'antibiografia del secondo Vasari," in *Studi vasariani*, pp. 35–52, 157–70, and Bettarini, "Vasari scrittore: come la Torrentiniana diventò Giuntina," in *Atti* 1974, pp. 485–500.

LE VITE
DE' PIV ECCELLENTI PITTORI,
SCVLTORI, E ARCHITETTORI

Scritte
DA M. GIORGIO VASARI PITTORE
ET ARCHITETTO ARETINO,
Di Nuouo dal Medesimo Riuiste
Et Ampliate
CON I RITRATTI LORO
Et con l'aggiunta delle Vite de'viui, & de'morti
Dall'anno 1550. insino al 1567.

Prima, e Seconda Parte.

Con le Tauole in ciascun volume, Delle cose piu Notabili,
De' Ritratti, Delle vite degli Artefici, Et dei
Luoghi doue sono l'opere loro.

CON LICENZA E PRIVILEGIO DI N. S. PIO V. ET
DEL DVCA DI FIORENZA E SIENA.

IN FIORENZA, Appresso i Giunti 1568.

71. Title page of the 1568 edition of *The Lives*.

DELLE
VITE DE' PIV ECCELLENTI
PITTORI SCVLTORI ET ARCHITETTORI
Scritte da M. Giorgio Vasari
PITTORE ET ARCHITETTO ARETINO.

Secondo, et vltimo Volume
della Terza Parte.
Nel quale si comprendano le nuoue Vit,
Dall'anno 1550 al 1567.

Con vna breue memoria di tutti i piu ingegnosi
Artefici che fioriscano al presente
NELL'ACADEMIA DEL DISEGNO
In Fiorenza, et per tutta Italia, et Europa, &
delle piu importanti Opere loro.

Et con vna Descrizione de gl'Artefici Antichi,
Greci & Latini, & delle piu notabili
memorie di quella età,

Tratta da i piu famosi Scrittori.

CON LICENZA E PRIVILEGIO.

IN FIORENZA Appresso i Giunti. 1568.

72. Title page of the third volume of the 1568 edition of *The Lives*.

future, begun out of desire for immortality and completed by the study of such divine talents.[3]

With the section on celebrated masters of antiquity he wanted to show "the nobility and greatness" of his profession and how it had been universally "esteemed and prized," especially by the most noble talents and most powerful lords, to urge all to leave the world embellished with innumerable excellent works.[4] These objectives, however grandiose, were also practical; and by offering much more information not only about what and when, but how and for whom, Vasari made his models of behavior for both artists and patrons more precise. His orientation as a writer shifted from the mythical towards the factual, from the rhetorical to the narrative and discursive.

Vincenzo Borghini and the Purpose of History

In his revision of *The Lives*, Vasari was responding to a new attitude to historical writing, one of whose chief proponents was his close friend, Vincenzo Borghini (pl. 73).[5] In his essay on the origins of Florence, begun in the 1560s, concurrent with Vasari's work on the second edition, Borghini distinguished between legend and history and emphasized the need to reject the attraction of the former in favor of rigorous critical evaluation of sources.[6] Opposing accuracy to fancy, Borghini's approach was philological and antiquarian. In various notes and letters on the subject he argued for the careful examination of sources against the more subjective exercise of exemplary representation. He never questioned the didactic function of history, but he wanted to shift the act of judgment to the reader, who, as he expressed it, "received the food whole," not pre-digested, and who could "chew on it and get the juice for himself."[7] For Borghini, the writer could point out motives and reasons but should not serve as the ultimate judge. He connected good historical writing

3 Introductory letter, BB I, p. 176: "potrà forse essere questo uno sprone che ciascun séguiti d'operare eccellentemente e d'avanzarsi sempre di bene in meglio, di sorte che chi scriverà il rimanente di questa istoria potrà farlo con più grandezza e maestà, avendo occasione di contare quelle più rare e più perfette opere che di mano in mano, dal desiderio di eternità incominciate e dallo studio di sì divini ingegni finite, vedrà per inanzi il mondo uscire delle vostre mani."

4 *Ibid.*: "vedendo la nobiltà e grandezza dell'arte nostra e quanto sia stata sempre da tutte le nazioni e particolarmente dai più nobili ingegni e signori più potenti e pregiata e premiata, spingerci et infiammarci tutti a lasciare il mondo adorno d'opere spessissime per numero e per eccellenzia rarissime."

5 For this, see Waźbiński, "L'idée de l'histoire dans la première et la seconde édition des 'Vies' de Vasari," in *Atti* 1974, pp. 1–25. This has been thoroughly and insightfully studied by Williams, "Vincenzo Borghini and Vasari's 'Lives,'" Ph.D. (Princeton, 1988). For Borghini's contributions, see also Scoti-Bertinelli, *Giorgio Vasari Scrittore*, pp. 79–82.

6 Borghini, "Dell'Origine di Firenze," in *Discorsi*, I. For the date of this essay, published posthumously, see Rubinstein, "Vasari's Painting of *The Foundation of Florence* in the Palazzo Vecchio," in *Essays in the History of Architecture Presented to Rudolph Wittkower*, ed. Fraser, Hibbard, and Lewine, p. 72, as originating in 1566–7. It is analyzed, with reference to Borghini's notion of history, by Williams, "Vincenzo Borghini and Vasari's 'Lives,'" Ph.D. (Princeton, 1988), pp. 85–110.

7 "Avvertimenti per la Historia," Biblioteca Nazionale, Florence, II, x, 106, fol. 134: "Io ho detto non per questa via perché io so molto bene che il fine nella historia è per chi scrive d'insegnare, e per chi legge imparare a vivere, e delle attioni altrui imprendere a regolare le sue. Ma ha caro ciascuno che gli sia proposto il cibo inanzi intero, e di masticarlo e cavarne il sugo da sé." This essay dates from some time after 1562. I would like to thank Robert Williams for bringing it to my attention.

73. Giorgio Vasari and Giovanni Stradano, *The Marquis of Marignano Returning to Florence after the Conquest of Siena*, detail of the ceiling panel, with portraits of (lowest row, left to right) Vincenzo Borghini, Giorgio Vasari, and Giovanni Battista Adriani; (above left) Giovanni Stradano; (above right) Battista Naldini; (at the top) Jacopo Zucchi. Florence, Palazzo Vecchio, Salone dei Cinquecento.

with rhetorical skills, and pondered the correct historical forms for his own researches, but these were to be employed for the direct exposition of the evidence. Nor did he divorce history from public interest. His life work, outlined in his will and left for others to publish, was a history of Florence, its families, and its language, all based on extensive archival research. Still bound to conventional definitions of history and established notions of its operations, what Borghini proposed was a modification of its means. Vasari's ordering of the visual arts was totally compatible with Borghini's thinking about cultural renewal and progress in other areas. What Borghini brought to the enterprise was a standard of appraisal based on documentary research and direct presentation of the facts.

Vasari's correspondence and the text of *The Lives* document Borghini's influence. Borghini's assistance is warmly acknowledged in an expansive aside, significantly placed in the first Life, Cimabue's, in association with Florence's greatest literary hero, Dante. Having quoted the famous verse from *Purgatory* V about Cimabue and Giotto, Vasari cites an early commentary:

> today in the hands of the most reverend don Vincenzo Borghini, prior of the [Ospedale degl'] Innocenti, a man renowned not only for his nobility, goodness, and erudition, but also as a lover and connoisseur of all the fine arts, so that he has deserved to be judiciously chosen by his Lordship Duke Cosimo as his deputy in our Accademia del Disegno.[8]

8 Life of Cimabue, BB ii, p. 43: "Il qual comento è oggi appresso il molto reverendo don Vincenzio Borghini, priore degl'Innocenti, uomo non solo per nobiltà, bontà e dottrina chiarissimo, ma anco così

Borghini acted as Vasari's intellectual mentor and chief literary adviser during the years of preparing the second edition. Their community of interests and combined ability to please their patron, Duke Cosimo, united them in a variety of undertakings during the 1560s, including the decoration of the Palazzo Vecchio, the foundation of the Accademia del Disegno, and the celebrations for the marriage of the duke's son and heir, Francesco, to the imperial princess Joanna of Austria. All of these enterprises are characterized by the desire to combine learning with artistic skill and to forward and foster the reputation of the arts and artists in Florence. The same goals characterize the new edition of *The Lives*.

Two passages in Borghini's letters to Vasari record the discussions between the artist and his intellectual friend about the purpose of *The Lives* and show Borghini seeking to impress Vasari with his view of historical writing:

> And again I remind you to put in order the material on living artists, especially the important ones, so that this work may be finished and perfect in all respects and a universal history of all the painting and sculpture in Italy etc., which is the purpose of your writing.[9]

For Borghini,

> The PURPOSE of your hard work is not to write about the lives of the painters, nor whose sons they were, nor of their ordinary deeds, but only their works as painters, sculptors, and architects, because otherwise it matters little to us to know the life story of Baccio d'Agnolo or Pontormo. The writing of lives is suitable only in the case of princes and men who have practiced princely things and not of low people, but here you have only as your end the art and the works by their hand. Therefore stick to this as much as you can and be diligent, and see that every detail is in its place.[10]

While Vasari's self-esteem and his deep-rooted belief in the dignity of his profession prevented his full capitulation to Borghini's ideal, his revisions were heavily influenced by Borghini's criteria. The new book is more detailed and more literally correct.

amatore et intendente di tutte l'arti migliori che ha meritato esser giudiziosamente eletto dal signor duca Cosimo in Suo luogotenente nella nostra Accademia del Disegno." Borghini's friendship of artists and ownership of their works are documented by Vasari in the 1568 edition, who records that he had a small painting by Fra Angelico ("una Nostra Donna piccola bellissima"; BB III, p. 271), a marble head of Christ by Mino da Fiesole ("fra le sue più care cose di quest'arti, delle quali si diletta quanto più non saprei dire"; BB III, p. 411), a votive picture by Salviati (BB v, p. 513, a gift from Vasari), and the painting of the 11,000 martyrs by Pontormo, who was a friend of Borghini as Vasari notes (BB v, pp. 325, 334). He collected drawings, which he organized into an album or book ("messo insieme in un gran libro infiniti disegni d'ecc[ellenti] pittori e scultori così antichi come moderni," BB III, p. 226); among them were drawings by Donatello (BB III, p. 226), Verrocchio (BB III, p. 538), Raffaellino del Garbo (BB IV, pp. 118–19), Rosso (Life of Lappoli, BB v, p. 183),

Rustici (BB v, p. 488), Federico Zuccaro (BB v, p. 563, a gift from Federico).

9 Frey II, cdlviii, p. 98 (Poppiano, 11 August 1564, to Vasari, Florence): "Et di nuouo ui ricordo, che mettiate a ordine le cose de uiuj, massime de principali, accio questa opera sia finita e perfetta da ogni parte, et che sia una HISTORIA uniuersale di tutte le pitture et sculture di Italia etc., che questo e il fine dello scriuer vostro."

10 Frey II, cdlix, p. 102 (Poppiano, 14 August 1564, to Vasari, Florence): "IL FINE di questa uostra fatica non e di scriuere la uita de pittori, ne di chi furono figliuoli, ne quello che e feciono dationj ordinarie; ma solo per le OPERE loro di pittori, scultori, architetti; che altrimenti poco importa à noi saper la uita di Baccio d Agnolo o del Puntormo. E lo scriuer le uite, e solo di principi et huominj che habbino esercitato cose da principi et non di persone basse, ma solo qui hauete per fine l'arte et l'opere di lor mano: Et pero insistete in questo piu che potete et usateci diligentia; et ogni minutia ci sta bene."

In the second letter Borghini indicates the type of information required to make identifications complete and clear. He gives the instance of a facade that Vasari said was painted by Pordenone on the Grand Canal in Venice. Borghini wanted to be able to know which facade, and the answer is given in the published text: the house of Martin d'Anna.[11] Throughout *The Lives* artists' careers are set out as accumulations of commissions, described with as much circumstance as possible, responding to Borghini's demands to know what things were, and where, for whom, and of what subject.[12]

The transformation of *The Lives* into a "universal history" of the arts was topographical, temporal, and technical. In organizing the index it struck Borghini as important that there be more works from major cities such as Genoa, Venice, Naples, and Milan.[13] Vasari amply met this suggestion through subsequent correspondence and travel, expanding earlier Lives in those directions and adding new accounts based on those cities; for example, the descriptions of artists like Titian, Jacopo Sansovino, Battista Franco, Tintoretto, and Paolo Veronese in Venice, Leone Leoni and others in Milan, Beccafumi and Montorsoli in Genoa, and the portions of Montorsoli's career spent in Naples. The letter on ancient art commissioned from Giovanni Battista Adriani, the long passages inserted on medieval architecture (derived in great part from Borghini's researches), and descriptions of works by Vasari's contemporaries completed the chronological survey.[14] A brief treatment of northern (*Fiamminghi*, that is Flemish and German) artists widened the geographical range. Chapters and additions on new techniques and other arts, such as printmaking (the *discorso* on engravers that formed the Life of Marcantonio Raimondi), manuscript illuminations (in Lorenzo Monaco's Life, those by Attavante added to the Life of Fra Angelico, and Giulio Clovio's Life), intarsia (in the Life of Giuliano da Maiano), glass painting (additions to the Life of Marcillat), gems (in the Life of Valerio Vicentino), grotesques (Andrea Feltrini added to the Life of Morto da Feltre and Giovanni da Udine's Life), interior decoration (in the Life of Dello and the Borgherini bedroom in Pontormo's Life), embroidery (additions to the Life of Raffaellino del Garbo), wax votive images and portrait busts (in the Life of Verrocchio), marble inlay (in the Life of Domenico Beccafumi), mosaic (in the description of Titian's works), coins and medals (in the chapter on Leone Leoni), precious stones (in the account of the academicians), and porphyry carving (added to the technical introduction) combine to form a truly encyclopedic commemoration of artistic accomplishment. He did not want to leave out a single thing that might be of use, pleasure, or benefit to his readers.[15] Means and media are celebrated. Technical observations

11 Life of Pordenone, BB IV, p. 431: "Fece anco in sul detto Canal Grande, nella facciata della casa di Martin d'Anna"; the 1550 text reads: "Fece ancora sul Canale Grande alla casa di certi gentiluomini."

12 Frey II, cdlix, p. 102 (Borghini, Poppiano, 14 August 1564 to Vasari, Florence): "quale ella è, et come . . . che ella ui è et perche."

13 Frey II, cdlvii (Poppiano, 8 August 1564, to Vasari, Florence), p. 98: "Jo ho ordinata tutta la tauola . . . Voi uorrej uedessi hauer da Genoua, Venetia, Napoli, Milano et in somma di queste citta principali piu numero di cose, cosi di pittura come di scultura et architettura . . . che uedrete, che importera assai."

14 For Adriani and his contribution, see M. Davis in Arezzo 1981, p. 229.

15 Life of Taddeo Zuccaro, BB V, p. 586: "per non lasciare indietro alcuna cosa, la quale essere possa di utile, piacere o giovamento a chi leggerà questa nostra fatica." In this case he is referring to a curious trick portrait of Henry II of France in the collection of Cardinal Innocenzo del Monte which he had heard about through the cardinal's secretary Alessandro Taddei and his friend don Silvano Razzi. Seen from one angle there was an inscription; when it was viewed with a special mirror the king's image appeared.

show how artists manifested or subverted their talents. Vasari praised, for example, Simone Mosca's handling of the drill as rendering his sculpted ornament palpable and real, whereas he criticized Tintoretto's defiance of drawing as leaving bold, slapdash sketches for finished works.[16] And drawings – the basis of the artist's creative procedure – also became part of history for Vasari. Along with Borghini he had begun to assemble an anthological collection, which he organized chronologically as a "book of drawings by the most famous painters." Its contents are duly cited in appropriate Lives, where they serve as "relics" of the artists and as testimonies to their techniques and their excellence.[17]

Although careful to supply biographical data and to record parentage and birthplaces, Vasari responded to Borghini's call to write about "the art and the works" of the artists. In Pontormo's Life, for example, the analysis of his singular and solitary personality is constantly turned towards an understanding of the vagaries of his style and evocations of his paintings. The case of Andrea del Sarto is also characteristic. His 1550 Life has a long introductory paragraph contrasting shame and honor, elevated and base behavior, blaming him for being blinded by desire for his wife and held to a humble state because he was too homesick to remain at the court of the French king. In 1568, however:

> Here, after the Lives of many artists, some excellent in the handling of color, some in drawing, some in invention, we have arrived at the outstanding excellence of Andrea del Sarto, in whose person nature and art demonstrated all that painting can achieve in drawing, the handling of color, and invention.[18]

For Borghini the study of a subject was self-defining, each field having its own terms of reference and proper line of inquiry. It follows, therefore, that in the second version of del Sarto's Life the artist's weakness is related to his inability to cope with the monuments of Rome rather than his unchecked lust for his wife. Integral to this differentiated historical awareness is the focus given to the question of style: how acquired and how perfected. The most conspicuous treatment of the topic is the discussion of Raphael's stylistic development at the end of his Life. This passage, however, is not unique. The relationship of master and pupil, the balance of nature and study and of imitation and innovation are themes frequently and progressively treated in descriptive notes and discursive asides added to existing Lives or put into new ones.[19]

16 Life of Simone Mosca, BB v, p. 337: "abbia . . . ridotte le sue cose con l'oprare dello scarpello a tal termine, ch'elle paiono palpabili e vere"; Life of Battista Franco, BB v, pp. 468–9, Tintoretto: "ha lavorato a caso e senza disegno, quasi mostrando che quest'arte è una baia. Ha costui alcuna volta lasciato le bozze per finite . . . che si veggiono i colpi de' pennegli fatti dal caso e dalla fierezza, più tosto che dal disegno e dal giudizio."

17 For the title given to the book, see, for example, the Life of Fra Filippo Lippi, BB iii, p. 341: "libro de' disegni de' più famosi dipintori." For drawings held as relics ("reliquie"), see BB ii, p. 105 (Oderisi da Gubbio in the Giotto Life). For the Libro de' disegni, see Ragghianti Collobi, Il Libro de' Disegni del Vasari, Petrioli Tofani in Il Disegno. I grandi collezionisti, ed.

Sciolla, pp. 14–22, and Fischer, in Arezzo 1981, pp. 246–53, with further references.

18 Life of del Sarto, BB iv, p. 341: "Eccoci, dopo le Vite di molti artefici stati eccellenti chi per colorito, chi per disegno e chi per invenzione, pervenuti all' eccellentissimo Andrea del Sarto, nel quale uno mostrarono la natura e l'arte tutto quello che può far la pittura mediante il disegno, il colorire e l'invenzione."

19 Life of Raphael, BB iv, pp. 204–8. See also, for example, the appraisal of Masolino's style added to his Life, BB iii, pp. 109–10; the passage on Mantegna's training, his early career, and opinions about studying ancient statues (BB iii, pp. 548–9); the discussions of Andrea del Sarto's style (BB iv, pp. 393–4) and the limitations of Battista Franco's method of assembling his figures (BB v, p. 464).

Under Borghini's guidance, *The Lives* became more strictly historical. Political events feature more largely. A notable number of worthy personages, popes, and princes, make their first appearances with full titles and relevant dates in the 1568 edition. This occurs frequently in Lives in Part 1, where contemporary chronicles and inscriptions form the basis of many additions.[20] The investigation of the early sources of Florentine history and literature was one of Borghini's greatest enthusiasms. His papers are filled with notes taken from such works and reminders of the necessity to "investigate and search out as many old books as possible and of every kind, that is to say of accounts, domestic matters, memoirs, letters."[21] He later produced an authoritative edition of Giovanni Villani's *Chronicle* and the first printed edition of Francesco Sacchetti's *Novelle*.[22] Vasari's increased appreciation of fourteenth-century artists, his knowledge of sources, and his sensitivity to historical context in the 1568 edition should be credited to Borghini.

Borghini suggested a method of "minute and detailed treatment," which was directly opposed to Giovio's broad method implicitly criticized by Vasari in his 1568 account of the writing of the first edition.[23] In the opening to his essay on the origins of Florence, Borghini wrote of his need to examine and criticize at length the various views, theories, and stories concerning the origins of the city in order to "guarantee the truth" of his theory.[24] Vasari's correspondingly careful examination of documents, to guarantee his truth, is demonstrated, for example, in his transcription of Michelangelo's deed of apprenticeship to Ghirlandaio, proving false the claims made by "someone who wrote his Life after 1550" that Domenico "never gave any assistance to Michelangelo."[25] Similarly, he cites the chronicles of the Dominican priory at Prato, where Baccio della Porta became Fra Bartolomeo "on the 26th day of July 1500."[26] In his Life of Ghiberti he added a paragraph appraising Ghiberti's *Commentaries*.[27] Not surprisingly, given Borghini's predeliction for letters, chronicles, and

20 See, for example, the Lives of Gaddo Gaddi (a chronicle of Santa Maria Novella, BB II, pp. 85–6), Margaritone of Arezzo (a chronology based on papal history, BB II, pp. 90–1), and Andrea Orcagna (Pisa Camposanto inscriptions, BB II, pp. 218–21).

21 Pozzi, "Il pensiero linguistico di Vincenzio Borghini," in *Lingua e cultura del Cinquecento*, p. 157: "andar investigando, ricercando più libri antichi che si potessi e d'ogni sorte, come dire di conti, di cose familiare, di ricordi, lettere."

22 Legrenzi, *Vincenzo Borghini: studio critico*, part 2, pp. 5–80, for Borghini's editions of Trecento works. See also Woodhouse, *Vincenzio Borghini: scritti inediti o rari sulla lingua*, and *Vincenzio Borghini: Storia della Nobiltà Fiorentina*, p. xlviii. See further Testaverde Matteini, "La biblioteca erudita di Don Vincenzo Borghini," in *Medici 1980*, II, pp. 611–43.

23 Borghini, *Discorsi*, I, p. 11, where he justifies his "minuta, e particolare trattazione," and Description of Vasari's works, BB VI, p. 389, of Giovio: "bastandogli fare gran fascio, non la guardava così in sottile . . . non dicea le cose come stavano apunto, ma così alla grossa."

24 Borghini, *Discorsi*, I, p. 11: "Il perchè a me non resta piccola fatica, intendendo d'esaminare diligentemente, e con nuove ragioni difendere, e assicurare la verità di questa opinione; di maniera che a nessuno possa rimaner luogo di dubitarne con ragione."

25 Life of Michelangelo, BB VI, pp. 6–7: "perché chi ha scritto la Vita sua dopo l'anno 1550 . . . tassando Domenico d'invidiosetto né che porgessi mai aiuto alcuno a Michelagnolo: il che si vidde essere falso, potendosi vedere per una scritta di mano di Lodovico padre di Michelagnolo, scritto sopra i libri di Domenico . . . Queste partite ho copiate io dal proprio libro per mostrare che tutto quel che si scrisse allora, e che si scriverà al presente, è la verità." The comment refers to Condivi's *Life of Michelangelo*. For Vasari's appropriation of Condivi's *Vita* (unacknowledged except to refute it), see Wilde, *Michelangelo*, pp. 1–16, and Barocchi, in *Studi vasariani*, pp. 35–52. Condivi's was not the first text absorbed and adapted by Vasari; a similar fate befell Manetti's Life of Brunelleschi for example, used as the basis for the 1550 and 1568 editions of the Brunelleschi Life.

26 Life of Fra Bartolomeo, BB IV, p. 92: "si fece frate in S. Domenico di quel luogo, secondo che si trova scritto nelle Cronache di quel convento, a dì 26 di luglio 1500."

27 Life of Ghiberti, BB III, p. 103. The *Commentaries* are mentioned in the Life of Stefano (BB II, p. 137) in both the 1550 and 1568 editions. Further acknowledged references in the second edition occur in the Lives of Barna (BB II, p. 254), Duccio (BB II, p. 260), and Ghiberti himself (BB III, p. 77).

old books, such records are quoted in the revised and added Lives, both in the earlier section and among the moderns.[28] Vasari was even moved to search for archival proof of an attribution to his great-grandfather of a fresco of St. Vincent in San Domenico, Arezzo (pl. 74).[29] With this added documentation, cited rather than paraphrased, the texture of the biographies is close to those in Diogenes Laertius' *Lives of the Philosophers*. The resonance of a renowned biographical model remains to support the diligently acquired material.

Vasari more readily comes forth in the 1568 *Lives* weighing evidence, offering definitive opinions, and assessing controversial points, as Borghini advocated. He wrote, for example, in concluding his account of the bitterly contested commission for the choir of San Lorenzo, that "although I might well have kept silent on these matters, I have not wanted to do so, because to proceed as I have done seems to me the duty of a faithful and truthful writer."[30] The author emerges with new authority. So he rapturously avowed his personal enthusiasm for Fra Angelico's *Coronation of the Virgin* then at San Domenico in Fiesole: "I for my own

28 For the earlier Lives Borghini supplied Vasari with notes from Paulus Diaconus's *Historia Langobardum* used in the preface to *The Lives*, see K. Frey ed., *Le Vite*, Part I, vol. I, p. 184. There is also the chronicle ("libretto antico") from Santa Maria Novella quoted at length in the Life of Gaddo Gaddi (BB II, pp. 85–6) and the "vecchio libro della Compagnia degl'uomini del Disegno" or "de' Dipintori," cited in the Lives of Andrea Tafi (BB II, pp. 77–8, about his pupil, possibly son, Antonio d'Andrea), Giotto (BB II, pp. 119–20, naming a pupil, Francesco), Buffalmacco (BB II, p. 171, about Bruno di Giovanni), and Jacopo di Casentino (BB II, p. 274), where Vasari quotes the *Capitoli* and gives a brief history of the Compagnia, the ancestor of the Accademia del Disegno. The amount of detail added about the history of Orsanmichele suggests that Vasari was looking at documents from the Consoli of the Arte della Seta or the Compagnia d'Orsanmichele, see the Lives of Taddeo Gaddi (BB II, p. 207; see Grassi, in *Le vite* [Club del Libro], I, p. 451), Andrea Orcagna (BB II, p. 223), and Jacopo di Casentino (BB II, p. 272). Vasari also took what facts he could find about major civic building projects and bridges from Giovanni Villani's *Cronica*, named as a source in the Lives of Arnolfo di Cambio (BB II, pp. 53–4, 56), Gaddo Gaddi (BB II, p. 86), Simone Martini (BB II, p. 200), used also for information in the Lives of Andrea Pisano (BB II, p. 157), Buffalmacco (BB II, p. 170), Taddeo Gaddi (BB II, pp. 207–8), Giottino (BB II, p. 232), Agnolo Gaddi (BB II, p. 246). Borghini's interest in early sources also led to long passages quoted from Sacchetti's *Novelle* (Giotto, BB II, pp. 120–1; Buffalmacco, BB II, pp. 161–4, *novelle* 161, 169, 191, 192), and probably the added references to Cennino Cennini (Taddeo Gaddi, BB II, p. 203; Agnolo Gaddi, BB II, pp. 248–9; Dello, BB III, p. 39). Borghini's papers include copies of contracts, Biblioteca Nazionale, Florence, II, X, 71, *Copie di più contratti antichi, cavati di più luoghi: dell'Archivio del Duomo, di Badia, di S. Miniato, di San Lorenzo e d'altri*. Scardeone's *De Antiquitate urbis Patavii & claris civibus Patavinis, Libri Tres*, which Borghini owned, is a source for early works in Padua. Letters, quoted and paraphrased, are sources referred to in the 1568 edition on a range of subjects, such as those by Paolo Giovio (BB III, p. 368, about Pisanello) and fra Marco de' Medici (BB III, p. 367, about Pisanello and about Veronese artists, see BB IV, p. 599), the Latin letter by Girolamo Campagnola to Leonico Timeo about painters who worked for the Carrara rulers of Padua (BB III, pp. 69, 548, 620, 621), one by the Friulian painter and architect Giovambattista Grassi (BB IV, p. 428), those by Sofonisba Anguissola and Pius IV about a portrait of the Queen of Spain (BB V, pp. 427–8), Annibale Caro describing the inventions for the paintings at Caprarola (BB V, pp. 576–85), Domenicus Lampsonius about northern artists (BB VI, pp. 228–9), Michelangelo (BB VI, pp. 84, 85, 88–95), Borghini and Duke Cosimo (Life of Michelangelo, BB VI, pp. 124–6).

29 Life of Lazzaro Vasari, BB III, p. 294: "se bene non è alcuna inscrizione, alcuni ricordi nondimeno de' vecchi di casa nostra, e l'arme che vi è de' Vasari, fanno che così si crede fermamente. Di ciò sarebbe senza dubbio stato in quel convento memoria; ma perché molte volte per i soldati sono andate male le scritture et ogni altra cosa, non me ne maraviglio." Another piece of family history – a particularly recondite discussion of the origins of the Alberti family inserted in the Life of Parri Spinelli, and cited in the Life of Leon Battista Alberti – shows Borghini's genealogical researches informing Vasari's artistic enterprises, see the Life of Parri Spinelli, BB III, p. 118 and the Life of Alberti, p. 285. Borghini was preparing a history of the Florentine nobility which, like most of his projects remained a series of notes, see Woodhouse, *Vincenzio Borghini: Storia della Nobiltà Fiorentina*.

30 Life of Pontormo, BB V, p. 331: "E se bene io arei potuto tacere queste cose, non l'ho voluto fare, però che il procedere come ho fatto mi pare ufficio di fedele e verace scrittore."

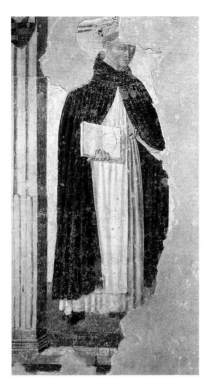

74. Lazzaro Vasari, *St. Vincent Ferrer*. Arezzo, San Domenico.

part can truly affirm that I never saw this work without being struck by its originality, and I never leave it sated."[31] The self-effacing, anonymous "one who was" with Andrea del Sarto, protégé of Ottaviano de' Medici, has become Giorgio Vasari, the acknowledged expert.[32]

History and Art at the Court of Cosimo de' Medici

The secure voice of the 1568 edition is that of the mature author. The change in tone owes as much to biography as to historiography. However much loving assistance Vasari received from friends like Borghini, "the labors, the discomforts, and the money" spent over many years, were his own.[33] The events of those years must be considered when analyzing the changes written into the second edition of *The Lives*. In the 1560s, when he undertook the rewriting of *The Lives*, Vasari was not a wandering young artist hungry for work; he was an established master, an experienced historian, *the* experienced art historian, and the respected

31 Life of Fra Angelico, BB III, p. 271: "io per me posso con verità affermare che non veggio mai questa opera che non mi paia cosa nuova, né me ne parto mai sazio." The painting is now in the Louvre, Paris. For an illustration, see Pope-Hennessy, *Fra Angelico*, pl. 127.

32 For this change in self-identification, see the Life of del Sarto, BB IV, p. 379, where he narrates the story of how del Sarto's copy of Raphael's portrait of Leo X fooled even Giulio Romano and how (in the 1550

version) "un che sté con Andrea . . . e creatura di messer Ottavio" revealed the deception to Giulio. In the 1568 Vasari names himself. For the "io vasariano" and its imposition on certain themes and specific intrusion in the Michelangelo Life, see Barocchi in Vasari, *La vita di Michelangelo*, ed. Barocchi, I, pp. xxvii–xxx.

33 Concluding letter to the artists, BB VI, p. 410: "E ben so io quante sieno le fatiche, i disagi e i danari che ho speso in molti anni dietro a quest'opera."

AVCTO IMPERIO

76. Giorgio Vasari and Marco da Faenza, *Cosimo il Vecchio Surrounded by Artists and Men of Letters*. Florence, Palazzo Vecchio, Quarter of Leo X, Sala di Cosimo il Vecchio.

77. Giorgio Vasari, *Duke Cosimo I Surrounded by the Artists of His Court*. Florence, Palazzo Vecchio, Quarter of Leo X, Sala di Cosimo I.

client of a powerful duke. He wrote "having had the space to understand many things better and to see many other things again."[34] This space can be understood as offering a different perspective, presenting Vasari with the opportunity to acquire new vistas and a broader understanding of artistic endeavors. It also represents a new position in society. As a salaried member of Duke Cosimo's court he had a defined place in a self-consciously defined society. He had become a form of artistic impresario, the versatile co-ordinator of ducal, then grandducal, enterprises where artistic and political vision were combined to express the glory of the Tuscan state ruled by Cosimo de' Medici (pl. 75). Under Cosimo the "diplomacy of taste" initiated shrewdly, but informally, by his ancestor Lorenzo il Magnifico was institutionalized so that numerous aspects of Florentine excellence – literature, learning, and the visual arts – fell under state protection and Cosimo's supervision.[35]

34 Prefatory letter to the artists, BB I, p. 175: "avendo avuto spazio poi d'intendere molte cose meglio e rivederne molte altre."

35 For an overview of Cosimo's cultural activities, see Cochrane, *Florence in the Forgotten Centuries 1527–1580*, pp. 66–87 with an extremely useful bibliographical note, pp. 510–28. For a political reading of those

actitivies see Plaisance, "La politique culturelle de Cosme Ier," *Les Fêtes de la Renaissance*, ed. Jacquot and Konigson, III, pp. 133–52, "Une première affirmation de la politique culturelle de Cosme Ier," in *Les écrivains et le pouvoir en Italie*, no. 2, pp. 361–438, and "Culture et politique à Florence 1542–1551," in *ibid.*, no. 3, pp. 149–242. Lorenzo de' Medici's "diplomacy of taste" is

75. Giorgio Vasari, *Apotheosis of Cosimo I*. Florence, Palazzo Vecchio, ceiling of the Salone dei Cinquecento.

History itself was brought under Cosimo's command. In 1546–7 the duke commissioned Benedetto Varchi to write a history of the years preceding his government, making available official records and the Medici archives, encouraging the study of source material as later espoused by Borghini.[36] Given this official interest in documentary history, it is not surprising that some of the Lives of Vasari's contemporaries are elaborately circumstantial, their tone combining chronicle and court intrigue. Through publishing the activities of the Accademia del Disegno and through the Lives of artists like Tribolo, Pierino da Vinci, Baccio Bandinelli, Gherardi, Pontormo, Aristotile da Sangallo, Ridolfo Ghirlandaio, Battista Franco, Salviati, and his own, he was able to produce a history of the cultural achievements of Cosimo's court. In other cases, such as that of his rival Cellini or of his friend Bronzino, court politics and Vasari's ambitions resulted in curtailed versions of their careers. Vasari, like his patron Cosimo, was a shrewd propagandist, both in what he publicized and what he suppressed. His interests and the duke's were often identical, and both are recorded in the additions to the second edition, which is explicitly Medicean and implicitly academic.

Vasari was instrumental in the design and definition of Cosimo's state imagery. He actively entered the duke's service in December 1554 and was given charge of the rebuilding and decoration of the Palazzo Vecchio. The conversion of the town hall to state residence was Vasari's principal task for over a decade. The subjects of the decorations – Olympian and allegorical on the upper floor, Medicean and historical on the main floor – were devised by Cosimo Bartoli, Giovanni Battista Adriani, and Vincenzo Borghini in conjunction with Vasari, and in close consultation with the duke. Neglecting the details of actual descendance, the chosen scenes traced a direct line from Cosimo Pater Patriae to Cosimo I (pls. 76, 77). With this program of decoration Cosimo appropriated the glories of the entire house of Medici and turned Florentine history into a celebration of Medici rule, which is similarly celebrated in *The Lives* where Medici magnificence is also illustrated across time.

This is not to deny a conspicuous Medici presence in the 1550 edition, where the Medici feature as friends of the arts and artists. Indeed, Cosimo il Vecchio's relations with artists are all represented according to the ideal of friendship. So when Michelozzo accompanies Cosimo in exile to Venice as Vasari said he did because of his infinite love for Cosimo, he is following an example given by Seneca as proof of true friendship.[37] Similar love and mutual esteem operate to the mutual benefit of Cosimo and his client artists in the Lives of Donatello and Fra Filippo Lippi. In these, as in other Lives, Vasari's professional dreams and personal experiences were incorporated in examples from the past. Cosimo had actually been a generous patron of Donatello, for example, and his sympathy for the arts and artists forms a significant section of Vespasiano da Bisticci's fifteenth-century biography in his

one of the subjects of Chastel's *Art et Humanisme à Florence au temps de Laurent le Magnifique.*

36 For Cosimo and contemporary historians and historiography, see von Albertini, *Firenze dalla repubblica al principato*, pp. 306–50. Soon after Varchi's death, the task of producing a history of Cosimo's reign was given to Vasari's friend, Giovanni Battista Adriani (*c.*1565–6).

37 Seneca, *Letters from a Stoic*, trans. R. Campbell, p. 50, letter IX. Cosimo left for exile on 4 October 1433. Michelozzo is documented working in Prato at least until 17 December of that year. There is no documentation to support Vasari's story. For a consideration of this, see Ferrara and Quinterio, *Michelozzo di Bartolomeo*, p. 19.

Lives of Illustrious Men. And the Medici had been remarkable in their sponsorship of artistic activity. This was easy for Vasari to recognize as he had, after all, been educated as a Medici partisan and dependent. Given Vasari's association with Paolo Giovio and acquaintance with the Guicciardini, it is not surprising that his view of the family's role as patrons followed the eulogistic appraisals of Cosimo il Vecchio, Lorenzo, and Leo X found in Francesco Guicciardini's *History of Florence* and Giovio's biography of Leo X.[38] Nonetheless, in the 1550 edition Vasari's appreciation of this family was subject to the schematic demands of the separate Lives, and, perhaps more importantly, it was tempered by the disappointments he had suffered as a Medici dependent, owing to the successive deaths of his benefactors. In the 1568 edition, by contrast, the house of Medici and the courtier-client relationship are programmatically exalted. The position of faithful friend and client is more explicitly stated and more extensively chronicled, as in the greatly enlarged Life of Michelozzo, or newly granted, as artists like Castagno are found to have been "a servant and obligated to the house."[39]

In the second edition the Medici become instrumental in the perfection of the arts. Masaccio returns from Rome to Florence "when he had news that Cosimo de' Medici, by whom he had been greatly helped and favored, had been recalled from exile," a device that replaces the 1550 summons from Brunelleschi.[40] Cosimo, though not the patron, thereby becomes the agent of Masaccio's fame and accomplishment in the Carmine frescoes, where that artist's skill created the order that would lead to "the beautiful style of the modern age."[41] For Vasari, Cosimo's son, Piero, was "among the first who caused Luca [della Robbia] to make things with colored clays" in the painted terracotta decoration of his study. A "singular" thing, its widespread fame resulted in a large-scale export business, to the advantage of Luca and Florentine merchants.[42] This offered an obvious parallel with some of Cosimo I's schemes, such as the establishment of tapestry-making in Florence. Similarly, Vasari reports that the interest of Lorenzo il Magnifico and his son Piero in ancient gems was the "reason that they brought masters from various countries in order to establish that art in their city."[43] By means of the Magnifico others learned this art,

38 For the image of the Medici and historians before Cosimo, see F. Gilbert, *Machiavelli and Guicciardini*, especially pp. 105–52.

39 Life of Castagno, BB III, p. 362: "servitore et obligato alla casa de' Medici." For these notions, see Warnke, *Hofkünstler*, and C. Davis, "Frescoes by Vasari for Sforza Almeni," *Mitteilungen des Kunsthistorischen Institutes in Florenz* (1980), pp. 127–202, for inventions on the theme of service.

40 Life of Masaccio, BB III, p. 128: "quando egli, avuto nuove che Cosimo de' Medici, dal qual era molto aiutato e favorito, era stato richiamato dall'esilio." The example of friendship underlies both constructions of the event, the later version changes it from the friendship of equals to the favors of clientage.

41 *Ibid.*, p. 131: "Laonde le sue fatiche meritano infinitissime lodi, e massimamente per avere egli dato ordine nel suo magisterio alla bella maniera de' tempi nostri."

42 Life of Luca della Robbia, BB III, pp. 53–4:

"Onde il magnifico Piero di Cosimo de' Medici—fra i primi che facessero lavorar a Luca cose di terra colorite—gli fece fare tutta la volta in mezzo tondo d'uno scrittoio nel palazzo . . . et il pavimento similmente, che fu cosa singolare . . . La fama delle quali opere spargendosi . . . erano tanti coloro che ne volevano, che i mercatanti fiorentini, facendo continuamente lavorare a Luca con suo molto utile, ne mandavano per tutto il mondo." The study, though singular, was not Luca's first work in enamelled terracotta. For Luca della Robbia's commissions from Piero de' Medici, see Pope-Hennessy, *Luca della Robbia*, pp. 42–5.

43 Life of Valerio Vicentino, BB IV, p. 620: "che furono cagione che per metter l'arte nella loro città e' conducessino di diversi paesi maestri." This tallies with Lorenzo's interventions, see, for example, Gombrich, "The Early Medici as Patrons of Art," in *Norm and Form*, p. 56, who cites the case of a gem-cutter, Pietro di Neri Razzati, who was granted tax exemption on the condition that he taught his lost art in Florence.

which "then increased to even greater excellence" under the practitioners of the pontificate of Leo X.[44]

In both editions patronage is represented as more than payment. It was defined as a matter of sympathy and understanding – a combination that created a basis of appreciation and reciprocal affection encouraging the arts to flourish. The Medici become increasingly conspicuous in this role. One of the most notable instances of their promotion is Lorenzo de' Medici's sculpture collection. In the 1550 edition of Michelangelo's Life Vasari had described Lorenzo's desire to honor himself and his city by creating a school for painters and sculptors in his garden, with Donatello's student Bertoldo as curator and teacher.[45] He repeats this statement in the 1568 edition and amplifies it in the Life of Torrigiano where his collection becomes a form of "school and academy for young painters and sculptors and for all the others who devoted themselves to drawing."[46] The garden academy is described at length in the Life of Torrigiano, but it features also in the Lives of Albertinelli, Andrea Sansovino, Granacci, Bugiardini, and Rustici.[47] There, according to Vasari, with Lorenzo's favor, talent was fostered as young artists learned through the assiduous study and imitation of the drawings, cartoons, and sculptures of distinguished masters.

Although Bertoldo was a member of Lorenzo's household and a sculpture garden existed and artists had access to it, it is unlikely that there was a systematic program of study.[48] The informal arrangements Vasari describes in the first edition of Michelangelo's Life are probably truer to the actual case and conform with Lorenzo's other interventions and interests. The garden of the second edition is instead a Laurentian precursor to the Accademia del Disegno founded in 1563. Lorenzo's academy makes him the patron of past excellence, just as the duke was being encouraged to become the "beneficent father" to future generations through the Accademia. Vasari hailed the garden academy as the "truly magnificent example of Lorenzo, which will always be imitated by princes and other honored persons and will bring to them honor and everlasting praise."[49]

Lorenzo's descendants, Leo X, Clement VII, and Ippolito, are also shown to have each

44 *Ibid*.: "Accrebbe poi in maggior eccellenza questa arte nel pontificato di papa Leone Decimo."

45 Life of Michelangelo, BB VI, p. 9: "Teneva . . . il Magnifico Lorenzo de' Medici nel suo giardino . . . Bertoldo scultore . . . desiderando egli sommamente di creare una scuola di pittori e di scultori ecc[ellenti], voleva che elli avessero per guida e per capo . . . Bertoldo, che era discepolo di Donato . . . dove egli desiderava di essercitargli e creargli in una maniera che onorasse sé e lui e la città sua."

46 Life of Torrigiano, BB IV, pp. 124–5: "erano come una scuola et academia ai giovanetti pittori e scultori et a tutti gl'altri che attendevano al disegno."

47 *Ibid*., pp. 124–6, and pp. 105–6 (Albertinelli), p. 275 (Andrea Sansovino), p. 601–2 (Granacci), BB V, p. 279 (Bugiardini), p. 475 (Rustici).

48 See Elam, "Lorenzo de' Medici's Sculpture Garden," *Mitteilungen des Kunsthistorischen Institutes in Florenz*, (1992), pp. 41–84, for a documented discussion of the location, functions, and history of the garden. See also *Il Giardino di San Marco*, exhib., Casa Buonarroti

(1992). See Draper, *Bertoldo di Giovanni*, pp. 15, 277 for Bertoldo's role with respect to Lorenzo's collection of antiquities, and pp. 64–75 for a discussion of early references to the sculpture garden. For the garden and Vasari and Lorenzo generally, see Rubin, "Vasari, Lorenzo, and the myth of magnificence," in *Lorenzo il Magnifico e il suo mondo*, ed. Garfagnini, pp. 178–88.

49 Life of Torrigiano, BB IV, pp. 125–6: "esempio veramente magnifico di Lorenzo, sempre che sarà imitato da prìncipi e da altre persone onorate, recherà loro onore e lode perpetua." Chastel was the first to note Vasari's creation of an academy from the collection, "Vasari et la légende Mediciéenne: L'École du Jardin de Saint-Marc," in *Studi* 1950, pp. 159–67. For the Academy's regulations, see Reynolds, "The Accademia del Disegno in Florence," Ph.D. (Columbia, 1974). Duke Cosimo is defined as "benigno padre" to the arts in the first chapter of the academy's first set of regulations, which were drafted in November and December 1562 and approved by the duke on 13 January 1563 (Reynolds, p. 222).

created vital situations for the arts where study and the exercise of talent were rewarded by commissions and informed appreciation. The point is made dramatically in Vasari's 1568 description of the pontificate of Adrian VI as a traumatic hiatus between those of Leo X and Clement VII:

> excellent artists were desperate and little short of dying of starvation (while Adrian was still alive). But while the court, accustomed to the splendors of Leo X, was completely stunned and all the best artists were wondering where they might take shelter, given that virtue was no longer held in regard, Adrian died as God willed, and Cardinal Giulio de' Medici was created sovereign Pontiff and was called Clement VII; from the very first day he revived all the arts of design and all other virtues besides.[50]

Vasari's writing of Medici history here depends on Giovio's in his Lives of Leo X and Adrian VI, but he found his own set of examples and participated in the articulation of the Medici myth with his own enthusiasm and for his own reasons. He attached artists' reputations to the fame of the Medici and other such *signori*, implying an equality of name and honor that fixed artists and the visual arts in a conspicuous social role. In the case of the Medici, following Cosimo's program of self-glorification, this role became ever more elevated. Vasari's desire to ennoble the arts was happily matched by Cosimo's own interest in nobility as he sought to refashion Florentine republican memory in terms of ducal display.

One theme in Duke Cosimo's iconography was Cosimo il Vecchio's comportment "not as a citizen but as an honored prince."[51] Symptomatic of this, and of Vasari's exploitation of it, is the elevation of the Palazzo Medici from a simple house in the 1550 edition (albeit one whose perfection is admired) to a dwelling not only fit for

> a private citizen as Cosimo then was, but for a most splendid and honored king, so that in our times, kings, emperors, popes, and many of the most illustrious princes in Europe have stayed there in comfort, with infinite praise both for the magnificence of Cosimo and for Michelozzo's exceptional skills as an architect.[52]

He is also insistent about the magnificence of Luca Pitti's palace, recently purchased by the duchess. He describes the palace as worthy of Duke Cosimo's power and grandeur of spirit.[53] He firmly attributes its design to Brunelleschi and describes its renovations under Ammannati. In this project, and over the span of a century, patrons and artists are linked

50 Life of Giulio Romano, BB v, p. 59: "Disperati ... gli ... artefici eccellenti, furono poco meno (vivente Adriano) che per morirsi di fame. Ma, come volle Dio, mentre che la corte avezza nelle grandezze di Leone era tutta sbigottita, e che tutti i migliori artefici andavano pensando dove ricovrarsi, vedendo niuna virtù essere più in pregio, morì Adriano, e fù creato sommo pontefice Giulio cardinale de' Medici, che fù chiamato Clemente Settimo, col quale risuscitarono in un giorno, insieme con l'altre virtù, tutte l'arti del disegno."

51 *Ragionamenti*, in *Le Opere*, ed. Milanesi, viii, p. 101, where he describes Cosimo il Vecchio rewarding artists: "non da cittadino, ma da onorato principe."

52 Life of Michelozzo, BB iii, p. 231, the living spaces had: "tutte quelle commodità che possono bastare nonché a un cittadino privato com'era allora Cosimo, ma a qualsivoglia splendidissimo et onoratissimo re, onde a' tempi nostri vi sono allo[g]giati commodamente re, imperatori, papi e quanti illustrissimi principi sono in Europa, con infinita lode così della magnificenza di Cosimo come della eccellente virtù di Michelozzo nella architettura."

53 Life of Brunelleschi, BB iii, p. 188: "E di vero al duca Cosimo non poteva venire alle mani alcuna cosa più degna della potenza e grandezza dell'animo suo."

through virtue or nobility of spirit, seeking to combine greatness and magnificence in the works sponsored and executed.[54] Vasari's account of Palazzo Medici and Palazzo Vecchio also expanded with his own experience as an architect (largely for Cosimo) and with his familiarity with Medici possessions – possessions exhaustively enumerated in an inventory of honorable ownership and progressive taste that spans Vasari's three ages.

Medici history was the focal point of Vasari's career as an artist during the late 1550s. It is logical that it became a viewpoint from which to survey the arts across the boundaries of biography. It is also logical that painting historical subjects he should redirect his interest in writing history. In the Palazzo Vecchio decorations the past was made present in a manner as circumstantial as it was celebratory. And in the second edition of *The Lives*, the present became a feature of the past as numerous additions break the seal of completed history. Vasari's treatment of the Palazzo Vecchio is paradigmatic. His first mention of its design, by Arnolfo di Cambio, is accompanied by a mention of its improvements over time, until the days of Duke Cosimo and under Giorgio Vasari it finally reached "that grandeur and majesty that one sees."[55] Subsequent, substantial treatments of the palace in the Lives of Michelozzo, Cronaca, and Baccio d'Agnolo follow the same line. The perfections of Vasari's age are demonstrated by the contrasting limitations of previous eras.

Vasari prepared for painting "by reading ancient and modern histories of the city" (notably Giovanni Villani and Guicciardini) and by searching out and studying works for documentary purposes.[56] The value of paintings as historical record is acknowledged in the 1568 *Lives*, in his description of a fourteenth-century fresco cycle at Santa Maria Novella, for example:

> Although it is not particularly beautiful, this painting is worthy of some praise if Buonamico's design and the invention are taken into consideration, and especially the variety of garments, the chin-guards and other armor of that time; I made use of them in some of the histories that I painted for His Lordship Duke Cosimo, where it was necessary to show men armed in the old fashion and other similar things of that epoch . . . And from this one can recognize how much is to be gained from the inventions and works done by these painters of the past and also in what a useful and convenient manner one can draw upon their works even though they might not be perfect.[57]

He found it an arduous and difficult task to collect images of all those portrayed in the

54 For the issue of nobility at Cosimo's court, which generated a literature discussing it as well as many new claimants to nobility, see Litchfield, *Emergence of a Bureaucracy*, part 1. Borghini's opinions on the topic of nobility are found in his notes for the *Storia della Nobiltà Fiorentina* dating from *c*.1560, ed. Woodhouse, see pp. 18–19. Vasari had turned Lorenzo il Magnifico into a supporter of both nobility of birth and of aspiring talent saying that he maintained that those who were born of noble blood could more easily arrive at perfection in all things, but also that he still provided in the sculpture garden for those who, being poor, would not otherwise have been able to undertake the study of drawing (Life of Torrigiano, BB IV, p. 125). This provision was made

in the revised regulations of the Accademia del Disegno, see Reynolds, "The Accademia del Disegno in Florence," Ph.D. (Columbia, 1974), p. 247, 1563 regulations, *capitolo* VII. See also Waźbiński, "Giorgio Vasari e Vincenzo Borghini come maestri accademici," in *Studi* 1981, pp. 297–8.

55 Life of Arnolfo di Cambio, BB II, p. 56: "di tempo in tempo, ha ricevuto que' miglioramenti che lo fanno esser oggi di quella grandezza e maestà che si vede."

56 *Ragionamenti, in Le Opere*, ed. Milanesi, VIII, p. 220: "io mi preparava per l'invenzione di questa sala nel leggere le storie antiche e moderne di questa città."

57 Life of Buffalmacco, BB II, p. 173: "Questa pittura, ancora che non sia molto bella, considerandosi il

Palazzo Vecchio paintings in their correct, but old-fashioned, clothing – an effort made because "everything must have meaning."[58] So when Arnolfo di Cambio is shown presenting the plan for the new walls of Florence, he is appropriately and archaically dressed, as is Antonio Giacomini as he urges his fellow Florentines to do battle against Pisa (pls. 78, 79). The dress in both is also recognizably republican. The passing of that age is made a matter of fashion, which Varchi chronicled in his history of Florence with a section on dress in the republican era. Historical accuracy was part of the meaning of the work, and part of its political context and message. In 1567 Vasari sent his assistant Battista Naldini to draw the sites of the battles they were to depict.[59] And earlier he had diligently sought out portraits in order to transform the vague instructions Cosimo Bartoli had given him on how to illustrate Cosimo il Vecchio's patronage into a literal depiction of that patronage with actual likenesses. Bartoli had written him suggesting that he show Cosimo "with a crowd of men of letters around him presenting him with books, and sculptors presenting him with statues."[60] In order to do this Vasari found portraits of Cosimo's favored philosophers and artists (pl. 76). Through Vasari's efforts Bartoli's generic commemoration became a specific celebration of historical figures: a change that heralds the editorial stance of the 1568 *Lives*.

Vasari's interest in both historical accuracy and portraits may well have been stimulated by his patron's. Vasari's correspondence over these years documents Cosimo's close control of the histories depicted (pl. 80).[61] Further, in 1552 Cosimo had sent Cristofano dell'Altissimo to Como to make copies after Giovio's portrait gallery, with the idea of creating a similar collection of historical portraits.[62] It cannot be accidental that Cosimo's palace was populated with images of famous men. Once again, Cosimo's and Vasari's interests happily coincided here. As discussed earlier, the conception of the first edition was bound up with Giovio's museum, his images and eulogies, and it is probable that a series of portraits was projected for that edition.[63] The decoration of the Palazzo Vecchio provoked

disegno di Buonamico e la invenzione ell'è degna di esser in parte lodata, e massimamente per la varietà de' vestiti, barbute et altre armature di que' tempi; et io me ne sono servito in alcune storie che ho fatto per il signor duca Cosimo, dove era bisogno rappresentare uomini armati all'antica et altre somiglianti cose di quell' età . . . E da questo si può conoscere quanto sia da far capitale dell'invenzioni et opere fatte da questi antichi, comeché così perfette non siano, et in che modo utile e commodo si possa trarre dalle cose loro."

58 *Ragionamenti*, in *Le Opere*, ed. Milanesi, VIII, p. 87: "tutto ha da aver significato."

59 Allegri and Cecchi, *Palazzo Vecchio e i Medici*, p. 262, and Frey III, lxvii and lxviii, pp. 138–40 (Florence, 27 and 28 April 1567) letters to Giovanni Caccini, *provveditore*, in Pisa, telling him of Naldini's arrival and detailing the views required.

60 Frey I, ccxxxiv, p. 440 (Florence, spring or summer 1556, to Vasari, Florence): "con un monte di letteratj atorno, che gli porgessino librj, et con statuarij, che gli porgessino statue," and *Ragionamento* I, day 2, in *Le Opere*, ed. Milanesi, pp. 100–1 for Vasari's portrait identifications and description.

61 For example, Frey I, ccclxxxix, p. 696 (Vasari, Florence, 20 January 1563, to Cosimo, Pisa), about the invention for the ceiling of the Salone dei Cinquecento being prepared with Borghini; cccxcvii, p. 722 (Florence, 3 March 1563), a letter from Vasari to the duke in Pisa presenting the first scheme for the ceiling (pl. 80), which was subsequently revised owing to the duke's criticisms; Frey II, ccdlxx, p. 125 (Cosimo, Pisa, 12 November 1564, to Borghini, Florence), approving the scene of the rebuilding of Florence. For a succinct account of the development of the project, see Rubinstein, "Vasari's Painting of *The Foundation of Florence* in the Palazzo Vecchio," in *Essays in the History of Architecture Presented to Rudolph Wittkower*, ed. Fraser, Hibbard, and Lewine, pp. 64–73. For the nature of the project and Borghini's role more generally, see Scorza, "Vincenzo Borghini (1515–1580) as iconographic adviser," Ph.D. (Warburg Institute, 1987).

62 Prinz in *Gli Uffizi: Catalogo Generale*, p. 603.

63 See the Preface to *The Lives*, BB II, p. 32, for Vasari's attention to artists' portraits in the 1550 edition, "mentioned and identified by me wherever they are to be found" ("citati et assegnati da me, dovunque e' si

78. Giorgio Vasari and Giovanni Stradano, *Arnolfo di Cambio Presenting the Plan for the Enlargement of Florence.* Florence, Palazzo Vecchio, ceiling of the Salone dei Cinquecento.

79. Giorgio Vasari and Giovanni Stradano, *Antonio Giacomini Inciting the People Against Pisa.* Florence, Palazzo Vecchio, ceiling of the Salone dei Cinquecento.

80. Giorgio Vasari, diagram plan for the ceiling of the Salone dei Cinquecento. ASF, Mediceo del Principato, Carteggio Universale 497a, fol. 1597.

a reconsideration of portraits, of paintings as historical record, as well as of artists as men of note. While his chief literary preoccupation between 1558 and 1560 was the composition of explanations of the frescoes there, the first section of the *Ragionamenti*, it seems likely that the painted histories in those rooms suggested a revival of the earlier portraits project and the artists' *Lives*, the two effectively becoming one, as the portraits were eventually published with *The Lives*.[64]

The strict association of historical figures and historical sequence in the research and design of the Palazzo Vecchio decorations is documented by a list in Vasari's *Zibaldone*. It has the names of famous men and the artists who portrayed them ordered along a dateline with entries from 1395 to 1450.[65] Vasari's dogged pursuit of portraits and his increased respect for portraiture are recorded in the numerous references to portraits added to *The Lives* either in descriptions of mural cycles or by naming them as separate works of art. Portrait indices were added to all three volumes of the 1568 edition. His regard for the genre is given historical formulation in an addition to the Life of the Bellini, where the custom of making portraits is traced to its ancient origins.[66]

Painting history also led Vasari to a greater appreciation of history painting, registered in additions to *The Lives* that described or re-evaluated such cycles for their documentary, expressive, and stylistic merits. A notably expansive piece of historical self-justification is inserted into the Life of the Bellini concerning Giovanni and Gentile Bellini's commission to decorate the Venetian Council Hall:

> some gentlemen began to argue that, given the opportunity of having such exceptional masters, it would be a good idea to decorate the hall of the Great Council with histories illustrating the honored magnificence of their marvelous city, its glories, exploits in war, enterprises, and other similar matters worthy of being painted for the memory of those who would come afterwards, so that to the profit and pleasure that is derived from the histories that can be read would be added entertainment for the eye and for the intellect in seeing the images of so many illustrious lords and the eminent deeds of so many gentlemen, so worthy of eternal fame and memory, and all created by such expert hands.[67]

This could serve also an explanation of the value of his own paintings in the former Florentine Council Hall and one that echoes Borghini's opinions on the choice of the

truovano"). For the project in the second edition, see Prinz, "Vasaris Sammlung von Künstlerbildnissen," *Mitteilungen des Kunsthistorischen Institutes in Florenz* (1966, supplement).

64 C. Davis in Arezzo 1981, pp. 257–9, for a discussion of an edition of the portraits printed separately, known in an example in the Berenson library at Villa I Tatti, Florence (L.XIII.4), *Ritratti de' più eccellenti pittori scultori et architetti Contenuti nelle vite di M. Giorgio Vasari Pittore, et Architetto Aretino*, Giunti (1568), and for Vasari's research, see Hope, "Historical Portraits in the 'Lives,'" in *Studi* 1981, pp. 321–8.

65 Del Vita, *Lo Zibaldone*, pp. 131–8.

66 Life of the Bellini, BB III, pp. 438–9.

67 *Ibid.*, pp. 430–1: "alcuni gentiluomini cominciarono a ragionare che sarebbe ben fatto, con l'occasione di così rari maestri, fare un ornamento di storie nella sala del Gran Consiglio, nelle quali si dipignessero le onorate magnificenze della loro maravigliosa città, le grandezze, le cose fatte in guerra, l'imprese, et altre cose somiglianti degne di essere rappresentate in pitture alla memoria di coloro che venisseno, acciò che all'utile e piacere che si trae dalle storie che si leggono, si aggiungnesse trattenimento all'occhio et all'intelletto parimente nel vedere da dottissima mano fatte l'imagini di tanti illustri signori e l'opere egregie di tanti gentiluomini, dignissimi d'eterna fama e memoria."

parallel histories of the war with Pisa (a past event) and that with Siena (Cosimo's own glorious victory) as subjects to be painted there. Borghini argued that both were "full of various battle episodes and marvelous occasions of valor and fortune, and where one could easily adorn the subject matter with the beauty of Painting and Painting with the greatness of the subject matter."[68] Both Borghini and Vasari make a connection between painted and prose accounts, a bookish approach to history painting explained by the painstaking research that preceded the visual translation of text. It is Vasari who cites historical values – the depiction of events and people worthy of record – and Borghini who points out the necessity of finding suitably pictorial subjects. Between them they formulate a theory of the genre.

Ten years of interior decorating gave Vasari a great respect for such large schemes, recalled in numerous enlarged and added descriptions.[69] He is expansive about parallel examples elsewhere in Italy, such as the vault frescoed by Beccafumi with ancient mythologies and histories in the house of Marcello Agostini in Siena (now the Bindi-Sergardi palace) and the exemplary deeds of classical heroes and virtues Beccafumi painted in the ceiling of the Sala del Concistoro in the Palazzo Pubblico.[70] Vasari gives an extensive tour and explanation of the painted rooms of Cardinal Alessandro Farnese's villa at Caprarola in the Life of Taddeo Zuccaro.[71] He returns to the decoration of the Sala Regia in the Vatican in various Lives, often appearing as an intermediary between successive painters and popes, his patronage of colleagues becoming a key aspect of the papal commissions.[72]

A notable case of a Life recast through Vasari's entrepreneurial experience is Giulio Romano's. In 1550 Giulio was presented as an example of a masterly artist *all'antica*: "So that if Apelles and Vitruvius were alive and in the company of artists, they would consider themselves vanquished by the style of this man who was always modern in an ancient way and ancient in a modern way," and whose Roman accomplishments were rewarded by princely, Mantuan, patronage.[73] While this remains a signficant component of the Life, in 1568 he emerges also as the ideal organization man, Raphael's trusted and favored assistant, a ready student and faithful executor of the master's projects, and after Raphael's death, a versatile designer and capable workshop manager. Vasari's detailed knowledge of Giulio's role in Raphael's shop must date from his 1541 visit with Giulio in Mantua. It seems that Vasari chose not to use that information in the first edition since it was not germane to the Life that he fashioned out of his friendship and respect for Giulio. As Vasari's priorities changed, so too did his view of what was important about Giulio's career. Vasari revisited

68 Lorenzoni, *Carteggio artistico inedito di D. Vinc. Borghini*, I, p. 55, to Girolamo Mei (1566): "subbietti ambidue pieni di vari casi d'arme et maravigliosi accidenti di virtu et di fortuna, et ove facilmente si poteva ornar la materia con la vaghezza della Pittura et la Pittura con la grandezza della materia."

69 For this with respect to Giulio Romano in particular, see Barocchi, "L'antibiografia del secondo Vasari," in *Studi Vasariani*, pp. 159–60. To her examples one might add, in the earlier Lives, the Life of Pintoricchio, which was greatly enlarged by a description of the Piccolomini library based on its inscriptions and Vasari's appreciation of that painter as one who

knew how to satisfy princes and great lords efficiently (BB III, pp. 572–3, 578).

70 Life of Beccafumi, BB V, pp. 168–71.

71 Life of Taddeo Zuccaro, BB V, pp. 571–86.

72 Life of Salviati, BB V, pp. 529–32, 536; Life of Daniele da Volterra, BB V, pp. 543–4, 548; Life of Taddeo Zuccaro, BB V, pp. 563–4; description of Primaticcio's works, BB VI, p. 151; account of various artists, BB VI, p. 221 (Siciolante da Sermoneta).

73 Life of Giulio Romano, BB V, p. 55: "Talché se Apelle e Vitruvio fossero vivi nel cospetto degli artefici, si terrebbono vinti dalla maniera di lui, che fu sempre anticamente moderna e modernamente antica."

Mantua in May 1566, and while there refreshed his memory of Giulio's frescoes, as is recorded in the extensive additions to his descriptions. He also learned about the activities of Giulio's students and inserted them as well. But this brief stay does not account for the details of Giulio's career, especially in Rome, which, retrieved from memory or memoranda, form the basis of many of the changes to the 1568 biography. In fact it is the 1541, not the 1566, visit that is featured in the revised Life. Giulio's career at the Gonzaga court is represented as a model for both patrons and artists. Vasari says that when Cardinal Gonzaga asked him what he thought of Giulio's works, he answered,

> (Giulio being present) that they were of such a nature that there deserved to be a statue of him placed on every corner of that city, and that for having renovated it, half of that state would not be sufficient to reward the labors and the virtue of Giulio. To which the cardinal replied that Giulio was more master of that state than he was himself.[74]

Hyperbole perhaps, but not far removed from Vasari's desire to be highly regarded and rewarded for his many labors in the service of Duke Cosimo.

The amount of information about sculpture is also greatly increased. Vasari registers a fascination for its techniques, giving a detailed description of the assembly of the tabernacle at Orsanmichele by Andrea Orcagna, for example.[75] This must owe a certain amount to the various sculptural and mixed-media projects being sponsored by Cosimo – the duomo choir enclosure by Baccio Bandinelli, the hotly contested commission for the Neptune fountain in Piazza Signoria (won by Vasari's candidate, Ammannati), the fountains at the villa of Castello (projected and begun by Tribolo), the bronze door for the duke's safe by another of Vasari's protégés, Vincenzo Danti (its imagery was part of a program of decoration devised by Borghini and Vasari for the duke's study). But Vasari's experience at designing and co-ordinating a large-scale project involving sculpture and architecture as well as painting pre-dated his time at Cosimo's court. In 1550 Pope Julius III entrusted him with the construction of a chapel in San Pietro in Montorio. Michelangelo acted as adviser. At Michelangelo's urging Ammannati was commissioned to do the tombs. This project is mentioned in the Lives of Simone Mosca and Michelangelo. Another sculptural enterprise that appears in the second edition is the complicated and drawn-out work at the Holy House of Loreto. Although begun by Julius II, Vasari charts its progress under the Medici popes Leo X and Clement VII, with a long addition in the Life of Andrea Sansovino, and mentions it in other Lives.[76] Baccio Bandinelli has one of the longest Lives in the book, and other sculptors like Montorsoli are given considerable attention.

Architecture also gained prominence in Vasari's career and in his history since he had

74 *Ibid.*, p. 79: "gli rispose (esso Giulio presente) che elle erano tali, che ad ogni canto di quella città meritava che fusse posta la statua di lui, e che, per averla egli rinovata, la metà di quello Stato non sarebbe stata bastante a rimunerar le fatiche e virtù di Giulio. A che rispose il cardinale Giulio essere più padrone di quello Stato che non era egli."

75 Life of Andrea Orcagna, BB II, p. 223.

76 Life of Andrea Sansovino, BB IV, pp. 277–80, Life of Baccio da Montelupo, BB IV, p. 294 (about his son, Raffaello, finishing a panel begun by Andrea Sansovino), Life of Antonio da Sangallo, BB V, p. 43, Life of Tribolo, BB V, pp. 203–4, Life of Baccio Bandinelli, BB V, p. 244, Life of Simone Mosca, BB V, p. 340, Lives of the Lombard artists, BB V, pp. 419–20 (Girolamo da Ferrara).

become a form of court architect, first in charge of the rebuilding of Palazzo Vecchio and then as designer and supervisor of a number of building projects in Florence and else-where.[77] He therefore wrote about architects − both in substantial revisions and in new Lives − with a greater enthusiasm and a more informed judgment. He held that such judgment based on practice was essential for achieving perfection in architecture and made the revised version of Alberti's Life an example of this.[78] With a few exceptions − Brunelleschi, Bramante, the Sangallos − architects' Lives written for the 1550 edition were perfunctory, and they were all revised with new information and critical observations. The professional roster increased considerably with completely new Lives and notices both of modern architects (such as Girolamo Genga, Michele Sanmichele, Vignola, Palladio, and the military architect Giovanni Battista Bellucci da San Marino) and of earlier ones. Vasari's treatment of architecture varies within *The Lives*. Architectural history forms a substantial part of the material added to the first part. But in that era it is mainly a matter of record, derived largely from his knowledge of Palazzo Vecchio and the information from chronicles supplied by Borghini. In later periods this treatment gives way to critical analysis, based on his newly engaged study of ancient and modern monuments and of architectural theory and practice. For example, even though he thought that the corner solution for the arches of the Rucellai loggia, which he attributed to Alberti, was cramped and clumsy, he found the palace to be

> built with much judgment and very commodious, for, besides many other conven-iences, it has two loggias, one facing south and the other west, both very beautiful, and made without arches on the columns, which is the true and proper method that the ancients used, so that the architraves that are placed on the capitals of the columns are flat . . . The good method . . . demands that on top of columns one should put flat entablatures and, when arches are desired, they should be put on piers and not on columns.[79]

Not only did he apply Albertian theory to Alberti's practice (Alberti had given similar advice on arched colonnades in *De re aedificatoria*), but he adopted the same design of column and architrave in the Uffizi, "to bring back into use the true method of building . . .

77 He designed the offices of the Magistrati, the Uffizi (model 1559, begun 1560, Arno portions finished 30 January 1563); Vasari added a description of this work to the technical introduction (BB I, pp. 59–60). He supervised the construction of the corridor connect-ing the two ducal residences, the Palazzo Pitti and the Palazzo Vecchio (March–December 1565). Through the duke he was also given the task of remodeling the church and palace of the Knights of St. Stephen in Pisa (1562–9) and the cupola of the church of the Madonna dell'Umiltà in Pistoia (1562–9). He was put in charge of remodeling the interiors of Santa Maria Novella in 1565 and Santa Croce in 1566. He also undertook to build a family burial chapel in the Badia of his native Arezzo (described in the Lives of Pietro Laurati [Lorenzetti], BB II, pp. 145–6 and Lazzaro Vasari, BB III, p. 298) and he was responsible for a number of building projects there,

such as the loggias in the Piazza Grande (1570–2). For these and other projects, see Conforti, *Giorgio Vasari architetto*, and Satkowski, *Giorgio Vasari, architect and courtier*.

78 Life of Alberti, BB III, p. 287: "il giudizio non si può mai far perfetto, se la scienza, operando, non si mette in pratica."

79 *Ibid.*: "fatta con molto giudizio e commodissima, avendo oltre agl'altri molti agi due logge, una vòlta a mez[z]ogiorno e l'altra a ponente, amendue bellissime e fatte senza archi sopra le colonne: il qual modo è il vero e proprio che tennero gl'antichi, perciò che gl'architravi che son posti sopra i capitegli delle colonne spianano . . . Adunque il buon modo di fare vuole che sopra le colonne si posino gl'architravi, e che quando si vuol girare archi si facciano pilastri e non colonne."

employed by the ancients" (pl. 100). This method had generally eluded Vasari's predecessors.[80]

In the 1568 edition architectural descriptions are reinforced with greater knowledge of the problems of "utility" and "commodity," of the ordering of plans and the difficulties of site and construction such as Michelozzo's ordering of the Medici palace and Cronaca's ingeniously devised wooden roof at San Salvatore. The competing opinions of the Sangallo set and Michelangelo, which set the tone for architectural design and debate through the 1540s and 1550s also influenced Vasari, who listened attentively to Michelangelo. He drastically modified his opinion of Antonio da Sangallo's model for St. Peter's, changing it from a Vitruvian paradigm to a near Gothic horror, for example.[81] He also applied Michelangelo's "compasses of the eyes" to Baccio d'Agnolo's cornice on the Bartolini palace, which was mocked as being disproportionately large − like a great cap on a child's head. Baccio defended it as having been copied from an ancient model, but Vasari points out that "good judgment and an exact eye are of more value than compasses."[82]

One of Vasari's most cherished projects during the years of revising *The Lives* and one that was highly significant for the revision was the foundation of the Accademia del Disegno. The Accademia's regulations were approved by the duke in January 1563 after a series of meetings dating from the spring of 1561.[83] Vasari was only one of the forty-eight founding members, but he was probably the most influential in promoting its interests with the duke. Borghini was also involved, and the duke appointed him as his deputy and first administrative head, *luogotenente*. An insertion to the Life of Jacopo di Casentino documents and details the history of the academy's predecessor, the painters' confraternity of St. Luke, and the foundation of the academy itself is described in Montorsoli's Life.[84] The Accademia, like *The Lives*, had both commemorative and didactic functions. Not only were funerals among its activities, but its regulations provided for a memorial book to record the death dates, burial places, and works of the academy's members and for a frieze in the academy's

80 Alberti, *L'architettura (De re aedificatoria)*, trans. Orlandi, II, Book VII, chapter 15, p. 642. Vasari, technical preface, chapter III on the orders, BB I, p. 59: "Onde, per ritornare in uso il vero modo di fabricare, il quale vuole che gl'architravi spianino sopra le colonne . . . nella facciata dinanzi ho seguitato il vero modo che usarono gl'antichi, come in questa fabrica si vede . . . questo modo di fare è stato dagl'architetti passati fuggito."

81 Life of Antonio da Sangallo, BB V, p. 48: "non piacciono, quelle tante aguglie che vi sono per finimento, parendo che in ciò detto modello immiti più la maniera et opera tedesca che l'antica e buona che oggi osservano gl'architetti migliori."

82 Life of Cronaca, BB IV, p. 236: "Non basta agl'artefici, come molti dicono, fatto ch'egli hanno l'opere, scusarsi con dire: elle sono misurate apunto dall'antico e sono cavate da buoni maestri, attesoché il buon giudizio e l'occhio più giuoca in tutte le cose che non fa la misura de le seste." For Vasari, Michelangelo, and this concept, see Summers, *Michelangelo and the Language of Art*, pp. 370−1.

83 For the founding, precedents, and aims of the Accademia, see Barzman, "The Università, Compagnia, ed Accademia del Disegno," Ph.D. (Johns Hopkins, 1985) and "The Florentine Accademia del Disegno: Liberal Education and the Renaissance Artist," in Boschloo ed., *Academies of Art Between Renaissance and Romanticism*, pp. 14−32, Dempsey, "Some Observations on the Education of Artists in Florence and Bologna During the Later Sixteenth Century," *Art Bulletin* (1980), pp. 552−69, Goldstein, "Vasari and the Florentine Accademia del Disegno," *Zeitschrift für Kunstgeschichte* (1975), pp. 145−52, Hughes, " 'An Academy for Doing,' " *Oxford Art Journal* (1986), pp. 3−10, 50−62, Jack, "The *Accademia del Disegno*," *Sixteenth Century Journal* (1976: 2), pp. 3−20, and Waźbiński, *L'accademia medicea del disegno a Firenze nel Cinquecento*. More generally see Pevsner, *Academies of Art Past and Present*, pp. 42−55.

84 Life of Jacopo di Casentino, BB II, p. 274, and Life of Montorsoli, BB V, pp. 506−9.

meeting place with painted and carved portraits of all the excellent artists from Cimabue's to Vasari's day.[85] Several passages on study put into The Lives publicize the academy's preoccupation with artists' training and its provisions for instruction. The academy's statutes stipulated the formation of a study collection from artists' bequests, and Vasari tells of Squarcione's care that his star pupil Andrea Mantegna "might learn more than he knew himself," having Andrea study "plaster casts modeled from ancient statues and paintings on canvas that had been brought from various places, particularly Tuscany and Rome."[86] Andrea's success is explained as the result of careful and caring tuition and Central Italian models. Shorter asides mention specific aspects of the academy's program. Anatomical demonstrations were to be held at the hospital of Santa Maria Nuova and the study of anatomy is newly cited in the Lives of Donatello, Verrocchio, Pollaiuolo, Leonardo, Raphael, and Michelangelo, for example. Vasari further tells how he and his friend Salviati studied anatomy from corpses in the Rome cemetery and praises a St. Bartholomew in a painting by Bronzino as being a true flayed figure.[87] A wax St. Jerome by Bandinelli showing the bones, muscles, nerves, and wrinkled, dry skin was judged to be the best of its sort by all the artists who saw it, particularly by Leonardo, Vasari says.[88] Throughout The Lives proper instruction and the desire to learn are given even greater emphasis, as is the progress from the acquisition of the rudiments of design to the mastery of the Florentine and Roman legacies (following Vasari's own course of study). Luca della Robbia, he says, sculpted by day and drew by night, his feet immersed in a basket of wood shavings to keep them from freezing. Luca is held up as an example of the suffering and perseverance required for artists to attain honors, not by sleeping, but by continually studying.[89] He tells how Cristofano Gherardi joined the militia hoping to get a chance to go to Florence and study the paintings and sculptures there.[90] Taddeo Zuccaro, he says, would have been willing to support the utmost discomfort and humiliation if his greedy and small-minded master had let him copy some Raphael drawings he had. In the end the young Taddeo ruined his health, but improved his art, sleeping rough beneath the Chigi loggia, whose paintings by Raphael he studied when he could.[91] Good masters are given new regard as teachers, as the roll calls of students and followers are greatly increased and detailed in almost all of the Lives. A section at the end of the 1568 Lives was devoted to describing works by members of the academy, young aspirants as well as eminent practitioners, the painters grouped as much as possible into the principal "schools" and successive generations (Pontormo and Bronzino's, Ridolfo Ghirlandaio's, and Vasari's). He appended Giambattista Cini's description of the arches and other decorations for the 1565 wedding festivites, in honor of the academicians'

85 Reynolds, "The Accademia del Disegno in Florence," Ph.D. (Columbia, 1974), p. 229, 1562 regulations, capitoli xxi, xxii.

86 Life of Mantegna, BB III, p. 548: "acciò che Andrea imparasse più oltre che non sapeva egli, lo esercitò assai in cose di gesso formate da statue antiche et in quadri di pitture che in tela si fece venire di diversi luoghi, e particolarmente di Toscana e di Roma." The collection, to be formed by donations, is prescribed in the 1562 regulations, capitolo xxxi (Reynolds, "The Accademia del Disegno in Florence," Ph.D. [Columbia, 1974], pp. 231–2).

87 Life of Salviati, BB v, p. 516, and Lives of the academicians, BB vi, p. 235

88 Life of Bandinelli, BB v, p. 243. This form of notomia secca is briefly discussed by Kornell, "Rosso Fiorentino and the anatomical text," Burlington Magazine (1989), pp. 842–7.

89 Life of Luca della Robbia, BB III, pp. 49–50.

90 Life of Gherardi, BB v, pp. 285–6.

91 Life of Taddeo Zuccaro, BB v, pp. 553–4.

efforts on that occasion. And the program of the funeral celebrations for Michelangelo, which was essentially the program of the academy, was published at the end of Michelangelo's Life.

The Accademia was a forum for theoretical as well as practical refinements. The view of artistic practice as a matter for definition and discussion is also present in the new edition, where discursive asides (*discorsi*) treat subjects such as the question of imitation (Cronaca), the understanding of the antique (Andrea Sansovino), painting and sculpture (Giorgione), poetic fury and the sketch (Luca della Robbia and Palma), the acquistion of style (Raphael), and, not unexpectedly, *disegno* itself (Correggio and Titian). *Disegno*, the idea and the act of drawing, is treated extensively in one of the longest additions to the technical introduction, placed at the beginning of the section on painting. *Disegno* was, of course, highly valued in the 1550 edition. This is logical, since it was equally valued in Florentine tradition. For Ghiberti it was "the foundation and theory" of both sculpture and painting.[92] The story of Giotto's faultlessly drawn circle is that of line, the complete command of drawing, later Alberti's "circumscriptio." The difference between the 1550 and 1568 editions in this respect is the institution. *Disegno* had received state approval with an academy to promulgate it. It had been given official status as the basis of Tuscan excellence in the arts, meant to flourish under Cosimo's aegis.

The dominance of *disegno* had a political dimension as Vasari's text took on the territorial identity of Cosimo's state. Substantial additions about Pisa, Pistoia, Vasari's own Arezzo, and even proud Siena, under Florentine rule since 1559, establish the new frontiers of Vasari's "space" as Cosimo's Tuscany. While Florence had been seen as the center of artistic excellence in the 1550 edition, there is an even more explicit regionalism pervading the 1568 *Lives*, because "Tuscany had an over-abundance of artists at all times."[93] Vasari recorded the achievements of other regions and schools, measured their accomplishments and their striving and ultimate shortfall against the standard of Tuscan tradition. This was ruefully noted by the Federico Zuccaro in his copy of *The Lives* about some of his brother's drawings briefly mentioned in Taddeo's Life: "And if those drawings had been by the hand of some Florentine, he would have praised them to the stars."[94] Vasari's appraisal of Dürer is an example of this bias: "if this man who was so rare, so diligent, and so universal had as his birthplace Tuscany, instead of Flanders, and had been able to study the works in Rome, as we did, he would have been the best painter in our land."[95] Instead he was more interesting than perfect and had to be content with qualified fame among the Northerners.

Conscientious artist as well as courtier, Vasari did not allow this politic regional pride to lapse into provincialism. It was in his interest not to do so. He gave ample space to other patrons and other endeavors. He also insisted on the artist's need to travel to learn, especially to master the Roman monuments. This prescription for greatness is drawn from Vasari's

92 Ghiberti, *Commentari*, ed. Schlosser, p. 5: "el disegno è il fondamento et teorica di queste due arti."

93 Life of Giorgione, BB IV, p. 46: "la Toscana soprabbondava di artefici in ogni tempo."

94 In the Bibliothèque Nationale, Paris. Quoted from *Le vite* (Club del Libro), VII, p. 43, n. 5: "E se deti disegni fosano di man di qualche firentino, gl arebe celebrati alle stelle."

95 Life of Marcantonio, BB V, p. 5: "se quest'uomo sì raro, sì diligente e sì universale avesse avuto per patria la Toscana, come egli ebbe la Fiandra, et avesse potuto studiare le cose di Roma, come abbiam fatto noi, sarebbe stato il miglior pittore de' paesi nostri."

course of study and is representative of the way that, throughout the second edition, Vasari's career becomes more explicitly canonical. Despite occasional frustrations at Cosimo's court, Vasari had finally found the secure employment and the rewards and rank that he felt were merited by his efforts and those of any diligent professional. He could, therefore, with the confidence born of success, make his own life the model and measure for others. *The Lives* became more autobiographical even as they became universal.

Revision and Research

With the second as with the first edition, the actual production of the book remains largely a matter for both speculation and amazement. Vasari had concluded the 1550 *Lives* with the promise of an addition.[96] In the letter to the artists, Vasari wrote that he was inspired by the almost daily requests of his friends and by the success of the 1550 edition: "of the great number that had originally been printed not even a single copy is to be found at the booksellers."[97] He excused the imperfections of the revised text, having interrupted writing "more than once for an interval not . . . of days, but of months owing either to travel or to the superabundance of work in hand: paintings, drawings, and building."[98] This extended process of composition is confirmed by Vasari's correspondence and by dates in the text itself. Among Borghini's papers there are notes about works in San Gimignano and Volterra datable to 1557.[99] Vasari referred to this information in the second edition, which not only documents Borghini's early assistance with the project, but suggests a date in the late 1550s for its inception, concurrent with the painting in the Palazzo Vecchio. Serious work on the new edition does not seem to have begun until the early 1560s, possibly delayed by Vasari's intention to write explanations about the Palazzo Vecchio decorations. An entry in the *ricordanze* dated 10 August 1560 states that on that day the engraving of the portraits of painters was started.[100] The first explicit and dated reference to work on the new edition is the letter of 17 April 1561 from Cosimo Bartoli in Pisa to Vasari answering a series of questions about the frescoes in the Camposanto there.[101] The detailed information, acquired with Bartoli's grudging good will ("I shat blood"), was divided among various fourteenth-century painters.[102] Vasari used the address side of this letter to make a list of thirteenth- and fourteenth-century dates. The seventeen items on the list are arranged chronologically; ten

96 Conclusion, BB VI, p. 413: "Pigliate dunche quel ch'io vi dono, e non cercate quel ch'io non posso: promettendovi pur da me fra non molto tempo una aggiunta di molte cose appartenenti a questo volume con le Vite di que' che vivono e son tanto avanti con gli anni che mal si puote oramai aspettar da loro molte più opere che le fatte." See for this promise, Kallab, *Vasaristudien*, p. 29.

97 BB I, p. 175: "d'un grandissimo numero che allora se ne stampò non se ne trova ai librai pure un volume."

98 Letter to the artists, BB VI, p. 410: "interrotto più di una fiata per ispazio non dico di giorni, ma di mesi, lo scrivere, o per viaggi o per soprabondanti fatiche, opere di pitture, disegni e fabriche."

99 Williams, "Notes by Vincenzo Borghini on works of art in San Gimignano and Volterra," *Burlington Magazine* (1985), pp. 17–21.

100 Frey II, p. 875, no. 266: "Ricordo, come questo anno a dj 10 dj Agosto si comincjo a intagliar le teste de picttorj, per fare il libro stanpato." The exact meaning of this entry remains a mystery. A separate volume of portraits was printed, but that at the same time as the full new edition. If the date of the entry is correct it refers to a project that was suspended until the full new book of *Lives* was realized with its portrait collection.

101 Frey I, cccxl, pp. 613–15.

102 *Ibid.*, p. 614: "Che ui giuro a Dio, che sono stato in campo santo forse sej hore et ho cacato il sangue a

of them have page references and appear to be taken from a chronicle similar to Giovanni Villani's. As a whole the letter shows Vasari gathering information according to a developing, if not yet determined, plan. Bartoli was just doing errands, however; he was Vasari's agent. Vasari never conceded the place of author to any editor or assistant, however intimate or grand. The parallel with his procedure as a painter, particularly at Palazzo Vecchio, seems very close. A project, planned in collaboration with literary advisers, was then developed in sketches (notes) and designs by Vasari and delegated in parts to trusted associates. Vasari remained the chief creative spirit and co-ordinator of the enterprise, responsible both for its shape and style, as well as for its successful accomplishment, no matter how great the effort required or how substantial the intervention.

Vasari's reliance on assistants and assistance is documented by the next surviving letter relating to *The Lives*. Dated 21 February 1563, it was written by fra Marco de' Medici in Bologna in response to one from Jacopo Guidi, one of Cosimo's secretaries:

> Concerning the information that you requested from me on behalf of messer Giorgio Vasari, I immediately took steps to get hold of his book concerning painters, in order to be able to put my observations about them in writing both more extensively and with a more solid foundation, with regards both to editing and to errors. Do not fear, your most reverend Lordship, that I will fail to supply a complete account of this subject, because it would be a great shame not to be equal to such a virtuous undertaking, and one by such an enlightened spirit as messer Giorgio, and so much the more since it was requested by your Honor.[103]

Fra Marco asks how much time he has to fulfill his charge. He was, he added, obliged to Vasari for his great courtesy in showing him the newly decorated rooms in Palazzo Vecchio. Fra Marco duly supplied information about North Italian painters, a fact acknowledged in the Lives of Gentile da Fabriano and Pisanello and the Veronese artists.[104]

Bartoli also continued to respond obligingly to Vasari's requests, and the next mention of work on the book is a letter from Venice dated 31 March 1563, which documents Bartoli's diligence in finding out about San Marco and its campanile.[105] Work on the revision of the first section must have been fairly advanced, for it was in this year that Vasari made a special trip to Assisi to study things there, as he states in the Life of Cimabue.[106] In August he added a postscript to a letter to Giovanni Caccini, the duke's agent, in Pisa, asking him to make contact with the son of the sculptor Simone Mosca to get him to send the portrait of his

leggere quelle cosaccie che uoj mi chiedete." Additions about the Camposanto murals, based partly on Bartoli's visit, see BB II, pp. 172 (Life of Buffalmacco), BB II, p. 197 (Life of Simone Martini), BB II, pp. 218–20 (Life of Orcagna), 265–6 (Life of Antonio Veneziano), 285–6 (Spinello Aretino).

103 Palli D'Addario, "Documenti vasariani nell' archivio Guidi," in *Studi* 1981, p. 388: "Quanto alle cose che Lei mi ricchiede per il nostro messer Giorgio Vasari, io di subito mi son dato a procacciare di haver li libri suoi delli pittori, per poterle anco et più distesamente et con fondamenti più soddi scriverle

quanto osservo in quelli, et per dimunitioni et per svario. Né vostra signoria reverendissima temi ch'io sia per mancare d'un compiuto raguaglio in questa materia, che certo sarebbe un grave peccato il mancare a sì virtuosa fatica, di cossì bello spirito come messer Giorgio è et tanto più poi, essendone ricercato per mezzo di vostra signoria."

104 Lives of Gentile da Fabriano and Pisanello, BB III, p. 367, and Lives of Fra Giocondo and other Veronese artists, BB IV, p. 599.

105 Frey I, cdiv, p. 743.

106 Life of Cimabue, BB II, p. 39.

father, otherwise it would not be included as all the others were being engraved.[107] In October of that year don Miniato Pitti wrote to Vasari from Rome saying that he had spoken to Michelangelo, and "I spoke to him of the work that you are redoing, the Live[s] of the Painters, and about the portrait heads and the excellent engraver."[108] This indicates not only that work was in progress, but that the portraits were integral to the revision and being collected along with other information. Not every one was helpful. Vasari names Daniele da Volterra's ungrateful and unloving students, Michele degli Alberti and Feliciano da San Vito, who resisted all his entreaties and failed to send a promised plaster cast of Daniele. He published a less adequate likeness, proof of his friendship and their ingratitude and indifference.[109]

Vasari also wrote to Angelo Niccolini, governor of Siena, commissioned by the duke to ask for a drawing and a brief description of a battle site in the Sienese war, so that he could paint it for the ceiling of the Salone dei Cinquecento. He added:

> Enclosed is a letter for master Giuliano the goldsmith where I state that I need him to give me some information about certain deceased painters and also their portraits. And if he might send it by way of Your Lordship, it would be a great favor to me [for you] to urge him to do this because my work on painters is about to be reprinted.[110]

This letter is fascinating because it demonstrates further the parallel nature of the projects, the demands for historical accuracy in the Palazzo Vecchio cycle, and Vasari's postal method of research. As with the letters answered by Bartoli, he was seeking out specific information from local informants to complete *The Lives*. A letter from Borghini to Vasari written on 14 August 1564 encouraged this:

> Remember again . . . to write, as I have told you, to Venice, Milan, Naples, etc., and other cities in order to dig out as many works as possible; I mean the most notable that there are, and thereby to enrich your work in this way with the names of the artists.[111]

Credited answers to such requests occur in several Lives, such as Bartoli's about Attavante and Gherardo manuscripts mentioned in the Lives of Fra Angelico and Bartolomeo della

107 Frey III, xxx (Florence, 20 August 1563, to Caccini, Pisa), p. 52: "Dite a Maestro Daujtte che scriua al Moschino che mandj il ritratto dj suo padre, che seglj indugia sarano intagliatj gli altrj per il ljbro senza il suo."

108 Frey II, cdxviii, p. 9 (10 October 1563): "Gli dissi della opera, che rifate della uita de' Pittori, et delle teste et dello intagliatore si eccellente." See also cdxxi, pp. 14–15 for Bartoli's help with portraits (15 December 1563).

109 Life of Daniele da Volterra, BB v, p. 550: "non ho voluto guardare a questa loro ingratitudine, essendo stato Daniello amico mio, che si è messo questo che, ancora che li somigli poco, faccia la scusa della diligenza mia e della poca cura et amorevolezza di Michele degli Alberti e di Feliciano da San Vito."

110 C. Davis and Kliemann in Arezzo 1981, p. 234 (9 October 1563): "In pero [il Duca] mi a commesso che io le scriva che la S.V. mi facci ritrarre il sito da quella banda dove fu la mortalita de le gente et mi facci porre a que luoghi secondo il sito quella Scaramucia scritta con brevi parole accio la possa dipigniere . . . Apresso mando una mia per maestro Giuliano orefice che o di bisognio che mi dia alcuni avisi di certi pittori morti, et cosi e ritratti loro. Et per via di V.S. me gli mandi mi fara gratia al raccomandargniene perche l'opera mia de Picttori è in fine per ristampalla." In the *Ragionamenti* Vasari notes that he painted the scene, *The Taking of the Fortress of Monastero*, as it really was (*Le Opere*, ed. Milanesi, VIII, p. 217: "ho ritratto il luogo al naturale, pieno di forti come stava allora"). For an illustration, see Muccini, *Il salone dei cinquecento*, p. 122.

111 Frey II, cdlix, p. 102 (from Poppiano, to Vasari, Florence): "Ricordouj anchora . . . di scriuere, come ui ho detto: A Vinetia,–Milano,–Napoli etc. et altre citta et di cauare le piu opere; delle notabilj parlo che vi sono, et arrichirne l'opera uostra cosi de nomi dellj arteficj." See also Frey I, ccclxxxiv, pp. 686–7 (25 November 1562),

Gatta.[112] Vasari's increased stature as an author owing to the success of the first edition undoubtedly made it easier for him to collect information in this way. Some people, like Lambert Lombard, wrote unsolicited letters, probably with the hope of being included.[113]

By 4 March 1564, Vasari was able to write that "within three months I shall once again send off for printing my Lives of the painters and sculptors." This was written to Michelangelo's nephew and legatee Leonardo Buonarroti in Rome, as he says, because,

> I should dearly like to have some information from you, and if you could write a note for me with recollections of any detail about [Michelangelo's] works after 1550, both about the building of St. Peter's as well as his other activities . . . so that I can embellish the final part of his Life.[114]

Work was well advanced by this date: the printing, probably of Part 1 only, was in sight. It is in this year that letters from Borghini show that he had begun to assist Vasari with editing the book and supervising its publication. Previously Borghini had been more interested in collecting and discussing their anthology of drawings, a historical hobby first documented in a letter of 1561 from Borghini to Vasari and important for *The Lives*.[115] But by 1564 there was enough of a text for Borghini to make notes and suggestions in a rigorous and comprehensive fashion. During the 1550s the role of Vasari's literary adviser had been shared with Cosimo Bartoli: Vasari often asked for ideas for the Palazzo Vecchio decorations from both. Beginning in the early 1560s, however, Borghini tended to dominate. Dominance became monopoly after Bartoli's departure for Venice in June 1562. While resident in Venice, Bartoli continued to offer new information and to answer Vasari's requests, which seem to have been frequent and demanding. At one point he promises to send a note about Titian's works, already started, "but give me time."[116] He also helped to organize the

citing a letter from Vasari to Giovanni Caccini in Pisa requesting information about Zoppo; Frey II, cdlxiii, p. 107, from Bartoli (Venice, 19 August 1564, to Vasari, Florence), reporting that he had seen Federico Zuccaro and had given him a letter from Vasari and that he was looking for "Paulo da Verona" (Veronese) ask him about something ("chiederlj quanto mi scriuete"); xdii, pp. 158–61, from Dominicus Lampsonius (Liège, 25 April 1565, to Vasari, Florence), answering Vasari's request for an account of northern artists ("qualche trattatello degli artefici nostrali"), saying that he had none to add to those mentioned in a previous letter except for his friend the painter and architect, Lambert Lombard, and he enclosed a Latin Life of Lombard as well as his own self-portrait.

112 Life of Fra Angelico, BB III, pp. 279–81 (naming Bartoli as the source, p. 279), and Life of the Abbate di S. Clemente (Bartolomeo della Gatta), BB III, pp. 467–8.

113 Frey II, xdiii, pp. 163–6 (Liège, 27 April 1565, to Vasari, Florence), with information about himself and earlier northern artists. There is also a manuscript of two sheets of *Notizie sulla vita di Jacopo Tatti*, with an address to "m. Giorgio" in Borghini's hand (Uffizi, Biblioteca

MS 60, Miscellanee Manoscritti I, ins. 23). The sheets are numbered 37 and 38. The text is in another hand. C. Davis has suggested that it was sent to Borghini who forwarded it to Vasari; he did not use it in the 1568 edition, but referred to it in the edition of the Sansovino Life published after Sansovino's death in November 1570 (Arezzo 1981, pp. 234–5, 293–5).

114 Frey II, cdxxxi, p. 29: "Aro ben caro saper da lej qualcosa, et che me poniate in nota, per uja di ricordj, qualche particulare dal 1550 in qua sopra le cose sua, si della fabrica dj San Pietro come dell'altre sue actionj; acjo poiche fra 3 mesi dj nuouo io rimando ristampare le Vite mie de picttorj et scultorj, io possa ornare il fine della uita sua."

115 Frey I, cccxlii, pp. 624–5 (Poppiano, 18 April 1561, to Vasari, Florence).

116 Frey II, cdxxi, p. 14 (15 December 1563, to Vasari, Florence): "Delle cose di Titiano ancora ui mandero una nota, che ho incominciata; ma datemi tempo."

engraving of the portraits.[117] But it was Borghini's more systematic scholarship and editorial acumen that guided the book to its final form.

Vasari seems to have submitted the project to Borghini's close scrutiny at the beginning of 1564. In a letter dated 21 February Borghini wrote:

> It also gives me no little pleasure that you seem to be satisfied with what has been said about the Lives; and if we were to spend two days together we could conclude many things, especially if Don Silvano were there: still one has to do what one can.[118]

Don Silvano Razzi was a Camaldolite monk, collector, and man of culture, who was not only Borghini's and Vasari's friend, but a patron of Bronzino and executor of Benedetto Varchi's will.[119] He is cited in the Lives of Giotto, Lappoli, Rustici, Salviati, Taddeo Zuccaro, and Bronzino for works he owned, for providing other information about paintings in the monastery of Santa Maria degli Angeli in Florence and in Cardinal del Monte's collection in Rome, and for passing on Giulio Clovio's story of the highly eccentric Bartolomeo Torri (a skilled anatomist, he kept bits of dismembered bodies under his bed).[120] His brother don Serafino later claimed that don Silvano was largely responsible for *The Lives*; there is little evidence to support this claim based on fraternal pride. It seems rather that don Silvano took on the responsibility of seeing the book through the press and possibly assisting with preparing the copy, for it is in those capacities that he is mentioned in Vasari's correspondence.[121]

Borghini's next letter to Vasari, dated 24 February, repeats the request for an intensive session together and reveals Borghini's careful efforts, not only in reading and correcting, but in researching the revision:

> Now I tell you that I am waiting for you, and it would be well if we could spend two or three days together so that we might finalize many things regarding the book, so that you and I might be free of worry . . . I received the book by Cennino last night at eleven; before I went to sleep I read two thirds of it and this morning the rest . . . I just want to point out to you that he mentions painting with oil, and he is also from long ago and in terms of his epoch seems to come before Antonello da Messina. But perhaps I am mistaken, and perhaps oil was little used and badly; and it was Antonello who introduced it in a more perfect and accomplished way. Give it all a thought.[122]

117 Bryce, *Cosimo Bartoli*, pp. 135–6.

118 Frey II, cdxxix, p. 24 (from Poppiano, to Vasari, Florence): "Et che del discorso fatto sopra le Vite ui siate sadisfatto, n'ho piacere non piccolo anche io; e se stiamo 2 di insieme, potremo fermare molte cose, massimamente, se ci fussi Don Siluano: pure si ha fare quel che si puo."

119 M. Davis in Arezzo 1981, pp. 193–4. Razzi produced a series of Lives, based on Vasari's, now in the Biblioteca Nazionale, Florence, II, I, 367: *Compendio delle vite de' Pittori composto dal R.o Abbate D. Silvano Razzi.*

120 BB II, p. 113 (Life of Giotto, a *Crucifixion* by Giotto and a painting by Raphael at Santa Maria degli Angeli), BB V, p. 186 (Life of Lappoli, about Bartolomeo Torri), BB V, p. 480 (Life of Rustici, a bas

relief of a nude horseman, given by Ruberto di Filippino Lippi to Razzi), BB V, p. 525 (Life of Salviati, a large drawing of the Crucifixion owned by don Silvano), BB V, p. 587 (Life of Taddeo Zuccaro, about del Monte), BB VI, p. 237 (a St. Catherine painted by Bronzino for don Silvano).

121 Frey II, dxxviii, p. 229 (Vasari, Rome, 14 April 1566, to Borghini, Florence), dxxxv, p. 240 (Vasari, Milan, 9 May 1566, to Borghini, Poppiano).

122 Frey II, cdxxx, p. 26 (from Poppiano to Vasari, Florence): "Hora ui dico, che ui aspetto; e sara bene, che ci stiamo 2 o 3 giornj insieme, che termineremo molte cose del libro, che uoj et io saremo fuor di briga . . . Hebbi il libro del Cennino hiersera a 3 hore; et

Collaboration and consultation were to mark the editorial process: Borghini deferring to Vasari's professional opinion, and Vasari typically asserting it, for Antonello remained the hero of oil painting, bringing the technique to Italy, where (according to Vasari) it passed from Venice to Florence by way of Domenico Veneziano. This is a clear case of Vasari not letting detail disturb the larger patterns of history. Cennino Cennini's text was not forgotten in the new edition, however. Vasari describes it at some length in an addition to the Life of Agnolo Gaddi.[123]

In March Borghini sent the "book of the lives" back to Vasari, probably the first part with his notes and suggestions for correction.[124] The book is next discussed at length by Borghini in August, and it is clear that while one portion was ready to print, others were not yet written:

> As regards the book that you are printing, I should mention that on reading the index of the old one (that is the one printed before) I find mention is made there of the duke's wardrobe, where very few things are noted. Now since I know that there are many things, both modern and ancient, at some opportune point I would discuss it a bit. But I think that there is still time because it will fit well towards the end. It would, however, be a good thing to think about it in good time and to provide for it, and occasionally, when one has nothing to do, one could write one of these discourses and put it aside for use in due time.[125]

In dealing with the Lives to be drafted and edited, Borghini seems to have begun where he left off, with the *tavole*, the name and place indices, putting them in better order and considering what might need adding or correcting.

In the event, Vasari did not expound upon the wardrobe, choosing to scatter the references to the duke's collection throughout *The Lives*, but Borghini's advice indicates one of the procedures followed in rewriting: separate *discorsi* or discursive critical remarks were prepared and then set aside for insertion in the most suitable places. One of the few

inanzi dormissi, ne lessi 1 2/3 et stamani il resto . . . Solo ui metto in consideratione, che fa mentione del colorire à olio, che costui e pure antico; e per una consideratione de tempi pare inanzi ad Antonello da Messina. Ma forse minganno, et forse era poco in uso et male; et quello Antonello la introdusse piu perfetta et risoluta: Voi considererete tutto." For the working relationship between Borghini and Vasari, see C. Davis, "Frescoes by Vasari for Sforza Almeni," *Mitteilungen des Kunsthistorischen Institutes in Florenz* (1980), p. 165, showing the way that Vasari used Borghini's memorandum about the facade imagery for the Montalvo palace with great freedom and some inaccuracy. See also Kliemann, "Zeichnungsfragmente aus der Werkstatt Vasaris," *Jahrbuch der Berliner Museen* (1978), pp. 157–208, and "Su alcuni concetti umanistici del pensiero e del mondo figurativo vasariani," in *Studi* 1981, pp. 73–82, also Williams, "Notes by Vincenzo Borghini on works of art in San Gimignano and Volterra," *Burlington Magazine* (1985), pp. 17–21.

123 Life of Agnolo Gaddi, BB II, pp. 248–9.

124 Frey II, cdxxxiv, p. 52 (Poppiano, 9/12–18/19 March, to Vasari, Florence): "Rimandoui il libro delle uite."

125 Frey II, cdlv, p. 89 (Poppiano, 3 August 1564, to Vasari, Florence): "Et per conto del libro, che uoj stampate, mj occorre ricordare, che leggendo io la tauola del uecchio, cioe dello stampato prima, ui truouo hauer fatto mentione della guardaroba del Duca, doue sono notate molte poche cose. Hora, perche io so, che e uiè di molte cose et moderne et antiche, in qualche buona occasione io ne farei un po di discorso: Che credo, ci sara tempo assaj, perche tornera bene intorno all'ultimo; ma e bene a buon'hora pensarui et prouedersi; et taluolta, che lhuomo non ha che fare, si puo scriuere un di questi discorsi et metterlo da banda per seruirsene al tempo suo." For the wardrobe (*guardaroba*), see Allegri and Cecchi, *Palazzo Vecchio e i Medici*, pp. 287–302.

surviving scraps pertaining to the second edition shows Vasari noting where such comments or commentaries need go. This note, too, is on the back of a letter from Cosimo Bartoli, dated 29 April 1564. It has ten items, numbered by Vasari, beginning with: "To Mich. L Buonarroti in the life discuss the proportions, that is of his Judgment, how it was managed to give grace to the figures by going beyond measure"; and ranging from "6. Discover, what is drawing" to "9. About Tapestries, hangings, and embroideries with figures."[126] He is concerned about the history of gems ("3. In Valerio Vicentino, in Alessandro Cesati. The medals of the ancients with the most beautiful type of lettering") and prints ("8. Names of German, Italian, and French masters of copper engravings. Must redo the life of Marcantonio [Raimondi] in order to put all those masters there").[127]

There is a draft paragraph or memorandum about drawing that answers item 6 (what is drawing) and it was added with some modification to the first chapter on painting in the introduction as a definition of design ("Che cosa sia disegno"). The note has been attributed to Borghini and in part it responds to issues raised in Varchi's dispute on the arts, which Borghini was reading at this time.[128] Whoever wrote the note, it was the result of a shared interest put to good purpose by the author and his highly engaged collaborator. In its final form it became Vasari's.

Vasari's list reveals him deciding between what he could simply add and what needed complete rewriting. The artists named in the list are in the second and third parts of *The Lives*, so that these notes were made in preparation for work on the later part of the book. That Vasari wrote following an outline for the revised book is clear from the text itself, where he occasionally alerts the reader to what will be discussed further on: "as will be said."[129] That he also worked quickly is evident, and leaves traces, as when he remembers a drawing by Michelangelo of the punishment of Tityus that Cardinal Ippolito had engraved in crystal by Giovanni di Castel Bolognese ("that I forgot above"), adding it to his narrative about Giovanni without turning back to correct the text or have it corrected, as it may be that he was dictating.[130] The other surviving notes are lists of artists' names: two on the

126 Frey II, cdxlv, p. 78: "Inn Mich.^L.^ Buonarrotj nella vita trattare delle misure, cie del Giudjtio suo, come se gouernato a dar gratia alle figure, usendo [uscendo] fuor della misure," "6. Ritrouare, che cosa el djsegnio," "9. De pannj d'Arazzo drapelloni et richamj dj figure." For another numbered memorandum of this sort, see Vasari's letter from Arezzo to Borghini about the printing of the first edition in Florence, Frey I, cxxv, p. 257 (before 22 February 1550).

127 Frey II, cdxlv, p. 78: "3. In Valerio Vicentino, in Alesandro Cesarj. Le medaglie meglio delle antiche con piu begli caratere di lettere." "8. Nomj di maestri delle stanpe dj rame Todeschj, Talianj et Franzesi. Bisogna rifare la ujta di Marca[n]tonio Bolognese per mettercj tuttj questj maestrj."

128 ASF, Carteggio di artisti, vol. II, ins. 3, n. 2. See Scoti-Bertinelli, *Giorgio Vasari Scrittore*, pp. 82–4, Kallab, *Vasaristudien*, p. 453, and K. Frey ed., *Le Vite*, Part I, vol. I, pp. 103–5. Frey II, cdlvi (Borghini, Poppiano, 5 August 1564, to Vasari, Florence), p. 93, for Borghini's reading of Varchi: "Io hebbj da messer Giulio Scalj quella oratione del Varchi, con quelle uostre lettere,"

mentioned also in a letter of 14 August (Frey II, cdlix, p. 101). His notes on Varchi's debate survive in a manuscript in the Kunsthistorisches Institut, Florence, *Selva di notizie*, MS K 783 (16), published by Barocchi ed., *Scritti d'arte*, I, pp. 611–73.

129 Of Bernardo Rossellino's works for Pope Nicholas V, mentioned in the Alberti Life, BB III, p. 285, with the promise of fuller explanation later: "come si dirà nella Vita d'Antonio suo fratello." For the addition about Bernardo in Antonio's Life, see BB III, pp. 394–6. Vasari cites Giannozzo Manetti's biography of Nicholas V as a source (p. 396).

130 Life of Valerio Vicentino, BB IV, p. 622: "Et avendo Michelagnolo fatto un disegno (il che mi si era scordato di sopra) al detto cardinale de' Medici d'un Tizio a cui mangia un avoltoio il cuore, Giovanni [l']intagliò benissimo in cristallo."

81. Frontispiece to the
first volume of the 1568
edition of *The Lives* (detail).

versos of drawings (one of artists from the first era and one of sixteenth-century artists) and
another list of fifteenth- and sixteenth-century artists on a separate sheet.[131] Their purpose
is unclear. The lists include artists who already had Lives and those only mentioned in the
second edition. The names are not in the order of published Lives. These may be checklists
for information and portraits to seek. There is also a memorandum explaining the inscrip-
tion chosen for the emblematic frontispiece to the first volume (pl. 81). Based on a passage
in Book viii of the *Aeneid*, it is interpreted to mean that while Vasari's history lived it could
never be said that the artists' works had perished or would remain buried.[132]

Borghini's next surviving letter to Vasari shows his attending more directly to the Lives
in Part 1, presumably about to go to press. Borghini was concerned about the use of

131 The separate sheet of notes is in the *Zibaldone*
(ed. del Vita, p. 232). A list of artists starting with
Cimabue is on drawing in the Uffizi (630F, for the
Incredulity of Thomas for Santa Croce, 1569); see
Barocchi, *Mostra di disegni del Vasari* (Uffizi, 1964), no.
44, p. 47, with the list. The drawing with the note
about modern artists is in the British Museum (1858-11-
13-31, for the *Transfiguration* in Cortona, 1554); C.
Davis in Arezzo 1981, pp. 232–3, gives a transcription of
the artists' names on this drawing, with a discussion of
these lists.

132 Beinecke Library, Yale University, Spinelli ar-
chive, Box 48, folder 1057 (in Borghini's hand?): "Il
concetto è cavato dal luogho di Virgilio, nel viii [ll.
470–1] . . . che esprimessi questo senso, che mentre
vivera questa Historia, et questa fatica, che ha fatto
messer G non si potrà con ragione dire, che tanti nobili
Artefici habbin veramente gustato morte o rimanghino
sepolti; Anzi, che vivino, et egli et l'opere loro, etc."

Petrarch's will in Giotto's Life and Sacchetti's *Novelle*, both sources he must have suggested to Vasari. He wants to distribute the additions, since the Life of Giotto

> is so full and so abundant, it is enough that certain things be simply noted, as they are, because they are more pleasing that way. It was not a bad idea to add those stories more liberally in the Life of Buffalmacco, because it lacked substance. However I would not touch what is already there.[133]

This letter is dated 5 August 1564. In it Borghini suggests also where Vasari might find copies of the texts in order to decide what to do. Vasari quoted Sacchetti in full in the Giotto Life, which became even more overtly literary than in the first edition. Petrarch's will seems to have gone astray. Two days later (7 August) it still needed to be transcribed, and Borghini wrote: "I am surprised that the Petrarch is not where I said it was. See if the Giunti have it, it will be enough simply to see those few words of the will."[134]

This letter contains one of the most valuable clues as to how Borghini and Vasari worked together on the revision. In it Borghini writes:

> I am writing at nine in the morning having been engaged until now reading the third part where I am noting what I need, and in two days time I will send you what I have considered; and I want to remember something that I already noted, but it must be in that other book that you have bound in vellum.[135]

Since dates in the text of the third part determine that it was not written until 1566, it seems likely that Borghini was reading the 1550 edition, or at most a rough draft of the new edition, closely following the 1550 text, and noting what was to be done to correct and complete it.

Borghini continued to work with the indices to find gaps. Four days later, on 11 August, having put the place index in order, he wrote his recommendation to Vasari to bolster his treatment of cities like Genoa, Venice, Naples, and Milan. It is in this letter that Borghini insists that this is to be a universal history and admonished Vasari to put the material on living artists in order.[136] The use of the index is referred to again in a letter of 14 August: "While arranging the index I have thought about many things, just as in reading the lives; and I have made a note of many of them, which in due course should be discussed."[137] Borghini was a passionate, not passive editor, involved in considering what *The Lives* should

133 Frey II, cdlvi, p. 93 (Poppiano, 5 August 1564, to Vasari, Florence): "perche e tanto piena et tanto copiosa, basta, che certe cose sieno accennate, come le sono, che danno piu gratia. Nella uita di Buffalmaco, perche era piu pouera di cose, non fu male aggiugneruj quelle nouelle piu diffusamente; pero io non toccherej piu di quello che ui e hora."

134 Frey II, cdlvii, p. 95 (from Poppiano, to Vasari, Florence): "Il Petrarca mj marauiglio non sia doue ho detto. Vedete, che n'haranno i Giunti, che basta ueder quelle poche parole del testamento." Vasari quoted Petrarch's will and his *Epistole Famigliari* (BB II, p. 117) as well as Sacchetti (BB II, pp. 120–1) in Giotto's Life. He also quoted Sacchetti's *Novelle* in the Life of Buffalmacco (BB II, pp. 161–4).

135 Frey II, cdlvii, p. 95: "scrivo a 13. hore, sendo occupatomj fino ad hora a legger la 3a parte, doue noto quello che mi occorre, et fra 2 di ui mandero quello ho considerato; et mi uuol ricordar, che gia notaj non so che, ma debbe essere in quello altro libro che hauete legato in carta pecora."

136 Frey II, cdlviii, p. 98 (Poppiano, 11 August 1564, to Vasari, Florence).

137 Frey II, cdlix, p. 101 (from Poppiano, to Vasari, Florence): "Nell'ordinare la tauola ho considerato di molte cose, cosi nel leggiere le uite; che molte ne ho notate, che sareno à tempo a ragionarne."

be; yet, though authoritative, he was not the author. The book remained Vasari's. Borghini's ideas contributed to their discussions; they were not forced into the text. In this letter he makes his ideas about detail and precision known strongly. He also writes of his dissatisfaction about the printing of the first part, underway by that time, saying, "As to the printing it seems to me that they are making too many mistakes"; he cited a particularly unfortunate error in the Life of Nicola Pisano where a "bis" dropped from the inscription on the Pisa Baptistery pulpit led to the work being misdated by a hundred years ("and of this sort there are quite a number").[138] He complains that the portrait of Nicola Pisano was too obviously modern, and warns Vasari of sabotaging the reputation of the work, "because if one errs in one thing, one is held guilty for everything."[139] Obviously there was leeway for change even in the printed text. Individual pages could be reset. It is very likely that some information and new descriptions were inserted after Vasari's trip around Italy in 1566.

The process of perfecting *The Lives* over the many busy and interrupted years from 1557 to 1568 was thus one of working through the original text from the beginning and noting what needed to be added and corrected and copy edited, with Vasari relying increasingly on Borghini's advice and assistance. Once drafted or assembled, the text seems to have been reread by Borghini and then sent to Vasari for final correction and finally to the printers for publication. The Lives in Part 1 were at the printers by the summer of 1564. In the Lives of Botticelli and Ghirlandaio Vasari refers to the transfer of their frescoes from the choir screen of Ognissanti "in this year 1564," "in these very days that the Lives are being printed for the second time."[140] The elaborate preparations for the wedding of Francesco de' Medici in December 1565 – festivities that lasted from the triumphal entrance of the bride-to-be, Joanna of Austria, on 16 December until May of the following year – sidetracked the author and his editor, as did the pressure to complete the work in Palazzo Vecchio. Borghini was entrusted with the inventions for the various events, and he sought out prototypes with characteristically pedantic zeal, arriving at a complete categorization and historical justification of triumphs.[141] This scholarship is registered in the second edition where one sentence in the Life of Il Cecca in the 1550 edition becomes the basis for a learned and lengthy excursus on old Florentine festivals and theatrical events and their organization and sponsorship.[142] The machinery used for the feast of the Annunciation at San Felice in Piazza, worthy of a few sentences in the first edition of Brunelleschi's Life, becomes the subject of a long technical description in the second.[143] A demonstration of the ingenuity and industry

138 *Ibid.*: "Quanto alla stampa mi pare che ui faccino troppi errorj . . . Ecco in que uersi di Niccola Pisano: Vi manca un 'bis', che importa tempo di cento annj; et de simili venè assaj." This was corrected, see BB II, p. 63.

139 *Ibid.*: "che uno erra in uno, factus est omnius reus."

140 Life of Botticelli, BB III, p. 513: "Questa pittura . . . questo anno 1564 è stata mutata del luogo suo salva et intera"; Life of Ghirlandaio, BB III, p. 480: "in questi propri giorni che queste Vite la seconda volta si stampano."

141 Testaverde Matteini, "Una fonte iconografica francese di Don Vincenzo Borghini per gli apparati effimeri del 1565," *Quaderni di teatro* (1980), pp. 135–44

for Borghini's research, and Bottari and Ticozzi, *Raccolta di lettere sulla pittura, scultura ed architettura*, I, pp. 125–204 for Borghini's letter to the duke setting out his results (5 April 1565). See the letters in Lorenzoni, *Carteggio artistico inedito di D. Vinc. Borghini*, I, pp. 21–32 and 60–62, for Borghini's instructions, and Scorza, "Vincenzo Borghini and *Invenzione*: the Florentine *Apparato* of 1565," *Journal of the Warburg and Courtauld Institutes* (1981), pp. 57–75. See also Starn and Partridge, *Art of Power*, pp. 149–212 for a description of the program and its execution.

142 Life of Il Cecca, BB III, p. 450 (1550), pp. 450–5 (1568).

143 Life of Brunelleschi, BB III, pp. 188–91.

of the inventor, it was also a precedent for the mechanical ingenuity that Vasari developed in inventing theatrical machines for a performance in the Palazzo Vecchio where he arranged for the opening of the heavens with cloud machinery and trap effects.[144] No wonder then, that in spite of recorded dispute over the origins of this type of machinery, he wanted to credit the most ingenious devices to the most famous architect of the fifteenth century in order to give his own activities a more glorious precedent.[145]

Part 3 may have been put in order in 1565 following Borghini's notes from the summer of 1564, but its final drafting seems to date from 1566, when Vasari made his tour of Italy. That is the year referred to most frequently in the text.[146] For Vasari the process of revision was literally one of seeing again and seeing more. The judgment he formed in front of the works made *The Lives* his book. As he stated unequivocally in the introduction to the Lives of the Lombard painters, it was not possible "to give an opinion about them, if I have not first seen them."[147] In 1566, therefore, "almost at the end of my task, before I could write them," Vasari set out to see the works of modern and old masters "to see them and judge them with my own eye."[148]

Having finished work in the Palazzo Vecchio, Vasari took his leave of the court and between the end of March and June 1566 he traveled around "almost the whole of Italy seeing once again infinite numbers of my friends and masters, and the works of many excellent artists."[149] Supposedly to recover from the exhaustion of working for the duke, he visited more than forty cities on this combination of busman's holiday ("a few months free") and triumphal progress ("I have been courted everywhere and by everyone as one beloved and desired"): sketching, measuring, inquiring, collecting.[150] He had the entire book in mind, looking at everything from medieval works to the most modern. His letters and Borghini's answers recall the excitement of the trip. They also show that he was extremely purposeful with his limited time. Both his enormous curiosity and formidable memory are

144 See Nagler, *Theatre Festivals of the Medici 1539–1637*, p. 17.

145 The more fantastic ("capriccioso") Piero di Cosimo provided the opportunity for a discussion and description of carnivals (BB IV, pp. 63–5). Charles V's progress around Italy was the subject of other festive and triumphal accounts, such as those added to the Lives of Andrea di Cosimo (BB IV, p. 523, his entry to Florence), Alfonso Lombardo (BB IV, pp. 407–8, his coronation at Bologna), and Amico Aspertini (BB IV, p. 497, his entry into Bologna). The entry into Rome is given expanded attention in the Life of Antonio da Sangallo (BB V, pp. 44–6) and his entry into Siena is described in the Life of Beccafumi (BB V, pp. 171–2). The *apparato* for Giuliano de' Medici on the Campidoglio is described in the Life of Peruzzi (BB IV, pp. 319–20). Leo X's entry into Florence, mentioned in the first edition of del Sarto's Life, is amplified there (BB IV, pp. 361–3) and is given extensive treatment in the Life of Granacci (BB IV, pp. 602–3). Lorenzo de' Medici's "mascherata" of the triumph of Paulus Emilius is also discussed in Granacci's Life (BB IV, p. 602). Medici festivals are treated at length in Lives newly written for the second edition, such as those of Pontormo, Tribolo, and Aristotile da Sangallo.

146 Scoti-Bertinelli, *Giorgio Vasari Scrittore*, pp. 102–20.

147 Lives of the Lombard artists, BB V, p. 409: "dar di quelle [opere] giudizio, se io non l'avessi prima vedute."

148 *Ibid.*: "essendo quasi al fine di questa mia fatica, prima che io le [vite] scriva, vederle e con l'occhio farne giudizio."

149 BB VI, p. 403: "poco meno che tutta Italia, rivedendo infiniti amici e miei signori, e l'opere di diversi eccellenti artefici." See Olivato Puppi, "Cosimo Bartoli, un intellettuale medieceo nella Serenissima," in *Medici 1980*, II, p. 739, for a letter from Bartoli to Duke Cosimo, dated 25 May 1566, which documents Vasari's visit with him. Vasari had just left Venice that evening and said that he intended to spend two days in Bologna (ASF, Mediceo del Principato, f. 2978, fol. 61r). For the other stops on this tour, see the Biographical Outline.

150 BB VI, p. 403: "alcuni mesi andare a spasso," and Frey II, dxxxv, p. 239 (Milan, 9 May, to Borghini, Poppiano): "per tutto et da tuttj, come cosa amata et desiderata, sono stato corteggiato."

chronicled in the new book, which accommodates large groups of artists, major masters, lesser followers, and promising newcomers learned about on this trip. These are mainly dealt with in regional groupings such as the Lombards and Ferrarese, the Veronese and Venetians, but his travels also allowed him to polish up significant single Lives such as Titian's.

Vasari was able to work quickly because he worked methodically. Following Borghini's injunction, he was careful to note full names of places and patrons, to seek out details of placement and complete identification of subjects. Works in private collections are most often noted as "very beautiful" ("bellissimo") and precious or "rare" ("raro"), with little detailed description. They are usually accounted for in terms of the status of the collectors and their esteem for their cherished possessions. Smaller works in private collections are often grouped together. Altarpieces are generally described by subject and then character-ized by a striking dramatic or technical effect. The selection of details such as beautiful draperies and lovely faces was probably a form of *aide mémoire* as well as a mark of Vasari's own love of stylish flourishes. In the case of larger cycles Vasari defines the division of the scenes and then moves scene by scene through the cycle, identifying the subjects and choosing a few dramatic moments to convey the emotional impact of the work. He made drawings on site to assist his memory and probably to serve as ideas for his own works. Borghini wrote that he was sure Vasari would return "with [his] head full of ideas and saddlebags full of sketches and copies."[151] Vasari's practiced eye and developed critical skill made it possible for him to absorb the innumerable impressions of the trip rather than be overwhelmed by them.

The New Book

Given Vasari's altered historiographic and professional priorities, how did he transform the 1550 edition of *The Lives*? This edition was obviously the basis for change: for alteration, addition, and correction. Efficiency and self-respect kept him from discarding the original text. Even the most drastically rewritten Lives preserve phrases and paragraphs from the first edition, which must have been continually to hand. Some portions of text were reprinted with minimal revision including even original printing errors.[152] The most polished parts of the first edition were also those most often preserved nearly intact or altered surgically by insertions – the technical introduction and the prefaces to each section being the most extensive unaltered portions. The Life of Raphael is another example of this, as are most of the elaborate descriptive passages. The descriptions were the proof of greatness, the point of the biographies. They were originally conceived with care and obviously deserved respect. This additive mentality resulted, as Vasari admitted, in some repetition. Many new facts about Correggio's paintings that he had learned from Girolamo da Carpi, for example, were put into Girolamo's Life.[153]

151 Frey II, dxxxiv, p. 237 (Poppiano, 6 May 1566, to Vasari in Venice): "et tornerete co 'l capo pien di concetti et con le bisacce piene di schizzj et di ritratti."

152 For this see Bettarini in BB I, pp. xiii–xvii.

153 Life of Girolamo da Carpi, BB V, pp. 414–15. In the letter to the artists Vasari explained that this was owing both to how he had asked for material and to the many interruptions in the course of revising and printing the book, BB VI, p. 410: "E se quello che una volta si è detto è talora stato in altro luogo replicato, di ciò due sono state le cagioni: l'avere così richiesto la materia di cui si tratta, e l'avere io, nel tempo che ho rifatta e si è l'opera ristampata, interrotto . . . lo scrivere."

In many cases one can imagine a 1550 Torrentino text being sent to the Giunti press with draft pages attached for insertion. Such a procedure is indicated by a note to the printer inadvertently copied into the Lives of Gentile da Fabriano and Pisanello, where the letter from Giovio had been added. The paragraph following the text of Giovio's letter opens, with little apparent sense, "Up to here Giovio, with that which follows."[154] More elegant and intentional are joins between old and new text marked by the phrase "But to return to" ("Ma per tornare a").[155]

The amount of change to an extant Life depended partly on its placement in the book: the Lives at the beginning and end of Parts 1 and 2 were substantially altered and those sections were reordered. It depended also on their original condition – some 1550 Lives were fragmentary or almost entirely anecdotal. Another determining factor was the selection of suitable vehicles for important topics, such as education and antiquity (Mantegna), history painting (Bellini, Pintoricchio), Medici patronage and architecture (Michelozzo), devotional painting and decorum (Fra Angelico). Many of the generalized eulogistic introductory passages were cut or removed and substituted with succinct statements of an artist's origins, apprenticeship, and principal contribution to the arts: an editorial procedure that strengthened the historical continuity of the book. Just over half the Lives in Parts 1 and 2 are changed in this fashion, and the proportion is similar for the Lives newly written for Part 3. The reader was made aware of what was happening "at the same time," as when Florence was acquiring fame through the works of Leonardo, and Venice contemporaneously received the ornament of Giorgione's excellence.[156] Openings that addressed key issues (Mino da Fiesole's on imitation) or that served as historical explanations (like those of Cimabue, Giotto, and Michelangelo) were retained. Others were written to expound upon important topics such as drawing (Titian) or studiously acquired skills that matched the model of the antique (Simone Mosca). Throughout Vasari coaches and coaxes the reader's judgment towards accepting his understanding of the excellence of the visual arts.

The critical attitude towards sources urged by Borghini resulted in the elimination of much, but not all, apocrypha. About two-thirds of the epitaphs and commemorative verses were removed. Vasari named the authors of many of the remaining verses: Annibale Caro (Masaccio), Giovanni Battista Strozzi (Brunelleschi, Cronaca), Fabio Segni (Masaccio, Correggio), Castiglione (Raphael), and Pietro Bembo (Raphael's tomb inscription in the Pantheon). This distinguished list suggests why he retained some without giving attributions, these are mainly in Latin, but there are also a few in Italian (Donatello, Desiderio, Leonardo). Many of the epigrams or epitaphs cited as tomb inscriptions were kept as well. Such commemoration sealed honor for eternity and searching for burial places had been one of Vasari's great efforts in writing *The Lives*, which he respected when rewriting them, even if it still meant quoting things that were as much invented as actually found.

Typical of what might be called editorial policy is the placement of poems or passages

154 Lives of Gentile da Fabriano and Pisanello, BB III, p. 369: "In sin qui il Giovio, con quello che séguita."
155 As in the Life of Antonio da Sangallo, BB v, p. 35.

156 Life of Giorgione, BB IV, p. 41: "Ne' medesimi tempi che Fiorenza acquistava tanta fama per l'opere di Lionardo, arrecò non piccolo ornamento a Vinezia la virtù et eccellenza [d']un suo cittadino."

celebrating the artist, descriptions of the drawings in Vasari's *libro de' disegni*, and acknowledgments of the sources of the artists' portraits at the end of a Life. Descriptive passages, particularly if based on Vasari's 1566 tour, were usually inserted *en bloc*, unless Vasari wished to build up a crescendo of accomplishment to a prestigious place (Rome or Florence) or patron (pope or prince). Works cited in certain cities, such as Perugia, Pisa, Pistoia, Pesaro, and Urbino are characteristic additions. While Vasari worked to perfect and enlarge *The Lives*, he took care not to make them monstrous and bloated. Addition was balanced where possible by elimination, usually of more or less fabricated or anecdotal information. But moral logic continues to operate as a motivating force and is used to link and explain episodes. Vasari also relied substantially on inference and imaginative reconstruction to arrive at verisimilitude if not the truth – a procedure even Borghini admitted as necessary when dealing with the distant past, and one amply employed in the Lives of the first period.

Editorial treatment varied according to the part of the book being revised. Undoubtedly a result, in part, of the prolonged process of rewriting, it was also a consequence of Vasari's attitudes towards different periods. The additions to the first era concentrate on universality, creating a wider geographical and technical range and adding factual material. Here he followed a declared bias, leaving space for later artists.[157] The addition of the Lives of the architect Arnolfo di Cambio and the sculptors Nicola and Giovanni Pisano to the opening of Part 1, following the Life of Cimabue, meant that he created a triad of the arts of design.[158] This emphasis on a global account of the arts recurs in the opening of Part 2 where the first five Lives from Jacopo della Quercia to Luca della Robbia were rewritten with a focus on technical appraisal. In that way the basis of the improvement of the second age became clearer. The Lives at the end of the period were also reorganized. In the 1550 edition, Perugino's was the concluding Life. It showed artists both "that he who works solidly and not as the whim takes him, leaves works, a name, wealth, and friends," and how a career could be thwarted by its own limitations.[159] In the 1568 edition this section concludes with a wider geographical spread (Venice, Carpaccio; Rome, L'Indaco; Umbria, Signorelli) and a painter, Luca Signorelli, who merited Michelangelo's praise not his censure. In this way, Vasari finished the era with a figure whose abilities in drawing and invention led directly to the next, reinforcing the historical progression. Moreover, he concluded with an artist who not only influenced Michelangelo, but encouraged Vasari, thus weaving the autobiographical thread into the beginning of the golden age. The opening Lives of that age were reworked to become statements about the nature of those times. While the opening paragraph of Leonardo da Vinci's Life is retained (though somewhat abbreviated) so that the great gifts of "celestial influences" concentrated in that remarkable character are not denied, subsequent openings are changed so that one sees how in all of Italy artists arose who surpassed their masters.

157 Life of Gaddo Gaddi, BB II, p. 84.

158 Lives of Nicola and Giovanni Pisani, BB II, p. 59: "Avendo noi ragionato del disegno e della pittura nella Vita di Cimabue e dell'architettura in quella d'Arnolfo Lapi, si tratterà in questa di Nicola e Giovanni Pisani della scultura e delle fabriche ancora che essi fecero di grandissima importanza."

159 Life of Perugino, BB III, p. 614 (1550): "mostrò agli artefici che chi lavora continuo e non a ghiribizzi, lascia opere, nome, facultà et amici." This sentence is retained in the 1568, but applied to the example of the third era. For Perugino's inability to cope with the new style and the coming generation, see pp. 608–10.

The third era is formed of the past, present, and future, beginning with artists, like Leonardo, who were already dead by two or more generations and ending with academy pamphlets. Hundreds of artists are added in single and grouped Lives and gatherings of notices. The sequence is basically chronological, but geographical, material, and even moral associations are used to give meaning to the order. For example, Beccafumi's Life follows Perino del Vaga's, both are examples of natural talents who were first fostered by mediocre masters and who learned their true lessons in Rome. Two Aretines (Giovanni Lappoli and Niccolò Soggi) are placed after the Sienese painter, and then follows a group of sculptors' Lives (Tribolo, Pierino da Vinci, and Bandinelli). Vasari discriminates to a degree between biographies, descriptions, and mere notes. He gives Lives to those who have died, placing Michelangelo at the end of the series as a fulcrum to the future. An intermediary group of older masters (Primaticcio, Titian, and Jacopo Sansovino) with their students mark the transitional moment to descriptions of works by other living masters, including Vasari himself.

The style of the second edition is deliberately historical. This is achieved by employing constructions linking events through the passage of time, and suggesting cause and effect. Words like "then" (*poi*), "after" (*dopo*) and "since" or "because" (*perché*) were inserted in the 1550 text and occur regularly in the 1568 text. Flowing participles, frequent in the first edition, are replaced by the past perfect, "being" (*essendo*) becoming "it happened that" (*avvenne che*). The past is re-created through a combination of narrated events, reported conversation, and quoted documentation. This is the expository as opposed to literary mode advocated by Borghini. As adopted by Vasari it gives *The Lives* variety and vitality. Vasari is omnipresent as guide and judge, a directing voice arguing cases for glory or for shame.

The eulogistic framework of biography so evident in the first edition, and apparently objected to by Borghini, is heavily burdened by the addition of new information: the accumulation of fact often overwhelms the impression of form. But the exemplary purpose remains a key to the whole project. It is as important a feature of Lives written for the 1568 edition as those originally conceived for the first project. The "bestial" Sodoma, for instance, ends his extravagant, licentious life in isolated poverty. His virtuous competitor in Siena, Beccafumi, was instead honored by the Sienese in Latin and vernacular verses. Battista Franco's Life is a lesson in the correct definition of *disegno*. And friendship, in its ideal and practical form, virtually determines the modern age; the source or nucleus for almost every Life added to the third era was Vasari's direct acquaintance with the artists welcomed into his history of the arts. Newly written full Lives, as opposed to descriptions or notices, usually follow the traditional topical structure from an artist's origins to his funeral and followers, with additional or associative material tacked on at the end.

Much of the first edition survives in the second. It was the nucleus of the new book, and its moralizing messages and momentum through exemplary actions are supplemented not supplanted in the expanded text. The same ethical outlook informs both versions. The 1568 text, like the 1550 edition, was formed from Vasari's experiences, and it must be understood as an acquisition of experience over time. It was time that better defined both the artist and his audience. The rather amorphous *artefici* addressed in the first edition had become his fellow academicians, and the new generation, his students. The unspecified aspirations of

the first edition had found a place, a patron, and a model in Duke Cosimo's court life. Because Vasari had found a *princeps* in Cosimo, his book could become more directly a *speculum* – a mirror whose flattering distortions were meant to instruct. Yet, while Vasari served, he was not subservient. In fact, the court had provided him with a stable position in a society valuing his talents. Just as he could address himself with familiarity to the *artefici*, he could speak with confidence to the *amatori*, the informed and appreciative friends of the arts. He expands his praise for their role, and his increased access to their collections and his appreciation of them is frequently recorded.

In the 1560s Vasari changed history according to the current context of his practice and with the assistance of his friends, above all with the advice of Vincenzo Borghini. His promised addition grew into a new edition.[160] Changes in the author's life made changes in the artists' Lives almost inevitable, so complete was Vasari's identification with his profession and so completely professional was his book. The fact that Vasari was not a historian by trade or training probably made him susceptible to the criticism of highly educated men like Borghini. But the second edition was born of a positive interest, a desire to continue to serve the arts as effectively as possible, not of a negative sense of inadequacy. The first edition is a measure of Vasari's devotion to his profession, the second is the result of his success.

160 For revised editions in this period, see Aquilecchia, "Trilemma of Textual Criticism (Author's Alterations, Different Versions, Autonomous Works). An Italian View," in *Book Production and Letters in the Western European Renaissance*, ed. Lepschy, Took, and Rhodes, pp. 1–6. Ariosto's *Orlando Furioso*, Tasso's *Gerusalemme Liberata*, and Castiglione's *Cortegiano* are all noteworthy examples of books revised by their authors.

VI

"AS A PAINTER":
WRITING ABOUT THE ARTS

VASARI PREFERRED PRAISE TO BLAME. When he wrote about his fellow artists, he wished to

> pay back in some part the obligation I owe to their works, which have been my teachers
> in learning such as I know, rather than, living in idleness, maliciously be censorious of
> works by others, attacking and condemning them as some are frequently wont to do.[1]

Artists were quite capable of insulting one another. Baccio Bandinelli, "extremely
loquacious" according to Vasari, spoke ill even of Michelangelo, for which, Vasari adds, he
was hated.[2] In the Life of Perino del Vaga, Vasari recalls how painters took pleasure in
gathering to hear criticism as well as praise of each other.[3] Cellini, as we know from his
autobiography, could fashion insults as masterful and memorable as his goldwork. Vasari
associated fault-finding with malice, jealousy, and disruption to work.[4] He included a long
and heartfelt speech on the subject in the Life of Aristotile da Sangallo, where he describes
how he intervened when Perino del Vaga threatened to give a biased appraisal of some stage
sets designed by Aristotile. Vasari spoke in defense of Aristotile and all artists, warning that
by making a judgment based on personal contempt and jealousy and by departing from the
truth, Perino harmed art, virtue, and his very soul. In an extensive and passionate piece of
oratory Vasari argues that "whoever seeks to ingratiate himself by exaggerating the merits
of his work, or to avenge himself for some insult by criticizing or underestimating the
quality of another's works, will in the end be known to God and other men for what he is,
that is malicious, ignorant, and evil."[5] His remark about Andrea Pisano's bronze door of the
Florentine Baptistery is characteristic of the balanced judgment he wished to exercise:

1 General preface to *The Lives*, BB I, p. 30: "render
loro in qualche parte l'obligo che io tengo alle opere
loro che mi sono state maestre ad imparare quel tanto
che io so, che malignamente, vivendo in ozio, esser
censore delle opere altrui accusandole e riprendendole
come alcuni spesso costumano."

2 Life of Baccio Bandinelli, BB V, p. 249.

3 Life of Perino del Vaga, BB V, p. 125.

4 See the Lives of Montorsoli and Salviati for
examples of the destructive effects of jealousy at the
court of Cosimo I, BB V, pp. 497–8, 522–4. For a
contrast of friendship and malice and the importance of
the former for progress in the arts, see Life of Gaddo
Gaddi, BB II, p. 82.

5 Life of Aristotile da Sangallo, BB V, p. 402: "E chi
cerca di gratuirsi ad alcuno, d'aggrandire le sue cose, o
vendicarsi d'alcuna ingiuria col biasimare o meno
stimare di quel che sono le buone opere altrui, è
finalmente da Dio e dagl'uomini conosciuto per quello
che egli è, cioè per maligno, ignorante, cattivo."

And even if many believe that in those stories there is not to be seen that beautiful drawing and that great skill that should go into figures, he does not merit censure, however, but very great praise, for having been the first.[6]

Vasari was capable of registering his distaste, disappointment, or dismay. Rosso Fiorentino puzzled him when in Santa Maria della Pace in Rome he painted what Vasari felt to be his worst work. He added that he could not imagine the cause, although he tried, offering two distinct explanations: the first (in 1550) was that Rosso's vanity made him over-ambitious, the second (in 1568) was that, like Andrea del Sarto and Fra Bartolomeo, he was overwhelmed by the grandeur of Rome.[7] When he reported criticism of the gallery that Baccio d'Agnolo designed to encircle the dome of Florence cathedral, he quoted Michelangelo's opinion that it looked like a cricket cage.[8] The Life of Baccio d'Agnolo is meant to demonstrate the difficulties of architecture and its perils for those lacking judgment and design skills, woodworkers like Baccio or Vasari's predecessor and rival in Palazzo Vecchio, Battista del Tasso.[9] Vasari's undoubtedly partisan but deeply felt reactions to the shortcomings of artists are most often provided with explanations that turn negative remarks to positive effect. In this way the practice of art was not divorced from the paradigms of history.

Vasari's appraisal of artists was eulogistic, based on distinguishing "the better from the good and the best from the better."[10] This follows logically from the basis of his *Lives* in the oratory of praise and blame. As a consequence of the demonstrative structure of his history, the objects of his study became the subjects of his prose. Typical verbs are those meaning to show, to demonstrate, to make known, recognize, or distinguish (such as *mostrare, dimostrare, far conoscere, riconoscere*). A common construction is that of earning or being worthy of praise, usually for a specific accomplishment, as in the case of Andrea del Castagno whose fresco of *St. Jerome and the Trinity* at Santissima Annunziata (pl. 67) was "done so well that Andrea deserved to be greatly praised for it, having managed the foreshortenings in a much better and more modern way than those before him."[11] Vasari's praise is not general, undirected enthusiasm. It is an argued case for the greatness of the visual arts and their practitioners. The works are the evidence. The reader is made into a witness.

6 Life of Andrea Pisano, BB II, p. 155 (1550): "E se bene pare a molti che in tali istorie non apparisca quel bel disegno e quella grande arte che si suol porre nelle figure, non merita però biasimo ma lode grandissima, per essere stato il primo."

7 Life of Rosso, BB IV, p. 480. The first explanation may owe something to the fact that Rosso was reported to have been critical of Michelangelo's work on the Sistine ceiling, a heresy so daring that Rosso felt called upon to write to Michelangelo to deny the rumor, see Barocchi and Ristori eds., *Il carteggio di Michelangelo*, II, dcclvii, pp. 235–7 (6 October 1526). And Benvenuto Cellini recalled that "while he was in Rome, then, being a man given to back-biting, he spoke so ill of Raffaello da Urbino's works, that the pupils of the latter were quite resolved to murder him" (*The Autobiography of Benvenuto Cellini*, trans. Symonds, Book i, chapter 98,

p. 180). The second explanation relates to a concern with study and the formation of style developed in the second edition.

8 Life of Baccio d'Agnolo, BB IV, p. 613.

9 An open appraisal of Tasso's ineptitude and his promotion as an architect through court politics rather than proper training or understanding is put in the Life of Tribolo, BB V, p. 224.

10 Preface to Part 2, BB III, p. 4: "mi sono ingegnato non solo di dire quel che hanno fatto, ma di scegliere ancora discorrendo il meglio dal buono e l'ottimo dal migliore."

11 Life of Andrea del Castagno, BB III, p. 355: "tanto ben fatto che Andrea merita per ciò esser molto lodato, avendo condotto gli scòrti con molto miglior e più moderna maniera che gl'altri inanzi a lui fatto non avevano."

The extensively visual nature of Vasari's biographies was unusual, as were their concretely didactic aims. He had to borrow, develop, and invent descriptive means that were commemorative, explanatory, and effective. The virtue of the artists was to be honored, as it deserved, and imitated – this depended upon the convincing powers of Vasari's writing, his eloquence as an advocate and teacher. These were generically different roles, one belonged to writing history, the other to prescriptive treatises. He borrowed techniques and terms from both categories and depended upon his authority as a practicing artist. His way of writing about the arts combined experience and workshop conversations with a respect for the conventions and resonance of literary forms. One of his tasks as a historian was generally to make his readers see the relation between individual styles and character and the "quality of the times."[12] The other was specifically to show artists how to excel. In both cases sight had to become insight or understanding through words. Vasari's technique is straightforward: he constantly urges the reader to look. In the renaissance construction of reading the appeal of words was to the ear; Vasari needed to inform the eye. For this reason he devoted his book in greatest part: "to our times, in which we can use the eye, which is a much better guide and judge than the ear."[13] This reliance on eye-witness was a determining factor in the range of the book. Throughout *The Lives* the reader is invited to see what Vasari had seen in the way he had seen it.

Vasari's address to the judicious eye of his reader depended in part on a definition of imagination as the inner sense (the *imaginativa*) that formed mental images of sense experience and impressed them upon memory.[14] The assumed link between perception and cognition made it possible for Vasari confidently to produce a book about images without illustration. Because memory was defined as imaginative he could rely on the reader to make mental pictures from his words by analogy, by relating described works or elements of works to those actually seen and already remembered. He regarded a text with figures as a technical treatise of the sort he was not interested in writing, despite requests. To do so, he said, would be to teach art, not write Lives. He cited Dürer, Serlio, and Alberti as authors of such works.[15] When Vasari added pictures in the second edition, they were of the artists. Biography was a form of likeness, a portrayal of individuals through their achievements and characteristic deeds. The engraved portraits reinforced the memorial message of *The Lives*. They were a comment on the greatness of artists, who could not be present to the reader, unlike the products of their artistry that might survive.

Vasari's ability to call upon the reader's habit of imagination was integral to the demon-

12 Preface to Part 2, BB III, p. 5: "la qualità de' tempi," which Vasari then characterizes in this preface with respect to the first and second ages and their merits and defects (pp. 5–19).

13 Preface to Part 2, BB III, p. 8: "a' tempi nostri, dove abbiamo l'occhio assai miglior guida e giudice che non è l'orecchio."

14 See Bundy, *The Theory of Imagination in Classical and Medieval Thought*, and Kolve, *Chaucer and the imagery of narrative*, Chapter 1. For the implications of judgment, see Summers, *The Judgment of Sense*, pp. 21–8.

15 In the section on various artists, he writes about a request from Domenicus Lampsonius in Liège that he write such treatises on the three arts of design, BB VI, p. 229: "In altre [lettere] poi mi ha pregato a nome di molti galantuomini di que' paesi, i quali hanno inteso che queste Vite si ristampano, che io ci faccia tre trattati della scultura, pittura et architettura con disegni di figure, per dichiarare secondo l'occasioni et insegnare le cose dell'arti, come ha fatto Alberto Duro, il Serlio e Leonbatista Alberti . . . La qual cosa arei fatto più che volentieri, ma la mia intenzione è stata di solamente voler scrivere le vite e l'opere degli artefici nostri e non d'insegnare l'arti, col modo di tirare le linee, della pittura, architettura e scultura."

strative aims and structure of his writing. The relation between observant reader and Vasari's subject is an active or interactive one. In the course of *The Lives* the reader becomes engaged in learning how to see in an informed manner – to "discern" – becoming familiar with the application of terms such as design, order, measure, invention, grace, and beauty. These form a vocabulary of judgment. That process of instruction will be examined here by first looking at some of the basic conceptual terms of Vasari's history: art itself, imitation, *disegno*, and style. Then the balance of literary and technical language will be considered to define the nature of his vocabulary of visualization. Some instances of its application will be given, but this is not intended as a Vasari lexicon or a study of sixteenth-century art theory and terminology. Rather it is a consideration of how Vasari used writing to give the visual arts a place in history. Finally his descriptive modes will be summarized to show how the invention and variety Vasari praised through writing were also structuring principles of his prose.

The Perfection of Art and the Meaning of Style

In the preface to *The Lives* Vasari says that he wanted his readers to be able to recognize the perfection or imperfection of works easily and to be able to distinguish between styles.[16] It is important to notice the difference between these two aims. It was possible for a master to have good style, but be imperfect in art. Vasari held that Titian, for example, had a pleasing style, but lacked training in drawing. It was possible also for a master to be admired for excellence in some aspect of his art while being defective in another, because as Vasari said of painting, it was so difficult and had so many parts that often it was not possible to master them all perfectly.[17]

For Vasari the aim of art was the imitation of nature, and good style resulted from the imitation of nature and of the best masters. Drawing, *disegno*, provided the technical and conceptual means to express the forms thus apprehended. Obviously interrelated, these were basic truths of his history. They also represented his truth to that history. This set of definitions or variants of them had existed in the periods he described. They constituted the tradition he turned into history by observing both the unity of ideals and the diversity of practice over time.

In its primary definition art, or an art, was something that could be acquired by training. Arts had rules that could be learned. Varchi wrote that poetry was called an art because it had been "organized according to precepts and teachings."[18] The third book of Alberti's treatise explicitly sets forth such precepts for study in order to instruct "the artist how he may and should attain complete mastery and understanding of the art of painting."[19] One of Vasari's explanations for the coarse and feeble works of earlier times was the destruction of ancient monuments, which meant that artists had to work "not according to the rules of the

16 General preface to *The Lives*, BB I, p. 29: "a conoscere agevolmente la perfezzione o imperfezzione di quelle [opere] e discernere tra maniera e maniera."
17 Life of Correggio, BB IV, p. 51: "E quest'arte tanto dificile et ha tanti capi, che uno artefice bene spesso non li può tutti fare perfettamente."
18 In the third *Lezzione . . . della maggioranza delle*

arti, see Barocchi ed., *Scritti d'arte*, I, pp. 263–4: "Ma devemo avvertire che la poesia si chiama arte . . . perché è stata ridotta sotto precetti et insegnamenti."
19 Alberti, *On Painting*, ed. Grayson, pp. 32, 33 (the dedicatory letter to Brunelleschi): "El terzo instituisce l'artefice quale e come possa e debba acquistare perfetta arte e notizia di tutta la pittura."

preceding arts, which they did not have, but according to the quality of their natural gifts."[20] Implicit here is the idea that innate talent alone does not suffice – a standard contrast of the complementary pair *arte* and *ingegno*. Successful attainment of artistry required study and diligence. Vasari associated study more with learning, diligence with the careful execution of works. He greatly valued individuality, facility, and inspiration, which were attached to *ingegno, furore,* and the adjective *divino*, but creative spontaneity and the uninhibited outpouring of artistic genius are concepts that contradict the period definition of art.

The arts, which were all useful human activities – practical and speculative – were traditionally divided into liberal and mechanical. They were further characterized as those merely serving necessity and those capable of producing intellectual pleasure.[21] To debate their status was both to engage with a venerable topic and to deal with the fundamental structures of the social construction of knowledge. The hierarchical placement of the visual arts was the subject of attention well before Vasari's *Lives* or Varchi's lectures to the Florentine academy. In the second quarter of the fourteenth century they were granted an intermediate status on the bell-tower of Florence where they were positioned between the mechanical and liberal arts. Boccaccio wrote that there was a difference between an art ("arte") and a trade ("mestiere"). An art, he said, was more than just manual labor. It required the artisan to use both intellect and industry. He gave the instance of having to compose a statue, where to give it just proportions involved much mental effort.[22] In the first chapter of his book on the art of painting, Cennino Cennini argued that the combination of manual skill and imagination required of the painter to make the invisible visible was reason to put his art next to theory ("scientia") and to crown it with poetry.[23] A similar concern for definition and repositioning is a subtext to Alberti's treatise on painting with its application of principles from mathematics and rhetoric to an art that he regarded as worthy of consideration by "noble intellects."[24] It is a preoccupation in Ghiberti's *Commentaries* and Leonardo da Vinci's notebooks and was an aspect of both of their careers – as Ghiberti advanced his standing through acquiring property and confraternity offices and Leonardo progressed from journeyman painter to court artist, architect, and scientific investigator.[25] In broad terms the shift from symbolic to represen-

20 Preface to *The Lives*, BB II, p. 21: "non trovandosi più né vestigio né indizio di cosa alcuna che avesse del buono, gl'uomini che vennono apresso . . . si diedero a fare non secondo le regole dell'arti predette, che non l'avevano, ma secondo la qualità degli ingegni loro."

21 For a history of the classification of the arts from antiquity to the eighteenth century, see Kristeller, "The Modern System of the Arts," in *Renaissance Thought and the Arts*, pp. 163–227. See further Summers, *The Judgment of Sense*, especially chapter 11, "The mechanical arts." For a selection of sixteenth-century texts referring to the definition and ranking of the visual arts, see Barocchi ed., *Scritti d'arte*, I, especially sections ii ("Arti e scienze") and iii ("Le arti").

22 *Opere volgari*, ed. Moutier, XI (*Il commento sopra la Commedia*, vol. 2), p. 118: "Intra 'l mestiere e l'arte è questa differenza, che il mestiere è esercizio, nel quale niuna opera manuale che dall'ingegno proceda s'adopra; . . . Arte è quella, intorno alla quale non sola-

mente l'opera manuale, ma ancora l'ingegno e l'industria dell'artefice s'adopera, siccome è il comporre una statua dove a davere proporzionarla debitamente si fatica molto l'ingegno."

23 Cennino Cennini, *Il libro dell'arte*, ed. Brunello and Magagnato, p. 4: "che conviene avere fantasia e operazione di mano, di trovare cose non vedute, cacciandosi sotto ombra di naturali, e fermarle con la mano, dando a dimostrare quello che non è, sia. E con ragione merita metterla a sedere in secondo grado alla scienza e coronarla di poesia."

24 *On Painting*, ed. Grayson, Book ii, chapter 28, pp. 64, 65. See further Hulse, "Alberti and History," in *The Rule of Art*, pp. 55–76.

25 Zervas, "Lorenzo Monaco, Lorenzo Ghiberti and Orsanmichele," *Burlington Magazine* (1991), pp. 814–16, for Ghiberti and the confraternity of Orsanmichele. For Ghiberti's career generally, see Krautheimer, *Lorenzo Ghiberti*. For a survey of Leonardo's combined interests,

tational forms in the late thirteenth and early fourteenth century in Italy brought about new perceptions of artists' roles and changes in the technologies of their arts.

Perfection in each art involved a mastery of skills that resulted in the ability to resolve particular problems or difficulties. So for painting, according to Vasari, the skills included rendering perspectives, the knowledge of anatomy, drawing from nature, and handling colors. Sculptures, he said, should resemble the chosen subject, be well proportioned, have appropriate parts (old for old, young for young), draperies that revealed the form beneath, and hair and beards that appeared soft.[26] Architects had to know the orders, their proportions, and their correct application. Part of the judicious viewing of the works of each art that Vasari was teaching was the ability to perceive technical difficulties and appreciate the proficiency of their resolution. Biographically it was the goal of each artist to excel in the requisite skills of his profession. Historically perfection was an accumulation of skills and solutions, discovered and mastered in the two ages preceding the modern era, when "supreme perfection" could be achieved by the best masters in all the arts.[27] The agreed means to bring any art to perfection were constant study and the imitation of the best masters: a notion that justified Vasari's history in creating a canonical past to provide examples for the future.

In the preface to the third part of *The Lives* Vasari listed the five principal additions made by the artists of the second period to the achievements of the first era so that artists of the modern age had the means to arrive at perfection. They were rule, order, proportion, drawing, and style.[28] Here Vasari defined rule architecturally, as "the process of taking measurements from antiquities and observing the ground-plans of ancient buildings in modern ones."[29] Order, in architecture, was the correct use of the orders. Although not defined in this preface, order applied also to the positioning of figures, to perspective, and to compositional symmetries. Proportion, in all the arts, was "the universal law . . . that all bodies should be made correct and true, with members in proper harmony."[30] Drawing, *disegno*, was the intellectual ability to perceive and the manual ability to transcribe the most beautiful parts of nature. Beautiful style resulted from copying and assembling those beautiful elements. In the third period, on the basis of this cumulative capability, what was previously difficult became easy and artists could dazzle the world with displays of expertise and invention. With the command of the fundamental principles came the possibilities both to make discriminating choices – to exercise judgment – and to make challenging new combinations of forms through the imaginative privilege of license. In Vasari's third era craftsmanlike artistry is superseded by creative artifice.

For Vasari artists of his time had gained the technical capacity to execute their works with a lightness of touch, imbuing them with refinement, graceful movement, and richness. The terms are those of the most exalted and most appealing style of rhetoric – the ornate. This value-laden language corresponds to the variety of complex and counterbalanced poses,

see Kemp, *Leonardo da Vinci*. For science and status, see Boskovits, " 'Quello ch'e dipintori oggi dicono prospettiva,' " *Acta Historiae Artium* (1963), pp. 140–1.

26 Technical introduction, BB I, pp. 82–3.

27 Preface to Part 3, BB IV, p. 3, describing how the artists of the third age: "poterono . . . condursi alla somma perfezzione, dove abbiamo le cose moderne di maggior pregio."

28 *Ibid*.: "regola, ordine, misura, disegno e maniera."

29 *Ibid*.: "il modo del misurare delle anticaglie, osservando le piante degli edifici antichi nelle opere moderne."

30 *Ibid*., p. 4: "la misura fu universale . . . fare i corpi delle figure retti, dritti, e con le membra organiz[z]ati parimente."

82. Michelangelo, *Judith and Holofernes* (detail), spandrel. Rome, Sistine Chapel.

the three-dimensional illusionism, and the sinuous contours visible, for example, in Michelangelo's Sistine vault, Vasari's illustration of "all the perfection" possible in painting (pl. 82).[31] The more pronounced silhouettes and precisely defined surfaces that characterize works produced in the shops of fifteenth-century artists like Verrocchio instead appeared to him, and were described to his readers, as labored and stilted (pl. 83). In the historical gamut of distinction they were good, but less than perfect. The hieratic figure scales and symbolic configurations of earlier times seemed to Vasari to be misunderstandings verging on madness. He criticized the contained figures of Giotto's style as rigid. For him the buildings of that time were aberrant. Their underlying systems of measurement looked lawless to him, their ornament random and eclectic.[32] On his periodic scale the very real differences

31 Life of Michelangelo, BB VI, p. 39: "tutta quella perfezzione che si può dare a cosa che in tal magisterio si faccia, a questa ha dato."

32 Preface to Part 2, BB III, p. 9.

83. Follower of Andrea del Verrocchio, *Tobias and the Angel*. London, National Gallery.

84. Pisa, *Baptistery*.

85. Bramante, Tempietto, San Pietro in Montorio, Rome.

between a building like the Baptistery at Pisa and Bramante's tempietto at San Pietro in Montorio (pls. 84, 85) registered as a lack of artistic judgment in the former. He saw earlier architectural forms and their articulation as arbitrary inventions of unguided intellects as opposed to examples of knowledgeable variation and pleasing license. Evidence of rule without rule, he described them as chaotic and cluttered, because built without reference to precedents whose logic represented the laws of nature.[33]

Rule, order, and proportion were important components of Vasari's notion of the "perfection of art" because to compose a painting, building, or sculpture with due measure was to seek correspondences to the essential forms of nature rather than to copy the accidents of material reality. Ultimately Aristotelian, the distinction was a commonplace assumption for Vasari and his contemporaries. It was one he observed when he praised figures whose bulk and fleshiness were refined by good design and judgment so as to be graceful, not coarse and clumsy "as in nature."[34] His understanding of the relation of the visual arts to nature and its imitation was classical in origin and idealizing in intention. Imitation was a form of abstraction that consisted of combining all the best parts of selected models to form the most beautiful whole. As Cicero told the story, in order "to embody the surpassing beauty of womanhood" in painting Helen for the temple of Juno in the city of

33 *Ibid.*

34 Preface to Part 3, BB iv, p. 5: "ricoperte di quelle grassezze e carnosità che non siano goffe come li naturali, ma arteficiate dal disegno e dal giudizio."

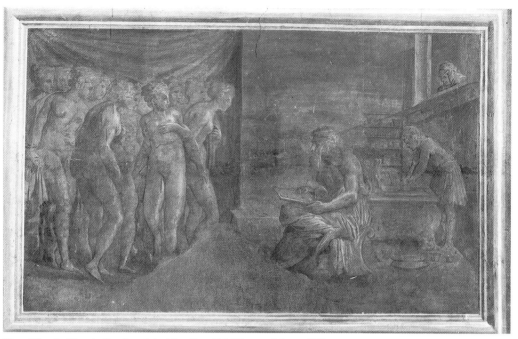

86. Giorgio Vasari, *Zeuxis and the Most Beautiful Women of Croton* [Pliny, *N.H.*, xxxv.64]. Arezzo, Casa Vasari, Sala del Trionfo della Virtù.

Croton, the painter Zeuxis chose five of the most beautiful girls of that city, "because he did not think that all the qualities he sought to combine in a portrayal of beauty could be found in one person, because in no single case has Nature made anything perfect and finished in every part."[35] Alberti repeated the story in his treatise on painting and echoed Cicero's formulation with respect to architecture, writing that "it was rarely given to anyone, or even to Nature, that she put forth anything completely resolved and in every way perfect."[36] The context is his discussion of beauty. Cicero's tale of Zeuxis and its moral represented the paradigm for the relation of art, beauty, and nature. Vasari illustrated the scene in his house in Arezzo (pl. 86) and a variant, Apelles painting Diana, in Florence.[37] In this formulation the seductive power of beauty is figured as female, the intellectual power of generation as male. The concepts of perfected reality and nature conquered endowed the artist with god-like powers to embody forms apprehended in his mind. It allowed both for personal vision and personal talent while referring to a general standard of idealization, as each artist could build and work from his own repertory of selected motifs. For Vasari this combination of portfolio and personal style satisfied both aesthetic theory and efficient practice. It is conspicuous in his paintings, which can be parsed into constituent quotations

35 *De Inventione*, II.1–2, pp. 166–9; similarly Pliny, *N.H.*, xxxv.xxxvi.64, pp. 308, 309, with some variation.
36 Alberti, *L'architettura*, trans. Bartoli, Book vi, chapter 2, p. 163: "di raro è concesso ad alcuno, ne ad essa Natura ancora, che ella metta inanzi cosa alcuna, che sia finita del tutto, & per ogni conto perfetta." Alberti, *On Painting*, ed. Grayson, Book ii, chapter 56, pp. 98, 99.

37 Jacobs, "Vasari's Vision of the History of Painting in the Casa Vasari, Florence," *Art Bulletin* (1984), pp. 407–12, discusses this notion of imitation and the consequent implications of Vasari's use of antique sources in this painting. See also Panofsky, *Idea*, pp. 47–50.

and adaptations. Inherent in this eclectic mode of distillation and stylization – now labeled as mannerist – is the purposeful observation that made Vasari such an effective chronicler of style.

For Vasari the recognition of beauty had to be matched by the ability to describe it through drawing, which he accordingly defined as "the imitation of the most beautiful in nature in all figures, sculpted as well as painted."[38] *Disegno* is that aspect of artistic skill in which theory and practice combine, hand and intellect meet. The artist had to have the technical command to reproduce what he saw; in great artists what was seen went beyond surface appearances to the perfected essence of perceived forms. The preface to *The Lives* opens with a history of the arts that attaches this notion of drawing to the Creation, defining *disegno* (the "foundation" of the arts) as "the very soul that conceives and nourishes within itself all the parts of man's intellect – already most perfect before the creation of all other things, when the Almighty God . . . shaping man, discovered, together with the lovely creation of all things, the first form of sculpture and painting."[39] Vasari elaborated his definition of drawing in the technical introduction:

> design, father of our three arts . . . proceeding from the intellect, draws from many things a universal judgment similar to a form or idea of all things in nature, which is most singular in its measures . . . [it] is cognizant of the proportion of the whole to the parts and of the parts to each other and to the whole . . . from this knowledge there is born a certain conception and judgment, so that there is formed in the mind that something, which when expressed by the hands is called design, we may conclude that design is none other than a visible expression and declaration of the inner concept, and of that which others have imagined and given form to in their idea . . . what design requires, when it has derived from the judgment an image of something, is that the hand, through the study and practice of many years, may be free and apt to draw and to express correctly . . . whatever nature has created. For when the intellect puts forth with judgment concepts purged [of the accidents of nature], the hand that has practiced drawing for many years makes known the perfection and excellence of the arts as well as the knowledge of the artist.[40]

The process of perception and transcription, where the artist's hand expresses or mediates

38 Preface to Part 3, BB IV, p. 4: "Il disegno fu lo imitare il più bello della natura in tutte le figure, così scolpite come dipinte."

39 Preface to *The Lives*, BB II, p. 3: "il disegno–che è il fondamento di quelle [arti], anzi l'istessa anima che concèpe e nutrisce in se medesima tutti i parti degli intelletti–fusse perfettissimo in su l'origine di tutte l'altre cose, quando l'altissimo Dio . . . formando l'uomo, scoperse con la vaga invenzione delle cose la prima forma della scoltura e della pittura."

40 Technical introduction, BB I, p. 111: "il disegno, padre delle tre arti nostre . . . procedendo dall'intelletto cava di molte cose un giudizio universale simile a una forma overo idea di tutte le cose della natura, la quale è singolarissima nelle sue misure . . . cognosce la proporzione che ha il tutto con le parti e che hanno le parti fra loro e col tutto insieme . . . da questa cognizione nasce un certo concetto e giudizio, che si forma nella mente quella tal cosa che poi espressa con le mani si chiama disegno, si può conchiudere che esso disegno altro non sia che una apparente espressione e dichiarazione del concetto che si ha nell'animo, e di quello che altri si è nella mente imaginato e fabricato nell'idea . . . questo disegno ha bisogno, quando cava l'invenzione d'una qualche cosa dal giudizio, che la mano sia mediante lo studio et essercizio di molti anni spedita et atta a disegnare et esprimere bene qualunche cosa ha la natura creato . . . perché, quando l'intelletto manda fuori i concetti purgati e con giudizio fanno quelle mani che hanno molti anni essercitato il disegno conoscere la perfezzione e eccellenza dell'arti et il sapere dell'artefice insieme."

between the sense of sight and the intellectual apprehension of abstract universal form is Aristotelian.[41] The reference to "idea," the conception present in the mind, is Neoplatonic. Its transfer to the visual arts had been made by Cicero in his description of the perfect orator in which he used sculpture and painting to show how "there is something perfect and surpassing . . . an intellectual ideal by reference to which the artist represents those objects which do not themselves appear to the eye . . . These patterns of things are called . . . ideas by Plato . . . these, he says, do not 'become'; they exist for ever, and depend on intellect and reason."[42] Philosophically impure, Vasari's highly charged definition of *disegno* sets the transcendental Platonic "idea" with is relation to beauty in a pragmatic Aristotelian framework that justified and explained the interdependence of sense and intellect. Here, too, the feminine − (mother) nature − is subordinated to the masculine − (father) *disegno*.

Vasari's concern to apply philosophy to the activity of drawing can be referred to Varchi's questioning of the relative merits of painting and sculpture, which Vasari, like others, resolved by finding their kindred and comparable excellence in design. But *disegno* had a long tradition in Tuscany as the basis of the arts. The mid-sixteenth-century academic debate had been similarly proposed and solved by Petrarch two hundred years earlier. In his dialogue on fortune (*De remediis utriusque fortunae*), dating from between 1354 and 1366, Petrarch included chapters on painting and sculpture where it is argued that "they sprang from one fountain . . . the art of drawing."[43]

The sources of Petrarch's dialogue included Pliny and Vitruvius, but his statement also had the authority of practice, or it would have been a dry fountain indeed. Drawing was the foundation of a painter's training, as described, for example, by Cennino Cennini. Cennino traced his artistic lineage to Giotto, and whatever the truth of the story about Giotto's sure-handed drawing of circles told by Vasari in his Life, his figures are bounded by clear outlines and constructed in carefully defined areas of graduated and contrasting tonalities (pl. 87). This, too, is an aspect of *disegno*, which is both figure drawing and the design of the figure. The system of color modeling described by Cennino and based on gradation of tones and application of highlights depended upon the breakdown of form into planes of light and dark, an analytic construction of form that is pervasive in Florentine painting and in preparatory drawings, where areas of relief and shadow are drawn as prismatic surfaces (pl. 88). Cennino's prescriptions were based on tempera and fresco techniques, but the method of study continued even when the blended gradations of oil coloring created new possibilities for modeling that were explored by artists developing the softly rounded forms praised by Vasari in the third period. Drawings by Vasari's teacher Andrea del Sarto are an example of both the change in tonality and the persistence of the structural design of the form (pl. 89).

Drawings were also part of contractual agreements between artists and their clients in Central Italy. As a word, *disegno* meant intention or plan. For artists it was a link between idea and execution. Vasari, trained in this tradition, accepted and promoted the primacy of

41 For a discussion of this, see Barzman, "Perception, Knowledge, and the Theory of *Disegno*," in *From Studio to Studiolo*, ed. Feinberg, pp. 39–40.

42 *Brutus, Orator*, trans. Hendrickson and Hubbell, *Orator*, iii.9–10, pp. 312, 313. See Panofsky, *Idea*, pp.

13–16, for the shift in the nature of "idea" represented by Cicero's passage and its relation to the prestige of the visual arts in antiquity.

43 For this remark, see Baxandall, *Giotto and the Orators*, p. 61.

87 (above left). Giotto, *The Death of St. Francis* (detail). Florence, Santa Croce, Bardi chapel.

88 (above right). Ghirlandaio, study for the Tornabuoni chapel *Birth of the Baptist*, pen and ink, 240 × 165 mm. London, British Museum, Department of Prints and Drawings, 1895-9-15-451.

89. Andrea del Sarto, study of a young man for a *Pietà*, red chalk, 270 × 340 mm. Florence, Uffizi, Gabinetto di disegni, 307F.

90. Titian, *Danaë*. Naples, Galleria Nazionale di Capodimonte.

drawing. He certainly admired the accomplishments of artists from other backgrounds: he praised Giorgione because "the best artists of the time confessed that he had been born to give life to figures and to re-create the freshness of living flesh more successfully than anyone who painted not only in Venice but anywhere."[44] But for Vasari artists in the north and other parts of Italy did not have the advantage of the best models, or the best training, particularly in *disegno*. He pitied those artists with a compassion as opportune as it was charitable. They were, after all, his competitors. And while they could achieve extraordinary beauty and lifelikeness – components of the perfection of art – he felt that artists of other regions and schools who failed to study the lessons of Central Italy and antiquity, literally to draw from them, lacked the ability to understand or express the true profundity of art through *disegno*.

He chose Titian's Life to express his regret for what he felt to be the characteristic North Italian inadequacy in drawing. His theoretical statement is made with vivid theatricality. The scene is set in the Belvedere of the Vatican, where he and Michelangelo went to look at Titian's recently completed painting of *Danaë* (pl. 90). Michelangelo says that

> his coloring and style pleased him greatly, but it was a pity that in Venice one did not
> learn to draw well from the beginning and that those painters did not have a better

44 Life of Giorgione, BB IV, pp. 42–3: "egli nel colorito a olio et a fresco fece alcune vivezze et altre cose morbide et unite e sfumate talmente negli scuri, ch'e' fu cagione che molti di quegli che erano allora eccellenti confessassino lui esser nato per metter lo spirito ne le figure e per contraffar la freschezza de la carne viva più che nessuno che dipignesse, non solo in Venezia, ma per tutto."

method of study: "Because," he said, "if this man had been helped at all by art and by drawing, as he has been by nature, especially with respect to imitating life, one could not do anything more or better, since he has a most beautiful spirit and a very charming and lively style." This is indeed the case, because those who have not drawn enough and studied excellent works, ancient or modern, cannot do well by skill alone or improve on things copied from nature, in order to give them that grace and perfection that art adds to nature, which usually produces some parts that are not beautiful.[45]

Vasari acknowledged the attraction of color and its role in creating the lifelike effects in painting. He used the example of another Venetian painter, Battista Franco, to caution against "a certain opinion held by many, who pretend that drawing alone suffices."[46] It was necessary to know how to "handle the brushes," but such dexterity was manual, and Vasari's descriptive and biographical technique was aimed at creating a taste for the considered inventions and beautiful conceptions that arose from the practice of drawing.[47] He said that artists like Giorgione, Palma, Pordenone were forced "to hide the effort of not being able to draw beneath the charm of their colors."[48] This expresses a traditional contempt or mistrust for the simplistic seduction of color, mentioned as a commonplace charge of inadequacy by Leonardo da Vinci for example.[49]

In his dialogue on painting, *L'Aretino* (1557), the Venetian writer Lodovico Dolce offered an alternative, making drawing only one of the three divisions of painting. The other two were invention and coloring. Color was so compelling, he claimed, that a good imitation of the tints and softness of flesh would lack only breath to bring things to life.[50] Dolce turned Michelangelo's superiority in drawing into a limitation. For Dolce "truly it is in Titian alone (and let the other painters take my saying this in good part) that one sees gathered together to perfection all of the excellent features which have individually been present in many cases. Both in terms of invention and in terms of draftsmanship, that is, no one ever surpassed him. And again, as regards coloring, there was never anyone who reached his level."[51] The defense of drawing that forms such a conspicuous part of Vasari's treatment of Titian was probably in part an answer to this. His account of Titian was written

45 Life of Titian, BB VI, p. 164: "dicendo che molto gli piaceva il colorito suo e la maniera, ma che era un peccato che a Vinezia non s'imparasse da principio a disegnare bene e che non avessono que' pittori miglior modo nello studio: 'Con ciò sia – diss'egli – che, se quest'uomo fusse punto aiutato dall'arte e dal disegno, come è dalla natura, e massimamente nel contrafare il vivo, non si potrebbe far più né meglio, avendo egli bellissimo spirito et una molto vaga e vivace maniera.' Et infatti così è il vero, perciò che chi non ha disegnato assai e studiato cose scelte, antiche o moderne, non può fare bene di pratica da sé né aiutare le cose che si ritranno dal vivo, dando loro quella grazia e perfezzione che dà l'arte fuori dell'ordine della natura, la quale fa ordinariamente alcune parti che non son belle."

46 Life of Battista Franco, BB V, p. 460: "lo stare ostinato in una certa openione che hanno molti, i quali si fanno a credere che il disegno basti a chi vuol dipignere, gli fece non piccolo danno."

47 See Vasari's statement about drawing that consti-

tutes the opening to the Life of Titian, BB VI, pp. 155–6. For the need to master painting technique, see Life of Battista Franco, BB V, p. 460: "E se Battista avesse prima cominciato a dipingere et andare praticando talvolta i colori e maneggiare i pennegli, non ha dubbio che averebbe passato molti."

48 Life of Titian, BB VI, p. 156: "avere a nascere sotto la vaghezza de' colori lo stento del non sapere disegnare."

49 Leonardo da Vinci, *Das Buch von der Malerei*, ed. Ludwig, I, p. 404, where he opposes the taste of the ignorant herd ("l'ignorante vulgo"), which wants only the beauty of colors, to those noble intellects who understand relief modeling. For the status of color, with further references, see Rubin, "The art of colour in Florentine painting of the early sixteenth century," *Art History* (1991), pp. 175–91.

50 *Dolce's "Aretino,"* ed. Roskill, pp. 152, 153.

51 *Ibid.*, pp. 184, 185.

91. Giorgio Vasari, *Justice*. Naples, Galleria Nazionale di Capodimonte.

in the 1560s, after Dolce and after the founding of the Accademia del Disegno, so the topic was certainly topical. Many may find Vasari's point of view debatable. And even in his time, Cardinal Alessandro Farnese probably enjoyed the luscious *Danaë* by Titian as much as the curiously contrived *Justice* by Vasari (pl. 91), both in his possession.

The perfection of *disegno*, and with it the realization of beauty, depended upon imitation – the selection of the best models, masters, and the most beautiful elements of nature. Vasari's most extensive treatment of the meaning of imitation to the practice and the history of the arts is in the opening of the Life of Mino da Fiesole. Strategically placed about

half way through *The Lives* in the 1550 edition, it was displaced in the 1568 expansion, but only slight, grammatical changes were made to this crucial statement:

> When our fellow artists try to do no more in their works than to imitate the style of their teacher or another man of excellence whose method of working pleases them ... with time and study they might make their works similar, but they can never attain perfection in their art with this alone, in as much as it is clearly evident that one who always walks behind rarely comes to the front ... for imitation is the sure art of copying what you do exactly after [the model of] the most beautiful things in nature ... Thus one has seen many of our fellow artists who have refused to study anything but the works of their teachers and left nature aside; to these it has happened that they failed to gain any real knowledge of them or to surpass their masters, and have done enormous injury to their talent; because had they studied the style [of their masters] and objects of nature together, they would have produced much better works.[52]

This key passage explains both the necessity of a history in the arts – a succession of masters to be copied – and the means to progress by a continuing process of imitation and reference to nature. It engages with a debate about the formation of style (on one model or on many) that was usually referred to Cicero.[53] In *De Oratore* Cicero advised that the student be shown a good model and then "strive with all possible care to attain the most excellent qualities of the model."[54]

Quintilian had a contrasting view: "imitation alone is not sufficient."[55] He argued that discovery and advance came from the natural force of imagination and he cited the case of painters:

> Shall we follow the example of those painters whose sole aim is to be able to copy pictures by using the measuring rod? It is a positive disgrace to be content to owe all our achievement to imitation. For what, I ask again, would have been the result if no one had done more than his predecessors? ... And even those who do not aim at supreme excellence, ought to press toward the mark rather than be content to follow in the tracks of others. For the man whose aim is to prove himself better than another, even if he does

52 Life of Mino da Fiesole, BB III, pp. 405–6: "Quando gli artefici nostri non cercano altro nell'opere ch'e'fanno che imitare la maniera del loro maestro o d'altro eccellente, del quale piaccia loro ... se bene col tempo e con lo studio le fanno simili, non arrivano però mai con questo solo a la perfezzione dell'arte, avvengaché manifestissimamente si vede che rare volte passa inanzi chi camina sempre dietro ... con ciò sia che l'imitazione è una ferma arte di fare apunto quel che tu fai come sta il più bello delle cose della natura ... le cose tolte da lei [natura] fa le pitture e le sculture perfette, e chi studia strettamente le maniere degli artefici solamente, e non i corpi o le cose naturali, è necessario che facci l'opere sue e men buone della natura e di quelle di colui da chi si toglie la maniera; laonde s'è visto molti de' nostri artefici non avere voluto studiare altro che l'opere de' loro maestri e lasciato da parte la natura, de'

quali n'è avenuto che non le hanno apprese del tutto e non passato il maestro loro, ma hanno fatto ingiuria grandissima all'ingegno ch'egli hanno avuto; ché s'eglino avessino studiato la maniera e le cose naturali insieme, arebbon fatto maggior frutto nell'opere loro che e' non feciono." Previously, in the opening to the Life of Pesello, Vasari made a statement about the competitive relationship between master and students, with pupils seeking to surpass their teachers (BB III, p. 371).

53 For the history of the concept of imitation and its place in Renaissance literary practice see Greene, *Imitation and Discovery in Renaissance Poetry*, and Pigman, "Versions of Imitation in the Renaissance," *Renaissance Quarterly* (1980), pp. 1–32.

54 *De Ora.*, II.xxii.90, vol. I, pp. 264, 265.

55 *I.O.*, x.ii.4, vol. IV, pp. 76, 77.

not surpass him, may hope to equal him. But he can never hope to equal him, if he thinks it is his duty merely to tread in his footsteps: for the mere follower must always lag behind.[56]

For Quintilian "the greatest qualities of the orator are beyond all imitation, by which I mean talent, invention, force, facility and all the qualities which are independent of art."[57] Notions derived from Quintilian's association of individual talent and progress were obviously attractive to Vasari, who adapted them to his purpose in advocating a model that explained how each artist could realize his talent, not walking behind or following the tracks of others but studying to develop a personal style.

Where art, *disegno*, and imitation were universals, style – *maniera* – could be subject to circumstances.[58] It had "causes" and "origins."[59] It could be good, bad, old, or modern. It could depend upon place and personality. It was up to Vasari to define those factors in each case and then to order them according to his containing scheme of development in the three ages.

In his letter of around 1519 to Pope Leo X about the antiquities of Rome, Raphael wrote of the three successive styles of building and sculpture that were found there: the good style of the ancients which dated from the first emperors until the destruction of Rome by the Goths and other barbarians; the period of domination by the Goths and for a hundred years after that; and subsequently the one that lasted to Raphael's time.[60] The division of architectural styles between ancient, German, and modern pre-dated this. It occurs in Manetti's biography of Brunelleschi, for example. And Raphael says that it was not necessary to speak about Roman architecture in order to compare it with barbarian, or German, building, "because the difference is very well known."[61] The word *maniera* had long been applied to painters as well. In his late fourteenth-century manual on painting, Cennino Cennini advised aspiring artists to find the best master and the one with the greatest reputation to copy. With daily study, he said, "it would be unnatural if you did not get some grasp of his style."[62] This counsel shows that both the differentiation and acquistion of style were integral to the tradition Vasari was describing.

In the concluding letter to *The Lives* he wrote of the importance he gave to checking all his written sources against the works themselves,

> because long practice, as you know, teaches adept painters to recognize the various styles of artists, just as a learned and experienced court official can recognize the diverse and

56 *I.O.*, x.ii.6–7,10, vol. IV, pp. 76–9.

57 *I.O.*, x.ii.12, vol. IV, pp. 80, 81.

58 For the definition of *maniera*, its origins and issues relating to the discussion of style in Vasari's day, see, Kemp, " 'Equal excellences,' " *Renaissance Studies* (1987), pp. 1–26, Mirollo, *Mannerism and Renaissance Poetry*, Shearman, " 'Maniera' as an aesthetic ideal," in *The Renaissance and Mannerism*, II, pp. 203–12, and *Mannerism*.

59 In the preface to Part 2, BB III, p. 4, Vasari explains that in order to inform those readers who would not know how to do it for themselves, he has investigated the causes and origins of artists' styles ("le cause e le radici delle maniere").

60 Golzio, *Raffaello nei documenti*, pp. 84–5: "Perchè di tre maniere di edificii solamente si ritrovano in

Roma, delle quali la una è di que' buoni antichi, che durarono dalli primi imperatori sino al tempo che Roma fu ruinata et guasta dalli Gotti et da altri barbari; l'altra durò tanto che Roma fu dominata da' Gotti et anchora cento anni di poi; l'altra da quel tempo sino alli tempi nostri."

61 *Ibid.*, p. 87: "Ma non è necessario parlar dell'architectura Romana, per farne paragone con la barbara, perchè la differentia è notissima."

62 Cennini, *The Craftsman's Handbook*, chapter 27, p. 15. *Il libro dell'arte*, ed. Brunello and Magagnato, p. 27: "guarda di pigliar sempre il migliore e quello che ha maggior fama; e seguitando di dì in dì, contra natura sarà che a te non venga preso di suo' maniera."

various hands of his peers and each [person can recognize] the characters of his nearest friends and relations.[63]

Ascription – recognition of personal style – was a form of description. Once grouped under the name of an artist, works could be understood as created according to his character. The artists' lives follow the order of manners, but there was considerable variation within the sequence of styles and that depended upon the particular talent and education of the individual – what came by nature and what by nurture, what were the circumstances that allowed style to be formed and to develop. Those less fortunate, such as artists of the benighted earlier ages, might have "old" style, like the architect Arnolfo di Cambio or poor Parri Spinelli whose figure style Vasari explained as tragically determined by the fact that he

suffered an armed assault by some of his relations with whom he was disputing something about a dowry . . . he was rescued without being harmed, but nevertheless it is said that the fright was such that from that time on not only did he always paint his figures leaning to one side but they also nearly always looked terrified [pl. 92].[64]

There were also period and regional styles. In the Life of Andrea Pisano Vasari says that those who understand such things can tell the difference between the styles of all countries.[65] He gives the example of Egyptian, Greek, and Etruscan styles and concludes with the Roman,

so beautiful in its expressions, poses, movements, nudes, and draperies, that it could be said that they took the best from all the other provinces and combined it into a single style so that it could be the best, which it is; in fact it is the most divine of them all.[66]

The Byzantine Greeks, "old, not ancient," by contrast, had a "rough and clumsy and common" style.[67] The figures in their paintings tottered on tiptoes and had hard outlines, pointed hands, and staring eyes which Vasari called monstrosities.[68] Good style was derived from seeking the most beautiful aspects of its source: so what was available influenced what was possible. It related to study, in finding models to copy, and to judgment, in the ability to make a proper selection and to understand the difference between dry repetition and the

63 Letter to the artists, BB VI, p. 411: "ho . . . sempre voluto riscontrare il lor dire con la veduta dell'opere: essendo che insegna la lunga pratica i solleciti dipintori a conoscere, come sapete, non altramente le varie maniere degl'artefici che si faccia un dotto e pratico cancelliere i diversi e variati scritti de' suoi eguali, e ciascuno i caratteri de' suoi più stretti famigliari amici e congiunti."

64 Life of Parri Spinelli, BB III, p. 120: "fu assaltato da certi suoi parenti armati con i quali piativa non so che dote . . . fu soccorso di maniera che non gli feciono alcun male; ma fu nondimeno, secondo che si dice, la paura che egli ebbe cagione che, oltre al fare le figure pendenti in sur un lato, le fece quasi sempre da indi in poi spaventaticce." See the Life of Arnolfo di Cambio, BB II, p. 47, where Vasari comments about the style of buildings of Arnolfo's time that they were "fabriche di maniera vecchia non antica."

65 Life of Andrea Pisano, BB II, p. 151: "si ri-

conosce . . . da chi intende, la differenza delle maniere di tutti i paesi."

66 Ibid.: "tanto bella per l'arie, per l'attitudini, pe' moti, per gl'ignudi e per i panni, che si può dire che egl'abbiano cavato il bello da tutte l'altre provincie, e raccoltolo in una sola maniera perché la sia, com'è, la miglior[e] anzi la più divina di tutte l'altre."

67 Life of Cimabue, BB II, p. 37: "la maniera di que' Greci . . . scabrosa e goffa et ordinaria." See the preface to The Lives, BB II, p. 29, where Vasari distinguishes between the "old" and the "ancient" Greeks ('vecchi e non antichi') and where he explains his definitions of "vecchio et antico."

68 Preface to Part 2, BB III, pp. 11–12, in Giotto's style: "si vede . . . levato via il proffilo che ricigneva per tutto le figure, e quegli occhi spiritati e' piedi ritti in punta, e le mani aguzze, et il non avere ombre, et altre monstruosità di que' Greci."

92. Parri Spinelli, *Crucifixion.*
Arezzo, Palazzo Comunale.

creative combination of elements.[69] It involved knowing where to start and when to stop. In the 1568 edition of his Life, Vasari makes Raphael a positive paradigm of this; the counter-example is provided by Pontormo's willful reliance on the German style of Dürer's prints, substituting extravagance for grace.[70]

For Vasari good style, which was beautiful, attractive, and charming, was inseparable from the constituent skills and qualities of perfection (or the artist perfecting those skills). So the sculptor Antonio Rossellino, so gracious in the practice of his art that he was well-nigh adored as a saint, was also "so sweet and delicate in his works, and so perfect in finish and polish, that his manner can justly be called true and truly be called modern" (pl. 93).[71] Vasari's vocabulary of praise and appraisal describes ends and means, often in the same word. It is far from systematic, but it is deliberate. In order to make the visual arts intelligible to the inner eye of understanding the physical matter of Vasari's history – paintings, statues,

69 See for this Nova, "Salviati, Vasari, and the Reuse of Drawings," *Master Drawings* (1992), pp. 83–108.

70 Life of Raphael, BB IV, pp. 204–8, where he also mentions Pontormo (p. 208), and the Life of Pontormo, BB V, pp. 319–22.

71 Life of Antonio Rossellino, BB III, p. 391: "il quale fece la sua arte con tanta grazia che da ogni suo conoscente fu stimato assai più che uomo et adorato quasi per santo per quelle ottime qualità che erano unite alla virtù sua . . . Fu costui sì dolce e sì delicato ne' suoi lavori, e di finezza e pulitezza tanto perfetta, che la maniera sua giustamente si può dire vera e veramente chiamare moderna."

93. Antonio Rossellino, detail from the Cardinal of Portugal monument. Florence, San Miniato al Monte.

buildings – had to be transcribed, transformed by words, and translated in order to express its value. To do so he formed his own style of description from a combination of sources. Like his style of painting, it was intended to have the authority and grace of the selected and imitated models and to give a suitable and pleasing form to its subject.

The Vocabulary of the Arts

In the general preface to *The Lives* Vasari apologizes to his readers for his language:

> It remains for me to apologize for having occasionally employed a term that was not proper Tuscan, about which I do not want to speak, having always taken more trouble to use the terms and words particular and proper to our arts rather than those that are charming or chosen by the refinement of writers. Allow me therefore to use the actual terms of artists in the actual language, and let all be assured of my good will, which has been moved to this end not to teach others things that I do not know for myself but by the wish to preserve at least this memory of the most celebrated artists.[72]

It was "above all," he said, not his "intention to teach how to write Tuscan, but only the life and the works of the artists that I have described."[73] These extraordinary disclaimers (why should biography be categorically confused with language instruction?) demonstrate how inextricably for contemporary readers the aims of *The Lives* might be seen to be bound up with their means of expression.

In a carefully turned phrase Vasari had also asked Cosimo to forgive him for writing as he spoke, in a natural and unrefined style, unworthy of both the duke's ear and the artists' merits.[74] In so doing he shrewdly rejected the affectation of learning while demonstrating the command of eloquence demanded by his chosen, exemplary, form of biography. Rhetoric included a "simple" style "following the current idiom of standard speech."[75] In the discussion of qualities that "should characterize an appropriate and finished style," part of *elegantia* (taste) is described as *explanatio* or clarity that

> renders language plain and intelligible. It is achieved by two means, the use of current terms and of proper terms. Current terms are such as are habitually used in everyday speech. Proper terms are such as are, or can be, the designations specially characteristic of the subject of our discourse.[76]

Vasari's manner of speaking provided him with "current terms" and his profession provided

72 General preface to *The Lives*, BB I, pp. 29–30: "Resterebbemi a fare scusa de lo avere alle volte usato qualche voce non ben toscana, de la qual cosa non vo' parlare, avendo avuto sempre più cura di usare le voci et i vocaboli particulari e proprii delle nostre arti, che i leggiadri o scelti della delicatezza degli scrittori. Siami lecito adunque usare nella propria lingua le proprie voci de' nostri artefici, e contentisi ognuno de la buona volontà mia, la quale si è mossa a fare questo effetto non per insegnare ad altri, che non so per me, ma per desiderio di conservare almanco questa memoria degli artefici più celebrati."

73 Conclusion, BB VI, pp. 412–13 (1550): "non essendo massimamente lo intento mio lo insegnare scriver toscano, ma la vita e l'opere solamente degli artefici che ho descritti."

74 Dedicatory letter, BB I, p. 3: "Ma se la scrittura, per essere incolta e così naturale com'io favello, non è degna de lo orecchio di Vostra Eccellenzia né de' meriti di tanti chiarissimi ingegni, scusimi."

75 *Ad H.*, IV.viii.11, pp. 252, 253.

76 *Ad H.*, IV.xii.17, pp. 268–71.

him with "proper terms." The rhetorical definition of current and proper terms underlies Annibale Caro's comment that he found Vasari's text to be written simply and well and that "in a work of this type I wish the writing to be exactly like speaking," for that is how he glossed it in the version of the letter to Vasari that he prepared for publication, adding, "so that it partakes more of the proper than the metaphorical . . . and of the current than of the affected."[77] As with his claim not to be a writer, Vasari's style of not-writing was as strategic as it was appropriate.

Moreover, if Vasari was truly writing as he spoke, he was given to making statements in periodic prose, and his way of speaking was often uncannily like that of protagonists in dialogues on other subjects. His style, however fluid and at times hasty, is not like the reported speech of court depositions or the street talk of the characters in Aretino's plays, both types of writing whose language is presumably closer to conversation than Vasari's in his book on the arts. Indeed, his periodic pretensions had provoked Caro to suggest that he remove certain latinate transpositions of words and verbs placed at the end of sentences, "for elegance."[78] The fact is that, despite all disclaimers, in writing *The Lives* Vasari became a writer. The legitimacy of his text depended in part on its relations to literary forms and literary language. Its validity depended on its fidelity to his subject, the source of his "actual" terms.

In his book on the vernacular, Pietro Bembo wrote about the power of speech to obtain a desired end if that aim could be expressed in a beautiful and graceful manner.[79] This highly influential dialogue is indicative of the importance given to discerning style and its effective potential: essential premises of Vasari's *Lives*. In his dialogue on the vernacular, Pierio Valeriano also wrote about the various ways of speaking. His terms of praise, like Bembo's, were grace and charm; a speaker should find an agreeable manner to express his ideas and have a "pleasing and sweet and attractive" mode of speech.[80] He wrote that to arrive at praiseworthy language it was necessary to follow Latin as closely as possible, and said that those Tuscans who did not wish to do so in pronunciation, words, or accent remained crude and inept.[81] Not only is Valeriano's gamut of distinction from *rozzo* to *grazioso* Vasari's, but so too is his definition of the means – an adaptive mastery of the models provided by classical antiquity.[82] In one case he wrote how Florentines avoided a certain pronunciation because it was "too clumsy and had something of German in it," showing that disapproval of the barbarian north went beyond building style.[83] Ultimately derived from classical writers, the

77 Frey i, cv, p. 210 (Rome, 15 December 1547 to Vasari, Florence), the version sent to Vasari reads: "In un' opera simile vorrei la scrittura a punto come il parlare." The version in the manuscript collection now in Paris (Bibliothèque Nationale, Ital. 1707) adds: "cioè ch'avesse più tosto del proprio che del metaforico . . . e del corrente più che de l'affettato" (*Lettere*, ii, p. 50). For the Paris manuscript, first published in 1572, but assembled by Caro before his death (in November 1566), see *Lettere*, i, pp. xx–xxi.

78 Frey i, cv, p. 210: "Solo ui desidero, che se ne leuino certi trasportamenti di parole e certi verbi, posti in fine, che si fanno tal uolta per eleganza."

79 Bembo, *Prose della volgar lingua*, ed. Marti, p. 40.

80 Valeriano, "Dialogo . . . sopra le lingue volgari,"

in *La infelicità dei letterati*, p. 327: "grata e dolce ed attrattevole maniera di dire."

81 *Ibid.*, pp. 328–9: "perchè i letterati conoscendo che niuna lingua è perfetta in sè, volendone fare una lodevole si servono della Latina, e quanto più possono vi si accostano . . . ed i Toscani che vogliono discostarsi dalla pronuncia, dai vocaboli, dagli accenti del Latino, restano rozzi ed inetti."

82 Similarly Bembo in the opening to Book iii of *Prose della volgar lingua*, ed. Marti, pp. 97–9.

83 Valeriano, "Dialogo . . . sopra le lingue volgari," in *La infelicità dei letterati*, p. 364: "Or vi confesso che i Fiorentini non pronunciano nè *laudare* nè *gaudere*, perchè par loro quel dettongo *au* troppo goffo, e che abbia del Tedesco."

corresponding Latin words for the dialectic of distinction common to these and other contemporary writers included *ornatus* (ornate), *suavis* (pleasing), *dulcis* (sweet), *gratia* (grace), and *aridus* (dry), *durus* (harsh), *asperitas* (harshness), *incultus* (untrained), *horridus* (rough). These contrasts were long established and were axiomatic by Vasari's day. They were enshrined in Petrarch's musing over the bitter-sweet torments of love and his longing for his beautiful and graceful lady, Laura.[84] They constituted the conventional structuring of critical perception, a symmetry of understanding matched by the ordered oppositions of forms in the compositions Vasari studied and described. The vocabulary was one of antithesis, based on things pleasing and unpleasing to the senses, including sight.

Vasari's critical method and his separation and characterization of the three ages is based on perceiving and in turns praising and blaming along the recognized trajectory from inept to polished: from the awkwardness and lack of proportion imposed on things by the grossness of the first era to the accomplished charm, polish, and sweetness of the third.[85] His aesthetic standard relates to the prevalent measures of style and beauty of his day. His text was part of a wider discussion of the ways, means, and modes of expression. The rhetorical premises of such discussion were particularly suited to representing the communicative power and charm of the type of work Vasari valued most highly – that based on the human figure. Within this framework sense became sensibility and desire, longing, and love were sanctioned responses. Formalized and informed desire further justified the embodiment of abstract values in figurative art, which gave shape to intellectually mediated beauty. The acceptance and diffusion of the rhetoric of refinement corresponded to a pervasive awareness of form, in forms of behavior, power, and polity as well as poetry, prose, and the visual arts. Artifice was adopted and appreciated in formulations of identity and its means of display.

Vasari's chosen terms express a range of associations given to visual experience in his time and suggest the cultural values attached or attachable to the three arts of design, from ethical notions of honor, reputation, and fame to the more strictly aesthetic ones of beauty, charm, and grace. The lexicon of *The Lives* includes specifically evocative as well as generally evaluative language. There were technical and material problems, or difficulties, faced by the masters of each art, and there were traditions of exchange and understanding proper to the different arts, as Vasari well knew from his own experiences and those of his friends.[86] These differences are registered in *The Lives* where the arts retain their material and conceptual identities through the "actual terms" Vasari used.

Architecture had the most extensive literature with theoretical, technical, and bio-graphical precedents for Vasari. He credited two writers (Vitruvius and Alberti) in the opening lines of his technical introduction. He relied heavily on another two works,

ˈ 84 For example, *Canzoniere* 132:3–4, opposing "l'ef-fecto aspro mortale" and the "sí dolce . . . tormento" of love, and *Canzoniere* 268:45, addressing his "Piú che mai bella et piú leggiadra donna" (ed. Contini, pp. 184, 338).

85 Preface to Part 2, BB III, p. 6, things improved in the second age: "tolto via quella ruggine della vecchiaia e quella goffezza e sproporzione che la grossezza di quel tempo le aveva recata adosso."

86 For the relation of language to theory and practice in the period, see Summers, *Michelangelo and the Language of Art* and *The Judgment of Sense*. For Vasari in particular, see Le Mollé, "L'invention sémantique chez Vasari," *Revue des études italiennes* (1985), pp. 36–57, and *Georges Vasari et le vocabulaire de la critique d'art dans les "Vite."*

Serlio's *Regole generali sopra le cinque maniere de gli edifici* and Manetti's Life of Brunelleschi, without naming them. For all of these authors and in the architectural practice of his time, the basis of architectural practice and of pleasing architectural style lay in the mastery of the classical language of architecture, in understanding the use of the orders, in the order represented by the proportional system and measures of those orders, and in the ability to produce informed variations. The "Vitruvian rule" was one Vasari used for architects and one studied by the architects of the period.[87] Vitruvius defined order as that which "gives due measure to the members of a work considered separately, and symmetrical agreement to the proportions of the whole."[88] Vasari takes this to be the rule of ancient architecture.[89] Where it is lacking, as in German or Gothic buildings, there was a deformity so disgusting to Vasari that he found it barely worth discussing.[90] He adapted Vitruvius's attack on the monstrous representations of architecture in contemporary wall-painting and the description of their faults to his own distaste for what he considered to be the irrational building of the German style.[91]

Following Manetti, Vasari vested the recovery of the rules in Brunelleschi's name. He defined architectural style before Brunelleschi as old, not ancient. Few names survived, even in the case of important and clearly expensive buildings, which caused him to marvel at the foolishness and limited desire for glory of men of those times.[92] In the résumé of building in the first period that constitutes the Life of Arnolfo di Cambio, Vasari gives little space to detailed descriptions, content to give some indication of what was done, and not much about in what way. Buildings were neither beautiful nor in a good style, only "very big and magnificent."[93] The latter is a word Vasari applied almost exclusively to architecture. Following Aristotle, the virtue of magnificence was "a fitting expenditure involving largeness of scale."[94] Architecture was the largest possible expense. As a private investment it brought beauty to the public sphere and as a public expenditure it honored the state. In the case of the first period Vasari equated magnificence with cost and size. His other comments demonstrate the misconceived efforts of the time, like the Pieve of Arezzo (pl. 94) where Marchionne

> finished the building . . . and the bell-tower as well. For the facade of this church, he sculpted three rows of columns, one above the other, with great variety not only in the fashion of the capitals and bases, but also in the shafts of the columns . . . He also made several kinds of animals that supported the weight of these columns on their backs, and all with the strangest and most extravagant inventions that one could imagine, not

87 Life of Peruzzi, BB IV, p. 321, for example, about Baldassare Peruzzi's design for the duomo of Carpi made "according to the rules of Vitruvius" ("secondo le regole di Vitruvio con suo ordine fabbricato"). Generally see Pagliara, "Vitruvio da testo a canone," in *Memoria dell'antico nell'arte italiana*, ed. Settis, III, pp. 67–74.

88 *The Ten Books on Architecture*, trans. Morgan, Book i, II.2, p. 13.

89 Preface to Part 3, BB IV, pp. 3–4.

90 Technical introduction, BB I, p. 68.

91 Gombrich, "The Stylistic Categories of Art History," in *Norm and Form*, pp. 83–4.

92 Life of Arnolfo di Cambio, BB II, p. 47: "non posso se non maravigliarmi della goffezza e poco disiderio di gloria degl'uomini di quell'età."

93 *Ibid.*: "se bene non sono né di bella né di buona maniera ma solamente grandissimi e magnifici, sono degni nondimeno di qualche considerazione."

94 Aristotle, *The Complete Works*, ed. Barnes, II, *Nichomachean Ethics*, Book IV, chapter 2, p. 1771 (1122a23). See further Fraser Jenkins, "Cosimo de' Medici's Patronage of Architecture and the Theory of Magnificence," *Journal of the Warburg and Courtauld Institutes* (1970), pp. 162–70.

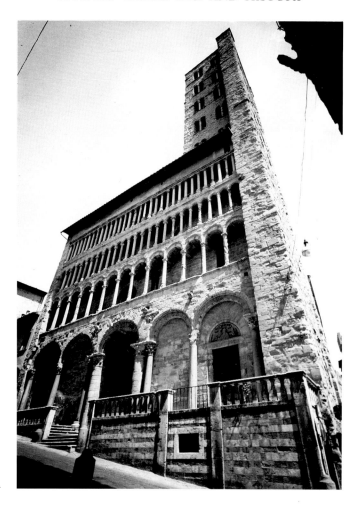

94. Arezzo, Pieve.

only disregarding the good precepts of the ancients, but also all correct and reasonable proportions.[95]

He excused Marchionne for trying to do his best. In doing so he assigned the facade design to a single artistic intention, however misguided, and made building primarily the expression of personal talent and period limitations, thereby validating his biographical premise. In reality building was generally credited to its sponsors and building histories were often complicated and long-drawn-out processes of consultation, delegation, and compromise. And in this case Vasari attributed the facade and completion of the building to the sculptor of the portal, who, as Vasari says, placed "his own name underneath in round letters, as was

95 Life of Arnolfo di Cambio, BB II, pp. 49–50: "Il medesimo Marchionne finì . . . la fabrica della Pieve d'Arezzo e similmente il campanile, facendo di scultura nella facciata di detta chiesa tre ordini di colonne, l'una sopra l'altra molto variatamente non solo nella foggia de' capitegli e delle base, ma ancora nei fusi delle colonne . . . Vi fece ancora molti animali di diverse sorti che reggono i pesi, col mez[z]o della schiena, di queste colonne, e tutti con le più strane e stravaganti invenzioni che si possino imaginare, e non pur fuori del buono ordine antico, ma quasi fuor d'ogni giusta a ragionevole proporzione."

the custom, and the date – namely, the year 1216."[96] The renovations of the Pieve of Santa Maria began in the twelfth century and the campanile dates from 1336.

The Pieve manifests the faults Vasari found typical of buildings in the "old" style: "without order, with bad method, sorry design, most strange inventions, most ungraceful grace, and even worse ornament."[97] The arcades of the facade with their richly varied columns and capitals are far from the orders used by architects of Vasari's day, which were clearly differentiated in their combinations of capitals and entablatures. Totally lacking the "due measure" of Vitruvius, the progressive narrowing of the intercolumniation, though regular, is not proportional according to the rules of the orders. Its "fanciful variety" did not constitute legitimate ornament in the classical or classicizing sense of elements related to each order in the architrave, frieze, and cornice.[98] The ornaments of the orders were explained by Vitruvius and by Alberti. The word ornament as used here is a technical term, and it is one Vasari generally reserved for architecture; but the link between the ornate or embellished and grace was also a commonplace association derived from classical rhetorical theory. The association of ornament and grace was the subject of Book VI, chapter 2 of Alberti's treatise. The qualitative connotations of embellishment were transferred by both Alberti and Vasari to a manufactured form, bringing to it a notion of delight.

Brunelleschi, according to Vasari, "was sent to us by heaven in order to give new form to architecture": in contrast with the confusion of the old that new form was ordered and correctly ornamented.[99] So he described Santo Spirito (pls. 95, 96):

The length of the church was one hundred and sixty-one *braccia*, and the width fifty-four *braccia*, and it was so well planned, both in the ordering of the columns and in the rest of the ornaments, that it would be impossible to make a work richer, more graceful, or lighter than that one . . . it is more lovely and better designed than any other.[100]

In addition to the order of the columns, the terms specific to architecture are also those of size – the actual measurements given – and of the subdivision of the space both in plan and elevation ("spartimento"). Both rich and graceful ("ricca," "vaga") are words linked with the orders when correctly used. "Ariosa" has a sense of both airy and pleasing; it complements the other terms and effectively conveys what it is like to walk into Santo Spirito.

Vasari describes Brunelleschi as having worked in a modern way, and as having "imitated and restored to the light, after many ages, the noble works of the most learned and

96 *Ibid.*, p. 50: "ponendovi sotto il nome suo in lettere tonde, come si costumava, et il millesimo, cioè l'anno MCCXVI."

97 Life of Brunelleschi, BB III, p. 138: "senza ordine, con mal modo, con tristo disegno, con stranissime invenzioni, con disgraziatissima grazia e con peggior ornamento."

98 Life of Arnolfo di Cambio, BB II, p. 50, Vasari concludes about the columns of the facade that they were "non pur fuori del buono ordine antico, ma quasi fuor d'ogni giusta e ragionevole proporzione," and that Marchionne "andò sforzandosi di far bene e pensò per avventura averlo trovato . . . in quella capricciosa

varietà." For Vitruvius's measure, see *The Ten Books on Architecture*, trans. Morgan, Book I, II.2, p. 13. For the orders, see Summerson, *The Classical Language of Architecture*.

99 Life of Brunelleschi, BB III, p. 138: "ci fu donato dal cielo per dar nuova forma alla architettura."

100 *Ibid.*, p. 194: "La lunghezza della chiesa fu braccia 161 e la larghezza braccia 54, e tanto ben ordinata, che non si può fare opera, per ordine di colonne e per altri ornamenti, né più ricca, né più vaga né più ariosa di quella . . . è il più vago e meglio spartito di qualunche altro."

marvelous ancients."[101] He thereby projected the sixteenth-century understanding and imitation of the articulation of the classical orders onto the early fifteenth century. One source for this was Manetti's biography. Dating from the 1480s, polemical and proud of its own antiquarian knowledge, this Life included a long, largely unsubstantiated, passage on Brunelleschi's detailed study of ancient monuments in Rome, which Vasari freely adopted. In this account of excavating, measuring, and drawing, Brunelleschi is credited with the rediscovery of "the fine and highly skilled method of building of the ancients and their harmonious proportions" and the first recognition of the characteristics of the orders, which he used in his buildings.[102] Affirming this allowed Vasari to maintain the Florentine priority in the progress of the arts. It neglects the fact that Brunelleschi did not employ the full vocabulary of the orders, devising instead a modified Corinthian from Tuscan Romanesque buildings and developing his own systems of proportional design.[103] But it observes the effect of Brunelleschi's insistently ordered and clearly articulated spaces and their difference from previous buildings.

As with painting and sculpture, true excellence belonged to the third era when the Florentine achievements were perfected in Rome. So Bramante,

> following Filippo [Brunelleschi's] footsteps, made the path of his profession of architecture secure for all who came after him, by means of his courage, boldness, intellect, and science in that art, based not only on theory, but more especially on skill and experience. Nor could nature have created a more vigorous intellect, or one to exercise his art and carry it into execution with greater invention and proportion, or with a more thorough knowledge than [Bramante] . . . for if the Greeks were the inventors of architecture, and the Romans their imitators, Bramante not only taught us by imitating them with new invention, but also added very great beauty and difficulty to the art, which we see embellished by him to the present day.[104]

The imitative relationship is carefully defined. Bramante is not content merely to tread in Brunelleschi's footsteps. He has those qualities "independent of art" − talent, invention, force − that Quintilian prescribed as necessary to the progress that Vasari observes between the architecture of Brunelleschi and that of Bramante.[105] The distinction between the two excellent architects of the two different eras is subtly achieved by naming their forms of imitation differently, giving Brunelleschi the more vernacular term of *contrafare*, which could

101 Life of Bramante, BB IV, p. 73: "avendo egli contrafatto e dopo molte età rimesse in luce l'opere egregie de' più dotti e maravigliosi antichi."

102 *Vita*, ed. De Robertis and Tanturli, p. 66: "fece pensiero di ritrovare el modo de' murari ecellenti e di grandi artificio degli antichi e le loro proporzioni musicali," and pp. 69–70: "col suo vedere sottile conobbe bene la distinzione di ciascuna spezie, come furono Ionice, Dorice, Toscane, Corinte et Attice, e usò a' tempi ed a' luoghi della maggiore parte, dove gli pareva meglio."

103 See Burns, "Quattrocento Architecture and the Antique. Some Problems," in *Classical Influence on European Culture*, ed. Bolgar, pp. 269–87.

104 Life of Bramante, BB IV, pp. 73–4: "[Bramante] seguitando le vestigie di Filippo, facesse agli altri dopo lui strada sicura nella professione della architettura, essendo egli di animo, valore, ingegno e scienza in quella arte non solamente teorico, ma pratico et esercitato sommamente: né poteva la natura formare uno ingegno più spedito, che esercitasse e mettesse in opera le cose della arte con maggiore invenzione e misura e con tanto fondamento quanto costui . . . se pure i Greci furono inventori della architettura e i Romani imitatori, Bramante non solo imitandogli con invenzion nuova ci insegnò, ma ancora bellezza e difficultà accrebbe grandissima all'arte, la quale per lui imbellita oggi veggiamo."

105 *I.O.*, x.ii.12, vol. IV, pp. 80, 81.

95. Filippo Brunelleschi, Santo Spirito, Florence, interior. 96. Filippo Brunelleschi, Santo Spirito, Florence, interior.

have the pejorative senses of counterfeiting or impersonating, and Bramante the more latinate *imitare*. According to Vasari, Bramante achieved a full revival of the classical principles and with this a rebirth of a style complete in all its details and parts, which he lists: "the outlines of the mouldings, the shafts of the columns, the graceful capitals, the bases, the consoles and the corners, the vaults, the staircases, the projections, and every order of architecture."[106] In this he captures a visible difference between the two architects and two understandings of the meaning and relevance of ancient buildings to modern practice (pls. 95, 96, 97). He uses the vocabulary of the orders in this Life as Bramante did in his career: specifying Doric, Ionic, and Corinthian in the Vatican Belvedere and the Rustic of the tribunal palace he began for Julius II on Via Giulia, for example.

Not only imitation, but invention is Bramante's. Vitruvius defined invention as "the solving of intricate problems and the discovery of new principles by means of brilliancy and versatility."[107] Finding new solutions was one of Alberti's requirements for an architect. He said that one of the distinguishing features between a builder (*muratore*) and an *architetto*

106 Life of Bramante, BB IV, p. 74: "le modanature delle cornici, i fusi delle colonne, la grazia de' capitegli, le base, le mensole, et i cantoni, le volte, le scale, i risalti, et ogni ordine d'architettura."

107 Vitruvius, *The Ten Books on Architecture*, trans. Morgan, Book i, II.2, p. 14. For the different forms of invention, see Kemp, "From 'mimesis' to 'fantasia,'" *Viator* (1977), pp. 347–98.

97. Bramante, Belvedere, Vatican.

was the inventive capacity of the latter.[108] In his discussion of the Doric order, Serlio called Bramante the "inventor of good and true architecture, which had been buried from the ancients until his time in the reign of Pope Julius II."[109] Bramante's inventive talent, his "ingegno capriccioso," is a defining theme of the Life, and it is related to architectural theory.[110] The terms for the artist are proper to his art. They are also crucial in expressing how the third period surpassed antiquity, not copying it, but absorbing its lessons and arriving at the ability to exercise the imaginative freedom – or license – that Vasari found essential to the excellence of the modern age.[111]

Where Bramante fulfills the Albertian ideal, Antonio da Sangallo the Younger is the Vitruvian man in *The Lives*. His biography is another instance of an ingenious adaptation of a source and its language to the characterization of the practitioner. In the 1550 edition Vasari represented Antonio explicitly as an architect whose buildings "never departed from Vitruvius's terms and proportions, and [he] studied him until he died."[112] Antonio da Sangallo was indeed a scrupulous observer, even critic, of the order and rules of "our author

108 Alberti, *L'architettura*, trans. Bartoli, Book ix.x, p. 351.

109 Serlio, *Regole generali sopra le cinque maniere de gli edifici*, Book iv, fol. 19r: "inventor de la buona & vera Architettura, che dagli antiqui sin al suo tempo sotto Iulio ii Pontefice massimo era stato sepolto."

110 Life of Bramante, BB iv, p. 78.

111 Preface to Part 3, BB iv, pp. 4–5.

112 Life of Antonio da Sangallo, BB v, p. 28 (1550): "non uscissero fuor de' termini e misure di Vitruvio, e continuamente infin che morì studiò quello."

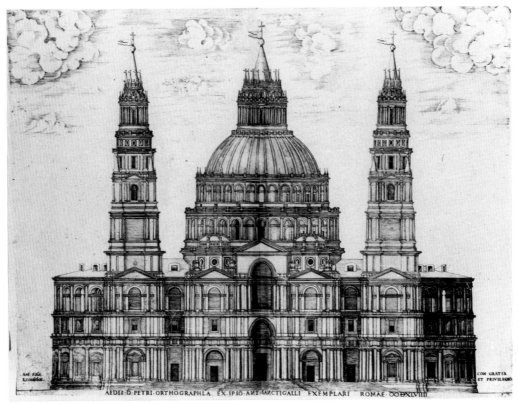

98. After Antonio da Sangallo, engraving after the wooden model for St. Peter's. Vatican.

Vitruvius," as he called him.[113] On a drawing for an Ionic entablature for a fireplace he noted, "Vitruvius is clumsy" and changed the proportions.[114] When Vasari first described Sangallo's most important project, the model for St. Peter's, he saw it and made the reader see it, as done "with grace and well-proportioned composition as well as with decorum and the distribution of its spaces with most beautiful elements situated and fixed in various parts" (pl. 98).[115] This praise neatly combines Vitruvius's order, disposition, proportion, decorum, and distribution, the "fundamental principles" of architecture set out in Book i of *The Ten Books on Architecture*. It also puts Antonio in his place with regard to Michelangelo whose originality Vasari celebrated as having broken the "bonds and chains" of a "common practice" too closely dependent on a reconstructed classical canon.[116] Part of Vasari's aesthetic formation was in the Vitruvian ambient of Claudio Tolomei's academic set, so he

113 On a drawing in the Uffizi (A 989): "questo nostro autore di Vitruvio."

114 Uffizi (A 981): "Vitruvio è goffo." For these and for Antonio da Sangallo and Vitruvius, see Pagliara, "Vitruvio da testo a canone," in *Memoria dell'antico nell'arte italiana*, ed. Settis, III, pp. 46–55, p. 47 (UA 989), 51 n. 24 (UA 981).

115 Life of Antonio da Sangallo, BB v, p. 48 (1550):

"di leggiadria e di proporzionata composizione e di decoro e distribuzione de' suoi luoghi con bellissimi corpi in più parti di quella [fabbrica] situati e fermi."

116 Life of Michelangelo, BB VI, p. 55: "gli artefici gli hanno infinito e perpetuo obligo, avendo egli rotti i lacci e le catene delle cose che per via d'una strada comune eglino di continuo operavano."

greatly commended a reliance on proportions and principles studied from the antique and valued it in architects like Antonio da Sangallo. But he also recognized the risk of repetitive conformity and was impressed, if somewhat alarmed, by Michelangelo's innovative approach in buildings such as the New Sacristy at San Lorenzo where

> he made a composite order more varied and novel than ancient or modern masters have ever been able to achieve; because in the innovations of such beautiful cornices, capitals and bases, doors, tabernacles and tombs, he proceeded quite differently in proportion, order, and rule from others who followed common practice, Vitruvius, and antiquity, not wishing to add anything. This license greatly encouraged those who saw his work to try to imitate it, and subsequently new fantasies have appeared containing more of the grotesque than of reason or rule [pl. 99].[117]

While Vasari wished to promote the artist's freedom, or license, to invent new forms as Michelangelo had in the New Sacristy, he was equally concerned that these should have a rational basis, relating both to nature and to its filter in the intellectual process of design. Vasari here followed Horace, who, when he granted painters and poets license, qualified it against "idle fancies . . . shaped like a sick man's dreams."[118] A painter could choose "to join a human head to the neck of a horse," but, lacking probability or decorum, such a thing would be monstrous.[119] Grotesques, also called *fantasie* and usually confined to decorative ornament, were a titillating mode of deliberate monstrosity. They belonged to a realm of excessive liberty and abnormal combinations. Vasari was concerned that the marginal might become monumental without the restraining force of rule or the judgment necessarily exercised by a talent of Michelangelo's order. Vasari found this to be the case with a window designed by his court rival Tasso "with an order of his own, using the capitals for bases and doing many other things without measure or order such that one could say that at his hand the German way of building had begun to be reborn in Tuscany."[120] To this he opposed a moderated reliance on Michelangelo's style of design in his own architectural inventions, as in the Uffizi where he operated with a well-regulated freedom – accommodating originality and antiquity to the Florentine idiom for a Florentine site (pl. 100).

For Vasari architects not only worked with proportion, order, and the orders, their buildings resulted in convenience – *comodo* – a word denoting both the utility and the social value of their profession. It was because architecture was the most necessary and useful art to mankind that Vasari treated it first in the technical introduction. Like magnificence, convenience had ethical and civic resonance and a traditional association with building. Utility was more than mere function: it was a concept that gave all aspects of building

117 *Ibid.*, pp. 54–5: "vi fece dentro un ornamento composito nel più vario e più nuovo modo che per tempo alcuno gli antichi e i moderni maestri abbino potuto operare: perché nella novità di sì belle cornici, capitegli e base, porte, tabernacoli e sepolture fece assai diverso da quello che di misura, ordine e regola facevano gli uomini secondo il comune uso e secondo Vitruvio e le antichità, per non volere a quello agiugnere. La quale licenzia ha dato grande animo, a quelli che ànno veduto il far suo, di mettersi a imitarlo, e nuove fantasie si sono

vedute poi, alla grottesca più tosto che a ragione o regola, a' loro ornamenti."

118 Horace, *Ars Poetica*, trans. Fairclough, pp. 450, 451.

119 *Ibid.*

120 Life of Tribolo, BB v, p. 224: "d'un ordine a suo modo, mettendo i capitegli per base e facendo tante altre cose senza misura o ordine, che si potea dire che l'ordine tedesco avesse cominiciato a riavere la vita in Toscana per mano di quest'uomo."

99. Michelangelo, New Sacristy. Florence, San Lorenzo.

dignity and prestige. Among the most necessary and useful forms of architecture in Vasari's day was the construction of fortifications – a branch of architectural practice that subsequent architectural historians have tended to neglect or study separately. Vasari paid it due respect

100. Giorgio Vasari, Uffizi, Florence.

in his architects' Lives, praising, for example, the grandeur and invention of Michele Sanmichele's new form of angled corner bastions on fortifications.[121]

Sculpture and painting have a different relation to their inherent properties as arts in *The Lives*. Their proper terms did not have as developed a theoretical subtext or context as those of architecture. Their "actual" terms are consequently more material and more technical. A contract signed by Perugino on 9 August 1494 for a fresco in the Great Council Hall at Venice states what were held to be "all those things belonging to the art of a painter." He was obliged to make a drawing for the painting, and to make it even more beautiful than the others in the Hall, as befitted such a worthy place. Specific to the "things of art," it was stipulated that the work be "richer" than the preceding one (by Guariento), and that he supply (at his expense) gold, silver, (ultramarine) blue, and other colors.[122] In contracts

121 Life of Michele Sanmichele, BB v, pp. 366–7.

122 He was to depict the *Battle of Spoleto* and the *Pope's escape from Rome*, but he did not paint the fresco. It was eventually done by Titian, see P. Brown, *Venetian Narrative Painting in the Age of Carpaccio*, p. 64, catalogue xiii, and p. 274, document 10: "maistro Piero sara obligato far tuor in desegno l'opera . . . et quella dara ai

prefati Magnifici Signori Provedadori, essendo obligado far essa historia più presto miorar che altramente de li altri lavori facti ne la dita Sala si come si convien a quello degno luogo. Dovendo far ditta opera più richa dela prima, a tutte soe spexe de oro arzento azuro et colori et de tutte quelle cosse apartien a larte del depentor."

mastery is repeatedly defined as diligent facture, competent handling of colors, above all the expensive ones, like ultramarine blue.[123] In 1437 Stefano di Giovanni (now known as Sassetta) agreed to paint the high altar of San Francesco in Borgo San Sepolcro "with gold and fine blue, and other fine colors, with ornaments and other things according to the refined talent of his pictorial art." He contracted to apply his knowledge and to make every effort so that it might be as beautiful as possible.[124] The charm, the ornament, and the effort were concentrated on fine colors and their skillful application. In this case, as others, the order, composition, and invention were a collaborative effort between the painter and his patrons and were detailed in a separate document.[125] It was left to the painter's skill to judge how things best be arranged, but the commissioning body knew other paintings and theirs was to be comparable, but more beautiful.[126] The competitive clause is typical. One of the motivating forces of Vasari's history was contractual. These terms of the art of painting hardly varied over the three hundred years chronicled in *The Lives*. They record the existence of formulaic assumptions about the subjects of altarpieces and devotional panels. Vasari relied upon this consensus regarding the principal stories, figures, and images when he noted them to his readers. He could rely also upon the habit of making comparisons between similar works in commission and design in order to suggest unusual or outstanding variants worthy of praise. In his history Vasari renegotiated the contract, however, giving the artist priority in decisions of design and invention. His description of paintings retains their material basis. Media and support are specified. Paintings are of oil or tempera, on panel, canvas, or walls. But Vasari changed the emphasis. Material richness is less important than compositional variety, and *colorito* or coloring is described for its optical qualities of relief modeling (*rilievo*) and blending (*unione*), not its surface charm. The mechanical ability demonstrated by diligent coloring is secondary to the more scientific, or learned, attainments of perspective, foreshortening (*scorci*), and anatomy, for instance. This follows a line of argument that can be traced through the fifteenth century along with the development of those skills. In their writings Ghiberti, Alberti, and Leonardo da Vinci engaged with the investigation and debate about the nature of artistic practice that enlarged and enriched both its technical capacity and its terms of reference. These terms were taken up enthusiastically in the mid-sixteenth century and were increasingly codified and diffused, with

123 For example, Perugino's *Resurrection* for San Francesco, Perugia (2 March 1499): "promisit . . . pingere et ornare quamdam eius tabulam altaris . . . secundum quam actenus in ea designatum est, pulcram et bene ornatam, cum cornicibus deauratis et campo et figuris optimorum colorum et finium, ad usum boni et legalis ac sufficientis magistri" (see Canuti, *Il Perugino*, no. 251, ii, p. 187). In his *ricordanze* Neri di Bicci noted a typical commission for an altarpiece (a *Coronation of the Virgin*), "all well embellished and worked with good and fine colors, and diligently executed, in the way of a good master, and all the gold, blue, and colors, and labor at my expense" (see Neri di Bicci, *Le ricordanze*, ed. Santi, no. 523, p. 274 [10 July 1466]: "tuta bene ornata e lavorata di buoni e fini cholori e diligentemente fatta di tuto, a uso di buono maestro, a tute mia ispese d'oro, d'azuro e chol[or]i e magistero").

124 Banker, "The program for the Sassetta Altarpiece in the Church of S. Francesco in Borgo S. Sepolcro," *I Tatti Studies* (1991), pp. 51–2: "ad aurum et azurrum finum et colores alios finos, cum ornamentis et aliis secundum subtile ingenium sue artis pictorie, et quanto plus venustius sciet et poterit et omni suo conatu."

125 Ibid., p. 54: "Per commissionem di frati, del Guardiano et deli operieri de'convento . . . de ordinare et componere le figure et l'istorie della taule sì como pare a noi et al maestro insiemi." This fascinating document is a remarkable survival of a type of note or agreement of subject often mentioned in contracts.

126 Ibid.: "In primo ordiniamo per più bellezza et como stanno l'altre–la virgine Maria col figliolo in collo et ornata con angeli como al maestro parrà che stia meglio."

the publication, for example, of Bartoli's translation of Alberti's treatise on painting (1550), Paolo Pino's *Dialogo della Pittura* (1548), Doni's *Disegno* (1549), and Varchi's debate (1549).

A painter by profession, and partisan, Vasari took care to publicize the particular problems of his art. In the Life of Andrea Pisano Vasari noted that sculpture had two fortunate aspects, being three-dimensional it was already closer to the life that it imitated than painting, which made painting a more difficult art, and while ancient paintings had not survived, sculptures had.[127] Primacy was given Masaccio who

> initiated beautiful attitudes, movements, liveliness, and vivacity, and a certain relief truly characteristic and natural . . . introducing many new methods, he made foreshortenings from every point of view much better than any other who had lived up to that time. And he painted his works with good unity and softness, harmonizing the flesh colors of the heads and of the nudes with the colors of the draperies, which he delighted to make with few folds and simple, as they are in life and nature.[128]

Masaccio's manifest concern for the convincing three-dimensionality of his figures is revealed to the reader in an explanation of his relief style, where he sought a unified tonality in shading. The solemnity and solidity of Masaccio's figures is studied from Giotto, but Giotto's strong delineation of form and shadow is replaced by areas of shading that create softer and more fully rounded contours (pls. 101, 102). This technical difference is observed by Vasari in his description of Masaccio's innovations, representing him as the artist who through his continuous study "could be numbered among the first who cleared away, in a great measure, the hardness, the imperfections, and the difficulties of art."[129]

The painterly creation of relief, successful foreshortening, and convincing drapery construction are technical matters expressed in the actual terms of the art of painting. They had a long tradition. Many occur in Cennino Cennino's workshop handbook, along with instructions about drawing and rules for finding the proportions or *misure* of figures. Just as the workshop system transmitted skills from one generation to the next, it created a consistent vocabulary of concern. The abiding problem posed by the imitative basis of the arts from the fourteenth century onwards was how to achieve sufficient artifice to arrive at pleasing deceptions. Solutions to that problem varied over time, but its core terms – including *disegno, misura, rilievo* – remained remarkably stable. Vasari could write in a current language because the language of the arts had widespread currency. Its circulation is recorded in Petrarch's remark about the resemblance of father to son, seen in "a sort of shadow, which our painters call air [*aerem*], most apparent in faces and eyes."[130] "Aria della testa" or "delle teste" is Vasari's formula for the physiognomy of expression, observed

127 Life of Andrea Pisano, BB ii, p. 150.

128 Life of Masaccio, BB iii, p. 124: "egli desse principio alle belle attitudini, movenze, fierezze e vivacità et a un certo rilievo veramente proprio e naturale . . . variando in molti modi, fece molto meglio gli scòrti–e per ogni sorte di veduta–che niun altro che insino allora fusse stato. E dipinse le cose sue con buona unione e morbidezza, accompagnando con le in-carnazioni delle teste e dei nudi i colori de' panni, i

quali si dilettò di fare con poche pieghe e facili, come fa il vivo e naturale."

129 *Ibid.*: "mediante un continuo studio imparò tanto che si può anoverare fra i primi che per la maggior parte levassino le durezze, imperfezzioni e difficoltà dell'arte."

130 *Le Famigliari*, ed. V. Rossi, iv, xxiii.19, p. 206. This passage and the term *aria* are discussed by Summers, *Michelangelo and the Language of Art*, p. 56.

101. Masaccio, *St. Peter Baptizing*.
Florence, Santa Maria del Carmine,
Brancacci chapel.

102 (below). Giotto, *Approbation of
the Rule*, detail of kneeling friars,
Florence, Santa Croce, Bardi chapel.

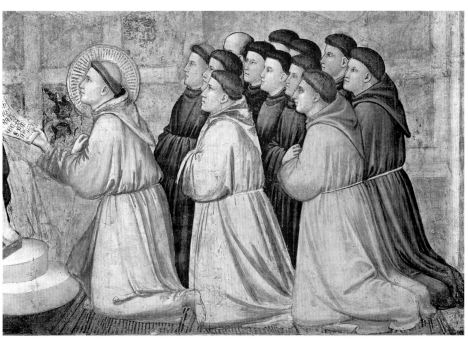

in a Cimabue crucifix or a Parmigianino Holy Family.[131] The early exchange between painter's studio and poet's study indicates an awareness of artists' ways of speaking about their work, a specialist vocabulary, which could find a legitimate place in the language of sight and sensation.

Sculpture is also given its distinct presence in *The Lives*. Statues are of marble, bronze, or clay, in relief or in the round. They are finished or rough-hewn. Vasari notes how they are incised, how assembled. In the first era the works of sculptors, like those of painters and architects, are more often listed than described. Vasari simply says where they are and what they are. He does not picture them in any detail for the reader, but he specifies size or scale and material and type for sculptures (statue, high or low relief). In the second era, sculptors, imitating both the antique and nature, are shown to bring the material to life. Vasari describes the arm of Ghiberti's bronze St. John the Baptist at Orsanmichele as appearing to be flesh.[132] Their skill became such that they could even defy the material, like Desiderio da Settignano on the tomb of Carlo Marsuppini at Santa Croce where his chisel turned marble to feathered wings in the ornamented base (pl. 103).[133] This is a precursor to Michelangelo's *Moses* on the tomb of Julius II at San Pietro in Vincoli, whose beard "is long and waving, and done in such a way in the marble that the hairs – which are so difficult in sculpture – are wrought with the greatest delicacy, feathery, soft, and detailed in such a manner that one cannot but believe that his chisel was changed into a brush" (pl. 104).[134] Such illusionistic mastery of the medium both places Michelangelo as paragon of all the arts and associates him with the paradigms of the antique. The sculptor Myron's rendering of soft hair and feathery beards praised by Pliny are brought to new form in the *Moses*.

Michelangelo is cited as the ultimate expert on sculpture in his opinion of Ghiberti's second set of Baptistery doors: being asked what he thought, "and whether these doors were beautiful, he answered, 'they are so beautiful that they would do well for the gates of Paradise,' praise truly appropriate and given by one able to judge."[135] And in the doors, Vasari says one sees

> how much the ability and the power of a craftsman in statuary can effect by means of figures, some being almost in the round, some in half-relief, some in low-relief, and some in the lowest, with invention in the grouping of the figures, and extravagance of attitude both in the males and in the females; and by variety in the buildings, by perspectives, and by having likewise shown a sense of fitness in the gracious expressions of each sex throughout the whole work, giving to the old gravity, and to the young elegance and grace. And it may be said, in truth, that this work is in every way perfect, and that it is

131 Life of Cimabue, BB II, p. 38 and Life of Parmigianino, BB IV, p. 537.

132 Life of Ghiberti, BB III, p. 88: "si vide cominciata la buona maniera moderna nella testa, in un braccio che par di carne e nelle mani et in tutte le attitudini della figura."

133 Life of Desiderio, BB III, p. 401: "Ma fra l'altre parti che in detta opera sono, vi si veggono alcune ali che a una nicchia fanno ornamento a piè della cassa, che non di marmo ma piumose si mostrano: cosa difficile a potere imitare nel marmo, attesoch'ai peli et alle piume non può lo scarpello aggiugnere."

134 Life of Michelangelo, BB, VI, p. 28: "la barba, la quale nel marmo svellata e lunga è condotta di sorte che i capegli, dove ha tanta dificultà la scultura, son condotti sottilissimamente, piumosi, morbidi e sfilati, d'una maniera che pare impossibile che il ferro sia diventato pennello."

135 Life of Ghiberti, BB III, p. 100: "dimandato quel che gliene paresse e se queste porte eron belle, rispose: 'Elle son tanto belle, che elle starebbon bene alle porte del paradiso': lode veramente propria e detta da chi poteva giudicarla."

103. Desiderio da Settignano detail from the tomb of Carlo Marsuppini. Florence, Santa Croce.

104. Michelangelo, *Moses*. Rome, San Pietro in Vincoli.

105. Lorenzo
Ghiberti, *Story of Noah.*
Florence, Baptistery,
East Door.

the most beautiful work that has ever been seen in the world, whether ancient or modern
[pl. 105].[136]

Vasari's language of judgment here joins the craftsman's skill with more conceptual
appraisal. Invention, variety, and decorum were literary values as well. The opposition of
grace and gravity was a standard polarity in oratory and in good prose. Through this form
of description Ghiberti's mastery is demonstrated as being complete in its command of the
material giving him the means to realize its expressive and aesthetic potential.

In his descriptions of all the arts Vasari married a language of appraisal to one of means
in order to bring out the artists' exercise of talent, skill, and judgment. Coloring, a term of
art, appears in conjunction with praise for its diligent application (the skill or *arte* of
contractual practice) and for its grace or beauty, for example. The vocabulary related to

136 *Ibid.*: "Nella quale opera . . . si conosce quanto il
valore e lo sforzo d'uno artefice statuario possa nelle
figure quasi tonde, in quelle mezze, nelle basse e nelle
bassissime oprare con invenzione ne' componimenti
delle figure, e stravaganza dell'attitudini nelle femmine e
ne' maschi, e nella varietà di casamenti nelle prospettive,
e nell'avere nelle graziose arie di ciascun sesso parimente
osservato il decoro in tutta l'opera: ne' vecchi la gravità e
ne' giovani la leggiadria e la grazia; et invero si può dire
che questa opera abbia la sua perfezione in tutte le cose,
e che ella sia la più bella opera del mondo e che si sia
vista mai fra gli antichi e' moderni."

judgment was one that had resonance with other activities. Vasari exploited well-established associative transfers of language that both made implicit comparisons of disciplines, notably with the other mimetic arts of writing, and that carried a cognitive charge.[137] Vasari was eager to validate the kinship between the arts. He asserted it, for instance, in describing the vault by Giulio Romano in the Palazzo del Te in Mantua, painted with episodes from the story of Psyche, "whose fanciful inventions he most pleasingly executed in a learned fashion, with poetic and painterly sensibility."[138] Since literary terms particularly came from developed critical systems, they also automatically suggested other logical or even predictable terms. So invention presupposed a series of activities: finding a composition expressive of the topic and embellishing it with suitably varied and striking effects. It relied upon imagination and fantasy (*capriccio, fantasia*). Beauty and grace were notions readily and typically associated with both ornament and pleasure. Vasari praised Perino del Vaga's frescoes of "the most beautiful stories from Ovid" in the Doria palace in Genoa for their "unimaginable beauty, abundance, and variety of small figures, foliage, animals, and grotesques, done with great invention."[139] Petrarchan love poetry supplied a vocabulary of pleasure or the pleasing, *piacevolezza*. There beauty was also defined in terms of grace and charm, which were opposed to the "masculine" values of dignity and gravity. In his dialogue devoted to female beauty, published in Florence in 1548, Angelo Firenzuola quoted Cicero, Aristotle, Ficino, and Dante to show that beauty was a grace born of harmony.[140] He explained the elements of the perfect composition of a lady's form, including grace of movement (*leggiadria*) and that attractive charm (*vaghezza*) inducing the desire to contemplate and enjoy beauty.[141] In his dialogue on the vernacular, Pietro Bembo claimed that there were two principal aspects to beautiful writing, gravity and charm (*gravità* and *piacevolezza*). The latter was defined by grace, delicacy, attractiveness, and sweetness (*grazia, soavità, vaghezza, dolcezza*).[142] In his description of Raphael's *St. Cecilia* (pl. 143), Vasari paired the contemplative figure of St. Paul, "his boldness turned to gravity," with that of the Magdalene, "in an attitude of most marvelous grace, turning her head, she seems full of joy at her conversion."[143] Here he observed the distinction of gravity and grace – male opposed to female – in the rhetoric of beauty, one probably also observed and exploited by Raphael in the pendant figures of turning and converted saints in this picture.

Similar groupings occur with reference to difficulty. When successfully resolved, its associates were facility, grace, charm, and liveliness (*facilità, grazia, leggiadrezza, prontezza*).

137 This process has been brilliantly analyzed by Baxandall in *Giotto and the Orators*, in *Painting and Experience in Fifteenth Century Italy*, and in "Alberti and Cristoforo Landino: The Practical Criticism of Painting," in *Convegno internazionale indetto nel V centenario di Leon Battista Alberti*, pp. 143–54.

138 Life of Giulio Romano, BB v, p. 68 (1550): "le quali capricciose invenzioni dottamente, con senso poetico e pittoresco, ha garbatissime finite." This comparison is a key theme in the Life of Giulio and its descriptions, see pp. 69, 72.

139 Life of Perino del Vaga, BB v, p. 141: "le più belle favole di Ovidio, che paion vere, né si può imaginar la bellezza, la copia et il vario e gran numero che sono per quelle di figurine, fogliami, animali e grottesche, fatte con grande invenzione."

140 Firenzuola, "Della bellezza delle Donne," in *Prose*, fols. 64r-v.

141 *Ibid.*, fols. 83r-v, 85v. For Vasari's debt to Petrarch and the literature of love, see below, Chapter IX, pp. 377, 392–4.

142 *Prose della volgar lingua*, ed. Marti, p. 63.

143 Life of Raphael, BB IV, p. 186: "in un San Paulo . . . si vede non meno espressa la considerazione della sua scienzia che l'aspetto della sua fierezza conversa in gravità . . . Èvvi poi Santa Maria Maddalena . . . in un posar leggiadrissimo, e svoltando la testa par tutta allegra della sua conversione."

For Vasari's artist, as for Castiglione's courtier, grace was born of making effort or skill (*arte*) look easy and natural, because, as Castiglione remarks, "everyone knows the difficulty of things that are singular and done well, so that in these things ease generates the greatest admiration."[144] Boldness, dexterity, promptness, and vigor (*fierezza, destrezza, prontezza, gagliardezza*) were also part of this group of related concepts. Words of presence, liveliness, and motion, they are also found in the literature of behavior, dance, and courtliness.[145] *Gagliardo*, for example, meant vigorous and the galliard was a particularly lively form of dance. When connected with movement it is evocative of its force. Taddeo Gaddi showed the improvements of the first age in giving his figures "greater vigor in their movements."[146] Andrea del Castagno could be characterized as "most vigorous in the motions of [his] figures."[147] *Gagliardo* also denoted strength and valor, appropriate to the bold physical presence Castagno achieved in his paintings. Vasari's phrase, making Andrea the subject and his figures the object of description, also demonstrates the mutuality of adjectives, applied both to artists and their works, as the character of the author is manifested in the product of his individual talent.

There were other ways to move. When Salome dances in Fra Filippo Lippi's *Feast of Herod* at Prato (pl. 106), one is asked to recognize her agility ("destrezza").[148] When he fought, Castiglione's courtier was always to show "readiness and courage" ("prontezza e core"), and when he danced, to temper dignity with "a light [*leggiadra*] and airy sweetness" of movement.[149] When Antonio del Pollaiuolo painted *Hercules killing the Hydra*, its serpent was so lifelike, "that more alive would not be possible. Here one sees the poison, the smoke, the ferocity, the rage, with such immediacy [*prontezza*] that it deserves to be celebrated and to be widely imitated in this by good artists" (pl. 107).[150] The ferocity of a fight to the death contrasts in its descriptive means with the charming presence of Parmigianino's figures, which had *leggiadria* (pl. 108).[151] His gift was granting them grace, sweetness, and lightness in their poses. Pollaiuolo's *prontezza*, life, was that of battle. Parmigianino's lightness was that of dance. Since the chief difficulty of art was the imitation of nature, this vocabulary resonant of gesture and movement was eminently suitable to Vasari's descriptive purposes, bringing, by association, life to the things described.

Difficulty that was forced or unresolved created another chain. Its constellations and cognates were hard, dry, coarse, and cutting (*dura, secca, cruda, tagliente*). These associates also link opposites: what is not one thing can be another. There is an implicit contrast between things unpleasantly hard or cutting and those that are pleasingly sweet and soft (*dolce,*

144 Castiglione, *Cortegiano*, ed. Cian, Book i, chapter 26, p. 63: "delle cose rare e ben fatte ognun sa la difficultà, onde in esse la facilità genera grandissima maraviglia."

145 Fermor, "On the Description of Movement in Vasari's Lives," in *Kunst, Musik, Schauspiel*, ii, pp. 15–21. For the importance of the literature of dance in relation to critical language, see Fermor, "Studies in the depiction of the moving figure," Ph.D. (Warburg Institute, 1990).

146 Preface to Part 2, BB iii, p. 12: "più gagliardezza ne' moti."

147 Life of Castagno, BB iii, p. 354: "gagliardissimo nelle movenze delle figure."

148 Life of Fra Filippo Lippi, BB iii, p. 337.

149 Castiglione, *Cortegiano*, ed. Cian, Book i, chapter 21, p. 53: "mostrar sempre prontezza e core," and ii, chapter 11, p. 154: "si gli convenga servare una certa dignità, temperata però con leggiadra ed aerosa dolcezza di movimenti."

150 Life of Antonio and Piero Pollaiuolo, BB iii, p. 505: "che più vivo far non si può. Quivi si vede il veleno, il fuoco, la ferocità, l'ira, con tanta prontezza che merita esser celebrato e da' buoni artefici in ciò grandemente imitato."

151 Life of Parmigianino, BB iv, pp. 531–2: "una certa venustà, dolcezza e leggiadria nell'attitudini."

106. Fra Filippo Lippi, *The Dance of Salome*, detail from *The Feast of Herod*, Prato, Cathedral.

morbido). Such groups made Vasari's writing both effective and efficient: to say or to see one, suggested the other. But they also related to perceptible qualities and differences. The roundess and grace that amazed Vasari in Michelangelo's nudes in the Sistine vault is different from the wiry strength of Pollaiuolo's, whose anatomical study Vasari praised as being the most modern of its time, but still found forced and lacking in grace (pls. 107, 109).[152] Vasari's vocabulary was neither random nor abstract; even when he relied on the refinement of writers, he was never far removed from the actual terms of artists, or an experienced view of their actual works.

"Visible Speech"

To organize the past according to the quality of the times, as Vasari did, was to perceive the past within the framework of decorum. The concept of propriety requiring the match of style to subject influenced the tone and the type of descriptions. Perceptive and purposeful,

152 Life of Michelangelo, BB VI, p. 39: "la stupendissima rotondità d'i contorni, che hanno in sé grazia e sveltezza." Life of Pollaiuolo, BB III, pp. 505–6: "Egli s'intese degli ignudi più modernamente che fatto non avevano gl'altri maestri inanzi a lui." In the preface to Part 3, BB IV, p. 6, Vasari wrote about the figures by artists like Verrocchio and Antonio Pollaiuolo that they had not achieved perfection, and did not have "la leggiadria et una pulitezza e somma grazia . . . ancora che vi sia lo stento della diligenzia."

107 (above left). Antonio Pollaiuolo, *Hercules Killing the Hydra*. Florence, Uffizi.

108 (above right). Parmigianino, *Virgin and Child with a Globe*. Dresden, Gemäldegalerie Alte Meister, Staatliche Kunstsammlungen.

109. Michelangelo, *Ignudo*. Rome, Sistine Chapel.

Vasari employed a number of techniques and rhetorical devices, the most conspicuous and the most extended being word pictures. To put a subject before the mind's eye using the figures of *descriptio* and *illustratio* (for events and places) or *effictio* (for people) was an important constituent of both historical writing and epideictic.[153] It is misguided to conceive of Vasari as producing rhetorical set pieces, however, and to identify them specifically as the exercise known as ekphrasis is misleading.[154] Ekphrasis is a Greek term. It was a category of composition taught in Byzantium, part of the training in rhetorical skills based on the graded exercises set out in the *Progymnasmata*, a late second-century collection still used for instruction in Constantinople in the fifteenth century. Derived from late classical rhetorical practice, explicit ekphrasis was reintroduced to the west by Byzantine humanists in the first half of the fifteenth century.[155] Neither the word nor the form as such was part of the Ciceronian rhetorical tradition that was the direct basis of renaissance literary expression in the west. Ekphrasis is not included in fifteenth- or sixteenth-century Latin or Italian rhetorical manuals or treatises, and ekphrastic compositions were not a standard part of the rhetorical curriculum as they were in the east. This is not to deny the role of description as a figure or device, nor its place as part of renaissance writing, but to situate it more accurately and less dogmatically among the prescriptions for expressive speech rather than as a formulaic mode for discussing paintings.

The essential values of the ekphrastic exercise were empathetic response, lifelikeness, and variety. It often proceeded by singling out affective as well as effective details. This was also the case with the western prescriptions for vivid illustration, which was meant to go beyond the sense of hearing to display the facts "in living truth to the eyes of the mind."[156] Such accounts were not necessarily or even primarily about paintings. In histories they recalled battles and valiant deeds, and in judicial oratory they were an impressive exposition of the consequences of an act.[157] The strong narrative and emotional emphasis in descriptions of this sort does not, therefore, depend on naturalistic art, however well suited it was to demonstrating the imitation of nature.

There were famous ekphraseis about painting known in the renaissance. The most pertinent to Vasari was the Elder Philostratus's *Imagines*, which purports to be a description of pictures in a Neapolitan collection. The setting and the paintings are a pretext for a demonstration of skill in evoking people, places, and events in history and mythology. They are re-creations of the effect and associations of viewing, not a textual transcription of actual paintings. Vasari reversed this process: starting from extant works, he placed them in the mind's eye, seizing on and expounding upon details and episodes that made them compelling and lifelike. The narrative basis of such descriptions suited the dramatic inten-

153 See Struever, *The Language of History in the Renaissance*, pp. 75–6, and O'Malley, *Praise and Blame in Renaissance Rome*, pp. 63–5, 78–9.

154 Alpers's article, "'Ekphrasis' and aesthetic attitudes in Vasari's 'Lives,'" *Journal of the Warburg and Courtauld Institutes* (1960), pp. 190–215, is the fundamental exposition of Vasari's critical and historical attitudes and how they are expressed. But its importance has tended to obscure the range of Vasari's descriptive techniques and to impose the term ekphrasis on his descriptions. For definitions of ekphrasis and the issues surrounding the term in art history, with further references, see James and Webb, "*Ekphrasis* and Art in Byzantium," *Art History* (1991), pp. 1–17, and Land, "Titian's *Martyrdom of St. Peter* and the 'Limitations' of Ekphrastic Art Criticism," *Art History* (1990), pp. 293–317, and Webb, "The Development of 'Ekphrasis' from late Antiquity to the Renaissance," Ph.D. (Warburg Institute, 1992).

155 Baxandall, *Giotto and the Orators*, pp. 85–8.

156 *I.O.*, VII.iii.62, vol. III, pp. 244, 245.

157 *Ad H.*, IV.xxxix.51, pp. 356, 357.

tions of pictured stories. The psychological element of sympathy was a link Vasari wished to forge between his reader/viewer and the objects he described, and one he assumed between the artist and the subject as he "imagined" it: so Michelangelo surpassed himself in the *Last Judgment*, having "imagined the terror of those days."[158]

The narrative form of description is also indicative of a form of perception and a model of composition. Vasari painted what he praised. The emphasis in his own pictorial narratives is on accumulated *avvertenze*, striking and inventive details. The combination of various figural episodes that make up the Cancelleria frescoes or his *Marriage of Esther and Ahasuerus* painted for the Badia at Arezzo, for instance, corresponds to his description of Fra Filippo Lippi's *Feast of Herod* at Prato. There "one recognizes" a series of incidents that are made of motion and emotions: "the majesty of the banquet, the dexterity of [Salome], the astonishment of the company, and their immeasurable grief when the severed head is presented in the charger" (pls. 110, 111).[159] The narrative premises of description – that it tells us about something that happened – also suggests that the pictorial organizations of painted histories were understood as events to be received in a narrative fashion, provoking responses in the form of mental or even verbal storytelling. The elements of time, action, reaction, and consequences that form the story were embodied in gestures and poses that were not conceived of as fixed to titles, but to a full understanding and exposition of the subject. So Masaccio did not paint *The Tribute Money* as we call it, but a scene, as Vasari related it, "where, in order to pay the tribute money, St. Peter, following Christ's command, takes the money from the belly of the fish" (pl. 31).[160] To the recognition of the story and its import – as Biblical example in a church or evocation of family glory in a palace – Vasari invariably adds recognition of what the artist did that merited admiration. In *The Lives* and through *The Lives* viewing became inseparable from the acknowledgment of skill and talent. Artists' works were taken from a principally utilitarian framework, from being objects of use, and placed firmly in an honorific one, becoming objects of value.

Vasari's word pictures were not all, and not entirely, narratives. He characteristically relied on verbal abundance to convey the effect of pictorial abundance, as in his description of Mantegna's *Triumphs* (pls. 112a,b) where he listed, with some alliterative exaggeration, a number of details, including sacrifices and sacerdotes, prisoners and perfumes.[161] A long recital of elements gives a cumulative impression of the beauty, interest, and variety of the work. Exotic words and exotic animals portray the creative pageantry of Andrea del Sarto's *Tribute to Caesar* at Poggio a Caiano (pl. 113) with its "Indian goats, lions, giraffes, panthers, lynxes, monkeys, moors, and other beautiful fantasies."[162] Typically, some of the fantasies

158 Life of Michelangelo, BB VI, p. 71: "superò sé medesimo, avendosi egli imaginato il terrore di que' giorni." See Webb, "The Development of 'Ekphrasis' from late Antiquity to the Renaissance," Ph.D. (Warburg Institute, 1992), pp. 188–91, for the differences between Vasari and Philostratus.

159 Life of Fra Filippo Lippi, BB III, p. 337: "la maestà del convito, la destrezza di Erodiana, lo stupore de' convitati, e lo attristamento fuori di maniera nel presentarsi la testa tagliata dentro al bacino."

160 Life of Masaccio, BB III, p. 130: "dove San Piero per pagare il tributo cava per commissione di Cristo i danari del ventre del pesce."

161 Life of Mantegna, BB III, p. 551: "i parenti, i profumi, gl'incensi, i sacrifizii, i sacerdoti, i tori pel sacrificio coronati, e' prigioni, le prede fatte da' soldati, l'ordinanza delle squadre, i liofanti, le spoglie, le vittorie, e le città e le rocche in varii carri contrafatte, con una infinità di trofei in sull'aste e varie armi per testa e per indosso, acconciature, ornamenti e vasi infiniti."

162 Life of Andrea del Sarto, BB IV, p. 373: "capre indiane, leoni, giraffi, leonze, lupi cervieri, scimie, e mori, et altre belle fantasie."

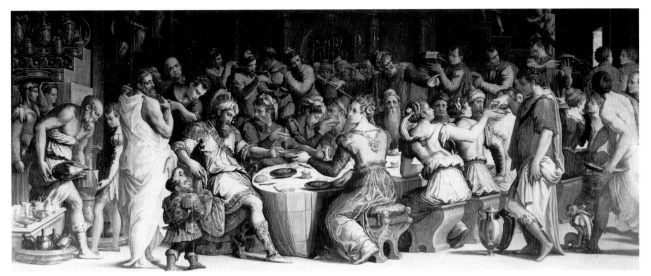

110. Giorgio Vasari, *The Marriage of Esther and Ahasuerus*. Arezzo, Museo Statale di Arte Medievale e Moderna.

111. Fra Filippo Lippi, *The Feast of Herod*. Prato, cathedral.

112 a and b. Andrea Mantegna, *The Triumphs of Caesar*: (a) *Bearers of Trophies of Arms, Coin, and Plate*; (b) *Bearers of Coins, Plate, and Trophies of Royal Armor*. Royal Collection, Hampton Court Palace.

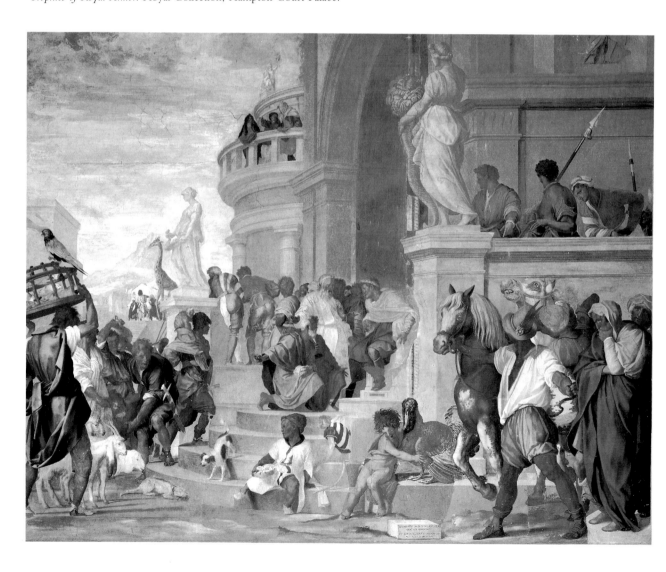

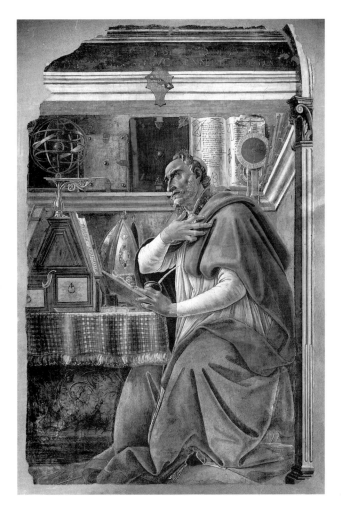

114. Sandro Botticelli, *St. Augustine*. Florence, Ognissanti.

are Vasari's, who added in number and kind to del Sarto's, as he did to other artists' compositions. Such enumerative descriptions emphasize the artist's inventive capacities. This device becomes part of Vasari's characterization of Filippino Lippi's entire output in a Life stressing copious invention, ornament, poetry, and the bizarre or *bizarrie*, recurrent words in his description of Filippino's works. A similar balance of art and Life occurs when the description of a single work matches Vasari's account of an artist's character. Botticelli's *St. Augustine* at the church of Ognissanti (pl. 114), the first work singled out in that Life, is described in terms of profound contemplation, refined sensibility, and investigation of difficult things, echoing Vasari's picture of that artist as one given, perhaps excessively, to philosophizing speculation. That a work of art is a form of self-portrait is an idea with origins in antiquity, which Vasari accepted and stated in the opening to the Life of Donatello.[163] So Botticelli's "singular brain" is matched by the singular or fantastic elements demonstrating the "perfection of his mastery" in his *Adoration of the Magi* (pl. 115).[164]

163 Life of Donatello, BB III, p. 201 (1550): "ritraendosi esprimevano se medesimi, e se medesimi assomigliavano." See below, Chapter VIII, pp. 330–1.

164 Life of Botticelli, BB, III, p. 511, for Botticelli's "cervello sì stravagante," and pp. 515–16 about the *Ado-* *ration*, describing Botticelli's differentiation of the retinues of the kings as done with: "tutte quelle stravaganzie che possono far conoscere la perfezzione del suo magisterio."

113. Andrea del Sarto, *Tribute to Caesar*. Poggio a Caiano.

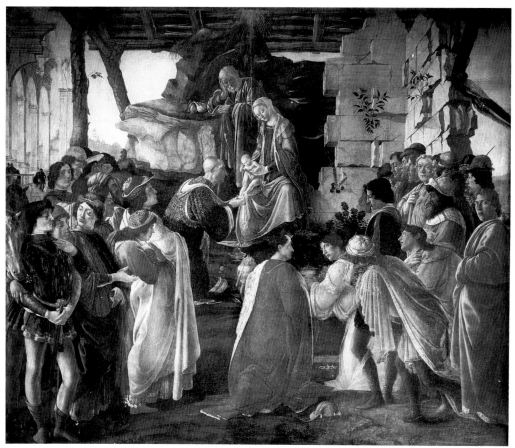

115. Sandro Botticelli, *Adoration of the Magi*. Florence, Uffizi.

Hyperbole was another device Vasari used to fuse the recollected image with a predicted response. Hyperbole was appropriate "when the magnitude of the facts passes all words."[165] So to express the "extremities" of artistry as represented by Michelangelo, Vasari allowed words to fail.[166] The entire construction of Michelangelo's historical persona is hyperbolic, he is "more heavenly than earthly."[167] The text of his Life is littered with disclaimers. The overwhelming power and perfection of his works leads Vasari to exclaim that "it cannot be said," "it cannot be imagined," or even described.[168] But of course, the impossible existed in the paintings, sculptures, and buildings thus evoked.

By far the most common type of description is the "demonstrative." A work, or the artist, is described as demonstrating an artist's ambitions and achievement in art, giving a proof of skill and leaving an example to follow. In the story of Isaac on the bronze doors, for example, Ghiberti "showed that in this work he surpassed himself in relation to the

165 *I.O.*, VIII.vi.76, vol. III, pp. 344, 335.

166 Life of Michelangelo, BB VI, p. 24, in the *Battle of Cascina* cartoon artists could see: "l'estremità dell'arte."

167 *Ibid.*, p. 4: "più tosto celeste che terrena."

168 *Ibid.*, p. 73: "Non si può dir quanto sia bene espressa la storia di Noè" (in the Sistine vault); "Né si può imaginare" (about the great variety in the heads of the demons in the *Last Judgment*).

problems of making buildings."[169] Ghiberti's autobiographical passage in the *Commentaries* indicates the importance of such demonstration to artistic prestige. The contest for the Baptistery doors was a "demonstration in great part of the art of sculpture," the resulting "palm of victory" established his career and fame.[170] In describing works as particular demonstrations of skill, Vasari was referring to a tradition of achievement and reward through which he could both qualify (by praising their ingenuity and skill) and quantify (through establishing individual achievement) contributions to the progress of the arts. His descriptions allowed him to single out and evaluate certain accomplishments, in perspective, anatomy, chiaroscuro, imitative naturalism, for instance, and to create examples.

Vasari's descriptive modes balanced consistency and variety. He relied on a set of terms and repeated them because they were instrumental to understanding. They established the standard that gave meaning to the process of the recovery, mastery, and ultimately surpassing of the rules and beauty of ancient art, the *rinascita*. They unite the arts conceptually and chronologically, making sense of history. But Vasari also had to bring out the manifest difference of the ages. To do this he obeyed stylistic propriety, reserving the ornate for the most worthy. The length and elaboration of description increases with artistic merit. This was intentional. As Vasari explained in the Life of Gaddo Gaddi, he was not going to give an extensive account of Gaddo's works because

> the styles of those masters were still so hard in the difficulties of art that it is not necessary to have much curiosity about them, and because the majority of those who have been most useful to artists and to the art will be described by us with refinement and ingenuity in accordance with that refinement and ingenuity with which they worked.[171]

And the works most vividly described in Part 1 are often the most gruesome. They are not the sweet Virgins and beautiful ladies singled out in later eras, nor graceful gestures, but putrefying corpses and terrifying devils, such as the nightmarish demons that, Vasari says, Spinello Aretino painted for the Compagnia di Santo Agnolo in Arezzo and the Lucifer that then came to haunt him in his sleep, ultimately frightening him to death. Striking examples of painters' skills, they also serve to demonstrate the unrefined imaginations of that coarse age.[172] Vasari never abandoned the dramatic in his descriptions, but as artistry advances and invention increases even the most bizarre and fantastic imaginations are shown to produce works more appealing than appalling. The "strange fantasies" of artists of the second era, like Filippino Lippi, did not consist of ugly beasts and seven-headed serpents, but of ancient dress

169 Life of Ghiberti, BB III, p. 97: "Mostrò anco avanzar se medesmo Lorenzo in quest'opera nelle difficultà de' casamenti."

170 Ghiberti, *Commentari*, ed. Schlosser, p. 46: "fummo sei a·ffare detta pruoua la quale pruoua era dimostrazione di gran parte dell'arte statuaria. Mi fu conceduta la palma della uictoria." For the importance of this, see Gombrich, "The Renaissance Conception of Artistic Progress," in *Norm and Form*, pp. 1–10, pp. 6–8 for Ghiberti.

171 Life of Gaddo Gaddi, BB II, p. 84 (1550): "Ora io non mi distenderò in raccontare tut[t]e l'opere di Gaddo, essendo le maniere ancora di questi maestri sì

dure nelle difficultà dell'arte ch'e' non bisogna aver molta curiosità di quelle, attesoché l'estremità di coloro che hanno fatto grande utile all'artefici et all'arte saranno secondo l'opre loro, con quella sottigliezza e curiosità ch'essi lavorarono, da noi sottilmente e curiosamente descritte."

172 For Spinello, see BB II, pp. 287–8; see also the Life of Barna, BB II, p. 254, and the description of a *Raising of Lazarus* by Agnolo Gaddi in San Jacopo tra i Fossi, BB II, p. 244, or Ambrogio Lorenzetti's paintings for the Franciscans in Siena, featuring torture and a tempest, BB II, pp. 179–80.

and grotesques resembling the antique: ornate abundance studied from the "antiquities of Rome" (pl. 116).[173]

Certain words common in the descriptions of the first era, notably those of roughness and clumsiness (*rozzezza*, *rozzo*, *goffo*, *goffezza*), are gradually displaced and replaced through the discoveries of the second era. In the opening to the Life of Masaccio, Vasari says that the artists of that generation literally removed the "rough and coarse styles" surviving until then.[174] This is a milestone in the passage to the perfection of the arts, one marked by the virtual elimination of those words from the subsequent descriptive vocabulary.

The improvements of that time are demonstrated in fuller descriptions of the works, which offered examples worthy of imitation and displayed the understanding of the precepts and rules of art. Where Agnolo Gaddi's late fourteenth-century fresco cycle in the high-altar chapel of Santa Croce earned lines, Ghirlandaio's high-altar chapel of Santa Maria Novella was granted pages. Accounted for scene by scene, it wins appreciation for its narrative invention, expressive details, and emotional highlights (*avvertenze*, *affetti*), and above all, for the lifelike quality of the heads. Both artists are considered in terms of technique, but only Ghirlandaio for invention. Even so, this is kept within the limits of his age: the chapel "was held to be a most beautiful thing," while a nude figure in the *Presentation in the Temple* — unusual in Ghirlandaio's time and praised then, Vasari says — did not have "that complete perfection" of those done in Vasari's day (pl. 117).[175]

Typical of Vasari's qualified yet instructive praise for artists of the second age is his account of Piero della Francesca's display of ingenuity in depicting night and the dramatically foreshortened angel in his fresco of the *Dream of Constantine* in San Francesco, Arezzo (pl. 118). The very darkness is a revelation, which Vasari said showed the importance of imitating and absorbing the lessons of nature. Having done this, Piero gave modern artists "a reason to follow him and to reach the supreme achievements that can be seen in our time."[176] The construction is characteristically transitional as Piero shows something indicating the way. The second era was that of discovery, as artists found, and then demonstrated, the way to master the difficulties of art in perspective construction, foreshortening, anatomy, oil technique, the understanding of proportion, and the rules of classical architecture.

The superlative comes into force in the third period: from better to best. Perfection and

173 Life of Filippino Lippi, BB III, p. 560: "fu il primo . . . che abbellisse ornatamente con veste antiche soccinte le sue figure. Fu primo ancora a dar luce alle grottesche che somiglino l'antiche . . . Onde fu maravigliosa cosa a vedere gli strani capricci che egli espresse nella pittura; e che è più, non lavorò mai opera alcuna nella quale delle cose antiche di Roma con gran studio non si servisse."

174 Life of Masaccio, BB III, p. 123: "E che questo sia il vero, lo aver Fiorenza prodotto in una medesima età Filippo, Donato, Lorenzo, Paulo Uccello e Masaccio, eccellentissimi ciascuno nel genere suo, non solamente levò via le roz[z]e e goffe maniere mantenutesi fino a quel tempo."

175 Life of Ghirlandaio, BB III, pp. 485–6: "v'è uno ignudo che gli fu allora lodato per non se ne usar molti,

ancorché e' non vi fusse quella intera perfezzione come a quegli che si son fatti ne' tempi nostri, per non essere eglino tanto eccellenti," and p. 490: "Questa cappella fu tenuta cosa bellissima." The complete description is BB III, pp. 484–90. Agnolo Gaddi's Santa Croce chapel is dealt with in a sentence in his Life, BB II, p. 245: "condusse quel lavoro con molta pratica ma con non molto disegno, perché solamente il colorito fu assai bello e ragionevole."

176 Life of Piero della Francesca, BB III, p. 262: "fa conoscere in questa oscurità quanto importi imitare le cose vere, e lo andarle togliendo dal proprio; il che avendo egli fatto benissimo, ha dato cagione a' moderni di seguitarlo e di venire a quel grado sommo dove si veggiono ne' tempi nostri le cose."

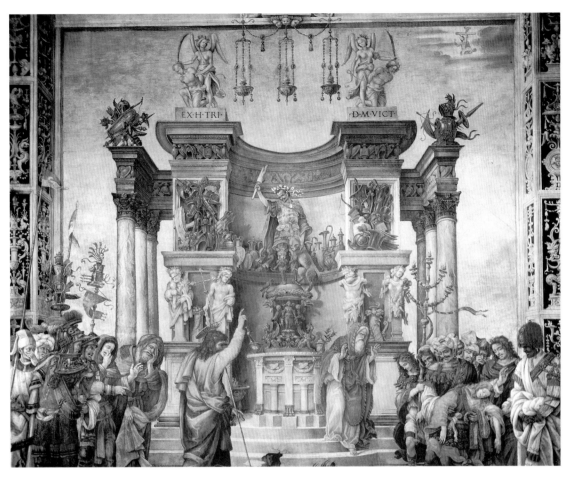

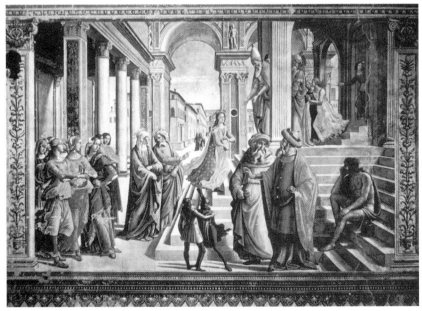

116 (above). Filippino Lippi, *St. Philip Exorcising the Demon at the Altar of Mars*. Florence, Santa Maria Novella, Strozzi chapel.

117. Domenico del Ghirlandaio, *Presentation in the Temple*. Florence, Santa Maria Novella, Tornabuoni chapel.

118. Piero della
Francesca, *The Dream
of Constantine*. Arezzo,
San Francesco.

its means are elaborated in lengthy descriptions. Charm, beauty, and grace are repeatedly
found and noted. The vocabulary of the ornate and of the convincing and pleasurable power
of artistry dominates. In this section, Vasari applied the imagery of divinity and victory, not
only to Michelangelo, but to other great artists of the age, representatives of "divinity itself"
and "mortal gods" like Leonardo da Vinci and Raphael.[177] These were artists whose skills
made them like gods because they were capable of creating new forms and seemed to give
life to inanimate matter.

Vasari's rendering of the past is dynamic. The ideals of art are eternal, fixed in the rules
of nature, but they had to be recovered, discovered, and conquered progressively and
according to the gifts and personalities of each artist. This is established in the early Lives.
Giotto, "moved by the desire for fame and aided by heaven and nature, went to such heights
with his thought that he opened the door of truth to those who have brought that trade to

177 See the Life of Leonardo da Vinci, BB IV, p. 15,
where Leonardo's every action is described as "divina,"
and Vasari states that "veramente il Cielo ci manda talora
alcuni che non rappresentano la umanità sola, ma la
divinità istessa" (1550). Life of Raphael, BB IV, p. 156,
of Raphael, as among those whose combined gifts make
them seem more than mere men ("non uomini
semplicemente, ma . . . dèi mortali").

the wonder and marvel that we see in our century."[178] Giotto's open door is representative of the metaphorical system operating in *The Lives*, guiding the arts and the reader through doors, along paths, upwards and forwards. The momentum is supplied by effort, the prompt is fame, and the result is honor and admiration or, especially in the modern era, wonder.

The progress charted by Vasari in *The Lives*, as artists like Masaccio "by means of their labors showed us the true path that led to great achievements," is reminiscent of Dante's voyage toward grace in *The Divine Comedy*.[179] As in *The Divine Comedy* perfection is not one quality, but a state compounded of virtues. The imagery of glory, light, and grace that Vasari applied to his third age, like his tripartite construction, was undoubtedly influenced by Dante's scheme. Vasari's matching of prose to purpose owed much to the tradition of literary decorum, but it was Dante's poem that had turned it to vivid practice. Vasari, following Dante, wished to create memorable images in a "visible speech" so that words formed pictures in the reader's mind.[180] But where Dante's poetic visions turned the inner eye to the contemplation of spiritual glory, Vasari's prose mediated between the perception of real objects and a recognition of their value.

A collection of artists' biographies, *The Lives* are an act of commemoration and an expression of professional aspirations. The arts were noble, because virtuous and difficult, and therefore worthy of record. In writing them Vasari fused many types and traditions. Daily practice, biographical models, didactic treatises, and rhetorical modes provided patterns, methods, and terminologies. *The Lives* are not copybook exercises or workshop chronicle, however; they are creative and original compositions. Vasari's artifice will be examined in the following chapters where a Life from each of the three parts has been chosen to analyze the ways in which he explained the "quality of the times" and arranged the order of the artists' styles.[181] Vasari's blending of instructive themes, dramatic narrative, and descriptive presentation of works to make the artists live again and forever through the medium of historical prose will be considered. The Lives to be examined are biographies of key figures from each period: Giotto, Donatello, and Raphael. Among the most carefully written, the most exemplary, these Lives were used by Vasari to propose models of behavior and studies of style – manners and *maniere* – to demonstrate the progressive elevation of the arts and artists from humble origins to divine status: from Giotto, the shepherd, to Raphael, the saint.

178 Life of Cimabue, BB II, p. 44 (1550): "mosso dalla ambizione della fama et aiutato dal cielo e dalla natura, andò tanto alto col pensiero ch'aperse la porta della verità a coloro che ànno ridotto tal mestiero a lo stupore et a la maraviglia che veggiamo nel secol nostro."

179 Life of Masaccio, BB III, p. 124: "che mediante le loro fatiche ci mostrarono la vera via da caminare al grado supremo." This metaphor occurs in other Lives, that of Benozzo Gozzoli, for example, BB III, p. 375, or in Part 1, the Life of Stefano, BB II, p. 138: "Onde certo grande obligo avere si dee a Stefano, perché che camina al buio e mostrando la via rincuora gl'altri, è cagione che, scoprendosi i passi dificili di quella, dal cattivo

camino con spazio di tempo si pervenga al disiderato fine." For Dante and Vasari, see Barolsky, *Walter Pater's Renaissance*, pp. 113–26.

180 *Purgatorio*, x:95: "visibile parlare"; in this canto Dante is looking at carvings of scenes from biblical and pagan history illustrating examples of humility.

181 For these expressions, see the preface to Part 2, BB III, p. 13, where Vasari asks his readers, when judging the artists of the first era, to take into consideration "la qualità di que' tempi," and the preface to *The Lives*, BB II, p. 32, where he says about the ordering of his work: "mi sforzerò di osservare . . . l'ordine delle maniere loro."

GIOTTO PITTORE, SCVLTORE
ET ARCHITETTO FIOR.

119. Portrait of Giotto from the 1568 edition of *The Lives*.

GIOTTO: "THE FIRST LIGHT"

GIOTTO HAD LONG BEEN COUNTED among the illustrious citizens of Florence by the time Vasari wrote his biography. In 1334 the priors of the Commune, seeking a "skilled and famous man" to supervise building works at the cathedral, chose Giotto, stating that:

> It is said that in the whole world no one can be found who is more capable in these and other things than master Giotto di Bondone, painter of Florence. He should have cause for agreeing to a continued domicile within it. With this many will profit from his knowledge and learning so that no little beauty will come to this city.[1]

And when Giovanni Villani recorded the beginning of the construction of the bell-tower in July of that year, he noted the appointment as superintendent and manager of the building work of "our fellow citizen Master Giotto: the most sovereign master of painting in his age, whose figures and gestures most resemble nature."[2] This reputation continued to grow after the artist's death. In his book *On the Origins of Florence and Its Famous Citizens*, written around 1380–1, Filippo Villani (Giovanni's nephew), followed "the ancients, who drew up their histories with such distinction [and] included the best painters of pictures and sculptors of statues together with other famous men" and celebrated Giotto as the painter, who, "not only the equal of ancient painters in the glory of fame, but their superior in craft and mind, restored painting to its high renown and pristine dignity."[3] Cennino Cennini traced his genealogy in art to Giotto who "changed the profession of painting from Greek back into Latin, and brought it up to date."[4] In 1395 Niccolò di Pietro Gerini and his associate Lorenzo di Niccolò, haggling with their patron over payments for a crucifix, declared that they had drawn it so well that Giotto himself would have nothing to complain about.[5] In

1 Quoted from Larner, *Culture and Society in Italy 1290–1420*, p. 305; for the original text, see Guasti, *Santa Maria del Fiore*, doc. 20 (12/13 April), p. 43. For an analysis of its terms, see Paatz, "Die Gestalt Giottos im Spiegel seiner zeitgenössischen Urkunde," in *Eine Gabe für Carl Georg Heise*, pp. 85–102. Vasari mentions Giotto's appointment as supervisor of works (with reference to the design and construction of the bell-tower) in the 1568 edition of the Life, BB II, p. 115.

2 *Cronica di Giovanni Villani*, ed. Dragomanni, III, p. 232 (xi, 12): "e soprastante, e provveditore della detta

opera di santa Reparata fu fatto per lo comune maestro Giotto nostro cittadino, il più sovrano maestro stato in dipintura che sì trovasse al suo tempo, e quegli che più trasse ogni figura e atti al naturale."

3 Quoted from Larner, *Culture and Society in Italy 1290–1420*, pp. 278–9. Larner gives a full translation of Villani's text on painters, pp. 278–80.

4 Cennini, *The Craftsman's Handbook*, trans. Thompson, p. 2.

5 Piattoli, "Un mercante del Trecento," *Rivista d'arte* (1930), p. 101. The commission was for the Pratese

his book *On Civil Life* (*c*.1440) Matteo Palmieri said that painting, dead before Giotto, had been revived by him.[6] Giotto's name was proverbial. It stood for a standard of artistry: a paradigm of fame maintained from Giotto's time to Vasari's, despite changes of style and taste.[7]

The Life is a revealing instance of Vasari's adoption of received ideas. He had no real affinity for Giotto's works; the only extended descriptive passage in the first edition is of a now destroyed fresco cycle in Rimini, datable to after 1356, over twenty years after Giotto's death. This passage was probably written when Vasari was in Rimini revising the text for publication and so not even part of the original draft. If Giotto's paintings did not inspire Vasari, his reputation did. It provided him with a ready-made hero. Giotto had an established historical identity, one conveniently combining civic pride and prestigious authors.

Sources

Giotto's position as the champion of the new style had secured him a uniquely extensive bibliography. Vasari had many more sources for his Life than for any other of the period. In verses in Dante's *Purgatory* (xi.94–7) he was coupled with Cimabue, which earned him a place in future commentaries on *The Divine Comedy*. Apart from Cristoforo Landino's (1481), Vasari knew, at least for the second edition, the anonymous early fourteenth-century commentary known as the *Ottimo Commento* (*c*.1330). Giotto featured in the fifth tale of the sixth day of *The Decameron* (*c*.1348–53). Boccaccio's appreciation of the artist is recorded also in his prophetic poem, the *Amorosa Visione* (iv:16–18; 1342), and in Book xiv of the *Genealogy of the Gods* (*Genealogia deorum gentilium*) where he is compared with the most celebrated painter of antiquity, Apelles. Petrarch likewise compared him with Apelles, in one of the letters collected in the *Rerum familiarum libri* (Book v, no. 17). Petrarch owned a painting of the Virgin by Giotto "whose beauty amazes the masters of art, though the ignorant cannot understand it," and which he bequeathed to the Paduan lord, Francesco da Carrara.[8] The Petrarch passages escaped Vasari's attention in the 1540s, but Borghini

merchant, Francesco di Marco Datini, who also invoked Giotto when he was angry at the amount he was charged by the painters (including Gerini) decorating his house in Prato with frescoes: "I don't think when Giotto was alive he did better business," Larner, *Culture and Society in Italy 1290–1420*, p. 321. This occurred in 1391.

6 Palmieri, *Della vita civile*, ed. Belloni, pp. 43–4. In a letter from July 1452 Aeneas Sylvius Piccolomini connected the revival in letters with that in painting, using Petrarch and Giotto as examples, *Der Briefwechsel des Eneas Silvius Piccolomini, ed.* Wolkan, iii, p. 100, note.

7 So, for example, the remark made by Cosimo de' Medici to his cousin Averardo in a letter dated 3 October 1431 (ASF, MAP iv, 246): "credo che tu non sii un buon dipintore, e pure giudicheresti che le fighure di Giotto stesson meglio che quelle del Balzanello," see Boskovits, *Pittura fiorentina alla vigilia del Rinascimento*, p. 258, n. 32. Matteo Palmieri invoked Giotto's name in a

discussion of poor translations from the great authors: "non altrimenti gli somigliono che una figura ritratta dalla più perfecta di Jocto per mano di chi non avesse operato stile né pennello s'asomigliasse all'exemplo" (*Della vita civile*, ed. Belloni, p. 5). For Giotto's reputation, see the summary of literature in Salvini, *Giotto Bibliografia*, i, pp. 1–23, for the literature before 1550. See also, Falaschi, "Giotto: The Literary Legend," *Italian Studies* (1972), pp. 1–27, C. Gilbert, "Cecco d'Ascoli e la Pittura di Giotto," "The Fresco by Giotto in Milan," "Boccaccio Looking at Actual Frescoes," in *Poets Seeing Artists' Work*, pp. 33–46, 67–196, Murray, "Notes on some early Giotto sources," *Journal of the Warburg and Courtauld Institutes* (1953), pp. 58–80, and Stewart, "Giotto e la rinascita della pittura," *Yearbook of Italian Studies* (1983), pp. 22–34.

8 Translation from Larner, *Culture and Society in Italy 1290–1420*, p. 277.

corrected the omission and supplied the texts for the second edition. Borghini also added stories from Sacchetti's *Novelle* (*c.*1388–95) to the sources for the revised edition. Giovanni Villani's *Cronica* provided information about the cathedral and the bell-tower, noted that Giotto had been sent to Milan, and gave his death date (January 1336 [1337 s. c.]). Giotto was the only artist of modern times named in the text of Alberti's treatise *On Painting* (*c.*1435). In Book ii he wrote about Giotto's mosaic of the *Navicella* in St. Peter's:

> They also praise in Rome the boat in which our Tuscan painter Giotto represented the eleven disciples struck with fear and wonder at the sight of their colleague walking on the water, each showing such clear signs of his agitation in his face and entire body that their individual emotions are discernible in every one of them.[9]

For Ghiberti he was the originator of the new art. He appears, with Masaccio, in a paragraph about the history of painting in Leonardo da Vinci's notes.[10] Two chapels in Santa Croce are cited in Francesco Albertini's guide to Florence (1510), and Giotto's works are listed in the manuscript notes that Vasari incorporated in *The Lives*.[11]

Ranging from prophetic verses to brief notations, these sources hardly offered a synoptic view of the artist's career. With the exception of Ghiberti and the notes, they were little concerned with Giotto's actual paintings or in any precise way with his style of painting. What they mainly provided were subjects for invention, the themes and topics from which Vasari could compose his narrative. Vasari's method as a historian can be illustrated and the historical value of the Life of Giotto better understood by looking in greater detail at the material he had at hand, the arguments he took from it, and then how those arguments were arranged.

Giotto's Fame: "and now Giotto has the cry"

Giotto was still alive when Dante immortalized him, paradoxically, by using his fame as an example of vanity:

> O empty glory of human powers!
> How short the time its green endures upon the top,
> If it not be overtaken by rude ages!
>
> Cimabue thought to hold the field in painting,
> And now Giotto hath the cry,
> So that the fame of the other is obscured.[12]

9 Alberti, *On Painting*, ed. Grayson, Book ii, chapter 42, pp. 82, 83. This passage may be due as much to Alberti's reliance on Villani, who describes the *Navicella* for the same reason and in similar terms, as to Alberti's own appreciation of Giotto. The dedicatory letter to the Italian edition, addressed to Brunelleschi and mentioning other of his contemporaries was not known in the sixteenth century.

10 Codice Atlantico 141rb/387r, see Leonardo da Vinci, *Leonardo on Painting*, ed. and trans. Kemp and Walker, p. 193.

11 Albertini, "Memoriale," in *Five Early Guides to Rome and Florence*, ed. Murray, unpaginated (p. 9): "Due cappelle cioe di scõ Io. e scõ Franc. fra laltare maiore & sacrestia p mano di Iocto," and Anon. Maglia., pp. 50–4.

12 *Purgatorio*, xi:91–6: "O vana gloria dell'umane posse,\com'poco verde in su la cima dura,\se non è giunta dall'etati grosse!\Credette Cimabue nella pittura\tener lo campo, ed ora ha Giotto il grido,\sì che la fama di colui è oscura." The translation is quoted from *The Purgatorio*, trans. Okey, p. 133.

Vasari's appraisal of the two artists was based on a long-established misinterpretation of the passage. For him it was proof of the fact that "if the greatness of Giotto had not stood in competition to Cimabue's glory, [Cimabue's] fame would have been greater."[13] For Vasari, Cimabue's ephemeral fame inspired, rather than discouraged. His student Giotto was motivated by "praiseworthy ambition."[14] Vasari could find models for this misreading of Dante's intention among his commentators, notably Cristoforo Landino who wrote in the preface to his 1481 edition of *The Divine Comedy* that "he left behind him a great reputation but would have left much more if he had not had such a noble successor, that is Giotto, Dante's contemporary."[15] Landino's preface was known to the now anonymous compiler of notes on artists, who, in around 1540, incorporated Landino's remarks about artists, without acknowledgment, into the opening captions of his entries. Vasari could have taken the paraphrased remarks from this source. He knew it well. But he is equally likely to have known Landino's text and its context. Landino's commentary was famous and familiar to mid-sixteenth-century readers and interpreters of Dante, numerous in Florence in the 1540s.[16] The study, exposition, and defense of Dante were among the chief activities of the Florentine academy. Vasari's friend Cosimo Bartoli gave five lectures on Dante between 1542 and 1548.[17] In his first lecture on Dante, Giovanni Battista Gelli declared him to be "no less a divine theologian and excellent philosopher than a fine and ingenious poet, Dante Alighieri, Florentine citizen, the special glory and honor of this most noble and illustrious city."[18]

Vasari, although never an academician, participated as a painter in the celebration of the great heroes of Tuscan genius fashionable at the time among the Florentine literary set. His friend Luca Martini commissioned a painting with portraits of the pre-eminent Tuscan poets of the past, placing Dante at the center, flanked by Petrarch, Boccaccio, and Guido Cavalcanti, "accurately based on early portraits" (pl. 120).[19] The project was a success, and

13 Life of Cimabue, BB II, pp. 42–3: "se alla gloria di Cimabue non avesse contrastato la grandezza di Giotto, suo discepolo, sarebbe stata la fama di lui maggiore."

14 *Ibid.*, p. 44: "Giotto . . . suo creato, mosso da lodevole ambizione." The 1550 text is even more explicit about the inspiring nature of Cimabue's reputation for his fellow Florentines: "Cimabue, destò l'animo ai compatrioti suoi," and Giotto was "mosso dalla ambizione della fama" (BB II, pp. 43–4).

15 Text published by Morisano, "Art Historians and Art Critics," *Burlington Magazine* (1953), p. 270: "et gran fama lasciò di sé: ma molto maggiore la lasciava, se non avessi avuto sì nobile successore, quale fu Giotto fiorentino coetaneo di Dante."

16 Mazzacurati, "Dante nell'Accademia Fiorentina," *Filologia e letteratura* (1967), p. 267, for the influence of Landino on Dante studies among the students of Francesco de' Vieri: Gelli, Varchi, Giambullari, Lenzoni. See also Vallone, *L'interpretazione di Dante nel Cinquecento*, and De Gaetano, *Giambattista Gelli*, pp. 297, 300.

17 Bryce, *Cosimo Bartoli*, pp. 253–80.

18 *Lettura Prima*, in *Opere di Giovan Battista Gelli*, ed.

Maestri, p. 563: "non manco divino teologo e ottimo filosofo, che bello e arguto poeta, Dante Alighieri, cittadino fiorentino, e gloria e onore particulare di questa nobilissima e illustrissima patria."

19 For this painting, now in Minneapolis, see Bowron, "Giorgio Vasari's 'Portrait of Six Tuscan Poets,'" *The Minneapolis Institute of Arts Bulletin* (1971–3), pp. 43–5. In Vasari's account of his works, BB VI, p. 384, he describes the painting: "in cui era Dante, Petrarca, Guido Cavalcanti, il Boccaccio, Cino da Pistoia e Guittone d'Arezzo; il quale fu poi di Luca Martini, cavato dalle teste antiche loro accuratamente, del quale ne sono state fatte poi molte copie." Kliemann in Arezzo 1981, p. 123, points out that the two figures at the left are actually Cristoforo Landino and Marsilio Ficino, and that in his autobiography and *ricordanze* Vasari confused the Martini commission with a subsequent version done for Giovio, a variant among the "many copies." Nelson, "Dante portraits," *Gazette des Beaux-Arts* (1992), pp. 59–77, describes the intellectual issues represented in the choice and arrangement of the figures in this and related paintings.

120. Giorgio Vasari, *Six Tuscan Poets*. Minneapolis, Minneapolis Institute of Arts.

it was repeated in copies and variants. The painter Bronzino, who was a member of the academy, and a friend of Vasari, was involved in the commission for this painting.[20] Martini, too, was studying Dante; he was writing, as Vasari remembered, "some things on Dante's *Comedy*."[21] Martini shared his interest in Dante with his artist friends in substantial ways, for "having explained to [Pierino da] Vinci the cruelty described by Dante" in the story of Ugolino, Pierino was prompted to do a sculpture of the scene:

20 Frey II, p. 861, no. 144 (15 September 1544): "Luca Martini Fiorentino mi aveva allogato per fino a di 10 di Luglio 1543 un quadro grande, di dua braccia e un terzo alto et braccia tre largho, per farvi dentro sei figure . . . che il Bronzino pittor fece lacordo."

21 Life of Pierino da Vinci, BB v, p. 233: "sopra la Commedia di Dante alcune cose."

No less did Vinci show his virtue in design than did Dante in his verses demonstrate the worth of poetry, because the actions formed in wax by the sculptor move whoever sees them to no less compassion than the accents and words recorded on the living pages by that poet move whoever is listening.[22]

Sculpture, poetry and painting, art and imitation were subjects of discussion among the academicians, as were the origins of Florence, and its place in the development of Italian culture. Carlo Lenzoni's *Defense of the Florentine Language, and of Dante* was approved by the censors of the academy on the same day as Cosimo Bartoli's translation of Alberti's *Ten Books on Architecture*: 28 February 1548.[23] The conspicuous place of Dante in Florentine culture at this time seems to have influenced his role in Vasari's *Lives*. In the Life of Cimabue, Dante is cited as an authority. In Giotto's, his position as contemporary and friend is noted.[24] His portrait in the chapel of the Bargello, attributed to Giotto, is the first work Vasari mentions (pl. 121).[25] Giotto's fame was firmly associated with Dante, and Giotto's name with fame.

While it was Cimabue's fate to remain more or less in the realm of the shades, little known, recorded mainly as a foil to Giotto, Giotto became a substantial and lively figure in the Florentine imagination.[26] Giotto was a remarkable genius, whose career ranged over much of Italy, whose workshop flourished, and whose students were active. This very real success accounts for the acclaim he earned and Dante broadcast, but not exactly for how it was expressed. For Dante, Giotto was an example of pride, for subsequent writers he became an example of fame – of artistic fame. Hence he became subject to the conventions and commonplaces of discussions of fame ("greater than the ancients") and of artists and artistry, in terms taken mainly from Pliny. He had a place in debates about the prestige of the arts and of the revival of culture after an age of darkness.

Giotto was officially declared a famous man in the document appointing him master of works at the cathedral. The Santa Reparata document is an important record of Giotto's success. It is communal acknowledgement of his skill and fame ("expertus et famosus vir"). It is also an important record of the rising social prestige of the arts in Florence. Implicit is a sense of civic pride in citizens who excelled in, until then, relatively humble occupations like painting. In the document Giotto's residence in the city is considered a benefit because "many will profit from his knowledge and learning [*scientia et doctrina*]." As a category, art or *ars*, was traditionally defined as something that could be learned, and it applied to

22 *Ibid.*, pp. 234: "Non meno in questa opera mostrò il Vinci la virtù del disegno che Dante ne' suoi versi mostrasse il valore della poesia, perché non men compassione muovono in chi riguarda gli atti formati nella cera dallo scultore, che faccino in che ascolta gli accenti e le parole notate in carta vive da quel poeta."

23 In the event, Lenzoni's *In difesa della lingua fiorentina, et di Dante* was published after Lenzoni's death, edited and completed by Francesco Giambullari and Cosimo Bartoli (1556).

24 Life of Giotto, BB II, p. 97: "coetano et amico."

25 *Ibid.*, BB II, p. 97. For this portrait and the history of its attribution see Gombrich, "Giotto's Portrait of Dante?" *Burlington Magazine* (1979), pp. 471–81, and Chastel, "Giotto coetaneo di Dante," in *Studien zur*

toskanischen Kunst, Festschrift für L.H. Heydenreich, ed. Lotz and Möller, pp. 37–44. See also Rambaldi, "Dante e Giotto nella letteratura artistica," *Rivista d'arte* (1937), pp. 357–69, about the growth of the legend of their close association and its place in Vasari's Life of Giotto. The pictures decorating San Lorenzo for Michelangelo's funeral included Giotto with his portrait of Dante (BB VI, p. 135).

26 See for this, Schlosser, "Zur Geschichte der Kunsthistoriographie," in *Präludien. Vorträge und Aufsätze*, pp. 248–95, Wickhoff, "Über die Zeit des Guido von Siena," *Mitteilungen des Instituts für Oesterreichische Geschichtsforschung* (1889), pp. 224–86, and Benkard, *Das literarische Porträt des Giovanni Cimabue*.

shoemaking as much as painting or medicine. But *scientia* and *doctrina* separated the liberal from the mechanical arts. This suggests that, in the minds of the city's priors, cobblers and painters were no longer craftsmen of equal status. Furthermore, Giotto's reputation is declared as extending far beyond the boundaries of his native city ("in universo orbe"), considerably enlarging the parochial perimeters of other valued masters, such as Arnolfo di Cambio who had preceded him in the cathedral post and been named as the most famous and expert church builder known in the region.[27] To his fellow citizens Giotto's mastery in painting suggested that he was capable of other things and that "no little beauty" would result from his efforts. To later writers, including Vasari, such recognition was part of the explanation for the concentration of artistic excellence in Florence:

> It is truly a useful and admirable deed to reward excellence generously at every opportunity and to honor its possessor, because an infinite number of gifted minds, which in certain times would remain dormant, excited by this stimulus, will endeavor . . . to excel, and to raise themselves to a useful and honorable rank, from which follows honor to their country, glory to themselves, and riches and nobility to their descendants.[28]

The values embodied in the terms of the appointment remained established in Florentine artistic life and continued to be attached to Giotto's name. Both the novelty and justice of the standing it granted to Giotto are registered in Boccaccio's tale in *The Decameron* of Giotto and the jurist, messer Forese da Rabatta. The tale is the fifth told on the sixth day, devoted to those who, "being provoked by some verbal pleasantry, have returned like for like, or who, by a prompt retort or shrewd manoeuvre, have avoided danger, discomfiture, or ridicule."[29] Giotto's placement is not as a buffoon, but as a wit, one whose quick mind is matched against a lawyer's.[30] Messer Forese remarks upon Giotto's disreputable appearance: " 'Giotto, supposing we were to meet some stranger who had never seen you before, do you think that he would believe that you were the greatest painter in the world?' " Giotto, who "pays him back in kind," answers: " 'Sir, I think he would believe it if, after taking a look at you, he gave you credit for knowing your A B C's. ' "[31] The last word is Giotto's, as is the compliment to his painting, despite the insult to his person: that "nature has frequently planted astonishing genius in men of monstrous appearance" is one object lesson of the story.[32] The quick-witted artisan was a traditional comic type, but Boccaccio's

27 For Arnolfo's appointment, see Guasti, *Santa Maria del Fiore*, p. 20, doc. 24 (1 April 1300): "quod ipse est famosior magister et magis expertus in hedificationibus ecclesiarum aliquo alio qui in vicines partibus cognoscatur."

28 Life of Taddeo Gaddi, BB II, p. 203: "È bella e veramente utile e lodevole opera premiare in ogni luogo largamente la virtù et onorare colui che l'ha, perché infiniti ingegni che talvolta dormirebbono, eccitati da questo invito, si sforzano . . . di venirvi dentro eccellenti per solevarsi e venire a grado utile et onorevole, onde ne segua onore alla patria loro e a se stessi gloria, e rec[c]hezze e nobiltà a' descendenti loro."

29 *Decameron*, ed. Branca, II, p. 123: "di chi con alcuno leggiadro motto, tentato, si riscosse, o con pronta risposta o avvedimento fuggì perdita o pericolo o scorno."

30 See Riccò, "Tipologia novellistica degli artisti vasariani," in *Studi* 1981, pp. 95–115.

31 *Decameron*, ed. Branca, II, pp. 151–2: " 'Giotto, a che ora venendo di qua allo 'ncontro di noi un forestieri che mai veduto non t'avesse, credi tu che egli credesse che tu fossi il miglior dipintor del mondo, come tu se'?'. A cui Giotto prestamente rispose: 'Messere, credo che egli il crederebbe allora che, guardando voi, egli crederebbe che voi sapeste l'abicì.' Il che messer Forese udendo, il suo error riconobbe, e videsi di tal moneta pagato, quali erano state le derrate vendute."

32 *Ibid.*, p. 148: "così ancora sotto turpissime forme d'uomini si truovano maravigliosi ingegni dalla natura essere stati riposti."

reference to it was tempered by his deep admiration for the artist. Another lesson of this tale is how fortune sometimes hides "very great treasures of excellence in humble arts."[33] In an earlier work, the *Amorosa Visione*, Boccaccio could express the beauty of the paintings in the imaginary castle of glory only by comparing them with Giotto's works. In *The Decameron* Boccaccio, no mean storyteller himself, calls Giotto a "fine talker," a considerable tribute to the artist's narrative gifts.[34] He devotes an extensive passage to the artist where he praises Giotto for his excellence of mind, his imitation of nature, and for having "brought back to light an art buried for centuries" beneath the errors of those aiming to delight the ignorant rather than satisfy the wise. For this, Boccaccio said, Giotto's work might be seen as a monument to Florentine glory: "and he acquired more glory from his great humility, for while living he was master of others, he always refused to be called master. This rejected title shone brightly in him, as it was desired and greedily usurped by those who knew less and by his pupils."[35]

The terms of Boccaccio's praise echo the appreciation for *scientia* and *doctrina* in the appointment document. Giotto's excellence of mind and the delight it affords the wise are aspects of painting raised above the practice of a craft. That the excellence functions also in service of Florentine glory seems to fulfill the wish of the appointing committee, and gives further voice to the connection of civic pride and artistic eminence. The social implications of this also form part of Boccaccio's text: Giotto, who earned the title of master, refused to accept it. The actual place of artists in the social hierarchy is indicated by Giotto's use of the formal *voi* when he addresses messer Forese, who answers with the familiar *tu*. Boccaccio's panegyric would seem to be an argument in favor of greater esteem.

Boccaccio's text is among the first examples of humanist writing on painting.[36] The vocabulary of pleasure and delight and the reference to the standard of nature are classical commonplaces. Even the paradoxical type of the ugly artist who makes beautiful paintings is to be found in Roman literature.[37] The context is novel, however. For Boccaccio also took up the notion of revival and the imagery of light and dark first given cultural currency by Petrarch.[38] Boccaccio named Giotto and Dante among the ancient philosophers and poets in his *Amorosa Visione*. For Boccaccio Giotto reawakened painting, just as Dante had poetry.[39]

33 *Ibid.*: "la fortuna sotto vili arti alcuna volta grandissimi tesori di virtù nasconde."

34 *Ibid.*, p. 151: "Giotto, il quale bellissimo favellatore era."

35 *Ibid.*, p. 150: "E per ciò, avendo egli quella arte ritornata in luce, che molti secoli sotto gli error d'alcuni, che più a dilettar gli occhi degl'ignoranti che a compiacere allo 'ntelletto de' savi dipignendo, era stata sepulta, meritamente una delle luci della fiorentina gloria dir si puote; e tanto più, quanto con maggiore umiltà, maestro degli altri in ciò vivendo, quella acquistò, sempre rifiutando d'esser chiamato maestro. Il quale titolo rifiutato da lui tanto più in lui risplendeva, quanto con maggior disidero da quegli che men sapevano di lui o da' suoi discepoli era cupidamente usurpato."

36 For this, see Baxandall, *Giotto and the Orators*. For the definition of humanist and for the hierarchy of the arts, see Kristeller, *Renaissance Thought and the Arts*. See also Boskovits, *Pittura fiorentina alla vigilia del Rinascimento 1370–1400*, pp. 159–88.

37 Macrobius, *The Saturnalia*, trans. Davies, II.ii.10, p. 164, about the painter Mallius. Petrarch cites this with reference to Giotto, *Epistolae de rebus Familiares*, Lib. v, ep. 17 (*Le Famigliari*, ed. V. Rossi, II, p. 39).

38 Mommsen, "Petrarch's Conception of the Dark Ages," *Speculum* (1943), pp. 226–42, and Simone, "La coscienza della rinascita negli umanisti," *La Rinascita* (1939), pp. 838–71.

39 See his Life of Dante, *Opere*, ed. Ricci, p. 573. For Boccaccio's place in humanist historiography, see Ferguson, *The Renaissance in Historical Thought*, p. 19. With relation to Giotto, see C. Gilbert, "Boccaccio's Devotion to Artists and Art," in *Poets Seeing Artists' Work*, pp. 49–65.

Boccaccio diffused the notion of cultural distance from the recent past and, by attaching it to specific figures – Dante and Giotto – brought classical glory to contemporary heroes. The practice of translating classical formulas into contemporary terms and applying them to Giotto was continued by Filippo Villani in the second part of his book *On the Origins of Florence* which he devoted to the eminent citizens of the city. Such exemplary cycles of illustrious men were in themselves a classical revival, one current in Villani's circle.[40] Villani cites the precedent of the ancients in deciding to include painters among those "learned and famous fellow citizens of [Dante] . . . the very recollection of whom could stimulate the capacities of the living to emulate their excellence."[41] Like Boccaccio's, Villani's view of his period was as a time of cultural renewal; for him, too, the hero was Dante, who rescued poetry, "lying prostrate without honor or dignity," by recalling it "as from an abyss of shadows into the light."[42] Villani lays part of the blame for the decay of poetry since the time of the emperor Claudian on the Catholic faith: "art was no longer prized, since the Catholic faith began to abhor the figments of the poetic imagination as a pernicious and a vain thing."[43] Vasari took up this view of cultural history in the introduction to *The Lives*.[44] The late fourteenth-century writer found a restoration of the creative imagination in the restoration of poetry. His statement that Giotto's works rivaled poetry is an early and influential instance of the revival of the classical comparison of painting and poetry (*ut pictura poesis*). This parallel became a key component in the elevation of the status of painting and painters.

Concern with issues of definition and professional hierarchy is an aspect of Villani's passage on Giotto. Like Boccaccio, he refers to the title of *magister* in a way that must reflect contemporary debate on the status of art and artists:

> According to the view of many intelligent people, indeed, painters are not inferior in mind to those made masters [*magistri*] by the liberal arts, since the latter obtain by study and learning in books what is required by their arts, while painters depend only on the high mind and tenacious memory which is manifest in their art.[45]

He then enlarges upon Giotto's talents, his "great understanding" and "experience in many things" such as history. He says that Giotto's works were painted poetry. Villani deals with the contemporary issue of social placement by relying on classical authority. In its conception and in its composition, Villani's chapter on painters is modeled on classical literature (his own way of "bringing things to light"). He had a convenient source, Pliny's chapters on painting in the *Natural History* on which his praise of Giotto and Cimabue is closely based.[46] Apollodorus "was the first artist to give realistic presentation of objects,

40 See Hankey, "Salutati's Epigrams for the Palazzo Vecchio at Florence," *Journal of the Warburg and Courtauld Institutes* (1959), pp. 363–5. Salutati provided titles for a painted cycle of illustrious men based largely on Petrarch's *De viris illustribus*, but which also included among the ancient worthies five Florentine poets, Claudian, Dante, Petrarch, Boccaccio, and Zanobi da Strada. Villani had Salutati correct his manuscript, Baxandall, *Giotto and the Orators*, pp. 68–9.

41 Quoted from Baxandall, *Giotto and the Orators*, p. 73.

42 Translated by Ferguson, *The Renaissance in Historical Thought*, p. 20.

43 *Ibid*.

44 Preface to *The Lives*, BB ii, pp. 18–19.

45 Quoted from Larner, *Culture and Society in Italy 1290–1420*, pp. 279–80.

46 See Baxandall, *Giotto and the Orators*, pp. 77–8, for an illuminating presentation of this.

and the first to confer glory as of right upon the paint brush," and the "gates of art having been . . . thrown open by Apollodorus they were entered by Zeuxis . . . who led forth the . . . paintbrush . . . to great glory."[47] For Villani it was Cimabue, who

> summoned back with skill and talent the decayed art of painting, wantonly straying far from the likeness of nature as this was . . . the road to new things now lying open, Giotto – who is not only by virtue of his great fame to be compared with the ancient painters, but is even to be preferred to them for skill [*arte*] and talent [*ingenio*] – restored painting to its former worth and reputation. For images formed by his brush agree so well with the lineaments of nature as to seem to the beholder to live and breathe.[48]

In adapting Pliny's history to his lives, Villani did not deny or neglect the reality of his times any more than did Vasari when he adapted Villani and Pliny, rather he saw the events of the past as analogous to those of the present. The naturalism, the narrative, and the drama of Giotto's works, like the *Navicella*, which Villani describes, were seen through the precedents cited in classical writings. These parallels confirmed the grandeur of the art of his day and established a measure of worth and reputation to which Giotto could then be compared, and then preferred – a procedure that in itself had its source in the classical topic of comparison.

For Vasari, both the origins of art and of the history of art were to be found in the literary record of Giotto. By the end of the fourteenth century, particularly through the writings of Boccaccio and Villani, Giotto's fame had been defined and explained following models from the classical world, whose glories he was seen to have restored. His name was linked with the idea of revival and with concepts of art and ingenuity, learning and skill, poetry and painting, fame and reputation. The precedents offered by the ancient world had been absorbed into the discussion of contemporary art. Villani had his manuscript vetted by an eminent scholar, Coluccio Salutati, to ensure that it was suitably Ciceronian. Vasari could look for no better authorities than Dante, Boccaccio, or Villani when he began to write about fourteenth-century art, or, indeed, the arts in Florence in general. He was very impressed by the amount of writing on Giotto and made it a feature of his biography: "The pens that have written from his time forward record great wonder at his name for having been the first to rediscover the way of painting that had been lost many years before."[49] For Vasari, such commemoration, which continued through the fifteenth century and included an epitaph by Poliziano commissioned by Lorenzo de' Medici for the duomo, was meant to inspire all artists with the hope of being worthy of such memorials.[50]

47 *N.H.*, xxxv.xxxvi.60–1, pp. 306, 307.

48 Baxandall, *Giotto and the Orators*, p. 77. Vasari also directly paraphrased Pliny's passage about "the gates of art," when he said that Giotto "che andando più alto col pensiero aperse la porta della verità," Life of Cimabue, BB II, p. 44.

49 Life of Giotto, BB II, p. 122 (1550): "Restò nelle penne che scrisse, a suo tempo a poi, tanta maraviglia del nome suo, per esser stato primo a ritrovare il modo di dipingere perduto inanzi lui molto anni." The 1568 text directly juxtaposes Giotto's works and his literary record, p. 122: "restò memoria di Giotto non pure nell 'opere che uscirono delle sue mani, ma in quelle ancora che uscirono di mano degli scrittori di que' tempi."

50 *Ibid.* (both editions).

Fifteenth- and Sixteenth-Century Sources

Fourteenth-century writings supplied Vasari with vocabulary, themes, and historical constructions on which to base his account of the period. They provided a rich stock of formulas – a "storeroom of invention" in rhetorical terms – but only a limited number of facts. Neither Dante nor Boccaccio mentions any works. Villani mentions two as being representative of Giotto's imitation of nature and dramatic abilities: a self-portrait and portrait with Dante in the Bargello chapel and the *Navicella* at St. Peter's (also an example of a prestigious site). Vasari had to look elsewhere for a preliminary list of works. One source was Ghiberti's *Commentaries*.[51] Villani's observation that Giotto "painted something in prominent places throughout almost all the famous towns of Italy," was substantiated by Ghiberti's proof of Giotto being "prolific in everything" – fresco, oil, wall and panel painting, mosaic, architecture, and even sculpture (by providing drawings) – through enumeration of works done in many places – Rome, Padua, Naples, Assisi, and, above all, Florence.[52] He lists about forty works, twenty-nine in Florence. Few had been cited by any previous writer, and of those that can still be seen, most are held to be reliable attributions.[53]

Ghiberti prefaced his list with an account of Giotto's origins, which were, for him, also the origins of the "new art" ("arte nuova"). Ghiberti describes a country boy, whose innate talent was demonstrated by drawing sheep and who was discovered by chance by the most famous painter of the day, Cimabue.[54] The connection between *ingegno* (innate talent) and *arte* (acquired skill) and the beginnings of the new art in the lessons of nature was turned to dramatic fiction. In writing this Ghiberti might have selected from the traditional accounts of Giotto's training. There was at least one other, reported by a late fourteenth-century commentator on Dante:

> It is said that Giotto's father had apprenticed him to the wool trade, and that every morning going to work he would stop at Cimabue's workshop. When his father asked the wool merchant how his son was doing, he replied: "It's a long time since he's been here. I found out recently that he stays with painters, where his nature draws him." So, having taken Cimabue's advice, the father took him from the wool trade to paint with Cimabue.[55]

Or he might have invented the story. For Ghiberti, and for Vasari who followed Ghiberti in this, the facts were that Giotto was the "inventor and discoverer of much learning that had been buried for about six hundred years," that Cimabue's "Greek" style was replaced by Giotto's naturalism, and that Giotto's talent as well as style were derived from nature.[56]

51 Kallab, *Vasaristudien*, pp. 153–4, for a detailed analysis of the *Commentaries* as a source for this Life. For a further evaluation, see C. Gilbert, "The Fresco by Giotto in Milan," in *Poets Seeing Artists' Work*, pp. 72–110, 151–5.

52 Villani, quoted from Larner, *Culture and Society in Italy 1290–1420*, p. 280; Ghiberti, *Commentari*, ed. Schlosser, p. 36: "Costui fu copio(so) in tutte le cose."

53 For Ghiberti's remarkable record, see C. Gilbert, "The Fresco by Giotto in Milan," in *Poets Seeing Artists' Work*, pp. 72–8, which refers as well to Bellosi,

Buffalmacco e il Trionfo della Morte, pp. 113–20, Appendix I ("Statistica Ghibertiana"). The latter, which finds Ghiberti to be seventy-nine percent correct in cases that can be substantiated by other means and probably so for the rest, should be read with the qualifying remarks by Maginnis about Bellosi's selectivity in choosing his test cases (review of Bellosi, *Art Bulletin* [1976], p. 127).

54 Ghiberti, *Commentari*, ed. Schlosser, p. 35.

55 Quoted from Larner, *Culture and Society in Italy 1290–1420*, p. 291.

The story or history of the shepherd boy was a narrative formula that fitted these facts and gave them a sense.[57] The accidental discovery of talent and its origins in nature had a prototype in the account of the youth of Lysippus in Pliny's *Natural History*:

> Lysippus of Sicyon is said by Duris not to have been the pupil of anybody, but to have been originally a copper-smith and to have first got the idea of venturing on sculpture from the reply given by the painter Eupompos when asked which of his predecessors he took for his model; he pointed to a crowd of people and said that it was Nature herself, not an artist, whom one ought to imitate. Lysippus as we have said was a most prolific artist and made more statues than any other sculptor.[58]

Giotto, too, was a student of nature and "a most prolific artist." The intervention of fate and nature here provides a form of explanation for the way in which "the art of painting began to rise in Tuscany."[59]

Giotto is the only artist whose origins are detailed in the *Commentaries*. Obviously Ghiberti understood them to be bound up with the renewal of painting. Vasari accepted this link of nature and talent, nature and art as fundamental to his picture of Giotto. That he understood the shepherd tale as a fabrication is indicated by his attitude towards the story of the similar discovery of Andrea Sansovino, which he repeats, but frames with qualifying remarks: "it is said that Andrea was born in 1540, and in his childhood, as is also said of Giotto, he would draw all day long in the sandy soil, and portrayed in clay one of the beasts that he was minding."[60]

Ghiberti's text supplied the core of works for this Life. Its formulaic listing of what Giotto did, and where, also underlies most of Vasari's record of his paintings, which is predominantly a naming of subjects and places. This mode of perception and recall was reinforced by the second major source of information, the sixteenth-century manuscript notes on artists. Its cumulative rhythm of works ("He painted," "he made," "he also painted," "he also did"; "dipinse," "fece," "dipinse anchora," "fece anchora") with simple identifications of places and subjects and limited, conventional appraisals – "done very outstandingly" ("molto egregiamente condotte"), "worked diligently" ("diligentemente condotte"), "wonderful" ("mirabile") – is also echoed in Vasari's account of Giotto's oeuvre. To the four chapels and four altarpieces in Santa Croce noted by Ghiberti, the manuscript notes added the high altar chapel (actually by Agnolo Gaddi) and its altarpiece (by Ugolino di Nerio), the Tree of Life in the "chapter house" (actually in the refectory, by Taddeo Gaddi), the historiated panels on the cupboards in the sacristy (by Taddeo Gaddi), and with greater accuracy, the altarpiece in the Baroncelli chapel, citing its inscription with Giotto's name.[61] Vasari omitted the main chapel, but otherwise accepted these enthusiastic accretions, even

56 Ghiberti, *Commentari*, ed. Schlosser, p. 36: "inventore e trovatore di tanta doctrina la quale era stata sepulta circa d'anni 600."

57 See Kris and Kurz, *Legend, Myth, and Magic in the Image of the Artist*, which analyzes the origins of this tale and its part in the "heroization of the artist in biography," pp. 13–38.

58 *N.H.*, XXXIV.xix.61, pp. 172, 173. Kris and Kurz, *Legend, Myth, and Magic in the Image of the Artist*, pp. 14–26.

59 Ghiberti, *Commentari*, ed. Schlosser, p. 35: "Cominciò l'arte della pictura a sormontare in Etruria."

60 Life of Andrea Sansovino, BB IV, pp. 271–2 (1568): "Nacque Andrea, secondo che si dice, l'anno MCCCCLX, e nella sua fanciullezza guardando gl'armenti, sì come anco si dice di Giotto, disegnava tutto giorno nel sabbione e ritraeva di terra qualcuna delle bestie che guardava."

61 Anon. Maglia., p. 52: "a pie del quale è il suo nome scritto."

suggesting further paintings in the same church (above the tombs of Carlo Marsuppini and Leonardo Bruni). He corrected the location of the Tree of Life, but still gave it to Giotto, and added the Last Supper and its surrounding scenes, which he identified as from the life of St. Louis (one is, the other three are not). In a slight variation on Landino the manuscript notes called Giotto a "student and contemporary of Dante" ("discepolo et coetaneo") and said that he had portrayed Dante in a chapel in the Palazzo del Podestà, information Vasari willingly accepted.[62] Vasari's order follows neither Ghiberti's nor the notes, which differ from each other. He recast their lists according to an itinerary of increasing fame and increasingly prestigious patrons. He also found out more names, giving patrons to the paintings. He is often more specific about the subjects, particularly in Florence and Rome, showing that his research was guided by, but not limited to, these sources, and that though he granted them due faith, as he said, he also checked them with his own eyes and against his experienced judgment.[63] But the chief amplifications are those of critical context and characterization. The artist emerges along with his works, and his public is defined both among his contemporaries and Vasari's, creating a climate of appreciation. The greatest influence is given to artists' judgments, and the greatest artist is brought in as a judge. Michelangelo is quoted as praising a small painting showing the death of the Virgin for its decorum in depicting the scene such that "it could not be closer to the truth."[64] And, Vasari adds, "in those times it was truly a miracle that Giotto could have painted with such charm, especially considering that in certain respects he had learned his craft without a teacher."[65]

The Debt to Nature: Giotto's Origins

How did Vasari compose Giotto's Life from Giotto's legacy? From its prologue to the concluding epitaph, the Life adheres to Vasari's biographical formula: the account of origins and training, followed by the narrative of works, naming of students, summary of character, funeral, epitaph. The chief topics of this Life are Giotto's natural gifts and study of nature, his friendship with Dante, his prolific output, his social standing, and his fame: all derived from the earlier literature. Giotto's personal accomplishment is located in his time, "that age both coarse and clumsy."[66] His birth signals an advance and sets the course for art, expressed here with echoes of the opening metaphor of Dante's *Divine Comedy*, the way or path. Giotto by means of his divine gift "revived what had been lost," or been on the wrong path ("mala via").[67]

62 *Ibid.*, pp. 50–1. The portrait was mentioned by Villani as well.

63 Letter to the artists, BB VI, p. 411.

64 Life of Giotto, BB II, p. 114: "Questa opera dagl'artefici pittori era molto lodata e particolarmente da Michel[agnolo] Buonarroti, il quale affermava . . . la proprietà di questa istoria dipinta non potere essere più simile al vero di quello ch'ell'era"–praise so valuable that the painting mysteriously disappeared between 1550 and the 1560s: "è stata poi levata via da chi che sia, che, forse per amor dell'arte e per pietà, parendogli che fusse poco stimata, si è fatto, come disse il nostro Poeta, spietato" (the reference is to Dante, *Paradiso*, IV:103–5). For other instances of validation by the artistic community Vasari is creating and commemorating through this history, see,

for example, of the Baroncelli altarpiece, BB III, p. 99: "gl'artefici che considereranno in che tempo Giotto, senza alcun lume della buona maniera, diede principio al buon modo di disegnare e di colorire, saranno forzati averlo in somma venerazione"; of the *Navicella* at St. Peter's, p. 106: "Le lodi, dunque, date universalmente dagl'artefici a questa opera se le convengono."

65 Life of Giotto, BB II, p. 114: "E veramente fu in que' tempi un miracolo che Giotto avesse tanta vaghezza nel dipingere, considerando massimamente che egli imparò l'arte, in un certo modo, senza maestro."

66 *Ibid.*, p. 95: "quella età e grossa et inetta."

67 *Ibid.*: "per dono di Dio quella che era per mala via risuscitò."

Vasari opens the Life by invoking nature:

That same debt that painters owe to nature – which serves continually as an example to those who, by taking from her the most admirable and beautiful parts strive always to imitate her – the same debt is owed to Giotto; since the methods of good paintings and their outlines had been buried for so many years by the devastations of wars, he alone, even though born among untalented artists, by means of his divine gift revived what had been lost and brought it to a state that can be called good. And it truly was a very great miracle that that coarse and clumsy age should have had the strength to work in Giotto in so learned a fashion, so that drawing, of which the men of those times had little or no knowledge, returned to life completely through the efforts of such a good artisan.[68]

Giotto is as much object as subject. He is an object of admiration and an example. Vasari actually creates two examples in the first sentence: nature and Giotto. The debt, the *obligo*, is owed by all painters to both.

A passage in Leonardo's notebooks is useful in helping to understand the nuances of Vasari's highly compressed opening line. In a brief account of the history of painting, Leonardo wrote:

The painter will produce pictures of little excellence if he takes other painters as his authority, but if he learns from natural things he will bear good fruit. We saw this in the painters who came after the Romans. They always imitated each other and their art went ever into decline from one age to the next. After these came Giotto the Florentine who was not content to copy the works of his master Cimabue. Born in the lonely mountains inhabited only by goats and other beasts, and being inclined by nature to such art he began to copy upon the stones the movements of the goats whose keeper he was. And thus he began to copy all the animals he found in the countryside in such a way that after much study he surpassed not only the masters of his age but all those of many centuries before.[69]

The artist must look to nature, not to other artists, otherwise style stagnates and declines.

68 *Ibid.* (1550): "Quello obligo istesso che hanno gli artefici pittori alla natura–la quale continuamente per essempio serve a quegli che cavando il buono da le parti di lei più mirabili e belle, di contrafarla sempre s'ingegnano–, il medesimo si deve avere a Giotto, perché essendo stati sotterrati tanti anni dalle ruine delle guerre i modi delle buone pitture e i dintorni di quelle, egli solo, ancora che nato fra artefici inetti, con celeste dono quella ch'era per mala via resuscitò e redusse ad una forma da chiamar buona. E miracolo fu certamente grandissimo che quella età e grossa et inetta avesse forza d'operare in Giotto sì dottamente, che 'l disegno, del quale poca o nessuna cognizione avevano gli uomini di qui tempi, mediante sì buono artefice ritornasse del tutto in vita." The 1568 text is much the same, with the significant addition of Vasari's direct opinion ("per mio credere") about the artists' debt to Giotto.

69 Codice Atlantico 141rb/387r, quoted from *Leo-*

nardo on Painting, ed. and trans. Kemp and Walker, p. 193. The original reads: "Siccome il pittore avrà la sua pittura di poca eccielenza, se quello piglia per autore l'altrui pitture, ma s'egli inparerà dalle cose naturali farà bono frutto, come vedemo in ne' pittori dopo i Romani, i quali senpre imitarono l'uno dall'altro e di età in età senpre andava detta arte in dechinazione; dopo questi venne Giotto Fiorentino, il quale [non è stato contento allo imitare l'opere di Cimabue suo maestro] nato in monti soletari . . . questo sendo volto dalla natura a simile arte, cominciò a disegniare sopra i sassi li atti delle capre delle quali lui era guardatore . . . che questo dopo molto studio avanzò non che i maestri della sua età, ma tutti quelli di molti secoli passati." See Richter, *The Literary Works of Leonardo da Vinci*, I, pp. 371–2, no. 660 (the passage in square brackets was crossed out by Leonardo).

Thus Vasari does not enjoin painters to copy Giotto only, but also to follow his model in copying from nature. Vasari develops this point later, in Part 2, in the opening to the Life of Mino da Fiesole where he warns that those artists who only imitate the styles of their teachers can never arrive at perfection, which is reserved only for those who imitate nature as well.[70] The similarity of Vasari's ideas to Leonardo's is remarkable. Although some copies of Leonardo's notebooks were circulating in the 1540s, Vasari does not mention Leonardo's writings in the 1550 edition of *The Lives*.[71] He may well have known about Leonardo's ideas from other artists in Florence, like Pontormo or Bandinelli. More likely Leonardo and Vasari shared a common source in ideas circulating in artists' shops.[72] The habit of discussion is recorded by Vasari in the Lives of Perino del Vaga and Baccio d'Agnolo. While such conversations cannot be reconstructed, their importance in creating a community of ideas remains.

Here Vasari has taken such ideas and put them into a historical framework. His description of the rebirth and resurrection of the arts adopts the formulations of the humanist historians.[73] For Boccaccio art had been buried beneath errors, for Vasari it was destroyed by wars.[74] This political explanation carried with it the implications of the benefits of peace. With the end of the wars the arts, like the cities, could flourish. In his account of Florentine history (the *Istorie Fiorentine*) Machiavelli based his theory of the rise and decline of states on the idea that virtue springs from order and from virtue, glory. A political explanation of cultural achievement could be found in Cicero as well: "Upon peace and tranquillity eloquence attends as their ally, it is . . . the offspring of a well-established civic order."[75] Similarly, for Vasari the course of art could be connected with social forces and the course of history.

Vasari was circumspect in his praise of Giotto. Giotto is the beginning of the right road, whose end is the art of Michelangelo. Giotto worked with "divine gift," Michelangelo's actions were "divine rather than earthly."[76] The miracle of resurrection, of return to life stated in the opening of Giotto's Life is not elaborated. It is fully developed only in the vocabulary of Michelangelo's biography. Giotto's place is that of a humble precursor to his divine successor.

And Giotto's humble origins are an important aspect of this biography. Giotto is a great man of modest birth. At his death, Vasari says, he was mourned by all, great and lowly alike, being a person: "Who, because of the rare virtues that were resplendent in him, certainly merited praise and most illustrious fame in spite of being born from humble

70 Life of Mino da Fiesole, BB III, pp. 405–6. For this passage, see above, Chapter VI, pp. 247–8.

71 Benvenuto Cellini claimed to have bought (before 1542) "the book written in pen copied from one by the great Leonardo about the three great arts." See Richter, *The Literary Works of Leonardo da Vinci*, I, p. 5, quoted from Cellini's *Della Architettura*: "Compraimi d'un povero gentiluomo per 15 scudi di oro il libro scritto a penna copiato da uno del gran Lionardo sopra le tre grande arti." Vasari's familiarity with Leonardo's notebooks would seem to date from the mid-1560s, however, when he saw them in Milan, and when he was visited in Florence by a Milanese painter who had some

writings by Leonardo about painting and who wished to have them printed (Life of Leonardo, BB IV, p. 28).

72 See Barocchi ed., *Scritti d'arte*, II, section IX, for texts and references to theories of imitation in the period.

73 See Ferguson, *The Renaissance in Historical Thought*, chapter 1.

74 Life of Giotto, BB II, p. 95.

75 Cicero, *Brutus, Orator*, trans. Hendrickson and Hubbell, *Brutus*, xii.45, pp. 48, 49.

76 Life of Giotto, BB II, p. 95, "con celeste dono" (1550), "per dono di Dio" (1568). Life of Michelangelo, BB VI, p. 4: "più tosto celeste che terrena cosa."

ancestry."[77] Vasari gives an elaborate and formal account of Giotto's "external circumstances": his fortune, descent, and boyhood. And by devoting such attention to them he made them important.

In this Life Vasari took the topics of ancestry and advantages of birth to counter nobility of birth with nobility of talent. In the 1550 edition particularly, Vasari embroidered Ghiberti's story of the shepherd boy by adding details about his father's reputation in the neighborhood and Giotto's character as a youth. Bondone, according to Vasari, "enjoyed such a good reputation in his life and was so skilled in the art of agriculture that no one who lived in that area was held in more esteem than he."[78] He handled his tools more as though "he had the refined hand of a skilled goldsmith or carver" than in the manner of a rustic.[79] He thus granted Giotto's farmer father the dexterity appropriate to an artist.

Vasari's representation of Giotto's father can be understood in the context of sixteenth-century thought about birth and breeding. This can be typified by the debate in Baldassare Castiglione's *Courtier*. Count Lodovico da Canossa, a partisan of nobility in the dialogue, voices the opinion that

> as a general rule, both in arms and in other worthy activities, those who are most distinguished are of noble birth, because Nature has implanted in everything a hidden seed which has a certain way of influencing and passing on its own essential characteristics to all that grows from it, making it similar to itself. We see this . . . in trees, whose off-shoots nearly always resemble the trunk . . . So it happens with men, who, if they are well tended and properly brought up, nearly always resemble those from whom they spring, and are often even better . . . It is true that, through the favour of the stars or of Nature, certain people come into the world endowed with such gifts that they seem not to have been born but to have been formed by some god with his own hands and blessed with every possible advantage of mind and body.[80]

Gaspare Pallavicino interposes, arguing that: "the finest gifts of Nature are often found in persons of very humble family."[81]

Giotto's father is given due credit for properly tending his offspring, and is, in his social sphere, endowed with much gentility. He was certainly not described as the "poor peasant" barely able to feed his family whom Vasari could find in the version of this tale in the manuscript notes.[82] And to this worthy father "nature gave the gift of a son," one who was

77 Life of Giotto, BB II, p. 117 (1550): "E così quel giorno non restò uomo piccolo o grande che non facesse segno con le lacrime o col dolersi della perdita di tanto uomo. Il quale, per le rare virtù che in lui risplenderono, meritò, ancora che e' fosse nato di sangue vile, lode e fama certo chiarissima."

78 *Ibid.*, pp. 95–6 (1550): "era tanto di buona fama nella vita e sì valente nell'arte della agricoltura, che nessuno che intorno a quelle ville abitasse era stimato più di lui."

79 *Ibid.*, p. 96 (1550): "dove i ferri del suo mestiero adoperava, più tosto che rusticalmente adoperati e' paressino ma da una mano che gentil fussi d'un valente orefice o intagliatore mostravano essere esercitati."

80 Castiglione, *The Book of the Courtier*, trans. Bull,

Book i, chapter 14, p. 54 (Cian ed., pp. 39–40). The metaphor of the tree comes from Plutarch's *Essay on Education*, an important influence in the network of ideas about upbringing that conditioned Vasari's rendering of artists' backgrounds and training. Castiglione is given as a typical example of a kind of argument, and one surely known to Vasari, for the terms of this debate and further examples, see Donati, *L'idea di nobiltà in Italia*.

81 Castiglione, *The Book of the Courtier*, trans. Bull, p. 56.

82 Anon. Maglia., pp. 50–1: "un pouero contadino . . . haueua gran carestia del uitto ne sapea, come si fare a nutriacere se non che e figluoli." For Giotto's origins and the genealogy of the arts, see Barolsky, *Giotto's Father*.

blessed with advantages, who, growing up "with the finest manners and evidence demonstrated even in all his childish actions a certain liveliness and a ready intellect extraordinary in one so young."[83] Vasari's description of Giotto's precocious gifts, such as his quickness ("prontezza"), seems to parallel Leonardo Bruni's account of the young Dante in his *Lives of Dante and Petrarch*. Bruni writes that "immediately there appeared in him a very great talent, most fitting to excellent things."[84] This may be a coincidence of commonplace. It is also the case that Dante's prodigious talents were a subject of study in Florence and Bruni's biography known; the reference could be intentional. But Dante, the student of letters, was able to follow a course of study, which Bruni makes a topic in his Life. "In childhood freely nourished and given into the care of teachers of letters," Dante was a learned type of poet, whose mastery came "through knowledge, study, discipline, and skill."[85] Giotto, the student of painting, had to follow the inclination of his own talent and imagination, for no such precepts or preceptors were available to him, as Villani had pointed out and Vasari repeated. So, while tending his sheep "inclined by nature to the art of drawing, he would constantly draw something from nature or which came from his imagination on flat stones or in the dirt or sandy earth."[86] Giotto's talent, Vasari emphasized, was a gift "only from nature."[87]

The gifts of nature were a topic of panegyric, as were the advantages of fortune (here the meeting with Cimabue). But they also have a special connection with the definition of ideal behavior, as indicated by *The Courtier*. Following these conventions such talent explained itself and needed no other context than nature to account for excellence. And following this premise, Vasari did not feel compelled, as we do, to look for other sources, teachers, or documents to explain Giotto's origins or his art.

Vasari's acceptance of Ghiberti's version of Giotto's childhood and training is an instance of Vasari's notion of historical accuracy. It fit into his construction of the artist. Not only did he accept Ghiberti's story, he embellished it. He enhanced its truth with details, all logical consequences of his picture of the artist. They are not indicative of further research but of a desire to give greater legitimacy to the story by reference to contemporary notions of proper education. Nothing is known of Giotto's childhood. Indeed, his birthdate is disputed.[88] In most documents Giotto is called the son of Bondone and described as being resident in the quarter of Santa Maria Novella. He bought property at Colle di Vespignano

83 Life of Giotto, BB II, p. 96 (1550): "A costui fece la natura dono d'un figliuolo . . . Questo fanciullo crescendo d'anni, con bonissimi costumi e documenti mostrava in tutti gli atti ancora fanciulleschi una certa vivacità e prontezza d'ingegno straordinario di una età puerile." The 1568 edition abbreviates Giotto's father's concern for his upbringing, but does not fail to mention it, p. 96: "l'allevò, secondo lo stato suo, costumatamente. E quando fu all'età di dieci anni pervenuto, mostrando in tutti gl'atti ancora fanciulleschi una vivacità e prontezza d'ingegno straordinario."

84 Baron ed., *Leonardi Bruni Aretino, Humanistisch-Philosophische Schriften*, p. 52: "subito apparve in lui ingegno grandissimo et attissimo a cose eccellenti."

85 *Ibid.*, pp. 52, 60: "Nella puerizia nutrito liberalmente e dato a' precettori delle lettere," "per iscienza, per istudio, per disciplina ed arte."

86 Life of Giotto, BB II, p. 96: "spinto dall' inclinazione della natura all'arte del disegno, per le lastre et in terra o in su l'arena del continuo disegnava alcuna cosa di naturale overo che gli venissi in fantasia."

87 Life of Beccafumi, BB V, p. 165, where Vasari compares the background of the two artists, both shepherds, beginning with the words: "Quello stesso che per dono solo della natura si vide in Giotto." In the 1568 edition of Giotto's Life, Vasari makes sure to reinforce the point of the relation of Giotto's talent and achievements to nature, p. 101: "E perché, oltre quello che aveva Giotto da natura, fu studiosissimo et andò sempre nuove cose pensando e dalla natura cavando, meritò d'esser chiamato discepolo della natura e non d'altri."

88 Murray, "On the date of Giotto's birth," *Giotto e il suo tempo*, pp. 25–34. Vasari might have taken his date, 1276, from the tomb slab in the duomo, mentioned in both editions. The 1550 text is specific about its lo-

in the Mugello. So his father's name and his country associations can be established, but little more about his origins. Giotto's business acumen – and the documents are convincing on this – suggests that the alternative version of his discovery of art as a truant apprentice from a wool merchant's shop may be closer to the truth than the version Vasari accepted and elaborated. Giotto's early contact with sheep is as likely to have been counting as drawing them.[89]

In Vasari's narrative, as in Ghiberti's, the roadside encounter by which art found its true way is told in detail. Art is brought to life in a vivid fashion. Vasari gives a picture of Cimabue coming upon the young Giotto drawing one of his sheep with a sharpened stone, of his amazement, and of the gracious transaction between son, artist, and father, resulting in Giotto's departure for Florence with Cimabue. There, Giotto continued to follow his instinct, and aided by nature and by Cimabue's instruction, soon not only equaled his teacher but "banished" the old Greek style – in this way Giotto "resuscitated the modern and good art of painting."[90] In addition, Vasari says, Giotto introduced the portrayal from nature of living persons, specifically Dante, his "friend and contemporary," in the Palagio del Podestà, the Bargello (pl. 121).

A portrait of Dante by Giotto was one of the two works mentioned by Villani, and Vasari exploited the possibilities of this.[91] In the chapter on painting, Pliny regrets that "painting once kept the physiognomy of men alive. This is no longer the custom."[92] Vasari echoes Pliny, saying that such portraiture had not been in use for centuries.[93] In the 1550 edition, Vasari chose the latinate word *effigie* ("si vede ritratto . . . l'effigie di Dante Alighieri"), which occurs also in Landino's translation of the *Natural History*. Pliny says that it was not customary to make portraits unless the subject deserved lasting commemoration for some

cation: "Restò in memoria della sua sepoltura in Santa Maria del Fiore, dalla banda sinistra entrando in chiesa, un mattone di marmo, dove è sepolto il corpo suo" (rephrased in the 1568 text, but not substantially changed, BB II, p. 117). The date did not come from the Libro di Antonio Billi, as Murray suggests, for it occurs only in the later, Petrei version, where it was probably copied from Vasari.

89 For the documents, see the register in Previtali, *Giotto e la sua bottega*, pp. 148–52.

90 Life of Giotto, BB II, p. 97: "aiutato dalla natura et ammaestrato da Cimabue, non solo pareggiò il fanciullo la maniera del maestro suo, ma divenne così buono imitatore della natura che sbandì affatto quella goffa maniera greca, e risuscitò la moderna e buona arte della pittura."

91 Villani's Latin text says that the portrait, with Giotto's self-portrait, was in the altarpiece of the chapel of the Palazzo del Podestà. When Manetti did his Italian translation in the mid-fifteenth century, the altarpiece was no longer there, so Manetti updated the identification and said that the portrait was in the wall frescoes, indicating that Vasari consulted Manetti's version of Villani. Vasari's manuscript source identifies the portrait as being opposite the entrance, to the right and next to the window ("a riscontro dell' entrata, a mano destra, a canto alla finestra, a capo all'altare"; Anon. Maglia., p.

51). The identification and attribution of this painting have been the subject of much dispute, summarized by Gombrich, "Giotto's Portrait of Dante?" *Burlington Magazine* (1979), pp. 471–81. An inscription in the chapel, saying that this work was done during the *podestà* of Fidemini of Verano (1336–8) means that at best the planning was by Giotto, not the painting. In any case, it was not done while Dante was alive. Gombrich suggests that the actual Dante portrait might have been in another Giotto fresco in the Bargello, that of the *Comune rubata*, a suggestion supported by sonnets written by a contemporary of Giotto's, Antonio Pucci. For the critical fortunes of the fresco and the identification see also Barocchi, "La scoperta del ritratto di Dante nel Palazzo del Podestà," in *Studi e ricerche di collezionismo e museografia* (1985), pp. 151–78.

92 Pliny, *Historia Naturale*, trans. Landino (1543), p. 852: "Colla pittura delle imagini si faceva che le effigie de gli huomini rimanevano un tempo in vita. Il che non e piu in uso" (*N.H.*, xxxv.ii.4, pp. 262, 263).

93 Life of Giotto, BB II, p. 97 (1550): "introdusse il ritrar di naturale le persone vive, che molte centinaia d'anni non s'era usato." The 1568 text is more historically specific, p. 97: "introducendo il ritrarre bene di naturale le persone vive, il che più di dugento anni non s'era usato."

121. School of Giotto,
"Dante." Florence, Bargello.

oustanding deed.[94] Involved as he had been in collecting *effigie* for Giovio's portrait museum, Vasari was keenly aware of the commemorative aspect of portraiture. Here the most distinguished poet of the fourteenth-century was painted by its most celebrated artist. And in doing so Giotto contributed to the development of art by reinventing portraiture, a type of work that had been held among the most prestigious.

In his book *On Painting*, Leon Battista Alberti, in order to explain "how painting is worthy of all our attention and study," gave as the first reason that

> Painting possesses a truly divine power in that not only does it make the absent present (as they say of friendship), but it also represents the dead to the living many centuries later, so that they are recognized by spectators with pleasure and deep admiration for the artist.[95]

Vasari registers the pleasure and admiration of the present for the past saying that "still today one can see" Dante portrayed there.[96] Alberti's aside about friendship refers to Cicero's book

94 *N.H.*, xxxiv.ix.16, pp. 138, 139.

95 *On Painting*, ed. Grayson, Book ii, chapter 25, pp. 60, 61.

96 Life of Giotto, BB ii, p. 97: "come ancor oggi si vede . . . Dante Alighieri."

on the subject.[97] Both sources were known to Vasari. Alberti's book had just been translated into Italian by Lodovico Domenichi, as Vasari noted in his Life of Alberti.[98] Vasari took the ideal of friendship described in Cicero's treatise as axiomatic and applied it elsewhere in *The Lives*.[99] Here the association of contemporaries, commemoration, and friendship was a powerful one. It helped to confirm the prestige of Giotto and of his art. The bond between the realm of letters and that of painting was strengthened by Vasari's subsequent mention of Boccaccio's praise for Giotto in the story of Forese da Rabatta.

There is, in modern terms, no evidence for Dante's having known Giotto, even though he knew of him, but for Vasari there was abundant authority that he had no reason to challenge and every reason to exploit. Giotto's friendship with Dante is part of Vasari's characterization of the artist, just as are his natural good manners – his courtesy to Cimabue and his respect for his father. It is also part of the description of the quality of the times, that they should give rise to two such remarkable men in Florence. The portrait of Dante is a demonstration of the fame of both men and of how art brings honor through lasting commemoration. Vasari chose it to precede all other works and serve as a prologue to Giotto's career.

The Narrative: Giotto's Works and Deeds

Villani had said that "wanting to extend his reputation" was a conscious aim of Giotto's, to do so "he painted something in prominent places throughout almost all the famous towns of Italy."[100] Vasari assigned Giotto by far the most works of any artist in Part 1, so that his greater fame was substantiated by his larger output. This volume is also a record of that reputation. In the 1550 edition, in most cases, Vasari is repeating attributions made by Ghiberti and the manuscript notes. For Vasari, Giotto, the most famous artist of the first period, was the author of the most respected works of that epoch. It was on that principle, I think, that Vasari based his attributions to Giotto where they did not already occur in other sources. It was important that Giotto's fame and influence cover the peninsula, so wherever Vasari went in the 1540s or the 1560s he found works by Giotto. In fact, with his own career in mind and attracted by the idea of a painter being the head of a flourishing school, he was even freer in accepting attributions in the 1560s. In the 1568 edition Vasari made substantial additions to the catalogue, finding paintings by Giotto virtually everywhere he went in his travels. These attributions include many works now assigned to his workshop, his students, and in some cases, completely unrelated masters. Any prominent, important work in the "old style" he saw was likely to be assigned to Giotto, by Vasari, or by its proud owners. Vasari's second campaign of research added twenty-two works, seven cities, and another country to Giotto's already wide-ranging activity (forty-three works, nine cities).[101]

97 *De Amicitia*, trans. Falconer, vii.23, pp. 132, 133.

98 Life of Alberti, BB iii, p. 285.

99 See below, Chapter viii, pp. 343–55.

100 Larner, *Culture and Society in Italy 1290–1420*, p. 280. Similarly, Ghiberti, *Commentari*, ed. Schlosser, p. 35: "Et fecionsi egregiissime opere et spetialmente nella città di Firençe et in molti altri luoghi"; Landino: "E refertissima Italia delle sue picture" (Morisano, "Art His-

torians and Art Critics," *Burlington Magazine* [1953], p. 270), and the anonymous notes, Anon. Maglia. pp. 51, 54: "Fece Giotto assai opere in molti luoghi . . . Et in altri luoghi operò assai, che piena si vede l'Italia delle sue picture."

101 The original order of places is Florence (Bargello, Badia, Santa Croce, Carmine, and Palazzo di Parte Guelfa), Arezzo, Assisi, Florence, Rome, Naples,

The revisions developed many of the themes set forth in the first edition. The vast accretion of works in the second edition is a confirmation of the basic premises of the 1550 Life: the recognition of Giotto's talent by his contemporaries and the honor he deserved because he was "very studious and worked ceaselessly."[102]

The manuscript notes and Ghiberti's *Commentaries* provided Vasari with a basis for his narration. Its order and embellishment depended upon his judgment of the works and their meaning as part of Giotto's career and his characterization of the artist. The Life of Giotto begins with a substantial group of works in Florence: the Badia, Santa Croce, the Carmine, and the Palazzo di Parte Guelfa. Giotto's first paintings, Vasari says, were in the high-altar chapel in the Badia. He distinguishes between early and important works. The Dante portrait, the important work, is noted first, as being a key to the description of Giotto in his Life. Among the many things regarded as beautiful in the Badia, Vasari singled out the fresco showing the Virgin at the moment of the Annunciation, "because in her he realistically expressed the fright and terror that, in greeting her, Gabriel provoked in the Virgin Mary, who seems filled with enormous fear, almost as though she wants to flee."[103] Vasari's description of the Badia *Annunciation* is formulaic. The fearful reactions of the Virgin were those that he felt were appropriate to the depiction of this event. He evokes them many times in his descriptions of Annunciations, notably that by Donatello in Santa Croce, also presented as a first, typical, work (pl. 134). When he designed the subject for a panel to be given to the nuns of the convent of Le Murate in payment of his sister's dowry there, Vasari wrote that perhaps he had made his Virgin look too terrified. He said they should remember that Gabriel enjoined Mary not to be afraid, but he was willing to modify the expression as advised.[104] Such imagery was derived from a common stock of visualizations of holy stories, which Vasari exploited both as painter and as author. There was both the manifest tradition of painted iconography and the habit of reference to images in prayer and meditation. Prayer handbooks suggested a discipline of impressing the story of the Passion on the mind by fixing the principal places and people in images.[105] This was a devotional address to the imaginative faculty. The agitated, excited rendering of the Annunciation at the moment of the Salutation, when the Virgin "was troubled and cast in her mind what manner of

Rimini, Ravenna, Florence (San Marco, Santa Maria Novella, Ognissanti, designs for Baptistery sculpture, bell-tower, San Giorgio, Badia, Bargello), Padua, Milan, Florence. The 1568 order is: Florence, Arezzo, Assisi, Florence, Pisa, Florence, Rome, Avignon, Padua, Verona, Ferrara, Ravenna, Urbino, Arezzo, Lucca, Naples, Gaeta, Rome, Rimini, Ravenna, Florence, Arezzo (by post, about Tarlati tomb), Padua, Milan, Florence. Both orders are at variance with present reconstructions of Giotto's career, which are at variance among themselves. For one example, see Vigorelli and Baccheschi, *L'opera completa di Giotto*, pp. 83–8: Florence, Assisi, Rome (1300), Padua, Florence, Rome (1310), Florence (presence documented 1311–15), Padua, Florence, Naples (1328–33 documented), Florence, Milan, Florence. The amount of debate about Giotto's activities is such that the English edition in this same series gives a different version, see Martindale's introduction to Martindale and Bacceschi, *The Complete Paintings of Giotto*.

102 Life of Giotto, BB II, p. 100 (1550): "studiosissimo e di continuo lavorava."

103 Life Giotto, BB II, p. 98: "perché in essa espresse vivamente la paura e lo spavento che nel salutarla Gabriello mise in Maria Vergine, la qual pare che tutta piena di grandissimo timore voglia quasi mettersi in fuga." Fragments of this have been discovered, it is not currently attributed to Giotto, see *Le vite* (Club del Libro), I, p. 301.

104 Frey I, xi, p. 31 (Vasari in Florence, December 1534, to Antonio di Pietro Turini, Arezzo): "Et se quella Nostra Donna, annuntiata dall' angelo, paresse troppo spauentata loro, per essere donne, considerino, che gli fù detto da Gabriello, che non temessi. Pure io la modererò, secondo che auuiserete."

105 Baxandall, *Painting and Experience in Fifteenth Century Italy*, pp. 45–56.

salutation this should be" (Luke 1:29), was almost a cliché. This is indicated by Leonardo's criticism of a picture

> of an angel who, in making the Annunciation, seemed to be trying to chase Mary out of her room, with movements showing the sort of attack one might make on some hated enemy; and Mary, as if desperate, seemed to be trying to throw herself out of the window. Do not fall into errors like these.[106]

By choosing to start with such a visual commonplace, Vasari could economically appeal to his readers' imaginations to give a form to Giotto's talent as praised by Villani (and accepted by Vasari), as creating images "with such exemplary gestures that they appeared to speak, weep, rejoice and do other things which gave great delight to those who seeing them, gave praise to the mind and hand of the constructor."[107]

Vasari divides the works he attributes to Giotto in Florence roughly in half, separating them into an early and late period, a point of departure and a glorious, honored return. After working in the Badia, Santa Croce, Carmine, and the Palazzo della Parte Guelfa, he says that Giotto went or was called to Assisi to finish works there by Cimabue. This reason for his departure from Florence was suggested by the statement in the manuscript notes that "at Assisi in the church of San Francesco he painted a fair amount, which had been begun by Cimabue."[108] Vasari generated circumstances of the journey from this bald remark, and an itinerary. Giotto is sent on a detour to Vasari's native town of Arezzo, where Vasari identified three works. It was at Assisi, however, that Giotto acquired "very great fame for the quality of the figures and for the order, proportion, liveliness, and the facility given to him by nature and augmented by study."[109]

In the 1550 edition Vasari made no further description of Giotto's work at Assisi. He probably had not seen it and certainly had not studied it. He applied critical values (order, proportion, liveliness, and facility) that were both generally suited to Giotto's work and contrasted with the stiff and hieratically composed paintings by his Byzantinizing predecessors. They were also terms derived from Pliny and that carried the resonance and authority of the famous prototype. So Pliny said that Parrhasius "contributed much to painting. He was the first to give proportions to painting and the first to give vivacity to the expression of the countenance."[110] The description is a characterization. As a formula it is close to the natural gifts of the ideal orator described by Cicero. Giotto's liveliness (*vivezza*) and facility (*facilità*) can be compared with Cicero's "lively activities of the intelligence," which "may through instruction become better."[111] Like the talented orator, Giotto acquired fame by exercising those gifts and increased them by study.

Characterization by works is followed by characterization by deeds. The consequence of

106 *Ibid.*, p. 56. Quoted from the *Treatise on Painting*.
107 Larner, *Culture and Society in Italy 1290–1420*, p. 279.
108 Anon. Maglia., p. 53: "A 'Scesi nella chiesa di San Francesco dipinse assaj, il che fu da Cimabue cominciato."
109 Life of Giotto, BB II, p. 100: "tutta questa opera acquistò a Giotto fama grandissima per la bontà delle figure e per l'ordine, proporzione, vivezza e facilità che egli aveva dalla natura, e che aveva mediante lo studio

fatto molto maggiore." For a concise summary of the considerable debate over what Giotto painted at Assisi, see White, *Art and Architecture in Italy, 1250–1400*, pp. 344–8. Vasari's order, with the works in Santa Croce preceding those in Assisi, is not followed in modern scholarship. I want to thank Joanna Cannon for her comments about the problems of Giotto chronology.
110 *N.H.*, xxxv.xxxvi.67, pp. 310, 311.
111 *De Ora.*, I.xxv.113, pp. 80, 81.

the fame achieved at Assisi was papal patronage. But Giotto did not simply go to Rome to answer a papal summons, his talent was recognized again. The pattern of recognition in this Life operates in *The Lives* in general. Giotto's talent is first seen by a fellow artist and then understood by those outside of the profession, connoisseurs (*intendenti*). Giotto's Life is important in establishing this model. The second discovery, like the first, is told at length. Pope Benedict, having heard the cry of Giotto's fame, was interested in his works. He sent one of his courtiers to Tuscany to find out about the artist and his works. The pope's emissary had spoken to many masters in Siena and been given drawings by them, and when he arrived at Giotto's shop in Florence, he asked for a sample of Giotto's drawing to take to the pope. The courteous artist drew a perfect circle for the courtier, with a brush he had at hand. The courtier felt slighted and doubted that it would be enough. "What I have done is enough and even too much," Giotto reassured him. And it was: the pope and many knowledgeable courtiers immediately saw "how far he supersedes in excellence all the other artists of his times." These are the learned and unlearned of Boccaccio's prologue, and they become proverbial. Vasari says that this episode resulted in the proverb: "you are rounder than Giotto's 'O.'" Round ("tondo"), Vasari adds, means both round and slow-witted.[112]

The courtier fears that he is being made the butt of joke ("beffato"), which he is. Vasari translated a story from Pliny into a Tuscan anecdote. The story of Giotto's "O" originates in Pliny's tale of Apelles' perfect line. Apelles, like the courtier, made a journey to visit an artist. Wishing to meet Protogenes, he went to Rhodes, arriving at Protogenes' studio when Protogenes was not at home. As a sign Apelles painted an extremely fine line across a panel, telling the maidservant, "Say it was this person." The old servant, like the fatuous courtier, did not understand. Protogenes, like the understanding courtiers (the *intendenti*), did: "as so perfect a piece of work tallied with nobody else." Protogenes answered with another line, but Apelles got the final word, cutting the two extant lines with a third, leaving no space for reply. Pliny says that the panel was "admired as a marvel by everybody," but particularly by artists.[113] Giotto has been made into a modern, Italian, Apelles. Even the proverbial nature of this story finds its parallel in Pliny, who says that Apelles never "let a day of business be so fully occupied that he did not practise his art by drawing a line, which has passed from him into a proverb."[114] The place of the artist in popular memory is a feature both of Pliny's account of Apelles, and of Vasari's of Giotto.[115]

112 Life of Giotto, BB II, p. 104: "fece un tondo sì parì di sesto e di proffillo che fu a vederlo un maraviglia. Ciò fatto, ghignando disse al cortigiano: 'Eccovi il disegno'. Colui, come beffato, disse: 'Ho io a avere altro disegno che questo?'. 'Assai e pur troppo è questo, – rispose Giotto – mandatelo insieme con gl'altri e vedrete se sarà conosciuto'. Il mandato . . . si partì da lui assai male sodisfatto, dubitando non essere uc[c]ellato . . . il Papa e molti cortigiani intendenti conobbero per ciò quanto Giotto avanzasse d'eccellenza tutti gl'altri pittori del suo tempo. Divolgatosi poi questa cosa, ne nacque il proverbio che ancora è in uso dirsi agl'uomini di grossa pasta: *Tu sei più tondo che l'O di Giotto* . . . pigliandosi *tondo* in Toscana, oltre alla figura circolare perfetta, per tardità e grossezza d'ingegno." In the 1550 edition Vasari even uses Dante's word, "cry"

for the reputation that attracted the pope's curiosity: "Sentì tanta fama e grido . . . papa Benedetto" (p. 103).

113 *N.H.*, xxxv.xxxvi.81–2, pp. 320, 321.

114 *N.H.*, xxxv.xxxvi.84, pp. 322, 323.

115 Vasari applied another Pliny anecdote to Giotto in the 1568 edition. Among the jokes ("burle") and many apt replies ("molte argute risposte") assigned to Giotto in the long section of stories about Giotto, his art, and character added to the second edition, Vasari included an adaptation of Pliny's story about Zeuxis and Parrhasius. Parrhasius had drawn an illusionistic curtain over Zeuxis' realistic grapes. Whereas the birds had been fooled by the grapes, Zeuxis was fooled by the curtain and concedes Parrhasius victory. Vasari tells how Giotto painted a fly on the nose of a figure painted by Cimabue, who tried to catch it more than once, think-

Vasari drew lessons from the past as recorded by Pliny and applied them to Giotto. It was Apelles "who surpassed all the painters that preceded him and all who were to come after him . . . He singly contributed almost more to painting than all the other artists put together."[116] His talent was matched by candor, courtesy, wisdom, and generosity. He was comfortable with kings. He knew his place in art, among his peers, and with his great patron, Alexander. As the most famous painter of antiquity, he supplied the perfect pattern for the most famous artists of modern times. Vasari returned to Apelles and referred elements of his legend to other artists, notably Raphael. Vasari took Apelles' behavior as typical. By being of the type, Giotto becomes a descendant of Apelles and a forerunner of Raphael.[117] Pliny supplied axioms and precedents for Vasari. His text was familiar.[118] It was probably the prototype suggested to Vasari. Vasari had greater ambitions, but he did not neglect the value of Pliny's model. By using Pliny he added authority to his own accounts. Precedent provided proof, from a source so widely diffused as to be easily recognizable to his readers.

Giotto's fame established by his works and his words, Vasari describes a series of commissions for eminent patrons: in Rome for the pope, in Naples a king, in Rimini the ruling lord. This series is interwoven with anecdotes and descriptions proving Giotto's wit and skill. Natural and spontaneous as they were, his apt and witty replies to the king of Naples demonstrated both his native intelligence and his ability to converse with kings. But his conversation, like that of Apelles with Alexander, is also a confirmation of his status in the social hierarchy. He speaks as a painter. As one of the exchanges goes: " 'Giotto, if I were you, now that it is hot I would break off a while from painting,' " the painter's answer was " 'And certainly so would I, if I were you.' "[119] This implies the same differentiation of *tu* and *voi* of the Forese da Rabatta story, the same self-recognition. Giotto, however great and at ease with kings, is still but a forerunner to Raphael who lived more like a prince than a painter.[120]

The first, and only, extended description in the 1550 edition is of a fresco cycle painted in the cloister of the church of San Francesco at Rimini. Giotto's wit, facility of mind, and prestige proven by the preceding anecdotes, the description demonstrates his skill in painting, defined by his artistic intelligence and figurative imagination. Devoted as it was to the Beata Michelina, this now destroyed cycle could not have been painted by Giotto. Michelina died in 1356 long after Giotto (1337). For Vasari, however,

> among all of the things done by [Giotto] in painting this can be said to be one of the best, because there is not a single figure amongst such a great number that does not in itself partake of the greatest skill, and is not arranged in an imaginative way.[121]

ing that it was real, before he realized his mistake ("si rimise più d'una volta a cacciarla con mano pensando che fusse vera, prima che s'accorgesse dell'errore"), BB II, pp. 121–2.

116 *N.H.*, xxxv.xxxvi.79, pp. 318, 319.

117 For the typological connection between Giotto and Raphael, see Riccò, "Tipologia novellistica degli artisti vasariani," in *Studi* 1981, p. 96.

118 For Pliny and Petrarch and the beginning of the tradition of reference to his text for axioms, precepts, and analogies, see Baxandall, *Giotto and the Orators*, pp. 62–4.

119 Life of Giotto, BB II, pp. 108–9: "dicendogli il re: 'Giotto, s'io fusse in te, ora che fa caldo tralasserei un poco il dipingere', rispose: 'Et io certo, s'io fussi voi.' " Similarly when Alexander the Great came to visit Apelles in his studio and would talk about painting, "without any real knowledge . . . Apelles would politely advise him to drop the subject" (*N.H.*, xxxv.xxxvi.85, pp. 324, 325).

120 Life of Raphael, BB IV, p. 212.

121 Life of Giotto, BB II, p. 111: "fra tutte le cose di pittura fatte da questo maestro, questa si può dire che sia una delle migliori, perché non è figura in sì gran

Why did Vasari describe these frescoes? Why not those at Santa Croce, or Assisi or Padua, so favored today as the fixed points of Giotto's fame? Before writing the first version of this Life, he had not visited Assisi and at best glanced at Padua. Vasari's decision to elaborate on this cycle probably resulted from its place both in Giotto's Life and his own. In Giotto's Life Rimini came in the section of amplification, in which Vasari elaborated and explained Giotto's standing and achievement, delighting and instructing his readers with suitably ornate prose. Vasari had placed Giotto among popes and princes and defined a patronage that recognized and honored such excellence, with the subsequent description of a work he concluded this section by focussing on Giotto's artistry. In Vasari's own life, Rimini came at the moment when he was completing his book. At Rimini, as the book was being transcribed to fair copy, Vasari had the opportunity to finish it. He was working in the church of San Francesco, and seeing the fourteenth-century frescoes there, he may have decided to dress up the Life, which was still relatively bare of description. Rimini also had the advantage of being remote. The Michelina cycle was probably fairly obscure, however attractive and locally esteemed. By publishing it in his Life, Vasari could both increase Giotto's fame by making another work known and make it known as he wished it to be.

In the preface to Part 2 Vasari defined Giotto's achievements, saying that he was the first to put emotions into painting, and to find suitable poses and facial expressions. Technically he attributed to Giotto a first understanding of perspective in foreshortening, as well as the ability to make drapery seem to follow the body with a natural ease.[122] The description of the Michelina cycle presents an illustration of those attainments, which are certainly essential aspects of Giotto's paintings. Vasari focusses on a series of highly dramatic moments where gestures demonstrate emotional and psychological states (*affetti*): the scorn and distrust of a jealous husband who accuses his wife of being a whore, her moving innocence and simplicity shown as her eyes gaze fixedly into his. In another scene a usurer's lust for money is revealed by a reflexive gesture as his hand covers the coins he is about to disburse to the Blessed Michelina who, contemptuous of worldy goods, is selling them to give the money to the poor.[123] A variety of states and contrasting vices and virtues are presented as a series of striking vignettes. Vasari also points out the foreshortening seen in a crowd of deformed beggars and the natural folds in the robes of the virtues, Obedience, Patience, and Poverty, visible as they hover in the air holding up St. Francis' habit.

In his vivid narrative description of the frescoes Vasari observes much that is shocking and horrid, features typical in his description of works in this period. There is a sick man whose sores smell, the avaricious usurer, a sailor spitting into the sea. The story Vasari tells of the young woman who is suspected of adultery and swears her innocence on a book seems a form of virtuous counterpart to the guilty yet sublime tale of Francesca da Rimini told by Dante in Canto v of the *Inferno*. There, too, a book is a protagonist and adultery is the issue. Vasari had been rereading his Dante. He put Dante and an inscription from *The Divine*

numero che non abbia in sé grandissimo artifizio e che non sia posta con capricciosa attitudine."

122 Preface to Part 2, BB III, p. 12. In the third of his 1547 lectures on the relative merits of the arts, Varchi compared poetry and painting. He wrote that while poets describe the external, painters make every attempt to show the internal states, the emotions ("cioè gli

affetti"). He cites Pliny as saying that Aristides of Thebes was the first among the ancients to do so and Giotto among the moderns (Barocchi ed., *Scritti d'arte*, I, p. 265). Vasari seems to have accepted and adopted this view.

123 Life of Giotto, BB II, pp. 110–11.

122. School of Giotto,
crucifix. Florence, Ognissanti.

Comedy in the frescoes he had just painted in the apse of the Riminese church of Santa Maria di Scolca.

In Vasari's account, after this triumph Giotto went home, following Vasari's itinerary, by way of Ravenna. Giotto returned to Florence "magnificently praised and rewarded" by the Malatesta of Rimini and "with the greatest of honor and wealth," as Dante never did.[124] Vasari might have intended this irony. It certainly would have been recognizable to many of his readers. The Florentines had spent many years trying to retrieve Dante's, by then, illustrious corpse from the place where he died in exile.[125] According to Vasari, Giotto did not rest on his laurels. He continued to produce panels and frescoes and the prototype crucifix in Ognissanti (pl. 122): "Puccio Capanna taking its design then painted many throughout Italy" (yet another invention, this one sacred).[126] Since he was so skilled at

124 *Ibid.*, p. 112: "non mancò il signor Malatesta di premiarlo magnificamente e lodarlo . . . tornò a Ravenna, et in San Giovanni Evangelista fece una capella a fresco . . . Essendo poi tornato a Firenze con grandissimo onor[e] e con buone facultà."
125 Gombrich, "Giotto's Portrait of Dante?"

Burlington Magazine (1979), pp. 479–81, and De Gaetano, *Giambattista Gelli*, pp. 95–9.
126 Life of Giotto, BB II, p. 113: "dal quale Puccio Capanna pigliando il disegno ne lavorò poi molti per tutta Italia." The Ognissanti crucifix is now regarded as by a follower.

design, he provided drawings for sculpture and architecture.[127] Giovanni Villani had recorded that Giotto died on 8 January 1336 (1337 s. c.) after his return from Milan. On the basis of this, Vasari sent the tireless Giotto on a last trip north, to Milan by way of Padua, before bringing him to his final, much lamented rest.

Vasari's method for organizing Giotto's career when he first described it was not determined by dates or documents or a rigorously reasoned stylistic development; it was based on places and people. Geography and esteem were its guiding principles. And Giotto's widespread influence is confirmed by his followers. To the Florentine students given by Ghiberti and the manuscript notes, Vasari added those he discovered in his own travels: Giottesque artists who painted along Vasari's route through the Marches, in Rimini, Ferrara, Faenza, and Forlì.

The 1568 Edition

Although the thematic content and organization remain the same, the compact and elegant framework of the first edition groans beneath the weight of information added for the second. It is in Part 1 that the old book was most radically transformed to become the new. The general interest in early fourteenth-century culture as the time of revival – the first age of the heroes of Florentine excellence – was replaced by more detailed study of the time for itself. Through his travels and the advice and information given him, mainly by Borghini, Lives in Part 1 more than double in length. The process and priorities of rewriting are easily discernible in Giotto's Life: dates, places, people, portraits are all added.[128] Different techniques and technical details are featured: manuscript illuminations, mosaic, and fresco. Vasari seems to have tried to work out a chronological plan, co-ordinating Giotto's commissions with the succession of popes, events in Dante's life (his exile in Ravenna and death in 1321), and dates in Florentine history (the duke of Calabria's residence as lord of Florence from 1325 to 1327).[129] The Life becomes more documentary. The love of "excellent men in all professions," in addition to Dante, is substantiated by Petrarch's will

127 In the first edition Vasari claims that Giotto provided drawings for Andrea Pisano's reliefs showing the life of St. John the Baptist for the Baptistery doors (Life of Giotto, BB II, p. 114). This attribution is omitted in the second edition, where Vasari elaborates instead upon Giotto's designs for the architecture of the bell-tower (BB II, pp. 114–15).

128 Because he had added portrait identifications to earlier Lives, Vasari could no longer say that Giotto was the first to have revived this lost art, but he says that he was by far the best (BB II, p. 97). Having revisited the chapel in the Bargello, Vasari adds Brunetto Latini (Dante's teacher, he notes) and Corso Donati "an important citizen" ("gran cittadino") there. The other portrait identifications added to this Life include: Clement IV, in the Palazzo della Parte Guelfa (BB II, p. 99); Farinata degli Uberti in the Camposanto in Pisa (BB II, p. 103); Clement V in Avignon (BB II, p. 107); Giotto's self-portrait in Gaeta, as among the figures in a Crucifixion in the church of the Annunziata (BB II, p. 109); and donor portraits of Paolo di Lotto Ardinghelli and his

wife kneeling below St. Louis in Santa Maria Novella (BB II, p. 112).

129 Life of Giotto, BB II, p. 108, where Vasari says the king of Naples wrote to the duke of Calabria in Florence wanting him to send Giotto to Naples, giving a historical gloss to the simple summons of the first edition. The scrutiny of the Life for such chronology and its consequent revision is evident with regard to papal history as well. In the 1550 edition Vasari wrote that Giotto went to Rome to work for Benedict XII of Toulouse, who was pope from 1334–42. This statement was obviously problematic as this was the height of the "Babylonian captivity" of the papacy, as the pope's French origins indicate—and also difficult, given Giotto's death in January 1337, which Vasari knew and quoted from Giovanni Villani. It also contradicted the implied, earlier, date of Giotto's summons to Rome just after working at Assisi. In the 1568 edition the pope given is Benedict IX da Trevisi, which is probably a misprint or mistranscription for Benedict XI (da Treviso), pope from 1303 to 1304 (in the Life of Michelangelo there is

and letters, Sacchetti's stories, and the *Ottimo Commento* – all supplied by Borghini.[130] From these Vasari created a long section on Giotto's reputation, where he also expanded his account of Giotto's followers, their output increasing proportionately to Giotto's.[131] Vasari added information from don Silvano Razzi about a crucifix at Santa Maria degli Angeli, Baccio Gondi (about fragments of a panel from Arezzo), and the old register of the painters' company (about a student, Francesco).[132] Vasari reread Ghiberti's *Commentaries*, quoted as evidence for Giotto's having made a model for the bell-tower and its sculpted reliefs.[133] He also revisited the churches and chapels of Florence to correct and enhance his descriptions, becoming more specific about subjects and patronage. He traveled to look at works he had listed but not seen before. He made a special trip to Assisi in 1563. He noted fourteenth-century works on his 1566 tour and in places that he regularly visited, like Pisa and Arezzo. He mentions the drawings and miniatures that he owned from this period, and that he held "as relics," and had collected with diligence, effort, and expense.[134]

Vasari added most of his new material in large blocks and place by place, trying to move Giotto's career along logical routes. Giotto is a much busier man in the second version of his life than in the first. The stately, if steady, build-up of patronage of the 1550 edition becomes a bustling series of obligations to important people. The circumstances of "forced to go," "forced to start," of obtaining formal leave (from the pope to depart from his court at Avignon), become features of this Life as do exchanges of letters: from the king of Naples to his son, the duke of Calabria, in Florence insisting that he send the artist to Naples; Pietro Saccone asking Giotto for design advice for the tomb of Bishop Guido Tarlati da Pietramala.[135] As he goes from town to town, serving his numerous lords and masters, rulers and popes, Vasari makes Giotto's travels, honorable and rewarding as they were, seem very demanding. Examples of his fame, they also demonstrate his courtesy – limitless as the demands. This courteous, sought after, artist is much more of a personal projection than the more distantly conceived Boccaccesque character of the first edition. Giotto's friendship with Dante also becomes a mirror of Vasari's with his literary friends. Dante intervenes with patrons and is said to have suggested subjects for paintings, exactly as Giovio, Bartoli, and Borghini did. Of the *Apocalypse* painted in Naples Vasari writes that the subject was Dante's, suggesting the same for Assisi: "and even if Dante was already dead at the time, they could

a similar error which exchanges Alexander VI for Alexander IV, BB vi, p. 26). In the 1568 edition Vasari says also that Giotto went to Avignon from Perugia with Clement V after his election in 1305 (BB ii, p. 106). Benedict XI died in Perugia in July 1304, Clement's conclave was held there, although he never came to Italy. Clement V was the first of the Avignon popes. Giotto's trip to Avignon was based the statement in Borghini's copy of the *Ottimo Commento*, quoted by Vasari (BB ii, p. 117), that Giotto went to "Vignone"; for this see Rambaldi, "Vignone," *Rivista d'arte* (1937), pp. 357–69. Vasari, probably helped by Borghini, conflated the dates and places of papal history with the commentary to make a logical sounding story about a trip to France as part of the papal household during the pontifical section of the Life.

130 Life of Giotto, BB ii, p. 116: "essendo stato in vita amato da ognuno e particolarmente dagl'uomini

eccellenti in tutte le professioni . . . oltre a Dante." He then quotes the Petrarch documents and the Dante commentary (p. 117), and later appends the excerpts from Sacchetti's *Trecento novelle* (pp. 120–1).

131 *Ibid.*, pp. 116–22.

132 *Ibid.*, p. 113 (for the additions based on information from Razzi and Gondi), pp. 119–20 (for the citation of the "vecchio libro della Compagnia de' Dipintori").

133 *Ibid.*, p. 115.

134 *Ibid.*, p. 105, where he describes drawings and miniatures he owned which he attributed to Oderisi da Gubbio and called "reliquie di man propria," and whose reputation he glossed by citing Dante (*Purgatorio* xi: 79–84); p. 123, for the drawings he owned by Giotto: "stati da me ritrovati con non minore diligenza che fatica e spesa."

135 *Ibid.*, pp. 108, 112–13.

have had some discussion about them, as often happens among friends."[136] That Giotto's importance became a parallel and prototype for Vasari's own standing is indicated by his remark about his own painting in Naples:

> But it is remarkable that in so great and noble a city there have not been masters who have done anything of importance in painting since Giotto . . . I tried to perform in such a way . . . that the talented minds of that city might be aroused to work on great and honorable things.[137]

Vasari's involvement with Giotto's career is announced in the first and last lines of the 1568 text. It was his belief ("per mio credere") that painters were obligated to Giotto, and it had been his efforts that provided the concluding evidence of Giotto's excellence by finding autograph drawings.

The greatly enlarged section on Assisi is representative of the changes made in the second edition: Vasari says that Giotto went there, having been summoned by fra Giovanni di Muro della Marca, at that time General of the Franciscan Order.[138] This is a good example of the historical logic operating in the revision. According to Vasari's ordering of the Life, Giotto's work in Assisi catapulted him to fame. It was, therefore, placed in his early maturity. It was probably not difficult for someone like Borghini to find out who held the position of General at about that time. Fra Giovanni served from 1296 to 1305, when, according to Vasari's birthdate for Giotto, he was between twenty and twenty-five years old. Vasari's short, one sentence, critical summary of Giotto's art at Assisi in the first edition was expanded to fill two pages. He carefully describes the division of the walls and the subject of the paintings in the Upper Church. But Giotto's style, austere and simple as it was, still did not attract Vasari's more florid tastes. Vasari had a very precise definition of Giotto's manner and its place in the sequence of styles as explained in the preface to Part 2. Here, as in the description of the Beata Michelina cycle, Giotto's primacy in painting "effects" predominates.[139] Vasari singles out the effects or affecting details of emotion and realistic behavior. Though appreciative of the general composition of the histories and the variety of gestures and poses as well as "the variety of clothing of that time and certain imitations and observations of things in nature," he limited his description to one detail, so as not to be long-winded he said, pointing out the man drinking water in the scene of the *Miracle of the Fountain* (pl. 123).[140] This selectivity is characteristic of his descriptions of Giotto's works in both editions. They confirm their truth to nature by their often

136 *Ibid.*, p. 108: "per quanto si dice; invenzione di Dante, come per avventura furono anco quelle tanto lodate d'Ascesi . . . e se ben Dante in questo tempo era morto, potevano averne avuto, come spesso avviene fra gl'amici, ragionamento"; see also p. 107, where Vasari tells how Dante arranged a commission for Giotto to paint frescoes in the church of San Francesco in Ravenna.

137 Description of Vasari's works, BB VI, p. 385: "Ma è gran cosa che, dopo Giotto, non era stato insino allora in sì nobile e gran città maestri che in pitture avessino fatto alcuna cosa d'importanza . . . per lo che m'ingegnai fare di maniera . . . che si avessero a svegliare gl'ingegni di quel paese a cose grandi e onorevoli operare."

138 Life of Giotto, BB II, p. 100.

139 Preface to Part 2, BB III, p. 12: "egli diede principio agli affetti."

140 Life of Giotto, BB II, p. 100: "E nel vero si vede in quell'opera gran varietà non solamente nei gesti et attitudini di ciascuna figura, ma nella composizione ancora di tutte le storie, senzaché fa bellissimo vedere la diversità degl'abiti di que' tempi e certe imitazioni et osservazioni delle cose della natura. E fra l'altre è bellissima una storia dove uno asetato . . . bee stando chinato in terra a una fonte con grandissimo e veramente maraviglioso affetto, intantoché par quasi una persona viva che bea. Vi sono anco molte altre cose dignissime di considerazione, nelle quali, per non esser lungo, non mi distendo altrimenti."

123. Giotto, *The Miracle of the Fountain*. Assisi, Upper Church.

"marvelous" effects. These are cited and praised. Giotto's convincing narrative talents are conveyed. But they are rarely combined with praise for their style of depiction, for grace, delicacy, or beauty.

Vasari, not expansive about the Upper Church, is much more enthusiastic about the frescoes in the Lower Church. His attributions to Giotto at Assisi resulted from his reading of the manuscript notes, which said that:

> He painted much at Assisi in the church of Saint Francis, which had been begun by Cimabue. Through this work he began to acquire fame, which from that time on always increased on account of his paintings . . . And he painted almost all the lower part of the church of the Franciscans.[141]

In the 1568 edition Vasari turned the completion of what Cimabue had begun and the lower part of the church into two separate works. Previously, in the 1550 version, he had interpreted this as simply the lower range.[142] This is the usual modern understanding of Giotto at Assisi – the lower range of frescoes in the Upper Church. On site, however, in 1563, Vasari followed his own understanding and divided the work into two commissions. It suited him that Giotto should have done a substantial part of the frescoes at Assisi. And given his own ability, proven at Palazzo Vecchio, to cover acres of available surface at speed and with variety of invention, he had no need to doubt Giotto's. If he noticed the disparity of style – the Lower Church frescoes he ascribes to Giotto are now given variously to Giotto students (the Maestro delle Vele) and to Pietro Lorenzetti and assistants – he had but to think of the range of personal idiosyncracies his own assistants imposed on his designs.

For Vasari the decision as to which frescoes in the Lower Church to ascribe to Giotto was probably fairly straightforward: he chose the most important, the frescoes of the high-altar chapel over the tomb of the saint (pls. 124, 125). It was not veneration of the saint that seems to have moved Vasari the most, but the complexities of the allegorical imagery. He gives a detailed account of the iconography, which he enjoyed because of its inclusion of imaginative and beautiful inventions.[143] The frescoes included also inscriptions identifying the major symbolic figures. Once copied these could provide a convenient key for recollection and description. Vasari was also appreciative of Giotto's fresco technique, the murals "worked with such diligence that they have remained fresh to this day."[144]

From San Francesco in Assisi, it was an easy transition to make to San Francesco at Pisa. Pisa features largely in the 1568 additions, as it did in Duke Cosimo's personal and political life – Duke Cosimo's and Vasari's. Vasari had worked for Cosimo there, on the palace of the Knights of St. Stephen. The major fourteenth-century monument at Pisa was the Camposanto, and so Vasari attributes six scenes from the life of Job to Giotto, which previously, following Ghiberti and the manuscript notes, he had given to Taddeo Gaddi.[145] Here, too, his real admiration and observation were largely technical. Giotto "judiciously"

141 Anon. Maglia., pp. 53, 54: "A'scesi nella chiesa di San Francesco dipinse assai, il che fu da Cimabue cominciato. E per tale opera comincio acquistare fama, laonde poi per l'opere sue sempre s'accrebbe . . . E nella chiesa de' frati minor quasi tutta la parte disotto della chiesa dipinse."

142 Life of Giotto, BB II, p. 100 (1550): "nella chiesa d'Ascesi de' Frati Minori tutta la chiesa dalla banda di sotto."

143 Ibid., p. 101: "con invenzioni capricciose e belle."

144 Ibid.: "con tanta diligenza lavorate che si sono insino a oggi conservate fresche."

145 Life of Taddeo Gaddi, BB II, p. 206 (1550).

124. Maestro delle Vele, *Poverty*. Assisi, Lower Church.

125. Maestro delle Vele, *Chastity*. Assisi, Lower Church.

considered that the salty sea air of Pisa would damage the frescoes and thinking of their conservation, used a specially mixed plaster.[146] In the stories, in addition to the the portrait of Farinata degli Uberti, given pride of place, the description focusses on the lowlife, the disgusting, and the smelly. The "stupendous grace" Vasari observes in one servant is not that of elegance, but of charity, as he remains to fan away the flies from his suffering, pustulent master.[147] Vasari remains faithful to the quality of the times in the added descriptions, here and elsewhere in the Lives of Part 1. His sympathy for them, stylistically, was no greater than before.

Vasari's notion of the Giottesque and of Giotto's painting in both editions is, by our standards, a crude and inaccurate one. But Giotto's art was, for Vasari, crude. It was the achievement of the second age that it succeeded in getting rid of the coarse and clumsy styles that had survived until then, as he said in the Life of Masaccio.[148] He believed that Masaccio's were the first figures to be lifelike and true, to move naturally and stand firmly on their feet, not on their tiptoes. Giotto's name recurs throughout *The Lives*. His eminence was infinite, his art finite. Giotto's style, the "maniera di Giotto," which dominated a century, was something later artists improved on and superseded.[149] In writing the first edition Vasari did not spend much time studying Giotto's works. He never seems to have visited Assisi or the Arena chapel in Padua. He did not even linger to look at the chapels in Santa Croce in Florence. His historical respect for Giotto was great, his artistic interest limited. What are for us masterpieces of fourteenth-century monumental narrative and naturalism were for him fumbling efforts made in still imperfect times, clumsy, stiff, and oafish attempts at art.

Vasari's construction of the history of the arts owed much to Cicero's idea that "nothing is brought to perfection on its first invention."[150] Improvement through stylistic advance is a key concept in the biographies. In his study of how famous men advanced art, Vasari made every effort to find "the poets before Homer" – that is, the artists who came before the most accomplished.[151] Thus Giotto is the precursor to Masaccio and Michelangelo, and Giotto is himself preceded by Cimabue, Andrea Tafi, Gaddo Gaddi, and Margaritone in the 1550 edition, to whom are added Arnolfo di Cambio and the Pisani in the 1568 edition.

Giotto was "born to give light to painting," but Cimabue was the first glimmer after the "infinite flood of evils" that had extinguished the arts in Italy.[152] Cimabue comes first in Part 1, because, Vasari says, he started the "new way of painting."[153] Vasari thought he did, because Cimabue's name was the one he knew from Dante, from Villani, Landino, and his other sources. He needed a name to explain a phenomenon, the change from the "Greek" style. It was the name that history gave him. Vasari was not hampered by his lack of

146 Life of Giotto, BB II, p. 102.

147 *Ibid.*, p. 103: "ha grazia stupenda la figura d'un servo che con una rosta sta intorno a Iobbe piagato . . . è maraviglioso nell'attitudine che fa, cacciando con una delle mani le mosche al lebroso padrone e puzzolente, e con l'altra, tutto schifo, turandosi il naso per non sentire il puzzo."

148 Life of Masaccio, BB III, p. 123: "levò via le roz[z]e e goffe maniere mantenutesi fino a quel tempo."

149 Preface to Part 2, BB III, pp. 11–13.

150 Cicero, *Brutu, Orator*, trans. Hendrickson and Hubbell, *Brutus*, xviii.71, pp. 66, 67.

151 *Ibid.*

152 Life of Giotto, BB II, p. 111: "[Giotto] nacque per dar luce alla pittura"; Life of Cimabue, BB II, p. 35: "Erano per l'infinito diluvio de' mali che avevano cacciato al disotto e affogata la misera Italia . . . spento affatto tutto il numero degl'artefici, quando . . . nacque . . . per dar e' primi lumi all'arte della pittura . . . Cimabue."

153 Preface to Part 1, BB II, p. 32 (1550): "dètte principio al nuovo modo del dipignere." The 1568 version reads "di disegnare e di dipignere."

information. He gathered what he felt to be enough to make sense of the past. In writing the Lives in Part 1, distanced as he was from detail, he was particularly reliant on conventions to supply historical explanation. And he used them to establish the principles of artistic practice. Cimabue surpassed his Greek masters by constant study and work, aided by talent. Inspirited by praise, he gained work and through this reputation. In the first Life of his book, Vasari transferred the model humanist's education to the painter, a transfer implied in the course of Cimabue's studies – the gifted youth first studied letters, but soon found his true talent was drawing. But this talent, less favored by nature than Giotto's, and fated to imitate the wrong masters, could never really progress towards the true modern way.

That was left to Giotto, who set painting on the path to perfection. Vasari was quite comfortable in his modernity and honest about his view of the limitations of Giotto's art. Acutely aware of the sylistic distance between his age and Giotto's, Vasari even felt the need to defend his praise for Giotto's works and those of his time in the preface to Part 2.[154] Vasari did not feign objectivity. The truth of the past was in its application to the present, which the light of Giotto's works served to illuminate.

154 Preface to Part 2, BB III, pp. 13-14: "Né voglio che alcuno creda che io sia sì grosso né di sì poco giudizio che io non conosca che le cose di Giotto e di Andrea Pisano e Nino e degli altri tutti–che per la similitudine delle maniere ho messi insieme nella Prima Parte–, se elle si compareranno a quelle di coloro che dopo loro hanno operato, non meriteranno lode straordinaria né è che io non abbia ciò veduto quando gli ho laudati. Ma chi considererà la qualità di que' tempi . . . arà piacere infinito di vedere i primi principii e quelle scintille di buono che nelle pitture e sculture cominciavano a risuscitare."

VIII

"ON FRIENDSHIP": DONATELLO
AND THE ARTISTS OF THE SECOND AGE

VASARI HAD HIS DOUBTS ABOUT DONATELLO. In the preface to the second part of *The Lives* he confessed that even though Donatello belonged to that period, he remained unsure "whether I want to put him in the third, seeing that his works compare with the good works of the ancients."[1] Resolved to follow the logic of time, he placed Donatello among the artists of the second era, but declared him the "rule for the others, for all the parts that one by one were divided among many were united in him alone."[2] Vasari praised him for having given his figures "a certain liveliness and promptness that puts them on the same level as both modern and . . . ancient works."[3] Donatello would seem to be the exception to the historical rules Vasari had just expounded in this preface, his anomalous position disturbing the tripartite scheme meant to mark the orderly sequence of styles from the medieval to the modern. His hesitation here admits a real complication to such a scheme: the fact that Donatello's reputation and influence in Vasari's day transcended the limits and limitations of Donatello's times. Vasari used this to strengthen, not subvert his scheme by establishing Donatello as a normative figure, a rule ("regola") for his age. Donatello sets a standard of accomplishment and behavior separating him from the old *maniera* and manners and marking a definitive step to the new.

Sources

The three main written sources for this Life were: Francesco Albertini's *Memoriale* of statues and paintings in Florence, published in 1510; the manuscript book of notes about artists used for the Giotto Life; and the fifteenth-century Life of Brunelleschi now attributed to Antonio Manetti.[4] Thirty-four of the approximately forty-one works Vasari mentions in Florence, and the Prato pulpit, are included in Albertini's guide. To this the manuscript notes add a

1 Preface to Part 2, BB III, p. 18: "Ma non mi risolvo in tutto, ancora che fussi ne' lor tempi, Donato, se io me lo voglia metter fra i terzi, restando l'opre sua a paragone degli antichi buoni."

2 *Ibid.*: "regola degli altri, per aver in sé solo le parti tutte che a una a una erano sparte in molti."

3 *Ibid.*: "dando loro una certa vivacità e prontezza che posson stare e con le cose moderne e, come io dissi, con le antiche medesimamente."

4 For Vasari and these sources, see Kallab, *Vasaristudien*, pp. 166–211, and for an interesting synoptic treatment of Donatello in the early literature, Collareta, "Testimonianze letterarie su Donatello. 1450–1600," in *Omaggio a Donatello. 1386–1986*, pp. 7–47.

few works in Florence, two more in Siena,[5] and the *Gattamelata* and the altar in the Basilica di Sant'Antonio (the Santo) in Padua.

That Vasari's account of Donatello's works is more or less an itinerary is, to a certain extent, explained by the fact that it was largely based on a guidebook.[6] Albertini produced his *Memoriale*, unable to refuse the request of his old friend, the sculptor Baccio da Montelupo, which explains why it was such a useful source: sculptures, above all Donatello's, dominate. Donatello is the first artist named, his *Dovizia* is the first statue cited.[7] Every possibility is taken to mention Donatello's works, which are usually given priority. Albertini's book not only records Donatello's presence at every turn in Florence, the result of his amazing productivity, which Vasari makes a topic of his praise for Donatello, but it is a useful index of Donatello's fame and importance in Florence in the early sixteenth century. The manuscript notes included a few extra works, additional bits of information and circumstance, and a suitable excerpt from Cristoforo Landino's 1481 Dante commentary, which Vasari also knew directly.

Vasari supplemented these sources with works he had seen in Naples, Venice, Faenza, Rome, and Montepulciano – all places that he had visited, passed through, or lived in between 1540 and 1547 when he was assembling material for *The Lives*. In spite of his claim to have checked everything in person, there is little evidence anywhere in *The Lives* that he spent much time in Siena. He is ill-informed about Donatello's contribution to the Siena Baptistery font, which is not included in Albertini or the notes.[8] And though it is possible that Padua was a staging post on Vasari's north Italian trip in 1541–2, he seems to have spent little time sightseeing there. His praise for the equestrian monument to the soldier Erasmo da Narni (the *Gattamelata*) is effusive but generic, and his description of the bronze altar in the Santo is vague and confused. Both could easily have been based on the reputation of the works rather than any real study of them. And where Vasari seems to quote from the Padua altar in his own north Italian work, the *Feast of St. Gregory*, painted for the refectory of San Michele in Bosco, Bologna, he is actually remembering Raphael's quotation from Donatello. The figures wrapping themselves around the columns at the left of Vasari's composition are based on those in Raphael's *Expulsion of Heliodorus*. In the Life of Raphael Vasari praises Raphael's "beautiful fancy," apparently unaware of its source in Donatello's relief panel of the *Miracle of the Miser's Heart*.[9] Among Vasari's current acquaintances there

5 Anon. Maglia., p. 78, for the commission for a bronze door and the unfinished bronze *St. John the Baptist* in Siena.

6 Vasari tended to organize *The Lives* topographically, but this is particularly noticeable here. In writing this Life Vasari overlooked the fact that in Brunelleschi's Life he had sent Donatello to Rome with Brunelleschi, a journey described by Manetti, Vasari's chief source for that biography (BB III, pp. 148–50). Each Life follows its own internal logic, according to the history Vasari wished to write from the sources and information he had available.

7 Albertini, "Memoriale," in *Five Early Guides to Rome and Florence*, ed. Murray, unpaginated (p. 3, for the *Dovizia*); for its composition, see Bentivoglio, "Un manoscritto inedito connesso al 'Memoriale di molte statue et picture' di Francesco Albertini," *Mitteilungen des*

Kunsthistorischen Institutes in Florenz (1980), pp. 345–56. Originally on a column in the Mercato Vecchio, the *Dovizia* was replaced in the early eighteenth century. See Wilkins, "Donatello's Lost *Dovizia* for the Mercato Vecchio," *Art Bulletin* (1983), pp. 401–23. See also Haines, "La colonna della Dovizia di Donatello," *Rivista d'arte* (1984), pp. 347–59, publishing documents that relate to the column and its installation between May 1429 and April 1430.

8 It is mentioned, but not described in the Life of Ghiberti, BB III, p. 88.

9 Life of Raphael, BB IV, p. 182, for the "bel capriccio" of the scrambling figures in the *Expulsion of Heliodorus*; see Jones and Penny, *Raphael*, pl. 132, for an illustration. For Vasari's painting, dated 1540, and now in the Pinacoteca Comunale, Bologna, see Corti, *Vasari*, p. 25.

were several, who, like Bartolomeo Ammannati, Benedetto Varchi, and Ugolino Martelli, had lived in Padua and who could offer him help and information, which in the case of that city consisted mainly of a group of extremely dubious-sounding works commissioned by the Florentine chaplain of a convent there.[10] Vasari's informant, and possible host, in Faenza was the gemcarver Giovanni di Castel Bolognese. Vasari probably stopped in Faenza during his journey to or from the Marches in 1547–8. This would account for the works there he attributes to Donatello: a wooden *St. John* and a *St. Jerome*.[11]

Vasari based his critical depiction of Donatello on Landino's appreciation. Landino wrote, and the manuscript author repeated, that Donatello was

> to be numbered among the ancients, admirable for his composition and variety, prompt and with great vivacity both in the arrangement and positioning of figures, all of whom appear to be in motion. He was a great imitator of the ancients and he understood a great deal about perspective.[12]

Landino's neat formulation was useful because it was apt. Its terms came from Donatello's time.[13] They described what Donatello was perceived as doing, and possibly how he conceived of doing it. Lifelike poses, expressive and diverse orderings of parts, and ingenious combinations of pose and setting are key aspects of Donatello's works. By describing Donatello as prompt Landino connected the artist's quickness of mind and hand to the sense of immediacy conveyed by the poses he gave his figures – a connection of cause and effect, particular intelligence and material result that Vasari accepted and developed. Vasari also admired Donatello's command of perspective praised by Landino, which is demonstrated both in the described and implied spaces of Donatello's narrative reliefs and his manipulation of actual space in his other statues and sculptures – a visual skill that relates to the period meaning of *perspectiva* as the science of optics and one that Vasari recognized and noted particularly with respect to the duomo singing gallery (pl. 126). And, as Landino and then Vasari said, Donatello imitated the antique. Donatello was actually regarded as an expert in antiquities in his time; he was called upon to judge them by Poggio Bracciolini and others.[14] For Vasari ancient sculptures gave the impression of being flesh, were composed of

10 Life of Donatello, BB III, p. 215.

11 Both statues are now in the Museo Civico, Faenza. The *St. John* is attributed to Antonio Rossellino. The attribution of the *St. Jerome* is debated. For a summary of the literature and discussion about Donatello's authorship of the *St. Jerome*, see Boucher in the exhibition catalogue *Donatello e i suoi*, ed. Darr and Bonsanti, no. 56, pp. 172–4, and "The St. Jerome in Faenza," in *Donatello-Studien*, pp. 186–93. For the case against the attribution to Donatello, see the exhibition reviews by Poeschke, "Donatello e i suoi," *Kunstchronik* (1986), p. 507, Zervas and Hirst, "Florence. The Donatello Year," *Burlington Magazine* (1987), p. 208, and Wohl, "Donatello Studien," *Art Bulletin* (1991), p. 317. The statue has been attributed to Bertoldo by Draper, *Bertoldo di Giovanni*, pp. 186–97.

12 Morisano, "Art Historians and Art Critics," *Burlington Magazine* (1953), p. 270: "da essere connumerato fra gli antichi, mirabile in compositione et in varietà, prompto et con grande vivacità o nell'ordine o

nel situare delle figure, le quali tutte appaiono in moto. Fu grande imitatore degli antichi et di prospectiva intese assai." The text in the Anonimo Magliabechiano reads: "degno fra li antichj excellentj et rarj huominj d'essere connumerato, mirabile fu in compositione et pronto in varieta et le sue fiure, che di gran vivacita apparischono, con tale ordine situava, che in moto apaiaono, et possede assaj la prospectiva" (Anon. Maglia., p. 75).

13 Baxandall, "Alberti and Cristoforo Landino: The Practical Criticism of Painting," in *Convegno internazionale indetto nel V centenario di Leon Battista Alberti*, pp. 143–54, demonstrates how Landino was transmitting and exemplifying Alberti's opinions. For Landino's categories, see also Baxandall, *Painting and Experience in Fifteenth Century Italy*, pp. 114–57, "compositione" and "varietà," with reference to Donatello, pp. 133–7, "prompto," pp. 145–7.

14 Semper, *Donatello*, pp. 311–12. Ciriaco d'Ancona saw classical statues "apud Donatellum" (p. 312).

126. Donatello, singing gallery (*cantoria*). Florence, Museo dell'Opera del Duomo.

beautiful parts selected from life, and had poses and actions that were suggested anatomically through the graceful motions of individual parts, not stiff or distorting movements of the whole figure.[15] In Donatello he saw these qualities in the humble bow and graceful turn of the annunciate Virgin in the Cavalcanti *Annunciation* and the valiant stance of the St. George at Orsanmichele (pls. 127, 128), for example: poses that also embodied meaning and character and therefore brought the material to life. According to Vasari, one contributing factor in perfecting the skills and styles of the third age was the discovery in the late fifteenth and early sixteenth centuries of the most famous statues of antiquity known from Pliny. He said that Donatello merited even greater praise because his career preceded these discoveries.[16] Vasari saw him as one of the first among the moderns "to render illustrious the art of sculpture and good design by his practice, good judgment, and knowledge."[17] Manual skill and practice are complemented by a vocabulary of intellect recurrent throughout the Life: intelligence, judgment, knowledge (*intelligenza, giudizio, sapere*) were the component properties of a "learned hand" that could bring life to marble.[18] This language is in itself expressive of a relation to the antique. It connects Donatello's art to the intellectual virtues that are the subject of Book vi of Aristotle's *Nichomachean Ethics*. In chapter 7 Aristotle

15 Preface to Part 3, BB iv, p. 7: "con termini carnosi e cavati dalle maggior' bellezze del vivo, con certi atti che non in tutto si storcono ma si vanno in certe parti movendo, si mostrano con una graziossima grazia."

16 Life of Donatello, BB iii, p. 220.

17 *Ibid.*: "e' si può dire che in pratica, in giudizio et in sapere sia stato de' primi a illustrare l'arte della scultura e del buon disegno ne' moderni."

18 *Ibid.*, p. 225, one of the epitaphs: "QUANTO CON DOTTA MANO ALLA SCULTURA/GIÀ FECER MOLTI, OR SOL DONATO HA FATTO:/RENDUTO HA VITA A' MARMI, AFFETTO ET ATTO./CHE PIÙ, SE NON PARLAR, PUÒ DAR NATURA?"

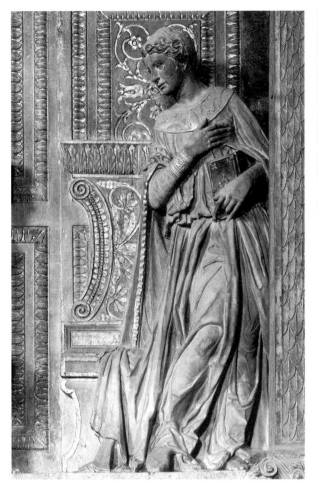
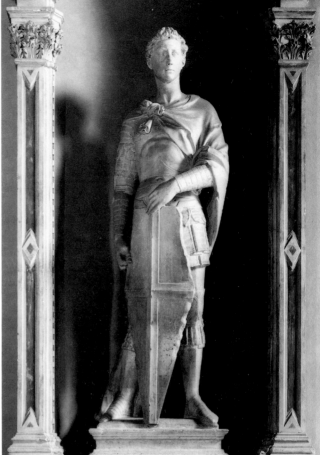

127. Donatello, *Cavalcanti Annunciation* (detail). Florence, Santa Croce.

128. Donatello, *St. George*. Florence, Museo Nazionale del Bargello.

discusses wisdom, starting with its most limited definition, which was, however, a useful one for Vasari in this case: "wisdom in the arts we ascribe to their most finished exponents, e.g. to Phidias as a sculptor and to Polyclitus as a maker of statues, and here we mean nothing by wisdom except excellence in art."[19] Donatello's excellence in returning sculpture to perfection made him directly comparable to those distinguished exemplars; it was the reason that he could serve as a rule for his art.

The notion of rule was itself a classical one and was applied by Pliny to the sculptor, Polyclitus, who:

made what artists call a "Canon" [*canona*] or Model Statue, as they draw their artistic outlines [*liniamenta artis*] from it as from a sort of standard; and he alone of mankind is deemed by means of one work of art [the *Doryphoros*] to have created the art itself.[20]

19 Aristotle, *The Complete Works*, ed. Barnes, II, *Nichomachean Ethics*, p. 1801 (1141a9–10).

20 *N.H.*, XXXIV.xix.55, pp. 168, 169.

The Italian translation that Vasari used gives the word *regola* for the canon found by Polyclitus whose statue, the *Doryphoros*, "artists called a standard, and took its contours and proportions as a law or rule, and because of his works, he alone was considered to have created the art."[21]

Vernacular tradition and living reputation were also vital to the picture Vasari formed of Donatello, who had left a vivid impression on the collective Florentine memory, where he flourished as an almost proverbial figure. Donatello's artistic ingenuity had been translated into Florentine wit. In Manetti's telling of the tale, Donatello was Brunelleschi's accomplice in an elaborate Boccaccesque hoax, a joke of mistaken identity played against the carpenter, Grasso.[22] He featured in an anthology of popular sayings assembled in the late fifteenth century, attributed to Poliziano, and published in 1548 by Lodovico Domenichi.[23] When he wrote to caution Vasari about the perils of his contemplated marriage, Paolo Giovio cited Donatello's habit of blackening the faces of his assistants to make them unattractive to others: advice that Vasari chose to ignore and an aspect of Donatello he resolutely suppressed.[24] While Donatello stories are incorporated in other artists' Lives and while he admitted the anecdotal into Donatello's Life, Vasari did not allow it to diminish his stature. Poliziano's anecdote about Donatello's reply to the question of what was the best thing Ghiberti ever did – "sell his villa" – is assigned to Brunelleschi and occurs in his Life instead.[25] A story told by Giovanni Battista Gelli about the irreverent Nanni Grosso and his friend the goldsmith Lauce exchanging remarks on their deathbeds, when Nanni asked for a crucifix by Donatello instead of one that was ill-made and crude, is put at the end of Verrocchio's Life.[26] Vasari also chose to reject Manetti's description of Donatello as presumptuous, proud, and arrogant.[27]

Donatello led a dual afterlife, however. In fact, well before his death in 1466, the historian Flavio Biondo had counted him among the most famous citizens of Florence (in *Italia Illustrata*, 1450). Vasari recalled how the aged Andrea della Robbia used to boast that he had been among Donatello's pallbearers.[28] He quoted Michelangelo and was aware of Leonardo's praise for Donatello.[29] He was also aware of proud Medici and Martelli family traditions regarding Donatello. Donatello's influence and fame, well established in the fifteenth century, were as inescapable as his jokes. Vasari based his Life largely on the former, retaining the latter mainly to show how the liveliness of Donatello's temperament was matched by the lifelike qualities of his works.

21 The section in Landino's translation is headed "Nobiltà d'Artefici & d'opere di bronzo," *Historia Naturale* (1543), p. 834 [p. 835]: "fece Doriphoro fanciullo ma di virile aspetto. Questo da gli artefici e chiamato Regola, & da lui tolgono eliniamenti & le proportioni, come da certa legge & regola, & solo di tutti gli huomini per le sua opere e giudicato hauere facto l'arte."

22 Manetti, *Vita*, ed. De Robertis and Tanturli, pp. 8–9, 30–8.

23 Domenichi, *Facetie et motti arguti* (1548). For this collection, see Wesselki, *Angelo Polizianos Tagebuch*, and Folena, "Sulla tradizione dei 'Detti piacevoli' attribuiti al Poliziano," *Studi di filologia italiana* (1953), pp. 431–48.

24 Frey I, cx, p. 194 (Rome, 5 March 1547, to Vasari,

Florence): "Et se cela menassi con uoi, bisognerebbe metterci le brache di ferro et tignerle il uolto come faceua Donatello al suo fattore." Variants of this occur in Poliziano and Domenichi; Wesselki, *Angelo Polizianos Tagebuch*, nos. 230, 322, pp. 118, 168.

25 *Ibid.*, no. 42, p. 27: "a vendere Lepriano; imperò che questa era una sua villa da trarne poco frutto," and Life of Brunelleschi, BB III, p. 195.

26 Life of Verrocchio, BB III, p. 542, and Gelli, "I capricci del bottaio" in *Opere*, ed. Maestri, p. 151.

27 *Vita*, ed. De Robertis and Tanturli, p. 110.

28 Life of Luca della Robbia, BB III, pp. 56–7.

29 See the Life of Michelangelo, BB VI, p. 116, for Michelangelo's opinion of the *St. Mark* at Orsanmichele, for Leonardo, see the Life of Bandinelli, BB V, p. 240.

Vasari was as efficient as he was diligent. He did not seek to know everything, just enough to write an effective biography. One consequence of Donatello's fame and energy was an abundance of material, a remarkably rich combination of works, writings, and anecdotes. Many of the other Lives of the period were based on much less and were written by expanding the references in his manuscript source, using notes made on site and embellishing them with morals and circumstances, usually invented from the works themselves. The account of the patronage of Mino da Fiesole's tomb of Bernardo Giugni in the Badia of Florence, for example, is based on its Latin inscription. This gave Giugni's name and titles and recorded that the monument was placed there by his brothers, statements translated into Vasari's text.[30] Otherwise Mino's Life is constructed around Vasari's picture of him as Desiderio's student. Its comments and descriptions are about instruction and imitation.

The 1568 Edition

In writing Donatello's Life Vasari followed his familiar biographical structure: from opening eulogy to deathbed, disciples, and epitaphs. Donatello's works are grouped topographically, his career geographically. A body of works in Florence results in fame, fame in travel, first north to Padua, Venice and Faenza, then south to Rome and Siena.[31] There was no single narrative source to cause any eccentricities or disruption to the organizing scheme, as was the case with Brunelleschi's Life which precedes it. As with other Lives, this armature survives beneath the numerous additions made for the second edition. And as with other Lives, the changes made reflect Vasari's friendship with Borghini and his status and activities in the 1560s as the chief artist at Duke Cosimo's court when he had realized in his own life the ideal of service described in Donatello's. There is a long addition based on the duke's collections in his wardrobe. The description of a drawing from Borghini's collection closes the biography with a comparison of Michelangelo and Donatello – making explicit a connection implied in the biography as originally conceived. The "most learned and reverend don Vincenzio Borghini" had mounted a drawing by Donatello opposite one by Michelangelo with a Greek inscription that Vasari quoted in Latin and Italian translations, saying that, "Either the spirit of Donato works in Buonarroto or that of Buonarroto previously worked in Donato."[32]

Most of the additions are concentrated in a long insertion placed after Donatello's last-mentioned public work, the statue of St. Louis (pl. 130), and before the concluding account of his character and death.[33] This section is devoted mainly to small-scale works and private

30 "BERNARDO IUNIO EQ.TI FLOR.NO PV.CE/CONCORDIAE SEMPER AUCTORI ET CIVI VERE POPULARI PII FRATRES FRATRI DE SE DEQ. REP.CA OPT.E MERITO POSUERUNT." Vasari's text reads: "fu fattogli allogazione di una sepoltura per il magnifico messer Bernardo cavaliere d' i Giugni, il quale per esser stato persona onorevole e molto stimata meritò questa memoria da' suoi fratelli" (Life of Mino da Fiesole, BB III, pp. 409–10).

31 Vasari's lack of concern about Donatello's chronology has frustrated modern scholars, see Pope-Hennessy, "The Fifth Centenary of Donatello," in *Essays on Italian Sculpture*, pp. 23–4. It is, of course, misguided to accuse Vasari of not doing what he never set out to do. For a brief summary of Donatello's career and related literature, see Pope-Hennessy, *Italian Renaissance Sculpture*, pp. 247–68, for detailed entries on the sculptures and illustrations, see Janson, *The Sculpture of Donatello*, and for the documents, Herzner, "Regesti donatelliani," *Rivista dell'Istituto Nazionale d'Archeologia e Storia dell'Arte* (1979), pp. 169–228.

32 Life of Donatello, BB III, p. 226: "O lo spirito di Donato opera nel Buonarroto, o quello di Buonarroto anticipò di operare in Donato."

33 *Ibid.*, pp. 218–20.

commissions, things treasured by their present owners, "true gentlemen" and "art-lovers" all. Donatello's patronage was a theme of the 1550 Life, but the volume and variety of works added brings another dimension to Donatello's career and to his reputation. Almost everyone of consequence and good taste owned, or claimed to own, something by Donatello. So much and so many that Vasari was forced to say that "whoever wanted to narrate his life and works fully would have a much longer history than it is our intention to write in these Lives."[34]

Donatello's works, always prized, seem to have become a topic for connoisseurship and critical study. Vasari returns twice to the singing gallery in the cathedral (the *cantoria*) to describe its sketchy (*abbozzate*) figures and animated composition: once in Donatello's Life and once in Luca della Robbia's. In the Donatello Life he adds a sentence to be more precise about the interaction of placement and lighting on the appearance of Donatello's works. In the della Robbia Life the *cantoria* becomes the focus of a discussion of poetic furor and inspiration.[35] This interest in sketch, design, and imaginative inspiration probably resulted from discussions about design and definitions of art related to the founding of the Accademia del Disegno. Vasari's description of Donatello's drawing style ("In drawing he was resolute, and drew with such skill and boldness that he has no equals"), and Borghini's pairing of Michelangelo and Donatello drawings can be connected with this developed interest in drawing and its recently institutionalized role.[36] The added observation about the statue of the penitent Magdalene in the Baptistery, that she is a perfect anatomical study, her flesh "being consumed by fasts and abstinence," can also be connected to the Accademia del Disegno; the study of anatomy was provided for in the academy's regulations and in the second edition of *The Lives*, Vasari promoted it at opportune moments.[37]

There are other predictable additions such as the portrait frontispiece (pl. 129), based on the portrait of Donatello in the painting of "five famous men" that Vasari attributed to Paolo Uccello.[38] There is a historical note about the Roman origins of the *Dovizia*'s column.[39] Based on Albertini, this is an instance of Vasari and/or Borghini rereading an original source with new interest. The location of works is brought up to date, like the bronze *David*, which had been moved by Duke Cosimo from one part of Palazzo Vecchio to another.[40] The festive decorations for the coronation of Emperor Sigismund in Rome by

34 *Ibid.*, p. 219: "chi volesse pienamente raccontare la vita [e] l'opere che fece, sarebbe troppo più lunga storia che non è di nostra intenzione nello scrivere le Vite."

35 *Ibid.*, p. 207, and Life of Luca della Robbia, BB III, pp. 51–2.

36 Life of Donatello, BB III, p. 224: "Nel disegnar fu risoluto, e fece i suoi disegni con sì fatta pratica e fierezza che non hanno pari." Vasari is specific about the mount, not the drawing in Borghini's book. A drawing in the Musée des Beaux-Arts in Rennes with the *Massacre of the Innocents* on the recto and a figure of David on the verso has been connected with Vasari's book of drawings. For a discussion of this, see Degenhart and Schmitt, *Corpus der Italienischen Zeichnungen 1300–1450*, I-2, pp. 343–65, cat. no. 265, pls. 255–6.

37 Life of Donatello, BB III, p. 206: "essendo consumata dai digiuni e dall'astinenza, in tanto che pare in tutte le parti una perfezzione di notomia benissimo

intesa per tutto." Vasari's connection of a spare, dry body-type with actual anatomies (*notomia secca*) and anatomical study in this case and elsewhere is discussed by Kornell, "Rosso Fiorentino and the anatomical text," *Burlington Magazine* (1989), p. 846.

38 Life of Paolo Uccello, BB III, p. 70 (1568): "ritrasse di sua mano in una tavola lunga cinque uomini segnalati"; Life of Donatello, BB III, p. 224 (1568): "Il ritratto suo fu fatto da Paulo Uc[c]elli." Now in the Louvre, Paris, Vasari had seen it in the house of Giuliano da Sangallo. In the first edition he attributed it to Masaccio, Life of Masaccio, BB III, p. 134. See Pope-Hennessy, *Paolo Uccello*, pp. 157–9, and Prinz, "Vasaris Sammlung von Künstlerbildnissen," *Mitteilungen des Kunsthistorischen Institutes in Florenz* (1966), *Beiheft*, p. 17.

39 Life of Donatello, BB III, p. 206.

40 *Ibid.*, p. 210.

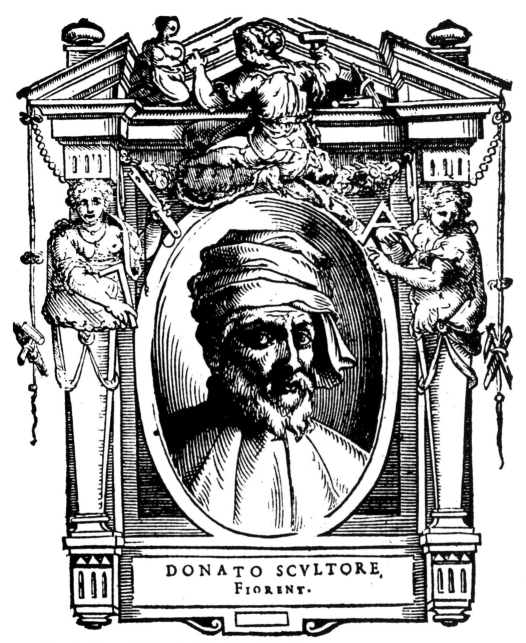

DONATO SCVLTORE,
FIORENT.

129. Portrait of Donatello from the 1568 edition of *The Lives*.

Pope Eugene IV are mentioned. Donatello, forced to participate, acquires "enormous fame and honor."[41] Vasari eliminates the story, derived from the manuscript notes, of Donatello's sole error when in his simplicity he allowed himself to be persuaded by a friend to destroy and abandon his work in Siena, blemishing his reputation. Vasari's second explanation for

41 *Ibid.*, p. 220: "nel che si acquistò fama et onore grandissimo."

Donatello's departure is less dramatic, less specific, and less impolitic (Siena had become part of Cosimo's territory). Donatello just leaves the city with his friend for an unexplained reason.[42] Vasari also changed his story of Donatello's deathbed scene and named more students.[43] He accepted the attribution of a horse's head in the house of Count Matalone in Naples, which he had previously rejected, describing it as being in the antique style and noting that Donatello had never been to Naples.[44] Vasari may have let his judgment be swayed from antique to *all'antica* by his decision to emphasize collections and collectors in the second edition of the Life.

Vasari retained the epitaphs, which he had presented as verses composed in different times and different languages to honor Donatello and not as tomb inscriptions. But he eliminated the elaborate and somewhat polemical introductory paragraph. The 1568 Life begins simply with the artist's birth: "Donato, who was called Donatello by his relations and signed himself thus in some of his works, was born in Florence in the year 1403."[45] This was a matter of editorial policy. Vasari's adviser, Borghini, pressed him to concentrate on matters of fact.[46] It was also one of balance. Despite numerous additions, the second edition of the Life is not much longer than the first. But the 1550 opening established themes that remain important to understanding both editions and is worth examining.

The Portrait of the Artist

The first idea presented in Donatello's Life in the 1550 edition is that artists portray themselves in their works:

42 *Ibid.*, p. 217.

43 *Ibid.*, pp. 222–4.

44 *Ibid.*, p. 226 (1550): "non è verisimile che così sia, essendo quella maniera antica e non essendo egli mai stato a Napoli"; p. 213 (1568): "Et in casa del conte di Matalone . . . è una testa di cavallo di mano di Donato tanto bella che molti la credono antica." In the second edition it is placed after Donatello's other work exported to Naples, the Brancacci monument at Sant Angelo a Nilo. Vasari may well have seen this statue when he was in Naples in 1544–5. Now in the Museo Nazionale, Naples, the attribution and dating of this head seem to have been a matter of debate even in Vasari's time. The author of the Anon. Maglia. manuscript says that Donatello made the head, which was to be part of an equestrian monument to King Alfonso of Naples, and that it was in the house of the Count Matalone de' Caraffa (Anon. Maglia., p. 78). In Antonio Billi's book of notes it says that the head was part of such a monument, then in the Matalone palace (Fabriczy, "Il Libro di Antonio Billi," *Archivio storico italiano* [1891], p. 320). Billi's entry seems to be an elaboration of the information from the other set of notes or one like it. Both seem to be reporting received information rather than direct impressions. The head was very famous in Naples, as were the Matalone possessions. It is mentioned in Pietro Summonte's letter to Michiel (1524): "in casa del signor conte di Matalone, di man di Donatello, è quel bellissimo cavallo in forma di colosso" (Nicolini,

L'arte napolitana del Rinascimento, p. 166). Francisco de Hollanda attributed it to Leonardo da Vinci in his treatise, *De la pintura antiqua* (1548). It appears in the Carafa inventories as by Donatello from 1582. The head was a given by Lorenzo de' Medici to Count Diomede Carafa of Naples in 1471, and it is not known whether he or the cardinal thought it was antique or knew it to be by Donatello or some other contemporary sculptor. During this century it has been called antique, but this has been challenged by technical analysis which suggests that it is a fifteenth-century sculpture. For the history of the attribution, see Beschi, "Le sculture antiche di Lorenzo il Magnifico," in *Lorenzo il Magnifico e il suo mondo*, pp. 293–5.

45 Life of Donatello, BB III, p. 201: "Donato, il quale fu chiamato dai suoi Donatello e così si sottoscrisse in alcune delle sue opere, nacque in Firenze l'anno 1403."

46 In this case the fact is a mistake. The date 1403 is the result of a copyist's or printer's error. Both editions say that Donatello died at the age of eighty-three on 13 December 1466. Simple subtraction arrives at 1383. The 1550 edition used Roman numerals. When these were changed to arabic the date was transformed to 1303, either by the scribe or the printer. This glaring error in the text was spotted and "corrected" to 1403 in the notice of *Errori seguiti nello Stampare*, probably without reference to the original text or even the conclusion of the 1568 text.

The sculptors that we have called old but not ancient, overwhelmed by the many complexities of art, arranged their figures with such a lack of skill and beauty that, whether they were of metal or of marble, they were nothing else but coarse, as they had coarse minds and foolish and dull wits; and it all arose from this, that in portraying themselves, [the sculptors] expressed and resembled themselves.[47]

The equation of artist and artistry made here can be taken as a statement of principle. That the portrait of the artist and the description of his works are to an extent interchangeable is an important premise in Vasari's biographies. That the character of the art is a manifestation of the artist explains how he could link styles to individuals.

Vasari's statement about self-portrayal is also a variant of a remark that Vasari quotes in Michelangelo's Life:

Some painter or other had made a work where there was an ox that was better than the rest. [Michelangelo] was asked why the painter had made it more lifelike than the other things. He said "Every painter portrays himself well."[48]

The humor of Michelangelo's remark was not lost on Vasari. There is a comic element to the opening lines of the Donatello Life where old-fashioned artists are described in an ungainly and rude way, and Nature is said to be tired of being mocked, "justly indignant at seeing herself practically ridiculed by the strange figures that those [sculptors] left to the world."[49]

The jest and the Boccaccesque are used intentionally here. This passage brings out Donatello's transitional role by relating him to both the old and new ages. The first words of the Life reminded the reader of Vasari's careful differentiation between old and ancient ("vecchio" and "antico") in the preface to The Lives, as well as establishing the comparison with the antique in this Life.[50] The word tondo, used to describe the coarse stupidity of old-fashioned artists, is one that Vasari defined at length in the Life of Giotto, where Giotto's "O," the demonstration of his skill, was proverbially linked to "slowness and coarseness of intellect."[51] Tondo was a word Vasari appreciated for its ambiguity as signifying a perfect circle, thus something beautiful like Giotto's drawing, and absolute stupidity. It is used here with equal subtlety. It occurs also in the Life of Andrea Pisano, where it is applied

47 Life of Donatello, BB III, p. 201 (1550): "Gli scultori che noi abbiamo chiamati vecchi ma non antichi, sbigottiti dalle molte difficoltà della arte, conducevano le figure loro sì mal composte di artifizio e di bellezza, che, o di metallo o di marmo che elle si fussino, altro non erano però che tonde, sì come avevano essi ancora tondi gli spiriti e gli ingegni stupidi e grossi: e nasceva tutto da questo, che ritraendosi esprimevano se medesimi, e se medesimi assomigliavano."

48 Life of Michelangelo, BB VI, p. 118: "Aveva non so chi pittore fatto una opera, dove era un bue che stava meglio de l'altre cose; fu domandato perché il pittore aveva fatto più vivo quello che l'altre cose; disse: 'Ogni pittore ritrae sé medesimo bene.'" For this idea, see Kemp, "'Ogni dipintore dipinge se': a Neoplatonic echo in Leonardo's art theory?" in Cultural Aspects of the Italian Renaissance, ed. Clough, pp. 311–23, and Klein, "Judgment and Taste in Cinquecento Art Theory," in Form and Meaning, pp. 161–9, and pp. 250–1, n. 1, for bibliography and for occurrences of this notion, first in the ambience of Florentine neoplatonism. For the consequences of the likeness between maker and work and the representation of women artists, see Jacobs, "The construction of a life: Madonna Properzia De' Rossi," Word and Image (1993), pp. 122–32.

49 Life of Donatello, BB III, p. 201 (1550): "la Natura, giustamente sdegnata per vedersi quasi beffare da le strane figure che costoro lasciavano al mondo."

50 Preface to The Lives, BB II, p. 29: "Ma perché più agevolmente s'intenda quello che io chiami vecchio et antico, antiche furono le cose, innanzi a Costantino, di Corinto, d'Atene e di Roma e d'altre famosissime città . . . l'altre si chiamano vec[c]hie che da S. Salvestro in qua furono poste in opera da un certo residuo de Greci."

51 Life of Giotto, BB II, p. 104.

specifically to sculpture, which, like nature, is three-dimensional.[52] It is a good descriptive term, evocative of the full, heavy and often static figures of fourteenth-century sculpture. It also had qualitative associations for Vasari in expressing the limited capacities of the artists. Vasari's procedure here repeats the tactic used in the opening to the Brunelleschi Life, where he adopted Boccaccio's description of Giotto in a manner obviously meant to recall Michelangelo – a diminutive person, but one of awe-inspiring spirit. Here, too, Giotto and Michelangelo, old and new, converge on a mediating figure.

Throughout this Life in both editions, Vasari retained the element of humor, the vernacular tone of the short story introduced in the prologue. It was Vasari's stated intention to write his history according to the quality of the times and the order of styles. It was appropriate to both that the manners of the artists of the second period should be less polished and less perfect than those of the third. There are picturesque, pathetic, and even dangerous characters in the third age; Vasari did not abandon either good stories or the historiographic structure of praise and blame, but it was not until Raphael that nature was to be conquered by both art and manners, that an artist should be paragon, painter, and prince – or until Michelangelo that an artist honor both heaven and earth by his life and work.

In this preamble Donatello's gifts are credited to the "wish and deliberation" of Nature, who was tired of being mocked.[53] Given this origin, it is not surprising that truth to life is a defining feature of Donatello's sculptures. Nor is it accidental that it is Nature, not the heavens that made this decision. Vasari was very careful about such conventions. Donatello is a transitional figure, placed, for all his greatness, among his contemporaries in the second period. In *The Lives* Masaccio, Brunelleschi, and Donatello (in that sequence) form a trio whose separate accomplishments in painting, architecture, and sculpture prefigure and prepare the way for their combination in Michelangelo's achievements in all three arts. It is a mark of the difference between the ages that the heavens did not dispose to send the universal genius until the third era. Vasari does not elevate Donatello beyond his period, however important an example he was for modern artists.

Vasari also names the gifts ("doti") of Donatello's character here: his kindliness, judgment, and love ("benignità," "giudizio," "amore"). His generosity of spirit is pointedly contrasted with the envy, pride, and vain ambition of modern artists. Vasari here follows classical prescriptions for "praise awarded to character." Quintilian, for example, advises the orator to

> bear in mind the fact that what most pleases an audience is the celebration of deeds which our hero was the first or only man or at any rate one of the very few to perform . . . emphasising what was done for the sake of others rather than what he performed on his own behalf.[54]

But Vasari's topic of praise was also extremely pointed blame. Where modern sculptors would harm others, he says, Donatello always made every effort to help others, and not only

52 Life of Andrea Pisano, BB II, p. 150.

53 Life of Donatello, BB III, p. 201 (1550): "per meglio adiempere la volontà e la deliberazione sua, colmò Donato nel nascere di maravigliose doti."

54 *I.O.*, III.vii.16, vol. I, pp. 470–3.

his friends, finding them work and advancing them with modest praise and judicious respect. The contrast is with the contentious artists of Duke Cosimo's court, above all Benvenuto Cellini and Baccio Bandinelli who did their best to frustrate each other and everyone else in their efforts to obtain commissions.[55]

Vasari drafted the first edition of *The Lives* in Florence during the spring and summer of 1547, while trying once again to make his way in the partisan world of Duke Cosimo's court. His invocation of Donatello's time is heartfelt and wistful:

> Oh happiest of days and most blessed centuries that you enjoyed so much virtue and excellence, when good artists were fathers, friends, and masters and companions to whoever desired to learn! They spoke of, that is, they showed whoever was working his mistakes, but gently . . . they did not spread abroad the shame of others. They behaved to one another like brothers with charitable loving kindness and always assisted each other in their needs.[56]

With this Vasari embellishes, or amplifies, his introduction, as was proper in the rhetoric of praise, using the device of affirmation by negation. With this device he brought past and present together in instructive comparison. The model of charitable love and mutual assistance put forward here was one dear to him.

Vasari's hopes and frustrations form a subtext to the Donatello Life. It was a suitable place in which to vest these interests. The parallel between Cosimo il Vecchio's backing of Donatello and Duke Cosimo's patronage was an obvious one. Bandinelli used it when making requests to the duke for assistants on the duomo choir project.[57] Vasari exploited the fact of the first Cosimo's generosity to Donatello with the hopes of encouraging similar beneficence on the part of his descendant and namesake.

Vasari was also addressing a very real problem for Florentine sculptors at that time: lack of work.[58] That Florence could nurture talent but not employ it was a fact of Vasari's life

55 Vasari used *The Lives* more than once to criticize Bandinelli and Cellini. Ghiberti's candor (BB III, pp. 79–80) and Mastro Mino's presumption and boastfulness (BB III, pp. 342–3) were both jibes directed at Cellini. The criticism in Donatello's Life of those who hid away to work ("riserrandosi a lavorare per le buche a ciò che i modi della bella maniera sua non gli fussino veduti operare," BB III, p. 201 [1550]) is probably also aimed at Cellini, whose arrogant and secretive behavior Vasari could neither understand nor abide. He probably had Bandinelli in mind when he praised Donatello's mastery of bas-relief, which still found no comparison ("nell'età nostra ancora non è chi lo abbia paragonato"; BB III, p. 202). Similarly his criticism in the technical preface of sculptors who ruin the original stone and have to piece statues together (BB I, pp. 90–1) attacks errors he later ascribes to Bandinelli (Life of Bandinelli, BB V, p. 263). He compares Bandinelli's base for his statue of Orpheus in the courtyard of Palazzo Medici unfavorably with Donatello's for the *David* that had previously occupied the same position (BB V, p. 245).

56 Life of Donatello, BB III, p. 202 (1550): "Felicissimi giorni e beati secoli, che vi godeste tanta virtù e tanta bontà, quando gli artefici buoni erano padri, amici, maestri e compagni a chi voleva imparare! dicevano, cioè mostravano, gli errori a chi operava, ma dolcemente . . . non publicavano la altrui vergogne; usavano insieme da fratelli con caritativa amorevolezza, e sempre nelle occorenze loro si giovavano l'uno all'altro." See the Life of Tribolo, BB V, p. 221, for Pierfrancesco Ricci, Duke Cosimo's *maggiordomo*, and his faction at the court in the early 1540s, when many, including Vasari, "who might have become excellent" with Cosimo's support, were "abandoned" unless they had the support of Ricci, or of Battista del Tasso, the architect of the palace at that time. See also the note in the Life of Bandinelli, *Le vite* (Club del Libro), VI, p. 47, for references to contemporary criticism and satirical poems provoked by Bandinelli's *Hercules* in Piazza Signoria, which Vasari said forced Duke Alessandro to imprison some of the more disrespectful commentators.

57 Bottari and Ticozzi, *Raccolta di lettere sulla pittura, scultura ed architettura,* I, xxvii, pp. 70–2 (7 December 1547).

58 See for this C. Davis, "Benvenuto Cellini and the Scuola Fiorentina," *North Carolina Museum of Art Bulletin* (1976), pp. 1–70, particularly pp. 27–9.

and one he had observed in others. The frustrations of his vagrant career are written into many other Lives. Vasari was not alone in his regrets. His friend Cosimo Bartoli wrote on this subject in the first book of his *Ragionamenti*, which originated as academic lectures given when Vasari was working on *The Lives* in the 1540s. The state of sculpture in Florence is one of the topics of discussion. The perfection of modern sculpture is remarked upon as is the presence of young artists in Florence, who, if they had the opportunity, would do works that granted as much fame to that city as the ancient sculptors did to Rome. Instead, Bartoli says with regret, they cannot afford to stay there and are to be found scattered throughout the world. In the Life of Perugino Vasari describes the market strategy Florence forced upon artists, and the sad consequences of not keeping up.[59] In this Life, with his account of Cosimo's loving support for Donatello and Donatello's equally loving relationship with the Martelli, Vasari sought to redress the balance. In summing up his career, Vasari said that Donatello had left the world so full of his sculptures "that it can truly be affirmed that no artist had ever worked more than he had."[60] Donatello's productivity recalls Pliny's description of Lysippus, who "was a most prolific artist and made more statues than any other sculptor."[61] For Vasari this productivity was essential to the perfection of sculpture in an era lacking examples.

The Artist Portrays Himself: Life and Works

Vasari's account of Donatello's many works combines episode and description. The theme of self-portrayal established in the opening paragraph is developed through anecdotal vignettes, which create a lifelike, vivid portrait of the artist. The technique Vasari employs here is exactly that described by Plutarch in the preamble to his Life of Alexander:

> I am writing biography, not history, and the truth is that the most brilliant exploits often tell us nothing of the virtues or vices of the men who performed them, while on the other hand a chance remark or joke may reveal far more of a man's character . . . When a portrait painter sets out to create a likeness, he relies above all upon the face and the expression of the eyes and pays less attention to the other parts of the body: in the same way it is my task to dwell upon those actions which illuminate the workings of the soul, and by this means to create a portrait of each man's life.[62]

Vasari tells different kinds of stories to convey different aspects of Donatello's character. Some of the stories fall into the category of *facetie* or *detti piacevoli*, witticisms and wise words. These had a place in biography. Machiavelli concluded his *Life of Castruccio Castracani*

59 Life of Perugino, BB III, p. 597.

60 Life of Donatello, BB III, p. 225: "Delle opere di costui restò così pieno il mondo che bene si può affermare con verità nessuno artefice aver mai lavorato più di lui."

61 *N.H.*, xxxiv.xix.62, pp. 172, 173.

62 Plutarch, *The Age of Alexander*, trans. Scott-Kilbert, p. 252, and *La prima parte delle vite di Plutarcho di greco in latino: & di latino in volgare tradotte* (1537), fol. 478v–9r: "noi intendemo non scrivere le historie ma solamente le vite di quelli [Alexander and Caesar]. Aggionge se a

questo che non sempre quelli fatti che sono dignissimamente operati, dechiarano la virtu o vitii delle huomini, ma una picciola cosa da per se, una parola, una piacevolezza molto piu manifesta li costumi de qual se voglia sia . . . Pero non altramente che fannoli depentori liquali disprezzano tutte le altre parti & membri del corpo pigliano la lor similitudine dalla forma del volto, de laquale se puo pigliare iudicio delli costumi, cosi a noi se deve perdonare, se per mostrare le parti de l'animo di costoro, dimostraremo la lor vita scrivendo quelle cose che piu rendeno iudicio de l'animo."

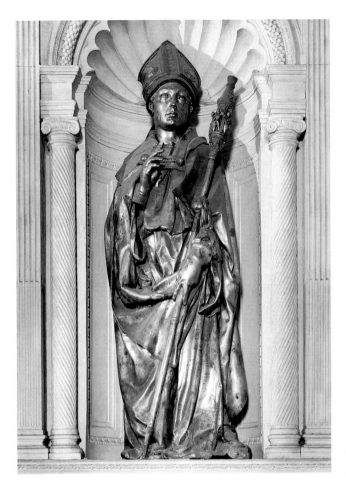

130. Donatello, *St. Louis*. Florence, Museo dell'Opera di Santa Croce.

with an anthology of such sayings, as did Vasari at the end of Michelangelo's Life in the 1550 edition, to show how Michelangelo had "gained the reputation of being a wise man."[63] Similar ability at making such remarks was one of Vasari's topics of praise for Brunelleschi, another artist who was "most witty in his arguments and very shrewd in his replies."[64] For Donatello, this sort of aptitude is concentrated on his works, demonstrating his judgment and wisdom in art, which is contrasted with his disregard for practical matters. He defended his statue of St. Louis (pl. 130),

> being accused that it was awkward [*goffo*] and perhaps the worst thing he had ever done, he answered that he had made it like that after much study, for [St. Louis] had been foolish [*goffo*] in leaving his kingdom to become a monk.[65]

63 Life of Michelangelo, BB VI, p. 116 (1550): "e di continuo sino al presente con bellissime e savie risposte s'ha fatto conoscere com'uom prudente." The full section of anecdotes in the first edition is BB VI, pp. 116–18 (Torrentino, II, pp. 989–91). This section was enlarged in the 1568 edition (BB VI, pp. 116–21; Giunti, III, pp. 778–81).

64 Life of Brunelleschi, BB III, p. 195: "facetissimo nel suo ragionamento e molto arguto nelle risposte."

65 Life of Donatello, BB III, p. 218: "del quale, essendo incolpato che fosse goffo e forse la manco buona cosa che avesse fatto mai, rispose che a bello studio tale l'aveva fatto, essendo egli stato un goffo a lasciare il reame per farsi frate."

Another such "wise response" was that Donatello made to the Consuls of the Arte de'
Linaiuoli about the statue of St. Mark at Orsanmichele (pl. 131). When they saw it on the
ground they did not like it. Donatello put it into its allotted niche, covered, and pretended
to work on it for another fifteen days. Unveiled, and actually untouched, but transformed
by its new position, everyone marveled and praised it. Donatello's wit and expertise are
shown to triumph in a demonstration of his ability to site statues. This triumph was
confirmed in Vasari's time when Michelangelo matched his wit to Donatello's in his praise
for the statue. When asked his opinion of it Michelangelo replied that "he had never seen
a figure with a more convincing expression of an upstanding man than that one, and if St.
Mark were like that then one could believe what he had written."[66] The artist's judgment
in matters of art prevails. Similarly, when a Genoese merchant did not recognize the value
of a head sculpted by Donatello, the sculptor, rather than accept the fee or argue about the
price, smashed the statue, angrily hurling it from Palazzo Medici to the street below, telling
the merchant that, "in a fraction of an hour he had known how to destroy the toil and value
of a year . . . [and] clearly showed himself to be more accustomed to trading in beans than
statues."[67]

With this incident Vasari chose an episode that had Plinian echoes. There was the statue-
smashing sculptor Syllanion, who was: "of quite unrivalled devotion to the art and a severe
critic of his own work, who often broke his statues in pieces after he had finished them, his
intense passion for his art making him unable to be satisfied."[68] And Apollodorus gave away
his works, "saying that it would be impossible for them to be sold at any price adequate to
their value."[69] Donatello seems to have had a reputation for breaking things: besides
dropping eggs on Brunelleschi's floor, one of Poliziano's *facetie* tells how he threatened to
shatter the head of the *Gattamelata*.[70] Both of Pliny's anecdotes are about the artist's self-
image and removal from the norm, showing extraordinary behavior resulting from extra-
ordinary talent. Donatello, satisfied with his work, but not the quibbling over its value,
similarly removed himself from the normal commerce of craft.

Donatello's shrewd self-valuation is the subject of another pricing story put in the Life of
Nanni di Banco, for Vasari a follower of Donatello. Here Vasari tells how the Arte de'
Calzolai had transferred the commission for the *St. Philip* (pl. 132) at Orsanmichele from
Donatello to Nanni di Banco, thinking to spend less. When the statue was completed and
Nanni asked more than Donatello's original price, the Consuls of the guild went to
Donatello for arbitration:

> the Consuls of that guild firmly believed that since he had not made [the statue] he would
> value it out of jealousy at much less than if it had been his work; they deceived
> themselves, however, because Donato judged that Nanni should be paid much more for

66 Life of Michelangelo, BB VI, p. 116: "non vedde
mai figura che avessi più aria di uomo da bene di quella,
e che, se San Marco era tale, se gli poteva credere ciò
che aveva scritto." In the 1568 edition of this Life,
Vasari tells a similar story about Michelangelo and Piero
Soderini's opinion of the *David* (BB VI, pp. 20–1),
indicating that the confrontation of artist and patron,
expert and authority, was based on a topos, like the
other anecdotes in this Life.

67 Life of Donatello, BB III, p. 212: "disse al
mercante che in un centesimo d'ora averebbe saputo
guastare la fatica e'l valore d'uno anno . . . ch'e' ben
mostrava d'essere uso a mercatar fagiuoli e non statue."
68 *N.H.*, xxxiv.xix.81–2, pp. 186, 187.
69 *N.H.*, xxxv.xxxvi.62, pp. 308, 309.
70 Life of Donatello, BB III, p. 205, and Wesselski,
Angelo Polizianos Tagebuch, no. 44, p. 27.

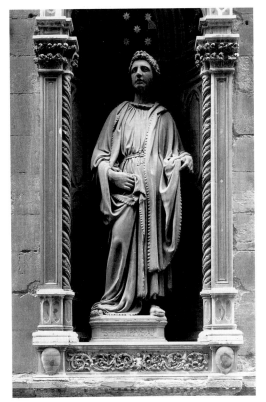

131. Donatello, *St. Mark.* Florence, Orsanmichele. 132. Nanni di Banco, *St. Philip.* Florence, Orsanmichele.

the statue than he had asked himself. The Consuls absolutely did not want to accept this judgment, and exclaimed to Donato: "Why, if you would have done this work for a lower price, do you value it more highly when it is by another, and insist that we pay him more than he himself has asked? And yet you know, as we do also, that it would have been much better had you done it." Donatello answered, laughing: "This poor man is not my equal in art and endures far more toil in his work than I do. As the fair men I believe you to be, you are obliged, if you wished to satisfy him, to pay him for the time he has expended."[71]

This has some resonance with Pliny's account of Apelles who,

kindly among his rivals, first established the reputation of Protogenes at Rhodes. Protogenes was held in low esteem by his fellow-countrymen . . . when Apelles asked

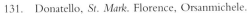

71 Life of Nanni di Banco, BB III, p. 44: "credevano al fermo i Consoli di quell'Arte che egli per invidia, non l'avendo fatta, la stimasse molto meno che s'ella fusse sua opera; ma rimasero della loro credenza ingannati, perciò che Donato giudicò che a Nanni fusse molto più pagata la statua che egli non aveva chiesto. Al qual giudizio non volendo in modo niuno starsene i Consoli, gridando dicevano a Donato: 'Perché tu, che facevi questa opera per minor prezzo, la stimi più essendo di man d'un altro, e ci strigni a dargliene più che egli stesso non chiede? e pur conosci, sì come noi altresì facciamo, ch'ella sarebbe delle tue mani uscita molto migliore.' Rispose Donato ridendo: 'Questo buon uomo non è nell'arte quello che sono io, e dura nel lavorare molto più fatica di me: però sete forzati volendo satisfarlo, come uomini giusti che mi parete, pagarlo del tempo che vi ha speso.' "

133. Donatello, *Zuccone* (detail).
Florence, Museo dell'Opera del
Duomo.

him what price he set on some works he had finished, he had mentioned some small sum,
but Apelles made him an offer of fifty talents for them, and spread it about that he was
buying them with the intention of selling them as works of his own. This device aroused
the people of Rhodes to appreciate the artist, and Apelles only parted with the pictures
to them at enhanced price.[72]

Donatello's generous rather than invidious estimation of Nanni's worth was also intended
to arouse appreciation of the artist, in this case Donatello himself. But the anecdote is much
more barbed than Pliny's: the ancient topos is transformed by the irony and role reversal of
the Tuscan *novella*. Donatello's quick wit is set against Nanni's slow work, and the sculptor
bests the merchants at their own game. The artist sets the terms of exchange.[73]

Vasari tells other stories related to artists' legends that reinforce the creative myth.
Donatello urging his prophet, the old pumpkin-head Zuccone (pl. 133), to speak is a rugged
variant of the Pygmalion legend. Donatello, Vasari says, would swear by the statue and
swear at it as well: "By the faith that I have in my Zuccone" and "Speak, speak or may
you shit blood."[74] Donatello, unlike Michelangelo, is unable to bring stone to life. It takes

72 *N.H.*, xxxv.xvi.88, pp. 324–7.

73 A similar story is told in Michelangelo's Life about
the tondo he painted for Agnolo Doni, BB vi, pp. 14–
15 (1550), 22–3 (1568).

74 Life of Donatello, BB iii, p. 209: "Alla fé ch'io
porto al mio Zuccone"; "Favella, favella che ti venga il
cacasangue!" Bennett and Wilkins, *Donatello*, p. 206,
note the interesting paradox that the idea of the speaking
statue was attached to Donatello's *Zuccone/Habbakuk*,
since Habbakuk inveighed against graven images arguing
the futility of urging dumb stone to speak.

one of Michelangelo's divinity to "bring back to life one who was dead," as Michelangelo did with the marble for the *David*.[75] The close identification of Donatello with the *Zuccone* is attested to by the fact that in the cloth hangings made for Michelangelo's funeral, Donatello was shown with "his *Zuccone* from the campanile beside him."[76] Here the artist as portrayed in his work − homely and awkward − is still far from the refined beauty and perfection of Vasari's modern times.

The number of anecdotes in this Life is not surprising given Donatello's survival in the Florentine storytelling tradition. Vasari chose from among a large stock. He did not use them all, and he did not use them only in Donatello's Life. Vasari was well aware of the traditional image of artists and took care not to lapse into the undignified stereotypes it offered. So Donatello, like his Boccaccesque predecessors on the Via del Cocomero, Buffalmacco and Bruno, though of modest condition, was able to live happily.[77] But unlike them, indeed unlike the Donatello of Manetti's hoax, he does not play cruel jokes on simple-minded victims.

Vasari acknowledges the storytelling tradition in the deathbed scene of the 1550 edition. First he tells how Brunelleschi had to be brought to beg Donatello to confess and to take communion; not because Donatello was not "good and faithful, but because of the supreme disregard that he had for everything except his art." Brunelleschi urged him to the act, in the name of their friendship, arguing for the special thanks talented men owed to God for their intellectual gifts and the honor accorded them as well as the need to "disabuse those who had the opinion that all elevated and beautiful spirits were heretical."[78] Vasari reports Brunelleschi's speech at length, allowing for all his points about friendship, genius, and artistic personality to be made, and then he demonstrates that this scene could never have taken place. A manifest "fiction," for Donatello was devout and Brunelleschi was dead, "as seen in his public epitaph." Vasari says that it was most likely entirely false and "a mere invention by someone who wanted to speak ill of artists."[79] Disavow it as he might, he used the episode. Not only was it a way to comment on the special qualities of artists, but it gave him a final opportunity to bring the two friends together in an episode that confirmed his characterization of Brunelleschi as always convincing in argument and of Donatello as courteous, uncalculating, and absorbed in his art. Such acknowledged apocrypha had little chance of survival into the second edition, where another deathbed scene is substituted in

75 Life of Michelangelo, BB VI, p. 20: "far risuscitare uno che era morto."

76 *Ibid.*, p. 135: "al suo Zuccone del Campanile, che gl'era a canto."

77 *Decameron*, ed. Branca, II, VIII.9, p. 398, for Bruno and Buffalmacco's apparently carefree condition and modest circumstances, as "poveri uomini e dipintori." Boccaccio (p. 397) gives their address as Via del Cocomero. Vasari says that Donatello died there, "in una povera casetta che aveva nella via del Cocomero vicino alle monache di San Niccolò" (BB III, p. 222).

78 Life of Donatello, BB III, p. 222 (1550): "dicono alcuni che e' non si poteva però indurlo . . . a confessarsi e communicarsi ad usanza di buon cristiano: non perché e' non fusse e buono e fedele, ma per quella somma straccurataggine che ebbe sempre in ogni sua cosa,

fuori che nella arte. La qual cosa intendendo Filippo . . . amicissimo suo . . . gli disse: '. . . per il che dovendo noi più che gli altri conoscere la bontà di Dio per lo ingegno che e' ci ha dato e per lo onore che ci è stato fatto sopra gli altri uomini, voglio per ricordanza della tanta nostra amicizia un servizio da te avanti la morte . . .' Soggiunseli Filippo allora che per la salute sua e per isgannare infiniti che avevano opinione che tutti gli ingegni elevati e begli fussino eretici."

79 *Ibid.*, p. 223 (1550): "Così dicono alcuni de la morte di Donatello, ancora che manifestamente si conosca il tutto essere finzione, sì perche e' fu veramente fedele e buono, e sì perché Filippo morì anni XX prima di lui, come nel publico epitaffio suo si vede . . . Laonde bisogna dire . . . che tutto è falso et un mero trovato di chi ha voluto cardar gli artefici."

which Donatello's liberality rather than spirituality is tested. Certain of his relatives schemed to be given a farm, showing him tender attentions in his illness. But Donatello,

> whose works were all good, said to them, "I cannot satisfy you, my kinsmen, because I intend to leave it – as appears to me reasonable – to the peasant who has always worked it and endured great labor thereby, and not to you, who without having bestowed upon it anything more profitable than the thought of possessing it, expect me to leave it to you because of your visit. Go, and God bless you."[80]

Charity conquered cupidity. The historical truth of these stories was derived from the popular recollection of Donatello as both generous and somewhat irreverent. He is recalled as such in one of the fifteenth-century *facetie*, for instance: "Not for the love of God, but because you are needy. So said Donatello to a poor man who asked him for alms for the love of God."[81]

The anecdotes in this life demonstrate Donatello's gifts (*doti*) of character: his kindliness, judgment, and love. There is an intentional play on the roots of his name in the verb *dare*, to give, that is made throughout the Life, particularly in the first edition. These stories are complemented by descriptions that show the way he was a "rare sculptor and marvelous maker of statues."[82] This is, in part, material. Vasari points out the technical advances, discoveries or recoveries from the antique made by Donatello. This constitutes his mastery, *magisterio*, which is frequently noted and which was a great part of his legacy to the future. In other respects the terms of Landino's appreciation of Donatello provided the keynote and the vocabulary for Vasari's descriptions – the comparison with the ancients and the achievement of life or liveliness (*vivacità, prontezza*). To these Vasari added boldness or *fierezza*. This translates Pliny's praise for the *audacia* of ancient sculptors to a modern word. The works that Vasari describes at greatest length and with the greatest familiarity are the *Annunciation* at Santa Croce (pl. 134), the Orsanmichele *St. George* (pl. 128), and the *Judith and Holofernes* in the Piazza della Signoria. All in public view, they offered Vasari opportunities to describe relief sculpture, free-standing figures, stone and bronze, architecture and setting. They range from the beauty of the Virgin to the valor of the armed figure, and the cold slumber of a drunken death.[83] They were also all in Florence, evidence of Vasari writing there, checking his notes against observation. The *Gattamelata* in Padua is described with enthusiasm, but not in detail. The "snorting and quivering of the horse" and the bold presence of its rider are an evocation of a type – a classical type – and it is duly said to have equaled the antique.[84] The *Gattamelata* description probably represents a suitable

80 *Ibid.* (1568): "Donato, che in tutte le sue cose aveva del buono, disse loro: 'Io non posso compiacervi, parenti miei, perché io voglio, e così mi pare ragionevole, lasciarlo al contadino che l'ha sempre lavorato e vi ha durato fatica, e non a voi, che senza avergli mai fatto utile nessuno né altro che pensa d'averlo, vorreste con questa vostra visita che io ve lo lasciassi; andate, che siate benedetti.' "

81 Wesselki, *Angelo Polizianos Tagebuch*, no. 367, p. 186: "Non per l'amor di Dio, ma perchè tu n'hai bisogno. Questo disse Donatello a un povero che gli chiedeva limosina per l'amor di Dio."

82 Life of Donatello, BB III, pp. 201–2: "scultore raro e statuario maraviglioso."

83 *Ibid.*, p. 203 (the *Annunciation*), p. 208 (the *St. George*), p. 210 (the *Judith and Holofernes*).

84 *Ibid.*, p. 214: "fece il cavallo di bronzo che è in sulla piazza di S. Antonio, nel quale si dimostra lo sbuffamento et il fremito del cavallo, et il grande animo e la fierezza vivacissimamente espresse dall'arte nella figura che lo cavalca . . . veramente si può aguagliare a ogni antico artefice in movenza, disegno, arte, proporzione e diligenza."

response to a subject, the bronze equestrian monument to a brave leader, rather than an actual reaction to the object.

The specific vocabulary used to describe the works is played against a general vocabulary of reaction and appreciation. Works are esteemed and praised (*stimato* and *lodato*), they cause *stupore* or amazement. The strength of reaction is more intense than that of the first period. In *The Lives* things are valued according to their merits. The marvelous details and effects of Giotto's works earn universal praise (*lode*), they do not cause wonder (*stupore*).[85] The beauty, grace, design, and difficulty found in Donatello's works are elements of the perfection in skills and qualities that mark the improvements of the second age. They are a mark of his position as the rule for the age – setting a standard to be measured against antiquity.

The first work Vasari describes is not, nor is it meant to be, Donatello's earliest work. Instead Vasari focusses on a representative work, one where the artist's style is defined: the *Annunciation* for the Cavalcanti chapel in Santa Croce which "brought him great renown and made him known for what he was" (pl. 134).[86] Vasari begins with its frame "alla grottesca," an inventive form of architectural design that both influenced and prefigures Michelangelo. In this work Donatello's distinctive ingenuity and art are fully demonstrated following Landino's terms. So Vasari points out the composition and placement of the figures and the frame with its putti "holding on to one another for reassurance, as though afraid of heights." He notes the variety, motion, and liveliness ("vivacità") of the figures, above all the startled Virgin, timidly moving away as though frightened by the sudden appearance of the angel, at the same time graciously turning to receive with gratitude the unexpected gift. The elegance of the figures is eloquently expressed in a play on the words of grace and giving. And the eloquence of the figures, the all-important match of form and subject, is purposefully evoked. Vasari concludes the description stating that in the turning and folds of the drapery and in seeking to indicate the form of the naked body beneath, Donatello demonstrated how he "was attempting to discover the beauty of the ancients, hidden for so many years."[87] The conspicuous turning of folds, revealed bodies, and expressive gesture constituted the imitation of the antique in Vasari's art (pl. 135). In Donatello's Life the vocabulary of discovery, demonstration, and mastery establishes the basis for appreciating the sculptor whose design and judgment were made manifest by his skillful hand and chisel.

Having started with works in Santa Croce, Vasari remains there, pointing out the

85 For *stupore* as a mannerist reaction, see Altieri Biagi, "La 'Vita' del Cellini. Temi, termini, sintagmi," in *Convegno sul tema: Benvenuto Cellini artista e scrittore*, p. 88–9. See also Barocchi ed., *Vita di Michelangelo*, II, p. 73.

86 Life of Donatello, BB III, p. 203: "gli diede nome e lo fece per quello che egli era conoscere."

87 *Ibid.*, pp. 203–4: "fece un ornato di componimento alla grottesca . . . aggiugnendovi sei putti che reggono alcuni festoni, i quali pare che per paura dell'altezza, tenendosi abbracciati l'un l'altro, si assicurino. Ma sopra tutto grande ingegno et arte mostrò nella figura della Vergine, la quale impaurita dall'improviso apparire dell'Angelo, muove timidamente con dolcezza la persona a una onestissima reverenza, con bellissima grazia rivolgendosi a chi la saluta, di maniera che se le scorge nel viso quella umiltà e gratitudine che del non aspettato dono si deve a chi lo fa, a tanto più quanto il dono è maggiore. Dimostrò oltra questo Donato, ne' panni di essa Madonna e dell'Angelo, lo essere bene rigirati e maestrovelmente piegati; e col cercare l'ignudo delle figure come e' tentava di scoprire la bellezza degl'antichi, stata nascosa già cotanti anni." See Summers, *Michelangelo and the Language of Art*, pp. 146–63, for the implications of the term *grottesco* and for the relationship between Donatello's and Michelangelo's architectural language. As Summers points out Vasari says that Donatello was highly regarded for his architecture, "nell'architettura molto stimato" (BB III, p. 202), a remark that should be glossed with reference to Michelangelo's esteem.

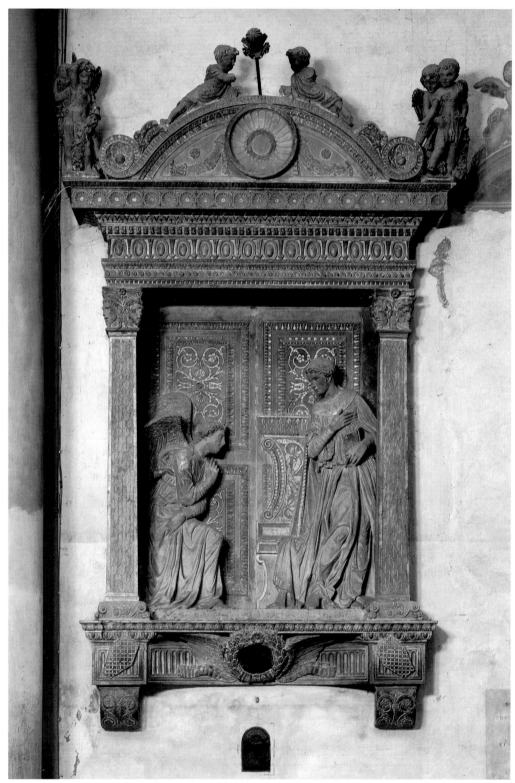

134. Donatello, *Cavalcanti Annunciation*. Florence, Santa Croce.

135. Giorgio Vasari, *Fortune*. Arezzo, Casa Vasari, Sala del Trionfo della Virtù.

wooden crucifix (pl. 136). Rather than give his own opinion, Vasari cites Brunelleschi's, "that it was a peasant and not a Christ." He also recounts how Donatello, who had begged his friend for his opinion, was upset by the unexpected criticism that he received. And so provoked, Vasari says, that he challenged Brunelleschi to make one of his own: " 'If it was as easy to do as to pass judgment, you would believe my Christ to be a Christ and not a peasant: just get a piece of wood, however, and try to do it yourself.' "[88] Which Brunelleschi did, in secret and with great success.

What results from this exchange is a competition between the friends. Competitions and competition were facts of Florentine artistic life.[89] And Vasari's explanation for the progress of the arts in the second period combined the good will of Nature in creating excellent men with the good will of those men whose friendly rivalry forwarded the arts. Imitation was the

88 Life of Donatello, BB III, pp. 204–5: " 'Se così facil fusse fare come giudicare, il mio Cristo ti parrebbe Cristo e non un contadino: però piglia del legno e pruova a farne uno ancor tu.' "

89 In Vasari's day, consider the proliferating contemporary portrait heads of Cosimo de' Medici as Bandinelli and Cellini fought it out at Cosimo's court. For the

tradition, see Kosegarten, "The origins of artistic competitions in Italy," in *Lorenzo Ghiberti nel suo tempo*, I, pp. 167–86. See also Gombrich, "The Leaven of Criticism in Renaissance Art," in *The Heritage of Apelles*, pp. 111–31, and "The Renaissance Conception of Artistic Progress and its Consequences," in *Norm and Form*, pp. 1–10.

136. Donatello, crucifix. Florence, Santa Croce.

means to perfection, but competition was the motivation. In this case, Donatello lost both his dinner – for he dropped the shopping, "stupefied" by the sudden sight of Brunelleschi's crucifix (pl. 137) – and the contest. Donatello's reaction was not one of defeat, however, but of constructive self-criticism, acknowledging to Brunelleschi that " 'it falls to you to do the Christs and to me the peasants.' "[90] Donatello is once again closer to earth than to heaven.

The subtext to this episode and its behavioral explanation is provided by the renaissance concept of friendship. *Amicitia* – as virtue and practice – was a defining ethos of social life. It was a daily reality in the clientage of political and economic operations, of transactions

90 Life of Donatello, BB III, pp. 205–6: "vinto e tutto pieno di stupore . . . rispose . . . a te è conceduto fare i Cristi et a me i contadini."

137. Filippo Brunelleschi, crucifix. Florence, Santa Maria Novella.

between and among individuals, families, and states.[91] It was an ideal celebrated in letters, presented in dialogues, and codified in treatises on moral philosophy, the nature of love, and civil life. Its formulation was based largely on Aristotle's treatment of friendship as a virtue in Books viii and ix of the *Nichomachean Ethics* and Cicero's dialogue *On Friendship*. Its terms were taken from these sources and often repeated. Chapter 30 of Book ii of Castiglione's *Courtier* and Antonio Brucioli's dialogue *Della amicizia* are typical rephrasings of both. Vasari knew these terms well. The ideal of friendship permeates his relationships and was propagated in his constructions of artists' actions and interactions as in the Life of Donatello.

91 See, for example, Lytle, "Friendship and Patronage in Renaissance Europe," in *Patronage, Art, and Society in Renaissance Italy*, ed. Kent and Simons, pp. 47–61, and Lowe, "Towards an Understanding of Goro Gheri's Views on *amicizia* in Early Sixteenth-Century Medicean Florence," in *Florence and Italy*, ed. Denley and Elam, pp. 91–105.

Its principles were commonplaces, but highly charged ones. What and how Vasari writes about friendship was based on his experience and borrowed from the discourse of civility. So the contest of Christs between Donatello and Brunelleschi is structured according to the tenet found in Cicero that friends should

> dare to give true advice with all frankness; in friendship let the influence of friends who are wise counsellors be paramount, and let that influence be employed in advising, not only with frankness, but, if the occasion demands, even with sternness, and let the advice be followed when given.[92]

Similar self-knowledge and friendly behavior are credited to Donatello and Brunelleschi in Vasari's two accounts of the contest for the Baptistery doors in the Lives of Ghiberti and Brunelleschi. In spite of all the evidence he had about this competition from Manetti's *Life of Brunelleschi* and Ghiberti's *Commentaries*, which indicated that it was a bitter one, and that it never included Donatello, Vasari chose to describe it as "certainly a great example of their love for art" and of "the true goodness of friends, virtue without envy and sound judgment in knowing themselves."[93] Donatello and Brunelleschi renounce the commission in favor of Ghiberti. Brunelleschi makes an inspirational speech on the occasion.[94] The love and mutual esteem informing Vasari's account of these artists is a complete transformation of the bitterness and polemic of Manetti's account of Brunelleschi and of his vexed relationship with Donatello.[95] Vasari said that Brunelleschi

> Declared himself to be a capital enemy of vice, and a friend of those who practiced virtue. He never spent his time uselessly, but would labor to meet the needs of others, either by himself or by the agency of other men; and he would visit his friends on foot and always help them out.[96]

Why was it so important for Vasari that these artists be friends? The answer is that "friendship cannot exist except among good men."[97] Vasari's interpretation of the relationship between Donatello, Brunelleschi, and the other *virtuosi* of their day is based upon the ideal of friendship that operated in the period. In *De Amicitia*, good men are defined as "Those who so act and so live as to give proof of loyalty and uprightness, of fairness, and

92 Cicero, *De Amicitia*, trans. Falconer, xiii.44, pp. 156, 157. Italian texts were widely available. Manuscript translations of the *De Amicitia* exist from the fifteenth century onwards. It was published in 1528, 1539, and 1544 in collections of Cicero's moral philosophy (*De gli uffici*, trans. Vendramino [1528], and *Opere*, trans. Vendramino and Brucioli [1539, 1544]). Brucioli's dialogue is a pastiche of Cicero and Aristotle that includes most of the passages cited here. It was published in 1526, 1537–8, and in 1544–5 with a dedication to Vasari's patron and friend, Ottaviano de' Medici. One of the protagonists in the dialogue is Francesco Molza, another of Vasari's friends who he names in association with the origins of *The Lives*. For the passage quoted here and the function of friendly criticism, see Brucioli, *Dialogi*, ed. Landi, pp. 404, 413–14.

93 Life of Ghiberti, BB iii, p. 82 (1550): "esemplo

certo grandissimo di amore che all'arte avevano," and Life of Brunelleschi, BB iii, p. 147: "fu veramente questo una bontà vera d'amici et una virtù senza invidia et uno giudizio sano nel conoscere se stessi."

94 Life of Ghiberti, BB iii, pp. 81–2 (1550).

95 Manetti, *Vita*, ed. De Robertis and Tanturli, pp. 109–10, about the Old Sacristy at San Lorenzo.

96 Life of Brunelleschi, BB iii, pp. 138–9: "Dichiarossi nimico capitale de' vizii et amatore di coloro che si essercitavano nelle virtù. Non spese mai il tempo invano, che o per sé o per l'opere d'altri nelle altrui necessità non s'affaticasse, e caminando gli amici visitasse e sempre sovvenisse."

97 *De Amicitia*, trans. Falconer, v.18, pp. 126, 127. See also *Cortegiano*, ed. Cian, Book ii, chapter 30, pp. 182–3.

generosity; who are free from all passion, caprice, and insolence, and have great strength of character."[98] They are "also entitled to be called by that term because, in as far as that is possible for man, they follow Nature, who is the best guide to good living."[99] The kindly ("benigno") Donatello models himself after kind mother Nature, and the goodness of his art is a manifestation of the goodness of character.[100] Furthermore, since according to the principles explaining friendship, virtue "both creates the bond of friendship and preserves it . . . in Virtue is complete harmony," it was impossible for there to have been any real discord among those artists bound by love for each other and their art.[101] Hence, no sour note was sounded between Donatello and Brunelleschi, Manetti notwithstanding. The rivalry between those artists was the "rivalry of virtue" and in their friendship by definition must "abide all things that men deem worthy of pursuit – honour and fame and delighful tranquillity of mind; so that when these blessings are at hand life is happy."[102] Donatello and his contemporaries were, Vasari says, exactly such "happy spirits, who, while they helped one another took delight in praising the labors of others."[103] The opposite is demonstrated by a counter-example in the Life of Paolo Uccello, where Paolo asks for Donatello's opinion about the *Doubting Thomas* he had painted over the door of San Tommaso di Mercato. Paolo is unable to accept Donatello's rebuke, given with appropriate consideration, candor, and good intention: "having looked hard at the work, he said: 'Well, Paolo, now would be the moment to conceal this work and you reveal it.' "[104] Uccello, like Donatello at Santa Croce, had expected praise and received censure; but instead of coming to terms with the criticism he had solicited, the timid Paolo "shut himself up in his house," becoming solitary and obsessive, "not having the temerity, thus humiliated, to go out any more" and devoted himself to perspective, "which kept him poor and depressed until his death."[105] Donatello, of whom boldness (*fierezza*) was a defining feature, benefited from criticism and was successful in society. Supported by the love and esteem he had earned, he "lived cheerful and carefree."[106] He "spent his old age extremely happily, and when he became decrepit had to be helped by Cosimo [de' Medici] and by other friends of his, since he could no longer work."[107] Help was forthcoming, because his capacity for friendship was one of his gifts.

The contrasting careers of Paolo Uccello and Donatello are examples of social and anti-social behavior and part of a larger structure of praise and blame operating in *The Lives*

98 *De Amicitia*, trans. Falconer, v.19. pp. 128, 129. See also Brucioli, *Dialogi*, ed. Landi, pp. 406, 409.

99 *De Amicitia*, trans. Falconer, v.19, pp. 128, 129.

100 Life of Donatello, BB III, pp. 201–2 (1550).

101 *De Amicitia*, trans. Falconer, xxvii.101, pp. 206, 207. Similarly Brucioli, *Dialogi*, ed. Landi, p. 403.

102 *De Amicitia*, trans. Falconer, xxii.84, pp. 190, 191. Compare Vasari's statement about Brunelleschi and Donatello who almost could not live without one another for their mutual love: "et insieme per le virtù l'un dell'altro si posono tanto amore, che l'uno non pareva che spesse vivere senza l'altro" (BB III, p. 141; Life of Brunelleschi) with Cicero "there is nothing more lovable than virtue, nothing that more allures us to affection," *De Amicitia*, trans. Falconer, viii.28, pp. 138, 139.

103 Life of Brunelleschi, BB III, p. 147: "felici spiriti, che mentre giovavano l'uno all'altro godevano nel lodare le fatiche altrui."

104 Life of Uccello, BB III, p. 71: "guardato che ebbe l'opera ben bene, disse: 'Eh, Paulo, ora che sarebbe tempo di coprire, e tu scuopri.' "

105 *Ibid.*: "non avendo ardire, come avvilito, d'uscir più fuora, si rinchiuse in casa attendendo alla prospettiva, che sempre lo tenne povero et intenebrato insino alla morte."

106 Life of Donatello, BB III, p. 221: "visse lieto e senza pensieri."

107 *Ibid.*, p. 220: "Passò la vecchiezza allegrissamamente, e venuto in decrepità, ebbe ad essere soccorso da Cosimo e da altri amici suoi, non potendo più lavorare."

by which such examples are used to balance each other. The vice that is the counterweight or "contrappeso" of Uccello's virtue in art is reluctance ("la ritrosia").[108] Vasari says: "Indeed, in men of this type solitude and the little delight in serving others and bringing them pleasure through their works have such force that they are often held back by poverty."[109] Donatello, as Uccello's "dear friend," often tried to warn Paolo away from what would become his obsession: "Oh Paolo, this perspective of yours will make you leave certainty for doubt."[110] Good advice given to no avail. Uccello, by rejecting the support of friendship, remains solitary. This is a condition that goes against nature, which "loving nothing solitary, always strives for some sort of support, and man's best support is a very dear friend."[111] Uccello's failure is therefore a natural consequence of his anti-social behavior, his rejection of the ties, duties, and benefits of friendship, the highest and most productive form of social integration.

Donatello's Life is a model of friendship and its rewards, not only in his relations with Brunelleschi and other fellow artists, but with the Martelli and the Medici, his patrons. Vasari never considers Donatello's parentage or ancestry. Instead he substitutes Nature and Florence for his birth and origins, the antique for his teacher, and the Martelli for his family. Vasari is here applying the virtuous model of the client relationship that also derived from friendship, which:

> springs rather from nature than from need, and from an inclination of the soul joined with a feeling of love rather than from calculation of how much profit that friendship is likely to afford . . . there is nothing more lovable than virtue, nothing that more allures us to affection.[112]

Donatello's virtue naturally merited the friendship and protection of the Martelli clan: "for his good qualities and his study of virtue, he not only deserved to be loved by [Roberto Martelli], but also by all of that noble family."[113] And he naturally returned this friendship. Vasari writes:

> In the houses of the Martelli there are many narrative reliefs in marble and bronzes, among others a *David* three *braccia* high and numerous other things by him, given with great liberality as a pledge of the servitude and the love that he bore that family.[114]

108 Life of Uccello, BB III, p. 61 (1550).

109 *Ibid.* (1550): "Anzi, tanto può in questi sì fatti la solitudine e'l poco dilettarsi di servire altrui e fare piaceri nell'opre loro, che spesso la povertà li tiene . . . impediti"; (1568) "bene spesso si diventa solitario, strano, malinconico e povero, come Paulo Uccello, il quale . . . non ebbe altro diletto che d'investigare alcune cose di prospettiva difficili et impossibili."

110 *Ibid.*, pp. 62–3: "Onde Donatello scultore, suo amicissimo, li disse molte volte . . . 'Eh, Paulo, cotesta tua prospettiva ti fa lasciare il certo per l'incerto.'" Vasari expanded his statements about Uccello's single-minded preoccupation in the 1568 edition where he was concerned to define the difference between diligent study and obsession. The solitary, eccentric character of Uccello presents an obvious parallel with Pontormo, one

that Vasari made explicit in the 1568 edition of the Life of Raphael (BB IV, p. 208).

111 *De Amicitia*, trans. Falconer, xxiii.88, pp. 194, 195. Similarly Brucioli, *Dialogi*, ed. Landi, pp. 399, 415.

112 *De Amicitia*, trans. Falconer, viii.27–28, pp. 138, 139. Similarly Brucioli, *Dialogi*, ed. Landi, p. 401.

113 Life of Donatello, BB III, p. 203: "per le buone qualità e per lo studio della virtù sua non solo meritò d'essere amato da lui [Roberto Martelli], ma ancora da tutta quella nobile famiglia."

114 *Ibid.*, pp. 212–13: "Sono nelle case de' Martelli dimolte storie di marmo e di bronzo, et infra gli altri un David di braccia tre, e molte altre cose da lui, in fede della servitù e dell'amore ch'a tal famiglia portava, donate liberalissamente." A *braccia* is approximately two feet (58.36 cm).

138. (?) Donatello, *Martelli St. John the Baptist*. Florence, Bargello.

Another relic of this relationship was a three *braccia* tall, free-standing, marble *St. John the Baptist* still in the house of Roberto's heirs, which Vasari said, by testamentary obligation,

> could not be pledged, or sold or given away, without heavy penalties, as a testimony and token of the affection shown by [the Martelli] to Donato, and by him to them, in recognition of his excellence, which he had learned through the protection and the comforts that they had afforded him.[115]

What is the truth, and what the source, of Vasari's statement that Donatello was "raised from childhood in the house of Roberto Martelli?"[116] The article of faith, the marble *St. John* (pl. 138), had been borrowed from the Martelli in 1541 to form part of the decoration

115 *Ibid.*, p. 213: "un S. Giovanni tutto tondo di marmo . . . di 3 braccia d'altezza, cosa rarissima, oggi in casa gli eredi di Roberto Martelli; del quale fu fatto un fideicommisso che né impegnare né vendere né donare si potesse senza gran pregiudizio, per testimonio e fede delle carezze usate da loro a Donato, e da esso a loro, in riconoscimento de la virtù sua, la quale, per la protezzione e per il comodo avuto da loro aveva imparata."

116 *Ibid.*, p. 203: "Fu allevato Donatello da fanciullezza in casa di Ruberto Martelli."

for the baptism of Cosimo's heir, Francesco. Vasari's knowledge of its status as a carefully guarded heirloom probably stems from that occasion, for which he supplied a painted chiaroscuro cloth hanging showing the baptism of Christ. In fact, a member of the Martelli family, Luigi (Roberto's great-nephew), was responsible for paying Vasari.[117] The manuscript notes and the somewhat earlier book of Antonio Billi both cite this statue as being in the "house of Roberto's heirs."[118]

The Martelli owned two other statues attributed to Donatello and set into the walls of Roberto's house: a bronze *St. John* and a marble *David*. This house was purchased from Roberto's heirs in 1487 and belonged to his great-nephew Luigi. Those two statues were inventoried in the palace around 1489 and 1493 when the bronze was listed as by Donatello.[119] A marble *David* features in the background of Bronzino's portrait of Luigi's son, Ugolino, painted around 1540 (pl. 139). Thus three of the "many things" Vasari said Donatello made for the Martelli clan can be traced to Roberto's house.

In the fifteenth century the Martelli were Medici partisans.[120] In the sixteenth they were a prestigious and culturally conspicuous clan. In the Life of Rustici, Vasari says that Rustici lived in the Via de' Martelli and that he was "a close friend of all men of that family, which has always had such virtuous and meritorious men."[121] Albertini's guide mentions that there were many Roman antiquities in the Martelli palace.[122] Luigi, the man responsible for

117 Luigi was a chamberlain of the Opera di San Giovanni. The payment of 50 ducats ordered by the duke was made on 10 July 1541, Frey II, p. 858, no. 115. The Martelli *St. John* crowned the baptismal font, which had been constructed by Tribolo and is described by Vasari in the Life of Tribolo (BB V, p. 220). This statue featured again in the baptism of Francesco's daughter, twenty-seven years later. Vasari gives and account of this decorative program in a letter to Guiglielmo Sangalletti, mentioning the "bellissima statua di marmo di San Giouanni Battista, alta circa tre braccia, di mano di Donatello, eccellentissimo scultore, la quale si è hauuta di casa i Martelli, che non la possono sanza loro grandissimo pregiudizio, per le cagioni che vi sapete, alienare," Frey II, dcxx, p. 370 (Florence, 28 February 1568, to Sangalletti, Rome). See Civai, "Donatello e Roberto Martelli," in *Donatello-Studien*, pp. 253–62, who has discovered this testamentary clause in the 1523 will of Roberto's son, Francesco (pp. 254–5).

118 Anon. Maglia. p. 77: "hoggi in casa dell" erede di Ruberto Martellj"; Fabriczy, "Il Libro di Antonio Billi," *Archivio storico italiano* (1891), p. 321: "oggi in casa li eredi di Ruberto Martelli." It remained in the possession of Roberto's direct descendants until 1752 when the line died out. See Cropper, "Prolegomena to a new interpretation of Bronzino's Florentine Portraits," in *Renaissance Studies in Honor of Craig Hugh Smyth*, II, pp. 149–60, p. 153, for this and for a careful untangling of the provenance of this and the other statues attributed to Donatello and owned by the Martelli. The *St. John* is described as being in the house of Roberto's heirs by Bocchi in *Le Bellezze della città di Fiorenza* (1591) pp. 10–11. It is now in the Museo Nazionale del Bargello, Florence, and is often attributed to Desiderio da

Settignano, see Janson, *Donatello*, 1979, pp. 191–6, pls. 92–3, who argues in favor of Donatello. Whatever the modern opinion, by the mid-sixteenth century it was one of Donatello's most celebrated works, proudly and tenaciously owned by the descendants of Roberto Martelli. It certainly accorded well with Vasari's understanding of Donatello's style, which actually favored its interpretation by his followers and other artists working in the 1460s and 1470s. See the Lives of Desiderio da Settignano and Antonio da Rossellino for example.

119 These inventories were discovered by Kent Lydecker. Lydecker's findings are summarized in Detroit Institute of Art, *Italian Renaissance Sculpture in the Time of Donatello*, no. 53, pp. 175–8, and *Donatello e i suoi*, pp. 232–3; see also Cropper, "Prolegomena to a new interpretation of Bronzino's Florentine Portraits," in *Renaissance Studies in Honor of Craig Hugh Smyth*, II, p. 152. The *David*, now in the National Gallery of Art, Washington, is another disputed work. Pope-Hennessy's proposal of Bernardo Rossellino's authorship is widely accepted, "The Martelli David," *Burlington Magazine* (1959), pp. 134–9. Schlegel has argued for its invention as being Donatello's, relating it to a bronze statuette in the Staatliche Museen, Berlin, "Problemi intorno al David Martelli," in *Donatello e il suo tempo*, pp. 245–58.

120 Martines, "La famiglia Martelli e un documento sulla vigilia del ritorno dall'esilio di Cosimo dei Medici (1434)," *Archivio storico italiano* (1959), pp. 29–53.

121 Life of Rustici, BB V, p. 476: "amicissimo di tutti gl'uomini di quella famiglia, che ha sempre avuto uomini virtuosissimi e di valore."

122 Albertini, "Memoriale," in *Five Early Guides to Rome and Florence*, ed. Murray, unpaginated (p. 6, fol. a.iiii r): "assai cose antique di Roma."

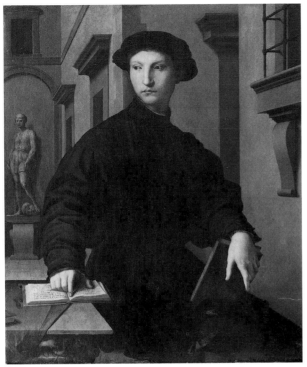

139a. Bronzino, *Ugolino Martelli*. Berlin, Staatliche Kunst-
sammlungen, Gemäldegalerie.

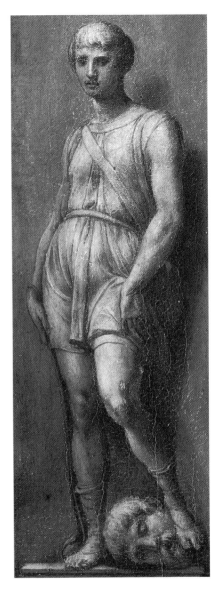

139b. Bronzino, *Ugolino Martelli* (detail). Berlin, Staatliche
Kunstsammlungen, Gemäldegalerie.

paying Vasari in 1541, was also a dinner companion of Rustici and other artists. They
belonged to an eating club, the Company of the Trowel, one of whose extravagant
theatrical entertainments devised by Luigi was described as part of Vasari's lengthy account
of their feasts in the Life of Rustici.[123] Luigi's son Ugolino was also a friend of Tribolo, as
well as of Annibale Caro, Bronzino, and Benedetto Varchi. Ugolino and some of his
cousins, Niccolò, Sigismondo, and Pandolfo, were founders and early members of the

123 Life of Rustici, BB v, p. 487, for the Compagnia
della Cazzuola.

Florentine academy.[124] Another, Vincenzo, though in exile, was a good friend of Caro and of Cosimo Bartoli. Bartoli made him an interlocutor in his first *Ragionamento*, about sculpture. Vasari had ample opportunity to know and to admire those most excellent Martelli.

The basis of his statement about Donatello and the Martelli was probably their pride of possession and belief in their early patronage of Donatello. They certainly claimed to own, collectively, more works by Donatello than any family other than the Medici. Since Donatello was actually an independent master before Roberto was born (Roberto lived from 1408 to 1468, Donatello was born around 1386), he was not raised by Roberto, but he could have been favored by the family. And during the first half of the century Roberto's house was actually the family palace, where all the Martelli brothers lived.[125] It was probably Vasari who transformed their ownership of works they believed to be by Donatello into their fostering of the artist. For Vasari it was important that the goodness of Donatello's era could be demonstrated from the very beginning of his life in the match of good artist and willing patrons. In addition, as a Martelli protégé, Donatello prefigured the young Michelangelo's and, indeed, the young Vasari's experience with the Medici.[126] Vasari's service to the Martelli tradition in his description of Donatello's career may have served his career as well. In 1549 he received a major commission from the Martelli for an altar in the family chapel in San Lorenzo. The commission came from Pandolfo and Vincenzo Martelli acting as executors for their cousin Sigismondo Martelli, who died in 1548. Cosimo Bartoli acted as Vasari's agent. Vasari saw this commission as a chance to demonstrate his skill and establish his reputation in Florence. The executors had a simple composition with a Virgin and Saints in mind. Vasari volunteered to do a much more ambitious subject, a display piece on a large scale, for the same price. He conceived of it as an investment in his future. In the end he designed, for his "very dear friends" Luigi and Pandolfo Martelli, a monumental frame and an altarpiece showing the "horrendous spectacle" of the martyrdom of St. Sigismund (pl. 140).[127] This preceded the publication of *The Lives*, but Vasari's project already had an established reputation in Florence. Varchi mentioned it in his lecture to the academy on the debate about the arts, published in 1549. The Martelli may well have been flattered by Vasari's curiosity about their collections, knowing his intention to celebrate them in his book.

In fact, Donatello's career was made to mirror Vasari's directly. "Raised," Vasari said, in the house of Niccolò Vespucci, Vasari was a Medici dependent, just as Donatello, raised by

124 See Litta, *Famiglie celebri italiane*, IX, "Martelli," Caro, *Lettere*, I, pp. 44–5, 46, 47, 48, 52, 59, 60, 178, and C. Davis, in Arezzo 1981, p. 137.

125 Martines, "La famiglia Martelli e un documento sulla vigilia del ritorno dall'esilio di Cosimo dei Medici (1434)," *Archivio storico italiano* (1959), pp. 32–3, and Cropper, "Prolegomena to a new interpretation of Bronzino's Florentine Portraits," in *Renaissance Studies in Honor of Craig Hugh Smyth*, II, p. 152.

126 For Vasari's account of Lorenzo de' Medici's support of the young Michelangelo, see BB VI, pp. 10–11.

127 See Vasari's description of his works, BB VI, p.

395, for the commission from his "amicissimi," Luigi and Pandolfo Martelli, and for a full description of his composition showing the "orrendo spettacolo" of the martyrdom of the saint and his family. See also the letters from Cosimo Bartoli, Frey I, cxxx, p. 269 (Florence, 8 March 1550, to Vasari, Rome), and cxxxvii, p. 281 (Florence, 5 April 1550, to Vasari, Rome). The work, commissioned 14 October 1549, was completed in the summer of 1550 (Frey II, p. 869, no. 196). Now destroyed, it is recorded by a compositional study in Lille, Musée des Beaux-Arts, Inv. 549, pen and ink, 420 × 295 mm (pl. 140).

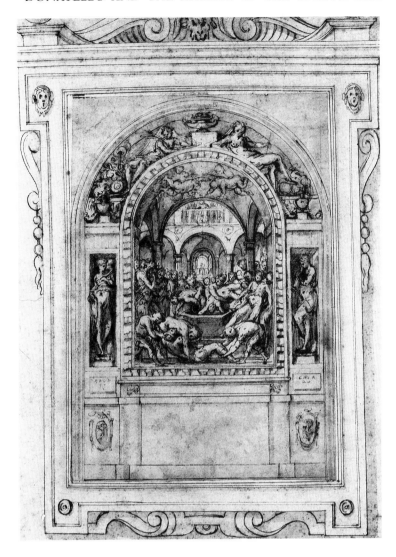

140. Giorgio Vasari, compositional study for *The Martyrdom of St. Sigismund*, pen and ink, 420 × 295 mm. Lille, Musée des Beaux-Arts.

the Martelli, had served the Medici.[128] The relationship that Vasari describes between Cosimo and Donatello is model of patronage, of love and service:

And so great was the love that Cosimo bore for Donato's virtue, that he kept him continually at work, and Donato, on the other hand, bore so great a love for Cosimo that he could divine his every wish from the slightest sign and continually obeyed him.[129]

128 Frey I, i, p. 2 (Rome, 1532, to Niccolò Vespucci, Florence): "da che sono alleuato in casa sua"; on p. 1, he describes his service with Ippolito and Alessandro de' Medici.

129 Life of Donatello, BB III, p. 211: "E fu tanto l'amore che Cosimo portò alla virtù di Donato, che di continuo lo faceva lavorar[e]; et allo incontro ebbe tanto amore verso Cosimo Donato, ch'ad ogni minimo suo cenno indovinava tutto quel ch'e' voleva e di continuo lo ubbidiva." See C. Davis, "Frescoes by Vasari for Sforza Almeni," *Mitteilungen des Kunsthistorischen Institutes in Florenz* (1980), pp. 126–202, for the iconography of a cycle devoted to the theme of service devised by Bartoli and painted by Vasari and Cristofano Gherardo in the *salotto* of Almeni's palace in 1554–6 and for further bibliography on the subject of service.

Under Cosimo's auspices, according to Vasari, Donatello lived happily, content, and protected until the end of his days. Their mutual love lifted servitude beyond mere servility. As a motivating force, love endowed service with a moral basis. It involved reciprocal obligations and respect. This model was based on prescriptions of friendship derived from the precepts of the *De Amicitia* promulgated in writings on behavior. It was further tempered by Neoplatonic concepts of the ties of love, which Vasari had incorporated into his view of himself, his profession, and his status from his youth.

The ties and obligations of patronage and service were themes that Vasari had addressed in his correspondence and presumably his conversations with his great friend and protector Ottaviano de' Medici.[130] Vasari said that Ottaviano treated him like a most beloved father.[131] It was probably Ottaviano, who along with Paolo Giovio, gave Vasari his information about the earlier Medici. Ottaviano and Giovio had been involved in creating glorified Medici history: Giovio in the program and Ottaviano in the administration of the fresco decoration of the great hall of the villa at Poggio a Caiano, where Cicero's return from exile and his title *Pater Patriae* were used to prefigure Cosimo il Vecchio's.[132] The analogy between Cosimo and Cicero was repeated by Giovio in his *Elogio* of Cosimo.[133] And this classicizing conception of Cosimo seems to be reflected in the aspects of Cosimo's patronage that Vasari emphasized in this Life. In the 1550 edition, the only works added to those cited in other sources are antique or *all'antica*: the tondi in the courtyard of Palazzo Medici copied from ancient cameos and medals, the restoration of a marble *Marsyas*, and "infinite" classical heads, which Donatello restored and adorned with Medici emblems.[134] Vasari also makes the special relation between Donatello and Cosimo the explanation for the revival of interest in the antique in Florence: "And he was the main reason why Cosimo de' Medici wished to bring the antiquities to Florence that were and still are kept in the Medici house, and he restored all of them with his own hands."[135] The ends and means to the perfection of the arts were concentrated in their mutual esteem, a regard so great that Cosimo's support for Donatello lasted beyond both their lifetimes. Donatello was buried next to Cosimo, according to his wish: "So that their bodies might be together in death, as their souls had always been in life."[136]

130 Frey I, xxxv, p. 92 (Arezzo, December 1537, to Ottaviano, Florence), and xxxvi, p. 94 (Rome, Spring 1538, to Ottaviano, Florence). See Bracciante, *Ottaviano de' Medici e gli artisti*, and in Arezzo 1981, pp. 75–7.

131 Description of Vasari's works, BB VI, p. 372.

132 Life of Andrea del Sarto, BB IV, pp. 372–3: "fu data la cura di quest'opera e di pagar i danari al magnifico Ottaviano de' Medici, come a persona che non tralignando dai suoi maggiori s'intendeva di quel mestiere et era amico e amorevole a tutti gl'artefici delle nostre arti, dilettandosi più che altri d'avere adorne le sue case dell'opere dei più eccellenti"; Life of Franciabigio, BB IV, p. 511, for the respective roles of Ottaviano and Giovio. For the iconography, see Winner, "Cosimo il Vecchio als Cicero," *Zeitschrift für Kunstgeschichte* (1970), pp. 261–97.

133 Giovio, *Gli Elogi*, ed. Meregazzi, Book III, no. I, p. 329. For Giovio's image of Cosimo il Vecchio and early Medicean patronage, see the opening to his biogra-

phy of Leo X, *Le Vite di Leon Decimo et d'Adriano Sesto sommi pontefici*, trans. Domenichi (1549), pp. 1–5.

134 Life of Donatello, BB III, p. 211.

135 *Ibid.*, p. 220: "Et egli fu potissima cagione che a Cosimo de' Medici si destasse la volontà dell'introdurre a Fiorenza le antichità che sono et erano in casa Medici, le quali tutte di sua mano acconciò."

136 *Ibid.*, pp. 223 (1550), 222 (1568): "E fu sotterato nella chiesa di San Lorenzo vicino alla sepoltura di Cosimo, come egli stesso aveva ordinato, a cagione che così gli fusse vicino il corpo già morto come vivo sempre gli era stato presso con l'animo." Lightbown, *Donatello and Michelozzo*, II, pp. 327–8, has published the extract from the fifteenth-century *Repertorio delle sepolture* at San Lorenzo which says that Donatello was buried in the crypt at San Lorenzo "per commissione del mag.co piero di cosimo." For Cosimo's support of Donatello as reported in the fifteenth century, see Vespasiano da Bisticci's biography, *Le Vite*, ed. Greco, II, pp. 193–4.

With Cosimo and Donatello Vasari presents a model of service that was both practically sound and philosophically justified. With Donatello and his contemporary artists he creates a model of friendship and friendly rivalry in which co-operation and criticism promote *virtù* through assistance and instruction. Vasari represented Donatello as the first sculptor to approach the ancients in his abilities and discoveries. He was unable, even when commissioned to do so, to produce clumsy and old-fashioned works:

> In a convent of nuns [in Padua] he made a St. Sebastian in wood at the request of one of their chaplains, a Florentine and intimate friend of his. This man brought him one that they had that was old and clumsy, begging him to make one the same. Wherefore Donato strove to imitate it in order to please the chaplain and the nuns, but even in the imitation of that clumsy work, he could not avoid displaying his usual brilliance and skill.[137]

The old style had become inimitable. Donatello's gifts – part of his nature and his name – and his diligence in studying such Greek and Roman remains as he could, endowed all his works with animation, artifice, goodness, proportion, and design. These values made them canonical for all times. According to Vasari, Donatello had wonderful skill in his art. He was born, however, in a still imperfect age. What he had in art he lacked in manners. While Vasari's Donatello is in many ways exemplary in his behavior – courteous and generous, a good and virtuous friend – he is not a gentleman. The stories Vasari tells about Donatello serve to confirm a conventional, slightly comical view of artists as "impractical and whimsical."[138] Donatello is somewhat temperamental (he throws statues out of windows), impulsive, impractical, and totally absorbed in his art. These are qualities he shares with many of the great artists of his time as Vasari describes them: the reclusive Paolo Uccello, the abstracted Masaccio, the otherwordly Fra Angelico, and the all too worldly Fra Filippo Lippi, for example. Part 2 of *The Lives* features many such lively characters and enlivening anecdotes of odd, outrageous, and even, in the case of Andrea del Castagno, murderous behavior.

The return to nature in art is described with naturalistic narrative. Domenichi's highly successful updating and publication of a book of fifteenth-century witticisms proves that there was a taste for those stories circulating from the recent past. The previous century was but a few generations old. It had a certain immediacy and undoubtedly survived vividly in popular recollection. This is registered in Vasari's treatment of the second age, which was adolescence after all. The arts, "taken from the wet nurse" in the first age, had yet to arrive at the maturity and perfection of Vasari's day.[139] Vasari used the traditions and tales to make a point about the quality of the times. They amuse and they instruct. They are a part of his portrait of an era, in which Donatello's artistic excellence set a standard, his virtue and generosity an example, and his quirky character proved the rule.

137 Life of Donatello, BB II, p. 215: "In un monastero di monache fece un S. Sebastiano di legno a' preghi d'un capellano loro, amico e domestico suo, che era fiorentino; il quale gliene portò uno che elle avevano vecchio e goffo, pregandolo che e' lo dovesse fare come quello. Per la qual cosa sforzandosi Donato di imitarlo per contentare il capellano e le monache, non poté far sì che, ancora quello che goffo era imitato avesse, non facesse nel suo la bontà e l'artificio usato."

138 Life of Raphael, BB IV, p. 155: "astratti e fantastichi."

139 Preface to Part 2, BB III, p. 14: "levate da balia."

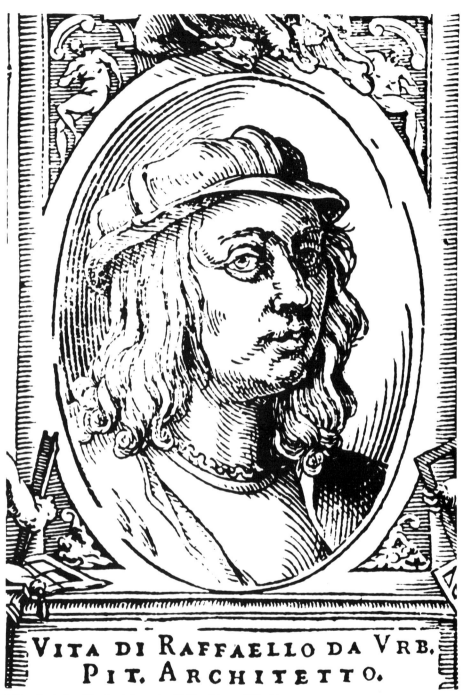

141. Portrait of Raphael from the 1568 edition of *The Lives*.

IX

RAPHAEL, THE NEW APELLES

IN THE WINTER OF 1532, whenever Pope Clement VII went to the country (which he did frequently), the young Vasari and his friend Francesco Salviati would be let into the Vatican to draw, which they did "as soon as His Holiness rode off . . . and they stayed from morning until night, eating nothing but a bit of bread and almost freezing to death."[1] Raphael was one of Vasari's models in art. He was also one in life. Vasari was impressed with the fact that those who followed Raphael had achieved success.[2] He had extensive, if second-hand, experience of Raphael's talents and charm. When Raphael died in April 1520 Vasari was still a schoolboy in Arezzo, but Raphael's fame was a living memory and part of Vasari's formation as an artist.

Raphael set a standard by which Vasari was judged. Thanking Vasari for a drawing of the *Fall of Manna*, Pietro Aretino wrote: "you have acquitted yourself in such a way in the drawing that you sent me that the one in which the truly amiable and charming Raphael drew a similar subject does not surpass it to such an extent that you have cause for regret."[3] The sources for this Life are to be found in the circumstances and events of Vasari's career. Vasari never met Raphael, but he shared many of Raphael's experiences. He was offered similar commissions, set similar tasks, and confronted by similar problems. Vasari, like Raphael, went to Florence "to learn," and then perfected those lessons in Rome.[4] Like

1 Life of Salviati, BB V, p. 515: "sùbito che Sua Santità cavalcava, come spesso faceva, alla Magliana, entravano per mezzo d'amici in dette stanze a disegnare, e vi stavano dalla mattina alla sera senza mangiare altro che un poco di pane e quasi assiderandosi di freddo." There are four drawings in the Louvre by Vasari after frescoes in the Stanza della Segnatura that probably date from those visits: two after figures in the *Parnassus* (inv. 4047, 4048); and two from the *Disputa* (inv. 4046, 4049); Monbeig-Goguel, *Vasari et son temps*, p. 209. Identified by Philip Pouncey, they are discussed by Winner, "Il giudizio di Vasari sulle prime tre stanze di Raffaello in Vaticano," in *Raffaello in Vaticano*, pp. 180–2. There is a red-chalk drawing in the Uffizi after the lady carrying a vase in *Fire in the Borgo*, which Anna Maria Petrioli Tofani has attributed to Salviati and which can be associated with these visits (Uffizi 1345F, under "scuola di Raffaello").

2 Life of Raphael, BB IV, p. 213: "ritrovo che chiunche che lo imitò essersi a onesto porto ridotto."

3 Frey I, xliv, pp. 107–8 (15 December 1540): "voi vi sete portato di sorte nel foglio mandatomi, che quello, dove il veramente dolce e gratioso Raphaello disegnò simil cosa, non lo supera di tanto, che ve ne haviate a dolere." However personal, this was not a private exchange. As Vasari well knew, Aretino's letters were intended for publication. This one duly appeared in 1542 in the *Libro Secondo delle Lettere di Pietro Aretino*, pp. 334–5. Vasari's drawing is now lost. Aretino is presumably referring to the print by Agostino Veneziano after Raphael.

4 Golzio, *Raffaello nei documenti*, p. 10, for Raphael's letter of introduction from Giovanna Feltria della Rovere to the *gonfaloniere* of Florence, Piero Soderini (1 October 1504), stating that he wished to come to Florence "per imparare."

Raphael, he had been a Medici client and had contact with papal courts. Like Raphael, he had employed a number of assistants on large-scale decorative projects while continuing to produce portraits, small panels, and altarpieces. In Raphael he saw one in whom art and virtue

> combined were able to move the greatness of Julius II and the generosity of Leo X, exalted as they were in rank and dignity, to treat him as a most intimate friend and extend toward him every sort of generosity, such that by their favor and the wealth that they bestowed upon him, he was able to do great honor both to himself and to art.[5]

In the 1540s when he was writing this Life Vasari was still searching for such recognition in order to bring similar honor to himself and to his art. The immediacy of Vasari's respect and the urgency of his ambitions are registered in this Life, which is as deeply felt as it is detailed.

Sources

Vasari wrote about Raphael and his times with enviable authority. This Life is important as a record of Raphael's works, their patronage, and their provenance.[6] It determined a view of Raphael's career that divides it into distinct stylistic and topographical phases (Umbria 1494–c.1504, Florence c.1504–8, Rome 1508–20) and that emphasizes Rome. Vasari's representation of Raphael is connected to the circle that fostered Raphael's talents and his self-presentation – the papal court of the early sixteenth-century.[7] In this case Vasari's descriptive techniques are historically bound to their objects and the circumstances of their production. They originated in a culture of eloquence whose messages Raphael made pictorial and Vasari was readily able to decipher. Raphael's Life marks a key point in the development of the social identity of the artist and the definition of the creative personality. Vasari wrote about Raphael's career and his style using a vocabulary that transcribed the essential values of Raphael's self-consciously projected persona as prolific inventor and gentleman painter. Raphael was responsive to a setting where style was fashionable: styles of poetry, of prose, of behavior. These interests, indeed passions, resulted in a literature of manners and debates on imitation and expression among whose protagonists were Raphael's friends and sitters, Baldassare Castiglione, Pietro Bembo, Andrea Navagero, and Agostino Beazzano. One of the few art-historical comments made by a renaissance pope pertains to Raphael's style. Leo X remarked to Sebastiano del Piombo: " 'Look at Raphael's works,

5 Life of Raphael, BB iv, pp. 212–13: "le quali in Raffaello congiunte, potettero sforzare la grandezza di Giulio II e la generosità di Leone X, nel sommo grado e degnità che egli erono, a farselo familiarissimo e usarli ogni sorte di liberalità, talché poté col favore e con le faculta che gli diedero fare a sé et a l'arte grandissimo onore."

6 Subsequent scholarship and "scientific cataloguing" have changed the form, but not radically altered the substance or order of Raphael's painted oeuvre as chronicled by Vasari. The most significant omissions in Vasari are Raphael's small panels and numerous Virgin

and Child paintings. This is consistent with Vasari's hierarchy of genres and his criterion of noting only those things "worthy of mention" (preferring altarpieces and monumental wall paintings), as well as his access to private collections. For Raphael's oeuvre, see Dussler, *Raphael. A Critical Catalogue*. Where possible references are given to illustrations in the widely available monograph by Jones and Penny, *Raphael*.

7 Hulse, "The Circle of Raphael," in *The Rule of Art*, pp. 77–114, and Rubin, "Raphael and the Rhetoric of Art," in *Renaissance Rhetoric*, ed. Mack, pp. 165–82.

as soon as he had seen Michelangelo's he abandoned Perugino's style and came as near as possible to Michelangelo's.' "[8] Vasari's Life registers this interest; style is one of its chief themes and lessons. The other is behavior, the courteous behavior that wins favor and thereby opportunities to increase fame.

This Life can profitably be read in a number of ways. It can be read for its abundant information, whose nature and accuracy should be evaluated according to its sources, given below. It can be read to elucidate the criteria that influenced the conception and reception of Raphael's works in his lifetime. And it can be read to show how Vasari turned Raphael into a historical subject through his choice and arrangement of topics to create an image of the artist that best fit the didactic aims of *The Lives*.

The study of Raphael's works was part of Vasari's training, and the drawings he made were undoubtedly among the "records" ("ricordi") that he used when writing the Life. Marcillat's frequent borrowings from Raphael indicate that his portfolio was well stocked with prints and drawings after Raphael, which became Vasari's primer in art.[9] Vasari's curiosity about Raphael is indicated in a letter from don Miniato Pitti. Trying to entice the artist to visit him in Perugia in 1537, Pitti wrote: "And if you came . . . you would see many beautiful things by Raphael and other excellent masters."[10] Vasari managed to resist at this time, as he had no commissions to take him to Perugia and would not have been able to mix his pleasure with business. In 1534, on the other hand, the young Vasari had gone to Città di Castello in the company of Antonio da Sangallo and Pierfrancesco da Viterbo on an errand for Duke Alessandro. They also saw to the repair of a garden wall of the Vitelli palace and Vasari did drawings for its interior and exterior decorations, executed by Cristofano Gherardi.[11] He was able to see works by the young Raphael, whom he says had also gone there with some friends.[12] In the Life he writes about them in their order of execution and charts the course of Raphael's improving style in his description of them.[13] When he traveled to Bologna in 1539, he saw Raphael's painting of *St. Cecilia with Sts. Paul, John the Evangelist, Augustine, and Mary Magdalene*, then in the chapel of the Beata Elena Duglioli dall'Olio in San Giovanni in Monte. A figure in a red-chalk drawing by Vasari in the Uffizi is based on Raphael's St. Paul (pls. 142, 143).[14] Vasari's admiration for

8 Barocchi and Ristori eds., *Il carteggio di Michelangelo*, II, cdlxxiv, p. 247 (Sebastiano in Rome, 15 October 1520, to Michelangelo, Florence): " 'Guarda l'opere de Rafaelo, che come vide le hopere de Michelagniolo, subito lassò la maniera del Perosino et quanto più poteva si acostava a quella de Michelagnolo.' "

9 Marcillat's influence on Vasari's memory of the vault the Stanza d'Eliodoro has been suggested by Henry, "Letter to the Editor," *Burlington Magazine* (1990), pp. 571–2, where he notes that Vasari's misidentification of *Noah's Thanksgiving after the Flood* as *God appearing to Abraham* might be based on Marcillat's Abraham scene in the vault of Arezzo cathedral. Vasari himself turned Raphael's *God commanding Noah to build the Ark* to *God blessing Abramo's Offspring* in the vault of the Camera di Abramo in his Arezzo house.

10 Frey I, xxvii, pp. 81–2 (23 February): "Et però, quando tu uenissi qua . . . ci uedresti di molte belle cose di Raffaello et d'altri eccellenti maestri."

11 Life of Gherardi, BB V, p. 286.

12 Life of Raphael, BB IV, p. 158: "partitosi da Perugia, se n'andò con alcuni amici suoi a Città di Castello."

13 *Ibid.*, pp. 158–9: a panel in Sant'Agostino (the altarpiece of *St. Nicholas of Tolentino*, documented 1500–1, severely damaged by an earthquake in 1789, the surviving fragments are in the Museo Nazionale di Capodimonte, Naples, the Pinacoteca Tosio Martinengo, Brescia, and the Louvre, Paris); the *Crucifixion* in San Domenico (now in the National Gallery, London, datable to 1503 by an inscription on the altar stone); and the *Marriage of the Virgin* in San Francesco (pl. 154; now in the Pinacoteca di Brera, Milan, dated 1504 by an inscription on the spandrels of the arches in the temple in the background). See Jones and Penny, *Raphael*, pls. 14–17, 19, 24.

14 Uffizi 6494F; see Barocchi, *Mostra di disegni del Vasari e della sua cerchia* (Uffizi, 1954), no. 10, pl. 13.

142. Giorgio Vasari, drawing after Raphael's *St. Paul*, red chalk, 384 × 131 mm. Florence, Uffizi, 6494F.

143. Raphael, *St. Cecilia with Sts. Paul, John the Evangelist, Augustine, and Mary Magdalene*. Pinacoteca Comunale, Bologna.

this painting is registered in the full and evocative description of it in the Life.[15] His identification with Raphael is indicated by the fact that he struck the pose of the St. Paul in his pensive self-portrait at the left edge of the *Nations paying Homage to Pope Paul III* in the Cancelleria, where he positioned himself beneath Mercury, god of industry (pl. 63). While in Bologna he also learned about, and probably saw, the *Vision of Ezechiel*, then in the house of Count Vincenzo Arcolano.[16] His stay in Naples in 1544–5 gave him the opportunity to see Raphael's panel of the *Virgin and Child with the Archangel Raphael, Tobias, and St. Jerome* in the church of San Domenico.[17]

Vasari knew some of Raphael's patrons and their descendants. In 1534 don Miniato Pitti advised him to seek Duke Alessandro's intercession with the cardinal of Santi Quattro, the bishop of Pistoia, Antonio Pucci, that he might be given a commission for the cathedral at Pistoia.[18] This suit does not seem to have been successful, quite the reverse of Raphael with Antonio's uncle and predecessor, Lorenzo Pucci, "who asked Raphael as a favor to paint a panel for San Giovanni in Monte in Bologna."[19] On the other hand, one of Vasari's most ambitious early works, and certainly his highest priced, was the *Immaculate Conception* he painted for Bindo Altoviti's chapel in Santi Apostoli in 1540 (pl. 46).[20] Bindo commissioned a *Pietà* from Vasari in 1542, which he showed to Cardinal Alessandro Farnese as a means to introduce the artist to the cardinal's court.[21] Vasari says that Raphael painted Altoviti's portrait "when he was young," and that it was "considered most wonderful."[22] He describes a *Virgin and Child with St. Ann and St. John the Baptist*, in the 1550 edition located in Bindo's house in Florence, by 1568 in Duke Cosimo's possession, serving as an altarpiece "in the chapel of the new rooms built and painted" by Vasari in the Palazzo Vecchio.[23]

It was through Medici connections that Vasari was able to study the frescoes in the Vatican. It was also through his Medici connections that Vasari had precise information about the counterfeit version of Raphael's portrait of Leo X sent to Federico Gonzaga as the original. As a protégé of Ottaviano de' Medici he witnessed Andrea painting the clandestine copy. Ottaviano's heirs also owned Raphael's portraits of the dukes Lorenzo and Giuliano

This figure was to find its way into numerous compositions of the 1540s–50s: the catalogue cites the Camaldoli *Deposition* (1540), the *Nations paying Homage to Pope Paul III* in the Cancelleria (pl. 63; 1546), and the *Marriage of Esther and Ahasuerus* in Arezzo (pl. 110; 1548–9).

15 Life of Raphael, BB IV, pp. 185–7.

16 *Ibid.*, p. 187; now in the Galleria Palatina, Palazzo Pitti, Florence, see Jones and Penny, *Raphael*, pl. 203.

17 Life of Raphael, BB IV, pp. 184–5, known as the *Madonna del Pesce*, now in the Prado, Madrid, see Dussler, *Raphael. A Critical Catalogue*, pl. 85.

18 Frey I, ix, p. 26 (Pistoia, 19 January 1534, to Vasari, Florence).

19 Life of Raphael, BB IV, p. 185: Pucci "ebbe grazia con esso che egli facesse per San Giovanni in Monte di Bologna una tavola" (the *St. Cecilia*, pl. 143).

20 Description of Vasari's works, BB VI, pp. 380–1. For the numerous replicas by Vasari and other artists, see Kliemann in Arezzo 1981, pp. 103–7.

21 *Ibid.*, pp. 382–3, Frey II, p. 860, no. 129. Finished

on 4 December 1542, now lost, the composition is known from a preparatory drawing in the Louvre, Paris, see Monbeig-Goguel, *Vasari et son temps*, no. 194, pp. 150–1.

22 Life of Raphael, BB IV, p. 187: "Et a Bindo Altoviti fece il ritratto suo quando era giovane, che è tenuto stupendissimo"; now in the National Gallery, Washington, D.C., see Jones and Penny, *Raphael*, pl. 174.

23 Life of Raphael, BB IV, pp. 187–8: "il qual quadro è oggi nel palazzo del duca Cosimo nella cappella delle stanze nuove e da me fatte e dipinte, e serve per tavola dell'altare"; known as the *Madonna dell'Impannata*, now in the Galleria Palatina, Palazzo Pitti, Florence, see Dussler, *Raphael. A Critical Catalogue*, pl. 86. The identity of the two female saints at the left is disputed: the older, identified as St. Ann by Vasari, has also been called St. Elizabeth. The younger is sometimes identified as St. Catherine. For this question, see *Raffaello a Firenze*, p. 166.

de' Medici.[24] Vasari was familiar with the fate and location of other works by Raphael through such connections. He describes at length a *Holy Family* painted for Leonello da Carpi and owned by his son the Cardinal of Carpi, "a great connoisseur of painting and sculpture"; Cardinal Ridolfo Pio da Carpi had been a protector and employer of Paolo Giovio.[25] Vasari also saw the *Holy Family* painted for Domenico Canigiani, then with his heirs (pl. 150).[26] Vasari not only was able to describe the *Virgin and Child with St. John the Baptist* painted for Raphael's friend, Lorenzo Nasi, but was able to tell its dramatic history. It was smashed by a landslide in 1547, which destroyed Nasi's house. Nasi's son Battista, an amateur of art, became an amateur of restoration, putting the pieces together "in the best way he was able" (pl. 155).[27] Vasari also records two paintings done for Taddeo Taddei, "one naturally inclined to welcome" such talent. They were still to be seen in the Taddei house.[28] Vasari's account of Raphael's friendship with that merchant is corroborated by Raphael's letter to his family asking them to extend every courtesy to Taddei during his visit to Urbino.[29] This amicable state of affairs between patron and painter was an ideal relationship for Vasari, one also forwarded in his account of the portrait of Raphael's mistress, then owned by Matteo Botti. Botti was a member of a rich and influential banking family. He was *maggiordomo maggior* at Cosimo I's court. Vasari describes him in greater detail than the portrait he owned, "friend and confidant of all worthy people and especially of painters," who treasured the picture "like a sacred relic, for the love he bore for art and Raphael in particular."[30] Vasari even adds effusive praise for Matteo's brother, and his own friend in Rome, the banker Simone Botti.[31] Another painting Vasari knew from his contacts

24 Life of Raphael, BB IV, p. 189. The portrait of Giuliano is now Metropolitan Museum of Art, New York, that of Lorenzo, in the collection of Ira Spanierman, New York, see Jones and Penny, *Raphael*, pls. 172, 175.

25 Life of Raphael, BB IV, p. 185 (1550): "della pittura e scultura amator grandissimo." For Giovio, see *Lettere*, ed. Ferrero, I, nos. 47, 88. The cardinal died in 1564; Vasari accordingly changed his text in the second edition: "dee esser appresso gli eredi suoi" (BB IV, p. 185). The painting is thought to be the one known as the *Madonna del Divin' Amore*, now in the Museo Nazionale di Capodimonte, Naples, see Dussler, *Raphael. A Critical Catalogue*, pl. 104.

26 Life of Raphael, BB IV, p. 163, now in the Alte Pinakothek, Munich.

27 Life of Raphael, BB IV, pp. 160–1; called the *Madonna of the Goldfinch*, now in the Uffizi, Florence. Vasari gives two dates for the landslide: 9 August 1548 in the first edition and 17 November 1548 in the second. Milanesi notes that the disaster actually is recorded as occurring on 12 November 1547 (*Le Opere*, ed. Milanesi, IV, p. 322, n. 1). Seventeen pieces have been joined back to form the present panel, for an x-ray and discussion of the painting's condition, see *Raffaello a Firenze*, pp. 80–5.

28 Life of Raphael, BB IV, p. 160; one is identified as the painting called *Madonna of the Meadow*, in the Kunsthistorisches Museum, Vienna, see Jones and Penny, *Raphael*, pl. 43.

29 Golzio, *Raffaello nei documenti*, p. 19, to his uncle

Simone Ciarla (Florence, 21 April 1508, to Urbino): "uenendo la Tadeo Tadei . . . elquale nauemo ragionate più uolte insieme lifacine honore senza asparagnio nisuno e uoi ancora li farete careze per mio amore che liso ubligatissimo quanto che uomo che uiua."

30 Life of Raphael, BB IV, p. 190: "amico e familiare d'ogni persona virtuosa e massimamente dei pittori, tenuta da lui come reliquia per l'amore che egli porta all'arte e particularmente a Raffaello."

31 *Ibid.*, pp. 190–1: "oltra lo esser tenuto da tutti noi per uno de' più amorevoli che faccino beneficio agli uomini di queste professioni, è da me particulare tenuto e stimato per il migliore e maggiore amico che si possa per lunga esperienza aver caro, oltra al giudicio buono che egli ha e mostra nelle cose dell'arte." The painting referred to is called the *Donna Velata*, now in the Galleria Palatina, Palazzo Pitti, Florence, Jones and Penny, *Raphael*, pl. 179. For Vasari's friendship with Simone and Matteo Botti, see the letters where they are mentioned as mutual friends and contacts: Frey I, xcvi, p. 199 (Giovio in Rome, 8 July 1547, to Vasari, Florence); xcvii, p. 200 (Giovio in Rome, 2 September 1547, to Vasari, Florence); ci, p. 207 (Giovio in Rome, 5 November 1547, to Vasari, Rimini); cviii, p. 216 (don Ippolito in Monte Oliveto, 20 February 1548, to Vasari, Arezzo), and cxiii, p. 224 (Florence, 11 July 1548, to Vasari, Arezzo) from don Miniato Pitti, who comments on the good wine of the Botti household. See also cxlix, pp. 301–2 (25 February 1551, to Matteo Botti, Florence) in which Vasari (in Rome) sends his good

in Florence was a *St. John the Baptist* that Raphael painted for Cardinal Pompeo Colonna, who, Vasari says, gave it to his physician Jacopo da Carpi as the requested and desired payment for a cure. It subsequently belonged to Francesco Benintendi.[32]

Vasari was informed about Baldassare Turini and his family. Baldassare was a papal datary in Leo X's court between 1518 and 1521 and one of the executors of Raphael's will. He came to own the altarpiece commissioned by the Dei family in Florence and still unfinished when Raphael left for Rome in the autumn of 1508.[33] Turini was in Rome in the 1530s as a member of Clement VII's household and again in the early 1540s when he corresponded with Cosimo I about Baccio Bandinelli and the project for papal tombs in Santa Maria sopra Minerva.[34] Vasari might have met him there on either occasion. In Pierino da Vinci's Life he notes Pierino's commission from Turini's heirs for his tomb.[35] The family had Aretine connections. Antonio di Pietro Turini of Arezzo looked after Vasari's interests there and was one of his correspondents.[36]

Like Raphael, Vasari moved in court circles, conversing and corresponding with the learned men attached to the households of his patrons. Some had met Raphael. Pietro Aretino, for example, was attached to Agostino Chigi's household from around 1517. In the *Dialogue on Painting* Dolce quotes Aretino as saying: "You must be well aware that Raphael . . . was a very dear friend of mine."[37] Paolo Giovio came to Rome in 1512, and from 1513 was a member of Leo X's court. His Lives of Raphael and Leo X were both sources for Vasari: the first suggesting essential themes (Raphael's social and stylistic grace) and the second recording Leo's patronage, particularly of the Vatican loggia and the Sistine tapestries. Vasari's collaborator in the program of the Cancelleria frescoes, Giovio possibly guided his understanding of the subjects of the Stanze frescoes. The relations drawn between past and present moments and the emphasis on portraits in Vasari's descriptions repeats priorities of the Cancelleria cycle, and of Giovio's portrait collection.[38]

wishes to Matteo for his recent marriage. In the Life of Daniele da Volterra, BB v, p. 546, Vasari says that he found Daniele a place to live in one of Botti's properties when he came to Florence ("l'accomodò . . . in una casa di Simone Botti suo amicissimo").

32 Life of Raphael, BB iv, p. 202; now in the Uffizi, Florence, see Dussler, *Raphael. A Critical Catalogue*, pl. 100.

33 Life of Raphael, BB iv, p. 165 (1550): "e dopo la morte sua rimase a messer Baldassarre da Pescia, che la fece porre a una cappella fatta fare da lui nella Pieve di Pescia." Rephrased in the 1568 edition. The chapel architecture is described in the 1568 Life of Baccio d'Agnolo, BB iv, p. 614, as by Baccio's son, Giuliano. The painting, called the *Madonna del Baldacchino*, is now in the Galleria Palatina, Palazzo Pitti, Florence, see Jones and Penny, *Raphael*, pl. 56.

34 See Gaye, *Carteggio inedito d'artisti*, ii, pp. 286–8 (4 April 1541). See also Winner, "Il giudizio di Vasari sulle prime tre stanze di Raffaello in Vaticano," in *Raffaello in Vaticano*, p. 182.

35 Life of Pierino da Vinci, BB v, p. 235. He also knew about two paintings by Leonardo da Vinci in Pescia that Giulio Turini had inherited from Baldassare, BB iv, p. 35 (1568).

36 Frey i, xi, pp. 29–31 (December, 1534) and Degli Azzi, "Documenti Vasariani," *Il Vasari* (1931), p. 218, for the document appointing Antonio Turini his agent (*procuratore*), 3 January 1536.

37 *Dolce's "Aretino,"* ed. Roskill, p. 91 and p. 95, "Raphael used to say to me." See also Aretino's letter to Jacopo del Giallo where he claimed that Raphael, Sebastiano, and Titian paid attention to his judgment about painting ("Io non son cieco ne la pittura, anzi molte volte e Rafaello e fra' Bastiano e Tiziano si sono attenuti al giudizio mio"), *Lettere sull'arte di Pietro Aretino*, ed. Pertile and Camesasca, i, xxv, p. 45 (23 May 1537). Similar intimacy and esteem is recorded in a letter to Giovanni da Udine, cxxv, p. 198 (5 September 1541).

38 See the letters from Giovio to Cardinal Alessandro describing the progress on the project, especially the portraits, Frey i, p. 180 (8 August 1546 and 25 September): "de ritratti dal naturale io non resto anchora satisfatto." When Giovio reported to Vasari about the cardinal's reaction he said that the cardinal was content, but wished that the portraits were better, Frey i, lxxviii, p. 176 (18 December 1546): "El cardinale e restato contento . . . vorrebbe ben' li ritracti megliori." For the portraits from the Stanze, given to Giovio by Giulio Romano, see the Life of Piero della Francesca, BB iii,

Vasari collected such written records of Raphael as he could: Aretino's play *La Talanta*, Giovio's Life, epigrams, and epithets. Writings by Raphael are among the few sources specifically named for *The Lives*.[39] Some Raphael papers possibly remained with the Ghirlandaio shop. Ridolfo del Ghirlandaio probably received letters from Raphael, written when Raphael "tried in many ways" to bring him to Rome.[40] During his 1566 trip to Urbino Vasari visited Timoteo Viti's heirs and saw such letters from Raphael to Timoteo Viti urging him to come to Rome.[41] Vasari mentions an exchange of letters between the Bolognese painter Francia and Raphael.[42] Some of Raphael's papers must have been stored in the enormous cabinet that Giulio Romano opened and emptied for Vasari when he went to visit him in Mantua in 1541. Giulio, with Giovanni Francesco Penni and Perino del Vaga had inherited Raphael's possessions. Giulio's papers probably included his will or a copy of it. Vasari gives a summary of its contents.[43] He might have seen the letter to Leo X about the antiquities of Rome, which traces a history of the decline and destruction of Roman architecture and sculpture in terms similar to those he used in the preface to *The Lives*.[44] He made very little use of it in Raphael's Life, however. He does not allude to the projects for a plan of Rome or for measured drawings of all the classical remains there, whose method is elaborately described in the letter. Raphael's archeological interests are summed up in one sentence and subsumed in a general discussion of Raphael's greatness and concern to forward his art by sending draftsmen throughout Italy and as far as Greece to make drawings after the antique.[45] Perhaps most important are Raphael's analysis of different styles – *maniere* – of buildings and the association of beautiful style with grace – interests and values that Vasari applied directly to Raphael himself. Vasari was interested in the literary record of Raphael. He concluded his rapturous description of the *St. Cecilia* with a Latin verse. Unattributed, Vasari says that it was among the many poems in Latin and Italian written to honor the painting.[46] Raphael's reputation in poetry was important to Vasari; the association

pp. 259–60 (1568). Vasari's experience of papal courts was also a guide to the Stanze. In a talk given at the Courtauld Institute on 15 March 1977 John Shearman pointed out that this experience allowed him to identify the ritual features of Raphael's compositions, describing, for example, the scene of the *Coronation of Charlemagne* according to pontifical ceremony (BB IV, p. 196).

39 Letter to the artists, BB VI, p. 411.

40 Life of Ridolfo Ghirlandaio, BB V, p. 438: "cercò per molte vie."

41 Life of Timoteo Viti, BB IV, p. 267 (1568).

42 Life of Francia, BB III, p. 590: "così feciono tra loro a parole tanta amicizia, che il Francia e Raffaello si salutarono per lettere." Malvasia published a letter from Raphael to Francia (from Rome, 5 September 1508) in *Felsina pittrice* (1678). It has been given a literary gloss that separates it stylistically from Raphael's unpolished prose and it has been doubted. Charles Dempsey has made a case in favor of its authenticity, "Malvasia and the Problem of the Early Raphael and Bologna," in *Raphael Before Rome*, ed. Beck, pp. 57–72.

43 Life of Raphael, BB IV, pp. 209–10. It is also mentioned in the Life of Lorenzetto, BB IV, pp. 306–7.

44 This was pointed out by Shearman, "Raphael, Rome, and the Codex Escurialensis," *Master Drawings*

(1977), p. 138. Vasari does not seem to have made a copy of the letter or very detailed notes. While the outline of the arguments about the fate of Roman antiquities is similar, Vasari's examples are different from Raphael's. The closest case is the discussion of the styles of sculpture on the arch of Constantine, but this occurs only in the 1568 edition and the wording is also different from Raphael's text. For the letter, see Golzio, *Raffaello nei documenti*, pp. 78–92. Written with Castiglione's assistance, it is generally dated 1519. For dating, authorship, and further references see Thoenes, "La 'Lettera' a Leone X," in *Raffaello a Roma*, pp. 373–81. Vasari does not seem to have known the 1514 letter to Castiglione attributed to Raphael (see below n. 85) or the letter about the project for the Villa Madama.

45 Life of Raphael, BB IV, pp. 196–7. In the Life of Giulio Romano, BB V, p. 79, Vasari says that Giulio made sure to show him drawings made after ancient buildings, probably during these campaigns ("particolarmente tutte le piante degli edifizii antichi di Roma, di Napoli, di Pozzuolo, di Campagna, e di tutte l'altre migliori antichità . . . disegnate parte da lui e parte da altri").

46 Life of Raphael, BB IV, pp. 185–6.

of poetry and painting is an important component of this Life. Vasari quotes an epitaph by Castiglione at its conclusion, in addition to the tomb inscription by Pietro Bembo.

Vasari also collected prints after Raphael's works. He used them for both his painted and his prose compositions. Print sources explain his detailed descriptions of paintings far from his field of vision, such as the *St. Michael* sent to France in 1518 or the altarpiece of *Christ carrying the Cross* shipped to the monastery of Santa Maria dello Spasimo in Palermo.[47] The former was engraved by Agostino Veneziano; the latter by Marcantonio Raimondi, a print mentioned by Vasari in Marcantonio's Life and used for an altarpiece from his workshop showing the same subject.[48] Vasari's description of *Parnassus*, with numerous nude putti in the air collecting laurel branches and making wreaths, which are not in the fresco, is based on Marcantonio's print after a compositional drawing by Raphael (pls. 144, 145).[49] A similar reliance explains Vasari's rather syncretic interpretation of the fresco of the *School of Athens*, which he describes as "theologians reconciling philosophy and astrology with theology" (pl. 146).[50] As an instance of one of the expressive and lifelike details of the composition, he concentrates on a group whose central figure he identifies as St. Matthew. In his 1695 description of the Vatican frescoes Giovanni Bellori pointed out that Vasari was referring to a print by Agostino Veneziano done after the Pythagoras group in the lower left-hand corner of the fresco (pl. 147).[51] Instead of the pagan philosopher the print shows the Evangelist Luke, a transformation probably intended to facilitate the sale of the print as a sacred subject.[52] In neither *Parnassus* nor the *School of Athens* are the inaccuracies inappropriate. When Vasari put the Evangelists among the philosophers in the *School of Athens* the result was an explanation of the imagery of the room as a whole, as a compendium of knowledge in the service of the Church. In the case of the *Parnassus* he used poetic license in a poetic musing on Apollo's haunt, to evoke its shady and sweet air: "a wood heavily shaded with laurels in which one almost senses through their verdure the trembling of the leaves in the sweet breezes, and in the air there is a countless number of Cupids."[53] Vasari embellished Raphael's work in suitable terms. This description is an analogous experience rather than a direct account of either the painting or the print.

These confusions are revealing about Vasari's writing and research. He surely did not write the polished and intricate passages about the Stanze while standing in front of the paintings. He worked, probably in Florence, from his notes, his drawings, and his memory to create an account of the rooms. The room he calls (and that is still called) the Stanza

47 *Ibid.*, p. 199, for the *St. Michael*, now in the Louvre, Paris, Jones and Penny, *Raphael*, pl. 202; BB IV, pp. 191–2 for the *Christ carrying the Cross* (called *Lo Spasimo*), now in the Prado, Madrid, see Jones and Penny, pls. 259–60. For a useful discussion and compendium of prints after Raphael, see Massari, "Il Cinquecento," in the catalogue *Raphael Invenit*, ed. Bernini Pezzini, Massari, and Rodinò, pp. 9–18, and the subsequent entries grouped by prints after specific works and then by subject.

48 Life of Marcantonio Raimondi, BB V, p. 11. The altarpiece is now at the University of Kansas Museum of Art, Lawrence, Kansas. For an illustration see Corti, *Vasari*, p. 84.

49 Life of Raphael, BB IV, p. 170. For a discussion of

this, see Shearman, "Raphael's unexecuted projects for the Stanze," in *Walter Friedländer zum 90. Geburtstag*, ed. Kauffmann and Sauerländer, pp. 158–9, 161–3.

50 Life of Raphael, BB IV, p. 166: "una storia quando i teologi accordano la filosofia e l'astrologia con la teologia."

51 Bellori, *Descrizzione delle imagini dipinte da Raffaelle d'Urbino*, p. 15.

52 Oberhuber, *Polarität und Synthese in "Raphaels Schule von Athen,"* pp. 53–4.

53 Life of Raphael, BB IV, p. 170: "una selva ombrosissima di lauri, ne' quali si conosce per la loro verdezza quasi il tremolare delle foglie per l'aure dolcissime, e nella aria una infinità di Amori."

144. Raphael, *Parnassus*. Rome, Vatican Palace, Stanza della Segnatura.

145. Marcantonio Raimondi after Raphael, *Parnassus*. Engraving, London, British Museum, Department of Prints and Drawings.

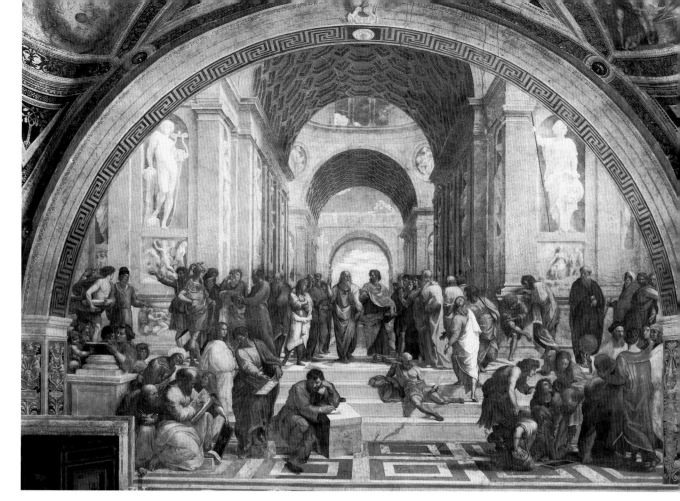

146 (above). Raphael, *School of Athens*. Rome, Vatican Palace, Stanza della Segnatura.

147. Agostino Veneziano after Raphael, *Evangelists*. London, British Museum, Department of Prints and Drawings.

della Segnatura became the site of the papal tribunal or *Signatura Gratiae* only during the pontificate of Paul III in 1541, when building works were undertaken to convert it.[54] Vasari records these works in Perino del Vaga's Life where he notes that Pope Paul ordered a chimney from the Stanza dell'Incendio (which he calls the "camera del fuoco") to be put in "that of the Segnatura" where there had been "wooden perspective panels made by the hand of the woodcarver fra Giovanni for Pope Julius II."[55] Perino del Vaga painted the socle in place of the wooden wainscoting, which was removed as Vasari describes. The room had actually been called the Camera della Tarsia. Vasari's description of the intarsia perspective panels in Raphael's Life is a tribute to famous works, which had been part of the identity of the room. Indeed, they were to remain so; the room was still called Camera della Tarsia long after their removal.[56] The panels were there when Vasari first knew the rooms in 1532. He describes them in Raphael's Life, assuming them to be contemporary with Raphael's work there for Julius II. They are actually documented to Leo X's pontificate.[57] By describing the panels without alluding to their fate Vasari created a historical reality based on his first recollection of the ensemble. It is a reconstruction and is typical of the combination of elements − memories and commemorative motives − that informs his account of Raphael and these rooms.

The surviving members of Raphael's workshop provided Vasari with his most direct links to Raphael. Giulio could have told Vasari about the workshop. Vasari used this information mainly in separate accounts of the artists who had been there: Lorenzetto, Giovanni Francesco Penni, and Pellegrino da Modena.[58] With respect to subsequent art history, Raphael's assistants are conspicuous by their absence from his Life. Giulio probably took full credit for his participation in Raphael's projects, saying that he worked after designs by Raphael in the Vatican loggia and in the Camera di Torre Borgia (now called the Stanza dell'Incendio), especially the socle, and that he did a great portion of the frescoes in the Chigi loggia, the *Holy Family* and the *St. Margaret* sent to Francis I, and all but the head of the portrait of Joanna of Aragon (also sent to France). Giulio claimed that he did architectural drawings for Raphael and major design work on the Villa Madama as well. He also said that after Raphael's death he put into execution the cartoons that Raphael had

54 Shearman, "The Vatican *Stanze*: Functions and Decorations," *Proceedings of the British Academy* (1972), p. 66, n. 41.

55 Life of Perino del Vaga, BB v, p. 150: "Fu fatto levare per ordine di papa Paolo un cammino ch'era nella camera del Fuoco, e metterlo in quella della Segnatura, dove erano le spalliere di legno in prospettiva fatte di mano de' fra' Giovanni intagliatore per papa Giulio."

56 Shearman, "The Vatican *Stanze*: Functions and Decorations," *Proceedings of the British Academy* (1972), p. 48, n. 96, cites a 1551 payment for work and a conclave plan of 1565–6. That Vasari made notes for this Life in Rome in the 1540s is substantiated by his remarks about the Chigi chapel in Santa Maria del Popolo in the Life of Raphael, BB iv, p. 201 (1550): that work was halted by the deaths of Raphael and of his patron, Agostino Chigi, that the commission was then given to Sebastiano del Piombo, and that the chapel was still closed ("Ma la morte di Raffaello, e poi quella di Agostino, fu cagione

che tal cose si desse a Sebastian Veniziano, che fino al presente la tiene coperta"). This statement dates from before Sebastiano's death in June 1547, a date given by Vasari in his biography of Sebastiano. In the Life of Raphael in the 1568 edition, Vasari eliminated the phrase about the chapel's closure. For a discussion of Vasari's sources and interpretations in his Stanze descriptions, see Winner, "Il giudizio di Vasari sulle prime tre stanze di Raffaello in Vaticano," in *Raffaello in Vaticano*, pp. 179–93.

57 Life of Raphael, BB iv, pp. 173–4. Shearman, "The Vatican *Stanze*: Functions and Decorations," *Proceedings of the British Academy* (1972), p. 48, n. 95, cites payments of 28 May and 26 June 1513 to fra Giovanni for intarsia work.

58 Life of Lorenzetto, BB iv, pp. 305–7, and the Lives of Giovanni Francesco Penni and Pellegrino da Modena, BB iv, pp. 332–3.

made for the Sala Grande (Sala di Costantino).[59] Vasari was aware of issues of workshop participation. He deliberately describes Raphael's working on the *Transfiguration* "continually" and says that "with his own hand, he brought it to its final perfection."[60] His testimony, and by inference Giulio's, should be given great weight. This is not to deny workshop intervention, but to say that by contemporary standards, by the workshop itself, the painting was regarded as Raphael's in its design and execution. The *Transfiguration* must be seen, as Vasari presents it, as Raphael's last, and not Giulio Romano's or Giovanni Francesco Penni's first, masterpiece.

Other artists, like Perino del Vaga, Antonio and Aristotile da Sangallo, Giovanni da Udine, and Ridolfo del Ghirlandaio, were able to offer direct testimony of Raphael.[61] Another of Vasari's friends, Jacopo Sansovino, had been a protégé of Bramante, who ordered a wax model of the *Laocoön* from him as part of a contest. Raphael judged Sansovino's to be the best by far. Bramante found Sansovino rooms in the Borgo Vecchio where Perugino was also lodging while working in the Torre Borgia. They became associates. Perugino commissioned some wax models from him.[62] Vasari knew a number of Perugino's Florentine students: Aristotile da Sangallo, Bacchiacca, and Niccolò Soggi. Soggi had also been in Rome during the pontificate of Leo X.[63] Ridolfo del Ghirlandaio also knew Perugino. He and Francesco Granacci, with Perugino, appraised Mariotto Albertinelli's *Annunciation* painted for the Compagnia di San Zanobi.[64] All of them could offer information about Raphael's training and early work. Ridolfo del Ghirlandaio had studied with Fra Bartolomeo, so may have been the source about the exchange of lessons in perspective and coloring made between Raphael and Fra Bartolomeo.[65] Vasari had met other friends of his amiable hero who were still alive at the time of writing the first edition, but who were included only in the second edition. He had seen Benvenuto Garofalo in Ferrara in 1540. Garofalo had gone to Rome, eager to learn, and had the good fortune to

59 Life of Giulio Romano, BB v, pp. 56–61, for these projects. See also the Life of del Sarto, BB iv, pp. 379–80, for Giulio's claim to have worked on the portrait of Leo X. In this connection it should be noted that the portrait of Bindo Altoviti, often attributed to Giulio, is not included on the list, nor anything sounding like it. The unusual aspect of this portrait is, I think, related to the influence of Sebastiano del Piombo and not to Giulio's intervention. For the attribution, see Dussler, *Raphael. A Critical Catalogue*, p. 66.

60 Life of Raphael, BB iv, p. 202: "la quale egli di sua mano continuamente lavorando ridusse ad ultima perfezzione."

61 For these artists, see: the Life of Perino del Vaga, BB v, pp. 112–15, for Perino's role among Raphael's assistants in painting the Vatican loggia; see the Life of Antonio da Sangallo, BB v, p. 33, about St. Peter's; the Life of Giovanni da Udine, BB v, pp. 447–51 (1568 only); the Life of Raphael, BB iv, pp. 159–60, about Raphael's friendship with the young painters in Florence, of whom Vasari names Ridolfo and Aristotile ("abitò in essa per alcun tempo tenendo domestichezza con giovani pittori, fra i quali furono Ridolfo Ghirlandaio et Aristotile San Gallo"). Vasari also notes that Ridolfo completed the drapery on a painting that Raphael left unfinished when

he departed for Rome (Life of Raphael, BB iv, p. 165). The painting is also mentioned in the Life of Ridolfo, as is Raphael's regard for him and desire that Ridolfo join him in Rome (BB v, p. 438). The painting has been thought to be the one known as the *Belle Jardinière* in the Louvre, Paris. Recent technical analysis disproves this identification, see Galeries nationales du Grand Palais, *Raphaël dans les collections françaises*, pp. 81–4, no. 6.

62 Life of Jacopo Sansovino, BB vi, p. 178. These included the *Deposition* now in the Victoria and Albert Museum, London. Vasari saw the wax models in the collection of Monsignor Giovanni Gaddi. He regularly sent his greetings to Sansovino in Venice in his letters to his other friends there, see Frey i, xvi, p. 48 (March 1536), to Aretino; xvii, p. 61 (28 April 1536), to Aretino; xlv, p. 109 (20 July 1541), to Francesco Leoni.

63 Soggi later settled in Arezzo, Vasari said of him: "Fra molti che furono discepoli di Pietro Perugino, niuno ve n'ebbe, dopo Raffaello da Urbino, che fusse né più studioso né più diligente di Niccolò Soggi" (Life of Soggi, BB v, p. 189).

64 Life of Albertinelli, BB iv, p. 110. See also Borgo, *The Works of Mariotto Albertinelli*, cat. no. 20, signed and dated 1510, payments July 1506–November 1511.

65 Life of Raphael, BB iv, pp. 163–4.

meet Raphael, "who, most gracious . . . taught him many things, and aways helped and favored Benvenuto."[66] Similarly, he knew the Urbinate Girolamo Genga who had studied with Perugino at the same time as Raphael and "who was a great friend of his."[67] Such testimonies probably helped to confirm the image of Raphael's affability, so important to Vasari's representation of that artist and his times. Vasari knew also Raphael's great rivals, Michelangelo and his ally Sebastiano del Piombo. Typically he turned the bitter contest between them, kept resentfully alive by both Michelangelo and Sebastiano, to good account. He makes no mention of it in Raphael's Life, where such feuds had no place. He put it instead into Sebastiano's, where their competition becomes a spur to Sebastiano's achievement, resulting in his collaboration with Michelangelo, and works that won him praise.

The 1568 Edition

Vasari supplemented this impressive number of sources when he wrote the second edition of the Life. Among the many things he saw on his tour in the spring of 1566 were paintings by Raphael in Perugia and works in the collection of the dukes of Urbino at Pesaro. These were added more or less in one block in the 1568 Life as a single interruption to Raphael's sojourn in Florence, obeying a usual correlation of chronology and geography.[68] He could have learned details about Raphael and Urbino from Timoteo Viti's heirs. Vasari's associate since the early 1550s, the sculptor Bartolomeo Ammannati was married to the poetess Laura Battiferi. She came from Urbino and her father, Giovanni Antonio Battiferri, was Raphael's friend and patron. The facade of Battiferri's Roman house was frescoed after a design by Raphael. This connection may have resulted in new information about Raphael in both Urbino and Rome.[69] Vasari seems also to have met and quizzed Perugian artists. It is probably their reaction to the altarpiece in the convent of Sant'Antonio that caused Vasari to single it out for description as being highly praised by all the painters there. This altarpiece had greatly impressed Raphael's Umbrian contemporaries and was much copied.[70] The surgical insertion of the Urbino and Perugia works into the 1550 text limits the value of the new version for constructing an accurate chronology of Raphael's early career. Vasari's previous knowledge of Raphael's oeuvre was so extensive that very few works were added to the second edition.[71] Among the most notable were the portraits of Angelo and Maddalena Doni, placed after Raphael's return from Urbino and Perugia as a transition to

66 Lives of the Lombard artists, BB v, p. 411 "il quale, come gentilissimo . . . insegnò molte cose, aiutò e favorì sempre Benvenuto." Garofalo died in 1559.

67 Life of Genga, BB v, p. 347: "che di lui era molto amico."

68 Life of Raphael, BB IV, pp. 161–3.

69 This was pointed out to me by Charles Davis.

70 Life of Raphael, BB IV, p. 162. For a discussion of the influence of the Sant'Antonio altarpiece, see Ferino Pagden, "The Early Raphael and His Umbrian Contemporaries," in Raphael before Rome, ed. Beck, pp. 98–100. For this altarpiece, whose components are divided between the Metropolitan Museum of Art, New York, the Isabella Stewart Gardner Museum, Boston, the National

Gallery, London, and Dulwich Picture Gallery, London, see Oberhuber, "The Colonna Altarpiece in the Metropolitan Museum: Problems of the Early Style of Raphael," Metropolitan Museum Journal (1978), pp. 55–91.

71 These were: two small paintings of the Virgin and Child done for Guidobaldo da Montefeltro, then in Pesaro (the painting known as the Madonna Orléans, Musée Condé, Chantilly, is sometimes identified with one of these paintings, see Dussler, Raphael. A Critical Catalogue, p. 21); also for Guidobaldo an Agony in the Garden, then owned by the Camaldolite monks in Florence, a gift from the Duchess Elisabetta da Montefeltro, now lost (for this provenance, which cor-

Florentine works. The results of Vasari's visit to Doni's heirs at the family palace, whose address he gives, were scattered throughout many Lives. Vasari had also learned about the fragments of the cartoon for the *Expulsion of Heliodorus* owned by Francesco Masini. Vasari is appreciative of both the collector and the drawing.[72] The respect for Masini can be attributed in part to Vasari's own veneration of drawings, which he was collecting in his *Libro de' disegni*. He owned sketches by Raphael for the Piccolomini library in Siena. These were cited in the 1568 Life of Pintoricchio to support his statement that Raphael made cartoons and drawings for that project.[73]

The changes that Vasari did not make in Raphael's Life are almost more interesting than those he did. So, for example, although he corrected a probable slip of the pen made in describing the Chigi frescoes, where he had once called Psyche Pandora, he did not alter other errors here.[74] The Stanze descriptions are also virtually untouched. That these remained inviolate to the critical scrutiny of both Vasari and Borghini is an indication of their stature as historical prose. The same is true of his account of the altarpiece formerly on the high altar of Santa Maria in Aracoeli in Rome. By 1565 it had been taken to Foligno, the birthplace of its donor, Sigismondo de' Conti.[75] Apparently content with his impressions of the painting, Vasari did not seek to revise them in subsequent visits to Rome or in his reconsideration of Raphael's biography.

Nor did Vasari add to his brief but comprehensive account of Raphael's architecture, in spite of the fact that Vasari's experiences had resulted in numerous additions to his treatment of architecture in the 1568 *Lives*. This is probably because Raphael's was not, for Vasari, a significant contribution to architectural history except as an instance of the many demands made upon his time and talents as a designer in the papal court. Giulio Romano, whom Vasari called both Apelles and Vitruvius in the 1550 edition, had taken credit for a portion of Raphael's architectural activity. Antonio da Sangallo, another Vitruvian paragon and associate of Raphael, seems to have been unimpressed by his architectural talents. He was responsible for repairing the loggias in the Vatican and probably for the remark that, under Raphael, the progress on St. Peter's was indifferent.[76] Vasari may well have been maintaining a discreet silence on what he viewed as a relative failure. He knew of incomplete works (the Chigi stables), rejected or relegated projects (San Lorenzo in Florence, St. Peter's), and

rects Vasari's, see Golzio, *Raffaello nei documenti*, pp. 15–16); an altarpiece for the Ansidei chapel in the Servite church of San Fiorenzo in Perugia (dated 1505, now in the National Gallery, London, Jones and Penny, *Raphael*, pl. 25); the fresco of *Christ in Glory with Six Saints* in the Camaldolite monastery of San Severo, Perugia (Jones and Penny, pl. 30); the altarpiece for the convent of Sant'Antonio; the portraits of Agnolo Doni and his wife (now in the Galleria Palatina, Palazzo Pitti, Florence, Jones and Penny, pls. 38–9). He gives fuller, more circumstantial descriptions of the commission from Atalanta Baglioni for the *Entombment* for the family chapel in San Francesco al Prato, Perugia (dated 1507; now in the Galleria Borghese, Rome, Jones and Penny, pl. 49), the subject and style of the *Coronation of the Virgin* painted for the Oddi chapel also in San Francesco, Perugia (now in the Pinacoteca Vaticana, Rome, Jones and Penny, pl.

23), and the subject and the owner's regard for the *Virgin and Child with the Young St. John the Baptist and St. Elizabeth* belonging to the Canossa counts in Verona (Vasari calls the female St. Ann; now in the Prado, Madrid, Dussler, *Raphael. A Critical Catalogue*, pl. 108).

72 Life of Raphael, BB IV, p. 182.

73 Life of Pintoricchio, BB III, pp. 571–2. See Oberhuber, "Raphael and Pintoricchio," in *Raphael before Rome*, ed. Beck, pp. 155–74.

74 Life of Raphael, BB IV, p. 200.

75 *Ibid.*, p. 171; now in the Pinacoteca Vaticana, Rome, it is called the *Madonna di Foligno*, see Jones and Penny, *Raphael*, pl. 99.

76 Life of Antonio da Sangallo, BB V, pp. 33–4: "E così in compagnia di Raffaello da Urbino si continuò quella fabbrica assai freddamente" (p. 33).

designs executed by others (Giulio Romano and Giovanni Francesco Penni and Aristotile da Sangallo).[77] The Vatican loggias, which had threatened to collapse, were examples more of courtesy than of architectural skill.[78] And perhaps more importantly, for Vasari Raphael was the perfect painter and Michelangelo alone the divine master of all the arts of design.

Vasari's activities as the grandducal decorative impresario had, however, increased his admiration for Raphael's peaceful and productive workshop. This admiration was registered mainly in Giulio Romano's Life. In Raphael's an appraisal of the role of master and assistants forms part of the long discourse on style added to its conclusion. The significant facts about the workshop – attributions and division of labor – were put into Giulio's Life. Almost completely rewritten for the second edition, Giulio was transformed from perfect courtier artist to perfect collaborator. The Raphael Life, though added to, was little changed. Its original arrangement and expressions were respected. This is a sign of the considerable effort made in writing the first edition. Vasari believed that is was the duty of those who came after Raphael "to keep a most gracious record of him in mind and always to accord him the most honored memory in one's speech."[79]

"A most gracious record"

The Raphael Life is a polished exercise in historical writing – an exemplary Life for an exemplary painter. Some Lives might have been "mere drafts" as Vasari claimed, preliminary notes intended to save artists from "dust and oblivion"[80] but Raphael scarcely needed such rescue. His contemporaries had conferred immortality upon him. The Mantuan envoy Pandolfo Pico della Mirandola reported his death to the duchess of Mantua, writing:

> And truly from what they say, every great thing was possible for him to achieve . . . On his death the heavens wished to show one of those signs they manifested on the death of Christ when "lapides scisi sunt," thus a crack opened in the pope's palace.[81]

To which she answered: "there can be no other reply except great sorrow at the death of messer Raphael, a man worthy of immortality."[82] A sense of wonder as well as loss informs accounts of his death, on the same day as his birth, which Vasari gives as Good Friday.[83]

77 For a current discussion of Raphael as an architect, see Frommel, Ray, and Tafuri eds., *Raffaello architetto*.

78 Life of Raphael, BB IV, p. 198.

79 Life of Raphael, BB IV, p. 211: "tenerne nell'animo graziosissimo ricordo e farne con la lingua sempre onoratissima memoria."

80 Conclusion, BB VI, pp. 410–11 (1550), stating that it was his sole intention to leave "questa nota, memoria o bozza," and that he had simply "questi artefici . . . tolti alla polvere et alla oblivione."

81 Golzio, *Raffaello nei documenti*, pp. 114–15 (7 April 1520): "Et in vero per quello se dice, ogni gran cosa se pottea permettere da lui . . . Di questa morte li cieli hanno voluto mostrare uno de li signi che mostrorno su

la morte del Christo quando *lapides scisi sunt*; così il palazzo del Papa si è aperto de sorte chel minaza ruina."

82 *Ibid.*, p. 126 (16 April 1520): "Alla vostra di VII non accade altra risposta se non che molto ne dole dela morte de mes. Raphaelo, homo digno de immortalità."

83 Bembo's tomb epitaph, which Vasari reproduces, says that Raphael died on the day he was born ("quo die natus est"). Vasari states that Raphael died "the same day as he was born," Good Friday ("finì il corso della vita il giorno medesimo ch'e' nacque, che fu il Venerdì Santo, d'anni XXXVII"; BB IV, p. 210). Marcantonio Michiel's diary entry instead says that he died in the night of 6 April, Good Friday, the day before his birthday ("Tra il 6 e 7 aprile 1520. Item morse Raffaello da Ur-

Raphael's immortality soon took the form of divinity. Raphael's friend, the poet Tebaldeo, wrote an epigram: "What wonder if you like Christ should perish by the light – He was the god of nature, you the God of art."[84] Transfigured like the Christ of his own painting, Raphael is represented as a figure of light and inspiration. This is the manufacture of genius. The workshop transforming traditional talent (*ingegno*) to divinity was not only Raphael's studio and its production, but its setting in the papal courts of Julius II and Leo X. The increasing artifice of Raphael's compositions was chiefly addressed to the pleasure of this refined audience, which found its aesthetic measures in classical rhetoric and poetics.[85] With his classicizing figures Raphael developed a pictorial language to meet this taste and to approach "the perfection of art," as Bembo acknowledged in the opening to the second book of his dialogue on the vernacular.[86] That good style was sweet and graceful and that beauty could be transcendent were conversational topics and stylistic premises of Raphael's circle of sponsors and patrons. That analogies from painting could illuminate the practices of eloquence in modern times as it had in ancient ones was shown by Paolo Giovio in his dialogue *De viris illustribus*, where, like Quintilian and Cicero, he used painters to demonstrate points about style, talent, training, and imitation. In this dialogue the "celebrated lights of perfect art," Leonardo, Michelangelo, and Raphael, eclipse Perugino

bino . . . Morse a hore 3 di notte di venerdì santo, venendo il sabato, giorno della sua Natività"; Golzio, *Raffaello nei documenti*, pp. 112–13). The two days had already been collapsed to one, however, in a letter from Michiel to Antonio Marsilio, dated 11 April 1520, recorded in a summary in Sanuto's diaries: "Il Venerdì Santo, di note, venendo il Sabato, a hore 3 morse . . . Raphaelo di Urbino . . . morte, havendosi invidiosa rapito il mastro giovini di anni 34, et nel suo istesso giorno natale" (Golzio, p. 113).

84 *Ibid.*, p. 119: "De Raphaele pictore/Quid mirum si qua Christus tu luce peristi?/Naturae ille Deus, tu Deus artis eras." See Ferino Pagden, "From cult images to the cult of images: the case of Raphael's altarpieces," in *The Altarpiece in the Renaissance*, ed. Humfrey and Kemp, pp. 165–89, for the veneration soon granted to Raphael's altarpieces and the legends associated with them, quoting the story of the shipwreck survival of the *Spasimo*, repeated by Vasari in a storytelling mode, "as they say" ("secondo che e' dicono"), BB iv, p. 192.

85 See, for example, Pietro Bembo's letter on imitation, part of an epistolary debate with Giovanfrancesco Pico della Mirandola dating from 1512–13, Santangelo ed., *Le epistole "De Imitatione" di Giovanfrancesco Pico della Mirandola e di Pietro Bembo*. Andrea Navagero was an editor for the Aldine press and in 1514 produced editions of Cicero, Quintilian, and Virgil. In the prefatory letters to Cicero's *De arte rhetorica* and Virgil's works Aldo Manuzio invokes Bembo as the great hope of a new Rome and likens him to Virgil. Navagero dedicated Book i of his edition of Cicero's orations to Leo X, Book ii to Bembo, and Book iii to Leo's other secretary, Jacopo Sadoleto. Sadoleto and Bembo (along with Castiglione and Tommaso Inghirami, another of

Raphael's friends and sitters) were among the members of Johannes Goritz's academy. Devotees of neo-Latin poetry, they contributed poems to the annual festivities to honor Goritz's patron saint, St. Ann, attaching them to a statue group of the Virgin and Child with St. Ann by Jacopo Sansovino beneath Raphael's fresco of Isaiah, an altar shrine in Sant'Agostino. The poems were published in 1524 in a collection, the *Coryciana* (after Goritz's Latin name, Corycius). In them Christ and the Virgin become classical gods inhabiting Olympus. It was the style mania of this set of Roman humanists that Erasmus attacked in his dialogue, the *Ciceronianus*. Raphael's complicity in these terms is documented in the 1514 letter to Castiglione written in Raphael's name, where, with deft irony, Cicero's *Orator* (iii.9–10) is paraphrased as the platonic Idea is applied to Raphael's creative procedure in painting beautiful ladies, see Golzio, *Raffaello nei documenti*, pp. 30–1, and Rubin, "Raphael and the Rhetoric of Art," in *Renaissance Rhetoric*, ed. Mack, pp. 171–2. The letter was published as by Raphael by Dolce, *Lettere di diversi eccellentiss. huomini* (1554), pp. 227–8, and again in the 1559 edition of the *Lettere*, and later by B. Pino, *Della nuova scielta di lettere di diversi nobilissimi huomini* (1574), Book ii, no. 249, pp. 400–1, and in the 1582 edition, Book ii, no. 229, pp. 443–4. Owing to its accomplished literary nature, Raphael's direct authorship has been doubted, see Cian, *Baldassar Castiglione*, p. 83, as by a common friend, but not Pietro Aretino to whom the letter has been attributed, but who was not in Rome until 1517. More recently, with bibliography, see Thoenes, "Galatea: Tentativi di Avvicinamento," in *Raffaello a Roma*, p. 66.

86 Bembo, *Prose della volgar lingua*, ed. Marti, pp. 97–8.

whose "sterility of talent" bound him to repetition of the forms he found in his youth.[87] This was a comparison Vasari accepted and developed.

Vasari relied on rhetorical contrivance to introduce Raphael to his readers. In the prologue to the Life Vasari contrasts past artists with Raphael. They had a certain madness and wildness that obscured the splendor of their virtue. To this he opposed the shining light of Raphael's spirit.[88] Praise and blame are applied historically. The past is set, in "affirmation by negation," against the present as represented by Raphael's undying glory. Raphael is here endowed with heroic virtue. Aristotle's definition of "superhuman excellence, something heroic and divine," which can make men into gods, is a key to the form Vasari gave his admiration for Raphael. The opposite state to such excellence, following Aristotle, is brutishness, and the opposition of the humane to the savage is also part of Vasari's praise.[89] This opening paragraph applies the forms of epideictic rhetoric to determined effect. Praise was meant to inspire the emulation of virtue, and "rarest virtues of the spirit" are the subject in this case.[90] Vasari's invocation is appropriately ornate, applying rhetorical devices of amplification: repetition, comparison, and affirmation by negation. Vasari's style is as lofty as his purpose. So too is the combination of ideas and ideals that contribute to lift Raphael and his career from the humble status of artisan to the exalted one of mortal god.[91] Vasari is explicit about his purpose as providing a model for imitation: "Now it is up to us who come after him to imitate the good, nay excellent manner that he left us as an example."[92] Vasari does not negate the value of past lessons. Raphael justifies Vasari's history, his glory is cumulative. It depends on "all those graces and rare gifts divided among many over a long time."[93] Vasari acknowledges the stereotype of the impractical and whimsical artist, but he puts that type before Raphael. With Raphael art and manners conquer nature and another kind of artist emerges: the modern age has a champion, one of impeccable manners, charm, and grace. The craftsman has turned courtier.

Vasari's fabrication was not a fiction. Giotto had bought country property, Raphael owned one Roman palace and had made plans to build another. At ease in the papal court, each success led to a new series of commissions. He was forced to balance ducal against papal and royal claims for his time; but he was always mindful of the obligations of friendship and produced portraits of and for his friends.[94]

87 Quoted from Zimmerman, "Paolo Giovio and the evolution of Renaissance art criticism," in *Cultural Aspects of the Italian Renaissance*, ed. Clough, p. 411.

88 Life of Raphael, BB IV, pp. 155–6.

89 The definition of heroic virtue is the subject of Book VII, chapter 1, of the *Nichomachean Ethics*. It is the opening to a discussion of incontinence, a very suggestive placement, for Vasari is here implicitly defending his hero against possible charges of sexual incontinence. Interestingly he applied a similar definition of virtue to another artist whose sexual incontinence was part of his reputation, Fra Filippo Lippi (in the opening to the 1550 edition of his Life, BB III, p. 327). In both cases Vasari literally corrupted the concept by allowing the virtue to override the vice. Aristotle opposes them, but Vasari's terms and juxtapositions are derived from the Aristotelean definition, which was both widely diffused and of current interest. For the term, its applications and implications in the Renaissance, see Weise, *L'ideale eroico*

del rinascimento, I, pp. 79–119. Heroic virtue was a topic among Florentine academicians in the 1540s, when Bernardo Segni was preparing his Italian translation and commentary of the *Ethics* (*L'Ethica d'Aristotle*, 1550). I would like to thank Nicholas Webb for discussing this with me.

90 Life of Raphael, BB IV, p. 156: "le più rare virtù dell'animo."

91 *Ibid.*: "Laonde si può dire sicuramente che coloro che sono possessori di tante rari doti quanto si videro in Raffaello da Urbino, sian non uomini semplicemente, ma . . . dèi mortali."

92 *Ibid.*, p. 211: "Ora a noi, che dopo lui siamo rimasi, resta imitare il buono, anzi ottimo modo da lui lasciatoci in esempio."

93 *Ibid.*, p. 155: "tutte quelle grazie e più rari doni che in lungo spazio di tempo [il Cielo] suol compartire fra molti individui."

94 See, for example, the correspondence document-

Raphael's combination of art and manners, his ease with the great and the good, was the introductory topic of Giovio's Life of Raphael written around 1523–7. Raphael is included among illustrious men, third of the great artists (after Leonardo and Michelangelo). He achieved this place

> by virtue of the marvelous sweetness and diligence of his biddable gifts. The great intimacy with the powerful, which he obtained by his outstanding courtesy, no less than the excellence of his works, gained him a fame such that he never lacked the opportunity to demonstrate his splendid artistry.[95]

This is a distinct contrast to Michelangelo, whom Giovio had criticized as being "rough and wild."[96] Vasari took up Giovio's implicit comparison of Michelangelo's *feritas* with Raphael's *humanitas* in favor of Raphael's manners, but he deflected Michelangelo's uncouth behavior to past generations of artists.[97] Giovio further wrote, balancing praise with blame in accord with the eulogistic form of this Life: "In all his paintings of every sort a charm was never lacking, which is interpreted as grace, although he did go sometimes to excess in articulating the muscles of the limbs when he ambitiously strove to display a force of art beyond his nature."[98] Vasari accepted the praise and turned the criticism into a virtue, making Raphael realize his own nature by not seeking to base his art on the heroic nude, but on other elements of painting.

The well-mannered Raphael was also the subject of a brief dialogue in Pietro Aretino's comedy, *La Talanta*, commissioned by the Compagnia della Calza, the Sempiterni, for their Carnival festivities in February 1542. Vasari designed the setting. It was a memorable event. Vasari wrote a long letter to Ottaviano de' Medici describing the decorations, which were admired by Vasari's friends, Jacopo Sansovino and Titian.[99] In Act iv, scene 21, two of the characters are in Santa Maria della Pace in Rome. One recalls how, when previously in Rome, he used to go to mass because of the pleasure he took in contemplating the beauty of the Sibyls painted there by Raphael. He then says how much he enjoyed Raphael's pleasant company ("affabilità") and his willingness to explain his paintings because he "was of gentle manner, noble bearing, and fine spirit."[100]

ing the duke of Ferrara's frustrated attempts to get a painting of the *Triumph of Bacchus* from Raphael, excerpted by Golzio, *Raffaello nei documenti*, pp. 53–5, 64, 66–8, 74–7, 92–8, 105–6. The duke's efforts were only cut short by Raphael's death. On 27 May 1518, for example, the agent reported that (instead of fulfilling the duke's wishes), Raphael had "fornito la opera del Chr.mo Re qualle è uno S.to Michaele cul dracone . . . et simelmente ni ha fornito un'altra per la M.ta de la Regina . . . una Nostra Dona," paintings sent by the pope to Francis I, Golzio, p. 68. Raphael did portraits of Inghirami, Castiglione, Cardinal Bibbiena, Andrea Navagero and Agostino Beazzano, and Tebaldeo.

95 Translated from Barocchi ed., *Scritti d'arte*, i, pp. 13–14: "Tertium in pictura locum Raphael Urbinas mira docilis ingenii suavitate atque solertia adeptus est. Is multa familiaritate potentium, quam omnibus humanitatis officiis comparavit, non minus quam nobilitate operum inclaruit adeo, ut numquam illi

occasio illustris defuerit ostantandae artis." See pp. 1098–101 for the date and further literature.

96 *Ibid.*, p. 12: "agrestis ac ferus."

97 It is specifically referred to Piero di Cosimo, who serves as counter-example to Raphael. For Piero di Cosimo and Vasari, see Fermor, *Piero di Cosimo*, pp. 13–40.

98 Barocchi ed., *Scritti d'arte*, i, p. 15: "Caeterum in toto picturae genere numquam eius operi venustas defuit, quam gratiam interpretantur; quamquam in educendis membrorum toris aliquando nimius fuerit, quum vim artis supra naturam ambitiosius ostendere conaretur."

99 Frey i, xlvii, pp. 111–16 (February 1542).

100 Aretino, *La Talanta*, Act iv, scene xxi, *Tutte le commedie*, p. 432: "elle sono di mano di Raffaello d'Urbino, con l'affabilità del quale tenni strettissima conversazione, perocché egli, che era gentile di maniere, nobile di presenza e bello di spirito, aveva gran piacere nel mostrarmi de le sue opere." For a period definition

Both Giovio's praise and Aretino's speech are echoed in Vasari's prologue describing

the no less excellent than gracious Raphael Sanzio of Urbino, who was endowed by nature with all that modesty and goodness customary in those who possess to an unusual degree a humane and gentle nature adorned with gracious affability, who always showed himself sweet and pleasant with persons of all rank and in all circumstances. Thus nature gave him to the world having been conquered by art at the hand of Michelangelo Buonarroti and desirous of being conquered by both art and manners through Raphael.[101]

Vasari, following Giovio and Aretino, compounded his Raphael out of the qualities that were the quintessential characteristics of the civilized man, the *uomo civile*: modesty, goodness, humanity. From these were held to follow all the virtues of ordered society and civilized existence, and all excellence of achievement.

In his book *The Courtier* Baldassare Castiglione describes don Ippolito da Este as an example of one of those not born, but fashioned by some god and "adorned with every advantage of mind and body," who easily reach the peak of excellence; among his innate abilities and his "ornaments" was that, "in conversation with all kinds of men and women . . . he retains a certain sweetness and such gracious manners, so that everyone who speaks to, or sees him, has to feel forever inspired with affection for him."[102] Castiglione's perfect courtier must have

a certain grace and, as one says, a temperament, that makes him welcome [*grato*] and likeable at first sight to whoever sees him, and this should be a mark of distinction that affects and accompanies all his actions, and he should promise in his aspect to be worthy of any great lord's company and grace.[103]

Raphael's affability was similarly full of grace ("graziata"), and as with Castiglione's courtier, his grace found grace.[104] This was an effect of both his exemplary behavior and his exemplary painting. Works like the *St. Cecilia* (pl. 143) show "how much grace joined with

of affability and the pleasure of conversing and consorting with the affable (who are "garbati, accorti, gentili & cortesi" as opposed to "rozzo"), see Bartoli, *Ragionamenti accademici*, fol. 59v. For affability as a programmatic virtue and its relation to courtesy, see further C. Davis, "Frescoes by Vasari for Sforza Almeni," *Mitteilungen des Kunsthistorischen Institutes in Florenz* (1980), p. 157.

101 Life of Raphael, BB IV, p. 155: "non meno eccellente che grazioso Raffael Sanzio da Urbino; il quale fu dalla natura dotato di tutta quella modestia e bontà che suole alcuna volta vedersi in coloro che più degl'altri hanno a una certa umanità di natura gentile aggiunto un ornamento bellissimo d'una graziata affabilità, che sempre suol mostrarsi dolce e piacevole con ogni sorte di persone et in qualunque maniera di cose. Di costui fece dono al mondo la natura quando, vinta dall'arte per mano di Michelagnolo Buonarroti, volle in Raffaello esser vinta dall'arte e dai costumi insieme."

102 *Cortegiano*, ed. Cian, Book i, chapter 14, pp. 40–1: "che par che non siano nati, ma che un qualche dio

con le proprie mani formati gli abbia, ed ornati di tutti i beni dell'animo e del corpo . . . nel conversare con omini e con donne d'ogni qualità . . . tiene una certa dolcezza e così graziosi costumi, che forza è che ciascun che gli parla o pur lo vede gli resti perpetuatamente affezionato."

103 *Ibid.*, pp. 41–2: "una certa grazia e, come se dice, un sangue, che lo faccia al primo aspetto a chiunque lo vede grato ed amabile, e sia questo un ornamento che componga e compagni tutte le operazioni sue, e prometta nella fronte quel tale esser degno del commercio e grazia d'ogni gran signore."

104 Life of Raphael, BB IV, p. 155, for his "graziata affabilità," and pp. 211–12, for his exemplary way of dealing with men of all stations, with his fellow artists, and his success with great patrons, like Pope Julius II and Pope Leo X. For the property of grace to generate grace, see Saccone, " 'Grazia, Sprezzatura, Affettazione,' " in *Castiglione: The Ideal and the Real in Renaissance Culture*, ed. Hanning and Rosand, pp. 45–68.

art can achieve through Raphael's most delicate hands."[105] Here grace is an empowering force and a life-giving quality that makes poses and expressions convincing and attractive.

Raphael's grace is a key to his character, his success, and his art. The gracious Raphael was a modern equivalent to the charming Apelles, who was also pleasing company and therefore agreeable to Alexander the Great.[106] And like Apelles, Raphael's talent was manifested in the grace of his works. Pliny says that Apelles' art was unrivaled for "graceful charm" – "venustas" – which Quintilian labeled "gratia" in his description of Apelles.[107] When Giovio interpreted *venustas* as *gratia* in his Life of Raphael, he was glossing Pliny with Quintilian. In the classical critical vocabulary of Pliny and Quintilian grace was related to softness, its opposites were hard, harsh, and dry. Vasari applied the latter terms to artists of the second age, including Raphael's teacher, Perugino. With the third era came softness, the illusion of fully rounded forms, easy movement, and the fluid gestures that were constituents of Raphael's grace. But there were other connotations and Vasari accepted and exploited the full range of applications of grace and its variants. Held to be a quality of both art and manners, it was linked with beauty as both a moral and aesthetic ideal.

The literature of love, itself a courtly production, argued that beauty inspired love and defined beauty in terms of grace. Writings such as Bembo's dialogue on love, the *Asolani* (1505), the discourse given to him in Book iv of *The Courtier* (1516–18, published 1528), Agostino Nifo's *De pulchro et amore* (1531), Benedetto Varchi's book on beauty and grace (*Libro di beltà e grazia*, 1543), and Antonio Brucioli's dialogue on the same subject (in his *Dialogi della morale philosophia*, dedicated to Ottaviano de' Medici, 1544) represent the genre and give a genealogy of argument on the subject from Raphael's circle of acquaintances to Vasari's. When Vasari said that Raphael's pictures were loved for their beauty, as Cardinal Colonna's *St. John the Baptist*, he was making a simple statement with profound resonance.[108] Implied in this love-inspiring grace is a harmonious arrangement of parts and a level of idealization that corresponds to spiritual essence, to the Platonic idea. Paintings and painter are imbued with divinity.

When Vasari wrote of the brightness and splendor of Raphael's virtues or of the bright splendor of the light emanating from Christ in the *Transfiguration*, he was employing a language that is distinctly Neoplatonic.[109] These are the terms, for example, of Marsilio Ficino's explanation of universal love in his treatise on Plato's *Symposium*.[110] The connection

105 Life of Raphael, BB IV, p. 185: "quanto la grazia nelle delicatissime mani di Raffaello potesse insieme con l'arte." For a related term applied to this painting, *leggiadria*, see Fermor, "On the Description of Movement in Vasari's Lives," in *Kunst, Musik, Schauspiel*, II, pp. 15–21.

106 *N.H.*, xxxv.xxxvi.85, pp. 324, 325; *Historia Naturale*, trans. Landino (1543), p. 865: "Era piaceuole nel parlare, il perche era grato ad Alessandro Magno." He was also kind to his followers ("benigno inuerso e sua emoli," p. 865 [864]), as was Raphael according to Vasari (Life of Raphael, BB IV, p. 212).

107 *N.H.*, xxxv.xxxvi.79, pp. 318, 319, and *I.O.*, XII.x.6, vol. IV, pp. 452, 453. Pliny, *Historia Naturale*, trans. Landino (1543), p. 863: "Fu eccellente la sua venusta nell'arte sua, & nella eta sua furono eccellenti

pittori, equali sommamente lodo. Ma disse mancare loro una certa venusta, laquale e Greci chiamano Charis, benche hauessino tutte l'altre cose, & in questo nessuno essere pari allui."

108 Life of Raphael, BB IV, p. 202: "Fece al cardinale Colonna un San Giovanni in tela, il quale portandogli per la bellezza sua grandissimo amore."

109 *Ibid.*, p. 156, of Raphael's virtues, where Vasari writes of "la chiarezza e splendore di quelle virtù che fanno gli uomini immortali," and how in Raphael nature "facesse chiaramente risplendere tutte le più rare virtù dell'animo." The terms used to describe the light in the *Transfiguration* are "chiarezza di splendore" (p. 204).

110 *El libro dell'Amore*, ed. Niccoli, Book v, chapter 4, "Che la bellezza è lo splendore del volto di Dio," pp. 85–7.

between Raphael's character, his person, and his paintings can be related to Ficino's reasoning:

> One perfection is interior, another exterior. The interior we call goodness: the exterior, beauty. Therefore that which is completely good and beautiful we call most blessed as being perfect in each part . . . and the virtue of the mind outwardly displays a certain spiritual rectitude in words, actions, and in most honest deeds. In all these things the interior perfection produces the perfection on the exterior: and the former we call goodness and the latter, beauty.[111]

Vasari need not have been a philosopher to find out about such ideas or their association with courtly behavior. Ficino's thought had already permeated polite society.[112] In fact, it had its place in impolite society, or at least kept company with comic characters. The figure of Plataristotile in Aretino's play *The Philosopher* is compounded of philosophical commonplaces, freely garbled by this pseudo-sage. Such satire suggests familiarity. Neoplatonic notions of love and beauty were fundamental to popular writings on ladies and love. This was a literature that related courtesy, gentility, and beauty and that, in the most widely diffused form, reflected on the range of behavior from bestiality – *feritas*, Vasari's *salvatichezza* – to humanity and divinity.[113]

Ficino's ideas were a current topic of interest among Vasari's friends in Florence. Cosimo Bartoli published Ficino's text in Italian in 1544. Vasari may not have understood the nuances of Neoplatonism or penetrated the subtleties of Plato's or Plotinus's teachings, but he certainly had a command of their language as translated into contemporary philosophizing about spiritual and physical grace. He used what he understood and took to be valid in order to explain and to dignify artistic personality. He was very deliberate in his reference to such concepts, reserving philosophical ideals of spiritual perfection for the age of artistic perfection.

Just as Raphael had accumulated gifts, Vasari accumulated sources to give authority to his characterization of both the artist and his works. He referred to Giovio, Aretino, and Pliny. He evoked hagiography, playing on Raphael's family name – Sanzio – and gave him saintly traits. A latterday St. Francis, Raphael was overflowing with charity and goodness and was beloved by animals as well as men.[114] As the model artist Raphael is also endowed with the qualities of the model courtiers and orators of the literature of exemplarity. The civilized/*civile* Raphael is also a "good man," like the perfect orator of Cicero's and Quintilian's treatises and their renaissance derivatives like Giovanmaria Memmo's *L'oratore*

111 *Ibid.*, Book v, chapter 1, pp. 75–6: "Alcuna perfectione è interiore, alcuna exteriore. La interiore chiamiamo bontà, la exteriore bellezza. E però, quello che è in tutto buono e bello chiamiamo beatissimo, come da ogni parte perfecto . . . e la virtù dell'animo dimostra di fuori uno certo ornamento nelle parole e gesti e opere honestissimo . . . In tutte queste cose la perfectione di dentro produce la perfectione di fuori, e quella chiamiamo bontà, e questa bellezza."

112 See *Marcel Ficin. Commentaire sur le Banquet de Platon*, trans. Marcel, for the diffusion of Ficino's ideas in treatises on love. See also Garin's essay on "Platonismo e filosofia dell'amore," in *L'umanesimo italiano*, pp. 133–55.

113 Life of Raphael, BB iv, p. 155, for Vasari's comment about artists before Raphael's time: "la maggior parte degl'artefici stati insino allora si avevano dalla natura recato un certo che di pazzia e di salvatichezza." For the literature of love and manners, see Crane, *Italian Social Customs of the Sixteenth Century*, pp. 138–41, and Pozzi ed., *Trattati d'amore del Cinquecento*, pp. lv–lix, for further references.

114 Life of Raphael, BB iv, p. 212: "[la] sua buona natura . . . era sì piena di gentilezza e sì colma di carità, che egli si vedeva che fino agli animali l'onoravano nonché gli uomini."

(1545). This was fitting, as much of Raphael's Life is given over to a demonstration of his visual eloquence. Furthermore, in the prescriptive texts that are Vasari subtexts here – discussions of civil life, courtiership, oratory – it is frequently argued that although talent and grace are gifts of nature that cannot be taught, they can be improved through diligence and study. This, too, is a theme of the Raphael Life.

An Essay on Education

The notion that accumulated gifts bestow immortality occurs in Plutarch's *Moralia* in the *Essay on the Education of Children*. Plutarch says that it is a "token of divine love if ever a heavenly power has bestowed all the qualities needed to produce perfectly right action": nature, reason (the act of learning), and habit (constant practice).[115] Plutarch also wrote that the concurrence of these qualities "formed a perfect union in the souls of . . . all who have attained an ever-living fame."[116] Plutarch's *Essay on Education* is important in considering Vasari's editorial bias in this Life. His new Apelles was made, not born: made by studying the old and modern masters. "More than any" of those preceding him in Part 3, Raphael

> studied the labors of the old and the new masters and took the best from all, and, having assembled these things, he enriched the art of painting with the same complete perfection that in ancient times the figures of Apelles and Zeuxis possessed, and more, if one could describe and show his and their work together for comparison.[117]

Raphael's career marks the definitive passage from the second to the third age. The idea of acquisition and development of style is fundamental to this Life and its placement in *The Lives*. The concluding Life of the second period in the 1550 edition was Perugino's. Perugino went to Florence, an artistic milieu vividly characterized in that Life. He encountered Michelangelo, who called him "awkward in art."[118] According to Vasari, unlike his brilliant pupil Raphael, he was unable to learn. He failed to understand the new ideas and so died in Umbrian obscurity. Perugino's Life is preceded by Francia's, the artist who died of dismay, Vasari says, overwhelmed at seeing Raphael's painting of *St. Cecilia* when he unwrapped it upon its arrival in Bologna.[119] The first painters of the third age are described as artists who were able to surpass their masters, but who often, even given golden opportunities of talent and education, failed to realize their advantages. Instead they subverted their talents through unreasonable behavior.[120]

Raphael, the model painter, is also the model student. Vasari's account of Raphael's birth, nurturing, and apprenticeship refers to ideals common to all the standard works on

115 *Moralia*, trans. Babbitt, 1.2, vol. 1, pp. 8, 9. Plutarch's essay was fundamental to much of humanist educational theory. Absorbed, quoted, and paraphrased in fifteenth and sixteenth century texts, it was published in Latin editions and Italian versions. Page references are given here to *Alcuni opusculeti de le cose morali del divino Plutarco* (1543), fol. 113v, for the text quoted above.

116 *Moralia*, trans. Babbitt, 1.2, vol. 1, pp. 8, 9; *Opusculetti* (1543), fol. 113v.

117 Preface to Part 3, BB IV, pp. 8–9: "il quale studiando le fatiche de' maestri vecchi e quelle de'

moderni, prese da tutti il meglio, e fattone raccolta, arrichì l'arte della pittura di quella intera perfezzione che ebbero anticamente le figure d'Apelle e di Zeusi, e più, se si potessi dire o mostrare l'opere di quelli a questo paragone."

118 Life of Perugino, BB III, p. 608: "Michele Agnolo in publico gli dicesse ch'egli era goffo nell'arte."

119 Life of Francia, BB III, pp. 590–1.

120 For the organization of the beginning of Part 3, see Riccò, *Vasari scrittore*, pp. 87–104.

education, notably Plutarch's essay, Quintilian's book on the study of oratory (*Institutio Oratoria*), and the writings based on them, such as those by Mafeo Vegio, Pier Paolo Vergerio, Matteo Palmieri, Leon Battista Alberti, and Antonio Brucioli.[121] Vasari's adaptation of such educational ideals not only provided a prestigious model for the artist's training but had the important corollary of associating it with the liberal arts, since Villani the traditional way of enhancing the status of the profession. These ideals also reinforced the moral and professional messages of Vasari's biography, for education was believed to lead to moral excellence. Plutarch had written that it was

> good education and proper training . . . which leads on and helps towards moral excellence and towards happiness. And, in comparison with this, all other advantages are human and trivial. Good birth is a fine thing, but it is an advantage which must be credited to one's ancestors . . . learning, of all things in this world is alone immortal and divine.[122]

Raphael's saintly character may have been innate, but his immortality was a result of study.

With this in mind, what is the substance of Vasari's account? Raphael, born in the famous city of Urbino, was nursed by his mother and taught by his father, Giovanni Santi, a painter who destined his son to painting and was eager to give him every advantage. The talented young boy collaborated with his father, who, recognizing his own limitations decided to place Raphael with the master held to be among the best of his day, the highly praised Perugino. Santi went to Perugia to meet the artist. Perugino was in Rome, so he waited, doing some works in the church of San Francesco. Upon his return Perugino accepted Raphael as his pupil. Vasari concludes his account with a joyful father, a tearful mother, and a brilliant student matched with a good master. If taken as fact, this means that Raphael would have been apprenticed to Perugino around 1493–4. Giovanni Santi died in August 1494. But Giovanni Santi is not recorded as having worked in San Francesco in Perugia and Raphael's mother died in October 1491. His litigious stepmother is hardly likely to have wept.

All the educational treatises stress the duty of the father to attend to the education and proper upbringing of his child from birth. For Vergerio, who was citing a commonplace, a splendid birthplace and a noble and decorous name were considered essential, hence Vasari's emphasis on Urbino's fame and Santi's choice of a well-augured name:

> Raphael . . . was born in Urbino, a most important city of Italy, in the year 1483, on Good Friday at the third hour of the night to one Giovanni Santi, a painter of no great merit, but a man of fine talent and one well able to direct his children along that good path that, owing to his own bad fortune, he had not been shown in his youth. On the birth of his son, whom he named Raphael as a sign of hope for the future, Giovanni, knowing how important it was for children to have their own mother's milk and not that of a wetnurse, wished . . . that his mother nurse him, so that in his tender years he would

121 See Müller, *Bildung und Erziehung im Humanismus der Italienischen Renaissance*. See also Garin, *L'educazione in Europa 1400/1600*, pp. 109–48, and, for a selection of texts, his *Educazione umanistica in Italia*. See also Woodward, *Studies in Education in the Age of the Renaissance 1400–1600*.

122 *Moralia*, trans. Babbitt, 1.5, vol. 1, pp. 24, 25; *Opusculetti* (1543), fols. 118r–v.

learn at home the manners of his equals rather than the less genteel and loutish manners and habits of ill-bred and common men in their houses.[123]

In this account Vasari also heeds the conventions of panegyric alluding to the external circumstances of fortune and descent, before going on to that of education showing that Raphael "was well and honourably trained in worthy studies throughout his boyhood."[124] Vasari uses the device of repetition ("Venerdì Santo," "d'un Giovanni de' Santi") to bring out the saintly origins of Raphael's "saintly habits."[125] This blessed son, given the name of an archangel, he says was nursed by his mother and not by a wet nurse. Perhaps this is an accurate picture of domestic bliss in the Santi household, but it is also a prescription found in Plutarch and elsewhere.[126] Vasari's remarks on the good habits of the Santi home reflect the importance given in all the treatises to the choice of early associates and formation of character. His account of Raphael's inclination to art and his early activity as a painter echoes the general concern that the father should observe the natural bent of the child and keep him gainfully occupied. When the child passed the nursery stage it was up to the dutiful father to choose the best possible master for his son and to be on friendly terms with the teacher so as to "make his teaching not a duty but a labor of love."[127] This explains the importance of Giovanni Santi's trip to meet Perugino. The skillful master, in turn, was attentive to his young pupil's ability and character, just as Vasari describes Perugino judging Raphael's drawing, manners, and habits.[128] A model pupil, like Raphael, was a ready imitator and an affectionate student who reciprocated the master's love – tangibly in the case of Raphael and Perugino. According to Vasari, Raphael preserved Perugino's frescoes on the vault of the Stanza dell'Incendio in the Vatican because "he did not want to destroy them on account of his memory and his affection for him, as [Perugino] had been the origin of the position that he held in that field of excellence."[129]

The passage on Raphael's early years is not a simple or even a complex series of references to treatises on education. Vasari was not quoting from handbooks, but alluding to widely held views on proper instruction and its benefits. His representation of Raphael's early years applies those ideas to what he had learned about Raphael's apprenticeship in order to fashion a historical account, one that would serve the profession. That some of the details were

123 Life of Raphael, BB IV, pp. 156–7: "Nacque . . . Raffaello in Urbino, città notissima in Italia, l'anno 1483, in Venerdì Santo a ore tre di notte, d'un Giovanni de' Santi, pittore non molto eccellente, ma sì bene uomo di buono ingegno et atto a indirizzare i figliuoli per quella buona via che a lui, per mala fortuna sua, non era stata mostra nella sua gioventù. E perché sapeva Giovanni quanto importi allevare i figliuoli non con il latte delle balie ma delle proprie madri, nato che gli fu Raffaello, al quale così pose nome al battesimo con buono augurio, volle . . . che la propria madre lo allattasse, e che più tosto ne' teneri anni aparasse in casa i costumi paterni che per le case de' villani e plebei uomini men gentili o rozzi costumi e creanze."

124 Ad H., III.vi.10, pp. 174–5, and vii.13, pp. 180, 181.

125 Life of Raphael, BB IV, p. 213, for his "costumi santi." In the 1568 edition Raphael's birth ('Nascita di Raffael d'Urbino"), is an entry in the index of the most noteworthy things (tavola delle cose più notabili).

126 Moralia, trans. Babbitt, I.5, vol. I, pp. 12–14; Opusculetti (1543), fol. 115r, and, for example, Alberti, I Libri della Famiglia, ed. Romano and Tenenti, p. 44, Palmieri, Della vita civile, ed. Belloni, pp. 17–20, and Brucioli, "Del modo dello instruire i figliuoli," in Dialogi, ed. Landi, p. 75.

127 I.O., I.ii.15, vol. I, pp. 46, 47.

128 Life of Raphael, BB IV, p. 158: "Pietro, veduto la maniera del disegnare di Raffaello e le belle maniere e' costumi, ne fe' quel giudizio che poi il tempo dimostrò verissimo con gl'effetti."

129 Ibid., p. 196: "non la volse guastar per la memoria sua e per l'affezzione ch'e' gli portava, sendo stato principio del grado che egli teneva in tal virtù," and I.O., II.ix.1, vol. I, pp. 270, 271, for the reciprocal love and duties of master and student.

manufactured according to the logic and demands of those theories is confirmed by their omission in the 1568 edition, which keeps the outline and the sense of the account while being less specific about the nursery. In preparing the first edition Vasari was unfamiliar with Perugia. In spite of don Miniato Pitti's desire to tempt him there in 1537 using Raphael's works as the bait, Vasari apparently resisted until much later. His knowledge of Perugino, for example, seems to have come mainly from Florentine sources: his 1550 Life includes almost no works in Perugia. Vasari's contacts at the time were with Perugino's Florentine students and associates, Niccolò Soggi, Bacchiacca, and Ridolfo del Ghirlandaio. While this may have left Vasari ignorant of details of Raphael's works in Perugia, such contacts could have offered him information about Raphael in Perugino's shop. And, of course, Vasari could have asked Giulio Romano about Raphael's training. In the first edition Vasari says at least four times that Perugino was Raphael's teacher (in the Lives of Pintoricchio, Perugino, and Soggi as well as Raphael's). He had no doubts. Nor should we. However, his account cannot be taken as evidence for the date and duration of Raphael's apprenticeship, conflating as it does second-hand information with moralizing purpose. Where he is specific about this, he is inaccurate.

It is possible that the kernel of truth about a contact between Giovanni Santi and Perugino relates not to San Francesco in Perugia, but the Franciscan church in Fano, Santa Maria Nuova, for which Giovanni Santi and Perugino both produced altarpieces. Perugino is documented as working in Fano and receiving commissions for paintings there between 1488 and 1490.[130] He painted an altarpiece with a Virgin and Child enthroned. Commissioned in 1488, but completed only in 1497 according to an inscription on the step at the base of the throne, this work influenced both Giovanni and his son Raphael. Perugino's Virgin is nearly identical to one that Giovanni made the centerpiece of a fresco in the Tiranni chapel in the church of San Domenico at Cagli.[131] And the *Presentation* and *Annunciation* panels of predella of Raphael's altar of the *Coronation of the Virgin* painted for San Francesco in Perugia around 1503 are variations and improvements on Perugino's compositions, showing exactly how the young painter both imitated and surpassed the older master (pls. 148, 149). The predella panels of Perugino's altar have, in fact, been attributed to the (very) young Raphael.[132] In their renovations of the church at Fano, the Franciscans had also commissioned altarpieces of the *Annunciation* from Perugino and the *Visitation* from Giovanni Santi.[133] It is possible that during the late 1480s Giovanni Santi and Perugino were in contact in Fano. Giovanni registered his respect for Perugino in his rhymed chronicle, written around 1493, where he pairs him with Leonardo da Vinci:

130 Battistelli, "Notizie e documenti sull'attività del Perugino a Fano," *Antichità viva* (1974), no. 5, pp. 65–8, who publishes a contract dated 21 April 1488 for the altarpiece of the *Virgin and Child with Saints* in Santa Maria Nuova in Fano, and Canuti, *Il Perugino*, II, docs. 147–8, 154. See also Becherucci, "Il Vasari e gl'inizi di Raffaello," in *Atti* 1974, pp. 179–95, for an analysis of Vasari's account, p. 188, 190–1, for Fano as the point of contact between Giovanni Santi and Perugino.

131 Dubos, *Giovanni Santi*, pp. 101–2, pls. XVII,

XVIII, and Becherucci, "Il Vasari e gl'inizi di Raffaello," in *Atti* 1974, p. 188.

132 See the entry on the drawing for the *Nativity of the Virgin* for Perugino's predella in Ferino Pagden, *Disegni umbri del Rinascimento da Perugino a Raffaello* (Uffizi, 1982), no. 47, pp. 74–8, for a consideration of this question, and convincing arguments in favor of Perugino's authorship.

133 Dubos, *Giovanni Santi*, pp. 98–9, pl. XIII.

148. Perugino, *Presentation in the Temple*, predella panel from the Fano altarpiece. Urbino, Galleria Nazionale delle Marche.

149. Raphael, *Presentation in the Temple*, predella panel from the Oddi *Coronation of the Virgin*: Rome, Pinacoteca Vaticana.

> Two young men like in fame and years—
> Leonardo da Vinci and Pietro Perugino
> Of Pieve, a divine painter.[134]

There are two churches dedicated to San Francesco in Perugia, San Francesco al Monte and

134 Translation from Baxandall, *Painting and Experience*, p. 114.

San Francesco al Prato. While Giovanni Santi does not seem to have worked in either, Perugino supplied more than one work for both.[135] And the Franciscan foundations in Perugia were to figure largely in Raphael's early career. The Oddi *Coronation of the Virgin* and Baglione *Entombment* were painted for chapels in San Francesco al Prato. The nuns of the convent of Monteluce were Franciscans, as were the nuns of Sant'Antonio. Vasari associated San Francesco in Perugia with Raphael's first work, writing in the first edition that people could not tell the difference between his works and Perugino's, citing as evidence "some figures that can be seen among Pietro's in San Francesco."[136] In the 1568 edition, the painting is identified as Raphael's own, the *Coronation of the Virgin* painted for Maddalena degli Oddi. It is also the case that Perugino returned to Umbria from Rome, where he had been from 1491 to 1493. Vasari probably combined what he had heard of these scattered events and commissions in order to make one historical narrative bringing Giovanni Santi, his son, and Perugino together at San Francesco in Perugia. The moral message made sense of the information he had and made what he could say true and suitable to the didactic purposes of this Life in particular and *The Lives* in general.

The Studious Master

In Vasari's biography, Raphael's life follows the course of conventional wisdom that natural gifts must be "cultivated by skillful teaching, persistent study, and continuous and extensive practice."[137] Raphael moves from Perugia to Florence and Rome, graduating from able assistant to head of a school – first imitating, then surpassing his master, continually studying, continually working, looking at old and new masters, the antique, and above all, Michelangelo, in order to perfect his style as he advanced his career. The progressive achievements of Raphael's art are commemorated by Vasari in the numerous detailed descriptions in the Life. The works dominate the Life. There are very few anecdotes, but there are an abundance, variety, beauty, and invention of description intended, I think, to match those qualities that Vasari found in Raphael's paintings.

To Vasari, whereas "other paintings might be called paintings, those of Raphael are living things; the flesh quivers, the figures breathe, their pulses beat, and they are utterly true to life."[138] Raphael's artistry transcends technique. Almost ghoulishly and certainly remarkably, with respect to the Canigiani *Holy Family* he observes that "each stroke of color in the heads, the hands, and the feet is a brushstroke of flesh rather than paint" (pls. 150, 151).[139] The material becomes miracle. He remarks of the figures in the *Parnassus* how "through the imperfect medium of colors human ingenuity can make things painted appear

135 See Castellenata and Camesasca, *L'opera completa del Perugino*, nos. 77, 96, two altars for San Francesco al Prato, and nos. 76, 91, frescoes and an altar for San Francesco al Monte.

136 Life of Raphael, BB IV, p. 158 (1550): "fra le cose sue e di Pietro non si sapeva certo discernere, come apertamente mostrano ancora in S. Francesco di Perugia alcune figure che si veggono fra quelle di Pietro."

137 *I.O.*, I.i.27, vol. I, pp. 18, 19.

138 Life of Raphael, BB IV, p. 186 (of the *St. Cecilia* altarpiece): "E nel vero che l'altre pitture, pitture nominare si possono, ma quelle di Raffaello cose vive, perché trema la carne, vedesi lo spirito, battono i sensi alle figure sue e vivacità viva vi si scorge."

139 *Ibid.*, p. 163: "ogni colpo di colore nelle teste, nelli mani e ne' piedi sono anzi pennellate di carne che tinta di maestro che faccia quell'arte."

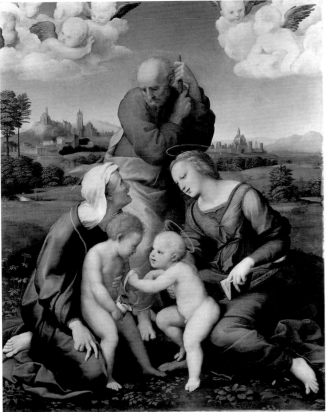

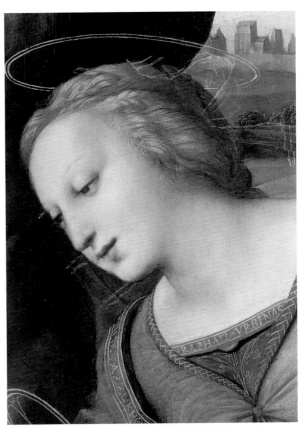

150. Raphael, *Canigiani Holy Family*. Munich, Alte Pinakothek.

151. Raphael, *Canigiani Holy Family* (detail). Munich, Alte Pinakothek.

alive through the excellence of design."[140] Their beauty has the "breath of divinity."[141] The painter is conqueror and god: his colors vanquish nature to produce living forms. These masculine metaphors of creativity that Vasari applied to Raphael became central to the modern conception of artistic genius.

The vividness of the Life results from Raphael's brush as Vasari makes present a large and varied cast of characterizations: humble Virgins, contemplative, ascetic, and ecstatic saints, distraught mothers, fearsome warriors, startled soldiers, and loving, playful children. Notably Vasari does not fix Raphael's paintings to titles. He narrates them, tributary to Raphael's inventive powers. There is no *Transfiguration*, but a *storia* in which Raphael "figured Christ transfigured" on Mount Tabor, in which there are waiting apostles, a suffering boy, a drama of fear, pain, compassion, hope, and splendid illumination (pl. 152).[142] In his prose renderings of Raphael's altarpieces and devotional panels, Vasari registers Raphael's transformation of the traditions of religious imagery from static forms to participatory dramas. Here as elsewhere in *The Lives*, paintings are not compressed into the

140 *Ibid.*, pp. 170–1: "come possa ingegno umano, con l'imperfezzione di semplici colori, ridurre con l'eccellenzia del disegno le cose di pittura a parere vive, sì come anco vivissimi que' poeti che si veggono sparsi per il monte."

141 *Ibid.*: "fiato di divinità."

142 *Ibid.*, pp. 202–3: "Nella quale storia figurò Cristo trasfigurato"; the full description is BB IV, pp. 202–4.

152. Raphael, *Transfiguration*. Rome, Pinacoteca Vaticana.

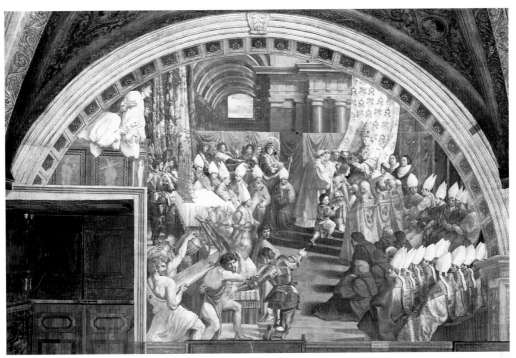

153. Raphael, *The Coronation of Charlemagne*. Rome, Vatican Palace, Stanza dell'Incendio.

convenient captions of art-historical practice. There is no *School of Athens*, *Expulsion of Heliodorus*, or *Fire in the Borgo* in the Stanze, for example. In this case, Vasari perceived these paintings probably very much as Raphael had conceived of them, as histories that unfold in actions, each understood for its emotional charge and given appropriate gestures. Writing thus he demonstrates Raphael's gift of invention, which he praised in the preface to Part 3.[143] The term is rhetorical, as are the decorum of representation and eloquence of expression fundamental to Raphael's compositions. The acutely observed details seem to speak in their silence, as Vasari wrote of the *Coronation of Charlemagne* (pl. 153), and he gave them voice through his prose.

Vasari's verbal evocations of Raphael's paintings combine the description of their subject matter and its emotional appeal with comments on their style. The vocabulary of the latter revolves around grace and its associated terms of beauty, delicacy, sweetness, and softness. These two seemingly separate aspects of description – discursive and critical – are actually linked by the rhetorical premises understood by both Raphael and Vasari, that style is not separable from matter and, further, that in order to receive the favorable attention of the audience, style must be pleasing.

The descriptions follow the course of Raphael's mastery to show what Raphael learned and therefore what he had to teach: both the process of study and its results are set forth as models for imitation. Raphael begins his career imitating Perugino "so precisely and in all

143 Preface to Part 3, BB IV, p. 9: "l'invenzione era in lui sì facile e propria quanto può giudicare chi vede le storie sue, le quali sono simili alli scritti."

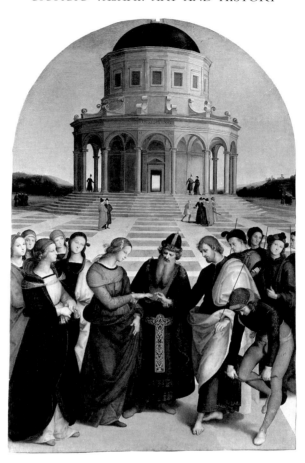

154. Raphael, *Marriage of the Virgin*.
Milan, Pinacoteca di Brera.

things . . . that his copies could not be distinguished from the master's originals."[144] The first three works by Raphael that Vasari records, all in Città di Castello, establish his progress away from Perugino's style, the third, the *Marriage of the Virgin* (pl. 154), being that "in which one expressly recognizes the increase in Raphael's ability as it became more subtly refined and surpassed Pietro's style."[145] Vasari points out and admires the "difficulties of his profession" that Raphael sought to master in the perspective construction of the temple.[146] He does not talk about expressions or gestures or hairstyles. Instead he concentrates on what Alberti had defined as the scientific basis for painting and on a notion of difficulty that, when resolved, demonstrates its opposite, facility. Vasari says that in Florence Raphael taught perspective to Fra Bartolomeo in exchange for lessons in painting ("colorito") in a model of friendly exchange of skills.[147]

144 Life of Raphael, BB IV, p. 158: "la [maniera di Pietro] imitò così a punto e in tutte le cose, che i suo ritratti non si conoscevano dagl'originali del maestro."

145 *Ibid*., p. 159: "nel quale espressamente si conosce l'augumento della virtù di Raffaello venire con finezza assotigliando e passando la maniera di Pietro."

146 *Ibid*.: "che è cosa mirabile a vedere le difficultà che egli in tale esercizio andava cercando."

147 *Ibid*., pp. 163–4. This is also possibly intended as an antidote to Giovio's finding fault with Raphael's perspective in his Life, Barocchi ed., *Scritti d'arte*, I, p. 15: "Optices quoque placitis in dimensionibus distantiisque non semper adamussim observans visus est."

155. Raphael, *"Madonna of the Goldfinch."* Florence, Uffizi.

Passing from Città di Castello to Florence Raphael also graduates from Book i of Alberti to Book ii – from skill and the science of perspective to the accomplishments of invention and composition. He goes also from Perugino's influence to Leonardo's and Michelangelo's, and studies Masaccio.[148] The first painting Vasari describes at this stage of Raphael's career is the *Virgin and Child and Young St. John the Baptist* that he painted for the recently married Lorenzo Nasi (pl. 155). Here Vasari describes the dramatic relationship of the figures and their poses, which are suited to their characters and actions – the playful children, the Virgin full of grace. They appear to be of "living flesh," and the Virgin infused with divinity.[149] The description of the painting is bracketed by a description of its patronage. Raphael had formed a great friendship with Nasi, who held the painting in great veneration. Vasari established a framework of friendship and respect, of diligent artist and appreciative patron, which demonstrates from the outset of the artist's career the interaction of good behavior and good style. Throughout the Life Vasari makes a point of naming the patrons of Raphael's works. In fact, in this early passage, Raphael's kindness ("gentilezza") and Taddeo

148 Life of Raphael, BB IV, pp. 159, 163.

149 *Ibid.*, p. 160: the figures "sono tanto ben coloriti e con tanta diligenza condotti, che più tosto paiono di carne viva che lavorati di colori e disegno; parimente la Nostra Donna ha un'aria veramente piena di grazia e di divinità."

Taddei's affection for such talents precedes the Nasi commission, as does Raphael's intimacy with other young painters.

And when Raphael was called to Rome, Vasari says that he was welcomed by Julius II with affection and favors. It is in the pope's apartments that Raphael's mastery is demonstrated. In this most prestigious of sites, Raphael undertakes Alberti's "great work of the painter" – painting histories.[150] Vasari begins his account of Raphael's work for Julius II with a description of the painting now called the *School of Athens* (pl. 146), for him the narrative *storia* showing "the theologians reconciling philosophy and astrology with theology."[151] Like Alberti, Vasari wished to capture the imagination of his reader by describing the story or history in words and to excite admiration by detailing its invention. Alberti says, relying on Cicero's ideas for rhetoric: "When the spectators dwell on observing all the details, then the painter's richness will acquire favour."[152] For Alberti "invention is such that even by itself and without pictorial representation it can give pleasure."[153] Vasari wanted to convey the sensations of discovery and delight in experiencing Raphael's inventions and the various actions, motions, and emotions depicted in order to create a verbal equivalent of viewing so that the reader/viewer might gain an understanding of the artist's achievement. He moves from group to group, identifying philosophers, noting their positions, pointing out portraits (Federigo Gonzaga, Bramante, Raphael himself), commenting on the beautiful poses, and the modes of contemplative conversation.

Alberti praises histories that are charming and attractive, richly varied but restrained and full of dignity and modesty. The best are properly arranged according to the subject with the figures having different attitudes demonstrating their feelings.[154] Vasari discovers exactly those qualities, balancing pleasing details against the composition of the narrative as a whole, divided with order and proportion. His conclusion is that in this painting Raphael made known his determination to hold "the field without dispute" among painters – a phrase that recalls Dante's description of Giotto's former triumph.[155]

The Stanze descriptions gain complexity as Raphael gains in artistry through the study of ancient remains and Michelangelo's methods, and comes to his new, grander, and more magnificent style. Vasari cites Raphael's talents "in the inventions of compositions."[156] He praises Raphael's ingenuity in dramatically resolving the problems posed by the window walls in the *Mass of Bolsena* and the *Liberation of St. Peter* (pls. 156, 157). The parallels between history, poetry, and painting become increasingly explicit. Vasari states that Raphael sought to "depict stories as they are written and to put into them stylish and excellent things" (of the *Liberation of St. Peter*).[157] With the encounter of Pope Leo I and Attila (pl. 158), where Raphael introduced the imaginative embellishment ("capriccio") of

150 For Alberti's statement, see *On Painting*, ed. Grayson, Book ii, chapter 35, pp. 72, 73.

151 Life of Raphael, BB iv, p. 166: "una storia quando i teologi accordano la filosofia e l'astrologia con la teologia."

152 *On Painting*, ed. Grayson, Book ii, chapter 40, pp. 78, 79.

153 *Ibid.*, Book iii, chapter 53, pp. 94, 95.

154 *Ibid.*, Book ii, chapter 40, pp. 78, 79.

155 Life of Raphael, BB iv, p. 167: "E oltra le minuzie delle considerazioni, che son pure assai, vi è il componimento di tutta la storia, che certo è spartito tanto con ordine e misura che egli mostrò veramente un sì fatto saggio di sé, che fece conoscere che egli voleva, fra coloro che toccavano i pennelli, tenere il campo senza contrasto."

156 *Ibid.*, p. 167, for Raphael's developing style. *Ibid.*, p. 179: "Laonde veramente si gli può dar vanto che nelle invenzioni dei componimenti, di che storie si fossero, nessuno già mai più di lui nella pittura è stato accomodato et aperto e valente."

157 *Ibid.*, pp. 179–80: "avendo egli cercato di

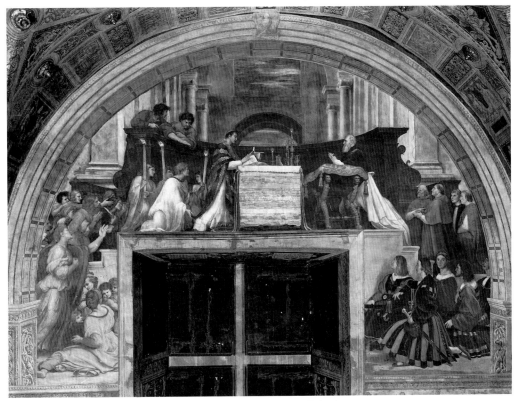

156. Raphael, *Mass at Bolsena*. Rome, Vatican Palace, Stanza d'Eliodoro.

157. Raphael, *Liberation of St. Peter*. Rome, Vatican Palace, Stanza d'Eliodoro.

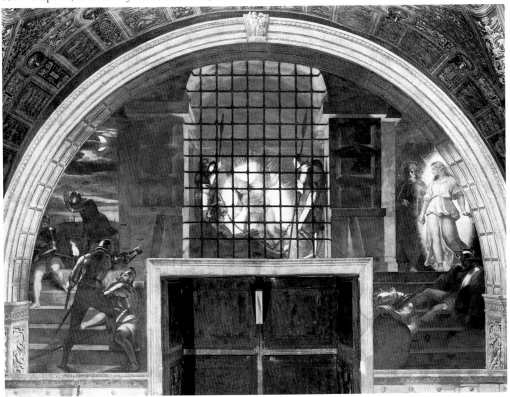

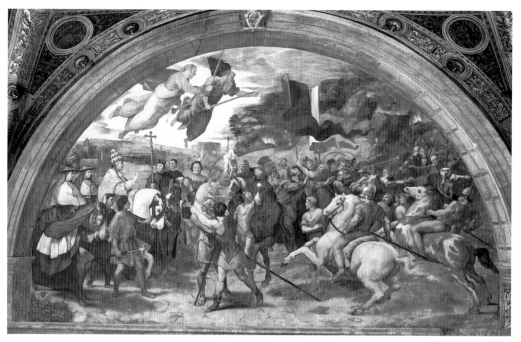

158. Raphael, *Repulse of Attila*. Rome, Vatican Palace, Stanza d'Eliodoro.

Sts. Peter and Paul hovering over the scene, defending the Church, Vasari introduces the concept of poetic license: "in poetry as in painting one can use fantasy to embellish the work, never indecorously abandoning the primary significance."[158] Another poetic observation is that of the group in the left foreground of the *Fire in the Borgo*, where an old man is carried on the shoulders of a young one, "in the same way that Virgil describes how Anchises was carried by Aeneas" (pl. 159).[159]

License was first among those things Vasari had used to distinguish the artists of the second period from those of the third: the works of the former "were not so perfect as to attain complete perfection, for there was still lacking in their rule a certain license."[160] Raphael, as poetic painter, achieves this decorous freedom in his "figuring" of events such as the dangers of the *Fire in the Borgo*.[161] The charm, grace, and sweetness (*leggiadria, grazia, dolcezza*) repeatedly noted by Vasari as constituent elements of the beauty of Raphael's works also have poetic implications. They are the distinguishing features of Petrarch's style

continuo figurare le storie come elle sono scritte, e farvi dentro cose garbate et eccellenti." See Shearman, *Raphael's cartoons in the collection of Her Majesty the Queen*, pp. 128–9, for history, poetics, and Raphael's "mature historical style."

158 Life of Raphael, BB IV, p. 183: "e se bene la storia di Leon III non dice questo, egli nondimeno per capriccio suo volse figurarla forse così, come interviene molte volte che così le pitture come le poesie vanno vagando per ornamento dell'opera, non si disconstano però per modo non conveniente dal primo intendimento."

159 *Ibid.*, pp. 193–4: "nel medesimo modo che Vergilio descrive che Anchise fu portato da Enea." See also the description of the Chigi loggia, "pittura e poesia veramente bellissima" (BB IV, p. 201).

160 Preface to Part 3, BB IV, pp. 4–5: "elle non erano però tanto perfette che elle finissino di aggiugnere all'intero della perfezzione, mancandoci ancora nella regola una licenzia."

161 Life of Raphael, BB IV, p. 193: "v'è figurato."

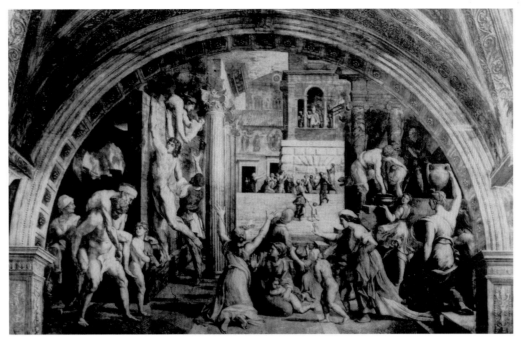

159. Raphael, *Fire in the Borgo*. Rome, Vatican Palace, Stanza dell'Incendio.

as understood by Raphael's and Vasari's contemporaries. The comparison was one made in the period. It occurs in Dolce's dialogue *L'Aretino*. Raphael, "pleasing and gracious" ("piacevole e gratioso"), and the charm of his style (his "leggiadrezza di stile") are contrasted with Michelangelo's more awe-inspiring form ("forma più terribile"): "So that some have compared Michelangelo to Dante, and Raphael to Petrarch."[162] In his lecture on poets and painters given to the academy in 1547 Varchi spoke of Michelangelo's imitation of Dante in his poetry and in his painted and sculpted works, which he endowed "with that grandeur and majesty manifest in Dante's ideas."[163] Vasari observed this standard differentiation between Petrarch and Dante when of the *Parnassus* he wrote that Raphael portrayed "the most divine Dante" and "the graceful Petrarch."[164] Michelangelesque majesty was the quality Raphael gave to his style when he improved and "aggrandized" it after his first sight of the Sistine ceiling.[165] The comparison between Dante and Petrarch is implicit in Vasari's treatment of Michelangelo and Raphael, where he stresses the grandeur of the former and the charm of the latter.

The courtly painter, Raphael, is associated with the Petrarchan tradition of courtly love.[166] It was in the discussion of Petrarch in the mid-sixteenth century that the Neoplatonic moral concepts of love and beauty found a stylistic pendant. Petrarch was

162 *Dolce's "Aretino,"* ed. Roskill, p. 172. Roskill also notes that this characterization was a given of literary description of the day and appears in Lenzoni's *In difesa della lingua fiorentina, et di Dante,* p. 311.

163 Barocchi ed., *Scritti d'arte,* I, p. 267: "dando loro quella grandezza e maestà che si vede ne' concetti di Dante."

164 Life of Raphael, BB IV, p. 171: "èvvi . . . il divinissimo Dante, il leggiadro Petrarca."

165 *Ibid.,* p. 176: "per le cose vedute di Michele Agnolo, migliorò et ingrandì fuor di modo la maniera e diedele più maestà."

166 See Toffanin, "Petrarchismo e trattati d'amore," *Il Cinquecento,* VI, pp. 122–48, and for the "fashion of

another of the patrons of the Florentine academy. He was actually favored as a subject for lectures.[167] The beauty that Vasari discerns in Raphael's works is consistent with his characterization of Raphael's gentility or courtesy (*gentilezza*); Vasari's own sense of decorum led him to apply an entirely appropriate set of concepts to Raphael, as the discussion of love and imitation of Petrarch were current in Raphael's circle as well as Vasari's and were an aspect of the development of Raphael's art in Rome. Equally consistent is the fact that Raphael's one vice should be his amorousness – a vice converted to virtue when Raphael, on his deathbed, "like a Christian sent his beloved away from the house and left her the means to live honestly."[168] This scene is also used to remind the reader of Raphael's love for his fellow artists. He divides his things among his disciples. The loving Raphael is a persistent presence in the third period. His interventions are recorded in many other Lives.[169]

The fact that Raphael painted histories did not make him prosaic. Poetry and history were allied arts in the sixteenth century. Poetry like history had an instructive function. Benedetto Varchi, for example, wrote in his treatise on poetics (*Della Poetica*) that poetry should "portray or represent in order to amend and correct life."[170] Truth and verisimilitude were the objects of both. And both were meant to produce an effect, poetry perhaps more than history, by touching the emotions through beauty.[171] And the poet's style was the most embellished, the most ornate and elegant. Traditionally poetry alone of all the imitative arts was associated with creativity. The poet's talent derived from divine inspiration, platonic *furor*.[172] Such poetic associations were a component of Vasari's notion of artistic divinity. This was combined with the equally empowering tradition of the divine artificer. As a creator of life the artist could be compared with God, the divine Artist, and Vasari's history of the arts begins with God's creation.

Vasari did not only appreciate Raphael through the literary conventions and conversations of his day. He was acutely aware of the talent it took to arrive at works more lifelike than life. This is reflected, almost literally, in the description, full of luster and light, of the portrait of Leo X, where Vasari lists element by element the details contributing to its remarkable presence (pls. 160, 161). This appreciation was based on Vasari's own experience of copying the portrait for Ottaviano de' Medici. In a letter to Ottaviano referring to this task, Vasari confessed his inability to equal the "fiato," the life's breath, of the original,

courtly love" in this period and its connection with the equally fashionable *petrarchismo*, see Cropper, "On Beautiful Women, Parmigianino, *Petrarchismo*, and the Vernacular Style," *Art Bulletin* (1976), pp. 374–94, for Raphael's time, see pp. 374–6, and p. 390, n. 91, for further references.

167 De Gaetano, *Giambattista Gelli*, p. 114. Between 20 December 1541 and 16 December 1545, for example, there were sixty-one lectures based on Petrarch, twenty-nine on Dante.

168 Life of Raphael, BB IV, p. 209: "come cristiano mandò l'amata sua fuor di casa e le lasciò modo di vivere onestamente." Respect for women and the protection of the weak as well as loyalty to friends were other traditional attributes of the courtly, courteous gentleman, see Paparelli, *Feritas, Humanitas, Divinitas*, p. 89.

169 See, for example, BB IV, pp. 263, 266–7, 305, 331 (Lives of Vincenzio da San Gimignano and Timoteo Viti, Il Fattore, Lorenzetto, Genga).

170 Quoted in Garin, *L'umanesimo italiano*, p. 186: "fingere o rappresentare per ammendare e correggere la vita." Dolce cited Aristotle's *Poetics* in his discussion of the disposition of narrative, see *Dolce's "Aretino,"* ed. Roskill, p. 121.

171 See for this Weinberg ed., *Trattati di poetica e retorica del Cinquecento*, pp. 554, 556.

172 Kristeller, *Renaissance Thought and the Arts*, pp. 168–9 and p. 179, for the sixteenth-century understanding of this, with additional references.

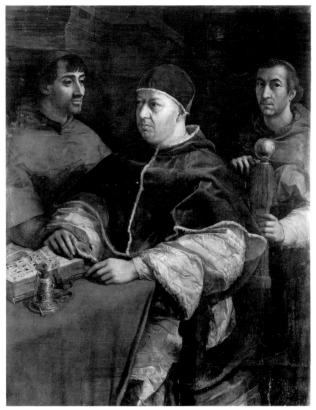

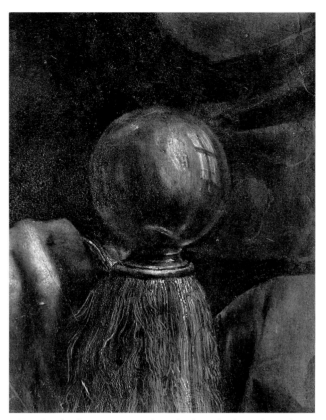

160. Raphael, *Pope Leo X with Cardinals Giulio de' Medici and Luigi de' Rossi*. Florence, Uffizi.

161. Raphael, *Pope Leo X with Cardinals Giulio de' Medici and Luigi de' Rossi* (detail). Florence, Uffizi.

although he was confident that he could reproduce the form and the colors.[173] And the problem of reflections, like that on the knob of the pope's chair, was one that had tried him greatly in painting the armor in the portrait of Alessandro de' Medici (pl. 44).

In painting "things that cannot be represented" as well as remarkably lifelike portraits, both Raphael and Vasari were rivals of Apelles.[174] When Vasari answered Benedetto Varchi's enquiry about the relative merits of painting and sculpture he concluded his discussion by describing those things that could not be found in sculpture and that represented the most difficult things to paint: "satin, velvet, silver and gold and jewels with the luster of pearls." It took "beautiful and learned" talents to be able to appreciate such things perfectly.[175] And in Raphael's painting Vasari pointed out that there are to be found "velvet pile, damask . . . that resonates and shines, the golds and silks imitated such that they do not

173 Frey I, xxxv (December 1537), pp. 92–3. Vasari's copy is now in the collection of Lord Leicester, Holkham Hall, see Langedijk, *The Portraits of the Medici*, II, p. 1407, no. 103, 13. Life of Raphael, BB IV, p. 188, for Vasari's description of Raphael's portrait, which plays throughout on the way that its elements, like the book of miniatures, are depicted in an exceptionally lifelike way: "che più vivo si mostra che la vivacità."

174 Pliny, *N.H.*, xxxv.xxxvi.88, pp. 326, 327, and xxxvi.96, pp. 332, 333.

175 Frey I, lxxxix, p. 191 (12 February 1547): "il raso, velluto, l'argento et loro et le gioie con i lustri delle perle, le quali pitture à quelli artefici che perfettamente le operano, recano inegli ornamenti dorati come castoni le eccellenti pitture, come gioie dal mondo veramente tenute, massime da begli et dotti ingegni."

appear to be pigments, but to be gold and silk."[176] Vasari's evocation of Raphael's portrait through its painterly qualities, like his appreciation of Raphael's use of color and ability to compose histories, is fundamental to his characterization of the artist. Michelangelo's talent was universal. But Raphael was supreme in the art of painting and presented a model of artistry Vasari tried to emulate.

The description of the portrait of Leo X is an instance of Vasari writing as a painter: autobiography written into biography. So too is his wondering amazement at Raphael's heaven-sent power to create uncharacteristic unity among painters working on projects together, "an effect so contrary to the dispositions of us painters."[177] This is more than a nostalgic memory of Raphael transmitted by Giulio Romano to his friend Vasari. The astonishment and admiration at the harmony of Raphael's shop is registered in direct proportion to the kind of acrimony, competition, and general ill-humor rampant in the artistic circles familiar to Vasari. He was also often in the position of co-ordinating complicated co-operative ventures, experience that could only have increased his respect for Raphael's administrative skills.

Another autobiographical note is sounded in Vasari's description of the difference between the frescoes in the Chigi loggia and the *Transfiguration*, which he added to the second edition. The figures in the Psyche frescoes

> gave absolutely no satisfaction . . . because they are lacking in that grace and sweetness that were peculiar to Raphael: which was largely caused by his having others paint them after his design. Having realized this error, and being a man of judgment, he resolved afterwards to execute by himself and without the assistance of others the panel of the Transfiguration of Christ at San Pietro a Montorio, in which one finds, as has already been said, all those qualities looked for and required in a good painting.[178]

This not only registers contemporary criticism of the Chigi cycle, it also repeats Vasari's conclusions about his own painting in the Cancelleria.[179]

Vasari was certainly writing as painter-personal as well as painter-professional in the 1568 edition when he decided to "discourse . . . about Raphael's styles."[180] Vasari's own efforts are incorporated in his description of Raphael working with "incredible diligence" to master Michelangelo's style, studying the difficult foreshortenings of the *Battle of Cascina*

176 Life of Raphael, BB IV, p. 188: "quivi è il veluto che ha il pelo, il domasco . . . che suona e lustra . . . gli ori e le sete contrafatti sì che non colori, ma oro e seta paiano."

177 *Ibid.*, p. 211: "E certo fra le sue doti singulari ne scorgo una di tal valore che in me stesso stupisco, che il cielo gli diede forza di poter mostrare ne l'arte nostra uno effetto sì contrario alle complessioni di noi pittori; questo è che naturalmente gli artefici nostri . . . lavorando ne l'opere in compagnia di Raffaello stavano uniti e di concordia tale che tutti i mali umori nel veder lui si amorzavano."

178 *Ibid.*, p. 207: "non sodisfeciono affatto . . . perché mancano di quella grazia e dolcezza che fu propria di Raffaello: del che fu anche in gran parte cagione l'avergli fatto colorire ad altri col suo disegno; dal quale errore ravedutosi, come giudizioso, volle poi lavorare da

sé solo e senza aiuto d'altri la tavola di San Pietro a Montorio della Trasfigurazione di Cristo, nella quale sono quelle parti che già s'è detto che ricerca e debbe avere una buona pittura."

179 For Raphael, see the (admittedly partisan) letter from Leonardo Sellaio in Rome to Michelangelo in Florence (1 January 1518): "È schoperta la volta d'Agostino Ghisi: chosa vituperosa a un gran maestro; pegio che l'ultima stanza di palazo, asai" (Golzio, *Raffaello nei documenti*, p. 65). For Vasari, see the Life of Perino del Vaga, BB V, p. 155, and Vasari's account of his own works, BB VI, p. 389.

180 Life of Raphael, BB IV, p. 204: "discorrere . . . intorno alle maniere di Raffaello" (an addition of three pages, Giunti edition, II, pp. 84–6, BB IV, pp. 204–8).

cartoon (pl. 29), making himself adept "in all those things that are required of an excellent painter," and finally exercising great judgment in deciding that

> painting does not consist only in representing nude men, but that it has a wide field, and that one can also count among the perfect painters those who know how to express narrative inventions well and with facility and [express] their fancies with good judgment; and you can define as a worthy and judicious artist one who in composing narratives knows not to make them confused with too much nor to impoverish them with too little, but can arrange them with beautiful invention and order.[181]

Vasari's works for Cosimo de' Medici, the numerous histories of the Palazzo Vecchio, teem with those elements, exactly those things other than nudes that were necessary to the art of painting: hairdos and houses, landscapes, lovely ladies, fancy dress, varied perspectives, youths and old men, the flight of horses in battle, the bravery of soldiers, armor, animals, beards, vases, trees, grottoes, rocks, fires, clouds, rain, thunder, lightning, clear days, and moonlit nights (pl. 162).[182] Vasari, like Raphael, used his judgment and chose to succeed at this worthy task rather than fail to arrive at Michelangelo's perfection. Vasari gives Raphael's stylistic and technical choices the gloss of Aristotelian virtue, as he tells how Raphael arrived at a mean style ("modo mezzano"), having exercised prudence to avoid setbacks.[183] The allusion to Aristotle gives the *discorso* greater legitimacy, by placing its terms within the realm of philosophy. It also derives from the fact that at the time of the founding of the Accademia del Disegno Borghini was rereading and criticizing Varchi's 1547 lectures, which debated the merits of the arts in Aristotelian terms. Vasari's account of his own life chronicles the long process of study by which he mastered his art. This passage on Raphael's style is to a degree another apology or confession, not only as a student, but as a master.

The publication of Condivi's *Life of Michelangelo* (1553), Dolce's *Aretino* (1557), and the foundation of the Accademia del Disegno were three other factors motivating this discourse. Condivi's Life had raised the issue of the development of Raphael's style, particularly in relation to Michelangelo's.[184] Vasari's desire to demonstrate how Raphael correctly

181 Life of Raphael, BB IV, p. 206: "si fece eccellente in tutte le parti che in uno ottimo dipintore sono richieste. Ma conoscendo nondimeno che non poteva in questa parte arrivare alla perfezzione di Michelagnolo, come uomo di grandissimo giudizio considerò che la pittura non consiste solamente in fare uomini nudi, ma che ell'ha il campo largo, e che fra i perfetti dipintori si possono anco coloro annoverare che sanno esprimere bene e con facilità l'invenzioni delle storie et i loro capricci con bel giudizio, e che nel fare i componimenti delle storie chi sa non confonderle col troppo et anco farle non povere col poco, ma con bella invenzione et ordine accomodarle, si può chiamare valente e giudizioso artefice."

182 *Ibid.* This is not only an effective list, but a return to Alberti. See, *On Painting*, ed. Grayson, Book ii, chapter 40, pp. 78, 79: "the first thing that gives pleasure in a 'historia' is a plentiful variety . . . in painting variety of bodies and colours is pleasing. I would say a picture was richly varied if it contained a properly arranged mixture of old men, youths, boys, matrons, maidens, children, domestic animals, dogs, birds, horses, sheep, buildings, and provinces." See further, Book iii, chapter 60, pp. 102, 103, about "variety and abundance [*copia*], without which no 'historia' merits praise."

183 Life of Raphael, BB IV, p. 207: "prese da [Fra Bartolomeo] . . . un modo mezzano di fare, così nel dissegno come nel colorito; e mescolando col detto modo alcuni altri scelti delle cose migliori d'altri maestri, fece di molte maniere una sola, che fu poi sempre tenuta sua propria . . . Ho voluto . . . fare questo discorso . . . per utile degl'altri pittori, acciò si sappiano difendere da quelli impedimenti dai quali seppe la prudenza e virtù di Raffaello difendersi."

184 Condivi, *The Life of Michelangelo*, trans. Wohl, p. 94, where he reports that Raphael, "however anxious he might be to compete with Michelangelo, often had the occasion to say that he thanked God that he was born in Michelangelo's times, as he copied from him a style which was quite different from the one which he learned from his father . . . or from his master Perugino." That this actually concerned Michelangelo is

162. Giorgio Vasari, *The Taking of Milan*, ceiling panel. Florence, Palazzo Vecchio, Quarter of Leo X, Sala di Leone X.

realized painting did not only "consist of painting nude men," but had a "wide field" was a constructive answer to Condivi's conclusion that Michelangelo's figures presented "such a concentration of art and learning that they are almost impossible for any painter whatever to imitate."[185] For Condivi art had found an unsurpassable limit in Michelangelo's inimitable figures. Vasari accepted Michelangelo's superiority in this, almost quoting Condivi, but he could not accept a limit to art. He wanted Michelangelo's and Raphael's examples to inspire, not to defeat future generations. Similarly, his wish "to show with how much effort, study, and diligence that honored artist always worked" was a positive response to Condivi's report of Michelangelo's comment that "Raphael did not come by his art naturally, but through long study."[186] This was intended by Condivi as an unfavorable comparison with Michelangelo's innate genius. In answer to this Vasari points out, and at length, that the right degree of systematic study following natural inclination and good judgment can result in excellence. He produces examples of excessive and misguided study, Paolo Uccello and Pontormo, to reinforce this point. Michelangelo, with or by way of Condivi, was seeking to create his own myth of genius, as an artist who had "no fixed place or course of study."[187] He denied his sojourn in Ghirlandaio's shop. Vasari's response was to produce and publish the document of indenture.[188] He thereby vindicated study with fact in Michelangelo's Life and more theoretically in Raphael's Life.

Study was literally becoming an institution in Florence in the early 1560s with the founding of the Accademia del Disegno. The aim of the academy was to increase the prestige of the arts and to operate "for the benefit of the young who are learning these . . . arts by giving them those means [gradi] and those honors awarded them by the ancients."[189] This didactic aim is one that informs many of the changes in *The Lives*. Raphael, as the outstanding example of the learned, Albertian artist, whose natural gifts were "cultivated and increased by industry, study and practice," becomes the focus for developing these ideas.[190] At times the passage inserted at the end of the Life "for the benefit of our artists" reads like a brochure advertizing the academy.[191] It sets out the steps and difficulties of learning. The benefit to the artist of learning "early the sound principles and the style that he intends to adopt" is pointed out, as is the need to imitate good masters and to study anatomy.[192] The addition to the Raphael Life demonstrated exactly how the artist

suggested by the letter from Sebastiano to Michelangelo reporting Leo X's remark about Raphael and Perugino, see above pp. 358–9. In a letter dated 24 October 1542, Michelangelo said that "all Raphael had in art, he had from me" ("ciò che haveva dall'arte, l'aveva da me"), Barocchi and Ristori eds., *Il Carteggio di Michelangelo*, IV, mi, p. 155, a comment that has a Plinian cast, see *N.H.*, xxxv.xxxvi.62, pp. 306, 307, "Zeuxis robbed his masters of their art and carried it off with him."

185 Life of Raphael, BB IV, p. 206: "come uomo di grandissimo giudizio considerò che la pittura non consiste solamente in fare uomini nudi, ma che ell'ha il campo largo"; Condivi, *Life of Michelangelo*, trans. Wohl, p. 93.

186 *Ibid.*, p. 106. Life of Raphael, BB IV, p. 207, Vasari says that he wrote his discourse: "per mostrare con quanta fatica, studio e diligenza si governasse sempre

mai questo onorato artefice." For Vasari and Condivi, see Wilde, *Michelangelo*, pp. 8–16, especially pp. 15–16.

187 Condivi, *Life of Michelangelo*, trans. Wohl, p. 10.

188 Life of Michelangelo, BB VI, pp. 6–7.

189 Academy regulations, quoted from Pevsner, *Academies of Art*, p. 297.

190 Alberti, *On Painting*, ed. Grayson, Book iii, chapter 60, pp. 102, 103.

191 Life of Raphael, BB IV, p. 204: "non voglio che mi paia fatica discorrere alquanto per utile de' nostri artefici intorno alle maniere di Raffaello."

192 *Ibid.*, p. 205: "chi non impara a buon'ora i buoni principii e la maniera che vuol seguitare . . . non diverrà quasi mai perfetto." This is an educational principle based on Quintilian, *I.O.*, II.iii.2–3, pp. 218, 219. The study of anatomy through the comparative study of the nude, dissections, and considering flayed bodies, as

could proceed from good to better, just as Raphael had progressed from the dry manner of Perugino to a style rich in invention and accomplishment.

Vasari judges Raphael's style in terms of Michelangelo's, saying that in the depiction of the nude (the noblest form of design), Raphael could not achieve Michelangelo's perfection.[193] The comparative value of Raphael's art is an important element in Vasari's scheme. He was the consummate painter. His skills were the handling of color and the creation of convincing narrative. In both editions, Michelangelo was meant to represent the universal artist. Vasari's deliberate consideration of Raphael's style at the end of this Life was probably also prompted in part by the publication in 1557 of Lodovico Dolce's *Dialogue on Painting*.[194] The dialogue is constructed around a comparison between Michelangelo and Raphael. It begins with exaggerated praise for Michelangelo as one whose "excellence is so great that, without going beyond the truth, one may suitably compare it to the light of the sun, which far surpasses and dims all other lights." It soon transpires that the

> commonly held opinion of Michelangelo's superiority (particularly over Raphael) is . . . an opinion of the ignorant, perhaps – the kind of people who, with no further under-standing, run along behind the opinions of others, like one sheep following another; or of certain daubers, who are apers of Michelangelo.[195]

The argument continues to go in favor of Raphael, until it concludes: "You can see now for yourself very clearly indeed that Raphael was not just Michelangelo's equal in painting, but his superior"; worse still, Vasari's Life is quoted as an authority to prove Raphael's success.[196] Vasari had demonstrably failed. The passage of criticism and evaluation inserted at the end of Raphael's Life redresses the balance, so that Raphael's success is shown to be relative, making a constructive response to Dolce's ironic praise, and reinstating Michelangelo at the summit of achievement. He was, after all, the hero of the Accademia del Disegno.

Raphael's glory is undiminished, however. The conclusion of the Life is unchanged. Raphael's career remains a model. Raphael lived "not as a painter, but as a prince."[197] A "noble artist," Vasari promises that "those who imitate his labors in art will be honored by the world, and those who resemble him in his saintly conduct will be rewarded by heaven."[198] Vasari recounts how, at his death, Raphael's body was laid out in the room where he was working on the *Transfiguration*: dead and living bodies juxtaposed, a contrast causing all present to be overcome with grief. The painting, the living body, was placed on

described by Vasari in this passage (p. 205), relates to its practice as proposed by the Accademia del Disegno. See, for the academy and anatomical study at the time, Kornell, "Artists and the Study of Anatomy in Sixteenth-Century Italy," Ph.D. (Warburg Institute, 1993), chapter 1.

193 Life of Raphael, BB IV, p. 206.

194 This was pointed out by John Shearman in his 1977 talk. For other changes prompted by Dolce's dialogue, above all with respect to Venetian art, see *Dolce's "Aretino,"* ed. Roskill, pp. 63–5.

195 *Ibid.*, pp. 87, 91. It is probably Condivi who is intended here as the dauber. This comment is a paraphrase of and answer to Condivi's question of "to whom

should [Michelangelo] defer? Certainly to no one, in the judgment of men concerned with the art, unless we follow the opinion of the herd, who blindly admire antiquity" (Condivi, *Life of Michelangelo*, trans. Wohl, p. 94).

196 *Dolce's "Aretino,"* ed. Roskill, pp. 181, 179.

197 Life of Raphael, BB IV, p. 212: "Egli insomma non visse da pittore, ma da principe."

198 *Ibid.*, p. 210, "questo nobile artefice," and p. 213: "e così quegli che imiteranno le sue fatiche nell'arte saranno onorati dal mondo, e ne' costumi santi lui somigliando, remunerati dal Cielo."

the high altar of San Pietro in Montorio and greatly prized for every detail.[199] In that painting the "strength of art" resplendent in the face of Christ shines forth with a beauty that Vasari saw as illuminating the efforts of all who would follow Raphael's example.[200] Giotto's light was there transcended by Raphael's splendor.

199 *Ibid.*, p. 210.

200 *Ibid.*, p. 204: "il valor dell'arte nel volto di Cristo."

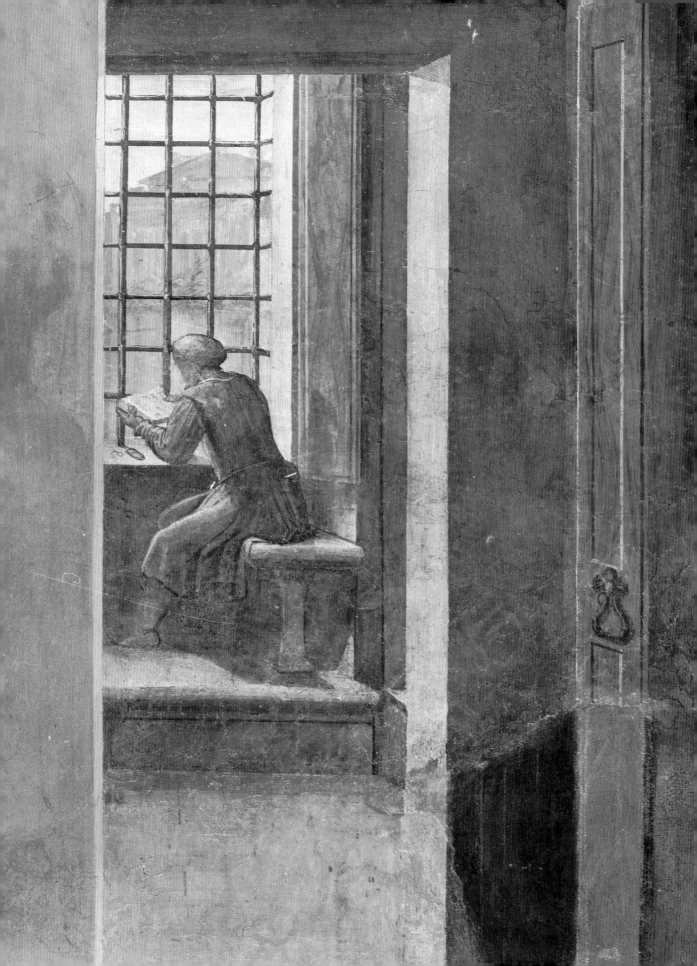

CONCLUSION:
A LETTER TO HIS READERS

VASARI KNEW WHAT HE WAS DOING, or what he was trying to do. He stated his intention quite clearly to his readers. He had undertaken to write history to serve and to honor the arts.[1] He was aware of his limitations, being a painter not a writer or historian. He was equally aware of his special qualifications as an artist. His "love, knowledge, and judgment about the most beautiful and virtuous arts" made him able to discern the ways and means of their changes and to "tell things as they really are."[2]

Vasari could address his readers directly and purposefully because he wrote for a defined and differentiated public: "my virtuous artists" and "you other most noble readers."[3] He wished to instruct the artists by examples and give pleasure to all the others.[4] He wished also to attract the notice and receive the protection of great benefactors. He dedicated his work to Duke Cosimo de' Medici. A proud artist, he was also a humble servant, a "subietto basso."[5] He hoped that his efforts would by rewarded by the "liberality" and "magnanimity" of the duke and of Pope Julius III. Such powerful patrons constituted another category of reader.

Vasari's book had well-defined aims and a distinct, if divided, audience, which did not include specialist students of art history searching for source material.[6] Vasari's text becomes problematic, inadequate, and inaccurate when it is relied upon as a biographical dictionary. It is a period piece – not a quaint, crude or archaic compilation of artists' lore – but a brilliantly crafted, carefully conceived, and totally integrated product of its time. It has the same validity as all the other great cultural manifestations of the period. And it can still please and instruct.

1 Preface to Part 2, BB III, p. 4: "avendo io preso a scriver la istoria de' nobilissimi artefici per giovar all'arti . . . et appresso per onorarle."

2 Frey I, cxxxi, p. 270 (Rome, 8 March 1550, to Duke Cosimo de' Medici, Pisa), Vasari writes of: "l'amore, la cognitione et il giuditio, che ho di queste belle et uirtuose arte." In his description of the genesis of the project, he tells how he convinced Cardinal Alessandro Farnese and his friends of the need for someone: "dell'arte a mettere le cose a' luoghi loro et a dirle come stanno veramente" (Description of Vasari's works, BB VI, p. 389).

3 BB VI, p. 409 (1550), the "Conclusione della opera agli artefici et a' lettori," opens addressing "virtuosi Artefici miei, e voi altri lettori nobilissimi."

4 Dedicatory letter to Duke Cosimo, BB I, p. 3: "con l'esempio di tanti valenti uomini e con tante notizie di tante cose . . . ho pensato di giovar non poco a' professori di questi esercizii e di dilettare tutti gli altri che ne hanno gusto e vaghezza."

5 Letter to Cosimo, Frey I, cxxxi, p. 270.

6 See Baxandall, "Doing justice to Vasari," *Times Literary Supplement* (1 February 1980), p. 111.

163. Giorgio Vasari, *Reader*. Arezzo, Casa Vasari, Sala del Trionfo della Virtù.

Vasari respected writing. He knew its value to the arts.[7] Pliny had taught him the lesson of survival. Mindful of tradition, Vasari made a great innovation. He removed the visual arts from the realm of subsidiary example and made them a subject of discussion to be respected for themselves. Previously the arts had most often been treated peripherally, a role found in classical literature. Following this tradition, it is as a gentlemanly accomplishment and topic of conversation that they appear in Castiglione's *Courtier*, for example. Pliny treated artists under the categories of their materials. Usually artists' skills and excellence were seen as analogous to skills and accomplishments in other fields. When allowed the honor of being included among Great Men (*uomini illustri* or *viri illustres*), as by Filippo Villani or by Giovio, the particulars of their work were hardly touched upon. Vasari by contrast insisted that things be looked at in detail and that knowing about their techniques be a prerequisite to a serious discussion or understanding of their greatness.[8]

To change these priorities was one of Vasari's most difficult and delicate tasks, because it was aimed primarily at the amateurs (*amatori*) and the *signori*, the virtuous gentlemen and the great lords, whose side-long glances at art Vasari wanted to convert to careful study. Some artists took their work for granted, and Vasari duly used history to chastise their frivolity. But as often as his other readers discussed beauty, grace, and style, they seldom focussed their learned discussions on the visual arts. With *The Lives* Vasari gave them an example of how this could be done, how individual talent related to painting, architecture, and sculpture, and how those arts should be valued. Vasari proved, object by object, life by life, how abstract and beautiful notions could be transferred to works of art and their makers. Vasari's book and his purpose were, for this reason, elitist.

Vasari was perplexed and annoyed by an artist like Pontormo who would work only when and for whom he wished, not serving honorable patrons like Ottaviano de' Medici, instead doing "anything for a low and common man and for an extremely low price."[9] Vasari resented the fact that men like the bricklayer Rossino, however good at his job, should receive payment in paintings that ought to be owned by worthier gentlemen. He also knew that "there is not a shoemaker's house that does not have German landscapes, attracted by their charm and their perspective."[10] But he was not interested in such simple-minded delight in pretty pictures, particularly German ones. He differentiated between "the eyes of those who take delight and those who do not."[11] True pleasure was informed and intelligent, and such pleasure was above the common mass.

Vasari does not elaborate on the functions of art within society as a whole. In one of the few passages in which he talks explicitly about patronage and context, he is demonstrating the relative crudity of the first age:

7 See, for example, the opening of Simone Martini's Life (BB II, p. 191), or Alberti's (BB III, pp. 283–4), or the Life of Palma (BB IV, p. 549), for Vasari's assessment of the role of writers in praising artists.

8 Description of Vasari's works, BB VI, p. 389, for Vasari's critique of Giovio's broader method.

9 Life of Pontormo, BB V, p. 328: "ogni cosa per un uomo vile e plebeo, e per vilisssimo prezzo."

10 Frey I, lxxxix, p. 188 (Florence, 12 February 1547, to Benedetto Varchi, Rome): "che non è casa di ciauattino che paesi Todeschi non siano, tirati dalla uaghezza et prospettiua di quegli."

11 *Ibid.*: "à tanta delettatione reca gli occhi di quegli che si dilettano et non si dilettano." Waźbiǹksi, "Artisti e pubblico nella Firenze del Cinquecento," *Paragone* (1977), p. 16, argues that these remarks are instances of a populist attitude towards the arts. While they show Vasari to be aware of the diversity of the public, in context they demonstrate the opposite, a contempt, however courteous, for popular opinion and ownership of art.

The age of Giotto was most fortunate for everyone who painted, because people then were attracted by the novelty and charm of the art that artists had greatly improved on. The Dominican and Franciscan Orders had finished building their convents and churches, and were preaching in them continuously; with their sermons they were attracting hearts hardened by evil-doing to the Christian faith and a life of goodness, and exhorting them to honor the saints; with the result that every day chapels were being built and the unlettered were commissioning their decoration, desirous of reaching heaven: and thus by moving the ignorant minds of men, they were having their churches beautifully decorated.[12]

Vasari here plays on the venerable justification of paintings as the Bible of the illiterate pronounced in the sixth century by Gregory the Great. The division between learned and unlearned viewers characterizing renaissance discussions of the arts was based on the fourteenth-century reformulations of this dictum. And in his account of this almost accidental recovery of beautiful decoration, Vasari relied on the notion of informed delight applied to the arts by their first learned defenders, such as Petrarch and Boccaccio.[13] *The Lives* abound with information about where, what, and for whom. The structures and etiquette of commission and execution of works over three centuries are fully described. The various uses of drawing or design can be extrapolated from his text, but this kind of functional fact is embedded in another message, that of the critical importance of the works as creative artifacts: difficult, ingenious, and divine, like poems.

Vasari knew his profession to be defined as manual and not intellectual.[14] He did not deny this but qualified his acceptance of the traditional status of painting, sculpture, and architecture by applying intellectual terms to manual works. Invention, for example, was for Vasari "the honorable mother of everything which, with sweet passages of poetry, in various guises first leads your mind and eyes to stupendous wonder."[15] And, he argued, in the Life of Andrea Orcagna:

Rarely is there a talented man who excels in one thing who is not able to learn others easily, especially ones that are similar to his first profession, and that proceed, as it were, from the same source, as in the case of Orcagna of Florence, who was painter, sculptor, architect, and poet.[16]

12 Life of Ugolino da Siena, BB II, p. 139 (1550): "Fu felicissima l'età di Giotto per tutti coloro che dipingevano, perché in quella i popoli tirati dalla novità e dalla vaghezza dell'arte che già era ridotta dagli artefici in maggior grado, avendo le Religioni di San Domenico e di San Francesco finito di fabricare le muraglie de' conventi e delle chiese loro et in quelle predicando del continovo, tiravano con le predicazioni a la cristiana fede et a la buona vita i cuori indurati nelle male opere e quegli esortavano ad onorare i Santi di Gesù, di sorte che ogni dì si fabricavano cappelle e dagli idioti si facevano dipignere per desiderio di giugnere in paradiso: e così costoro col muovere gl'intelletti ignoranti degli uomini, acomodavano le chiese loro con bellissimo ornamento."

13 Baxandall, *Giotto and the Orators*, pp. 58–62, about learned and unlearned in Petrarch's *De remediis utriusque fortunae*, its sources, and the subsequent development of these categories among later humanists.

14 See the Life of Alberti, BB III, p. 284, where artists' works are called "opere manuali," or the Life of Sogliani BB IV, p. 439, where he writes of the "scienzie delle lettere" (1550) or "essercizii delle lettere" (1568) and the "arti ingegnose manuali" (in both editions). See also Vasari's letter to Benedetto Varchi, Frey I, lxxxix, p. 186.

15 *Ibid.*, p. 190: "d'ogni cosa madre honoranda, la quale con dolci tratti di poesia sotto uarie forme vi duce lanimo e gli occhi prima à marauiglia stupenda." Similarly the Life of Lippo, BB II, p. 297: "Sempre fu tenuta e sarà la invenzione madre verissima dell'architettura, della pittura e della poesia, anzi pure di tutte le migliori arti e di tutte le cose maravigliose che dagl'uomini si fanno."

Vasari took the Horatian *ut pictura poesis* to his heart and to his hearth. In the room he painted in his house at Arezzo devoted to Fame and the arts, Poetry was included with Painting, Sculpture, and Architecture (pls. 59, 60, 164, 165).

Vasari's application of literary modes to visual arts was precedented. Impressively so: not only Petrarch and Boccaccio, but Villani, Alberti, Bembo, Castiglione, and Giovio, among others, provided prestigious models known to Vasari. But he combined this form of appreciation with an acknowledgment and explanation of the specifically mechanical difficulties of his art. When answering Benedetto Varchi's enquiry about the relative importance of the arts of painting and sculpture, Vasari suggested that the eminent academician prove his excellence by trying to model something out of clay or by taking a sheet of paper and trying to draw.[17] He prefaced *The Lives* with a technical introduction: "so that every gentle spirit might first understand the most important things."[18] By understanding the "ways of working" the reader could then better understand or learn about "the perfection or imperfection" of the artists' works and the differences of their styles as set out in the biographies.[19] He considered this to be theory as well as practice and called the technical section the "Teoriche."[20] It was part of Vasari's service to his profession, understood from the prescriptive treatises among his models, to elucidate the skills necessary to becoming a perfect practitioner. Just as he made artists more like gentlemen, he made the *amatori* more like artists as they read. His text was a mediator between two types of training and experience. Vasari apprenticed his readers to the arts and gave them material grounds for respecting those arts. Having done so by way of introduction, in *The Lives* he allowed the reader to grow in sophistication as he described those arts. Vasari used a specialist vocabulary, the particular terms of the arts that made the discussion of style concrete.[21] Imitation, invention, order, and design were not separated from brush, chisel, stone, or stylus. Similarly, grace and beauty were not only cognitive and critical categories, but also the products of recognizable skill, of *arte*. Vasari created a new form of discourse by combining the language of "secrets" with that of writers.[22] He did so by taking those secrets out of the workshop and putting them in a book, thereby granting them a new kind of attention.

It was a successful approach. Vasari's book sold out.[23] He had, with instinct and insight, responded to an interest, even a need.[24] The amount of encouragement, assistance, and

16 Life of Orcagna, BB II, p. 217: "Rade volte un ingegnoso è eccellente in una cosa che non possa agevolmente apprendere alcun'altra, e massimamente di quelle che sono alla prima sua professione somiglianti e quasi procedenti da un medesimo fonte, come fece l'Orgagna fiorentino il quale fu pittore, scultore, architetto e poeta."

17 Frey I, lxxxix, pp. 186–7.

18 General preface to *The Lives*, BB I, p. 28: "a cagione che ogni gentile spirito intenda primieramente le cose più notabili."

19 *Ibid.*, p. 29: "nella Introduzzione rivedranno i modi dello operare e nelle Vite di essi artefici impareranno dove siano l'opere loro et a conoscere agevolmente la perfezzione o imperfezion di quelle e discernere tra maniera e maniera."

20 Description of Vasari's works, BB VI, p. 396.

21 General preface to *The Lives*, BB I, p. 29: "le voci et i vocaboli particulari e proprii delle nostri arti."

22 For the term "segreti," see *ibid.*, p. 11.

23 Waźbińksi, "Artisti e pubblico nella Firenze del Cinquecento," *Paragone* (1977), p. 15, n. 67, suggests that 1,500 copies were printed, by analogy with Bartoli's translation of Alberti's *L'Architettura*.

24 Anton Francesco Doni, who wanted to print the book, wrote to Francesco Revesla about the project of *The Lives* and the "introduttione nell'arti del medesimo non meno necessaria che nuova," Frey I, p. 213 (10 March 1547).

deference he had in writing both editions was a sign of a shared enthusiasm and his acknowledged expertise. His audience was prepared and delighted to hear what he had to say. It was a novelty couched in pleasingly familiar and acceptable terms. It provoked discussion and prompted reactions like Dolce's dialogue *L'Aretino* and Condivi's *Life of Michelangelo*. It was quoted or challenged as an authority, by Anton Francesco Doni in his dialogue *I Marmi* (1552) and Carlo Lenzoni in his *Defense of the Florentine Language and of Dante* (1556).[25] As a historian Vasari was an opportunist: he seized upon a general awareness and brought it to issues that concerned him, a strategy he was to repeat in the second edition. He was also a careerist. The hope for personal success as well as professional glory permeates the text.

It is highly unlikely that Vasari thought that he would make a living from the sale of popular art books. *The Lives* were probably not a commercial venture, they were a career move. Vasari had a distinct flair for writing and a true commitment to his subject, which he combined to try to make a name for himself, following a trend in vernacular writing.[26] Vasari had not even decided on a publisher or dedicatee when he began writing them. When Giovio heard that the book was completed he wrote to Vasari saying that he should bring the manuscript to Rome so that they could discuss it together and have it printed there, if that pleased Vasari, or that if Vasari decided to dedicate it to Duke Cosimo ("to whom you should"), it would then be printed with the newly licensed Torrentino press in Florence.[27] It was undoubtedly love of art and not love of gain that motivated and sustained his efforts as a writer. But he hoped that such love would find its rewards. He had been assured it would. Paolo Giovio had urged him to write: "Because gain comes from praise, but praise does not come from gain."[28]

The Lives, instructive and pleasing as they were to artists and art-lovers, were meant also to guide patrons by showing them how much their reputations would profit from supporting the arts. Vasari was in fact very tough on unsophisticated or inattentive patrons. He did not hesitate to use historical distance, for example, to criticize Pope Eugene IV who was not diligent enough in seeking out artists when he decided to commission a bronze door for St. Peter's. The pope chose Filarete as opposed to any truly excellent master like Brunelleschi or Donatello, with disgraceful results, Vasari felt, still visible in "our times."[29] He was

25 Doni, *I Marmi*, ed. Chiòboli, II, p. 22: "Leggete la vita di Filippo di ser Brunellesco scritta da messer Giorgio Vasari, e vedrete quanta fatica egli durò a mostrar la sua virtù a dispetto degli invidiosi vostri," Lenzoni, *In difesa della lingua fiorentina, et di Dante*, p. 10, choosing example of attainment among artists, one interlocutor comments: "Tutto che Giotto sia così stranamente lodato, dal vostro Giorgio Vasari."

26 Large-scale commercial circulation, career writers, and professional editors were an emerging, but still rare phenomenon, see Rochon, "Letteratura e società nel Rinascimento italiano," in *Il Rinascimento*, ed. Branca *et al.*, p. 82.

27 Frey I, xcvi, p. 199 (Rome, 8 July 1547, to Vasari, Florence): "et quando uerrete per andare a Napolj, lo spediremo in un tratto et lo faremo stanpare qua in Roma, se cosj ui piaciera, eccietto se il .D. Cosimo, al qual douerette intitular lopera, quando non uolesse dedicarla a persone piu basse, dico, che in quel caso della dedicattione la faria stampare a quelli sua noui Todeschi." See also Frey's comments, Frey I, p. 213, and Giovio's letter of 29 January 1548 to Vasari when he was in Rimini with the final draft: "A me par', che per mille viue ragioni lo dedichiate al Signor Duca Cosimo con fargli un stringato et semplice proemio, verbi gratia fratello di questo, che vi mando per modello" (Frey I, cvii, p. 215). Don Miniato Pitti also wrote to Vasari advising him print with Torrentino rather than Doni in Venice (Frey I, cix, pp. 217–18 [Florence, 22 February, to Vasari, Arezzo]).

28 Frey I, xcv, p. 198 (Rome, 7 May 1547, to Vasari, Florence): "Perche da la laude uiene il guadagnio, e dal guadagnio non uiene la laude."

29 Life of Filarete, BB III, p. 243: "Se papa Eugenio Quarto, quando deliberò far di bronzo la porta di S. Piero di Roma, avesse fatto diligenza in cercare d'avere

164 (following page). Giorgio Vasari, *Architecture*. Arezzo, Casa Vasari, Camera della Fama e delle Arti.

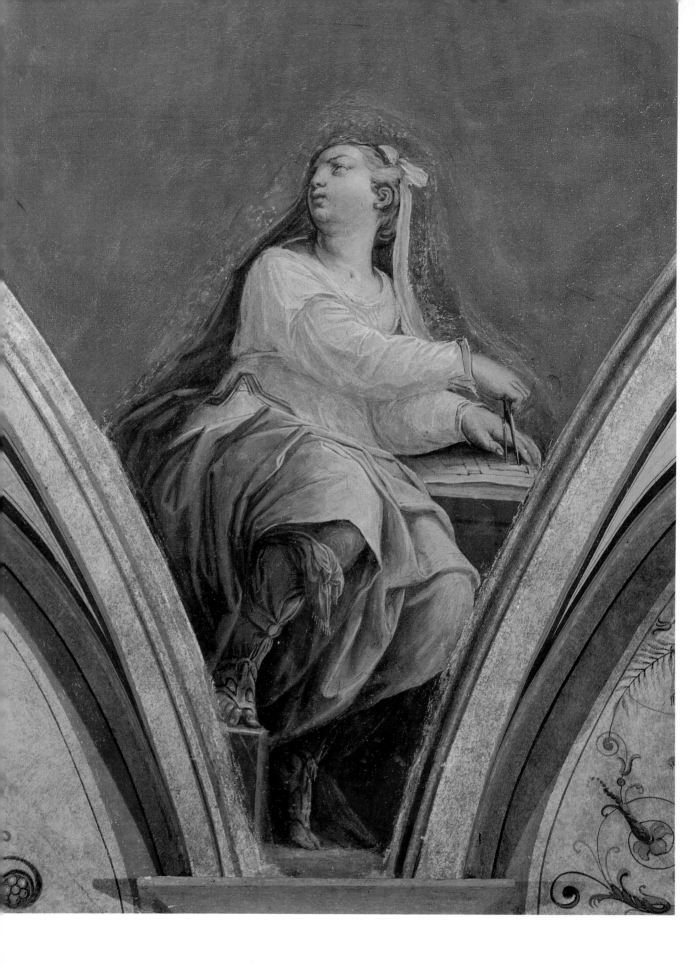

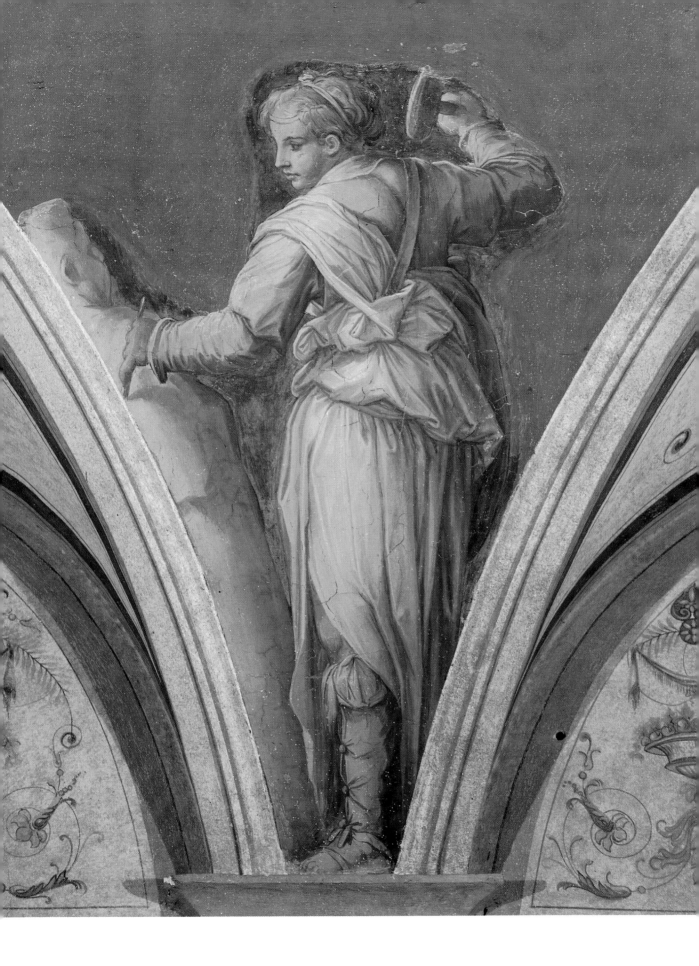

also unsparing about Pope Sixtus IV's little intelligence when, with equally little under-standing, he was fooled by the glitter of Cosimo Rosselli's gold in the Sistine decorations and declared him the best among the painters there.[30]

Following Paolo Giovio's advice, Vasari dedicated the book to the heir of his first protectors, Duke Cosimo de' Medici. Even so, the dedication divides its compliments, devoting a section to another possible patron at the time, the newly elected Pope Julius III. Vasari clearly waited until the last minute to decide what to do. Pope Julius was elected in February 1550. Experience had taught Vasari the courtier's lesson, never to trust to one protector, but to keep contacts with many, to be able and ready to find new employment. Despite its drawbacks, Vasari's ideal society remained the court, and his public, enlightened gentlemen, his peers and his patrons.

Vasari described his great discomfort at the time of the Medici expulsion from Florence in 1527. His father's death and the plague forced him to go out "into the woods to make saints for churches in the countryside."[31] He makes this period sound like a reversion to primitive existence, redeemed only when he was able to go to Rome "to serve the great Ippolito de' Medici, as formerly, when still a child living in your house, I served both him and Duke Alessandro."[32] For Vasari civilization was in service. From his remarks it is hard to tell or to remember that he was just a year or so younger than his great patrons. Vasari connected the development of his talent with their support. This is intriguingly indicated by his transformation of the shepherd-boy topos in the Lives of Andrea del Castagno and Andrea Sansovino. Whereas Giotto had been discovered by another artist, they were found by patrons who set them on the path to glory by providing for their education. In the case of Castagno Vasari says that it was Bernardetto de' Medici.[33] Bernardetto was Ottaviano de' Medici's father. In the case of Sansovino it was Simone Vespucci, father of Vasari's first benefactor in Florence, Niccolò Vespucci. The works by Sansovino that he describes in the Vespucci household, at the Ponte Vecchio, were well known to him; he later owned one of them: a terracotta head of the emperor Galba, copied from an antique medal.[34]

Vasari's discovery by Silvio Passerini and his privileged upbringing with the Medici is essential to understanding *The Lives*. It was his personal myth. It replaced, with great distinction, a regular, systematic workshop apprenticeship. The importance Vasari gives to early training in the lives of other artists to a certain extent supplies a deficiency in his own. Vasari's training was made up as much of good behavior as of grinding colors, and he was well schooled in the conventions of courtesy. Brought up, he said, in the service of Ippolito and Alessandro de' Medici, as a child and adolescent (from the ages of ten to sixteen), he forged the reciprocal bonds of servitude and friendship, love and gratitude with or beneath (*sotto*) his patrons which remained in force despite the disappointments of their deaths and the years of wandering. It was a model he never rejected, even though he said that in a bleak moment after the sudden death of Cardinal Ippolito, he "began to know how vain were

uomini eccellenti per quel lavoro... non sarebbe condotta quell'opera in così sciaurata maniera come ella si vede ne' tempi nostri."

30 Life of Cosimo Rosselli, BB III, pp. 445–6.

31 Frey I, i, p. 1 (Rome, 1532, to Niccolò Vespucci, Florence): "ne' boschi à fare de santi per le chiese di contado."

32 *Ibid.*: "à seruire il grande Hipolito de Medici, come gia stando in casa uostra à Firenze putto, seruiuo et lui et il duca Alessandro."

33 Life of Andrea del Castagno, BB III, p. 353.

34 Life of Andrea Sansovino, BB IV, p. 272.

165 (previous page). Giorgio Vasari, *Sculpture*. Arezzo, Casa Vasari, Camera della Fama e delle Arti.

worldly hopes, and that it was necessary to trust mainly in one's self and to be worth something."[35]

The Lives are proof of both – the need to serve and the need to have self-respect. They are about being something. Biography presupposes the importance of the individual. Panegyric even more so, for it is based on the force of character to convince and to excite admiration and imitation. And in Vasari's *Lives*, personal style and personality, the unique virtues of each of his subjects, contribute more to success or failure than the operations of fortune or fate. The element of chance in the wheel of fate is most often offset by the persistence of the artists in the pursuit of their art with study and diligence. And even those "brought down by fortune" can be comforted by the fact that "time will bring truth and virtue to light, and reward past and future efforts with honor."[36]

Artists could not escape fortune, but they could escape oblivion. They could be ennobled and honored through their works. Vasari had an oligarchic view of society and accepted hierarchical notions of rank and station. But he felt that the artist's degree, his *grado*, was not fixed, it could be raised or enhanced through the due recognition of talent and of excellence, of *ingegno* and *virtù*. "The nobility of the art of painting" did not turn a painter into a prince, but it could make him like one in commanding respect and winning fame.[37] According to Vasari, an artist, like Giorgione, could be well mannered even if of humble birth.[38] Vasari's ambitions were extremely pragmatic. He became the head of his household at an early age and had to see to the welfare of his siblings. But his motivations were not only material. Vasari's concept of an artist's career was based on a philosophical or philosophizing notion of perfection that was essentially Neoplatonic – placing man at the midpoint of creation. In his treatise on the *Dignity of Man*, Pico della Mirandola wrote:

Neither heavenly nor earthly, neither mortal nor immortal have We made thee. Thou, like a judge appointed for being honorable, art the molder and maker of thyself; thou mayest sculpt thyself into whatever shape though dost prefer. Thou canst again grow upward from thy soul's reason into the higher natures which are divine.[39]

For Vasari artists were a channel for divinity. The artist, with his skill and "learned hand," could bring minds to contemplate the idea behind reality, the higher truth – the artist's intellect and invention being the mediators of things "heavenly, elevated, and divine."[40] He

35 Description of Vasari's works, BB VI, p. 374: "cominciai a conoscere quanto sono vane, le più volte, le speranze di questo mondo, e che bisogna in se stesso e nell'essere da qualche cosa principalmente confidarsi."

36 Life of Alfonso Lombardi, BB IV, p. 407 (1550): "Egli non è dubbio alcuno nelle persone sapute che la eccellenza del far loro non sia tenuta qualche tempo ascosa e dalla fortuna abbat[t]uta: ma il tempo fa talora venire a luce la verità insieme con la virtù, che delle fatiche passate e di quelle che vengono gli remunera con onore."

37 Life of Baldovinetti, BB III, p. 313, for the phrase "la nobiltà dell'arte della pittura." The question of how "talent born in poverty" was able to raise itself up ("sollevarsi") is treated in the addition to the Life of Torrigiano about Lorenzo de' Medici's sculpture garden and his support for artists (BB IV, pp. 124–5).

38 Life of Giorgione, BB IV, p. 42: "il quale, quantunque egli fusse nato d'umilissima stirpe, non fu però se non gentile e di buoni costumi in tutta sua vita."

39 Pico della Mirandola, *On The Dignity of Man*, ed. Miller, p. 5.

40 Life of Andrea Tafi, BB II, p. 77 (1550) about the excellence of painting: "la quale ha forza – quando è da dotta mano o in muro o in tavola, in superficie di disegno o con colore lavorata – tenere gli animi fermi et attenti a risguardare il magisterio delle opere umane, rappresentando la idea e la imaginazione di quelle parti che sono celesti, alte e divine, dove per pruova si mostra l'altezza dello ingegno e le invenzioni dello intelletto" ("when it is the work of a skilled hand on wall or panel, whether a drawn or painted surface, it has the power to enrapture the spirit and make it attentively observe the majesty of human works, by illustrating an idea and

also felt that the dignity of his profession allowed artists to "grow upward." By attention to their art, as in the case of Perino del Vaga, they might be rewarded by heaven to ascend from the "lowest depths where they are born to the heights of grandeur."[41] It was possible for an artist to "rise to heaven."[42] In this way his artist is quite different from Castiglione's courtier, who was advised to behave according to an Aristotelian mean, not to pass "certain bounds of moderation," warned that beyond this studied mediocrity lies affectation.[43] Vasari's book is normative and prescriptive in suggesting examples and rules for behavior and education. But his norm was the extreme: the superlative, the most inventive, the most graceful, the most beautiful.

Vasari's aesthetic and historical premises were identical. The past, both "ancient" and "old," had been surpassed. Classical rules and models had been assimilated and had become the basis for the perfection and the inventions of the modern age. The study and imitation with which Vasari formed his style also created an awareness of style transmitted in his description of different *maniere*. Borrowing and adaptation are features of his art. Vasari's understanding of compositional models, emulated not copied, was one he brought to his historical models. His sources in both writing and painting were absorbed and transformed into new expressive forms, whether on palace walls or in artists' lives. Both were meant to charm and please, to be varied and lifelike. They were true to nature, but nature idealized.

Both were modern. The book was more original. Nothing like it had existed before. Literary friends could offer suggestions, but no plan or scheme or program. *The Lives* are Vasari's own, and probably greatest, invention. It was up to him to find and combine forms that could both record the deeds and honor the accomplishments of his predecessors and his peers. This was not a sterile exercise. Vasari's book is a passionate one. It was based on intimacy and love. He was not a detached or casual observer. He wrote through the medium of his own experience. Talent and teaching, study and diligence, jealousy and friendship as well as *disegno*, imitation, and invention were part of his life. Vasari did not distance the past, he held up the mirror of history and captured its reflections for present and future generations.

creating an image of heavenly, elevated, and divine things"). See also the Life of Paolo Uccello, BB III, p. 62: "attesoché l'ingegno vuol essere affaticato quando l'intelletto ha voglia di operare, e che' l furore è acceso, perché allora si vede uscirne parti eccellenti e divini, e concetti maravigliosi" ("given that the mind must labor when the intellect desires to work, and becomes frenzied, because one can then see the excellent and divine results and marvelous concepts").

41 Life of Perino del Vaga, BB V, pp. 105–6, arguing against nobility of birth in favor of heaven's intervention in apportioning grace, so that even one born poor and soon orphaned like Perino could achieve great stature: "Grandissimo è certo il dono della virtù, la quale non guardando a grandezza di roba né a dominio di stati o nobiltà di sangue, il più delle volte cigne et abbraccia e solleva da terra uno spirito povero . . . Laonde si può senza dubbio credere che il Cielo solo sia quello che conduca gli uomini, da quella infima bassezza dov'e'

nascono, al sommo della grandezza dove eglino ascendono quando, con l'opere loro affaticandosi, mostrano essere seguitatori delle scienze ch'e' pigliano a imparare."

42 Life of Raffaellino del Garbo, BB IV, p. 115 (1550): "È gran cosa che la natura si sforza talora di far uno ingegno . . . che gli uomini si promettono di lui che e' debba salir sopra il cielo."

43 Castiglione, *Cortegiano*, ed. Cian, Book I, chapter 27, p. 65: "Non v'accorgete che questo che voi in messer Roberto chiamate sprezzatura, è vera affettazione? perché chiaramente si conosce che esso si sforza con ogni studio mostrar di non pensarvi: e questo è il pensarvi troppo; e perché passa certi termini di mediocrità, quella sprezzatura è affettata e sta male." See also Loos, *Baldassare Castigliones "Libro del Cortegiano"*, pp. 109–12, and Saccone, " 'Grazia, Sprezzatura, Affettazione,' " in *Castiglione: The Ideal and the Real in Renaissance Culture*, ed. Hanning and Rosand, pp. 54–6.

BIBLIOGRAPHY

SHORT TITLES AND ABBREVIATIONS

Ad H. [Cicero] *Ad C. Herennium Libri IV De Ratione Dicendi*, trans. H. Caplan, Loeb (London and Cambridge, Mass., 1954).

Anon. Maglia. *Il Codice Magliabechiano cl. XVII. 17*, ed. C. Frey, Gregg International Publishers (Westmead, Farnborough, Hants., 1969; reprint of Berlin, 1892 ed.).

Arezzo 1981 *Giorgio Vasari. Principi, letterati e artisti nelle carte di Giorgio Vasari, Casa Vasari. Pittura vasariana dal 1532 al 1554, Sottochiesa di S. Francesco*, exhib. Arezzo (1981), Edam (Florence, 1981).

ASF Archivio di Stato, Florence.

Atti 1974 Istituto Nazionale di Studi sul Rinascimento, *Il Vasari storiografo e artista. Atti del congresso internazionale nel IV centenario della morte (Arezzo-Firenze 2–8 settembre 1974)* (Florence, 1976).

BB Vasari, G., *Le vite de' più eccellenti pittori scultori e architettori nelle redazioni del 1550 e 1568*, ed. R. Bettarini and P. Barocchi, 6 vols., Sansoni (Florence, 1966–87).

De Ora. Cicero, *De Oratore*, trans. E.W. Sutton and H. Rackham, 2 vols., Loeb (London and Cambridge, Mass., 1976–7).

Frey Frey, K., *Der Literarische Nachlass Giorgio Vasaris*, 2 vols., Georg Müller (Munich, 1923, 1930).

I.O. Quintilian, *Institutio Oratoria*, trans. H.E. Butler, 4 vols., Loeb (London and Cambridge, Mass., 1959–68).

Medici 1980 Unione regionale delle province toscane, *Firenze e la toscana dei Medici nell'Europa del '500 (Convegno internazionale di studio, Firenze, 1980)*, 3 vols., Olschki (Florence, 1983).

N.H. Pliny, *Natural History*, trans. H. Rackham, 10 vols., Loeb (London and Cambridge, Mass., 1968), vol. IX.

Studi 1950 Istituto Nazionale di Studi sul Rinascimento, *Studi Vasariani. Atti del convegno internazionale per il IV centenario della prima edizione delle "Vite" del Vasari (Firenze-Palazzo Strozzi, 16–19 settembre 1950)*, Sansoni (Florence, 1950).

Studi 1981 *Giorgio Vasari: tra decorazione ambientale e storiografia artistica. Convegno di Studi (Arezzo, 8–10 ottobre 1981)*, ed. G.C. Garfagnini, Olschki (Florence, 1985).

A NOTE ON EDITIONS OF *THE LIVES*

The first edition of Vasari's book was published in 1550 by the Torrentino press in Florence. Two quarto volumes, its frontispiece gives the title: *Le vite de piu eccellenti architetti, pittori, et scultori italiani, da Cimabue insino a' tempi nostri: Descritte in lingua Toscana, da Giorgio Vasari Pittore Aretino. Con una sua utile & necessaria introduzzione a le arti loro* (pl. 48). The second edition of three volumes and including woodcut portraits of the artists, appeared from the Giunti press in Florence in 1568. There are two versions of the title page, the shorter reads: *Le vite de' piu eccellenti pittori, scultori, et architettori, Scritte, e di nuovo Ampliate da M. Giorgio Vasari Pit. et Archit. Aretino. Co' ritratti loro Et con le nuove vite dal 1550 insino al 1567 Con Tavole copiosissime De' nomi, dell'opere, E de' luoghi ou'elle sono* (pl. 71). A comprehensive list of subsequent Italian editions and selections can be found in the bibliography in volume viii of the Club del Libro edition of the *Vite*. A succinct history of critical editions and approaches is given by Julius von Schlosser in *La letteratura artistica* (pp. 332–46) and more extensively by Paola Barocchi in BB (*Commento*, i, pp. ix–xlv), with excerpts from selected prefaces.

A rarity by the 1560s and outdated according to Vasari, the first edition has come to be appreciated for its structural clarity and compact narrative. Connected to the revaluation of Vasari as writer, first seriously argued in this century by Ugo Scoti-Bertinelli in *Giorgio Vasari scrittore* (1905), Wolfgang Kallab (*Vasaristudien*, 1908), and von Schlosser, is a reappraisal of the merits of the 1550 *Lives*. In 1986 Einaudi publishers issued a one-volume version of the 1550 *Vite*, edited by Luciano Bellosi and Aldo Rossi, meant in size and presentation to emphasize the readability of *The Lives*. Judicious use of small print allowed for the inclusion of substantial critical apparatus, notes to the individual biographies, a bibliographic summary as well as introductions to Vasari, his book, its printings, and its survival.

Recognition that the comparison of the two editions not only helped in the reading of both, but was a key to developments in the critical, cultural, artistic, and historiographic thought of Vasari and his contemporaries resulted in parallel-text editions of *The Lives*: first the Michelangelo Life edited by Paola Barocchi (*La Vita di Michelangelo nelle redazioni del 1550 e del 1568*) and subsequently the complete *Lives*, edited by Paola Barocchi and Rosanna Bettarini (BB).

Correction and criticism of *The Lives* began with Vasari himself, as the first became the second edition. And the second, even as it was being published, was subjected to change. The variations in format and text of that edition are considered by Rosanna Bettarini in BB i, pp. xx–xl, and by Aldo Rossi in "La Vita vasariana di Michelangelo curata da Paola Barocchi," *Paragone*, 178 (1964), pp. 73–5, and in the Club del Libro edition, viii, pp. 281–93. The material so assiduously gathered for the expanded edition of 1568 was exploited by Vasari and his publishers. The Life of Michelangelo was printed separately, as were the portraits, both in 1568 (see U. Procacci and C. Davis in Arezzo 1981, pp. 284–5, pp. 257–9). Vasari continued to receive information about artists after the publication of his second edition. In the case of Jacopo Sansovino this resulted in a new Life published in 1570 (probably in Venice; for this, see C. Davis in Arezzo 1981, pp. 293–5).

The early critical reading of Vasari is documented by notes found in the margins of copies owned by such engaged and partisan readers as the artists Federico Zuccaro, El Greco, and the Carracci brothers (the latter, offended by Vasari's Tuscan bias, called him presumptuous, ignorant, and a liar; Schlosser, *La letteratura artistica*, pp. 333–4, M. Daly Davis in Arezzo 1981, pp. 243–4, also C. Dempsey, "The Carracci *Postille* to Vasari's *Lives*," *Art Bulletin*, lxviii [1986], pp. 72–6). The first critical edition of *The Lives* was published in Bologna in 1647, with notes by Carlo Manolessi. Claiming to correct the nearly infinite errors of the Giunti text, it added considerably to the faults and only (and literally) marginally to the information. It was the edition prepared about a hundred years later by the erudite Jesuit Giovanni Bottari that established a standard and an approach for subsequent editions (*Vite/de' più Eccellenti/pittori scultori/e architetti/scritte/da Giorgio Vasari/pittore et architetto aretino/Corrette da molti errori/e illustrate con note*, 3 vols., Niccolò and Marco Pagliarini,

Rome, 1759–60). Although deploring printing and factual errors in the Giunti edition, Bottari did not seek to revise the book systematically. He declared that his principal aim was to note changes since Vasari's time and to add such information as seemed lacking. A philologist, Bottari emended the text according to linguistic and editorial ideals of his time, using the 1568 edition, but comparing and combining it with the 1550 edition. A keen amateur, his memory, library, and letters served him well, and his notes and commentary, correcting and updating *The Lives*, became the basis for future annotated editions, both as source and inspiration.

During the nineteenth century editions of Vasari's *Vite* expanded to become editions of his literary works, including all his known letters and his description of the decorations of the Palazzo Vecchio, the *Ragionamenti*. The most comprehensive and extensively commentated edition was that produced between 1878 and 1885 in nine volumes by the librarian and archivist Gaetano Milanesi (*Le vite de più eccellenti pittori scultori ed architettori scritte da Giorgio Vasari pittore aretino con nuove annotazioni e commenti*, Sansoni, Florence). Appreciating Vasari as a writer and artist and sympathizing with his lack of resources and sources, Milanesi's editorial attack was on what he viewed as a lack of certainty and order: the "notable defects" in Vasari's narration of history (I, p. vi). Fortified by the love of truth and having the complete freedom of the Florentine archives, Milanesi's diligence in searching out and interpreting sources and establishing chronologies made his edition invaluable for the study of Renaissance art. It was reprinted by Sansoni in 1973 with an introduction by Paola Barocchi. There are substantial differences between Milanesi's *Vite* and Vasari's, however. Milanesi did not include the artists' portraits. He altered Vasari's punctuation and spelling to suit nineteenth-century standards. This rephrasing has the unfortunate result of occasionally changing the sense along with the style of the original prose.

Twentieth-century editors of Vasari have been concerned to re-establish the text as well as the critical context of *The Lives*. For this reason BB, the Einaudi 1550 reprint, and the Club del Libro edition, all based on the study and comparison of existing originals and carefully argued editorial principles must be considered the most reliable versions to read, as well as the most current to consult for notes and commentary.

English Translations

In his manual of instruction for the *Compleat Gentleman* (1622), Henry Peacham referred those who might wish to read the lives of the painters to the "two volumes of Vasari." He added that he had not seen them but that he knew of two copies, one in the library of Inigo Jones. Seeking to acquaint the aspirant gentleman with the best masters Italy had afforded, he included a brief section with eighteen artists' lives very loosely derived from Vasari by way of Carel van Mander (twelve from Part 1, five from Part 2, and Raphael). Vasari was next presented to the English reader when taste and the Grand Tour were becoming fashionable. William Aglionby, who wanted "to make Painting Familiar and Easie to the Nobility and Gentry of this Nation" so that they might become "Promoters of an art that lies in Nice Observations," added eleven of Vasari's Lives to his *Painting illustrated in Three Diallogues, containing some choice observations upon the Art*, published in London in 1685 and again in 1719. This amateur tradition has dominated the treatment of Vasari in English. In the nineteenth century, Mrs. Jonathan Foster produced the first full set of *The Lives* with "notes and illustrations, chiefly selected from various commentators" (5 vols., H.G. Bohn, Bohn's Standard Library, London, 1850; a sixth volume with notes by J.P. Richter was published in 1885 by G. Bell and sons, *Commentary containing notes and emendations from the Italian edition of Milanesi and other sources*). Mrs. Foster left scholarship to the Germans, noting "their unconquerable patience of research, and minuteness of investigation." And indeed, there are two German translations of the 1568 *Lives* with important commentary and several editions of individual biographies with detailed scholarly notes (L. Schorn and E. Förster, *Leben der ausgezeichnesten Maler, Bildhauer und Baumeister von Cimabue bis*

zum Jahre 1567, beschreiben von Giorgio Vasari, Maler und Baumeister, 6 vols., Stuttgart and Tübingen, 1832–49; reprinted with an introduction by J. Kliemann, Werner'sche Verlagsgesellschaft, Worms, 1983, and A. Gottschewski and G. Gronau, *Die Lebensbeschreibungen der berühmtesten Architekten, Bildhauer und Maler*, 7 vols., Strassburg, 1916, 1904–27). There is also a recent French edition, supervised and prefaced by André Chastel (*Giorgio Vasari. Les Vies des Meilleurs Peintres, Sculpteurs et Architectes*, 12 vols., Berger-Levrault, Paris, 1981–89). Illustrated and including notes on the artists, and introductions to Vasari as an artist and historian, this could serve as a model for a new English version. There is at present no complete critical edition of *The Lives* in English, and not even a very reliable translation.

Mrs. Foster's florid mid-Victorian Vasari was followed by A.B. Hinds's Temple Classics version in 1900 (*The Lives of the Painters, Sculptors & Architects by Giorgio Vasari*, J.M. Dent, London). This was revised and reissued with an introduction, very occasional notes, and a glossary in the Everyman's Library in 1927; another revision of this text was published in 1963 (W. Gaunt ed., *Giorgio Vasari, The Lives of the Painters, Sculptors and Architects*, 4 vols., London and New York). More restrained than its predecessor, this translation often rephrases the original, alters sentence and paragraph structure, and consequently the meaning. Its virtues are availability and affordability. The same is true of the Penguin Classics paperback selections (*Lives of the Artists*, trans. G. Bull, 2 vols., 1987): an admittedly free translation, this modern rendering is very readable, but as a consequence it also disregards some of the subtleties of Vasari's language and underlying rhetorical structures. The Italian has been followed more closely, but the text abridged, in the annotated selections by Julia Conaway Bondanella and Peter Bondanella, which include thirty-four of the biographies, the prefaces to each part, and Vasari's letter to his fellow artists (*The Lives of the Artists*, Oxford University Press, Oxford, 1991). The 1912 translation by Gaston de Vere is intentionally literal and often avowedly awkward (*Lives of the Most Eminent Painters Sculptors and Architects by Giorgio Vasari*, 10 vols., Macmillan and Co. and the Medici Society, London, 1912–14). Although illustrated, it lacks detailed commentary, so that it is as unlikely to inform as to delight the inexperienced reader. The De Vere translation was used as the basis for a glamorously produced edition with an introduction by Kenneth Clark (*Giorgio Vasari, Lives of the Most Eminent Painters Sculptors and Architects*, illustrations selected and annotated by M. Sonino, 3 vols., H.N. Abrams, New York, 1979). It includes the frontispieces and portraits and has a more extensive index than other English editions. In design and scale these volumes give a sense of the original Giunti edition. Like the other English versions, it is an edition of the biographies not *The Lives*: none includes the technical introduction and, except for De Vere and Foster, Vasari's dedicatory letters are omitted. Fortunately Louisa S. Maclehose's *Vasari on Technique, being the Introduction to the Three Arts of Design* (J.M. Dent, London, 1907; Dover Publications, New York, 1960 reprint) provides a translation of the introduction. An illustrated companion to Vasari is currently being prepared under the supervision of Sir John Pope-Hennessy (to be published by Philip Wilson). This intends to illustrate the paintings and sculptures mentioned in *The Lives* with accompanying quotations from the passages related to the works and with a critical note on Vasari's attributions.

Until recently T.S.R. Boase's *Giorgio Vasari. The Man and the Book* (Princeton University Press, Princeton, 1979) has been the only synoptic treatment of *The Lives* in English. It is more of a descriptive than a critical consideration of the book and is based largely on quotation and paraphrasing from the 1568 edition. Paul Barolsky's engaging and illuminating trilogy (*Michelangelo's Nose, Why the Mona Lisa Smiles, Giotto's Father*, Pennsylvania State University Press, University Park, Pa., 1990–2) sets out to chart the fascinating territory of Vasari's literary and historical imagination and alerts modern readers to Vasari's literary art and its underlying structures and themes. Another welcome addition to the bibliography is Laura Corti's illustrated catalogue, *Vasari. Catalogo completo dei dipinti* (Cantini, Florence, 1989). Vasari has generally been studied according to his roles (painter, writer, courtier, architect), a division and historical definition reflected in the literature.

The present book is about Vasari's book and, it is hoped, contributes to an understanding of how those various roles, identities, and identifications are incorporated and expressed in *The Lives*. The bibliography that follows refers to works cited and consulted. It is not intended to be a complete Vasari bibliography any more than this book is intended to present, create, or construct a historical chimera, a complete Vasari.

BIBLIOGRAPHY

Sources

Alberti, L.B., *L'architettura di Leonbatista Alberti. Tradotta in lingua Fiorentina da Cosimo Bartoli*, Torrentino (Florence, 1550).

Alberti, L.B., *L'architettura (De re aedificatoria)*, trans. G. Orlandi, ed. P. Portoghesi, Edizioni il Polifilo (Milan, 1966), 2 vols.

Alberti, L.B., *I Libri della Famiglia*, ed. R. Romano and A. Tenenti, Einaudi (Turin, 1969).

Alberti, L.B., *On Painting and on Sculpture*, ed. and trans. C. Grayson, Phaidon (London, 1972).

Alberti, L.B., *Opere volgari*, III, ed. C. Grayson, Laterza (Bari, 1973).

Alberti, L.B., *La pittura di Leonbattista Alberti tradotta per M. Lodovico Domenichi*, Gabriel Giolito de Ferrari (Venice, 1547).

Albertini, F., "Memoriale di Molte Statue et Picture sono nella inclyta Cipta di Florentia . . ." (Rome, 1510), in *Five Early Guides to Rome and Florence*, ed. P. Murray, Gregg International Publishers (Westmead, Farnborough, Hants., 1972).

Aretino, P., *Lettere scritte al Signor Pietro Aretino da molti Signori, Comunità, Donne di ualore, Poeti, & altri Eccellentissimi Spiriti*, Francesco Marcolini (Venice, 1552; colophon 1551).

Aretino, P., *Lettere sull'arte di Pietro Aretino*, 3 vols., ed. F. Pertile and E. Camesasca, Edizioni del Milione (Milan, 1957–60).

Aretino, P., *Libro Secondo delle Lettere di Pietro Aretino*, Marcolini (Venice, 1542).

Aretino, P., *Tutte le commedie*, Mursia (Milan, 1968).

Ariosto, L., *Orlando Furioso secondo l'edizione del 1532 con le varianti delle edizioni del 1516 e del 1521*, ed. S. Debenedetti and C. Segre, Commissione per i testi di lingua (Bologna, 1960).

Aristotle, *The Art of Rhetoric*, trans. J.H. Freese, Loeb (London and New York, 1926).

Aristotle, *The Complete Works of Aristotle. The Revised Oxford Translation*, 2 vols., ed. J. Barnes, Princeton University Press (Princeton, N.J., 1984).

Aristotle, *L'Ethica d'Aristotle tradotta in lingua vulgare fiorentina et comentata per Bernardo Segni*, Torrentino (Florence, 1550).

Aristotle, *Rettorica e poetica d'Aristotile tradotte di greco in lingua vulgare fiorentina da Bernardo Segni gentil'huomo, & accademico fiorentino*, Torrentino (Florence, 1549).

[Aristotle], *Il Segreto de Segreti, le Moralita, & la Phisionomia d'Aristotile*, trans. G. Manente, Zuan Tacuino da Trino (Venice, 1538).

Baglione, G., *Le vite de' pittori scultori et architetti. Dal Pontificato di Gregorio XIII. del 1572. In sino a' tempi di Papa Urbano Ottauo nel 1642*, facsimile of 1642 edition, ed. V. Mariani, R. Istituto d'archeologia e storia dell'arte (Rome, 1935).

Barocchi, P., ed., *Scritti d'arte del Cinquecento*, 3 vols., Riccardo Ricciardi (Milan-Naples, 1971–7).

Barocchi, P., ed., *Trattati d'arte del Cinquecento fra manierismo e controriforma*, 3 vols., Laterza (Bari, 1960–2).

Barocchi, P., and R. Ristori, eds., *Il carteggio di Michelangelo*, 5 vols., Sansoni/S.P.E.S. (Florence, 1965–83).

Bartoli, C., *Discorsi historici universali*, Francesco de Franceschi (Venice, 1569).

Bartoli, C., *Ragionamenti accademici di Cosimo Bartoli gentil'huomo et Accademico Fiorentino sopra alcuni luoghi difficili di Dante, con alcune inventioni et significanti*, Francesco de Franceschi (Venice, 1567).

Bellori, G.P., *Descrizzione delle imagini dipinte da Raffaelle d'Urbino nelle Camere del Palazzo Apostolico Vaticano* (Rome, 1695), Gregg International Publishers reprint (Westmead, Farnborough, Hants., 1968).

Bembo, P., *Prose della volgar lingua*, ed. M. Marti, Liviana (Padua, 1955).

Bembo, P., *Prose scelte*, ed. F. Costèro, Sonzogno (Milan, 1880).

Biondo, F., *Roma ristaurata, et Italia illustrata*, trans. L. Fauno, M. Tramezzino (Venice, 1543).

Boccaccio, G., *Decameron*, ed. V. Branca, 2 vols., Felice Le Monnier (Florence, 1952).

Boccaccio, G., *The Decameron*, trans. G.H. McWilliam, Penguin Classics (Harmondsworth, Middlesex, 1972).

Boccaccio, G., *Opere*, ed. P.G. Ricci, Riccardo Ricciardi (Milan-Naples, 1965).

Boccaccio, G., *Opere volgari di Giovanni Boccaccio*, I.

Moutier (Florence, 1821), XI (*Il commento sopra la Commedia*, vol. 2).

Bocchi, F., *Le Bellezze della città di Fiorenza*, B. Sermartelli (Florence, 1591).

Borghini, V., *Discorsi di Monsignore D. Vincenzo Borghini*, 2 vols., Pietro Gaetani Viviani (Florence, 1785).

Bottari, S., and G.S. Ticozzi, *Raccolta di lettere sulla pittura, scultura ed architettura*, 8 vols., Giovanni Silvestri (Milan, 1822–5).

Bracciolini, P., *Historia Fiorentina tradotta da Iacopo suo figlio*, Jacopo de' Rossi (Venice, 1476), ed. E. Garin, Biblioteca della Città di Arezzo (Cortona, 1980).

Brucioli, A., *Dialogi della morale philosophia*, Francesco Brucioli (Venice, 1544).

Brucioli, A., *Dialogi*, ed. A. Landi, Prismi (Naples, 1982).

Bruni, L. *Historiarum Florentini populi libri XII e Rerum suo tempore gestorum commentarius*, ed. E. Santini and C. di Pietro, S. Lapi (Città di Castello, 1926).

Bruni, L., *Leonardo Bruni Aretino, Humanistisch-Philosophische Schriften*, ed. H. Baron, B.G. Teubner (Leipzig, 1928).

Bruni, L., and P. Bracciolini, *Storie Fiorentine*, ed. E. Garin, Biblioteca della Città di Arezzo (Cortona, 1984).

Cambi, G., *Istorie*, III, *Delizie degli Eruditi Toscani*, ed. I. di San Luigi, Gaetano Cambiagi (Florence, 1786), vol. XXII.

Caro, A., *Lettere familiari*, 3 vols., ed. A. Greco, Felice Le Monnier (Florence, 1957–61).

Castiglione, B., *The Book of the Courtier*, trans. G. Bull, Penguin (Harmondsworth, Middlesex, 1967).

Castiglione, B., *Il Libro del cortegiano*, ed. V. Cian, Sansoni (Florence, 1957).

Cellini, B., *The Autobiography of Benvenuto Cellini*, trans. J. Symonds, Garden City Publishing (Garden City, N.Y., 1927).

Cellini, B., *Opere di Benvenuto Cellini*, ed. G. Ferrero, Unione Tipografico–Editrice Torinese (Turin, 1971).

Cellini, B., *Delle Rime di Benvenuto Cellini*, ed. A. Mabellini, G.B. Paravia (Rome, 1885).

Cellini, B., *Vita di Benvenuto Cellini*, ed. O. Bacci, Sansoni (Florence, 1901).

Cennino Cennini, *The Craftsman's Handbook. "Il libro dell'arte"*, trans. D.V. Thompson Jr., Dover (New York, 1960).

Cennino Cennini, *Il libro dell'arte*, ed. F. Brunello and L. Magagnato, Neri Pozza (Vicenza, 1971).

[Cicero], *Ad. C. Herennium Libri IV De Ratione Dicendi*, trans. H. Caplan, Loeb (London and Cambridge, Mass., 1954).

Cicero, *Brutus, Orator*, trans. G.L. Hendrickson and H.M. Hubbell, Loeb (London and Cambridge, Mass., 1971).

Cicero, *De Inventione*, trans. H.M. Hubbell, Loeb (London and Cambridge, Mass., 1949).

Cicero, *De Officiis*, trans. W. Miller, Loeb (London and New York, 1913).

Cicero, *De Oratore*, 2 vols., trans. E.W. Sutton and H. Rackham, Loeb (London and Cambridge, Mass., 1976–7).

Cicero, *De Partitione Oratoria*, trans. H. Rackham, Loeb (Cambridge, Mass. and London, 1977).

Cicero, *De Senectute, De Amicitia, De Divinatione*, trans. W.A. Falconer, Loeb (London and New York, 1927).

Cicero, *Di Marco Tullio Cicerone. De gli uffici. Della amicitia. Della vecchiezza. Le Paradosse. Tradotte par un nobile vinitiano*, trans. F. Vendramino, B. di Vitale Vinitiano (Venice, 1528).

Cicero, *Opere di Marco Tullio Cicerone tradotte in lingua vulgare di nuovo impresse et corette. De Gli Uffici, Della Amicitia, Della Vecchiezza, Le Paradosse, Il Sonno di Scipione*, trans. F. Vendramino and A. Brucioli, Giovanni da la chiesa Pavese (Venice, 1539 and 1544).

Cicero, *Pro Archia Poeta*, trans. N.H. Watts, Loeb (Cambridge and London, 1929).

[Cicero], *Rhetorica di Marco Tullio Cicerone, tradotta di latino in lingua toscana per Antonio Brucioli*, Bartolomeo de Zanetti da Brescia (Venice, 1538; Gabriel Giolito de Ferrari, Venice, 1542).

Colasanti, A., "Il memoriale di Baccio Bandinelli," *Repertorium für Kunstwissenschaft*, XXVIII (1905), pp. 406–43.

Condivi, A., *The Life of Michelangelo by Ascanio Condivi*, trans. A.S. Wohl, ed. H. Wohl, Louisiana State Press (Baton Rouge, 1976).

Cortesi, P., *De Hominibus Doctis Dialogus*, trans. and ed. M.T. Graziosi, Bonacci (Rome, 1973).

Dante Alighieri, *La Divina Commedia*, ed. C.H. Grandgent, revised by C. Singleton, Harvard University Press (Cambridge, 1972).

Dante Alighieri, *The Purgatorio of Dante Alighieri*, trans. T. Okey, Temple Classics, J.M. Dent & Sons (London, 1964).

Diodorus Siculus, *Diodoro Siculo delle antique historie fabulose nuovamente fatto vulgare & con diligentia stampato*, Heredi di Philippo di Giunta (Florence, 1526).

Diodorus Siculus, *Diodorus of Sicily*, trans. C.H. Oldfather, Loeb (London and New York, 1933).

Dolce, L., *Lettere di diversi eccellentiss. huomini*, G. Giolito & fratelli (Venice, 1554).

Domenichi, L., *Facetie et motti arguti*, Torrentino (Florence, 1548).

Domenichi, L., *Facetie, motti, et burle di diversi Signori et persone private*, Iacomo Leoncini (Venice, 1584).

Doni, A.F., *Disegno*, ed. M. Pepe, Electa (Milan, 1970).

Doni, A.F., *Lettere*, Doni (Florence, 1547).

Doni, A.F., *La Libraria del Doni Fiorentino*, Gabriel Giolito de Ferrari (Venice, 1550).

Doni, A.F., *I Marmi*, ed. E. Chiòboli, Laterza (Bari, 1928).

Doni, A.F., *Prose antiche di Dante, Petrarcha, et Boccaccio, et di molti altri nobili et virtuosi ingegni. Nuovamente raccolte*, Doni (Florence, 1547).

Fabriczy, C. von, "Il Libro di Antonio Billi e le sue copie nella Biblioteca Nazionale di Firenze," *Archivio Storico Italiano*, ser. v. VIII (1891), pp. 299–334; Gregg International Publishers reprint (Westmead, Farnborough, Hants., 1969).

Ficino, M., *Commentary on Plato's "Symposium" on Love*, trans. S. Jayne, Spring Publications (Dallas, 1985).

Ficino, M., *El libro dell'Amore*, ed. S. Niccoli, Olschki (Florence, 1987).

Ficino, M., *Marcel Ficin. Commentaire sur le Banquet de Platon*, trans. R. Marcel, Société d'Édition "Les Belles Lettres" (Paris, 1956).

Ficino, M., *Sopra lo amore o ver' Convito di Platone. Comento di Marsilio Ficini fiorentino sopra il Convito di Platone*, ed. G. Ottaviano, Celuc (Milan, 1973).

Filarete, *Trattato di architettura*, ed. A.M. Finioli and L. Grassi, Edizioni il Polifilo (Milan, 1972).

Firenzuola, A., *Prose*, Giunti (Florence, 1548).

Florus, L. Annaeus, *Epitome rerum Romanorum*, trans. E. Forster, Loeb (London and New York, 1929).

Fornari, S., *La Spositione di M. Simon Fornari da Rheggio sopra L'Orlando Furioso di M. Ludovico Ariosto*, Torrentino (Florence, 1549).

Frey, C. ed., *Il codice Magliabechiano*, G. Grote'sche Verlagsbuchhandlung (Berlin, 1892; Gregg International Publishers reprint [Farnsborough, Hants., 1969]).

Frey, C., ed., *Il libro di Antonio Billi esistente in due copie nella Biblioteca Nazionale di Firenze*, G. Grote'sche Verlagsbuchhandlung (Berlin, 1892).

Frey, H.W., *Neue Briefe von Giorgio Vasari (Der Literarische Nachlass*, vol. III), August Hopfer (Burg b. M., 1940).

Frey, K., *Der Literarische Nachlass Giorgio Vasaris*, 2 vols., Georg Müller (Munich, 1923, 1930).

Gaye, G., *Carteggio inedito d'artisti dei secoli XIV. XV. XVI*, 3 vols., Giuseppe Molini (Florence, 1839–40).

Gelli, G.B., *Lezioni petrarchesche di Giovan Battista Gelli*, ed. C. Negroni, Gaetano Romagnoli (Bologna, 1884).

Gelli, G.B., *Opere di Giovan Battista Gelli*, ed. D. Maestri, Unione Tipografico – Editrice Torinese (Turin, 1976).

Ghiberti, L., *Lorenzo Ghibertis Denkwürdigkeiten (I Commentari)*, ed. J. von Schlosser, Julius Bard (Berlin, 1912).

Giovio, P., *De Romanis piscibus*, F.M. Calvi (Rome, 1524).

Giovio, P., *Elogia veris clarorum virorum imaginibus apposita*, Tramezini (Venice, 1546).

Giovio, P., *Elogia virorum bellica virtute illustrium*, Torrentino (Florence, 1551).

Giovio, P., *Gli Elogi degli Uomini Illustri*, ed. R. Meregazzi, Istituto Poligrafico dello Stato, *Pauli Iovii Opera*, VIII (Rome, 1972).

Giovio, P., *Lettere*, ed. G.G. Ferrero, Istituto Poligrafico dello Stato, *Pauli Iovii Opera*, I (Rome, 1956).

Giovio, P., *Pauli Iovii Novocomensis Episcopi Nucerini de vita Leonis Decimi Pont. Max. Libri IIII*, Torrentino (Florence, 1548).

Giovio, P., *Le Vite di Leon Decimo et d'Adriano Sesto sommi pontefici et del Cardinal P. Colonna*, trans. L. Domenichi, Torrentino (Florence, 1549).

Golzio, V., *Raffaello nei documenti, nelle testimonianze dei contemporanei e nella letteratura del suo secolo*, Pontificia Insigne Accademia del Virtuosi al Pantheon (Città del Vaticano, 1936).

Horace, *Ars Poetica*, trans. H.R. Fairclough, Loeb (Cambridge, Mass., and London), 1928.

[Landi, G.], *Formaggiata di sere Stentato al serenissimo re della virtude*, ser Grassino formagiero (Piacenza, 1542).

Landino, C., *Comento di Christophoro Landino Fiorentino sopra la Comedia di Danthe Alighieri Poeta Fiorentino*, Nicola di Lorenzo della Mappa (Florence, 1481).

Lenzoni, C., *In difesa della lingua fiorentina, et di Dante, da lui principiata, da Francesco Giambullari accresciuta, e da Cosimo Bartoli terminata*, Torrentino (Florence, 1556).

Leonardo da Vinci, *Das Buch von der Malerei. Nach dem codex Vaticanus (Urbinas) 1270*, ed. H. Ludwig, 3 vols., Wilhelm Braumüller (Vienna, 1888).

Leonardo da Vinci, *Leonardo on Painting*, ed. and trans. M. Kemp and M. Walker, Yale University Press (New Haven and London, 1989).

Liburnio, N., *Elegantissime sentenze et aurei detti di diuersi antiqui saui. Molti motti de piu boni authori*, G. Gioli (Venice, 1543).

Liburnio, N., *Le molte et diuerse virtu delli saui antiche*, B. Stagnino (Venice, 1537).

Liburnio, N., *Le tre fontane di Messer Niccolo Liburnio in tre libbri divise, sopra la grammatica, et eloquenza di Dante, Petrarcha, et Boccaccio*, Gregorio de Gregorii (Venice, 1536).

Livy, *Historiae ab urbe condita*, trans. B. Foster, Loeb (London and New York, 1919–29).

Lorenzoni, A., *Carteggio artistico inedito di D. Vincenzo Borghini*, Seeber (Florence, 1912).

Lucian, *I dilettevoli dialogi, le vere narrationi, le facete epistole di Luciano philosopho, di Greco in volgare*

tradotto per M. Nicolo da Lonigo, Francesco Bindoni & Mapheo Pasini (Venice, 1535/6).

Machiavelli, N., *Lettere*, ed. F. Gaeta, Feltrinelli (Milan, 1961).

Machiavelli, N., *Opere*, ed. M. Bonfantini, Riccardo Ricciardi (Milan-Naples, 1954).

Machiavelli, N., *The Prince*, trans. G. Bull, Penguin Books (Harmondsworth, Middlesex, 1961).

Machiavelli, N., *La vita di Castruccio Castracani da Lucca discripta da Niccolò Machiavelli et mandata a Zanobi Buondelmonti et a Luigi Alamanni suoi amicissimi*, ed. R. Brakee and P. Trovato, Liguori (Naples, 1986).

Macrobius, *The Saturnalia*, trans. P.V. Davies, Columbia University Press (New York, 1969).

Malvasia, C., *Felsina Pittrice. Vite de Pittori Bolognesi*, L'Erede de Domenico Barbieri (Bologna, 1678).

Mancini, G., "Vite d'artisti di Giovanni Battista Gelli," *Archivio storico italiano*, XVII (1896), pp. 32–62.

Manetti, A., *Vita di Filippo Brunelleschi preceduta da la Novella del Grasso*, ed. D. de Robertis and G. Tanturli, Edizioni il Polifilo (Milan, 1976).

Manuzio, P., *Lettere volgari di diversi nobilissimi huomini, et eccellentissimi ingegni, scritte in diverse materie. Nuovamente ristampate, & in più luoghi corrette*, Figliuoli di Aldo (Venice, 1544)

Memmo, G., *L'oratore*, Giovanni de Farri & fratelli (Venice, 1545).

Milanesi, G., *Sei lettere inedite di Giorgio Vasari tratte dall'Archivio Centrale di Stato di Firenze* (Lucca, 1868).

Miniatore, B., *Formulario ottimo & elegante, il quale insegna il modo del scrivere lettere messive & responsive, con tutte le mansioni sue a li gradi de le persone convenevoli*, Francesco di Alessandro Bindoni & Mapheo Pasini (Venice, 1531).

Morisano, O., "Art Historians and Art Critics – III: Cristoforo Landino," *Burlington Magazine*, XCV (1953), p. 270.

Neri di Bicci, *Le ricordanze (10 marzo 1453 – 24 aprile 1475)*, ed. B. Santi, Edizioni Marlin (Pisa, 1976).

Palmieri, M., *Della vita civile*, ed. G. Belloni, (Florence, 1982).

Petrarch, F., *Canzoniere*, ed. G. Contini, Einaudi (Turin, 1966).

Petrarch, *Le Famigliari*, ed. V. Rossi, 4 vols., Edizione Nazionale delle Opere di Francesco Petrarca, X–XIV, Sansoni (Florence, 1933–42).

Petrarch, *Le rime sparse e i trionfi*, ed. E. Chiòrboli, Laterza (Bari, 1930).

Pico della Mirandola, *On The Dignity of Man*, ed. P.J.W. Miller, Bobbs-Merrill (Indianapolis, N.Y., 1965).

Pino, B., *Della nuova scielta di lettere di diuersi nobilissimi huomini, et eccellentissimi ingegni scritte in diuerse materie* (Venice, 1574 and 1582).

Pino, P., *Dialogo della Pittura* (Venice, 1548), ed. R. and A. Pallucchini, Edizioni Daria Guarnati (Venice, 1946).

Platina, Il [B. Sacchi de Platina], *Delle vite e fatti di tutti i sommi pontefici romani, cominciando da Christo infino a Sisto Quarto con la giunta di tutti gli altri Pontefici, infino a Paulo terzo Pontefice Massimo*, Michele Tramezzino (Venice, 1543).

Pliny, *Historia naturale di Caio Plinio secondo*, trans. C. Landino, M. Sessa and P. di Ravani (Venice, 1516).

Pliny, *Historia Naturale di C. Plinio Secondo di Latino in volgare tradotta per Christophoro Landino*, ed. A. Brucioli, Gabriel Iolito di Ferrarii (Venice, 1543).

Pliny, *Natural History*, vol. IX, trans. H. Rackham, Loeb (London and Cambridge, Mass., 1967).

Plutarch, *The Age of Alexander*, trans. I. Scott-Kilbert, Penguin (Harmondsworth, Middlesex, 1973).

Plutarch, *Alcuni opusculeti de le cose morali del divino Plutarco in questa nostra lingua nuovamente tradotta*, Michiel Tramezino (Venice, 1543).

Plutarch, *Lives*, trans. B. Perrin, Loeb (London and New York), 11 vols., 1918–26.

Plutarch, *Moralia*, vol. I, trans. F.C. Babbitt, Loeb (London and New York, 1927).

Plutarch, *I motti et le sententie notabili de prencipi, Barbari, Greci, et Romani da Plutarcho raccolti*, Paulo Sirardo (Venice, 1543).

Polydore Vergil, *Polydoro Virgilio di Urbino, de la origine e de gl'inventori de le leggi, costumi, scientie, arti, ed di tutto quello che a l'humano uso conviensi*, trans. P. Lauro, Gabriel Giolito de Ferrarii (Venice, 1543).

Pozzi, M., ed., *Trattati d'amore del Cinquecento*, Laterza (Rome and Bari, 1980).

Quintilian, *Institutio Oratoria*, trans. H.E. Butler, 4 vols., Loeb (London and Cambridge, Mass., 1959–1968).

Richter, J.P., *The literary works of Leonardo da Vinci. Compiled & Edited from the Original Manuscripts*, 2 vols., Phaidon (New York, 1970; third edition).

Ridolfi, C., *Le maraviglie dell'arte, ovvero le vite degli illustri pittori veneti e dello stato*, ed. D. von Hadeln, 2 vols., G. Grote'sche Verlagsbuchhandlung (Berlin, 1914, 1924).

Roskill, M., *Dolce's "Aretino" and Venetian Art Theory of the Cinquecento*, New York University Press (New York, 1968).

Santangelo, G., ed., *Le epistole "De Imitatione" di Giovanfrancesco Pico della Mirandola e di Pietro Bembo*, Olschki (Florence, 1954).

Sanuto, M., *Diarii*, ed. G. Berchet, N. Barozzi, and M. Allegri, Visentini (Venice, 1901).

Sarayna, T., *De amplitudine ciuitatis Veronae*, A. Putelleti (Verona, 1540).

Scardeone, B., *De Antiquitate urbis Patavii & claris civibus Patavinis*, Libri Tres, Nicolaus Episcopius (Basel, 1560).

Seneca, *Letters from a Stoic. Epistulae Morales ad Lucilium*, trans. R. Campbell, Penguin (Harmondsworth, Middlesex, 1969).

Serlio, S., *Regole generali sopra le cinque maniere de gli edifici*, Francesco Marcolini (Venice, 1537).

[I. Sichardus], *En Damus Chronicon Diuinum plane opus eruditissimorum autorum, repetitum ab ipso mundi initio, ad annum usque salutatis 1512*, Henricus Petus (Basel, 1529)

Tolomei, C., *Il Cesano. Dialogo nel quale si disputa del nome, col quale si dee chiamare la uolgar lingua*, G. Giolito & fratelli (Venice, 1555).

Tolomei, C., *De le lettere di M. Claudio Tolomei. Lib. sette*, Gabriel Giolito de Ferrari (Venice, 1547).

Valeriano, P., "Dialogo di Pierio Valeriano sopra le lingue volgari. Quale sia più conveniente di usare," in *La infelicità dei letterati*, Malatesta di C. Tinelli (Milan, 1829).

Valeriano, P., *Pro sacerdotum barbis*, Calvi (Rome, 1531).

Varchi, B., *Due Lezzioni di M. Benedetto Varchi, nella prima delle quali si dichiara un Sonetto di M. Michelagnolo Buonarroti. Nella seconda si disputa quale sia piu nobile arte la Scultura, o la Pittura, con una lettera d'esso Michelagnolo, & piu altri Eccellentiss. Pittori, et Scultori, sopra la Quistione sopradetta*, Torrentino (Florence, 1549).

Varchi, B., *Opere di Benedetto Varchi*, ed. A. Racheli, 2 vols., Lloyd Austriaco (Trieste, 1859).

Varchi, B., *Storia fiorentina di Benedetto Varchi*, ed. L. Arbib, Società Editrice delle Storie del Nardi e del Varchi, 3 vols. (Florence, 1838–41).

Vasari, G., *Le Opere di Giorgio Vasari con nuove annotazioni e commenti di Gaetano Milanesi*, ed. P. Barocchi, 9 vols., Sansoni (Florence, 1973; reprint of 1906 edition).

Vasari, G., *La Vita di Michelangelo nelle redazioni del 1550 e del 1568*, 5 vols., ed. P. Barocchi, Riccardo Ricciardi (Milan and Naples, 1962)

Vasari, G., *Le vite de' più eccellenti pittori scultori ed architettori scritte da Giorgio Vasari pittore aretino con nuove annotazioni e commenti*, ed. G. Milanesi, 9 vols., Sansoni (Florence, 1878–85).

Vasari, G., *Le vite*, ed. K. Frey, Georg Müller (Munich, 1911).

Vasari, G., *Le vite de' più eccellenti pittori scultori e architettori*, ed. P. della Pergola, L. Grassi, and G. Previtali, 9 vols., Club del Libro (Milan, 1962–6; reprinted for the Istituto Geografico de Agostini, Novara, 1967).

Vasari, G., *Le vite de' più eccellenti architetti, pittori, et scultori italiani, da Cimabue insino a' tempi nostri nell'edizione per i tipi di Lorenzo Torrentino Firenze 1550*, ed. L. Bellosi and A. Rossi, Einaudi (Turin, 1986).

Vergerio, P. P., "De ingenuis moribus et liberalibus studiis adulescentiae," ed. A. Gnesotto, in *Atti e memorie della R. Accademia delle scienze, lettere ed arti in Padova*, XXXIV (1917–18).

Vespasiano da Bisticci, *Le Vite*, ed. A. Greco, Istituto Nazionale di Studi sul Rinascimento (Florence, 1976).

Villani, F., *Le vite d'uomini illustri fiorentini*, ed. G. Mazzuchelli, Sansone Coen (Florence, 1847).

Villani, G., *Cronica di Giovanni Villani*, trans. F.G. Dragomanni, Sansone Coen (Florence, 1845).

Vitruvius, *The Ten Books on Architecture*, trans. M.H. Morgan, Dover (New York, 1960).

Vitruvius, *Vitruvio. De Architectura. Translato Commentato et Affigurato da Caesare Caesariano. 1521*, ed. A. Bruschi, A. Carugo, and F.P. Fiore, Il Polifilo (Milan, 1981).

Vitruvius, *Vitruvius on Architecture*, trans. F. Granger, Loeb, 2 vols. (Cambridge, Mass. and London, 1970).

Weinberg, B., ed., *Trattati di poetica e retorica del Cinquecento*, Laterza (Bari, 1970).

Wesselski, A., *Angelo Polizianos Tagebuch (1477–79)*, Eugen Diedrichs (Jena, 1929).

Wolkan, R., ed., *Der Briefwechsel des Eneas Silvius Piccolomini*, III, Alfred Hölder (Vienna, 1918).

Secondary Literature

Abbate, F., "A proposito del 'Trionfo di Sant' Agostino' di Marco Cardisco," *Paragone*, 243 (1970), pp. 40–3.

The Age of Correggio and the Carracci. Emilian Painting of the Sixteenth and Seventeenth Centuries, exhib., National Gallery of Art, Washington, D.C., Metropolitan Museum of Art, New York, and Pinacoteca Nazionale, Bologna (Washington, D.C., 1986).

Albertini, R. von, *Firenze dalla repubblica al principato*, Einaudi (Turin, 1970).

Allegri, E., and A. Cecchi, *Palazzo Vecchio e i Medici. Guida storica*, S.P.E.S. (Florence, 1980).

Alpers, S.L., " 'Ekphrasis' and aesthetic attitudes in Vasari's 'Lives,' " *Journal of the Warburg and Courtauld Institutes*, XXIII (1960), pp. 190–215.

Altieri Biagi, M.L., "La 'Vita' del Cellini. Temi, termini, sintagmi," in *Problemi attuali di Scienza e Cultura. Convegno sul tema: Benvenuto Cellini artista e scrittore (Roma-Firenze, 8–9 febbraio 1971)*, Accademia Nazionale dei Lincei (Rome, 1972), pp. 61–163.

Anselmi, G.M., F. Pezzarossi, and L. Avellini, *La "memoria" des mercatores. Tendenze ideologiche, ricordanze, artigianato in versi nella Firenze del '400*, Pàtron (Bologna, 1980).

Antonella, A., *L'Archivio della Fraternita dei Laici di Arezzo. Inventari e cataloghi toscani*, 17, La Nuova

Italia (Florence, 1985).

Aquilecchia, G., "Trilemma of Textual Criticism (Author's Alterations, Different Versions, Autonomous Works). An Italian View," in *Book Production and Letters in the Western European Renaissance. Essays in Honour of Conor Fahy*, ed. A.L. Lepschy, J. Took, D.E. Rhodes, The Modern Humanities Research Association (London, 1986), pp. 1–6.

Ariès, P., *Centuries of Childhood. A Social History of Family Life*, trans. R. Baldick, Vintage Books (New York, 1962).

Assunto, R., *La critica d'arte nel pensiero medioevale*, Il Saggiatore (Milan, 1964).

Atti del convegno Paolo Giovio. Il rinascimento e la memoria (Como, 3-5 giugno 1983), Società Storica Comense (Como, 1985).

Babcock, R., and D.J. Ducharme, "A Preliminary Inventory of the Vasari Papers in the Beinecke Library," *Art Bulletin*, LXXI (1989), pp. 300–4.

Baldwin, C.S., *Medieval Rhetoric and Poetic (to 1400) Interpreted from Representative Works*, Macmillan (New York, 1928).

Banker, J., "The Program for the Sassetta Altarpiece in the Church of S. Francesco in Borgo S. Sepolcro," *I Tatti Studies*, IV (1991), pp. 11–58.

Barbi, M., *Dante nel Cinquecento*, Annali della R. Scuola Normale Superiore di Pisa. Filosofia e filologia, series 13, VII (Pisa, 1890), pp. 1–407.

Bareggi, C., "In nota alla politica culturale di Cosimo I: l'accademia fiorentina," *Quaderni storici*, viii (1973), pp. 572–4.

Barocchi, P., *Mostra di disegni del Vasari e della sua cerchia*, exhib., Gabinetto Disegno e Stampe degli Uffizi, Olschki (Florence, 1964).

Barocchi, P., "Palazzo Vecchio fra le due redazioni delle 'Vite' vasariane," in *Medici* 1980, III, pp. 801–18.

Barocchi, P., "Schizzo di una storia della critica cinquecentesca sulla Sistina," in *Atti dell'Accademia Toscana di Scienze e Lettere. La Colombaria*, VII (1956), pp. 221–35.

Barocchi, P., "La scoperta del ritratto di Dante nel Palazzo del Podestà: Dantismo letterario e figurativo," in *Studi e ricerche di collezionismo e museografia. Firenze 1820–1920. Quaderni del seminario di storia della critica d'arte*, Scuola Normale Superiore di Pisa, II (1985), pp. 151–78.

Barocchi, P., "Storiografia artistica: lessico tecnico e lessico letterario," in *Convegno Nazionale sui lessici italiani del sei e settecento. Pisa, Scuola Normale Superiore 1-3 Dicembre 1980. Contributi* (Florence, 1981), I, pp. 1–38.

Barocchi, P., "Storiografia e collezionismo dal Vasari al Lanzi," in *Storia dell'arte italiana. Materiali e problemi. L'artista e il pubblico*, II, Einaudi (Turin, 1979), pp. 5–81.

Barocchi, P., *Studi vasariani*, Giulio Einaudi (Turin, 1984).

Barocchi, P., "Il valore dell'antico nella storiografia vasariana," in *Il mondo antico nel Rinascimento. Atti del V convegno internazionale di studi sul Rinascimento (Firenze 2–6 settembre 1956)*, Sansoni (Florence, 1958), pp. 217–36.

Barocchi, P., "Vasari, Giorgio (1511–1574)," in *Dizionario Critico della Letteratura Italiana*, ed. V. Branca, Unione Tipografico–Editrice Torinese (Turin, 1974), pp. 579–82.

Barocchi, P., *Vasari Pittore*, Club del Libro (Milan, 1964).

Barolsky, P., *Giotto's Father and the Family of Vasari's "Lives,"* Pennsylvania State University Press (University Park, Pa., 1992).

Barolsky, P., *Michelangelo's Nose. A Myth and its Maker*, Pennsylvania State University Press (University Park, Pa., 1990).

Barolsky, P., "Vasari's 'Portrait' of Raphael," in *Raphael and the Ruins of Rome*, ed. P. Fehl and S. Prokopoff, Krannert Art Museum, University of Illinois (1983), pp. 25–33.

Barolsky, P., *Walter Pater's Renaissance*, Pennsylvania State University Press (University Park, Pa., 1986).

Barolsky, P., *Why the Mona Lisa Smiles and Other Tales by Vasari*, Pennsylvania State University Press (University Park, Pa., 1991).

Barzman, K., "The Florentine Accademia del Disegno: Liberal Education and the Renaissance Artist," in A. Boschloo ed., *Academies of Art Between Renaissance and Romanticism, Leids Kunsthistorisch Jaarboek*, V–VI (1986–7), pp. 14–32.

Barzman, K., "Perception, Knowledge, and the Theory of *Disegno* in Sixteenth-Century Florence," in *From Studio to Studiolo*, ed. L. Feinberg, exhib., Allen Memorial Art Museum, Oberlin College (Oberlin, Ohio, 1991), pp. 37–48.

Barzman, K., "The Università, Compagnia, ed Accademia del Disegno," Ph.D. thesis, Johns Hopkins University (1985).

Battaglia, S., *La coscienza letteraria del Medioevo*, Liguori (Naples, 1965).

Battistelli, A., "Notizie e documenti sull'attività del Perugino a Fano," *Antichità viva*, XIII (1974), no. 5, pp. 65–8.

Baxandall, M., "Alberti and Cristoforo Landino: The Practical Criticism of Painting," in *Convegno internazionale indetto nel V centenario di Leon Battista Alberti (Roma-Mantova-Firenze 25–29 aprile 1972)*, Accademia Nazionale dei Lincei (Rome, 1974), pp. 143–54.

Baxandall, M., "Doing justice to Vasari," *Times Literary Supplement* (1 February 1980), p. 111.

Baxandall, M., *Giotto and the Orators. Humanist Observers of Painting in Italy, and the Discovery of Pictorial*

Composition 1350–1450, Oxford University Press (Oxford, 1971).

Baxandall, M., "The Language of Art History," *New Literary History*, X (1979), no. 3, pp. 452–65.

Baxandall, M., *Painting and Experience in Fifteenth Century Italy*, Oxford University Press (Oxford, 1972; paperback 1974).

Baxandall, M., *Patterns of Intention*, Yale University Press (New Haven and London, 1985).

Baxandall, M., and E. Gombrich, "Beroaldus on Francia," *Journal of the Warburg and Courtauld Institutes*, XXV (1962), pp. 113–15.

Bean, J., and F. Stampfle, *Drawings from New York Collections. I. The Italian Renaissance*, exhib., Metropolitan Museum of Art, Pierpont Morgan Library (New York, 1965).

Bec, C., *Les Livres des Florentins (1413–1608)*, Olschki (Florence, 1984).

Bec, C., *Les Marchands écrivains. Affaires et humanisme à Florence 1375–1434*, Mouton (Paris – The Hague, 1967).

Becatti, G., "Plinio e Vasari," in *Studi di storia dell'arte in onore di Valerio Mariani*, Libreria scientifica editrice (Naples, 1971), pp. 173–82.

Becherucci, L., "Il Vasari e gl'inizi di Raffaello," in *Atti 1974*, pp. 179–96.

Bellinger, K., *Die Zeichnung in Florenz/Drawing in Florence 1500–1600*, Harari & Johns (London, 1991), cat. no. 6.

Bellosi, L., *Buffalmacco e il Trionfo della Morte*, Einaudi (Turin, 1974).

Belting, H., "Vasari and His Legacy. The History of Art as a Process?" in *The End of the History of Art?*, trans. C. Wood, University of Chicago Press (Chicago and London, 1987), pp. 65–120.

Benkard, E., *Das literarische Porträt des Giovanni Cimabue*, Bruckmann (Munich, 1917).

Bentivoglio, E., "Un manoscritto inedito connesso al 'Memoriale di molte statue et picture' di Francesco Albertini," *Mitteilungen des Kunsthistorischen Institutes in Florenz*, XXIV (1980), pp. 345–56.

Bernini Pezzini, G., S. Massari, and S. Prosperi Valenti Rodinò, *Raphael Invenit. Stampe da Raffaello nelle collezioni dell'Istituto Nazionale per la Grafica*, Edizioni Quasar (Rome, 1985).

Beschi, L., "Le sculture antiche di Lorenzo il Magnifico," in *Lorenzo il Magnifico e il suo mondo. Convegno Internazionale di Studi (Firenze, 9–13 giugno 1992)*, ed. E. Garfagnini, Olschki (Florence, 1994), pp. 291–317.

Bettarini, R., "Vasari scrittore: come la Torrentiniana diventò Giuntina," in *Atti 1974*, pp. 485–500.

Bevilacqua, A., and A. Quintavalle, *L'opera completa del Correggio*, Rizzoli (Milan, 1970).

Bianconi, L., and A. Vassalli, "Circolazione letteraria e circolazione musicale del madrigale: il caso di Giovan Battista Strozzi," in *Medici 1980*, II, pp. 439–55.

Black, R., "Benedetto Accolti and the beginnings of humanist historiography," *English Historical Review*, XCVI, no. 378 (1981), pp. 36–58.

Black, R., *Benedetto Accolti and the Florentine Renaissance*, Cambridge University Press (Cambridge, 1985).

Black, R., "The Curriculum of Italian Elementary and Grammar Schools, 1350–1500," in *The Shapes of Knowledge from the Renaissance to the Enlightenment*, ed. D.R. Kelley and R.H. Popkin, Kluwer Academic Publishers (The Netherlands, 1991), pp. 137–63.

Black, R., "The Donation of Constantine: A New Source for the Concept of the Renaissance?" in *Language and Images in Renaissance Italy*, ed. A. Brown, Oxford University Press (Oxford, 1995).

Black, R., "Humanism and Education in Renaissance Arezzo," *I Tatti Studies*, II (1987), pp. 171–237.

Black, R., "The new laws of history," *Renaissance Studies*, I (1987), pp. 126–56.

Black, R., "Politica e cultura nell'Arezzo Rinascimentale," in *Arezzo al tempo dei Medici*, Studio La Piramide (Arezzo, 1992), pp. 17–31.

Black, R., and L. Clubb, *Romance and Aretine Humanism in Sienese Comedy, 1516: Pollastra's "Parthenio" at the Studio di Siena*, Biblioteca Studii Senensis (Siena, 1993).

Blunt, A., *Artistic Theory in Italy 1450–1600*, Oxford University Press (Oxford, 1962).

Boase, T.S.R., *Giorgio Vasari. The Man and the Book*, The A.W. Mellon Lectures in the Fine Arts, 1971; Bollingen series XXXV. 20, Princeton University Press (Princeton, N.J., 1979).

Bologna e l'umanesimo 1490–1510, ed. M. Faietti and K. Oberhuber, Nuova Alfa (Bologna, 1988).

Borgo, L., *The Works of Mariotto Albertinelli*, Garland (New York, 1976).

Borsook, E., *Ambrogio Lorenzetti*, I Diamanti dell'Arte, Sadea (Florence, 1966).

Boskovits, M., *Pittura fiorentina alla vigilia del Rinascimento 1370–1400*, Edam (Florence, 1975).

Boskovits, M., "'Quello ch'e dipintori oggi dicono prospettiva,'" *Acta Historiae Artium Academiae Scientiarum Hungaricae*, VIII (1962), pp. 241–60, IX (1963), pp. 139–62.

Boucher, B., "The St. Jerome in Faenza: a case for restitution," *Donatello-Studien. Italienische Forschungen herausgegeben vom Kunsthistorischen Institut in Florenz*, 3rd ser., XVI, Bruckmann (Munich, 1989), pp. 186–93.

Bowron, E., "Giorgio Vasari's 'Portrait of Six Tuscan Poets,'" *The Minneapolis Institute of Arts Bulletin*, LX (1971–3), pp. 43–53.

Bracciante, A.M., *Ottaviano de' Medici e gli artisti*,

S.P.E.S. (Florence, 1984).

Brown, P., *Venetian Narrative Painting in the Age of Carpaccio*, Yale University Press (New Haven and London, 1988).

Brucker, G., *The Society of Renaissance Florence. A Documentary Study*, Harper Torchbooks (New York, 1971).

Bruni, F., *Sistemi critici e strutture narrative (Ricerche sulla cultura fiorentina del Rinascimento)*, Liguori (Naples, 1969).

Bryce, J., *Cosimo Bartoli (1503–1572). The Career of a Florentine Polymath*, Librairie Droz (Geneva, 1983).

Buck, A., *Das Geschichtsdenken der Renaissance*, Scherpe Verlag (Krefeld, 1957).

Buddensieg, T., "Gregory the Great, the Destroyer of Pagan Idols. The History of a Medieval Legend Concerning the Decline of Ancient Art and Literature," *Journal of the Warburg and Courtauld Institutes*, XXVIII (1965), pp. 44–65.

Bundy, M.W., *The Theory of Imagination in Classical and Medieval Thought*, Illinois Studies in Language and Literature, 12, nos. 2, 3 (1927).

Burgess, T.C., "Epideictic Literature," *University of Chicago Studies in Classical Philology*, III (1902), pp. 89–261.

Burns, H., "Quattrocento Architecture and the Antique. Some Problems," in *Classical Influences on European Culture A.D. 500–1500*, ed. R.R. Bolgar, Cambridge University Press (Cambridge, 1971), pp. 269–87.

Cadogan, J., "Michelangelo in the workshop of Domenico Ghirlandaio," *Burlington Magazine*, CXXXV (1993), pp. 30–1.

Calamandrei, P., "Sulle relazioni tra Giorgio Vasari e Benvenuto Cellini," in *Studi* 1950, pp. 195–214.

Campbell, M., "Il Ritratto del Duca Alessandro de' Medici di Giorgio Vasari: Contesto e Significato," in *Studi* 1981, pp. 338–59.

Cantagalli, R., and N. de Blasi, "Bartoli," in *Dizionario Biografico degli Italiani*, Istituto della Enciclopedia Italiana (Rome, 1964), VI, pp. 561–3.

Canuti, F., *Il Perugino*, Editrice d'arte "La Diana" (Siena, 1931).

Capucci, M., "Forme della biografia nel Vasari," in *Atti* 1974, pp. 299–320.

Carroll, E., *Rosso Fiorentino, Drawings, Prints, and Decorative Arts*, exhib., National Gallery of Art (Washington, D.C., 1987).

Cast, D., "Reading Vasari again: history, philosophy," *Word and Image*, IX (1993), pp. 29–38.

Castellenata, C., and E. Camesasca, *L'opera completa del Perugino*, Rizzoli (Milan, 1969).

Cecchi, A., "Nuove acquisizioni per un catalogo dei disegni di Giorgio Vasari," *Antichità viva*, XVII (1978), no. 1, pp. 52–61.

Cecchi, A., "Nuove ricerche sulla casa del Vasari a Firenze," in *Studi* 1981, pp. 272–83.

Cecchi, E., *Pietro Lorenzetti*, Fratelli Treves (Milan, 1930).

Centre de Recherche sur la Renaissance italienne, *Formes et significations de la 'beffa' dans la littérature italienne de la Renaissance*, 2 vols., ed. A. Rochon et al. (Paris, 1972, 1975).

Cervigni, D.S., *The "Vita" of Benvenuto Cellini. Literary Tradition and Genre*, Longo (Ravenna, 1979).

Chastel, A., *Art et humanisme à Florence au temps de Laurent le Magnifique. Études sur la Renaissance et l'Humanisme platonicien*, Publications de l'Institut d'Art et d'Archéologie de l'Université de Paris IV, Presses Universitaires de France (Paris, 1959).

Chastel, A., "Giotto coetaneo di Dante," in *Studien zur toskanischen Kunst, Festschrift für L.H. Heydenreich zum 23. März 1963*, ed. W. Lotz and L.L. Möller, Prestel-Verlag (Munich, 1964), pp. 37–44.

Chastel, A., "Vasari et la légende medicéene: L'école du jardin de Saint Marc," in *Studi* 1950, pp. 159–67.

Cheney, I., "The Parallel Lives of Vasari and Salviati," in *Studi* 1981, pp. 301–8.

Cheney, L de Girolami, "The Paintings of the Casa Vasari," Ph.D. thesis, Boston University (1978).

Christie's, *Catalogue of Old Master Drawings*, London (8 April 1986).

Cian, V., *Un illustre nunzio pontificio del Rinascimento: Baldassar Castiglione*, Biblioteca Apostolica Vaticana (Città del Vaticano, 1951).

Civai, A., "Donatello e Roberto Martelli: nuove acquisizioni documentarie," in *Donatello-Studien. Italienische Forschungen herausgegeben vom Kunsthistorischen Institut in Florenz*, 3rd ser., XVI, Bruckman (Munich, 1989), pp. 253–62.

Clough, C.H., "The cult of Antiquity: letters and letter collections," in *Cultural Aspects of the Italian Renaissance. Essays in Honour of Paul Oskar Kristeller*, ed. C.H. Clough., Manchester University Press (Manchester, 1976), pp. 33–67.

Cochrane, E., "Le Accademie," in *Medici* 1980, I, pp. 3–17.

Cochrane, E., *Florence in the Forgotten Centuries 1527–1800*, University of Chicago Press (Chicago and London, 1973).

Cochrane, E., *Historians and Historiography in the Italian Renaissance*, University of Chicago Press (Chicago and London, 1981).

Cochrane, E., "Paolo Giovio e la storiografia del rinascimento," in *Atti del convegno Paolo Giovio. Il rinascimento e la memoria (Como, 3–5 giugno 1983)*, Società Storica Comense (Como, 1985), pp. 19–30.

Cohn, S., *Death and Property in Siena, 1205–1800. Strategies for the Afterlife*, Johns Hopkins University Press (Baltimore and London, 1988).

Collareta, M., "Testimonianze letterarie su Donatello.

1450–1600," in *Omaggio a Donatello. 1386–1986*, exhib., Museo Nazionale del Bargello (Florence, 1985), pp. 7–47.

Conforti, C., *Giorgio Vasari architetto*, Electa (Milan, 1993).

Corti, L., "Arezzo al tempo dei Medici. Un artista e la sua casa: Giorgio Vasari," in *Arezzo al tempo dei Medici*, Studio La Piramide (Arezzo, 1992), pp. 17–31.

Corti, L., *Vasari. Catalogo completo*, Cantini (Florence, 1989).

Crane, T.F., *Italian Social Customs of the Sixteenth Century and their Influence on the Literatures of Europe*, Yale University Press (New Haven, Conn., 1920).

Cropper, E., "On Beautiful Women, Parmigianino, *Petrarchismo*, and the Vernacular Style," *Art Bulletin*, LVIII (1976), pp. 374–94.

Cropper, E., "Prolegomena to a new interpretation of Bronzino's Florentine Portraits," in *Renaissance Studies in Honor of Craig Hugh Smyth*, ed. A. Morrogh *et al.*, Giunti Barbera (Florence, 1985), II, pp. 149–60.

Cummings, A.M., *The Politicized Muse: Music for Medici Festivals, 1512–1537*, Princeton University Press (Princeton, N.J., 1992).

Curtius, E.R., *European Literature and the Latin Middle Ages*, trans. W.R. Trask, Bollingen series XXXVI, Pantheon Books (New York, 1953).

Dabell, F., "Domenico Veneziano in Arezzo and the problem of Vasari's painter ancestor," *Burlington Magazine*, CXXVII (1985), pp. 29–32.

D'Alessandro, A., "Vincenzio Borghini e gli 'Aramei': mito e storia nel principato mediceo," in *Medici 1980*, I, pp. 133–56.

Davidson, B., "Early Drawings by Perino del Vaga. Part Two," *Master Drawings*, I (1963), pp. 19–26.

Davidson, B., *Mostra di disegni di Perino del Vaga e la sua cerchia*, exhib., Gabinetto disegni e stampe degli Uffizi, Olschki (Florence, 1966).

Davis, C., "Benvenuto Cellini and the Scuola Fiorentina," *North Carolina Museum of Art Bulletin*, XIII, no. 4 (1976), pp. 1–70.

Davis, C., "Cosimo Bartoli and the Portal of Sant'Apollonia by Michelangelo," *Mitteilungen des Kunsthistorischen Institutes in Florenz*, XIX (1975), pp. 261–76.

Davis, C., "Frescoes by Vasari for Sforza Almeni, 'Coppiere' to Duke Cosimo I," *Mitteilungen des Kunsthistorischen Institutes in Florenz*, XXIV (1980), pp. 127–202.

Davis, C., "New Frescoes by Vasari: Colore and Invenzione in Mid 16th-century Florentine Painting," *Pantheon*, XXXVIII (1980), no. 2, pp. 153–7.

Davis, M.D., "Der Codex Coburgensis: Das Erste Systematische Archäologiebuch. Römische Antiken-Nachzeichnungen aus der Mitte des 16. Jahrhunderts. Austellung in den Kunstsammlungen der Veste Coburg, 7. September–2. November 1986. – Antikenzeichnung und Antikenstudium in Renaissance und Frühbarock. Symposion im Kupferstichkabinett der Vest Coburg, 8.–10. September 1986," *Kunstchronik*, XLI, no. 12 (December, 1988), pp. 661–2.

Davitt Asmus, U., *Corpus Quasi Vas. Beiträge zur Ikonographie der italienischen Renaissance*, Gebr. Mann (Berlin, 1977), pp. 41–113.

De Gaetano, A.L., "G.B. Gelli and the Rebellion against Latin," *Studies in the Renaissance*, XIV (1967), pp. 131–58.

De Gaetano, A.L., *Giambattista Gelli and the Florentine Academy: The Rebellion against Latin*, Olschki (Florence, 1976).

Degenhart, B., and A. Schmitt, *Corpus der Italienischen Zeichnungen 1300–1450*, Gebr. Mann Verlag (Berlin, 1968).

Degenhart, B., and A. Schmitt, "Methoden Vasaris bei den Gestaltung seines Libro," *Studien zur toskanischen Kunst, Festschrift für L. Heydenreich zum 23. März 1963*, Prestel (Munich, 1964), pp. 45–64.

Degli Azzi, G., "Documenti su artisti aretini e non aretini lavoranti in Arezzo," *Il Vasari*, IV (1931), pp. 49–69.

Degli Azzi, G., "Documenti Vasariani," *Il Vasari*, IV (1931), pp. 216–31.

Del Gaizo, V., *Palazzo Madama. Sede del Senato*, Editalia (Rome, 1969).

Del Vita, A., *Inventario e Regesto dei Manoscritti dell'Archivio Vasariano*, R. Istituto d'archeologia e storia dell'arte (Rome, 1938).

Del Vita, A., "L'origine e l'albero genealogico della famiglia Vasari," *Il Vasari*, III (1930), pp. 51–75.

Del Vita, A., *Lo Zibaldone di Giorgio Vasari*, R. Istituto d'archeologia e storia dell'arte (Rome, 1938).

Delehaye, H., S.J., *The Legends of the Saints. An Introduction to Hagiography*, trans. V.M. Crawford, Longman's, Green and Co. (London, 1907).

Dempsey, C., "The Carracci *Postille* to Vasari's *Lives*," *Art Bulletin*, LXVIII (1986), pp. 72–6.

Dempsey, C., "Malvasia and the Problem of the Early Raphael and Bologna," in *Raphael before Rome*, ed. J. Beck, *Studies in the History of Art*, XVII, National Gallery of Art (Washington, D.C., 1986), pp. 57–72.

Dempsey, C., "Some Observations on the Education of Artists in Florence and Bologna During the Later Sixteenth Century," *Art Bulletin*, lxii (1980), pp. 552–69.

Detroit Institute of Art, *Italian Renaissance Sculpture in the Time of Donatello*, exhib. (Detroit, 1985).

Dionisotti, C., *Geografia e storia della letteratura italiana*, Einaudi (Turin, 1967).

Donatello e i suoi. Scultura fiorentina del primo rina-

scimento, exhib., Forte di Belvedere, Florence, ed. A.P. Darr and G. Bonsanti, Founder's Society, Detroit Institute of Arts and Mondadori (Milan, 1986).

Donati, C., *L'idea di nobiltà in Italia. Secoli XIV–XVII*, Laterza (Bari, 1988).

Draper, J., *Bertoldo di Giovanni, Sculptor of the Medici Household: Critical Reappraisal and Catalogue Raisonné*, University of Missouri Press (Columbia, 1992).

Dubos, R., *Giovanni Santi. Peintre et Chroniqueur à Urbin, au XVe siècle*, Samie (Bordeaux, 1971).

Dussler, L., *Raphael. A Critical Catalogue*, Phaidon (London, 1971).

Einem, H. von, "Castagno ein Mörder?" in *Der Mensch und die Künste. Festschrift für H. Lützeler zum 60. Geburtstage*, Verlag L. Schwann (Düsseldorf, 1962), pp. 433–42.

Eisenstein, E., *The Printing Press as an Agent of Change. Communications and Cultural Transformations in Early Modern Europe*, 2 vols., Cambridge University Press (London, 1979).

Elam, C., "Lorenzo de' Medici's Sculpture Garden," *Mitteilungen des Kunsthistorischen Institutes in Florenz*, XXXVI (1992), pp. 41–84.

L'Estasi di Santa Cecilia di Raffaello da Urbino nella Pinacoteca Nazionale di Bologna, Edizioni Alfa (Bologna, 1983).

Falaschi, E., "Giotto: The Literary Legend," *Italian Studies*, XXVII (1972), pp. 1–27.

Ferguson, W.K., *The Renaissance in Historical Thought. Five Centuries of Interpretation*, Houghton Mifflin (Cambridge, Mass., 1948).

Ferino Pagden, S., "From cult images to the cult of images: the case of Raphael's altarpieces," in *The Altarpiece in the Renaissance*, ed. P. Humfrey and M. Kemp, Cambridge University Press (Cambridge, 1990), pp. 165–89.

Ferino Pagden, S., *Disegni umbri del Rinascimento da Perugino a Raffaello*, exhib., Gabinetto Disegni e Stampe degli Uffizi, Olschki (Florence, 1982).

Ferino Pagden, S., "The Early Raphael and His Umbrian Contemporaries," in *Raphael before Rome*, ed. J. Beck, *Studies in the History of Art, XVII*, National Gallery of Art (Washington, D.C., 1986), pp. 93–107.

Fermor, S., "On the Description of Movement in Vasari's Lives," in *Kunst, Musik, Schauspiel*, XXV. Internationaler Kongress für Kunstgeschichte (Vienna, 1983), II, pp. 15–21.

Fermor, S., *Piero di Cosimo. Fiction, Invention and "Fantasìa,"* Reaktion Books (London, 1993).

Fermor, S., "Studies in the depiction of the moving figure in Italian Renaissance art, art criticism and dance theory," Ph.D. thesis, University of London, Warburg Institute (1990).

Ferrai, L.A., *Lorenzino de' Medici e la società cortigiana del cinquecento*, Ulrich Hoepli (Milan, 1891).

Ferrara, M. and F. Quinterio, *Michelozzo di Bartolomeo*, Salimbeni (Florence, 1984).

Fetel, M., R. Witt, and R. Goffen, eds., *Life and Death in Fifteenth Century Florence*, Duke University Press (Durham, N.C., and London, 1989).

Fletcher, J., "Marcantonio Michiel, 'chi ha veduto assai,'" *Burlington Magazine*, CXXIII (1981), pp. 600–8.

Folena, G., "Borghini," in *Dizionario Biografico degli Italiani*, Istituto della Enciclopedia Italiana (Rome, 1970), XII, pp. 680–9.

Folena, G., "Sulla tradizione dei 'Detti piacevoli' attribuiti al Polizano," *Studi di filologia italiana*, XI (1953), pp. 431–48.

Fontes, A., "Le thème de la *beffa* dans le *Décameron*," in *Formes et significations de la 'beffa' dans la littérature italienne de la Renaissance*, ed. A. Rochon *et al.*, Université de la Sorbonne Nouvelle (Paris, 1972), I, pp. 11–44.

Foratti, A., "Note su Francesco Francia," *L'archiginnasio*, IX (1914), pp. 160–73.

Fortunati Pietrantonio, V., ed., *Pittura Bolognese del '500*, Grafis Edizioni (Bologna, 1986).

Fossi, M., "Documenti inediti Vasariani," *Antichità viva*, XII (1974), no. 3, pp. 63–4.

Freeman, J.G., *The Maniera of Vasari*, W. Westbury (London, 1867).

Franklin, D., "The Italian Career of Rosso Fiorentino," Ph.D. thesis, University of London, Courtauld Institute of Art (1991).

Franklin, D., *Rosso in Italy. The Italian Career of Rosso Fiorentino*, Yale University Press (New Haven and London, 1994).

Fraser Jenkins, A.D., "Cosimo de' Medici's Patronage of Architecture and the Theory of Magnificence," *Journal of the Warburg and Courtauld Institutes*, XXXIII (1970), pp. 162–70.

Frommel, C.L., S. Ray, and M. Tafuri, eds., *Raffaello architetto*, exhib., Palazzo dei Conservatori, Rome, Electa (Milan, 1984).

Fueter, E., *Geschichte der neueren Historiographie*, R. Oldenbourg (Munich and Berlin, 1936).

Furlan, C., *Il Pordenone*, Electa (Milan, 1988).

Galeries nationales du Grand Palais, *Raphaël dans les collections françaises*, exhib., Editions de la Réunion des musées nationaux (Paris, 1983–4).

Garin, E., *L'educazione in Europa 1400/1600. Problemi e programmi*, Laterza (Rome and Bari, 1976; first edition 1957).

Garin, E., *Educazione umanistica in Italia*, Laterza (Rome and Bari, 1975; first edition 1949).

Garin, E., "Giorgio Vasari e il tema della 'Rinascita,'" in *Atti 1974*, pp. 259–66.

Garin, E., *Medioevo e Rinascimento. Studi e ricerche*,

Laterza (Rome and Bari, 1980; first edition 1954).

Garin, E., *L'umanesimo italiano. Filosofia e vita civile nel Rinascimento*, Laterza (Rome, 1978; first edition 1947).

Gasparini, B., "La casa di Michelangelo Buonarroti," *Il Buonarroti*, I (1866), p. 179.

Gaston, R.W., "Attention and Inattention in Religious Painting of the Renaissance: Some Preliminary Observations," in *Renaissance Studies in Honor of Craig Hugh Smyth*, Giunti Barbèra (Florence, 1985), II, pp. 253–68.

Gavitt, P., *Charity and Children in Renaissance Florence. The Ospedale degli Innocenti 1410–1536*, University of Michigan Press (Ann Arbor, 1990).

Gavitt, P., *Cities of Women. Gender, Inheritance, and Abandonment in Sixteenth-Century Italy* (forthcoming).

Gianneschi, M., and C. Sodini, "Urbanistica e politica durante il principato di Alessandro de' Medici, 1532–37," *Storia della città*, X (1979), pp. 5–34.

Il Giardino di San Marco. Maestri e compagni del giovane Michelangelo, exhib., Casa Buonarroti, Florence, ed. P. Barocchi, Silvana Editoriale (Milan, 1992).

Gilbert, C., *Poets Seeing Artists' Work. Instances in the Italian Renaissance*, Olschki (Florence, 1991).

Gilbert, F., *Machiavelli and Guicciardini. Politics and History in Sixteenth Century Florence*, Princeton University Press (Princeton, N.J., 1965).

Gilbert, N.W., *Renaissance Concepts of Method*, Columbia University Press (New York, 1968).

Giudici, C., "Francesco Francia," in *Bologna e l'umanesimo 1490–1510*, ed. M. Faietti and K. Oberhuber, Nuova Alfa (Bologna, 1988), pp. 358–60.

Giusti, P., and P. Leone de Castris, *Pittura del Cinquecento a Napoli 1510–1540 forastieri e regnicoli*, Electa (Naples, 1988).

Goldberg, E., *After Vasari. History, Art, and Patronage in Late Medici Florence*, Princeton University Press (Princeton, N.J., 1988).

Goldberg, J., "Cellini's *Vita* and the conventions of early autobiography," *Modern Language Notes*, 89 (1974), pp. 71–83.

Goldstein, C., "Rhetoric and Art History in the Italian Renaissance and Baroque," *Art Bulletin*, LXXIII (1991), pp. 641–52.

Goldstein, C., "Vasari and the Florentine Accademia del Disegno," *Zeitschrift für Kunstgeschichte*, XXXVIII (1975), pp. 145–52.

Goldthwaite, R., *The Renaissance Building of Florence. An Economic and Social History*, Johns Hopkins University Press (Baltimore and London, 1980).

Gombrich, E.H., "Giotto's Portrait of Dante?" *Burlington Magazine*, CXXI (1979), pp. 471–83.

Gombrich, E.H., "The Leaven of Criticism in Renaissance Art: Texts and Episodes," in *The Heritage of Apelles*, Phaidon (Oxford, 1976), pp. 111-31.

Gombrich, E., "The Renaissance Conception of Artistic Progress and its Consequences," and "Norm and Form: The Stylistic Categories of Art History and their Origins in Renaissance Ideals," in *Norm and Form*, Phaidon (London and New York, 1978; first ed., 1966), pp. 1–10, 81–98.

Gombrich, E.H., "Vasari's 'Lives' and Cicero's 'Brutus,'" *Journal of the Warburg and Courtauld Institutes*, XXIII (1960), pp. 309–11.

Gorse, G., "Between Empire and Republic: Triumphal Entries into Genoa During the Sixteenth Century," in *"All the world's a stage..." Art and Pageantry in the Renaissance and Baroque*, ed. B. Wisch and S. Munshower, Department of Art History, Pennsylvania State University (University Park, Pa., 1990).

Gossage, J., "Plutarch," in *Latin Biography*, ed. T.A. Dorey, Routledge and Kegan Paul (London, 1967), pp. 45–77.

Gotti, A., *Vita di Michelangelo Buonarroti narrata con l'aiuto di nuovi documenti*, Tipografia della Gazzetta d'Italia (Florence, 1875).

Gottschewski, A., "Der Modellkopf von der Hand Michelangelos im Besitze des Pietro Aretino," *Monatshefte für Kunstwissenschaft*, II (1909), p. 399.

Graff, H., *The Legacies of Literacy: Continuities and Contradictions in Western Culture and Society*, Indiana University Press (Bloomington and Indianapolis, 1987).

Grafton, A., and L. Jardine, *From Humanism to the Humanities*, Harvard University Press (Cambridge, Mass., 1986).

Grassi, L., "Donatello nella critica di Giorgio Vasari," in *Donatello e il suo tempo. Atti dell'VIII Convegno Internazionale di Studi sul Rinascimento (Firenze-Padova, 25 settembre–1 ottobre 1966)*, Istituto Nazionale di Studi sul Rinascimento (Florence, 1968), pp. 59–68.

Gray, H., "History and Rhetoric in Quattrocento Humanism," Ph.D. thesis, Radcliffe College (1956).

Greenblatt, S., *Renaissance Self-fashioning. From More to Shakespeare*, University of Chicago Press (Chicago and London, 1980).

Greene, T.M., *The Light in Troy. Imitation and Discovery in Renaissance Poetry*, Yale University Press (New Haven and London, 1983).

Grendler, P.F., *Critics of the Italian World (1530–1560): Anton Francesco Doni, Nicolò Franco & Ortensio Lando*, University of Wisconsin Press (Madison, Milwaukee, and London, 1969).

Grendler, P.F., *Schooling in Renaissance Italy. Literacy and Learning 1300–1600*, Johns Hopkins University Press (Baltimore and London, 1989).

Grimm, H., *Das Leben Raphaels von Urbino. Italiänische Text von Vasari, Übersetzung und Commentar*, Ferd. Dümmler (Berlin, 1872).

Guasti, C., *Santa Maria del Fiore*, M. Ricci (Florence, 1887).

Gugliemetti, M., *La "vita" di Benvenuto Cellini*, G. Giappichelli (Turin, 1974).

Haines, M., "La colonna della Dovizia di Donatello," *Rivista d'arte*, XXXVII (1984), pp. 347–59.

Hale, J., *Florence and the Medici. The Pattern of Control*, Thames and Hudson (London, 1977).

Hall, R.A. Jr., *The Italian Questione della Lingua: An Interpretative Essay*, University of North Carolina Studies in the Romance Languages and Literature, no. 4 (Chapel Hill, N.C., 1942).

Hankey, T., "Salutati's Epigrams for the Palazzo Vecchio at Florence," *Journal of the Warburg and Courtauld Institutes*, XXII (1959), pp. 363–5.

Hardison, O.B., *The Enduring Monument. A Study of the Idea of Praise in Renaissance Literary Theory and Practice*, University of North Carolina Press (Chapel Hill, N.C., 1962).

Hartt, F., *Giulio Romano*, 2 vols., Yale University Press (New Haven, Conn., 1958).

Heffernan, T.J., *Sacred Biography*, Oxford University Press (Oxford, 1988).

Heikamp, D., "Rapporti fra accademici ed artisti nella Firenze del '500. Da memorie e rime dell'epoca," *Il Vasari*, XV (1957), pp. 139–63.

Henry, T., "Letter to the Editor," *Burlington Magazine*, CXXXII (1990), pp. 571–2.

Henry, T., "'Il Priore Dipentore': Guillaume de Marcillat at the Cathedral, Arezzo," M.A. report, University of London, Courtauld Institute of Art (1989).

Herzner, V., "Regesti donatelliani," *Rivista dell'Istituto Nazionale d'Archeologia e Storia dell'Arte*, 3rd series, II (1979), pp. 169–228.

Hirst, M., "Rosso: a Document and a Drawing," *Burlington Magazine*, CVI (1964), pp. 120–6.

Hoogewerff, G., "L'editore del Vasari: Lorenzo Torrentino," in *Studi* 1950, pp. 93–104.

Hope, C., "Historical Portraits in the 'Lives' and in the Frescoes of Giorgio Vasari," in *Studi* 1981, pp. 321–38.

Horster, M., *Andrea del Castagno*, Phaidon (Oxford, 1980).

Hughes, A., "'An Academy for Doing.' I: The Accademia del Disegno, the Guilds and the Principate in Sixteenth-Century Florence," *Oxford Art Journal*, IX (1986), pp. 3–10.

Hughes, A., "'An Academy for Doing.' II: Academies, Status and Power in Early Modern Europe," *Oxford Art Journal*, IX (1986), pp. 50–62.

Hulse, C., *The Rule of Art. Literature and Painting in the Renaissance*, University of Chicago Press (Chicago

and London, 1990).

Jack, M., The *Accademia del Disegno* in Late Renaissance Florence," *Sixteenth Century Journal*, VII, 2 (1976), pp. 3–20.

Jacks, P., "Giorgio Vasari's *Ricordanze*: Evidence from an Unknown Draft," *Renaissance Quarterly*, XLV (1992), pp. 739–84.

Jacobs, F., "The construction of a life: Madonna Properzia De' Rossi 'Schultrice' Bolognese," *Word and Image*, IX (1993), pp. 122–32.

Jacobs, F., "Vasari's Vision of the History of Painting: Frescoes in the Casa Vasari, Florence," *Art Bulletin*, LXVI (1984), pp. 399–416.

James, L., and R. Webb, "To Understand Ultimate Things and Enter Secret Places: *Ekphrasis* and Art in Byzantium," *Art History*, XIV (1991), pp. 1–17.

Janson, H.W., *The Sculpture of Donatello*, 2 vols., Princeton University Press (Princeton, N.J., 1963; paperback, 1979).

Jones, R., and N. Penny, *Raphael*, Yale University Press (New Haven and London, 1983).

Kallab, W., *Vasaristudien*, ed. J. von Schlosser, Karl Graeser and B.G. Teubner (Vienna and Leipzig, 1908).

Kemp, M., "'Equal excellences': Lomazzo and the explanation of individual style in the visual arts," *Renaissance Studies*, I (1987), pp. 1–26.

Kemp, M., "From 'mimesis' to 'fantasia': the Quattrocento vocabulary of creation, inspiration and genius in the visual arts," *Viator*, VIII (1977), pp. 347–98.

Kemp. M., *Leonardo da Vinci. The Marvellous Works of Nature and Man*, Harvard University Press (Cambridge, Mass., 1981).

Kemp, M., "'Ogni dipintore dipinge se': a Neoplatonic echo in Leonardo's art theory?" in *Cultural Aspects of the Italian Renaissance. Essays in Honour of Paul Oskar Kristeller*, ed. C.H. Clough, Manchester University Press (Manchester, 1976), pp. 311–23.

Klapisch, C., "Le chiavi fiorentine di Barbablù. L'apprendimento della lettura a Firenze nel XV secolo," *Quaderni storici*, 57 (1984), pp. 765–92.

Klapisch-Zuber, C., "Du pinceau à l'écritoire. Les 'ricordanze' d'un peintre florentin au XVe siècle," *Artistes, artisans et production artistique au moyen age*, ed. X. Barral I Attet, Picard (Paris, 1986), I, pp. 567–76.

Klapisch-Zuber, C., *La Maison et le nom: stratégies et rituels dans l'Italie de la Renaissance*, Éditions de l'École des Hautes Études en Sciences Sociales (Paris, 1990).

Klein, R., "Judgment and Taste in Cinquecento Art Theory," in *Form and Meaning. Essays on the Renaissance and Modern Art*, trans. M. Jay and L. Wieseltier, The Viking Press (New York, 1979), pp. 161–9.

Kliemann, J., "Giorgio Vasari: Kunstgeschichtliche Perspektiven," in *Wolfenbütteler Forschungen. Kunst und Kunsttheorie 1400–1900*, Herzog August Bibliothek (Wolfenbüttel, 1991), pp. 29–74.

Kliemann, J., "Il pensiero di Paolo Giovio nelle pitture eseguite sulle sue invenzioni," in *Atti del convegno Paolo Giovio. Il rinascimento e la memoria (Como, 3–5 giugno 1983)*, Società Storica Comense (Como, 1985), pp. 197–223.

Kliemann, J., "Su alcuni concetti umanistici del pensiero e del mondo figurativo vasariani," in *Studi* 1981, pp. 73–82.

Kliemann, J., "Zeichnungsfragmente aus der Werkstatt Vasaris und ein unbekanntes Programm Vincenzio Borghini für das Casino Mediceo in Florenz: Borghinis 'invenzioni per pitture fatte,'" *Jahrbuch der Berliner Museen*, XX (1978), pp. 157–208.

Klinger, L. S., "The Portrait Collection of Paolo Giovio," Ph.D. thesis, Princeton University (1991).

Kohl, B., "Petrarch's Prefaces to the *De Viris Illustribus*," *History and Theory*, XIII (1974), pp. 132–44.

Kolve, V., *Chaucer and the imagery of narrative. The first five Canterbury tales*, Edward Arnold (London, 1984).

Kornell, M., "Artists and the Study of Anatomy in Sixteenth-Century Italy," Ph.D. thesis, University of London, Warburg Institute (1993).

Kornell, M., "Rosso Fiorentino and the anatomical text," *Burlington Magazine*, LXXXI (1989), pp. 842–7.

Kosegarten, A., "The origins of artistic competitions in Italy," in *Lorenzo Ghiberti nel suo tempo. Atti del convegno internazionale di studi (Firenze, 18–21 ottobre 1978)*, Istituto nazionale di studi sul Rinascimento, Olschki (Florence, 1980), I, pp. 167–86.

Krautheimer, R., *Lorenzo Ghiberti*, Princeton University Press (Princeton, N.J., 1970).

Kris, E., and O. Kurz, *Legend, Myth and Magic in the Image of the Artist. A Historical Experiment*, trans. A. Laing and L.M. Newman, Yale University Press (New Haven and London, 1979).

Kristeller, P.O., "The Philosophy of Man in the Italian Renaissance," in *Renaissance Thought. The Classic, Scholastic and Humanist Strains*, Harper Torchbooks (New York, 1961), pp. 120–39.

Kristeller, P.O., *Renaissance Thought and the Arts. Collected Essays*, Princeton University Press (Princeton, N.J., 1980; originally published 1965).

Kurz, O., "'Il libro dei disegni' di Giorgio Vasari," in *Studi* 1950, pp. 225–8.

Land, N., "Titian's *Martyrdom of St. Peter* and the 'Limitations' of Ekphrastic Art Criticism," *Art History*, XIII (1990), pp. 293–317.

Landfester, R., *Historia Magistra Vitae. Untersuchungen zur humanistischen Geschichtstheorie des 14. bis 16. Jahrhunderts*, Librairie Droz (Geneva, 1972).

Langedijk, K., *The Portraits of the Medici. 15th to 18th centuries*, S.P.E.S. (Florence, 1983).

Larner, J., *Culture and Society in Italy 1290–1420*, B.T. Batsford (London, 1971).

Lechner, Sister J.M., *Renaissance Concepts of the Commonplaces*, Greenwood Press (Westport, Conn., 1974).

Legrenzi, A., *Vincenzo Borghini. Studio critico*, Tipografia Domenico del Bianco (Udine, 1910).

Le Mollé, R., "Il duplice linguaggio di Vasari nelle *Vite*: Vasari scrittore e Vasari artista," in *Letteratura italiana e arti figurative. Atti del XII convegno dell'associazione internazionale per gli studi di lingua e letteratura italiana (Toronto, Hamilton, Montreal, 6–10 maggio, 1985)*, ed. A. Franceschetti, Olschki (Florence, 1988), II, pp. 561–9.

Le Mollé, R., *Georges Vasari et le vocabulaire de la critique d'art dan les "Vite,"* Ellug (Grenoble, 1988).

Le Mollé, R., "L'invention sémantique chez Vasari," *Revue des études italiennes*, XXXI (1985), pp. 36–57.

Letteratura italiana. I. Il letterato e le istituzioni, Einaudi (Turin, 1982).

Letteratura italiana. II. Produzione e consumo, Einaudi (Turin, 1983).

Lightbown, R., *Donatello and Michelozzo*, 2 vols., Harvey Miller (London, 1980).

Litchfield, R.B., *Emergence of a Bureaucracy. The Florentine Patricians, 1530–1790*, Princeton University Press (Princeton, N.J., 1986).

Litta, P., *Famiglie celebri italiane*, Tipografia delle famiglie celebri italiane, vol. IX (Milan, 1868).

Longo, N., "*De epistola condenda*. L'arte di 'componer letter' nel Cinquecento," in *Le "carte messaggiere": Retorica e modelli di comunicazione epistolare: per un indice dei libri di lettere del Cinquecento*, ed. A. Quondam, Bulzoni (Rome, 1981), pp. 177–201.

Loos, E., *Baldassare Castigliones "Libro del Cortegiano." Studien zur Tugendauffassung des Cinquecento*, Vittorio Klosterman (Frankfurt am Main, 1955).

Lowe, K.J.P., "Towards an Understanding of Goro Gheri's Views on *amicizia* in Early Sixteenth-Century Medicean Florence," in *Florence and Italy. Renaissance Studies in Honour of Nicolai Rubinstein*, ed. P. Denley and C. Elam, Committee for Medieval Studies, Westfield College, University of London, (London, 1988), pp. 91–105.

Lucchi, P., "La Santacroce, il Salterio e il Babuino. Libri per imparare a leggere nel primo secolo della stampa," *Quaderni storici*, XXXVIII (1978), pp. 593–630.

Lunardi, R., "La Ristrutturazione vasariana di S. Maria Novella. I documenti ritrovati," *Memorie Domenicane*, n.s. 19 (1988), pp. 403–19.

Lytle, G., "Friendship and Patronage in Renaissance Europe," in *Patronage, Art, and Society in Renaissance Italy*, ed. F.W. Kent and P. Simons, Oxford

University Press (Oxford, 1987), pp. 47–61.

McLaughlin, M.L., "Humanist concepts of renaissance and middle ages in the tre- and quattrocento," *Renaissance Studies*, II (1988), pp. 131–42.

McManamon, J.A., *Funeral Oratory and the Cultural Ideals of Italian Humanism*, University of North Carolina Press (Chapel Hill and London, 1989).

McManamon, J.A., "The Ideal Renaissance Pope: Funeral Oratory from the Papal Court," *Archivum Historiae Pontificiae*, XIV (1976), pp. 9–76.

McTavish, D., "Vasari and Parmigianino," in *Studi* 1981, pp. 135–44.

Maginnis, H., "Review of L. Bellosi *Buffalmacco e il Trionfo della Morte*," *Art Bulletin*, LVIII (1976), p. 127.

Malanima, P., *I Riccardi di Firenze. Una famiglia e un patrimonio nella Toscana dei Medici*, Olschki (Florence, 1972).

Manca, J., *The Art of Ercole de' Roberti*, Cambridge University Press (Cambridge, 1992).

Manca, J., "Ercole de' Roberti's Garganelli Chapel Frescoes: A Reconstruction and Analysis," *Zeitschrift für Kunstgeschichte*, XLIX (1986), pp. 147–64.

Mancini, G., "Cosimo Bartoli (1503–1572)," *Archivio storico italiano*, ser. 6, LXXVI (1918), pp. 84–135.

Mancini, G., *Guglielmo Marcillat Francese. Insuperato pittore sul vetro*, G. Carnesecchi & figli (Florence, 1909).

Mancini, G., *Vita di Luca Signorelli*, Carnesecchi (Florence, 1903).

Martindale, A., and E. Bacceschi, *The Complete Paintings of Giotto*, Weidenfeld and Nicolson (London, 1969).

Martindale, A., and N. Garavaglia, *The Complete Paintings of Mantegna*, Weidenfeld and Nicolson (London, 1971).

Martines, L., "La famiglia Martelli e un documento sulla vigilia del ritorno dall'esilio di Cosimo dei Medici (1434)," *Archivio storico italiano*, CXVII (1959), pp. 29–53.

Massing, J.-M., *Du Texte à l'image. La Calomnie d'Apelle*, Presses Universitaires de Strasbourg (Strasbourg, 1990).

Mayer, T., and D. R. Woolf eds., *Rhetorics of Lifewriting in the Later Renaissance*, University of Michigan Press (Ann Arbor, 1994).

Mazzacurati, G., "Dante nell'Accademia Fiorentina (1540–1560) (Tra esegesi umanistica e razionalismo critico)," *Filologia e letteratura*, XIII (1967), pp. 258–308.

Mazzatinti, G., *Inventari dei Manoscritti delle Biblioteche d'Italia*, XII. Florence, Tipografia Sociale (Forlì, 1902–3).

Mendelsohn, L., *Paragoni. Benedetto Varchi's 'Due Lezzioni' and Cinquecento Art Theory*, University Microfilms International Research Press (Ann Arbor, Mich., 1982).

Migliaccio, L., "I rapporti fra Italia meridionale e penisola iberica nel primo Cinquecento attraverso gli ultimi studi: bilancio e prospettive. 2. La scultura," *Storia dell'arte*, XLIV (1988), pp. 225–31.

Miglio, M., "Biografia e raccolte biografiche nel Quattrocento italiano," in *Atti della Accademia delle Scienze dell'Istituto di Bologna, Rendiconti* (1974–5), pp. 166–99.

Milanesi, G., "Esame del racconto del Vasari circa la morte di Domenico Veneziano," *Giornale Storico degli Archivi Toscani* (1862), pp. 3–5.

Mirollo, J., *Mannerism and Renaissance Poetry. Concept, Mode, Inner Design*, Yale University Press (New Haven and London, 1984).

Mitchell, B.I., "The Patron of Art in Giorgio Vasari's 'Lives,'" Ph.D. thesis, University of Kansas (1976).

Mitsch, E., *Graphische Sammlung Albertina. Raphael in der Albertina. Aus Anlass des 500. Geburtstages des Künstlers*, exhib. (Vienna, 1983).

Mommsen, T., "Petrarch's Conception of the Dark Ages," *Speculum*, XVII (1943), pp. 226–42.

Monbeig-Goguel, C., "Giulio Romano et Giorgio Vasari. Le dessin de la *Chute d'Icare* retrouvé," *Revue du Louvre*, XXIX (1979), pp. 273–6.

Monbeig-Goguel, C., *Musée du Louvre, Cabinet des dessins. Inventaire général des dessins italiens I. Vasari et son temps*, Éditions des Musées Nationaux (Paris, 1972).

Monk, S.H., "A grace beyond the reach of art," *Journal of the History of Ideas*, V (1944), pp. 131–50.

Moretti, G., "Il cardinale Ippolito de' Medici dal trattato di Barcellona alla morte (1529–1535)," *Archivio storico dell'arte*, XCVIII (1940), pp. 137–78.

Morisani, O., "Geronimo Santacroce," *Archivio storico per le province napolitane*, n.s. XXX (1944–6), pp. 70–84.

Morrogh, A., "Vasari and Coloured Stones," in *Studi* 1981, pp. 309–20.

Mortari, L., *Francesco Salviati*, Leonardo-De Luca (Rome, 1992).

Muccini, U., *Il salone dei cinquecento in Palazzo Vecchio*, Le Lettere (Florence, 1990).

Müller, G., *Bildung und Erziehung im Humanismus der Italienischen Renaissance. Grundlagen – Motive – Quellen*, Franze Steiner (Wiesbaden, 1969).

Murray, P., "Notes on some early Giotto sources," *Journal of the Warburg and Courtauld Institutes*, XVI (1953), pp. 58–80.

Murray, P., "On the date of Giotto's birth," in *Giotto e il suo tempo. Atti del congresso internazionale per la celebrazione del VII centenario della nascita di Giotto. 24 settembre–1 ottobre 1967 (Assisi-Padova-Firenze)*, De Luca (Rome, 1971), pp. 25–34.

Nagler, A.M., *Theatre Festivals of the Medici 1539–1637*, Yale University Press (New Haven, Conn., 1964).

Nelson, J., "Dante Portraits in Sixteenth Century Florence," *Gazette des Beaux-Arts*, CXX (1992), pp. 59–77.

Nencioni, G., "Sullo stile del Vasari scrittore," in *Studi* 1950, pp. 111–15.

Nencioni, G., "Il Vasari scrittore manierista?" in *Atti e Memorie della Accademia Petrarca di Lettere, Arti e Scienze*, n.s. XXXVII (1958–64), pp. 260–83.

Nencioni, G., "Il volgare nell'avvio del principato mediceo," in *Medici* 1980, II, pp. 683–705.

Nicolini, F., *L'Arte Napolitana del Rinascimento e la lettera di Pietro Summonte a Marcantonio Michiel*, Riccardo Ricciardi (Naples, 1925).

Nova, A., "Salviati, Vasari, and the Reuse of Drawings in their Working Practice," *Master Drawings* XXX (1992), pp. 83–108.

Oberhuber, K., "The Colonna Altarpiece in the Metropolitan Museum: Problems of the Early Style of Raphael," *Metropolitan Museum Journal*, XII (1978), pp. 55–91.

Oberhuber, K., "Die Fresken der *Stanza dell'Incendio* im Werk Raffaels," *Jahrbuch der Kunsthistorischen Sammlungen in Wien*, LVIII, n.s. 22 (1962), pp. 23–72.

Oberhuber, K., *Polarität und Synthese in Raphaels "Schule von Athen,"* Urachhaus (Stuttgart, 1983).

Oberhuber, K., *Raffaello*, Mondadori (Verona, 1982).

Oberhuber, K., "Raphael and Pintoricchio," in *Raphael before Rome*, ed. J. Beck, *Studies in the History of Art*, XVII, National Gallery of Art (Washington, D.C., 1986), pp. 155–74.

Olivato, L., "Giorgio Vasari e Giorgio Vasari il Giovane: appunti e testimonianze," in *Atti* 1974, pp. 321–31.

Olivato, L., "Giorgio Vasari il Giovane: il funzionario del 'Principe,'" *L'arte*, n. 14 (1971), pp. 15–28.

Olivato, L., "Profilo di Giorgio Vasari il Giovane," *Rivista dell'Istituto nazionale di archeologia*, XVII (1970), pp. 181–229.

Olivato Puppi, L., "Cosimo Bartoli, un intellettuale mediceo nella Serenissima," in *Medici* 1980, II, pp. 739–50.

O'Malley, J.W., *Praise and Blame in Renaissance Rome: Rhetoric, Doctrine, and Reform in the Sacred Orators of the Papal Court, c.1450–1521*, Duke University Press (Durham, N.C., 1979).

Ossola, C., ed., *La Corte e il "Cortegiano,"* Bulzoni (Rome, 1980).

Paatz, W., "Die Gestalt Giottos im Spiegel seiner zeitgenössischen Urkunde," in *Eine Gabe für Carl Georg Heise zum 28. VI. 1950*, Gebr. Mann (Berlin, 1950), pp. 85–102.

Pagliara, P.N., "Vitruvio da testo a canone," in *Memoria dell'antico nell'arte italiana*, ed. S. Settis, Einaudi (Turin, 1986), III, pp. 67–74.

Palli d'Addario, M.V., "Documenti vasariani nell' Archivio Guidi," in *Studi* 1981, pp. 363–90.

Panofsky, E., "The First Page of Giorgio Vasari's 'Libro,'" in *Meaning in the Visual Arts*, Penguin Books (Harmondsworth, Middlesex, 1970), pp. 206–76.

Panofsky, E., *Idea. A Concept in Art Theory*, trans. J. Peake, University of South Carolina Press (Columbia, 1968).

Panofsky, E., *Renaissance and Renascences in Western Art*, Harper & Row Icon edition (New York, 1972; first edition 1960).

Paolucci, A., and A.M. Maetzke, *La casa del Vasari in Arezzo*, Cassa del Risparmio di Firenze (Florence, 1988).

Paparelli, G., *Feritas, Humanitas, Divinitas (L'essenza umanistica del Rinascimento*, Guida (Naples, 1973).

Pardo, V.F., *Arezzo*, Editori Laterza (Bari, 1986).

Parma Armani, E., *L'anello mancante. Studi sul manierismo*, SAGEP (Genoa, 1986).

Parma Armani, E., "Per una lettura critica della vita di Perino del Vaga," in *Atti* 1974, pp. 605–21.

Parronchi, A., "L'uovo del Brunelleschi," in *Scritti di storia dell'arte in onore di Ugo Procacci*, Electa (Milan, 1977), I, pp. 209–14.

Parshall, P.W., "Camerarius on Dürer – Humanist Biography as Art Criticism," in *Joachim Camerarius (1500–1574). Beiträge zur Geschichte des Humanismus im Zeitalter der Reformation*, ed. F. Baron, Wilhelm Fink (Munich, 1978), pp. 11–29.

Pasqui, U., *La famiglia dei Vasari e la casa dove nacque lo scrittore delle "Vite,"* Cooperativa tipografica (Arezzo, 1911).

Perini, G., "Biographical anecdote and historical truth: an example from Malvasia's 'Life of Guido Reni,'" *Studi secenteschi*, XXXI (1990), pp. 149–60.

Perini, G., "Carlo Cesare Malvasia's Florentine Letters: Insight into Conflicting Trends in Seventeenth-Century Italian Art Historiography," *Art Bulletin*, LXX (1988), pp. 273–99.

Perini, L., *Editoria e società. Firenze e la toscana dei Medici nell'Europa del Cinquecento*, exhib., Orsanmichele, Electa (Florence, 1980).

Perini, L., "Libri e lettori nella Toscana del Cinquecento," in *Medici* 1980, I, pp. 109–31.

Petrucci, A., *Il libro di Ricordanze dei Corsini (1362–1457)*, Istituto Storico Italiano per il Medio Evo (Rome, 1965).

Pevsner, N., *Academies of Art Past and Present*, Cambridge University Press (Cambridge, 1940).

Pezzarossa, F., "La memorialistica fiorentina tra medioevo e rinascimento. Rassegna di studi e testi," *Lettere Italiane*, XXXI (1979), pp. 96–138.

Phillips, M., "Machiavelli, Guicciardini, and the Tradition of Vernacular Historiography in Florence," *American Historical Review*, LXXXIV (1979), pp. 86–105.

Phillips, M., *The Memoir of Marco Parenti. A Life in Medici Florence*, Heinemann (London, 1990).

Piattoli, R., "Un mercante del Trecento e gli artisti del tempo suo," *Rivista d'arte*, ser. ii, II (1930), pp. 97–150.

Pigman, G.W., "Versions of Imitation in the Renaissance," *Renaissance Quarterly*, XXXIII (1980), pp. 1–32.

Pirotti, U., *Benedetto Varchi e la cultura del suo tempo*, Olschki (Florence, 1971).

Plaisance, M., "Culture et politique a Florence 1542–1551: Lasca et les 'Humidi' aux prises avec l'Académie Florentine," in *Les écrivains et le pouvoir en Italie a l'époque de la Renaissance*, no. 3, Centre de Recherche sur la Renaissance italienne, Université de la Sorbonne Nouvelle (Paris, 1974), pp. 149–243.

Plaisance, M., "La politique culturelle de Côme Ier et les fêtes annuelles à Florence 1541–1550," in *Les Fêtes de la Renaissance. Actes du quinzième colloque international d'études humanistes (Tours 1972)*, ed. J. Jacquot and E. Konigson, Éditions du Centre Nationale de la Recherche Scientifique (Paris, 1975), III, pp. 133–52.

Plaisance, M., "Une première affirmation de la politique culturelle de Côme Ier (1540–42): La transformation de l'Académie des 'Humidi' en Académie Florentine (1540–1542)," in *Les écrivains et le pouvoir en Italie a l'époque de la Renaissance*, no. 2, Centre de Recherche sur la Renaissance italienne, Université de la Sorbonne Nouvelle (Paris, 1973), pp. 361–438.

Poeschke, J., "Donatello e i suoi . . . ," *Kunstchronik*, XXXIX (1986), p. 507.

Pope-Hennessy, J., "The Fifth Centenary of Donatello," in *Essays on Italian Sculpture*, Phaidon (London and New York, 1968), pp. 22–36.

Pope-Hennessy, J., *Fra Angelico*, Cornell University Press (Ithaca, 1974).

Pope-Hennessy, J., *Italian Renaissance Sculpture*, Phaidon (London and New York, 1971; second edition), pp. 247–68.

Pope-Hennessy, J., *Luca della Robbia*, Phaidon Press (Oxford, 1980).

Pope-Hennessy, J., "The Martelli David," *Burlington Magazine*, CI (1959), pp. 134–9.

Pope-Hennessy, J., *Paolo Uccello*, Phaidon (London and New York, 1969; second edition).

Popham, A., "Sogliani and Perino del Vaga at Pisa," *Burlington Magazine*, LXXXVI (1945), pp. 85–90.

Pozzi, M., *Lingua e cultura del Cinquecento*, Liviana (Padua, 1975).

Previtali, G., *Giotto e la sua bottega*, Fratelli Fabbri (Milan, 1967).

Prinz, W., "La seconda edizione del Vasari e la comparsa di 'vite' artistiche con ritratti," *Il Vasari*, XXII (1963), pp. 1–14.

Prinz, W., "Vasaris Sammlung von Künstlerbildnissen," *Beiheft, Mitteilungen des Kunsthistorischen Institutes in Florenz*, XII (1966).

Procacci, U., "Sull'allogagione e sull'esecuzione della tavola del Vasari per l'altar maggiore della Badia Fiorentina," *Antichità viva*, XXX (1991), no. 6, pp. 5–11.

Quint, D., *Origin and Originality in Renaissance Literature*, Yale University Press (New Haven and London, 1983).

Quiviger, F., "Aspects of the Criticism and Exegesis of Italian Art, circa 1540–1600," Ph.D. thesis, University of London, Warburg Institute (1989).

Quiviger, F., "Benedetto Varchi and the Visual Arts," *Journal of the Warburg and Courtauld Institutes*, L (1987), pp. 219–24.

Raffaello a Firenze, exhib., Palazzo Pitti (Florence, 1984).

Ragghianti, C.L., "Il valore dell'opera di Giorgio Vasari," *Critica d'arte*, XLV (1980), pp. 207–59.

Ragghianti Collobi, L., *Il Libro de' Disegni del Vasari*, 2 vols., Vallechi (Florence, 1974).

Rambaldi, P.L., "Dante e Giotto nella letteratura artistica sino al Vasari," *Rivista d'arte*, XIX (1937), pp. 286–348.

Rambaldi, P.L. "Vignone," *Rivista d'arte*, XIX (1937), pp. 357–69.

Ratti, M., and M. Cataldi, "La pittura in Duomo dal Cinque al Seicento," in *Livorno e Pisa: due città e un territorio nella politica dei Medici*, exhib., Nistri-Lischi (Pisa, 1980).

Rave, P.O., "Paolo Giovio und die Bildnisvitenbücher des Humanismus," *Jahrbuch der Berliner Museen*, I (1959), pp. 119–54.

Reynolds, T., "The 'Accademia del Disegno' in Florence, its Formation and Early Years," Ph.D. thesis, Columbia University (1974).

Riccò, L., "Tipologia novellistica degli artisti vasariani," in *Studi 1981*, pp. 95–115.

Riccò, L., *Vasari scrittore. La prima edizione del libro delle "Vite,"* Bulzoni (Rome, 1979).

Ricottini Marsili-Libelli, C., *Anton Francesco Doni. Scrittore e stampatore*, Sansoni (Florence, 1960).

Rilli, J., *Notizie letterarie ed istoriche intorno agli uomini illustri dell'accademia fiorentina*, Piero Matini (Florence, 1700).

Robertson, C., *"Il Gran Cardinale," Alessandro Farnese, Patron of the Arts*, Yale University Press (New Haven and London, 1992).

Robertson, C., "Paolo Giovio and the 'Invenzioni' for the Sala dei Cento Giorni," in *Atti del convegno Paolo Giovio. Il rinascimento e la memoria (Como, 3–5 giugno 1983)*, Società Storica Comense (Como, 1985), pp. 225–38.

Robey, D., "Humanism and Education in the Early

Quattrocento: the *De ingenuis moribus* of P.P. Vergerio," *Bibliothèque d'Humanisme et Renaissance*, XLII (1980), pp. 27–58.

Rochon, A., "Un date importante dans l'histoire de la *beffa*: la Nouvelle du Grasso legnaiuolo," in *Formes et significations de la 'beffa' dans la littérature italienne de la Renaissance*, no. 2, Centre de Recherche sur la Renaissance Italienne, Université de la Sorbonne Nouvelle (Paris, 1975), pp. 211–376.

Rochon, A., "Letteratura e società nel Rinascimento italiano," in *Il Rinascimento. Aspetti e problemi attuali. Atti del x congresso dell'associazione internazionale per gli studi di lingua e letteratura italiana (Belgrado, 17–21 ottobre 1979)*, ed. V. Branca *et al.*, Olschki (Florence, 1982), pp. 63–112.

Roio, N., "Intorno alla vasariana 'gara delle città' per Francesco Francia: alcune precisazioni sull'attività dell'artista per Modena e Reggio Emillia," *Antichità viva*, xxx, no. 3 (1991), pp. 5–16.

Rolova, A., "Alcune osservazioni sul problema del livello di vita dei lavoratori di Firenze (seconda metà del Cinquecento)," *Studi in memoria di Federigo Melis*, Giannini (Naples, 1978), iv, pp. 129–46.

Romano, G., *Storia dell'arte italiana*, Einaudi (Turin, 1981), VI.1, pp. 51–2.

Roos, P., *Sentenza e proverbio nell'antichità e i "Distici di Catone,"* Morcelliana (Brescia, 1984).

Rossi, A., "La Vita vasariana di Michelangelo curata da Paola Barocchi," *Paragone*, 178 (1964), pp. 71–80.

Rossi, P., *The Artist and Society in Sixteenth Century Italy – Benvenuto Cellini*, Manchester University Press (Manchester, 1994).

Rossi, P., "The writer and the man. Real crimes and mitigating circumstances: *il caso Cellini*," in *Crime, Society, and the Law in Renaissance Italy*, ed. T. Dean and K. Lowe, Cambridge University Press (Cambridge, 1993), pp. 157–83.

Rossi, S., *Dalle botteghe alle accademie. Realtà sociale e teorie artistiche a Firenze dal XIV al XVI secolo*, Feltrinelli (Milan, 1980).

Roth, C., *The Last Florentine Republic*, Russell and Russell (New York, 1968).

Rouchette, J., *La Renaissance que nous a léguée Vasari*, Société d'Édition "les Belles Lettres" (Paris, 1959).

Rubin, P., "The art of colour in Florentine painting of the early sixteenth century: Rosso Fiorentino and Jacopo Pontormo," *Art History*, XIV (1991), pp. 175–91.

Rubin, P., "The Private Chapel of Cardinal Alessandro Farnese in the Cancelleria, Rome," *Journal of the Warburg and Courtauld Institutes*, L (1987), pp. 82–112.

Rubin, P., "Raphael and the Rhetoric of Art," in *Renaissance Rhetoric*, ed. P. Mack, Macmillan (London, 1994), pp. 165–82.

Rubin, P., "Vasari, Lorenzo, and the myth of magnificence," in *Lorenzo il Magnifico e il suo mondo*, ed. E. Garfagnini, Olschki (Florence, 1994), pp. 178–88.

Rubin, P., " 'What men saw': Vasari's Life of Leonardo da Vinci and the Image of the Renaissance Artist," *Art History*, XIII (1990), pp. 33–45.

Rubinstein, N., "Vasari's Painting of the 'Foundation of Florence' in the Palazzo Vecchio," in *Essays in the History of Architecture Presented to Rudolph Wittkower*, ed. D. Fraser, H. Hibbard, and M. Lewine, Phaidon (London, 1967), pp. 64–73.

Rylands, P., *Palma il Vecchio. L'opera completa*, Arnoldo Mondadori (Milan, 1988).

Saccone, E., " 'Grazia, Sprezzatura, Affettazione' in the 'Courtier,' " in *Castiglione: The Ideal and the Real in Renaissance Culture*, ed. R.W. Hanning and D. Rosand, Yale University Press (New Haven and London, 1983), pp. 45–68.

Salerno, L., "Il Vasari in Inghilterra," in *Studi* 1950, pp. 168–71.

Salmi, M., "Due lettere inedite di Giorgio Vasari," *Rivista d'arte*, VIII (1912), pp. 121–4.

Salvini, R., *Giotto Bibliografia*, 2 vols., R. Istituto d'archeologia e storia dell'arte. Bibliografie e cataloghi, IV, Palombi (Rome, 1938).

Samuels, R.S., "Benedetto Varchi, the *Accademia degli Infiammati*, and the Origins of the Italian Academic Movement," *Renaissance Quarterly*, XXIX (1976), pp. 599–634.

Satkowski, L., *Giorgio Vasari, architect and courtier*, Princeton University Press (Princeton, N.J., 1994).

Satkowski, L., "Studies on Vasari's Architecture," Ph.D. thesis, Harvard University (1977).

Sbaragli, L., *Claudio Tolomei, umanista senese del Cinquecento. La vita e le opere*, Accademia per le arti e per le lettere (Siena, 1939).

Sborgi, "La cultura artistica in Liguria attraverso le *Vite* del Vasari," in *Atti* 1974, pp. 623–36.

Schlegel, U., "Problemi intorno al David Martelli," in *Donatello e il suo tempo. Atti dell'VIII Convegno Internazionale di Studi sul Rinascimento (Firenze-Padova, 25 settembre-1 ottobre 1966)*, Istituto Nazionale di Studi sul Rinascimento (Florence, 1968), pp. 245–58.

Schlitt, M., "Francesco Salviati and the Rhetoric of Style," Ph.D. thesis, Johns Hopkins University (1991).

Schlosser, J. von, *Die Kunstliteratur*, Kunstverlag Anton Schroll & Co. (Vienna, 1924).

Schlosser, J. von, *Präludien. Vorträge und Aufsätze*, Julius Bard (Berlin, 1927).

Schlosser Magnino, J., *La letteratura artistica*, trans. F. Rossi, ed. O. Kurz, 3rd ed., La Nuova Italia (Florence, 1977).

Schulz, J., "Vasari at Venice," *Burlington Magazine*, CIII (1961), pp. 500–10.

Sciolla, G., ed., *Il Disegno. I grandi collezionisti*, Istituto Bancario San Paolo di Torino (Milan, 1992).

Scorza, R.A., "Vincenzo Borghini and 'Invenzione': the Florentine 'Apparato' of 1565," *Journal of the Warburg and Courtauld Institutes*, XLIV (1981), pp. 57–75.

Scorza, R.A., "Vincenzo Borghini (1515–1580) and Medici Artistic Patronage," M.Phil. thesis, University of London, Warburg Institute (1980).

Scorza, R.A., "Vincenzo Borghini (1515–1580) as iconographic adviser," Ph.D. thesis, University of London, Warburg Institute (1987).

Scoti-Bertinelli, U., *Giorgio Vasari Scrittore* (Pisa, 1905).

Seigel, J., *Rhetoric and philosophy in Renaissance humanism. The union of eloquence and wisdom, Petrarch to Valla*, Princeton University Press (Princeton, N.J., 1968).

Semper, H., *Donatello. Seine Zeit und Schule*, Wilhelm Brautmüller (Vienna, 1875).

Shearman, J., *Andrea del Sarto*, 2 vols., Oxford University Press (Oxford, 1965).

Shearman, J., *The Early Italian Pictures in the Collection of Her Majesty the Queen*, Cambridge University Press (Cambridge, 1983).

Shearman, J., " 'Maniera' as an aesthetic ideal," in *The Renaissance and Mannerism: Studies in Western Art. Acts of the XXth International Congress of the History of Art*, Princeton University Press (Princeton, N.J., 1963), II, pp. 203–12.

Shearman, J., *Mannerism*, Penguin (Harmondsworth, Middlesex, 1967).

Shearman, J., *"Only Connect . . ." Art and the Spectator in the Italian Renaissance*, Princeton University Press (Princeton, N.J., 1992).

Shearman, J., *Raphael's Cartoons in the Collection of Her Majesty the Queen and the Tapestries for the Sistine Chapel*, Phaidon (London, 1972).

Shearman, J., "Raphael, Rome, and the Codex Escurialensis," *Master Drawings*, XV (1977), pp. 107–46.

Shearman, J., "The Vatican Stanze: Functions and Decorations," *Proceedings of the British Academy*, LVII (1972), pp. 3–58.

Short-Title Catalogue of Books Printed in Italy and of Italian Books Printed in Other Countries from 1465 to 1600 now in the British Museum, Trustees of the British Museum (London, 1958).

Siebenhuener, H., "Studi topografici per le 'Vite' del Vasari," in *Studi 1950*, pp. 105–10.

Simon, R.B., " 'Blessed be the hand of Bronzino': the portrait of Cosimo I in armour," *Burlington Magazine*, CXXIX (1987), pp. 387–8.

Simone, F., "La coscienza della Rinascita negli Umanisti. I," *La Rinascita*, II (1939), pp. 838–71.

Smith, C., *Architecture in the Culture of Early Humanism. Ethics, Aesthetics, and Eloquence 1400–1470*, Oxford (Oxford University Press, 1992).

Solerti, A., *Le Vite di Dante, del Petrarca e del Boccaccio scritte fino al secolo decimosettimo*, Vallardi (Milan, 1904–5).

Soussloff, C., "*Lives* of poets and painters in the Renaissance," *Word and Image*, VI (1990), pp. 154–62.

Spingarn, J., *A History of Literary Criticism in the Renaissance*, Columbia University Press (New York and London, 1889).

Spini, G., *Cosimo I e l'independenza del principato mediceo*, Vallecchi (Florence, 1980).

Starn, R., and L. Partridge, *Arts of Power. Three Halls of State in Italy, 1300–1600*, University of California Press (Berkeley, 1992).

Stephens, J.N., *The Fall of the Florentine Republic 1512–1530*, Clarendon Press (Oxford, 1983).

Stephens, J.N., "Giovanbattista Cibo's Confession," in *Essays Presented to Myron P. Gilmore*, ed. S. Bertelli and G. Ramakus, La Nuova Italia (Florence, 1978), I, pp. 255–69.

Stewart, P. "Giotto e la rinascita della pittura: 'Decameron' VI.5," *Yearbook of Italian Studies*, V (1983), pp. 22–34.

Stridbeck, G.C., "Raphael Studies. I. A Puzzling Passage in Vasari's 'Vite,' " in *Acta Universitatis Stockholmiensis IV. Stockholm Studies in the History of Art* (Uppsala, 1960), pp. 8–45.

Strocchia, S., "Burials in Renaissance Florence, 1350–1500," Ph.D. thesis, University of California (Berkeley, 1981).

Strocchia, S., *Death and Ritual in Renaissance Florence*, Johns Hopkins University Press (Baltimore and London, 1992).

Struever, N., *The Language of History in the Renaissance. Rhetoric and historical consciousness in Florentine humanism*, Princeton University Press (Princeton, N.J., 1970).

Stubblebine, J.H., *Duccio di Buoninsegna and His School*, Princeton University Press (Princeton, N.J., 1979).

Summers, D., *The Judgment of Sense. Renaissance Naturalism and the Rise of Aesthetics*, Cambridge University Press (Cambridge, 1987).

Summers, D., *Michelangelo and the Language of Art*, Princeton University Press (Princeton, N.J., 1981).

Summerson, J., *The Classical Language of Architecture*, Methuen (London, 1964).

Tafi, A., *Il sole racchiuso nei vetri. Guglielmo de Marcillat e le sue vetrate istoriate di Arezzo*, Ente provinciale per il turismo di Arezzo (Arezzo, 1988).

Tanturli, G., "Le biografie d'artisti prima del Vasari," in *Atti 1974*, pp. 275–98.

Testaverde Matteini, A.M., "La biblioteca erudita di Don Vincenzo Borghini," in *Medici 1980*, II, pp. 611–43.

Testaverde Matteini, A.M., "Una fonte iconografica francese di Don Vincenzo Borghini per gli apparati effimeri del 1565," *Quaderni di teatro*, II (1980), no. 7, pp. 135–44.

Thiem, C. and G., *Toskanische Fassaden-Dekoration in Sgraffito und Fresko. 14. bis 17. Jahrhundert*, Verlag F. Bruckmann (Munich, 1964).

Thoenes, C., "Galatea: Tentativi di Avvicinamento," and "La 'Lettera' a Leone X," in *Raffaello a Roma. Il Convegno del 1983*, Edizioni dell'Elefante (Rome, 1986) pp. 59–73, and 373–81.

Ticozzi, S., *Storia dei letterati e degli artisti del dipartimento della Piave*, Francesc' Antonio Tassi (Belluno, 1813), I, pp. 85–150.

Tiraboschi, G., *Storia della Letteratura Italiana*, VII, part 1 (Venice, 1796).

Toffanin, G., "Petrarchismo e trattati d'amore," in *Il Cinquecento, Storia letteraria di Italia*, Francesco Vallardi (Milan, 1929), VI, pp. 122–48.

Trachtenberg, M., *The Campanile of Florence Cathedral "Giotto's Tower,"* New York University Press (New York, 1971).

Trompf, G.W., *The Idea of Historical Recurrence in Western Thought: From Antiquity to the Reformation*, University of California Press (Berkeley, Los Angeles, and London, 1979).

Trovato, P., "Notes on standard language, grammar books and printing in Italy, 1470–1550," *Schifanoia*, II (1986), pp. 84–95.

Gli Uffizi: Catalogo Generale, Centro Di (Florence, 1979).

Ullman, B.L., "Leonardo Bruni and Humanistic Historiography," *Medievalia et Humanistica*, IV (1946), pp. 45–61.

Vallone, A., *Cortesia e nobiltà nel Rinascimento*, Arethusa (Asti, 1955).

Vallone, A., *L'interpretazione di Dante nel Cinquecento*, Olschki (Florence, 1969).

Vasoli, C., "Osservazioni sui 'Discorsi Historici Universali' di Cosimo Bartoli," in *Medici* 1980, II, pp. 727–38.

Venchi, I., "La veridicità di G. Vasari nella biografia del B. Angelico," in *Beato Angelico. Miscellanea di Studi* (Rome, 1984), Postulazione Generale dei Domenicani, pp. 91–124.

Venturi, L., "La critica dell'arte alla fine del Trecento. Filippo Villani e Cennino Cennini," *L'Arte*, XXVIII (1925), pp. 232–44.

Venturi, L., "Pietro Aretino e Giorgio Vasari," in *Mélanges Bertaux. Recueil de travaux dédié a la mémoire d'Emile Bertaux*, E. de Boccard (Paris, 1924), pp. 323–38.

Vigorelli, G., and E. Bacceschi, *L'opera completa di Giotto*, Rizzoli (Milan, 1977).

Voss, H., "Kompositionen des Francesco Salviatis in der italienischen Graphik des XVI Jahrhunderts," *Die graphischen Künste*, XXXV (1912), pp. 30–7.

Wallace, W., "Michelangelo at Work: Bernardino Basso, Friend, Scoundrel, and Capomaestro," *I Tatti Studies*, III (1989), pp. 235–77.

Wallace, W., "Michelangelo In and Out of Florence Between 1500 and 1508," in *Leonardo, Michelangelo, and Raphael in Renaissance Florence from 1500 to 1508*, ed. S. Hager, Georgetown University Press (Washington, D.C., 1992), pp. 55–88.

Ward, J., "From Antiquity to the Renaissance: Glosses and Commentaries on Cicero's *Rhetorica*," in *Medieval Eloquence. Studies in the Theory and Practice of Medieval Rhetoric*, ed. J.J. Murphy, University of California Press (Berkeley, Ca., 1978), pp. 25–67.

Ward, J., "Renaissance Commentators on Ciceronian Rhetoric," in *Renaissance Eloquence. Studies in the Theory and Practice of Renaissance Eloquence*, ed. J.J. Murphy, University of California Press (Berkeley, Ca., 1983), pp. 126–73.

Warnke, M., "Die erste Seiten aus den 'Viten' Giorgio Vasaris: Der politische Gehalt seiner Renaissancevorstellung," *Kritische Berichte*, V, no. 6 (1977), pp. 5–28.

Warnke, M., *Hofkünstler. Zur Vorgeschichte des modernen Künstlers*, DuMont (Cologne, 1985).

Warnke, M., *Künstler, Kunsthistoriker, Museen: Beiträge zu einer kritischen Kunstgeschichte*, C.J. Bucher (Lucern and Frankfurt, 1979).

Watson, P., "Brunelleschi's Cupola, a Great Hill of Earth, and the Pantheon," in *Renaissance Studies in Honor of Craig Hugh Smyth*, Giunti Barbèra (Florence, 1985), I, pp. 523–31.

Waźbiński, Z., *L'Accademia Medicea del Disegno a Firenze nel Cinquecento. Idea e Istituzione*, 2 vols., Olschki (Florence, 1987).

Waźbiński, Z., "Artisti e pubblico nella Firenze del Cinquecento. A proposito del topos 'cane abbaiante,'" *Paragone*, XXVIII, no. 327 (1977), pp. 3–24.

Waźbiński, Z., "La cappella dei Medici e l'origine dell'Accademia del Disegno," in *Medici* 1980, I, pp. 55–69.

Waźbiński, Z., "Giorgio Vasari e Vincenzo Borghini come maestri accademici: il caso di G.B. Naldini," in *Studi* 1981, pp. 285–300.

Waźbiński, Z., "L'idée de l'histoire dans la première et la seconde édition des 'Vies' de Vasari," in *Atti* 1974, pp. 1–25.

Webb, R., "The Transmission of the 'Eikones' of Philostratos and the Development of 'Ekphrasis' from late Antiquity to the Renaissance," Ph.D. thesis, University of London, Warburg Institute (1992).

Weise, G., *L'ideale eroico del rinascimento e le sue premesse umanistiche*, I, Edizioni scientifiche italiane (Naples, 1961).

Weise, G., *Studî sulla scultura napolitana del primo Cinquecento. Revisioni critiche, confronti ed attribuzioni*, Edizioni scientifiche italiane (Naples, 1977).

White, J., *Art and Architecture in Italy, 1250–1400*, Pelican History of Art, 2nd edition (Harmondsworth, Middlesex, 1987).

Wickhoff, F., "Über die Zeit des Guido von Siena," *Mitteilungen des Instituts für Oesterreichische Geschichtsforschung*, X (1889), pp. 224–86.

Wieruszowski, H., "Arezzo as a Center of Learning and Letters in the Thirteenth Century," *Traditio*, IX (1953), pp. 321–91.

Wilde, J., *Michelangelo. Six Lectures*, Oxford University Press (Oxford, 1978).

Williams, R., "Notes by Vincenzo Borghini on works of art in San Gimignano and Volterra: a source for Vasari's 'Lives,'" *Burlington Magazine*, CXXVII (1985), pp. 17–21.

Williams, R., "Vincenzo Borghini and Vasari's 'Lives,'" Ph.D. thesis, Princeton University (1988).

Wilson, S., *Saints and their Cults*, Cambridge University Press (Cambridge, 1983).

Winner, M., "Cosimo il Vecchio als Cicero. Humanistisches in Franciabigios Fresko zu Poggio a Caiano," *Zeitschrift für Kunstgeschichte*, XXXIII (1970), pp. 261–97.

Winner, M., "Il giudizio di Vasari sulle prime tre stanze di Raffaello in Vaticano," in *Raffaello in Vaticano*, exhib., Città del Vaticano, 1984–5, Electa (Milan, 1984), pp. 179–193.

Wittkower, R., and M., *Born Under Saturn, The Character and Conduct of Artists: A Documented History from Antiquity to the French Revolution*, The Norton Library, W.W. Norton & Company (New York, 1969).

Wohl, H., "Donatello Studien," *Art Bulletin*, LXXIII (1991), pp. 315–23.

Woodhouse, J.R., "Some Humanist Techniques of Vincenzio Borghini," *Italian Quarterly*, XV (1971), no. 58/9, pp. 59–86.

Woodhouse, J.R., *Vincenzio Borghini: scritti inediti o rari sulla lingua* (Bologna, 1971).

Woodhouse, J.R., *Vincenzio Borghini Storia della Nobiltà Fiorentina*, Edizioni Marlin (Pisa, 1974).

Woodward, W.H., *Studies in Education during the Age of the Renaissance 1400–1600*, Russell and Russell (New York, 1965).

Wright, D.R.E., "Alberti's 'De Pictura': Its Literary Structure and Purpose," *Journal of the Warburg and Courtauld Institutes*, XLVII (1984), pp. 52–71.

Zervas, D., "Lorenzo Monaco, Lorenzo Ghiberti, and Orsanmichele: Part II," *Burlington Magazine*, CXXXIII (1991), pp. 812–19.

Zervas, D., and M. Hirst, "Florence. The Donatello Year," *Burlington Magazine*, CXXIX (1987), p. 208.

Zimmerman, T.C.P., "Confession and autobiography in the early Renaissance," in *Renaissance Studies in Honor of Hans Baron*, ed. A. Molho and J.A. Tedeschi, Northern Illinois University Press (DeKalb, Ill. 1971), pp. 121–40.

Zimmerman, T.C.P., "Fabio Vigile's 'Poem of the Pheasant'. Humanist Conviviality in Renaissance Rome," in *Rome in the Renaissance. The City and the Myth*, ed. P.A. Ramsay, Center for Medieval and Early Renaissance Studies (Binghamton, N.Y., 1982), pp. 265–78.

Zimmerman, T.C.P., "Paolo Giovio and the evolution of Renaissance art criticism," in *Cultural Aspects of the Italian Renaissance. Essays in Honour of Paul Oskar Kristeller*, ed. C.H. Clough, Manchester University Press (Manchester, 1976), pp. 406–24.

Zimmerman, T.C.P., "Paolo Giovio and the Rhetoric of Life-Writing," in *Rhetorics of Life-writing in the Later Renaissance*, ed. T. Mayer and D.R. Woolf, University of Michigan Press (Ann Arbor, 1994).

Zimmerman, T.C.P., "Renaissance Symposia," in *Essays Presented to Myron P. Gilmore*, ed. S. Bertelli and G. Ramakus, La Nuova Italia (Florence, 1978), I, pp. 363–74.

INDEX

PHOTOGRAPH CREDITS